Christa Lichtenstern

Henry Moore

Work – Theory – Impact

German edition copyright © Deutscher Kunstverlag München, Berlin

English edition copyright © 2008 Royal Academy of Arts, London

Translation from the German: Fiona Elliott and Michael Foster
Copy-editor for the English edition: Andrea Raehs
Production: Jens Möbius
Design and layout: M&S Hawemann, Berlin
Printing and binding: DZA Druckerei zu Altenburg GmbH, Altenburg

British Library Cataloguing-in-Publication Data
A catalogue record for this book is available from the British Library
ISBN 978-1-905711-21-5

Distributed outside the United States and Canada
by Thames & Hudson Ltd, London

Distributed in the United States and Canada
by Harry N. Abrams, Inc., New York

Printed in Germany

Contents

For Heinz Demisch

(1913 – 2000)

Preface by Tony Cragg CBE RA

In 1983, having just finished installing my work in a gallery in Toronto, I decided to visit the local museum, the Art Gallery of Ontario. Unsuspectingly I entered into the gallery where 20 of Henry Moore's large plaster sculptures were exhibited. This group of sculptures were a gift from Henry Moore to the AGO of the original plaster works from which many of his best-known works had been cast in bronze. I immediately became engaged by these energetically carved sculptures and the vivid marks left by their shaping. A precise range of tools had left their marks sometimes as subtle erosive agents and sometimes as a clear vocabulary of expressive gestures, equivalent to brush strokes. The apparent looseness of these markings, however, never relinquished the wilful control of form. Sculptural volumes result out of the composition of planes (surfaces), their contours and their edges (lines) manifesting themselves on the visible periphery of the material. It is Moore's masterful control of these sculptural volumes that is the essence of his genius. The experience of looking at this group of sculptures leaves the observer in no doubt that he is in the presence of great sculptural intelligence. This may seem as obvious as saying that Mozart was musical but it was definitely for me an important experience to look at Henry Moore's work without the usual accompanying awareness of the historical importance of this iconic sculptor.

As a schoolchild growing up in the 50's one knew of Henry Moore. He was the epitome of a modern sculptor, highly regarded by some and highly criticised, even ridiculed by others. Known by people interested in art and to the man on the street he became a household name and the willing culture flagship to a nation in the process of losing an empire and having to re-define its roll in the world.

The enormous success of Henry Moore, who came from the town of Castlebury in the north of England and a working-class background, certainly did not come about because he made pleasing, popularistic sculptures. On the contrary, his work was challenging for the public of that time because he rejected classic figurative aesthetic and he was among the first generation of sculptors in Europe who endeavoured to create sculptures not based on representation but emotional responses to material forms. When he was given public commissions he uncompromisingly followed the dictates of his work, pushing forward, unconcerned by the expectations of others.

The fact that artists moved away from the classic ideals of sculpture at the beginning of the 20th C had at least two major causes.

Firstly, up to the end of the 19th C all sculpture had been based on the figure. The figure is the main source of an aesthetic value system with which we evaluate all other forms in our surroundings. It is impossible to regard even the smallest part of the figure without being aware that it has an emotional effect. The high degree of perfection in rendering the figure that was a characteristic of the Greco-Roman tradition provided European cultures with aesthetic ideals of the figure with which emotions, beliefs and moral values could be expressed. After many centuries of use and abuse, the terms had become unclear and generalised and sculpture became governed by a system of neo-classical conventions, incapable of expressing certain aspects of the modern world with its new awareness of psychology and passion for individual freedom. Rodin and Rosso had indeed breathed new life into figurative sculpture and widened its scope of expression. But, at the same time that they put new demands on the material, almost expecting it to quiver and vibrate with emotion, they also showed the limits of the classic figurative tradition.

The second factor in this change of orientation was the influence of the influx into Europe of art, sculpture and sculptural artefacts from Asia, Africa and the American continents, as well as the excavation of several ancient cultures in Europe and the Near East. Europeans became aware that the formal language and aesthetic values of other cultures were readable for them, sometimes more vital than their own and had the advantage of not having been over-exploited. Picasso and Brancusi are two artists whose work clearly evolved through this experience.

Moore started to absorb these influences as a student. Sir Michael Sadler's sculpture collection was one of his first sources and while studying in London, the well stocked British Museum and the museums nearby the sculpture department of the Royal College of Art were, as I experienced many years later, an invaluable source of form and information. He seems to have looked at anything that offered him a new idea or, a new form in which the human figure could be represented. He obviously regarded different cultures, different movements, different styles and different artists' work, whether past or present, as all being part of the options available. His ambition to make great sculpture for the world, in fact, almost obliged him to have studied all the possibilities.

In many ways his attitude is contrary to the idealised concept of an artist producing totally original work and seems to treat at least sculpture making, if not all art, as a discipline like physics and chemistry that builds to a great extent up on the accumulated ideas and knowledge gained by many individuals. This could be taken as an example of Moore's down-to-earth, practical honesty, it is at the very least the acceptance of the fact that artists do not work in a vacuum. Obviously, Moore was very aware of his cultural context and made his choices in the clear light of this awareness. A demystifying honesty, untypical of the modernist tradition, where the emphasis is on the individual and also interesting when considered in the context of the global academy of the present post-modern art world, where all cultures have been assimilated and all sources are available to everyone. The apparent conflict between the notion of the artist as a unique creative

individual and the notion of an artist as part of a common cultural effort did not exist for Moore. He apparently believed that in making good art – in his terms 'major art' – one was in fact making a new and better world, but the way to achieve this was to do it as an individual. Some of the individual traits that he brought to art were a hard working ethic, great self-confidence, a burning ambition and the talent to turn the observations of his unique surroundings and experiences into sculpture.

Perhaps simply because Moore's plaster sculptures in Toronto are whitish and calcareous they certainly look very much like the limestone outcrops so typical of the Yorkshire moors and reveal the direct relationship between his work and the landscape in which he grew up. It is a landscape of harsh beauty, austere and serene with farms sheltered in its dales and its wind swept heights are home only to the hardiest of creatures. The only figures that can survive in that landscape do not need to sustain flesh and bone they are them-selves wrought and hewn from archaic materials and reside in time. They could be pagan, early Christian, aliens or, figures of the future, time becomes irrelevant because they are an amalgam of all those possibilities and their destination is eternity. These high aims stand in stark contrast to the mundane, physical reality of the red brick two up, two down terraced houses of a small coal-mining town. A potential force field of influences that provided Moore with a sling shot ambition to use material to project ideals well and beyond that of a moribund industrial reality.

All art is dividable into three categories from which the themes, motives and subjects of art are derived – the figure, the landscape and the still-life. The figure in art is obviously of primary importance because it is a representation of ourself. Sculptures of the human form are always a direct expression of the artist and his cultures' emotions, values, and ideas. The differences in the figure throughout history and from culture to culture reflect the differences in aesthetic ideals, cultural values, the beliefs and notions held and technological development.

The figures of Moore have little in common with the pious, devoted figures of the Middle Ages, nor with the figures of the Renaissance that are created in a world in which knowledge is gained from observation and deduction and the individual emerges as being central to that process. They do, however, take some regard of the works of Degas, Renoir and Rodin in which it becomes evident that there are unseen micro and macro forces and structures that are causal to form, some of them are related to the scientific advances of that period and others are due to the psychological and philosophical speculations of Nietzsche, Freud and others. In the 20th century the figure is subject to scientific speculations that relativises it in time and space, this becomes apparent in the challenging perspectives of cubism and futurism, and at the same time it became revolutionised by societal and political movements that demonstrate drastically the possibilities for political and social organisation and construction. Both communism and fascism, both in their thesis and in their antithesis resulted in aesthetic ideals of the human figure.

Moore who survived the 1st World War as a soldier and documented the consequences of war for the civil population during the 2nd World War had been a witness to the atrocious conflicts of the modern world. His work developed at the same time that Bertrand Russel, T. S. Eliot and W. H. Auden influenced the intellectual climate of Britain, dealing with themes and issues of human existence in a modern society. His response to that tumultuous and at times catastrophic period in history was to develop figurative sculptures that seem apart from all chaotic evolution and that seem divorced from the daily struggles of everyday existence. The formal development of these figures starts as far back as the Sumerian sculptures that interested Moore, the epochs and geographies of different civilisations become distilled to form an image of mankind that is archetypal, stoic and timeless. Far from being only formal, which is a frequently heard criticism of Moore's work, these figures transport the values and morals that Moore saw as being eternal and relevant to all human beings. They provide a physical support to the humanitarian ideals of the time and they are an attempt to give modern man back his dignity after having been embroiled in the inhumanity of two world wars and his subjugation in a harsh industrial society.

As much as Henry Moore may have been interested in making art that would be historically important, an aim that he definitely achieved, there is nothing conclusive or definitive about his use of the figure in art. The figure remains the central motif of art today, but the 21st century figure is not the same subject as at the time of Moore. It is related to all other biological structures, plant or animal, with whom we share the planet now and to all who have ever existed in the past. Making forms based on the exterior appearance of skin stretched over bone and muscle is only one way of describing the human body, but it is a method unable to express the metabolic and psychological complexities of humans that are interconnected genetically, culturally and economically.

The landscape as subject in sculpture almost enjoyed a renaissance due to the work of Henry Moore. His work has at times an almost geological quality, having been hewn out and eroded it often emerges out of the ground or from a plinth-like device that holds different elements together, giving the appearance of rock formations. This reference gives the work an almost geological timescale usually unobtainable by human beings. Moore placed his work outdoors, often directly in the landscape, more than any other sculptor previously had done. As a result, the landscape, which had been neglected for many years, became the focus of attention for artists.

If it is possible to relate the figure of today to all other organisms that ever existed and in doing so give all living material a special status in a hierarchy of materials (thinking material being at the top) then it is possible to regard any biological niche or framework of existence as a landscape. Whether at the bottom of the ocean, or on the surface of a distant planet, in a microscopic cell, or even in a space made out of complicated numbers all of these possibilities become landscapes.

It is perhaps particularly significant that the third thematic category of art, the still life, is almost non-existent in the works of Henry Moore. It is exactly this category of art that was to dominate, in many ways, the art of the 20th C. Even in the late 19th C artists had become aware of all the things that human beings produce to make their existence more comfortable. Accelerated by industrial production, the world began to fill up with man-made things. Artists like Van Gogh observed and commented on these things around them, but it was left to Marcel Duchamp to first use these objects in his art. This large group of objects that mitigate between the human figure and its environment are an essential part of our existential strategy. Dada, Fluxus, pop-art, arte povera and a great deal of the art of the late 20thC and early 21stC reflects on, and uses man-made objects, in an attempt to give this production meaning and poetry. Moore ignores this possibility. These human products are basically designed to help us survive and keep our naked bodies from the naked earth. This, however, is exactly what Moore wants, humanity denuded of all its accessories, strong and capable of survival, its strongest defence against the elements lies in the quality of human relationships. The figures he made are for the greater part female. Strong, natural and protective, at times they protect their off-spring in their embrace and at others they watch over and protect the observer who walks into their circumference.

Moore's contribution to art does not lie in the introduction of new materials into the realm of sculpture, he uses the traditional materials of sculpture and in doing so allows himself to be compared to a long tradition of sculpture making. His motif is the human figure and time is a factor. His work reminds us that for whatever reasons we are here and however long human beings exist, the form, shape and quality of this existence lays in our hands.

With his monumental works in bronze, stone and wood, seen today in locations throughout the world, Henry Moore (1898–1986) set new standards for the art of sculpture. Wherever these powerful motifs are to be found – in dialogue with trees, rocks, hills and lakes; holding their own against a high-rise building, or appealing directly to passers-by in a public space – they generate a rarely seen wealth of formal associations, interacting with their viewers and presenting them with entirely new spatial modes. For over half a century Moore's unique understanding of organic forms and their innate rhythms, his ability to incorporate hollows, holes and interstices into his works, and his sculptural analogies to the landscape, opened up new perspectives in attitudes to sculpture. By way of an introduction to his oeuvre, the first part of this study focuses, in chronological order, on groups of thematically related sculptures. Through his work, Moore exerted an unparalleled influence on a whole generation of younger artists, and part two examines the thinking that formed the basis of his theory of sculpture and its role in society today. The third section concentrates on the wide-ranging reception and impact of Moore's work, copiously exemplified with relation to artists from seven different countries, cultures and backgrounds, always paying due critical attention to the precise situation of these artists, be it in the East or the West.

The young Henry Moore was not only fully alert to the formal and thematic advances made by the pioneers of modern sculpture in the early twentieth century in London and Paris, but was also able to absorb these and ultimately produce a body of work in his own right that could take its place in the realms of 'humanity and form'. It was his declared aim – whatever the situation and in whatever new forms – to preserve, above all, the 'humanity' of his chosen genre. In doing so he was consciously establishing himself within the ongoing traditions of 'great art', towards which he always felt the highest responsibility – an attitude that no doubt cut him off from certain aspects of contemporary practice.

Numerous publications on a wide variety of aspects of Henry Moore's life and work have appeared over the years. But this study is the first to show that, as an artist, he had a highly individual and often theoretically grounded concept of sculpture. This concept arose as much from his lifelong interest in nature as from his sense of history, which in turn fuelled his forays into ethnology and his profound understanding of the development of sculpture through the ages in a whole range of cultures. Ultimately it was these myriad interconnections and his deep love of nature that gave his sculptures – be they figurative, biomorphous or purely abstract – their own supra-individual air of alert confidence.

To describe Moore as a representative of the second wave of Modernism is perfectly reasonable as long as this is not taken to imply that he was also an eclectic of sorts. The major retrospective at the Museum of Modern Art, New York, in 1946 and his receipt of the International Prize for Sculpture at the 1948 Venice Biennale established, once and for all, his reputation as one of the leading twentieth-century sculptors. By the 1950s and 60s he was universally accepted as having done for sculpture what Picasso had done for painting. With hindsight, it is clear that despite certain – often astonishing – similarities, the two artists were in fact worlds apart.

The first part of this study is primarily a chronological examination of the issues raised by the sculptural work of Henry Moore. Comparisons with the work of other artists such as Paul Cézanne, Henri Gaudier-Brzeska, Jacob Epstein, Aristide Maillol, Alexander Archipenko, Constantin Brancusi, Ossip Zadkine and Pablo Picasso are used to paint a picture of the full range of the sources of the young Moore's artistic inspiration. Arising from this is his finely calibrated response to surrealist imagery and concepts, which was to shape his œuvre as a whole. Moore's answer to the Surrealists' interest in the *objet trouvé* was the biomorphism of his *Transformation Drawings*, where he transmuted found, natural items – bones, pebbles, shells and the like – into new figures, humans and hybrid beings. This process, above all his characteristic treatment of bones, is analysed in detail in the pages to follow. Moore also reacted to and entered into dialogue with the work of specific artists, such as the surrealist output of Alberto Giacometti for one. Between 1936 and 1940 Moore often exhibited with the Surrealists, with whom he shared a keen interest in tribal masks, artefacts and everyday items. In his own unique way, above all in his drawings, he mastered the art of metamorphosis and double images. The formal freedom and greatly widened horizons that Moore acquired through his contact with Surrealism and the work of Picasso eventually led him to his own fluidly biomorphous image of the human figure. Yet his work was never other than firmly grounded in Nature and Moore constantly returned to re-examine and to deploy in new figurations the forms and rhythms that underpin the endless variety of shapes found in the human being, animals, plants, trees, shells, roots, stones and bones.

The artistic expertise, openness and flexibility that Moore developed in part through his active participation in the Surrealist movement allowed him to create a particular sense of artistic ambivalence and ambiguity in the *Shelter Drawings* that he was to produce during the war years. Moore sought to delve deeper into the given situation – thousands of Londoners sheltering in underground stations during air raids – and focussed on the human being at this extreme of existence, be it stoically holding out, uneasily asleep, or rigid with a fear that is close to death.

After the Second World War, when it seemed that there was a widespread reassessment underway of existing ethical and Christian values, Moore turned his attention to the matter of artistic tradition. As he deepened his understanding of

the Classical art of Antiquity, the images of recumbent figures and the use of drapery that he had developed in the *Shelter Drawings* took on a new importance. Consequently an entire chapter of Part I is devoted to Moore's progressive reconciliation with the Classical art that he had scorned as a young man caught up in the wake of Modernism and so called Primitivism.

This is followed by a detailed examination of Moore's late work and the new phenomenology of divided figural composition that first appeared as part of his output in 1959. From the 1960s onwards, Moore's work was to play a crucial part in the rapidly growing importance of sculpture in public places. With renewed vigour he sought to engage with architecture and, even more so, with the landscape. In his mature work he still wanted to alert his viewers to the fact that we live our lives surrounded by an overwhelming wealth of sculptural forms that impinge on us as human beings and that – like us – are determined by their own particular proportions. Moore felt compelled to explore these analogies in his sculptural work, and there was no question in his mind that these three-dimensional forms had both a spiritual being and a personality.

The chapter 'The Irish-Anglo-Saxon Constant' explores the question of Moore's particular 'Englishness', tapping into the role of Englishness in British art as championed in the 1930s by Moore's friend the poet, art critic and curator Herbert Read, and that has a new relevance in terms of present-day globalisation.

In the last chapter of Part I the aim is to locate Henry Moore in the history of sculpture as a whole. The historical yardstick used here is the life and work of Auguste Rodin. By investigating the various elements that either link or separate Moore from the predecessor he so admired, it is possible to cast a useful light on his own historical position.

Part II presents the first comprehensive exploration of Moore's own sculptural theory, with specific reference to its guiding principles and basis in the history of aesthetics. The point of departure is the belief that it is essential to be aware of the historical background and range of Moore's aesthetic principles in order to arrive at a more precise understanding of the way he managed, so comprehensively, to embrace both tradition and Modernism. During the course of this exploration it soon becomes apparent that, in his use of terms such as 'organic whole' and 'spiritual vitality', Moore was operating in a realm that had its roots in German Idealism but also extended into English Romanticism. In addition to this there is ample evidence of his interest in the work of Johann Wolfgang von Goethe, whose 'Prometheus' he illustrated in 1949. He favoured the same empirical approach to Nature as the German polymath and a similar, albeit intuitive, attitude to the laws governing the development of natural forms. This can be seen both in the group of reclining figures in wood,

and even more strikingly in his 'own' evolution of internal and external forms. A number of other concepts that he constantly referred to – balance, rhythm, size, space, intensity and metaphor – are also examined in terms of their importance for the sculptor Henry Moore. All these various ideas come together in his declared aim to unite 'humanity and form'. Despite Moore's avowedly sceptical attitude to theory, the foundations of his own thinking are revealed in the subtlety of his approach to aesthetics and aesthetic terminology.

Finally, in Part III, the perspective changes once again as the focus turns to the impact of Moore's artistic work since 1945 in the diverse political contexts of East and West Germany, Great Britain, the United States, Japan, Russia and Poland. As though his lifelong efforts to do justice to both abstraction and figuration had been skewed by a distorting mirror, the West was predominantly attracted by the surrealist, biomorphous, abstract works while the East preferred the legacy of the figurative, 'Classical', Moore working in the 1940s (as in the *Shelter Drawings*) and 1950s.

These trends and their cultural and political implications by definition point to Moore's sheer artistic versatility. Artists of very different nationalities and nurtured by diverse artistic traditions, but with a common respect for Moore's work, developed similar interests entirely independently of one another. The most frequent instances of direct influence may be seen in the following thematic areas: reclining figures, *taille directe*, Archaism, Surrealism, analogies to Nature, the victims of war, holes and biomorphous abstraction. The reader will discover for him or herself how artists the world over have had a hand in affirming the lasting importance of Moore's work.

The response to Moore's art was only so strong because – as anyone who studies his work will very quickly realise – he would never have been satisfied with the notion of 'art for art's sake'. His insistent investigations into the essence of form and its relationship to the space around it took him into many different areas – both cultural and political. All his life he was an avid reader. At the age of nineteen he wrote a stage play and he actively sought the company of poets and writers – Herbert Read, Stephen Spender, W. H. Auden, Maurice Ash and Walter Strachan were just some of his literary friends. As a student, he was invited to dinner parties at the home of William Rothenstein where he became personally acquainted with T. S. Eliot and William Butler Yeats. It is likely that he also met D. H. Lawrence, all of whose novels he had of course read. And he readily declared his allegiance to other authors, too: 'Tolstoy, Dostoyevsky, Stendhal formed a secret part of me. Their works help one to understand, to grow up, to change; algebra or electronics do not change one, I do not think so.'[1]

On a political level, Moore's left-wing convictions first came to the fore in the 1930s. Born into a Socialist household, Moore had no hesitation in taking a clear stand, together with his fellow Surrealists, against the rise of Fascism in Europe. As a

member of the Artists International Association (AIA) he found himself, in 1935, on the organising committee of the exhibition *Artists Against Fascism*, to which he also contributed. In 1936 he was one of the signatories to a document protesting against the British policy of non-intervention in Franco's Spain. Published with a drawing by Moore, this document declared that 'Economic justice is the first object of our intervention, but we demand also the vindication of the psychological rights of man, the liberation of intelligence and the imagination. Intervene as Poets, Artists and Intellectuals by violent or subtle superversion and by stimulating desire.' On 1 May 1936 Moore and other members of the AIA marched through the streets of London with a large banner bearing William Blake's dictum: 'A Warlike State Cannot Create.'[2]

Letters have survived from the years 1939–40 where Moore does not hide his aversion to Hitler, Fascism or any form of war. It seems highly unlikely that the *Shelter Drawings* could have had the same enduring impact were it not for their underlying acute sense of the monstrous nature of the Second World War. It was therefore only natural that, after 1945 when the country was struggling to get back on its feet, Moore was ready as an artist, an author and an interviewee to play his part whenever required in helping to meet the country's cultural and educational needs. Partly from a humanist sense of duty, he took on commissions for schools and churches in the wave of urban construction following the war, published large editions of his own prints for schoolchildren and was for many years on the boards of the National Gallery, the Arts Council of Great Britain, the Tate Gallery and on other committees promoting the arts in his native country. And in fact he served his country well. Under the auspices of the meticulously organised exhibitions that the British Council presented from 1948 onwards, Moore's name and his work became widely known – even far into the Eastern Bloc – and for decades successfully flew the flag of British culture and democracy abroad. Anyone who chooses to censure Moore for his tireless production can only be unaware of his sense of the deep-rooted place of high art within the intellectual and moral history of the nation as a whole. The contrast with our own time, which sets such store by living in the present, is all too apparent. The fact is that after the war, all over Europe, there was a hunger in the arts for free, humanist-democratic thinking. And time has shown that despite all the hindrances put in their way, the best artists on the other side of the Iron Curtain were striving for the same thing.

Like many others, Moore felt that the Second World War had changed him. Looking back he once commented: 'Without the war, which directed one's direction to life itself, I think I would have been a far less sensitive and responsible person – if I had ignored all that and went on working just as before. The war brought out and encouraged the humanist side in one's work.'[3] In the postwar Western World, Humanism was as

highly regarded a guiding principle as Christianity and Democracy. For Moore, the 'human values' that he strove for also involved the formation of the individual personality through art; this in turn made demands both on the individual and on civilised society – demands that Moore, for his part, did his best to live up to.

It was in this context that he accepted a commission in 1955, when he was invited to place a work of his own choosing outside the newly constructed UNESCO headquarters in rue Ségur in Paris. The five-metre long *Reclining Figure* in travertine, which was unveiled in November 1958 (fig. 1), was his largest sculpture to date. With its biomorphic concentration of balance, life and alert self-assurance, it embodies an image of humanity that, nurtured by his intense study of nature, had been germinating in Moore's mind since the 1930s. The aesthetics of the open, organic form he presented in Paris, is very much in keeping with his view of the arts as an 'organic process', which he urged UNESCO to support.[4] It is as though his UNESCO figure perfectly reflects this process: the human being and Nature are united in one over-arching rhythm.

There are certain books that take half a lifetime to complete. The subject matter, on one's mind for years at a time, can dip away out of sight for an equally long period, only to surface again later, clamouring for attention.

The decision to devote some serious study to the work of Henry Moore dates back to my student days in 1969, when I found myself drawn time and again to the Mathildenhöhe in Darmstadt, to the exhibition *Henry Moore* (70 Years of Henry Moore, documentation collected and edited by David Mitchinson). Even at that early stage I knew I wanted to understand the principles underpinning Moore's language of forms. Without a camera to my name, I spent hours drawing. Nine years later David Mitchinson took me on a tour of the, as yet unfinished, home of the Henry Moore Foundation in Much Hadham. That same year, on 12 October 1977, I met Henry Moore face to face for the first time. On this occasion and at subsequent meetings up until 1982 – in Much Hadham and once in Frankfurt am Main – our conversations were initially about his thoughts on the subject of metamorphosis. At the time I was preparing my habilitation thesis on this major issue in modern art, which was to include a number of relevant case studies. But soon our conversations were ranging far more widely – much of which is reflected in this volume.

It is solely due to the support of numerous friends and colleagues that this book now exists in its present form, despite the many necessary interruptions in the shape of other research projects, the demands of wide-ranging academic commitments and, not least, the inescapable requirement to participate in the implementation of never-ending university reforms. My sincerest thanks go to all of them. And I should

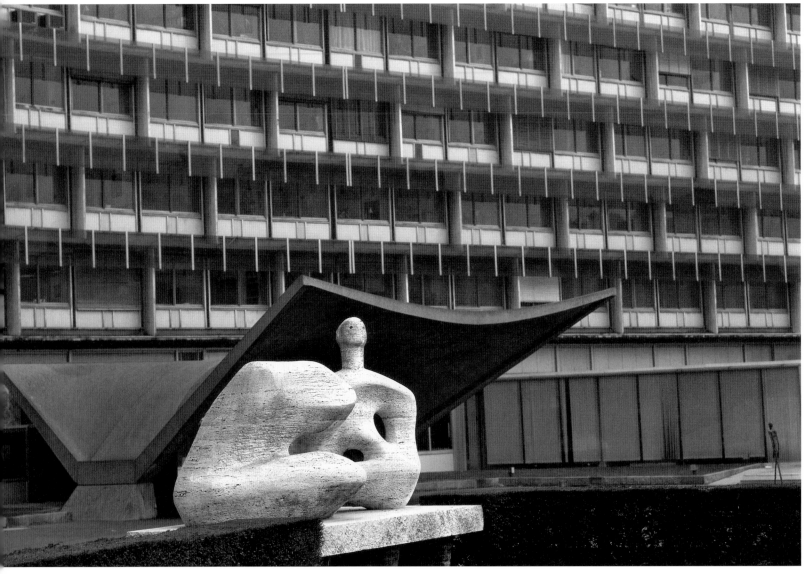

1 *Reclining Figure*, 1957/58, Roman Travertine marble, L. 500 cm, UNESCO-Building, Paris (LH 416)

like to dedicate this book to my father, the painter and writer Heinz Demisch (1913 – 2000), as an expression of my deep gratitude for his intellectual encouragement and unwavering loyalty.

Acknowledgements

Over the years I have been immensely grateful for the support I have received from the Henry Moore Foundation and for the numerous opportunities I have had to consult the archives in Much Hadham and Leeds. From the outset I was always able to turn for help and advice to David Mitchinson, Head of Collections and Exhibitions at the Henry Moore Foundation, and I am immensely grateful for that. In addition, this study could never have been published without the generous assistance with printing costs provided by the Foundation. My heartfelt thanks for this go to the Directors past and present, Sir Alain Bowness, Tim Llewellyn and Sir Richard Calvocoressi. I should also like to express my gratitude to the staff at the Foundation for their tireless help, in particular Anita Bennet, Emma Stower, John Farnham, Pru Maxfield, Martin Davis, Malcolm Woodward, Betty Tinsley (1906–1998) – Henry Moore's wonderful secretary – Angela Dyer, Julie Summers, Juliet Wilson, Alexander Davis and Michel Muller. I owe a very particular debt of gratitude to the Foundation's Archivist, Michael Phipps, who never let a single question go unanswered and was kind enough to read the manuscript for me.

At the Saarbrücken Institute I was immensely fortunate to receive editorial support from Myriam Elburn, Sandra Brutscher, Regina Maria Hillert, Larissa Ramscheid, Susanne Schmitz and, above all, Liane Wilhelmus; in Berlin I was assisted by Marion Thielebein. I should also like to thank the Institute's photographer Jörg Pütz for the new photographs (figs. 295–299a) taken at the Museum Würth in Schwäbisch-Hall. I also greatly appreciated the conversations I was able to engage in with expert colleagues, above all Andrew Causey (Manchester), Richard Morphet (London), Peter Anselm Riedl (Heidelberg), Brigitte Scheer (Frankfurt a.M.), Werner Schnell (Göttingen), Heribert Schulz (Osnabrück), Gunther Thiem (Stuttgart) and Eduard Trier (Köln). My thanks go to Andrea Raehs (Berlin) for reading the manuscript with her customary efficiency and commitment. I have Jürgen Geiger (Stuttgart) to thank for his advice and for making the connection with the Royal Academy. I should also like to thank the translators Michael Foster (chapters I–1, 2, 3, 5) and Fiona Elliott (the remaining chapters) for all their efforts. My particular thanks of course go to the Deutscher Kunstverlag, Elisabeth Roosens and the members of her staff, in particular the production team of Jens Möbius and M&S Hawemann for all the editorial care they have taken with this book.

At the Royal Academy my sincere gratitude goes to David Breuer, Nick Tite and Peter Sawbridge. I thank them for their interest and for doing me the honour of accepting this title as a Royal Academy book.

Besides the Henry Moore Foundation, my grateful thanks also go to my other sponsors: Johanna Quandt, Ernst von Siemens Kunststiftung, Aventis foundation, ALTANA, Kohl-Pharma, Swiss-Life, Ralf Kirberg, Saarland University, Saarbrücken, Hans-Joachim Throl and Reinhold Würth. Their generous support for this book secured its existence and gave this author the courage she needed.

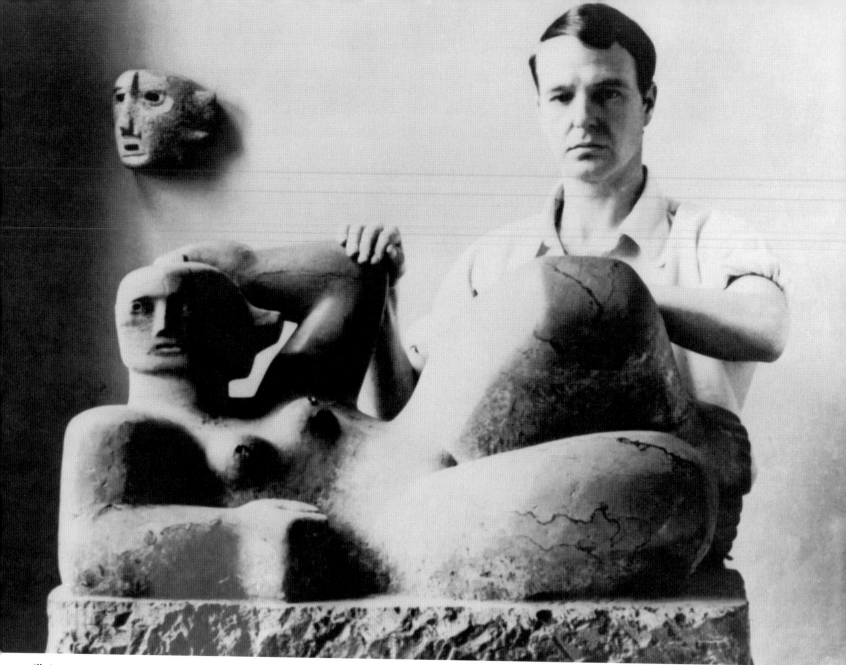

Ill. 1 Moore with *Reclining Figure*, 1930

Work

1. The Early Work

The *Reclining Figure* of Leeds (1929) and its Aztec Ancestor

The *Reclining Figure* of 1929 in the collection of Leeds City Art Galleries (fig. 2) is a landmark in Henry Moore's development of an expressive, archaicising style of sculpture. The figure encapsulates everything the young artist had learned in the first ten years of his career, all the impressions he had gained in Leeds, London, Paris and Italy, filtered through his own poetic sensibility. Those familiar with the sculpture from reproductions will be surprised to find that the original is only 84 centimetres long: illustrations make it appear considerably more monumental. The figure's real size becomes clear from a contemporary photograph showing the young Moore standing behind it with a resolute air (ill. 1). Raised on a high pedestal, as in the picture, the sculpture could be viewed as a whole as well as in terms of the original block of stone. The shape of the block possessed its own expressive power and the artist wished this to remain visible in the final image. To achieve his prime aim of preserving what he called 'stoniness'[1] he needed to work in a way that respected the qualities of the material.

This meant carving directly[2] from the hard Hornton stone in order to release the appropriate forms from within it. Moore accommodated the reclining figure so rigorously to the rectangular block that the stone's edges – existing and imaginary – seem to press in on it from all sides.[3] The block thus dominates the pose and the proportions of the figure: its presence is felt in the right-angles of the arms, in the shortness of the trunk, in the sharp bend of the lower legs and in the identical height of the left arm and leg. All parts of the body appear equally heavy.

This process of abstraction, in the sense of of deriving the structure of a figure from a block of stone, was founded in the following:

- a profound knowledge of the human body acquired through constant drawing from life;
- the artist's discovery of an Aztec *Chacmool* in Paris (fig. 7) and a resulting study of the history of sculpture, initially in books, then in the British Museum and the Victoria & Albert Museum in London;
- an approach orientated towards 'primitivism' as pioneered or practised by Paul Cézanne, Aristide Maillol, the Cubists

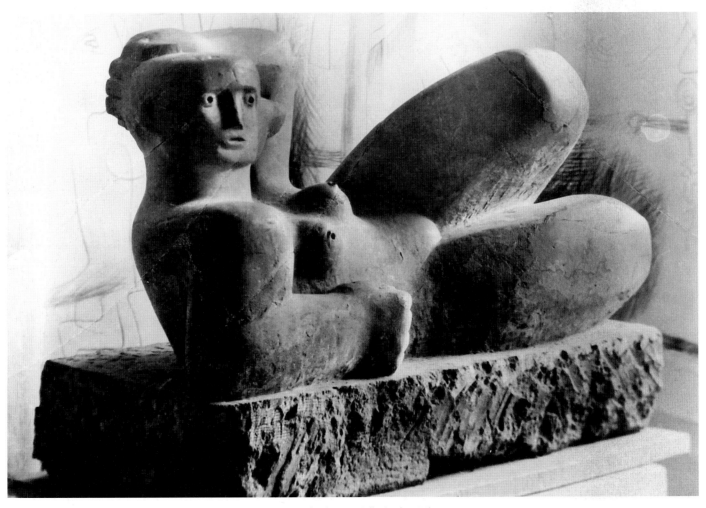

2 *Reclining Figure*, 1929, Brown Hornton stone, L. 83.8 cm, Leeds City Art Galleries (LH 59)

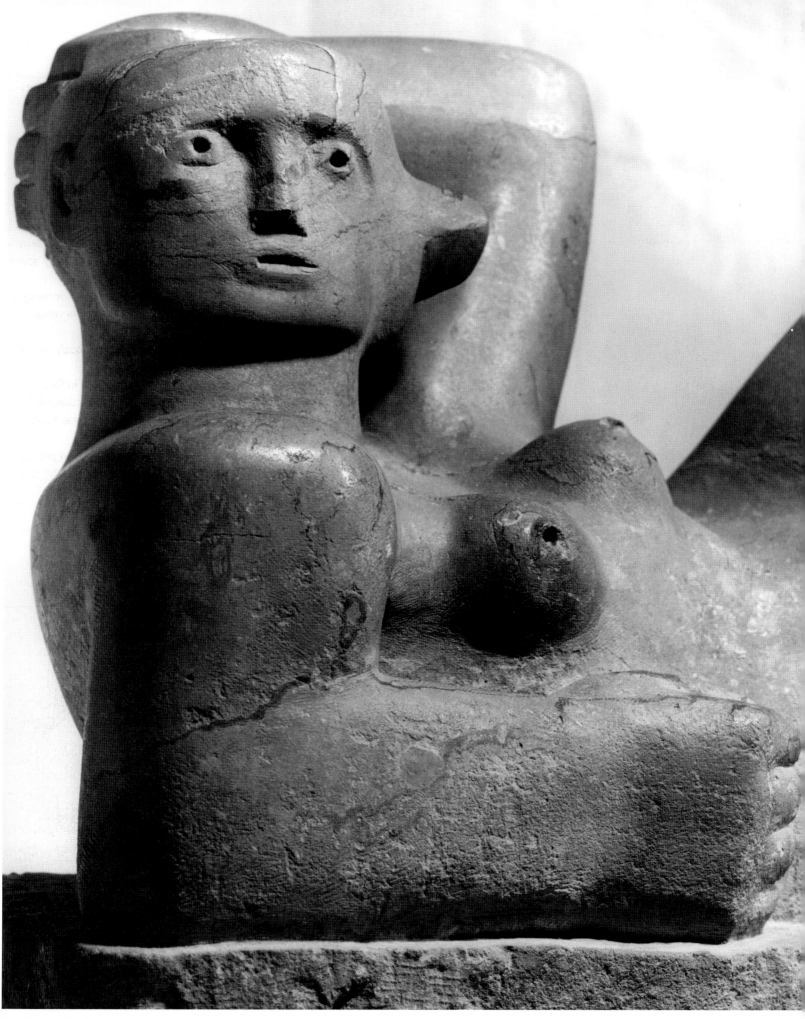

2a Detail of fig. 2

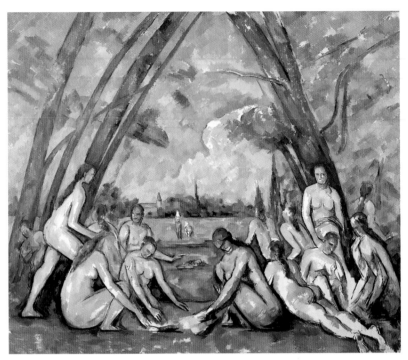

3 Paul Cézanne: *The Large Bathers*, 1895–1905, Oil on canvas, 208.5 x 251.5 cm, Philadelphia Museum of Art, W. P. Wilstach Collection

and, in particular, Henri Gaudier-Brzeska, Jacob Epstein, Ossip Zadkine, Aleksandr Archipenko and Pablo Picasso;
– an emphasis on the aesthetic properties of materials.

Moore himself spoke of life drawing and the study of works in museums, especially the British Museum, as the two pillars of his art. As regards life drawing, he gritted his teeth and patiently went through all the stages of academic artistic drill, beginning in 1919 with copies of poor plaster casts of antique statues[4] and ending in 1923 with some astonishingly fluent studies of nudes produced at the Royal College of Art in London, under his revered teacher Leon Underwood.[5] In 1924 he 'changed sides', teaching sculpture for seven years as an assistant at the Royal College, before becoming head of the new sculpture department at the Chelsea School of Art. In all his years as a teacher he set great store by life drawing. From the early 1920s to the early 1950s his draughtsmanship was augmented by a large number of preparatory sketches for sculptures, but time and again in his career he devoted himself exclusively to drawing from the model.[6] All his life he schooled his vision by studying the human body, although direct anatomical studies are extremely rare in his oeuvre.[7] He aimed instead to grasp the figure as a whole, interested less in surface appearances than in the correct disposition of volumes. His weighty, matron-like female figures stand firmly and calmly (see fig. 200) or sit in relaxed, clearly 'legible' poses: momentary gestures, erotic displays or individualised faces are nowhere to be found. Moore drew people as if they were envel-

oped in their own destiny. In their apparent simplicity they radiate an unbroken existential force.

Almost inevitably, this unshakable feeling for human dignity, and its embodiment in clearly constructed images, attracted Moore to Cézanne's late nudes. Already in Leeds he had seen work by the French artist in the collection of Sir Michael Sadler,[8] but his most far-reaching encounter with it occurred in Paris during the Whitsun of 1922, when he visited the home of Auguste Pellerin, a wealthy margarine manufacturer who had opened his collection of contemporary art to the public and who owned no less than eighty-nine Cézannes. In the entrance hall of Pellerin's house Moore saw Cézanne's foremost legacy in the realm of figure painting, the *Large Bathers* of 1895–1905 (fig. 3), now in the Philadelphia Museum of Art.[9] It made a 'tremendous impact' on him, 'the triangular bathing composition with the nudes in perspective, lying on the ground as if they'd been sliced out of mountain rocks. For me this was like seeing Chartres Cathedral.' The painting was 'the biggest effort that Cézanne made in all his life'.[10]

Later that year, in London, Moore made drawings of three figures from a reproduction of the *Large Bathers*[11] and thereafter would repeatedly return to the theme. In 1926, for example, he took his cue from the nude in its left foreground when sketching a seated figure with raised right knee (fig. 4) that seems to directly embody Cézanne's dictum: 'treat nature in terms of the cylinder, the sphere, and the cone'.[12] In a highly finished pen and ink drawing of 1925, *Three Figures against Tree Trunks* (fig. 5), Moore explored the compositional possibilities of massive female bodies with trees in a manner familiar to him from Cézanne's painting. In December 1960 he eventually acquired a Cézanne of his own, an oil study of *Three Women Bathers*, which he described as 'the joy of my life'.[13] His study of this canvas confirmed in him the belief that Cézanne's figures harboured a 'full realisation of the three-dimensional form'.[14] In a film made by the BBC in 1978 he demonstrated this by modelling individual figures from the painting in clay, then arranging the pieces in space so as to correspond to their position on the picture plane.[15] In this three-dimensional maquette, *Three Bathers – After Cézanne*, the figures could thus be drawn from every angle.[16] In the entire history of their artistic reception Cézanne's bathers have only once been addressed with comparable creative intensity, by Picasso.

Despite a clear preference for female nudes, Moore made drawings on a range of different subjects, including the occasional portrait, a few landscapes, figures not related to sculptures at all and fantastical abstractions.[17] His work reveals a constant delight in experimenting with combinations of various techniques. Until the early 1950s the largest number consisted of sheets of studies in which he jotted down ideas for sculptures or developed individual three-dimensional forms. This process of formal invention could sometimes extend over

4 *Notebook No. 6*, p. 57: *Reclining and Seated Figures*, 1926, Pencil, 22.3 x 17.3 cm, The Henry Moore Foundation, AG 26.27v (HMF 452)

5 *Three Figures against Tree Trunks*, c. 1925, Pen and ink, pencil, chalk, 19 x 17.8 cm, Withworth Art Gallery, University of Manchester, AG 25.88 (HMF 350)

several years. Indeed, one of the most fascinating aspects of Moore's drawings is that they enable the viewer to trace the course of a motif or the genesis of a major idea over long periods.[18]

The history of the Leeds *Reclining Figure* (fig. 2), for instance, has been chronicled by Alan Wilkinson using the artist's sketchbooks.[19] Some *Studies for Sculpture* (fig. 6) in *Notebook No. 2* of 1921–22 include two small sketches from memory of an Aztec *Chacmool* that Moore himself declared to have exerted the greatest influence on his early work (fig. 7). He first encountered it in the form of a plaster cast in the Musée de l'Homme (Musée du Trocadero) in Paris; then, around 1927, he discovered a reproduction of it in Walter Lehmann's book *Altmexikanische Kunstgeschichte* (1922)[20] and drew a number of variations on it in *Sketchbook 1928: West Wind Relief*.[21] Finally, in 1928 he made these variants the basis of the definitive, magisterial Study for the Reclining Figure in Leeds (fig. 8). All that remained of the original figure was its general geometrical cut, the head turned sharply over the shoulder to look to one side, the round fullness of the arms and legs (in different positions) and the aura of watchfulness. Asked by Wilkinson what it was about the original that had impressed him so deeply, Moore replied: 'its stillness and alertness, a sense of readiness, and the whole presence of it, and the legs coming down like columns.'[22] In 1941 he said of Aztec sculpture in general that it attracted him because of its '"stoniness", by which I mean its truth to material, its tremendous power without loss of sensitiveness, its astonishing variety and fertility of form-invention and its approach to a full three-dimensional conception of form, make it unsurpassed in my opinion by any other period of stone sculpture.'[23]

In the drawing Moore made considerable changes to the Aztec image. He transformed the clothed warrior, priest or offertory figure (with which scholars now tentatively identify the type)[24] into a female nude and thus transported it into his own formal world. He also made it more asymmetrical, by abandoning the rigid deportment of the original body, its position lying on its back and the parallel raised knees. As Dörte Zbikowski has noted, Moore 'dynamised the immobile reclining pose, the static calm of the *Chacmool*'.[25] In the final sculpture the artist moved even further away from this repose and 'breathed suppleness and life into the hard material of stone. As it turns on its side, the figure now opens up in space'.[26] In animating the figure in this way, he reduced the stylisation apparent in the drawing in, for example, the rather contrived correspondence of the left hand with the stepped area of hair above. The dominant feature of the sculpture is the control exercised over volumes. The abstraction applied to the figure in the drawing by enclosing it in a system of horizontal, vertical and diagonal lines is achieved in the sculpture by granting an almost tangible presence to the block of stone from which it was carved.

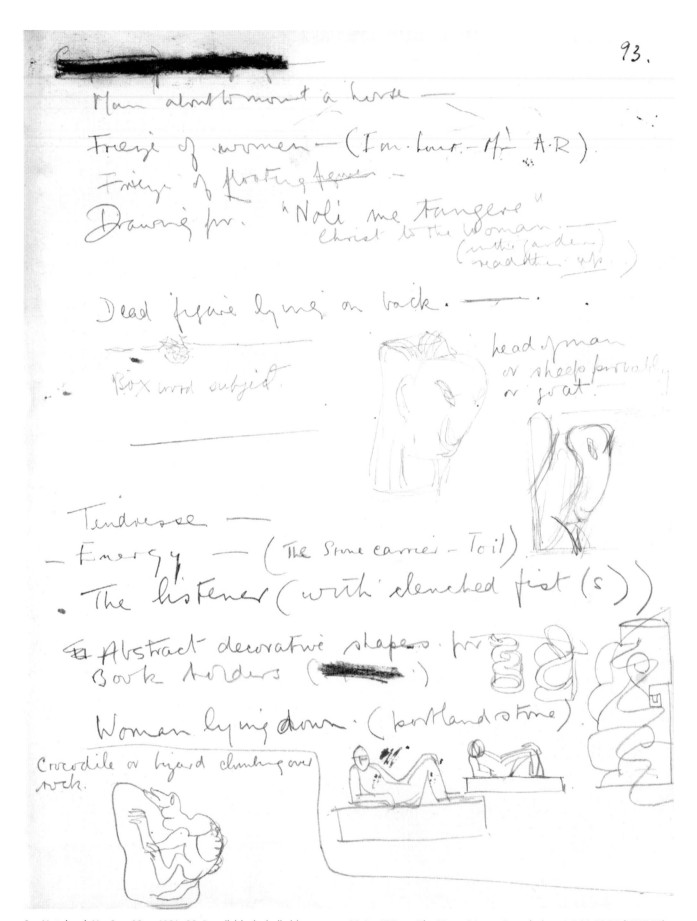

93.

Man about to mount a horse —

Frieze of women — (Im. Lour. M^r A·R)

Frieze of floating figures —

Drawing for. "Noli me tangere"
Christ to the Woman
(in the garden)
(read them up.)

Dead figure lying on back. —

Box wood subject.

head of man
or sheep perhaps
or goat.

Tendresse —
— Energy — (The Stone carrier – Toil)
. The listener (with clenched fist(s))

☒ Abstract decorative shapes for
Book borders (━━━━)

Woman lying down. (Portland stone)

Crocodile or lizard climbing over
rock.

6 *Notebook No. 2*, p. 93, c. 1921–22, Pencil, black chalk, blue crayon, 22.4 x 17.5 cm, The Henry Moore Foundation, AG 21-22.32 (HMF 66)

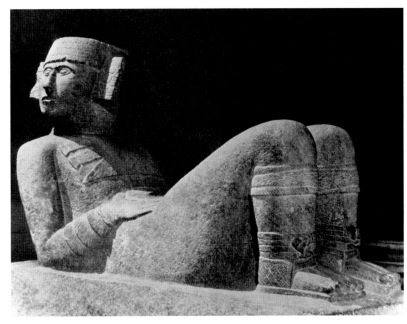

7 *Chacmool from Chichen Itza*, Maya – Toltecan (or Toltec), 11–12 century, Stone, L. 156 cm, H. 109 cm, D. 80 cm, Museo Nacional de Anthropologia, Mexico City

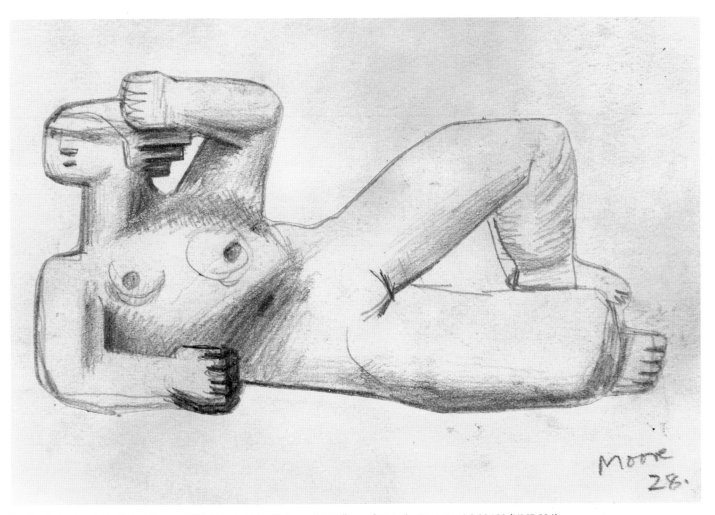

8 Study for *Leeds Reclining Figure*, 1928, Pencil, 12.1 x 18.1 cm, Art Gallery of Ontario, Toronto, AG 28.169 (HMF 684)

'Primitivism' as Liberation

It would be difficult to overestimate the importance of Moore's discovery of the *Chacmool* for his archaic depiction of the human figure and for his treatment of volume in a way compatible with stone. His free assimilation of its influence in 1929 represented the most successful result to date of a learning process he had embarked on deliberately, a process that established the 'primitive' tenor of his early work and was to inform the rest of his career as an artist: an unstinting exploration of the history of sculpture throughout the world, and of all times. Moore undertook this task with remarkable assiduousness. When he was finally able to commence his training as an artist at the age of twenty-one, after serving in the First World War and being gassed at the battle of Cambrai, he began teaching himself the basics of art history at Leeds public library. The thoroughness of his efforts is reflected in the *History of Sculpture Notebook* of 1920.[27] In thirty-nine pages of text and twenty-six drawings he recorded the characteristic features of Chaldean, Babylonian, Assyrian, Greek and Roman sculpture. In 1920 he investigated the principal ideas behind the work of Michelangelo, who was to become a lifelong paradigm.[28] Finally, he cultivated an interest in Greek, Roman, Byzantine, Gothic and Renaissance architecture.

In Leeds public library Moore chanced upon a copy of *Vision and Design* (1920), a collection of essays by the painter and leading British art critic Roger Fry. In two major exhibitions Fry had introduced London to the work of Cézanne, Gauguin, the Fauves and the Cubists.[29] His observations in the essay 'Negro Sculpture' were innovative and brilliant. Moore recalled: 'Fry [...] stressed the "three-dimensional realisation" that characterised African art and its "truth to material". More, Fry opened the way to other books and to the realisation of the British Museum. That was really the beginning.'[30] The artist pursued his interest in the history of European and non-European sculpture in a number of other ways. It was very important to the young miner's son that the Vice-Chancellor of Leeds university, Sir Michael Sadler, invited him to inspect his renowned art collection, which included work by Honoré Daumier, Gustave Courbet, Cézanne, Gauguin and Henri Matisse, along with examples of African art.[31] Sadler had acquired works by Wassily Kandinsky when he visited the artist in Bavaria, and in 1914 his son Michael had translated Kandinsky's *Über das Geistige in der Kunst* (1911), so it may be assumed that Moore was familiar with the treatise.[32]

Once in London Moore became something of a protégé of the director of the Royal College of Art, William Rothenstein, who recommended him to his brother Charles Rutherston. Moore visited the latter in Bradford and wrote enthusiastically to his friend Jocelyn Horner of a 'good opportunity of seeing probably one of the most important collections (outside museums) of ancient Chinese Art in England – besides [...] ex-amples of Negro [...] Scythian, Siberian, Archaic Greek & Egyptian Art'.[33] This juxtaposition of art from various cultures also fascinated Moore on his visits to the British Museum. In 1926, in *Notebook No. 6*, he was to write: 'Keep ever prominent the big view of sculpture – the world tradition'.[34] Fifty years later he explained: 'I was discovering that there could be, I thought, a world tradition of sculpture – for I found the same "form-idea", the same pose and compositional arrangement in a Negro sculpture from Africa as in an Eskimo sculpture from Alaska, thousands of miles away. Perhaps I believed there is something common in human nature which, in expressing in sculpture our human condition, through the human figure, simplifies it in some universal form-language. I think that by "World Tradition" and the "big view of sculpture" I was meaning something like that.'[35]

An entire book could be written about Moore's engagement with this 'world tradition' and its effect on his work: scholars have investigated only a few aspects of the subject.[36] The artist's study of the formal characteristics of non-European sculpture, principally African carving and the 'primitive' art of Oceania, Mexico, Alaska and Peru, is extensively documented in his early sketchbooks. He copied works reproduced in Carl Einstein's *Negerplastik* (Negro Sculpture; 1920), Herbert Kühn's *Die Kunst der Primitiven* (The Art of the Primitives; 1923) and Leo Frobenius's *Kulturgeschichte Afrika* (A Cultural History of Africa; 1930). As will be shown in the next chapter of this book, Moore's imagination was also fired by the second issue of *Minotaure* (June 1933), which contained a lavishly illustrated account of an ethnological expedition from Dakar to Somalia with, among other things, insights into the customs and rituals of the Dogon people.[37]

In the field of non-European art, as in everything else, Moore's changing interests were constantly reflected in his drawings and sculptures. As a carver in stone and wood, his approach to materials directed him first to the beauty of concise forms, fully worked out in space, rigorous and internally coherent. Then, in his Surrealist phase he was captivated by the new imaginative world of forms engendered by defamiliarisation, metamorphosis and magic. In old age, finally, after reassessing the ancient Greek art that he had still rejected in 1930,[38] he attained a kind of vital objectivity, as revealed in his many sculptures of animals and in his drawings after a fourth-century Persian sculpture of a lynx in his possession.[39]

In discovering 'primitive' sculpture for himself, the young Moore was naturally standing on the shoulders of such pioneers as Gauguin, Gaudier-Brzeska, Epstein, Constantin Brancusi, Picasso, Matisse, André Derain, Ernst Ludwig Kirchner, Karl Schmidt-Rottluff, Archipenko, Jacques Lipchitz and Zadkine. Non-European art helped them all to establish and maintain a modernist stance. In this sense Moore's attitudes were inherited; and indeed, he was acquainted personally with Epstein, Brancusi, Picasso, Zadkine and Lipchitz. Yet none of

his predecessors kept the history of sculpture as a whole in their artistic sights over a period of decades as he did. He combined this historical approach with strong didactic interests. In showing visitors items from his collection he wished to broaden their horizons, to open their eyes to the 'universal form-language' that he felt had existed at all times. As a sculptor, he sought to promote awareness of similarities and differences within a constant stream of expressive 'form-ideas' from all cultures and countries. When Moore commented on major works in the British Museum – observations that resulted in *Henry Moore at the British Museum*, a book published in 1981 and quickly out of print[40] – he wished not only to provide new information on his own work, but also to awaken an understanding in the general public for that 'humanity of form'[41] which in his opinion all works of art shared.

In view of the young Moore's thirst for new stimuli it is scarcely surprising that he investigated closely the work of some of the pioneers named above, including its 'primitive' aspects. Alan Wilkinson has shown how familiar he was with the painting of Gauguin, for example,[42] and Moore's compelling slate *Relief Head* of 1923 suggests that he also knew carvings by the French artist.[43] Equally clearly, Moore paid a great deal of attention to the work of Gaudier-Brzeska and Epstein. When he moved to London in 1921, the turbulent pre-First World War days of Vorticism, the first major avant-garde movement in twentieth-century Britain, were already history and Gaudier-Brzeska, the bold experimenter, had been killed in action at the age of twenty-three.

Ezra Pound who, along with Wyndham Lewis, was the *spiritus rector* of Vorticism and inventor of its name,[44] had left London for Paris in 1920. Pound, Lewis and their friends Gaudier-Brzeska, David Bomberg, Jacob Epstein, Frederick Etchells, Cuthbert Hamilton and Edward Wadsworth used the word 'vortex' to denote a whirlwind of spiritual energy issuing from a creative centre. Moore recalled: 'Wyndham Lewis meant a lot to me in my early days, because at that time the Bloomsbury Group dominated English art. When I came to London as a raw provincial student, I read things like *Blast* and what I liked was to find somebody in opposition to the Bloomsbury people, who had a stranglehold on everything. Lewis was literally a blast of fresh air to me: offering not so much a belief or particular attitude as an opening-up, a freeing, which was a great help. Gaudier's writings and sculpture meant an enormous amount as well – they, and *Blast*, were a confirmation to me as a young person that everything was possible, that there were men in England full of vitality and life.'[45] In 1926 Moore made the acquaintance of Epstein, the second pillar of Vorticist sculpture after Gaudier-Brzeska.[46] Both touched the nerve centre of Moore's concerns, drawing on the formal potential of 'primitive' sculpture (which Epstein also collected)[47] and, as direct carvers, adhering to the doctrine of truth to materials.

More Early Inspiration

Under the Spell of Henri Gaudier-Brzeska

Henri Gaudier-Brzeska and Jacob Epstein both influenced Moore strongly, but in altogether different ways: in theoretical and formal terms he undoubtedly benefited more from the former, a French artist who had settled in England. Moore soon came across Pound's *Gaudier-Brzeska: A Memoir* (1916), which he found 'a great help and an excitement [...]. This was written with a freshness and an insight, and Gaudier speaks as a young sculptor discovering things.'[48] There was indeed no better introduction to the irrepressible Frenchman's fascinating personality and his necessarily small, stylistically diverse œuvre than this well-illustrated volume.[49] Moore must have sensed the enthusiasm of the poet who had shared the Vorticist years with Gaudier, who recognised a kinship between his own use of language and sculpture, had commissioned a colossal bust-length portrait of himself from the sculptor[50] and who was able to describe clearly the most significant features in the life and work of a friend six years his junior.

The aspects emphasised by Pound included:
– great value attached to stone or wood as artistic materials and to carving them directly,
– the importance of the resulting rigorous forms as an expression of authentic feeling, reality and intensity,[51]
– a predilection for sculptures of animals, to which Gaudier-Brzeska brought 'in this case an abnormal sympathy with, an intelligence for, all moving animal life, its swiftness and softness',[52]
– Gaudier-Brzeska as a 'complete artist'. As such, he possessed extensive knowledge both of his art and of things outside it. His quick intelligence and his capacity for 'form-understanding' gave 'an ability to 'arrange in order' not only the planes and volumes which are peculiarly *of* his art, but an ability for historical synthesis.'[53]

Pound's observations could equally well be applied to the artist that Moore was in the process of becoming, especially if one adds the primary importance that both sculptors attached to drawing, however different their use of the medium may have been.[54]

In Pound's book Moore first encountered an oft-quoted statement of his predecessor's, the sentiments of which he was to make very much his own: 'Sculptural energy is the mountain. – Sculptural feeling is the appreciation of masses in relation. – Sculptural ability is the defining of these masses by planes.'[55]

The volume reprinted in full, moreover, the two articles that Gaudier had published in *Blast* in 1914 and 1915. As a survivor of the First World War, Moore will have been especially struck by the following passage from the second article, written in the trenches and published posthumously: 'My views on

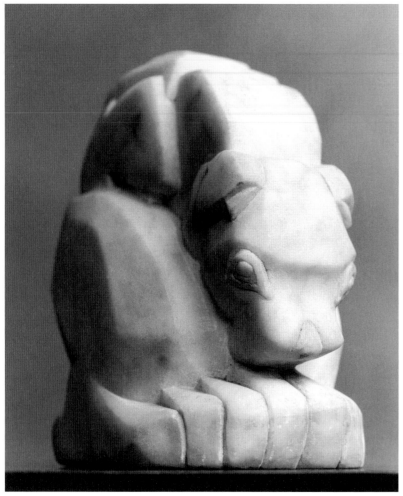

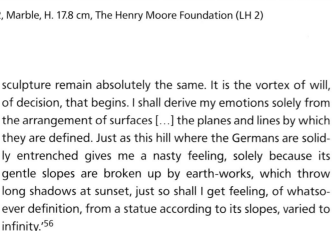

9 *Dog*, 1922, Marble, H. 17.8 cm, The Henry Moore Foundation (LH 2)

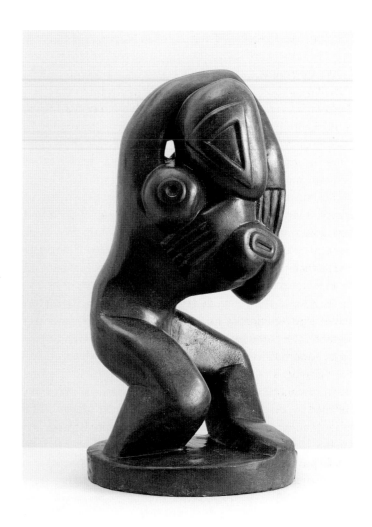

10 Henri Gaudier-Brzeska: *Red Stone Dancer*, 1913, Mansfield Stone, H. 43 cm, Tate Britain, London

sculpture remain absolutely the same. It is the vortex of will, of decision, that begins. I shall derive my emotions solely from the arrangement of surfaces […] the planes and lines by which they are defined. Just as this hill where the Germans are solidly entrenched gives me a nasty feeling, solely because its gentle slopes are broken up by earth-works, which throw long shadows at sunset, just so shall I get feeling, of whatsoever definition, from a statue according to its slopes, varied to infinity.'[56]

This existential approach to form must have affected Moore deeply. As embodiments of their creator's will, Gaudier-Brzeska's sculptures now began to speak to him with a different voice. Gaudier's invocation of energy, which he identified as movement tamed by a rigorous arrangement of planes, was clearly reflected in the major Vorticist works illustrated in Pound's book. Uniting Cubist and Futurist elements with features derived from African and Oceanic art, Gaudier's staccato-like formal structures bore witness to a range of influences as wide as that which Moore had been aiming for. Moore was no doubt also impressed by the juxtaposition of

abstraction and figuration in Gaudier's work,[57] a free combination of two modes that he himself was likewise to hold in balance. Furthermore, he encountered in Gaudier a passionate exponent of personal feeling in sculpture and perhaps this is reflected in the importance he later accorded the notion of 'intensity'.[58]

These parallels in the two artists' thinking find an echo in some early stone sculptures by Moore that reveal the influence of Gaudier-Brzeska's Vorticist work. In *Dog* of 1922 (fig. 9),[59] his first piece in marble, Moore created, not without a touch of wit, a many-faceted structure in which he seems to have inscribed features derived from Gaudier's elemental visual vocabulary. Note, for instance, how the front paws are arranged neatly in a triangle beneath the towering back. Gaudier's *Red Stone Dancer* of 1913 (fig. 10)[60] reveals a similar combination of geometrical and stylised organic forms, and a triangle appears in relief on the figure's face – a shape that a number of Gaudier's drawings suggest he developed from the triangular noses of Cycladic heads. In addition, the block-like form of *Dog* recalls Gaudier's own faceting of *Deer* (1914).[61]

The dovetailed head and body shapes in Moore's *Duck* of 1927 (fig. 11)[62] also recall Gaudier's Vorticist *pièce de résistance Bird Swallowing a Fish* (fig. 12),[63] while its polygonal base is reminiscent of his *Upright Birds*.[64] Or again, the cool charm of Gaudier's *Torso*[65] of 1913 is clearly felt in Moore's unusual *Torso*[66] of 1925–26. And as late as 1934 some of Moore's sketches for sculptures (for example, fig. 13)[67] are reminiscent of the geometrical syntax and additive vertical structure of Gaudier's small cut-brass *Torpedo Fish or Toy* (fig. 14).[68]

Beyond such individual points of contact with Gaudier-Brzeska's work, Moore was inspired by the French sculptor's new approach to sculpture as the product of the artist's will alone, an approach encouraged by the example of Brancusi and Archipenko. As expressed in Gaudier's sharply rhythmical arrangements of planes and lines, this corresponded exactly to Moore's desire for stony hardness, formal concentration and energy. Additionally, Moore paid homage to the mountain metaphor favoured by Gaudier in his statements (and adopted by Moore himself[69]), probably nowhere more so than in the marvellous *Mother and Child* of 1925 (figs. 15, 16). The Vorticist staccato of volumes, the subtle spatial approach to line evident in the diagonals, horizontals and angled verticals (note the child's right arm) and the combination of this with organic rounded masses (as in the full breast and in the child's head as seen in the side view [fig. 16]) do indeed cause the group to rise up in front of the viewer like a mountain.

The Influence of the Vorticist Jacob Epstein

Gaudier-Brzeska's early death meant that he remained a legendary figure for Moore. In Jacob Epstein, on the other hand, he found a friend and supporter. The two men first met in 1926. Believing that the young sculptor had a future, Epstein, who was eighteen years Moore's senior, not only purchased work by him, but also promoted his cause in newspaper articles and, in 1931, by writing the foreword to the catalogue of an exhibition of Moore's work.[70] In 1928 Epstein had helped secure Moore his first important public commission: *West Wind Relief* (fig. 150) for the façade of the headquarters of the London Underground.[71] In 1930 Moore joined Epstein and John Skeaping as representatives of the new British sculpture at the Venice Biennale. Since creating the *Tomb of Oscar Wilde* (Paris) in 1912, Epstein had repeatedly been vilified in the press. The hostile reception accorded Moore's early exhibitions was mild compared to the vituperative attacks occasioned by such works of Epstein's as *Hudson Memorial (Rima)* of 1925 and *Genesis* of 1931.[72] In his obituary of Epstein Moore gratefully recalled that the older man had taken the brunt of public insults and thus warded off criticism from the following generation of sculptors.[73]

Aside from the exceptional case of the radical *Rock Drill*,[74] Epstein's Vorticist work evinces several points of contact with

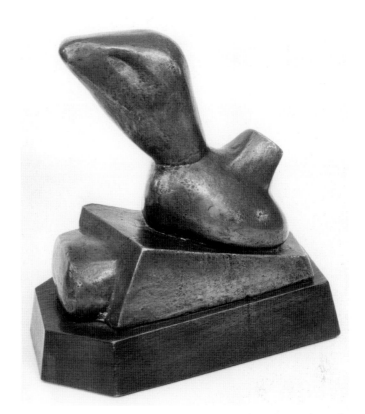

11 *Duck*, 1927, Cast Concrete, H. 15.25 cm, Private Collection (LH 44)

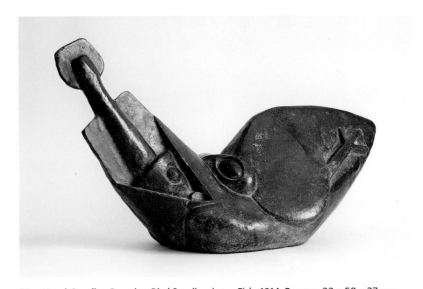

12 Henri Gaudier-Brzeska: *Bird Swallowing a Fish*, 1914, Bronze, 33 x 58 x 27 cm, Kettle's Yard, University of Cambridge

13 *Ideas for Metal Sculpture*, 1934, Pen and ink, brush and ink, wash, watercolour, 38.1 x 27.9 cm, Private Collection, AG 34.49 (HMF 1100)

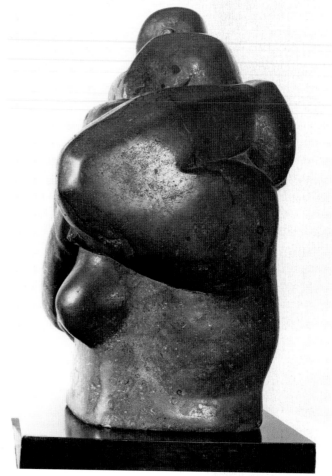

16

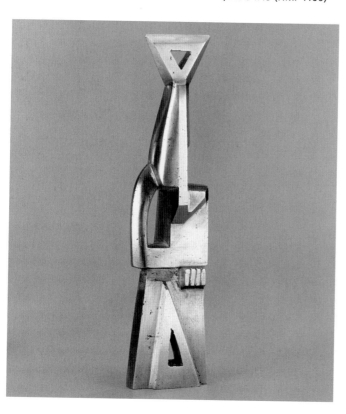

14 Henri Gaudier-Brzeska: *Torpedo Fish or Toy*, 1914, Bronze, 15.9 x 3.8 cm, Kunsthalle, Bielefeld

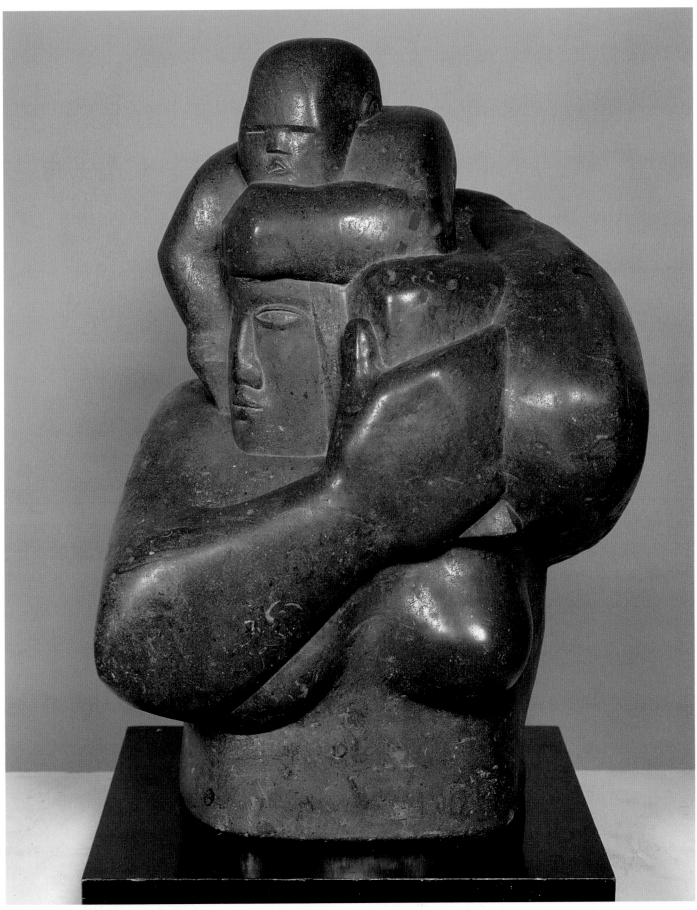

15/16 *Mother and Child*, 1925, Hornton stone, H. 56 cm, Manchester City Art Galleries (LH 26)

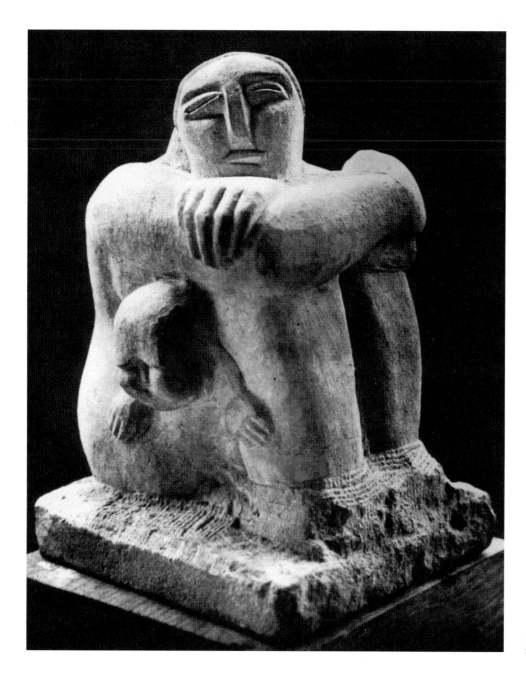

17 *Mother and Child*, 1922, Portland stone, H. 28 cm, Private Collection (LH 3)

Moore's early 'truth to materials' sculptures. His powerful *Mother and Child* (fig. 17) from the summer of 1922, for instance, would seem to be based on the same model as Epstein's *Sun Goddess, Crouching*[75] of 1910 (fig. 18): an Aztec *Seated Man* (fig. 19) in the British Museum, which Epstein must have known and for which Moore declared his admiration.[76] Both artists transformed the male statue into a female figure. Epstein attenuated the proportions of the model and showed the figure grasping her ankles in such a way that the fingers recall the decorative features on the legs of the Aztec god. Moore, on the other hand, retained the cubic form of the body, along with the folded arms and parallel legs 'coming down like columns'. The child, however, represents a major

departure from the model, appearing at the side with its large head as though it had burrowed its way through its mother's body with both hands in search of a lookout. The side view thus grants the sculpture a strikingly individual, almost anecdotal character. The turn of the mother's head towards her child is another important change, countering the orthogonals of the block-shaped body.

A comparable three-dimensional thrust counteracts the unity of the block in a different way in the stone sculpture *Two Heads* (fig. 20) of 1924–25. From a herm-like block, the artist carved two heads, one behind the other, one taller than the other. The taller head faces forwards, the smaller, behind it, upwards. The juxtaposition of two sculptural entities of dif-

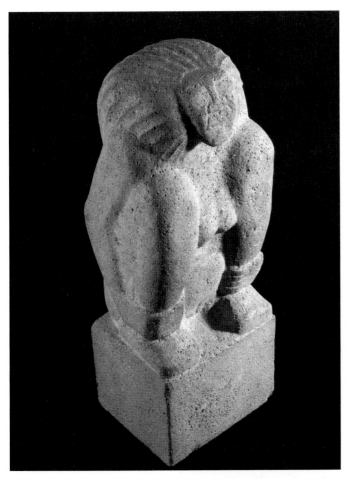

18 Jacob Epstein: *Sun Goddess, Crouching*, c. 1910, Limestone, 36 x 11 x 13 cm, Nottingham City Museums and Galleries

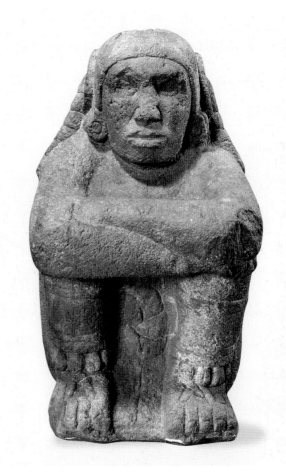

19 *Sitting Man*, ceremonial figure of the god Xochipilli, the 'Flower Prince', from Mexico, Aztec, 1325–1521, stone, 55 x 32 cm, Ethno.1825.12-10 (Bullock Coll.), British Museum, London

fering height – a task that was to attract Moore on several occasions[77] – recalls the second version of Epstein's *Doves* of 1914–15 (fig. 21).[78] Moore probably also knew Epstein's marble *Mother and Child* of c. 1913–15 (fig. 22),[79] in which the two heads are united in a 'chaste and frontal frieze',[80] aligned firmly to face the viewer. Epstein here mixes reminiscences of ovoid heads by Brancusi with elements derived from African woodcarving. Richard Cork has shown that the eyeless head of the mother in this work, which he calls 'one of the most advanced European sculptures of the time',[81] is a simplified version of that in an African Fang carving that Epstein had acquired from Brummer in Paris in 1913.[82] Moore may have noticed this connection. Certainly, a sketch in his *Notebook*

No. 3 of 1922–24[83] shows a mother and child that might almost be a free rendering of Epstein's marble. While the strong baseline is retained, the juxtaposition of the heads is more tender and dynamic and the African element more fully assimilated.[84]

The third work by Moore that belongs in this context, the walnut *Standing Woman* (fig. 23) of autumn 1923, confirms that he seems to have approached Epstein's sculpture chiefly in terms of its borrowings from 'primitive' art. Like his *Mother and Child*, the older artist's marble *Venus*[85] of 1913–15 (fig. 24) is clearly indebted to the Fang sculpture. Moore's *Standing Woman*, Epstein's *Venus* and the Fang figure all share parallel legs bent at the knee and a protruding stomach like that of a

20 *Two Heads*, 1924/25,
Mansfield stone, H. 31.7 cm,
Collection Mary Moore, London
(LH 25)

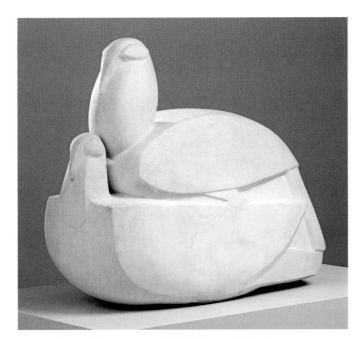

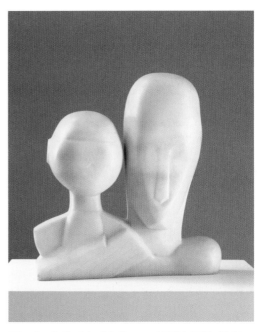

21 Jacob Epstein: *Doves*, 1914–15, Marble, 65 x 79 x 34 cm, Tate Britain, London

22 Jacob Epstein: *Mother and Child*, 1913–15, Marble, H. 41.2 cm, Museum of Modern Art, New York

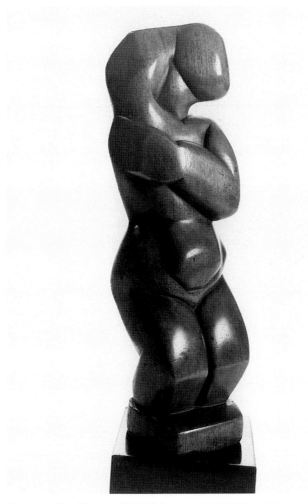

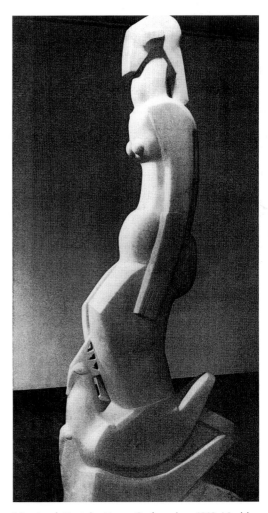

23 *Standing Woman*, 1923, Walnut wood, H. 30.5 cm, Manchester City Art Galleries (LH 5)

24 Jacob Epstein: *Venus*, 2nd version, 1913, Marble, H. 243.8 cm, Yale University, New Haven

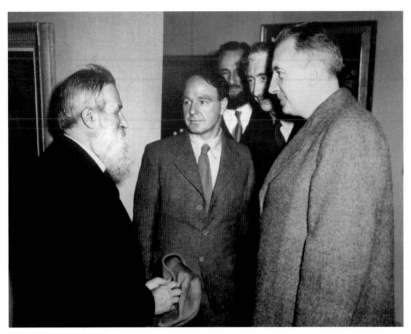

25 Photo: Henry Moore, Frank McEwen, Herbert Read and Paul Eluard in conversation with Brancusi, British Council Gallery, Champs Elysées, Paris 1945

child. From the waist upwards, however, Moore's woman becomes more 'European' and adult, her arms arranged in a traditional pose. Only the younger of the two twentieth-century artists could switch so effortlessly from one mode to another. As a Vorticist, Epstein felt obliged to keep his *Venus* hard and unyielding.

In Dialogue with Brancusi

London, the home of Vorticism and the British Museum, provided only some of the foundations of Moore's initial essays in a formal language based on truth to materials. Until the outbreak of the Second World War in 1939, they also received crucial impetuses from Paris. Beginning in 1922, Moore travelled to this artistic metropolis once or twice a year, paying countless visits to artists' studios, to public and private galleries and to bookshops in order to engage in a critical appraisal of everything the city had to offer, from post-Cubist to neoclassical trends, from Brancusi to Picasso, from the Louvre to the Musée de l'Homme.[86] The ideas he noted there in his sketchbooks, or developed from memory once back in England, testify to an astonishing curiosity and vitality, focussing chiefly on the 'world tradition' of sculpture and on contemporary work. Moore's art of the 1920s betrays clear knowledge of Archipenko, Maillol, Zadkine and Picasso, but curiously reveals no direct influence from Brancusi, one of the founding fathers of modern sculpture. Perhaps his forms appeared too absolute, too specifically Mediterranean and ultimately too centred in their own fullness.

In November 1945, when Moore revisited Paris for the first time since the War, he came to know the Romanian 'patriarch' first hand. A photograph, showing the impassive Brancusi in profile, with Moore looking on attentively, records their meeting (fig. 25). The shot was taken at the British Council-organised exhibition *Quelques contemporains anglais: Exposition de peinture et de sculpture*, held at the British Embassy in the Champs Elysées, in which Moore was represented by thirteen works.

Moore frequently expressed his admiration of the older man. Aware of Brancusi's historic role as a founder of direct carving, he saw in his valuable discovery of ovoid forms 'as the basis of sculpture'[87] the influence of Cycladic heads from the Louvre.[88] In 1937, with the confidence of someone being included for first time in an exhibition at the Tate Gallery, he frankly described Brancusi's achievement in an even-tempered way in his article "The Sculptur speaks" (The Listener) and compared his work to his own: 'Since the Gothic, European sculpture had become overgrown with moss, weeds – all sorts of surface excrescences which completely concealed shape. It has been Brancusi's special mission to get rid of this overgrowth, and to make us once more shape-conscious. To do this he has had to concentrate on very simple direct shapes, to keep his sculpture, as it were, one-cylindered, to refine and polish a single shape to a degree almost too precious. Brancusi's work, apart from its individual value, has been of historical importance in the development of contemporary sculpture. But it may now be no longer necessary to close down and restrict sculpture to the single (static) form unit. We can

26 *Notebook No. 3*, p. 50, *Studies of Wrestlers*, 1922–24, Pencil, 22.4 x 17.2 cm, The Henry Moore Foundation, AG 22-24.50r (HMF 134)

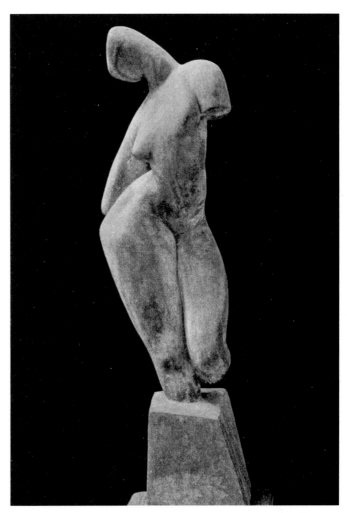

27 Alexander Archipenko: *Bather*, 1912, Concrete, H. 102.9 cm, whereabouts unknown. Frontispiece for Erich Wiese: *Alexander Archipenko,* Leipzig 1923

now begin to open out. To relate and combine together several forms of varied sizes, sections and directions into one organic whole.'[89]

Moore unequivocally acknowledged the role of Brancusi as the great purifier of form, and emphasised his epochal renewal of 'form-consciousness'. At the same time, he stressed only what interested him, namely the dynamic enhancement of the precise essence that Brancusi had 'sublimated'. He himself made use of no more and no less than Brancusi's 'essential form'[90] transformed into new, diametrically opposed relationships. Moore divided form, changed its size and direction and set it into flowing rhythmical relations, as for example in his contemporaneous *Reclining Figures*. In this way – differently to Brancusi – he drew on a concrete, dynamic multiplicity to try and attain his fusion of an 'organic whole'. Part Two will further examine the relevant theoretical and historical contexts for this argument.

Archipenko's Torsos and Their Impact on Moore

The first sketches that Moore made in Paris apparently included two nudes on a page in *Notebook No. 3* of 1922–24 (fig. 26).[91] The figure at upper left is inscribed 'Picasso', that at lower right 'The bather'. With its twisted body and broad, asymmetrical hips, the latter has little to do with Picasso, but rather a lot with Archipenko.[92] One thinks of a figure that Archipenko 'invented'[93] in 1909 and on which he was to produce several variations. One of these, *Seated Black Torso* of 1909,[94] was much exhibited and reproduced. In that vein there followed, in 1912, a torso in cement showing the head inclined deeply over the right shoulder. It was formerly in the collection of Herwarth Walden, Berlin, and called *Bather*. Moore could find this work in a publication from Erich Wiese from 1923 which he owned. Here it figured as frontispiz (fig. 27).[95] Archipenko based both works on studies of antique sculptures in the Louvre. He sought to meld the elements of

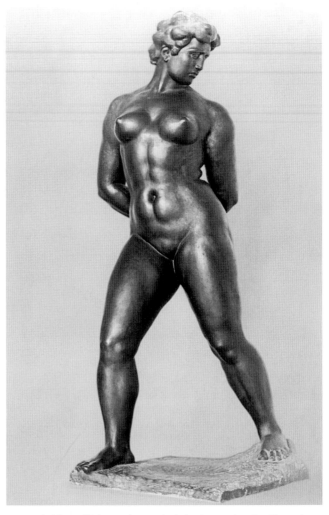

28 *Notebook No. 6*, p. 14: *Study of a Torso*, 1926, Charcoal (rubbed), 22.3 x 17.3 cm, The Henry Moore Foundation, AG 26.8 (HMF 433)

29 Aristide Maillol: *L' action enchaînée*, Statue for the Blanqui-Memorial, 1906, Bronze, H. 214.5 cm, Fondation Dina Vierny-Musée Maillol, Paris

the female body into a new whole and thus to invent an autonomous torso with its own logic.[96]

Moore seems to have aimed for the same thing in his free rendering of Archipenko's figure, which he probably jotted down from memory, although the various directional thrusts in his drawing are additive. The upper body looks as though it has been inserted into the hip section and whereas the heads in Archipenko's torsos are always inclined above the hip that protrudes farthest, Moore's nude turns her head over her raised shoulder on the opposite side of her body. This distribution of volumes results in a more stable figure.

Neither Moore in his published statements nor Roger Berthoud in his excellent biography of the artist has anything to say about his opinion of Archipenko, who in the 1920s had already achieved a renown comparable to that of Picasso. In 1955 Erich Wiese, however, the tireless promoter of the Ukrainian sculptor's work in Germany, claimed, without naming his source, that 'Moore especially reveres Archipenko as a master to whom he and an entire generation of sculptors

owes so much'.[97] It is indeed inconceivable that Moore should not have recognised Archipenko's historic achievement, in particular his symbolic use of space and his awareness of the evocative power of concave and convex forms.

Occasional Borrowings from Maillol

Other paths in Paris led Moore to Maillol.[98] The evidence indicates that Moore found himself in something of an artistic dilemma with regard to a sculptor so diametrically opposed to Rodin. In theoretical terms he was bound to reject Maillol's focus on harmony, but in practice adopted some of his formal ideas, whether consciously or unconsciously. On 4 May 1926 he recorded in his *Notebook No. 6*: 'Development of Sculpture from now not back to Maillol & archaic Greek & modelling.'[99] Yet in the same year he made a charcoal sketch of a torso that immediately brings Maillol to mind (fig. 28). The drawing is inscribed 'Bursting breasts' and 'Torso/Fecundity'. The French sculptor had invested the voluptuous female nude in his *Mon-*

30 Studies for the *West Wind Relief*, 1928, Underground Relief Sketchbook, p. 13, Pen and ink, chalk, 22.9 x 18.1 cm, The Henry Moore Foundation, AG 28.6 (HMF 616)

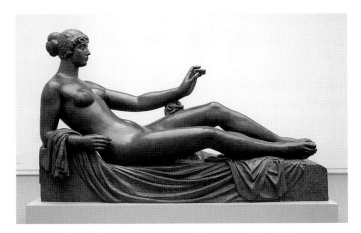

31 Aristide Maillol: *Monument à Paul Cézanne*, 1911–25, Bronze, L. 135 cm, Kunsthaus Zürich

ument to Louis Auguste Blanqui (1805–1881) with a comparable aura of fecundity. With her firm, conquering stride and proudly erect body, the figure, known as *L' Action enchaînée* ('Action in Chains' – Blanqui had been imprisoned for thirty years for his socialist convictions) epitomises defiance (fig. 29).[100] The fact that her hands are bound is reflected only in her lowered gaze and in the turn of her head over her left shoulder. Moore could scarcely have been unaware of this paragon of energy.

Another major work by Maillol must have had a similarly lasting impact on Moore. In the course of many studies for the *West Wind Relief* of 1928 (fig. 30) he gradually transformed the reclining female nude into a flying figure, but among the first drawings[101] are some that vary the kind of pose Maillol had explored when preparing his large stone *Monument to Paul Cézanne* (1911–25; fig. 31).[102] The salient features of Maillol's famous homage to Cézanne and its *bozzetti* – the

32 *Ideas of Sculpture: Torso*, 1925, Pencil, pen and ink, brush and ink, 24.9 x 29.4 cm, Art Gallery of Ontario, Toronto, AG 25.98 (HMF 360)

long legs, raised slightly, crossed or open, the arm stretched out over the thigh and the sense that the figure is gliding gently – all occur in Moore's initial, swiftly drawn sketches for *West Wind*. In the subsequent studies he soon departed from Maillol in his search for a more fluent overall solution.

Appreciating Zadkine's *taille directe*
Zadkine was another sculptor whom Moore will have come across in his investigation of direct carving. In the 1920s this Franco-Russian artist showed work at various exhibitions in Paris, Brussels and London, and in 1920 was included alongside André Derain, Georges Braque, Carlo Carrà, Marc Chagall

and others in an issue of *Valori Plastici*, a major series of publications produced in Rome. Zadkine was among those who introduced Cubism into sculpture. His early work comprised both compact, crystalline formal structures in the spirit of Analytical Cubism and large, intensely expressive wooden figures replete with a characteristically Russian 'primitive' charm. Moore investigated both these tendencies in Zadkine's work. At the upper left of a sheet of studies dating from about 1925 (fig. 32) he sketched two ideas for a cement figure eventually executed in 1926. The asymmetrical, tiered structure of the nude, the prismatic arrangement of the planes, the shifts of direction in its axis and the sharp turn of its head to the right clearly recall Zadkine's work of the early 1920s, specifically

La petite fille (fig. 33)[103] carved directly in marble in 1920–21. No doubt familiar with this figure at least from the illustration in Maurice Raynal's small volume on the artist of 1921,[104] Moore will have been attracted by its loosely Cubist style and its distorted proportions.

A drawing for a 1926 stone standing female figure (fig. 34)[105] testifies to Moore's admiration for Zadkine's full-length 'tree-trunk' statues, which he will likewise have known from Raynal's monograph and may even have seen in Zadkine's exhibition in 1925 at the Galerie Barbazanges in Paris. The sketch reproduces the deliberately 'awkward' appearance of Zadkine's archaistic wooden female figures, which attracted much attention at the time. The drawing is notably close to Zadkine's lifesize pearwood *Venus Caryatid* of 1919 (fig. 35),[106] a piece illustrated in the issue of *Valori Plastici* mentioned above. Moore was doubtless attracted by this figure's vibrant carving and especially by its combination of full, sensuous three-dimensionality with bold planes and outlines.

At Zadkine's Galerie Barbazanges exhibition the British landscape painter Richard Wyndham acquired an over-lifesize acacia wood *Venus* of 1923 (Tate Britain).[107] News of such things travels quickly in artistic circles, and Moore must surely

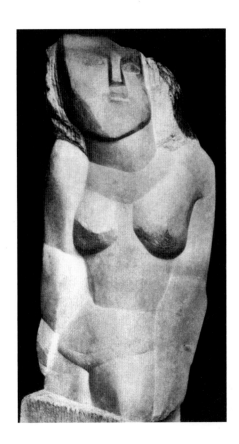

33 Ossip Zadkine: *La petite fille*, 1920–21, Marble, H. 30 cm, whereabouts unknown

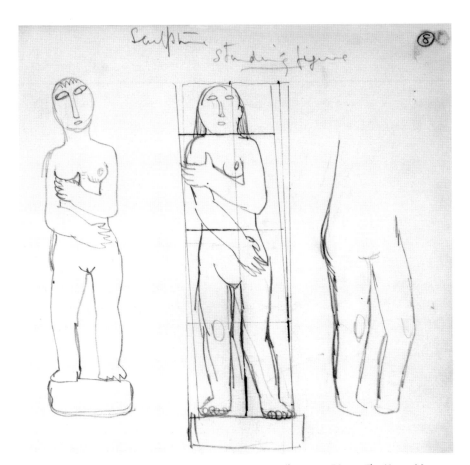

34 *Notebook No 6: Three Standing Figures*, 1926, Pencil, 22.3 x 17.3 cm, The Henry Moore Foundation, AG 26.5r (HMF 430)

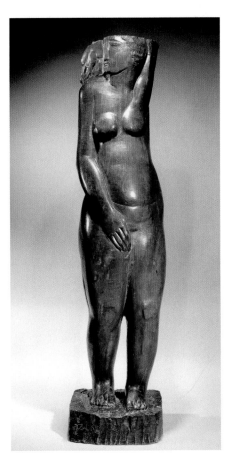

35 Ossip Zadkine: *Venus Caryatid*, 1919, Pear wood, 168 x 40 x 35 cm, Musée Zadkine, Paris

36 Pablo Picasso: *Three Women at the Spring*, 1921, Etching on zinc, 23.6 x 30.1 cm, Donation Pablo Picasso 1979, Musée Picasso, Paris

the bottom and the bent left arm. Like Picasso, Moore articulates the figure by means of a few simple volumes. Picasso's tendency to emphasise block-shapes chimed in with a similar concern of Moore's during this notably modernist phase in his oeuvre, an aspect he also studied in the work of Cézanne, Gaudier-Brzeska and Epstein. Further evidence of Moore's fascination with Picasso's full-bodied, almost Pompeian female nudes[111] comes from a highly-finished, mixed media study *Seated Nude with Mirror* of 1924 (fig. 37). Here, the intense sensuousness of the Spaniard's figures appears more abstract and, with his sights set on sculpture, Moore emphasises large volumes that would catch the light in the interests of 'stoniness'.

In 1924–25 Moore drew a number of nudes in which he paid homage to the new style of Picasso's *Bather* drawings of 1920, reducing the figures to outlines and making them apparently weightless. Ina Conzen has said of Picasso's large drawing *Two Nudes Seated on a Beach* (fig. 38),[112] to which

have been aware of the statue's arrival in England. Moreover, he himself showed work in an exhibition at Sydney Burney's gallery in London that included items by Zadkine, along with pieces by Skeaping and Barbara Hepworth. Traces of Zadkine's archaicising and organic nudes, bound to the shape of the tree trunk, can later be found in Hepworth's *Standing Figure* of 1930 and *Torso* of 1932.[108] The figure style represented by such sculptures and by the simplified nudes of Skeaping, Frank Dobson and Eric Gill has been called specifically English,[109] but the question arises as to whether it might not have been the result of outside influence, notably from Zadkine. The latter certainly shared with his younger British colleagues a knowledge of African carving and a strict adherence to the principles of truth to materials and direct carving.

A Multiplicity of Connections with Picasso

As both draughtsman and painter, Picasso played an important part in the impressions Moore gained in Paris early in his career. Evidence of this becomes increasingly strong over the years 1922 to 1931. From 1928 onwards, these influences involved 'curvilinear Cubism' and biomorphic constructivism and will thus be addressed in the next chapter of this book. At first, however, it was Picasso's neoclassical work that intrigued Moore. An early record of this is the page from *Notebook No. 3* of 1922–24 mentioned above in connection with Archipenko (fig. 26). The quickly drawn figure labelled 'Picasso' recalls Picasso's preparatory studies for his large painting *Three Women at the Spring* of 1921 (Museum of Modern Art, New York). Most strictly comparable is the similarly entitled etching of 1921 (fig. 36),[110] which shows the legs crossed at

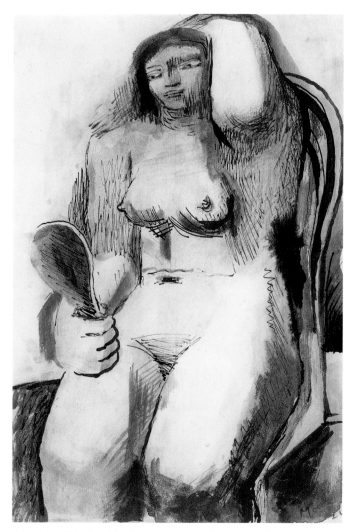

37 *Seated Nude with Mirror*, 1924, Pencil, charcoal, chalk, pen and ink, brush and ink, watercolour, wash on cream cartridge, 33.9 x 22.2 cm, Private Collection, UK, AG 24.54 (HMF 261)

38 Pablo Picasso: *Two Nudes Seated by the Shore*, 4.9.1920, Pencil, 75.2 x 104.5 cm, Metropolitan Museum, New York. Bequest of Scotfield Thayer, 1982 (1984.433.281)

39 *Two Seated Figures*, 1924, Pencil, pen and ink, 24.8 x 34.1 cm, Art Gallery of Ontario, Toronto, AG 24.55 (HMF 262)

40 *Two Seated Nudes*, c. 1925, Pen and ink, wash, 13.3 x 13.3 cm, Private Collection, Germany, AG 25.82 (HMF 344a)

41 *Three Nudes on a Beach*, c. 1928, Brush and ink, wash, 30.8 x 51.1 cm, Art Gallery of Ontario, Toronto, AG 29.46r (HMF 723)

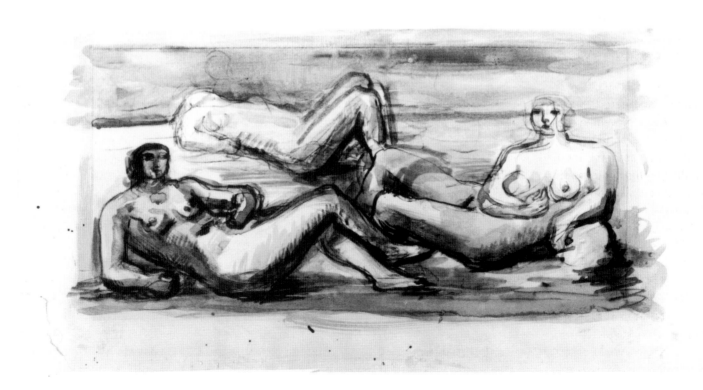

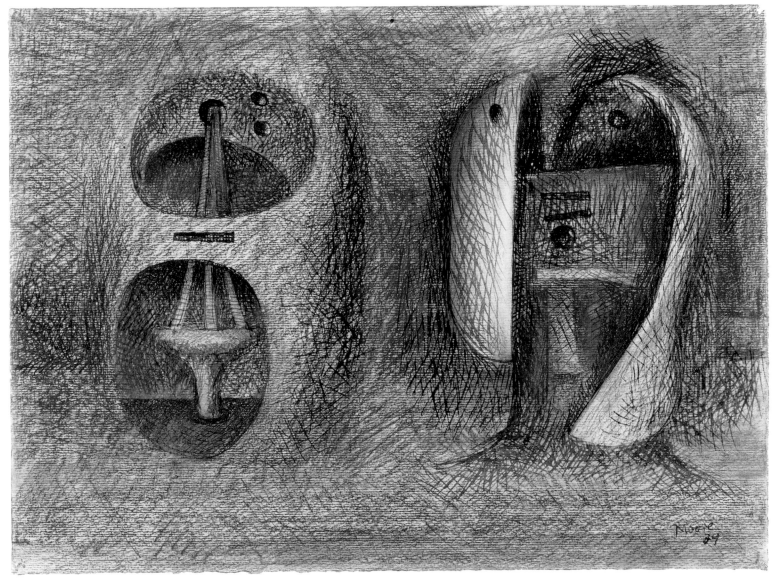

42 *Two Heads: Drawing for Metal Sculpture*, 1939, Charcoal, wash, pen and ink on cream heavy weight wove, 28.7 x 38.1 cm, The Henry Moore Foundation, AG 39.30 (HMF 1462)

Moore's *Two Seated Figures* is related (fig. 39),[113] that the artist 'evokes movement through several layers of space – from the foreground to the background, and vice versa – not by the classic academic method of linear perspective, but by lengthening the contours of the bodies. In this way the experience of reality is transmuted into an ideality, into a dynamic classicism of an unprecedented kind'.[114] The same applies to Moore's drawing, although its classicism is more static because, as is especially clear in the seated pose of the figure on the right, the artist had stone in mind. Picasso's 'ideality' also informs Moore's pen and ink drawing *Two Seated Nudes* of 1925 (fig. 40), in which the immediate juxtaposition of the two figures and the continuous hatching produce a comparable compactness. The two artists differ, however, in that Picasso focuses more on types, whereas Moore remains closer to his models and preserves an element of human warmth.

Moore seems to have returned time and again to Picasso's *Bathers* in the early 1920s. The watercolour *Three Nudes on a Beach* of 1929 (fig. 41) indicates that he was attracted by the compositional skill evident in Picasso's 'dynamic classicism' even more than by the figures' monumentality. The three reclining nudes in the drawing look as if they have been slotted into the broad horizontal space of the beach. All their bodies point towards the centre. Compositional braces of this kind, though bolder, also feature in Picasso's work, for example in two pastels dating from 1 May and 4 May 1921[115] that Moore could have seen at the Galerie Pierre Rosenberg in Paris.

As noted above, Moore's freer approach to Picasso's work in his biomorphic abstractions will be discussed in the next chapter. This, then, is a convenient place to examine his attitude to the older man later in his career. As his confidence as

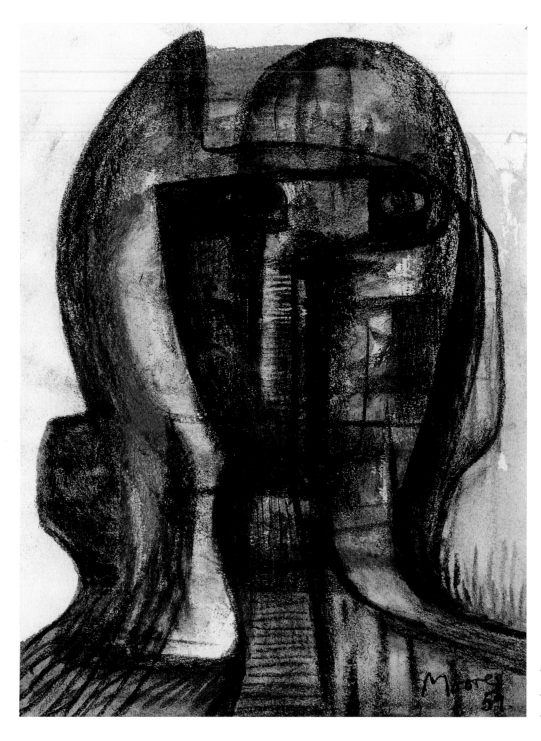

43 *Sketchbook 1958–59: Head*,
1958/59, Pastel, wash, 26 x 19.7 cm,
The Henry Moore Foundation,
AG 58-59r (HMF 2983)

an artist increased, Moore began to engage with Picasso on equal terms, whether consciously or not. This is especially clear when, in passing through his Surrealist phase, he developed an individual vocabulary of distortion and his own animal/human metamorphoses. Particularly in his heads – and not least owing to his knowledge of non-European masks – he occasionally achieved a demonic quality that matched Picasso's (though he never ventured into the abyss of the Spaniard's depictions of cruelty). Take *Two Heads: Drawing for Metal Sculpture* (fig. 42), executed in mixed media in the first year of the Second World War in preparation for the sculpture *The*

Helmet of 1939 (fig. 343). The subject of internal and external forms, which he had recently begun to address, takes a sinister turn in this drawing. A sense of anxiety pervades the image. The penetrating gaze of the eyes, the darkness in the hollows of the heads, the strangeness of the interior shapes and the hatching that seems to dig into the paper and uncover the heads mysteriously from the indeterminate background – all this has a compellingly phantasmagorical quality that need not fear comparison with Picasso.

Like Picasso's, Moore's visual imagination encompassed references to the contemporary world. In 1958–59, at the

44 Pablo Picasso: *Portrait of Dora Maar*, 1937, Oil on canvas, 92 x 65 cm, Musée Picasso, Paris

45 *Two Figures taking a Snack in a Shelter*, 1940/41, *Second Shelter Sketchbook*, p. 95, Pencil, wax crayon, coloured crayon, watercolour wash, pen and ink, 20.4 x 16.5 cm, The Henry Moore Foundation, AG 40-41.163 (HMF 1720)

height of the Cold War, he produced an uncanny pastel, *Page from Sketchbook: Head* (fig. 43), in which the black and violet head acts as a substitute wall, behind which the eyes take cover while holding the viewer captive. A trace of Picasso can be found even in the *Shelter Drawings*. In *Two Figures taking a Snack in a Shelter* of 1940–41 (fig. 45) Moore made use, probably unconsciously, of a compositional mode typical of the older artist. When he went with his wife, Irina, Alberto Giacometti, Max Ernst, Paul Eluard, André Breton and Roland Penrose to inspect the unfinished *Guernica* in Picasso's studio in May 1937[116] Moore may also have seen the well-known *Portrait of Dora Maar* (fig. 44),[117] which Picasso completed before *Guernica*. The generation of a claustrophobic box-shaped space in the portrait through a combination of grid and linear perspective construction recurs in a basically similar, if further intensified, form in Moore's shelter drawing. What Picasso's inner eye had imposed emotionally on the tense psyche of his beloved, Moore derived from his experience of reality in the Underground tunnels that afforded shelter during the bombing of London. Every mouthful of bread might be a person's last – hence the desperate emotional intensity in

a depiction of space that pulls the viewer into the drawing. Moore heightened the effect of the original box-shaped space still further in other *Shelter Drawings* by dynamising it as a niche.[118]

Moore naturally continued to keep track of developments in Picasso's work. Until the end of his days he viewed the Spaniard, eighteen years his senior, as an authority. The present author can testify to his admiration for Picasso the sculptor. During a visit we paid to the Städel-Museum in Frankfurt am Main in 1979, Moore suddenly stopped in front of the third version of the head of Marie-Thérèse. 'Oh that is powerful', he remarked, instantly struck by the compelling three-dimensional presence of this over-lifesize bronze. Moore no doubt took Picasso's innovations in sculpture as a point of reference when gauging his own vitality. By 1921 at the latest he was demonstrably aware of Picasso's importance as a great experimenter, the man who had invented Cubism and thereby secured the demise of mimesis in art and opened up new ways of seeing. Interviewed in 1973 by the BBC on the occasion of Picasso's death, Moore called his passing the end of an era and referred to him affectionately as a 'father'.[119]

Ill. 2 Moore in his Maquette Studio, Much Hadham, Perry Green, 1968

2. Surrealist Stimuli

The *Reclining Figure* in Leeds ended Moore's early work. He had created an individual style from the spirit of primitivism and from the *taille directe* (direct carving). With this style, Moore was at the cutting edge of Modernism in 1929. Archaic, expressive sculpture could have provided him with enough material for an entire life's work from then on, but instead the sculptor was inspired by new challenges. He was confronted with numerous influences, including the decisive conceptual and formal innovations that he assimilated from Surrealism around 1930. In the end, Moore would make a fundamental contribution to the novel appearance of Surrealist sculpture. This wide, topical spectrum will be pursued in this chapter. Moore's engagement with Surrealism provided him with the chief stimuli for his subsequent œuvre. From 1930 to 1940 – in some ways the most intensely experimental years of his career – he amassed a storehouse of sculptural ideas that revolved around a few interrelated basic motifs.[1]

The turn to Biomorphism – A Renewed Examination of Picasso

The process was set in motion by Moore's encounter with biomorphism. The biomorphic forms that appeared in Yves Tanguy's underwater imagery and in Hans (Jean) Arp's reliefs and subsequent plasters – dilating shapes, organic and full of latent movement – seem like some kind of amoebic *ur*-shapes in their evocation of transformational growth. Heralded by Art Nouveau's metamorphic richness of form, Arp's images could be apprehended in terms of dreams, of the cosmos or of clouds, independent, childlike and innocent. In Brancusi's 'world egg' (*The Beginning of the World*) biomorphic forms became the basis of a spiritual *Weltanschauung*. By contrast, Salvador Dalí, Joan Miró and Picasso filled them, in their surrealist work, with bitter irony, sexual symbolism and aggression. They stretched figures, inflated them and, as the artists' opposition to Fascism grew, invested them with an ambivalent expression of suffering and violence.

Attuned to the depths of the human psyche, Moore was attracted by the tensions in such imagery, not least by the organic deformations in Picasso's work. He once admitted: 'Picasso's value to people like me was the freedom he gave – he was bold enough to do things, and let other people see that they could do it too.'[2] As noted in the previous chapter, Moore first engaged with Picasso in the latter's neoclassical phase. This promoted a kind of sensibility that directed the younger artist towards biomorphism. Some nudes he executed on paper in 1927–30 seem to make a mockery of the weighty repose and the equilibrium of his previous life drawings. In them he took his cue from the 'curvilinear Cubism' recently developed by Picasso[3] and represented primarily by the painting *The Three Dancers* of 1925 (fig. 46), but only the

sharp juxtaposition of planes recalls Cubism proper. Restricting his palette, Picasso uses extreme, intensely sexual contortions of the body to defend life against the death present in the picture. With his sculptor's eye, Moore was no doubt especially fascinated by the frenetic movements of the figure on the left. The ecstasy it radiates seems to invade space. Picasso dissolved the body into areas of light and shade, let it form a 'bridge' to the other figures and pressed its head into a horizontal position, dividing the face into one astonished half and another madly laughing one. Moore must have been struck by the contrasts of light and dark, by the dissonant contortions, by the double-sided head (a motif that would occupy Picasso for many years) and, most of all, by the fracturing of the body (which was to become more fluid in Picasso's subsequent paintings). Where else in modern art had such emotional outpourings been allied to such rigorous economy of means?

In sometimes brightly coloured drawings Moore, too, began hollowing out the human body and defamiliarising it by means of autonomous shaded areas.[4] *Three-Quarter Figure*

46 Pablo Picasso: *The Three Dancers*, June 1925, Oil on canvas, 215 x 142 cm, Tate Britain, London

47 *Three-Quarter Figure*, 1928, Pen and ink, brush and ink, chalk, watercolour, 31.1 x 22.9 cm, The Henry Moore Foundation, AG 28.146 (HMF 663)

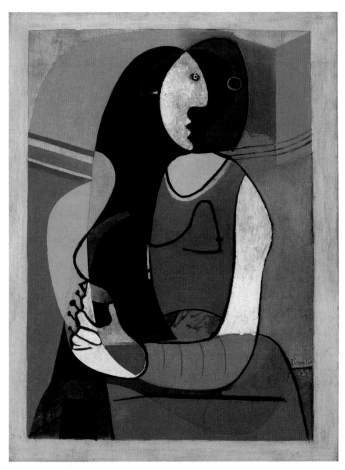

48 Pablo Picasso: *Seated Woman*, 1927, Oil on canvas, 130 x 97 cm,
The Museum of Modern Art, New York

ment that drawing is 'a means of generating ideas and also of sorting them out'.[9] The sketches develop three 'basic ideas' separately, before combining them in a single enigmatic figure and then refining it. The first drawing shows a female nude inscribed 'Torso' by the artist (fig. 49). Above the similar figure (without a base) in the next sheet of studies (fig. 50) he noted 'try this'. This sheet contains three views, one from each side and one from above. The version marked with a cross – denoting its suitability for execution – probably depicts the main view.

This stage in the genesis of *Composition* embodies a personal interpretation of the drawings for biomorphic sculptures that Picasso had made at Cannes in the summer of 1927. The hypertrophic breasts, the sign for the navel, the rounded 'feet' and the 'inflated', biomorphic volumes, for instance, recall Picasso's *Bathers* (fig. 51).[10] Even at this early point, however, Moore's approach differs markedly from Picasso's in its greater degree of abstraction (partly the result of the idea's origins as a torso) and in the strong spatial element inherent in a study conceived from the outset in terms of a sculpture visible from all sides.

Moore inscribed the sheet of drawings containing the second and third ideas (fig. 52) 'child suckling + Animal + portion of figure reclining'.[11] The artist's concern to grant an independant sculptural life to one round shape enclosed in another, here takes the form of a suckling baby and, on the left, an animal. The latter seems to indicate that Moore's thoughts had once again turned to Picasso. Herbert Read records that in 1930 Moore bought a special Picasso issue of the influential Surrealist-orientated periodical *Documents*,[12] which included

of 1928 (fig. 47), for instance, may be compared directly with a painting by Picasso, *Seated Woman* of 1927 (fig. 48).[5] Notable points in common are the division of the head, the displaced eye, the dark vertical areas and the firm outlines. Moore's drawing did not progress beyond the status of an experimental study, but as such it reveals all the more decisively how biomorphism led him to burst the seemingly unbreakable mould of his early work. The chronological proximity of the drawing to the artist's *Reclining Figure* in Leeds is thus particularly surprising. He suddenly opens out a figure to disclose the dark side, the abysses, of human existence. It is as if Moore wished to face up to the sombre mood of a time when Fascism had already started to make inroads into the political life of continental Europe.[6]

Picasso began producing 'biomorphic constructions'[7] in 1927. The volumes of his figures, especially his *Bathers*, swelled to resemble balloons. This added fuel to Moore's phantasmagorical engagement with biomorphism. The process can be traced in his *Composition* of 1931 in green Hornton stone (figs. 55, 56) and its related drawings. It was preceded by a number of pencil sketches[8] which confirm Moore's own state-

49 *Studies of Torso Figures*, c. 1930–31, Pencil, 16.2 x 20.1 cm, The Henry Moore Foundation, AG 30-31.6r (HMF 828)

50 *Torso Studies*, c. 1930–31, Pencil, 16.2 x 20.1cm, The Henry Moore Foundation, AG 30-31.8r (HMF 830)

52 *Study of Suckling Child*, c. 1930–31, Pencil, 16.2 x 20.1 cm, The Henry Moore Foundation, AG 30-30.9r (HMF 831)

51 Pablo Picasso: Sketchbook No. 95, *Bathers*, Cannes 1927, pencil, 30.3 x 23 cm, Musée Picasso, Paris

53 Pablo Picasso: *Femme au bord de la mer*, April 1929, Oil on canvas, 130 x 97 cm, whereabouts unknown

examples of the artist's latest work. Through one of them, the painting *Femme au bord de la mer* (fig. 53), he will have become acquainted with a design for a monumental bather[13] that William Rubin aptly described as 'like a granite nightmare of a Matisse odalisque'.[14] The animal in Moore's drawing shares with *Woman* the stake-like legs, the pointed breasts and a beak-shaped head that relates to the clasping hand in Picasso's picture. Moore will also have noted the bold fusion of breasts and buttocks: his own sketch marked with a cross (fig. 50) showed a comparable melding of these body parts. *Femme au bord de la mer*, then, is a second possible source for *Composition* in Picasso's work.

In the next sheet of studies Moore varied the torso and the suckling child, before attempting a synthesis in the final sheet (fig. 54). At the upper lefthand side he repeated the original torso motif with the protruding breasts, then drew three versions of the suckling child and finally brought together all three basic ideas in the sketch marked with a cross, which became the basis of his sculpture. The torso here forms the lower half: the round body of the child 'balances' on the breasts while its head meets that of the mother. With stronger

54 *Ideas for Composition in Green Hornton stone*, c. 1930–31, Pencil, 16.2 x 20.1 cm, The Henry Moore Foundation, AG 30-31.10r (HMF 832)

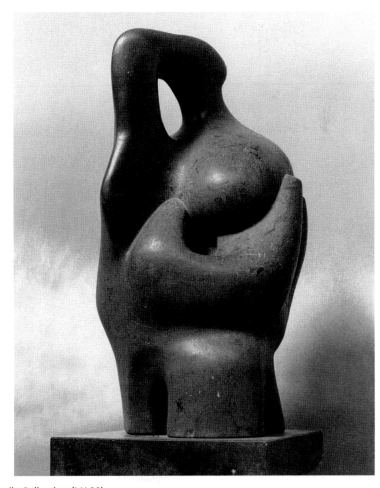

55/56 *Compositon*, 1931, Green Hornton stone, H. 48.3 cm, The Henry Moore Family Collection (LH 99)

57 *Drawing for Metal Sculpture*, 1931, Chalk, watercolour, oil paint, wash on cream heavyweight wove, 47 x 21.6 cm, The Henry Moore Foundation, AG 31.21 (HMF 856)

pencil lines the artist revised the section with the two heads, drawing them together to form a continuous bar. The second basic idea, the 'animal' that owed much to Picasso, clearly played a part in this replacement of the suckling motif.

In the sculpture Moore combined the views of the torso shown in the first two sheets of studies. Moving round the carving, the beholder notes how the round, sack-like body of the child has been 'suspended' in a protective interior space created between the mother's trunk and breasts, which hold it like arms. The juxtaposition of the child with the breasts gives rise to hollows on three sides. Further hollows appear in the area of the feet. From top to bottom, these negative volumes prepare the viewer for the hole that opens up between the two heads at the top. Carefully heralded in this way, the hole itself is the culmination of *Composition* and the various thrusts generated by its shifting axis. Thus, the composition of the whole opens up at the point at which it is also absorbed into a 'continuous movement'[15] by the linking bar.

The genesis of *Composition*, which in the final version, completed in 1931, combined human and animal associations, shows Moore arriving at a distinctive type of metamorphosis as the forms developed. Like Picasso's constructional metamorphoses, Moore's biomorphic transformation of form culminated in both animal and human allusions. Yet as the above analysis indicates, his prime concern was to create a coherent, intensely three-dimensional object that could reach fulfilment only in space. Metamorphosis was an integral part of Moore's approach to the autonomy of form. Hence, he could state that a sculpture should be 'like a new animal, a unified and varied object [...] a complete object.'[16]

Composition marked the beginning of that cross between human and animal that was to remain a feature of Moore's work until 1952, when it informed the head of the king in *King and Queen*.[17] A large study like *Drawing for Metal Sculpture* of 1931 (fig. 57)[18] shows that the artist quite deliberately included the aspect of metamorphosis in his experiments with forms. Using oil and watercolour, he developed a female figure whose head he altered during the final stage, painting over its black contour to give it an animal appearance. Coded as a double image in this way, the figure provides one further instance of the workings of a liberated imagination.

Study from nature, the *objet trouvé* and the *Transformation Drawings*

Along with his investigation of the 'world tradition' of sculpture, the study of nature formed the 'gold standard' of Moore's artistic activity. How, then, did the liberation of his imagination affect his approach to nature?

Pebbles are first mentioned in Moore's sketchbooks in 1926: 'Remember pebbles on beach.'[19] The artist did not just

collect them at the seaside; he also studied them in the Natural History Museum in London. His interest in these natural relics had a precedent in the jetsam reliefs produced in 1916 by Arp in his Dada phase. The achievements of biomorphic art in Paris also belong in this context: around 1930 Brancusi's reductions of forms to their essentials, Arp's supple formal creatures and Picasso's unruly 'biomorphic constructions' based on bones realised some of the expressive potential of natural forms. And Moore, of course, was familiar with the surrealist use both of the *objet trouvé* and, above all, of the 'insights' gained through hallucination.

Moore shared with the Surrealists a willingness to embrace the new freedom offered by the *objet trouvé* as a way to 'order the inspiration',[20] but differed from them in his exclusive focus on the formal givens of natural objects when developing 'his' shapes. In conversation he referred in this connection no less often to Leonardo da Vinci as done by his Parisian friends[21] and indeed Moore's insight into his natural finds is not hallucinatory but 'fantastic', in the true, poetic meaning of the word. The distinction is important. To hallucinate is to be overwhelmed by visions; to engage the fantasy is to maintain control over the self, to enter an imaginary realm without surrendering one's freedom. This fundamental difference can be demonstrated with reference to Moore's *Transformation Drawings* of 1930–35.

The significance of these sheets of pencil studies, forty of them produced in 1932 alone, can scarcely be overestimated. They show how the artist treated natural *objets trouvés*, how they formed a reservoir of ideas for his future sculptures and testify to his commitment to a new nature-based aesthetic. The *Transformation Drawings* take the viewer into the formal workshop in which Moore generated his organic abstractions.[22] As he told his friend the writer Stephen Spender, the drawings sought to explain the metamorphosis of objects, which differed depending on the *objet trouvé*. Spender recalled: 'He would turn a realistic subject into an abstraction through drawing it first realistically and then abstracting from it.'[23] Moore himself wrote in 1934:

'The human figure is what interests me most deeply, but I have found principles of form and rhythm from the study of natural objects such as pebbles, rocks, bones, trees, plants etc.

Pebbles and rocks show Nature's way of working stone. Smooth, sea-worn pebbles show the wearing away, rubbed treatment of stone and principles of asymmetry.

Rocks show the hacked, hewn treatment of stone, and have a jagged nervous block rhythm.

Bones have marvellous structural strength and hard tenseness of form, subtle transition of one shape into the next and great variety in section.

Trees (tree trunks) show principles of growth and strength of joints, with easy passing of one section into the next. They give the ideal for wood sculpture, upward twisting movement.

58 *Studies of Bones*, 1932, Pencil, 24.1 x 17.9 cm, Art Gallery of Ontario, Toronto, AG 32.58 (HMF 942)

Shells show Nature's hard but hollow form (metal sculpture) and have a wonderful completeness of single shape.

There is in Nature a limitless variety of shapes and rhythms (and the telescope and microscope have enlarged the field) from which the sculptor can enlarge his form-knowledge experience.'[24]

In the widest sense, the *Transformation Drawings* served this purpose of expanding the artist's knowledge of form. Depending on the sculptural concern he wished to address, Moore would choose bones, pebbles, shells, trees or plants. On one sheet from 1932 (fig. 58) he collects a section of tree and various bones apparently so as to use the formal characteristics of these different objects to investigate holes and hollows. The subject of the hole is broached at the top left in a thoroughly realistic depiction of a knot-hole carefully 'extracted' from a tree-trunk by means of pencil lines. Turning round the sheet of paper, Moore then sketched a shoulder blade

(scapula) twice. Below this, in the middle of the sheet, appear two curious, complex-looking shapes. These are considerably modified images of a lower jawbone (mandible) – apparently that of a mammal – with a vertical portion (ramus) resembling a head from one of Moore's reclining figures.[25] Behind this, the artist sketched an intricate structure of 'rods' in the upper drawing, accommodating them to the overall horizontality and appending the words 'New Ireland' – a reference to the rods of Malanggan figures. Moore contrasted the diaphanous spatial qualities of this *mixtum compositum* with a representation, on the right, of a compact bone with a marrow hole, marking the front of the hole with the words 'hole through'. Finally, at the bottom of the sheet, he drew two views of a vertebra. This *Transformation Drawing*, then, contains depictions of four different kinds of hole.

In another drawing from the same year (fig. 59)[26] Moore revisited the theme of holes and hollows using only a vertebra. Taking his cue from the bone's 'protective' arcs, he ended at the bottom left of the sheet with a female figure inscribed 'Torso'. The drawing process is again characteristic. Moore first recorded the modelling of the individual forms in gentle pencilstrokes, then superimposed stronger lines depicting the figurative shape derived from the forms. What had begun with the discovery of an *objet trouvé* – a discovery guided by the unconscious – concluded in a study for a sculpture seen three-dimensionally. This inventive seeing, the kind that determined content, was what concerned Moore. Hence, abstracting from one form to create another was a conscious process: 'It is what I see in [the forms] that gives them their significance.'[27] Moore both saw and felt his way into 'principles of form and rhythm',[28] which he perceived in nature in terms of movement. They conveyed to him the structure of, and the distribution of forces within, the human figure he was devising. The *Transformation Drawings* thus acquaint the viewer with image-making procedures that are analogous to creative processes in nature.

This is evident in the collaged section added upside-down at the top right of the same sheet of studies. Prompted by the hole in the vertebra, Moore repeated the outline of the bone several times in free, rhythmic curves. In this way, he spread the energy of the pierced form outwards in a series of waves, aiming, in the words of his inscription, to 'get [a] hard form'. What that form was going to look like remained unclear at this point, because he did not go beyond these circular motions. The search continued, however, in *Ideas for Sculpture: Transformation Drawing* (fig. 60). Here, the shape achieved figurative clarification in the sketch on the far right at the top. This is a preparatory stage in the creation of a figure that Moore carved from African Wonderstone in 1933 (fig. 61). This led in turn to the marble *Carving* (fig. 74), a half-figure with a hole pierced in it that, as explained below, marks a turning point in Moore's development.

The loose, circumscriptive lines in another *Transformation Drawing* (fig. 62) encapsulate the transition from the abstract notion of metamorphosis to its concrete realisation. The upper half of the sheet contains two sketches for a half-figure. Moore here permitted himself total artistic freedom. The head and shoulders in the left hand drawing crown a hollow surrounded by human elements. An arm reaches down from the imaginary figure's right shoulder, echoed on the left by a similar arc indicating a more abstract arm. The concave space delimited at the front by the arms suggests a deeply sucked-in thorax. At shoulder level a second figure with summarily indicated arms seems to appear behind the first. The motif of bracketing arms is intensified in a bizarre fashion in the adjoining sketch on the right. Here, three arms with claw-like hands enfold an extremely broad thorax with mammary glands and topped by two small heads. Such drawings suggest that Moore conceived his figures in an indeterminate state, undecided as to whether they should become human, animal or both. In the present case, he confined this transitional metamorphic state to the drawing: the wooden *Figure*[29] that resulted from it is a female half-nude. By contrast, as described above, the stone *Composition* (figs. 55, 56) balances animal and human allusions.

In exploring the 'principles of form and rhythm' embodied in the natural objects he depicted in the *Transformation Drawings*, Moore made a new and far-reaching contribution to the sort of nature-based aesthetic that had become increasingly significant in the art of the twentieth century. The watchword here – current before he embarked on a career as an artist – was 'as in nature'.[30] The maxim encouraged artists to immerse themselves in the form-generating motions and energies of nature. This approach, in essence initiated by Paul Klee, became one of the main aesthetic tenets of twentieth-century art and it appealed especially to carvers and modellers – that is, to those engaged in an art intimately connected with movement. Moore, Arp and Brancusi, along with Naum Gabo, Barbara Hepworth, Karl Hartung, Emil Cimiotti, Brigitte and Martin Matschinsky-Denninghoff, Theo Balden, Wieland Förster and many other sculptors, adopted the 'as in nature' standpoint. Brancusi, for instance, looked to nature to grant the elemental egg-shape a mystical dimension. Thus, in the sculpture *The Beginning of the World* of *c.* 1920 he aimed to capture the primal unity of humanity and the cosmos. Or again, in his self-reflecting bronzes he used rotational shifts of light to evoke organic movement 'as in nature', particularly 'as' in animals. His shining birds, 'as' if preparing to fly off, take this emancipatory act to the extreme point at which they become a shining spot visible from afar.[31]

Brancusi, the son of a peasant family from the Carpathian mountains, approached nature with a combination of fervent religiosity and down-to-earth practicality. Arp, poet and sculptor from the bilingual region of Alsace, aimed for a dif-

59 *Ideas for Sculpture: Transformation of Bones*, 1932, Pencil, collage on cream lightweight wove, The Henry Moore Foundation, AG 32.83r (HMF 972)

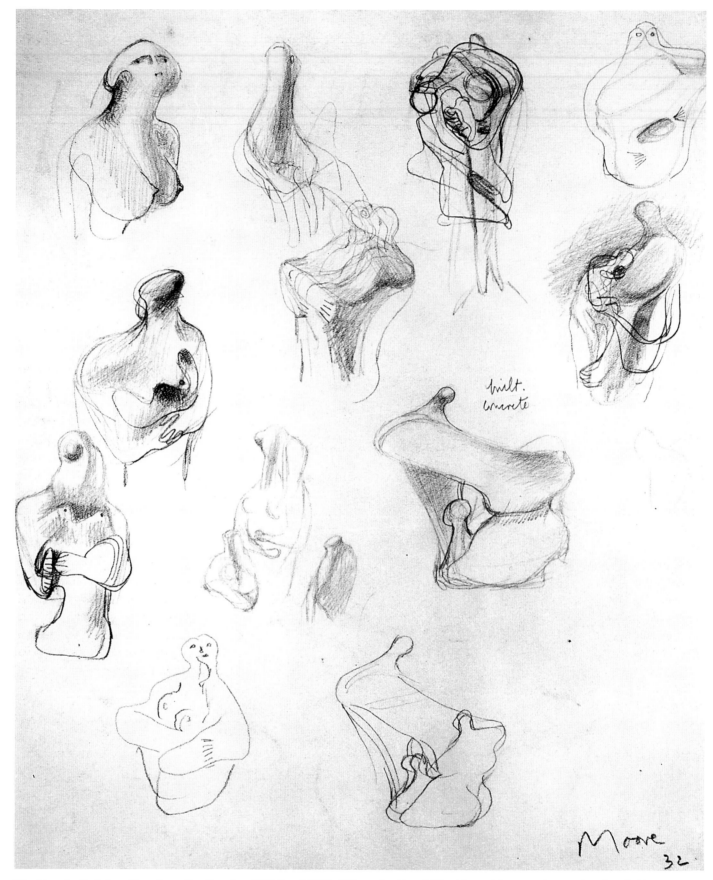

60 *Ideas for Sculpture: Transformation Drawing*, 1932, Pencil, 36.7 x 27.2 cm, David und Alfred Smart Museum of Art, University of Chicago, The Joel Starrels Memorial Collection, AG 32.90 (HMF 978)

ferent kind of mobility. He was concerned in his texts, collages and sculptures less with absolute truths than with poetic enchantment. As his marble *Growth* of 1930 shows,[32] metaphors of enlargement were of crucial importance to him. Hence, his aesthetic credo, formulated in 1940, stated: 'We do not wish to imitate nature. We do not wish to copy. We wish to shape, the way plants shape, but do not copy, their fruit. We wish to shape directly and not indirectly.'[33] With their flowing volumes, Arp's sculptures possess a suppleness and polyvalency that echo the surreal poetry of the natural analogies in his writings. Each form merges into the next, and the meanings evoked by his poetic titles likewise appear to intermingle.

Arp's generalised, all-encompassing lyricism contrasts with Moore's precise, individual focus in matters of form. With him, natural analogies must correspond exactly to reality in terms of the given sculptural possibilities. His concerns here were typical of British art around 1930 and they benefited, in turn, from knowledge of Surrealism. Moore's friendship with the English painter and photographer Paul Nash, whom he first met in 1927, is particularly important in this connection.[34] Taking his cue from surrealist *objets trouvés*, Nash showed roots under the title *Vegetable Kingdom* at the landmark *International Surrealist Exhibition* in London in 1936, which will be discussed in greater detail below. He also photographed roots, dead trees, rocks and waterfalls. Sometimes he incorporated these natural phenomena in his paintings, emphasising their monumental character still further or defamiliarising them physiognomically. In 1932 he had reviewed Karl Blossfeldt's *Art Forms in Nature* (a translation of the German original, *Urformen der Kunst*) for the periodical *The Listener*.[35] Moore must surely have been familiar with the photographic studies of the morphology of plants published in the book by Blossfeldt, who was himself a sculptor. Unlike Nash, Moore created no *objets personnages*, but his interests coincided with the painter's when he began to concern himself increasingly with the morphology of nature.

Another book that aroused considerable interest in artistic circles was the pioneering *On Growth and Form* by D'Arcy Wentworth Thompson (1860–1948). Like Gabo, Hepworth, Nash and Read, Moore owned a copy of the first edition, published in 1917.[36] In this work Thompson, a mathematician, biologist and zoologist with a classical education (he had translated Aristotle), developed a mathematical morphology. As Stephen Jay Gould explains in the most recent German edition, Thompson's main theses were 'that physical forces shape organisms directly (with "inner" and genetic forces responsible only for producing the raw material from which organisms are constructed in accordance with physical principles, admittedly in stages and in programmed chronological sequences); and that the ideal geometrical shapes valued so highly by the ancient Athenians moulded organic form because the laws of

61 *Composition*, 1933, L. 33 cm, African Wanderstone, whereabouts unknown (LH 131)

nature favoured such simplicity as the optimum embodiment of their forces'.[37] Thompson's investigation of the laws governing measurements and numbers in the genesis of plants and animals can only have stimulated Moore in his own study of nature. Thompson used mathematical formulae – logarithmic spirals, for example – to disclose the 'inter-relations of growth and form'[38] in the structures of plants and animals. He employed the 'mathematical language [...] even to define in general terms, the shape of a snail-shell, the twist of a horn, the outline of a leaf, the texture of a bone, the fabric of a skeleton, the stream-lines of fish or bird, the fairly lace-work of an insect's wing'.[39]

Special attention was paid to the final chapter of Thompson's treatise, headed 'On the theory of transformations, or the comparison of related forms'.[40] With coordinates and other aids, the author here sought 'to discover the relative growth rates of various structures – a method that has proved useful in embryology, taxonomy, palaeontology and even in ecology'.[41] The relevance of this chapter to the *Transformation Drawings* will not have escaped Moore. A passage such as the following must have caught his attention: 'We have dealt [...] with our coordinate method as a means of comparing one known structure with another. But it is obvious, as I have said, that it may be employed for drawing *hypothetical structures*, on the assumption that they have varied from a known form in some definite way. And this process may be especially useful ... [in finding] intermediate stages between two forms which are actually known to exist, in other words, of reconstructing transitional stages through which the course of evolution must have successively travelled if it has brought about the change from some ancestral type to its presumed descendant.'[42]

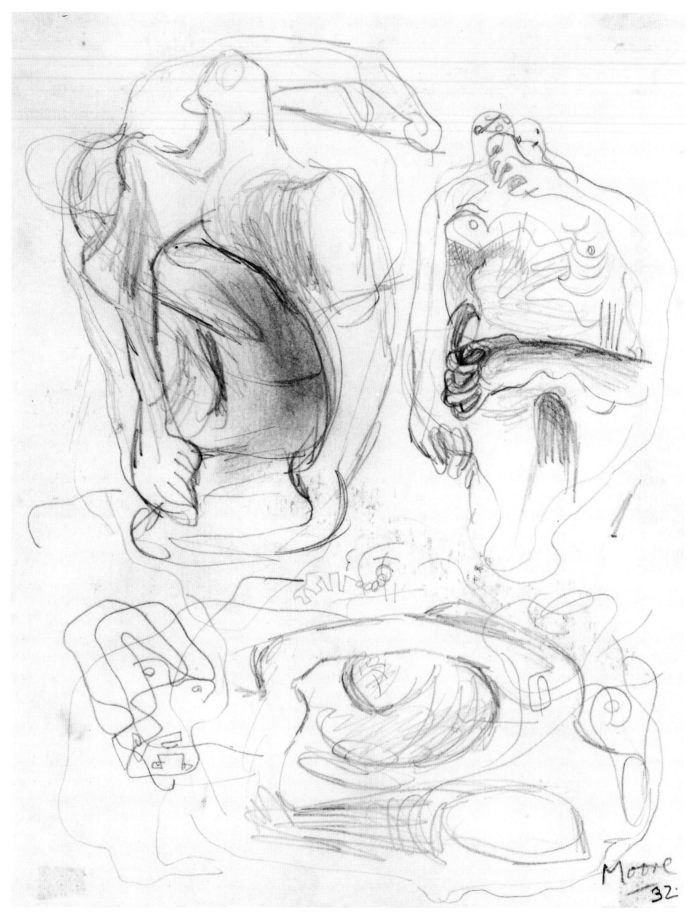

62 *Ideas for Sculpture: Transformation of Bones*, 1932, Pencil on cream light weight laid, 20.3 x 16.2 cm, The Henry Moore Family Collection, AG 32.73 (HMF 962)

It is only a short mental step from Thompson's scientific approach, which encompassed natural forms that 'are theoretically imaginable',[43] to the 'related forms' in Moore's *Transformation Drawings*. His 'imaginable forms', derived from nature, are his ideas for sculptures.

The bones – internal structures of the living form

The *Transformation Drawings* reveal a penchant for bones as a source and a generator of forms. Moore doubtless found encouragement for this approach in Thompson's book. The chapter headed 'On Form and Mechanical Efficiency'[44] dealt with the fundamentals of bone architecture. On the basis of function, Thompson discussed and illustrated, among other things, the pressure-lines and tension-lines of a thighbone (femur) when it bears weight.[45] Moore was doubtless fascinated by the vividness of these descriptions, and one senses a similar approach when he later explained: 'Flintstones, pebbles, shells and driftwood have all helped me to start off ideas, but far more important to me has been the human figure and its inner skeleton structure. You can feel that a bone has had some sort of use in its life; it has experienced tensions, has supported weights and has actually performed an organic function, which a pebble has not done at all.'[46] Moore went on: 'From my student days I have always been interested in bone structure. The Natural History Museum was so close to the Royal College of Art that I spent much time there. The wonderful collection of bones with such a variety of structures was terribly exciting for me, particularly the pre-historic bones which had become fossilised almost into natural sculpture.'[47]

Moore likewise adhered to D'Arcy Thompson's idea that the skeleton constitutes a field of linear tensions: 'In it is reflected a field of force: and keeping pace' as it were, in action and interaction with this field of force, the whole skeleton and every part thereof, down to the minute intrinsic structure of the bones themselves, is related in form and in position to the lines of force, to the resistances it has to encounter [...] We see [...] that between muscle and bone there can be no change in the one but it is correlated with changes in the other; that through and through they are linked in indissoluble association; that they are only separate entities in this limited and subordinate sense, that they are *parts* of a whole which, when it loses its composite integrity, ceases to exist.'[48]

Moore, too, viewed bones in terms of latent movement. In 1964, for instance, he stated: 'One of the things I would like to think my sculpture has is a force, is a strength, is a life, a vitality from inside it, so that you have a sense that the form is pressing from inside trying to burst or trying to give off the strength from inside itself, rather than having something which is just shaped from outside and stopped. It's as though you have something trying to make itself come to a shape from inside itself. This is, perhaps, what makes me interested in bones as much as in flesh because the bone is the inner structure of all living form. It's the bone that pushes out from inside; as you bend your leg the knee gets tautness over it, and it's there that the movement and the energy come from. If you clench a knuckle, you clench a fist, you get in that sense the bones, the knuckles pushing through, giving a force that if you open your hand and just have it relaxed you don't feel. And so the knee, the shoulder, the skull, the forehead, the part where from inside you get a sense of pressure of the bone outwards – these for me are the key points.'[49]

Such statements reveal the depth and subtlety of Moore's interest in bones. He respected the traces of life inherent in the organic shape of any bone. The flexibility of inner bone structures served to point him towards movements in fully developed forms. And his concern with mechanical bone movements – a bent knee, for example, or a fist – focused on visible pressure from inside outwards, on a toughness and power that he wished to retain in his sculptures. Accordingly, he always paid special attention to joints as the 'key points' of skeleton structure. As focuses of energy, the interlocking of bones and cavities at joints was a theme he addressed time and again in his art.

Moore's preoccupation with joints as repositories of potential movement is reflected in those *Transformation Drawings* in which he addresses the organic function, the structure and the latent mobility and spatiality of mandibles, vertebrae and scapulae. Later, too, joints were a frequent point of departure for his sculptures. A sheet of studies dating from 1939, for example, represents an important stage in the genesis of *Interior and Exterior Form* (fig. 63). The 'inner structures' here testify to Moore's masterly use of joints. The central figure in the lower row reveals that he viewed the upright interior form as a kind of integrated anatomical system. This system, which comprises the 'foot', the 'knee' and the hipbone, before ending above in a freely formed section, is inserted into the exterior form like a doll. Moore clearly saw it in functional terms. Linked by joints, the long-bones indicate the structural direction of the whole. Incorporating into his imaginary interior structure the bones' potential for stretching, turning and so forth at joints, he underscores the figures latent mobility. With drawings like this in mind, it is easy to recognise how an integrated anatomical system underlies the flowing leg forms in a major work of Moore's surrealist phase, the small lead *Reclining Figure* of 1938 in the Museum of Modern Art, New York (fig. 64). The artist was particularly fond of this sculpture, which derives much of its vitality from the delight in 'joints' that it reflects. Eventually enlarged to a length of nine metres, it was installed in 1986 as a kind of will and testament atop a specially created mound in the sculpture park at Much Hadham.

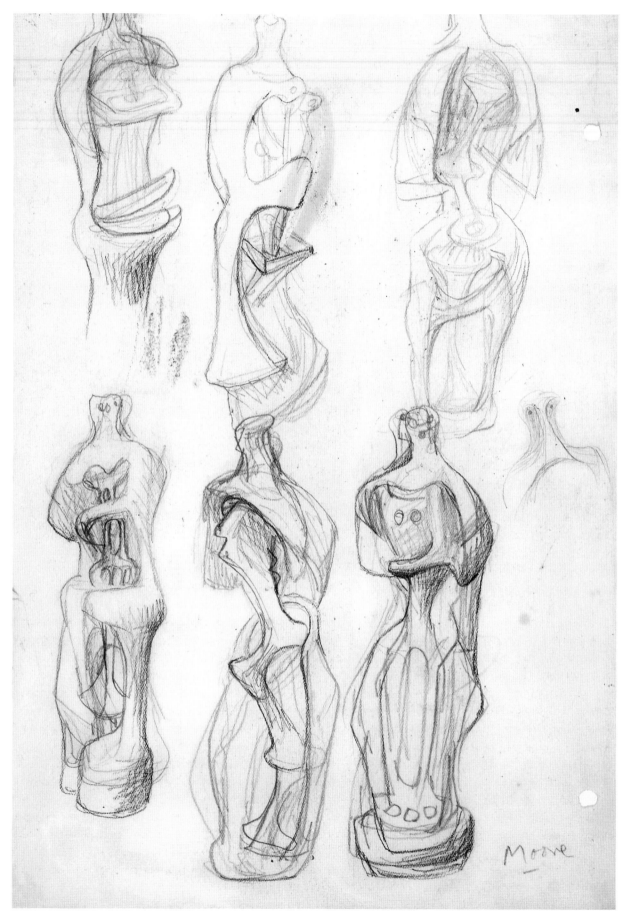

63 *Upright Internal/External Forms*, 1939, Pencil, crayon on cream middle-weight wove, 27.6 x 19 cm, The Henry Moore Foundation, AG 39.27r (HMF 1472)

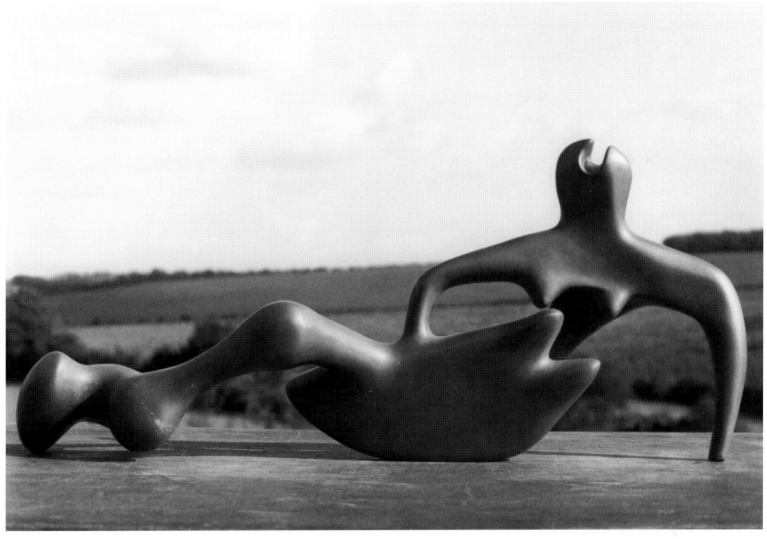

64 *Reclining Figure*, 1938, Lead, L. 33 cm, Museum of Modern Art, New York (LH 192)

The tension generated by pronounced joints informs much of Moore's sculpture in the 1950s, including many reclining figures and the *Warrior with Shield* (figs. 171–173). In his late work, generally more abstract in tenor, the theme of joints became increasingly self-sufficient. Examples are the large bronze *Locking Piece* of 1962 (figs. 218–20), discussed below, and *Three Piece Reclining Figure No 2: Bridge Prop* of 1963 (fig. 65). The sharply rising upper body of the figure in the latter work recalls a femur, with the raised greater trochanter (minus the tip), the neck and the head. As in some huge joint, the head rests on the dished central section, which acts as a support and a link. The movement of this part is taken up at the foot of the figure in the third section, which resembles a hipbone.

This brief excursion to 'Moore and bones' would not be complete without mention of the artistic consequences of the sculptor's study of the elephant skull. Late in his career, he

here drew on the full range of the creative understanding of phenomenology he had gained from his investigation of bones. In 1968 Juliette Huxley gave Moore an elephant's skull mounted on a rotating base.[50] The artist was overjoyed: 'The skull is three feet high and two feet wide and almost three feet from back to front. It is very monumental, a huge presence and very imposing. As soon as I saw it I was very thrilled and knew I wanted to draw it.'[51] He told the American critic Henry J. Seldis: 'I have never had the fortune of being able to study something as imposing as this elephant's skull at close quarters. [...] Some parts of its structure are very thick and strong and others are almost as thin as paper. Nature's sense of strength and structure is one of the marvelous things that you discover in studying such bones.'[52] There was 'even more complexity in [the elephant skull] than there is in a human skull – much more'[53]

At the instigation of Gérald Cramer, his print publisher, Moore decided to record his impressions of the skull with the

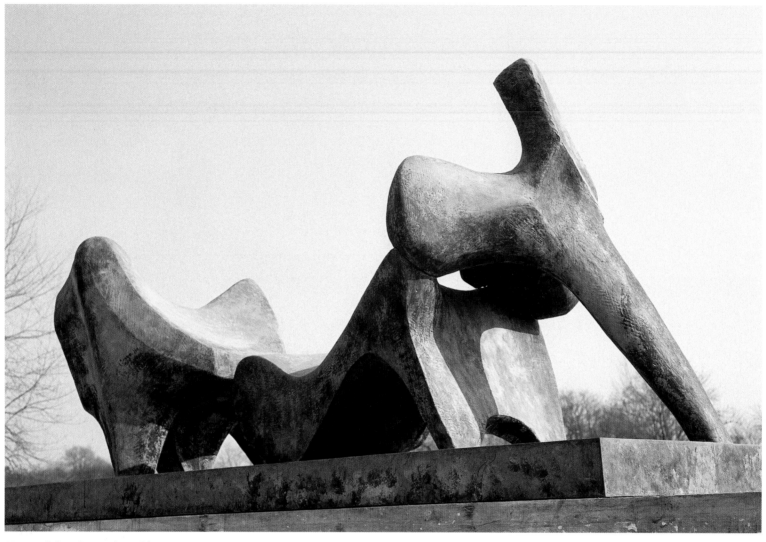

65 *Reclining Figure N° 2: Bridge Prop*, 1963, Bronze, 99 x 251 cm, Leeds City Art Galleries (LH 513) (Photography: Much Hadham)

etcher's needle. Over barely three weeks in 1969–70 he produced a portfolio of thirty-seven etchings in close collaboration with Jacques Frélaut, a Paris printer known for his work with Picasso, who travelled specially to Much Hadham.[54] Moore could achieve the same immediacy and subtlety on the coated etching plate as he could when drawing on paper. By his own account, he began by depicting the skull as a whole from all sides, only later closing in on it and engrossing himself in details. Among the first etchings is a rear view of remarkable grandeur (fig. 66), revealing how Moore focused immediately on the essential differences between an elephant and a human skull. In the human the bases of the rami are angular, whereas in elephants they rise in large, full arcs and end in hinge joints linking them with the cranium. In the etching Moore encourages the viewer's gaze to disappear into the labyrinthine abyss formed by the two cavities between the rami. Here too, then, Moore perceives the bone structure as an integrated system of interlocking elements, as in a building.

This structural aspect receded in the course of the artist's detailed examination of the skull. He occasionally rotated the etching plate to facilitate abstraction and to set up independent spatial tensions. He did this in the twenty-second etching (fig. 67), turning a vastly magnified detail of the mandible upside down so as to create a free-floating configuration susceptible to new, imaginative interpretations – as a coastal landscape, for example. Moore said of the skull and its transformations: 'In some places it looked like a desert to me. It began to have expanses in it with sandhills that stretched to the horizon. Or at times one could see architectural columns in it – or figurative elements – or mysterious caves.'[55] In each case he aimed to find an 'independent form'. If he glimpsed it through the anatomical givens of the skull, either in concrete terms or as an idea, he had reached his goal: 'In making these etchings I hoped to be able to isolate an idea found in the skull and to disassociate it from its entity. Starting from a specific view I tried to arrive at an independent form. This is why some of the etchings here are actually upside down or on their side

66 *Elephant Skull XXVIII*, 1969, Etching, 25.4 x 20 cm, The Henry Moore Foundation (CGM 141)

from what I saw.[56] Discovery of an 'independent form' by no means excluded reminiscences of earlier formal inventions of his own. A horizontal motif with a pierced arched section (fig. 68), for instance, relates to the artist's *Reclining Figure: External Form* of 1953–54 now in Freiburg (figs. 308, 309).[57]

Further interrelations of this kind are easy to find. In 1964–65, for example, Moore created a maquette for a work later entitled *Atom Piece* or *Nuclear Energy* (fig. 69).[58] Commissioned by the University of Chicago, it remembered the first controlled nuclear chain reaction, performed by Enrico Fermi in 1942 at the university campus. Although the basic two-part conception – a large cranium supported by an organic structure – seems to have been established early on, a photograph of Moore in his studio (fig. 70) indicates that he further clarified the composition in the light of his acquaintance with the elephant skull. Retaining the large eye-sockets, he metamorphosed the rami so that they supported the top as they did in the elephant skull. As Reinhard Rudolph has shown,[59] Moore incorporated other ideas derived from the skull in such sculp-

tures of 1969 as *Pointed Torso*,[60] *Two Piece Points: Skull*[61] and *Architectural Project*[62].

The importance that Moore attached to the study of the skeleton in general emerges from a statement like the following, made in 1978: 'Everything in the world of form is understood through our own bodies. From our mother's breasts, from our bones.'[63] In fact, although supported by the aesthetics of the surrealist *objet trouvé*, Moore's curiosity was stimulated by the variety of forms and spatial articulations of bones, no less than by his awareness of one's own body and its movements. When Herder speaks, in his well-known treatise 'Plastik', of a statue as a 'body that has gone through something',[64] he refers to the generally acknowledged fact that a sculptor often creates from his or her own physical condition and accompanying realm of experience. Thus, a sculptor's work exposes, as it were, the basic patterns of a 'physical truth'.[65] Viewed in such a way, it may be of interest that photographs taken in his youth indicate that Moore was physically neither bulky nor athletic, but rather delicate and propor-

67 *Elephant Skull XXII*,
1969, Etching,
23.5 x 30.8 cm,
The Henry Moore
Foundation (CGM 135)

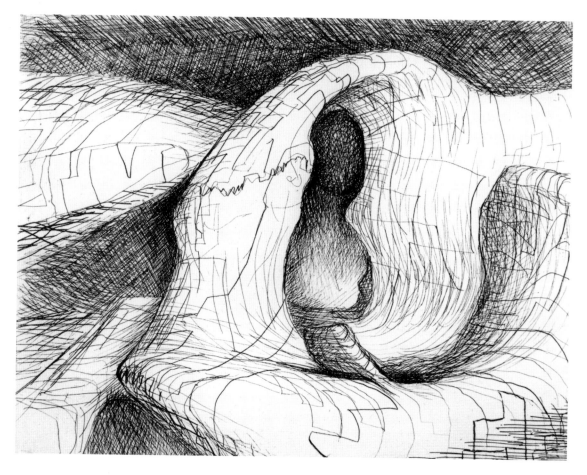

68 *Elephant Skull VIII*,
1969, Etching ,
23.5 x 30.8 cm,
The Henry Moore
Foundation (CGM 121)

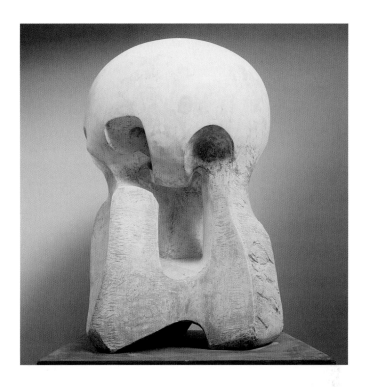

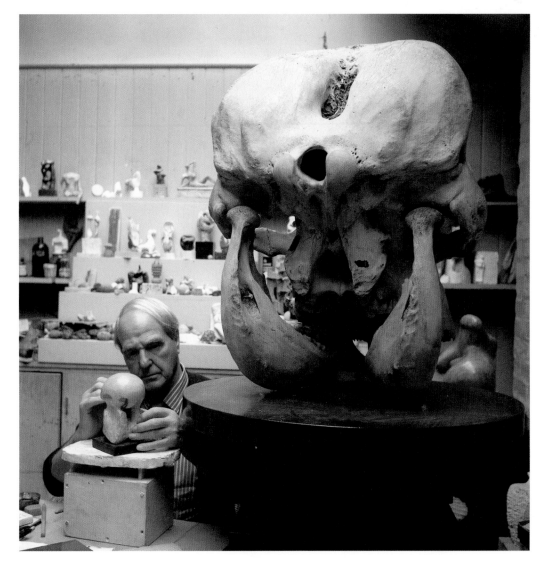

69 *Atom Piece. Working Model for Nuclear Energy*, 1964–65, cast, H. 120 cm, Art Gallery of Ontario, Toronto (LH 525)

70 Moore working on the maquette *Atom Piece*, Much Hadham, 1970

tionally built instead. He actively participated in sports and his movements were characterized by a distinct agility throughout his life. This agility – captured in sculpture – was Moore's pledge to his study of bones.

The Surrealist Years: 'a fortunate period for me'

Moore played an active and major part in introducing and spreading surrealist ideas in Britain. He did not, however, sacrifice his artistic independence to the new movement. He had already matured as an artist and a teacher by the time he first met Arp, Miró, Alberto Giacometti and other Surrealists, in Paris in 1931–32. He had left a distinctive early period behind him and now belonged with Hepworth, John Skeaping, Maurice Lambert and Richard Bedford among the outstanding members of the younger generation of sculptors in London, artists who were building, in their individual ways, on the modernist achievements of Henri Gaudier-Brzeska, Jacob Epstein, Frank Dobson, Eric Gill and Leon Underwood. In 1930 Moore represented his country at the Venice Biennale, together with Epstein and Skeaping.[66]

Although he, too, had witnessed the senseless brutality of the First World War as a soldier, Moore remained untouched by the artistic upheavals it had triggered on the Continent. The nonsense aesthetics promoted by the Dada movement, and its attacks on the traditional means of art, were foreign to him. Similarly, his positive view of himself as an artist, his confidence in the value of self-discipline and education and, not least, the Protestant ethos that formed part of his inheritance, made it impossible for him to become a whole-hearted adherant of the revolutionary doctrine of Surrealism as propagated by André Breton. Moreover, beginning in 1934 he created, alongside his 'Surrealist' works, abstract sculptures in a Constructivist style[67] that came closer to the purist tendencies cultivated by those artists who had studios close to his in Hampstead: Hepworth, Gabo and Ben Nicholson.[68] Significantly, from 1933 to 1940, Moore participated in group exhibitions of both surrealist and abstract art.[69] Hence, the critic David Gascoyne could write in the issue of *Axis* that appeared in January 1935 (the year in which the same author's *Short Survey of Surrealism* was published): 'Moore: Product of the multiform inventive artist, abstraction-surrealism nearly in control; of a constructor of images between the conscious and the unconscious and between what we project emotionally into the objects of our world; of the one English sculptor of large, imaginative power, of which he is almost master; the biomorphist producing viable work, with all the technique he requires.'[70]

Moore did indeed pursue a 'controlled' approach. This became crystal clear in 1937 when, at the height of his engagement with Surrealism, he contributed to the anthology *Circle:*

International Survey of Constructive Art and published his well-known 'The Sculptor Speaks' in *The Listener*, a statement much commented on at the time: 'The violent quarrel between the abstractionists and the surrealists seems to me quite unnecessary. All good art has contained both abstract and surrealist elements, just as it has contained both classical and romantic elements – order and surprise, intellect and imagination, conscious and unconscious. Both sides of the artist's personality must play their part.'[71] Towards the end of the text Moore appears to favour the surrealist aesthetic of the liberated imagination: 'It might seem from what I have said of shape and form that I regard them as ends in themselves. Far from it. I am very much aware that associational, psychological factors play a large part in sculpture. The meaning and significance of form itself probably depends on the countless associations of man's history. For example, rounded forms convey an idea of fruitfulness, maturity, probably because the earth, women's breasts, and most fruits are rounded, and these shapes are important because they have this background in our habits of perception. I think the humanist organic element will always be for me of fundamental importance in sculpture, giving sculpture its vitality. Each particular carving I make takes on in my mind a human, or occasionally animal, character and personality, and this personality controls its design and formal qualities, and makes me satisfied or dissatified with the work as it develops.'[72]

It would be erroneous to underestimate the fundamental significance of Surrealism to Moore between 1930 and 1940 merely because he never succumbed completely to its influence. He referred to the 'liberating impulses'[73] he had received from it as an established fact. Examination of a few examples will show to what extent these stimuli proved to be of permanent value to the artist as he combined them with his own concerns.

Moore's contribution to the *International Surrealist Exhibition*, London, 1936

In Hampstead in late 1935 Moore's friends David Gascoyne and Roland Penrose (a close acquaintance of Picasso, Max Ernst, Breton and Paul Eluard) formed a working group of surrealist artists in Britain that included Moore himself, Herbert Read, Humphrey Jennings and E. L. T. Mesens. Read, Britain's leading writer on art after Roger Fry,[74] had first met Moore in 1928 and was to become his most influential champion. Read's discussion of 'surréalisme' in his book *Art Now* of 1933 focused on Breton, Ernst and Klee. In his preface he described in detail the 'monstrous illogicality' of Nazi policies on art and museums in Germany[75] and thus prepared the way for the clear anti-Fascist stance later taken by the British Surrealist group, including Moore. Early in 1936 Moore (as honorary

treasurer) joined Nash and Penrose on the organisation committee of the first major exhibition of surrealist art to be mounted in Britain. Held at the New Burlington Galleries in June and July of that year, the *International Surrealist Exhibition* contained 390 items from nineteen countries and provided a comprehensive review of Surrealist art that encompassed work by Belgian, British, Czech, German, Scandinavian and Spanish artists, as well as by members of the core group in Paris. Accompanied by readings and lectures, the exhibition was a huge success, attracting what was then the sensational number of 20,000 visitors.[76] Moore showed seven works, the same number as Arp and one less than Giacometti. Brancusi and Alexander Calder were the only other sculptors represented.[77]

Over the next four years, until the summer of 1940, Moore contributed to surrealist exhibitions in London, New York and Paris and had work reproduced in their catalogues and in such art periodicals as *Minotaure*, the *International Surrealist Bulletin* and the *London Bulletin*. In November 1936 he signed a public 'Declaration to Spain', drawn up by the Surrealist Group of England in opposition to the British government's policy of non-intervention in republican Spain.[78] This did not prevent Moore's fellow Surrealists from later disowning the ally they had once been proud to call their own. They took the next best opportunity after the war – the catalogue of the Paris exhibition *Le Surréalisme en 1947* – to denounce him as a 'deserter' for accepting a commission for a Madonna and Child to be installed in St Matthew's church in Northampton.[79]

It may be assumed that in choosing works for the *International Surrealist Exhibition* Moore wished to acquaint the international art world with as broad a spectrum as possible of his surrealist concerns. Along with three drawings he showed four sculptures: *Reclining Figure*, lead, 1931 (cat. no. 230; figs. 71, 71a); *Reclining Figure*, reinforced concrete, 1933 (cat. no. 231; fig. 72); *Figure*, Corsehill stone, 1933–34 (cat. no. 232; fig. 73); and *Carving*, travertine marble, 1933 (cat. no. 233; fig. 74).[80] Firstly, one is struck by the wide range of materials. In lead, reinforced concrete, stone and marble he was testifying to his belief in the truth to materials doctrine, espoused in the 1920s and reiterated in 1934 in a programmatic statement.[81] Secondly, the sculptures date from a notably short period, 1931 to 1934. In other words, Moore did not exhibit his most recent work, presumably because he felt that it was less obviously surrealist in orientation.

The *Reclining Figures*, both based on drawings,[82] address characteristically surrealist concerns in three-dimensional depictions of the human body. Moore stresses the biomorphic fluidity of the volumes in a way that recalls the freely flowing lines of the 1928 drawings discussed above. He shaped the spaces within the figures by articulating them as a loosely rhythmic alternation of tense, compact masses with relaxed, expansive ones, giving the interior a three-dimensional life of

its own and granting it an emotional quality. This represents Moore's response to current efforts by Picasso, Jacques Lipchitz, Arp, Giacometti and others to create biomorphic sculptures that unfolded in space. In both figures he incorporated a disruptive element, à la Surrealism, in the shape of rods that contrast with the organic bodies. Unlike Lipchitz[83] and Giacometti,[84] who included vertical rods as markers in the transparent tissue of their figures, Moore used such features to intensify the spatial quality of his sculptures. Thus, in the lead figure the rods demarcate the hollow of the chest, and in the reinforced concrete figure they function as linear braces that guide the eye through space by binding together the voluminous sections of the body.

The context in which Moore's sculptures were displayed at the *International Surrealist Exhibition* (fig. 75) is revealing. The lead *Reclining Figure* of 1931 appeared near Richard Oelze's *Daily Torments* (1934) and Miró's *The Tilled Field* (1923–24) and faced Hans Bellmer's *Doll* assemblage and Dalí's *Dream* (1931), both works that evoked an imaginary dream world. Moore's figure also inhabits this domain, with its biomorphic fluidity, its attenuated volumes and its rods subverting in a distinctly surrealist way the realism traditionally associated with sculpture.

The juxtaposition of the powerful 1933 *Carving* with Giorgio de Chirico's enigmatic painting *The Tower* was equally telling (fig. 74). This was the first sculpture in which Moore carved a substantial hole in the centre. There was no compelling figurative reason for this: the abstract piercing served rather to disclose the three-dimensional potency of a void in stone. For Moore, holes were far more than framed openings. They were self-sufficient spatial forms, not only circumscribed by a mass, but also released and assimilated by it in equal measure in the course of sensitive shaping. Hepworth had been the first to adopt this dynamic approach to the hole: her alabaster *Pierced Form* of 1931 ranks as a 'trademark of modernism'.[85] Hepworth and Moore, friends since their art school days in Leeds, were engaged in a very fruitful exchange of ideas.[86] Since 1929 they had maintained studios close to one another in Hampstead. Nicholson moved into the district in 1931, followed by Gabo, Nash, Penrose, Piet Mondrian, Marcel Breuer, Walter Gropius and the writers Read, Adrian Stokes and Geoffrey Grigson. In this stimulating atmosphere artists constantly influenced each other.[87] Moore described in 1937 what the discovery of the hole had meant to him: 'The first hole made through a piece of stone is a revelation. The hole connects one side to the other, making it immediately more three-dimensional. A hole can itself have as much shape-meaning as a solid mass. Sculpture in air is possible, where the stone contains only the hole, which is the intended and considered form. The mystery of the hole – the mysterious fascination of caves in hillsides and cliffs.'[88]

Finally, with the *Figure* in Corsehill stone (fig. 73),[89] Moore exhibited a powerful example of his biomorphism, where the

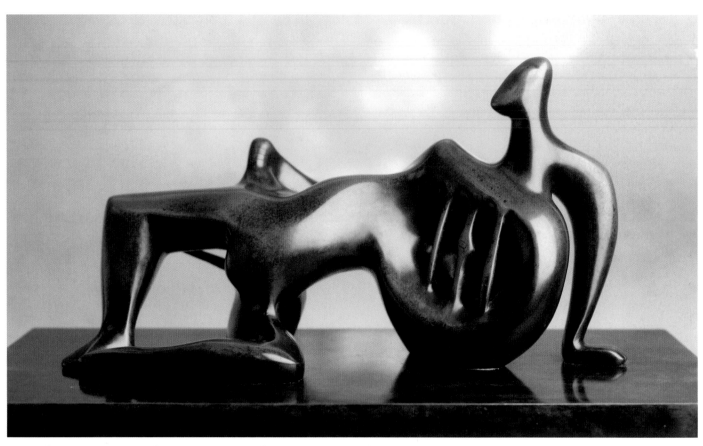

71 *Reclining Figure*, 1931, Lead, L. 43.2 cm, Private Collection, Bronze 1963, The Henry Moore Foundation (LH 101)

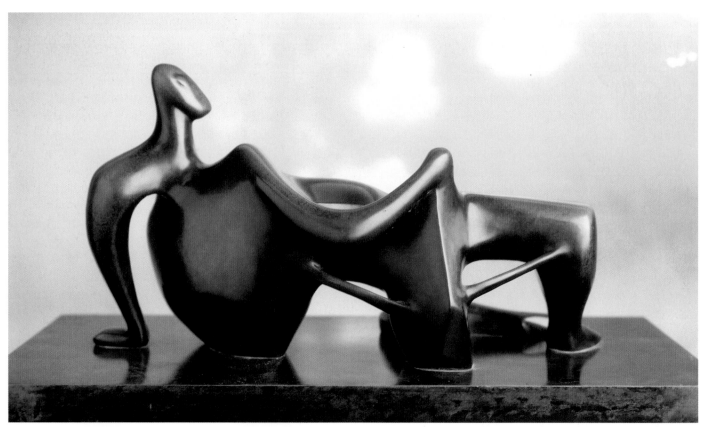

71a

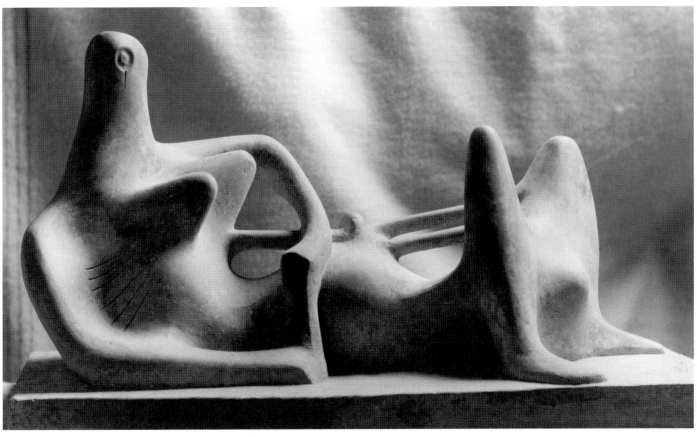

72 *Reclining Figure*, 1933, Iron concrete, L. 77.5 cm, Washington University Gallery of Art, Saint Louis (LH 134)

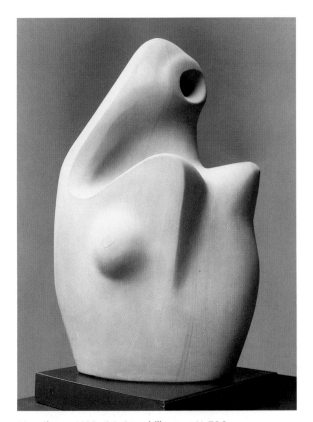

73 *Figure*, 1933–34, Corsehill stone, H. 76.2 cm,
Private Collection (LH 138)

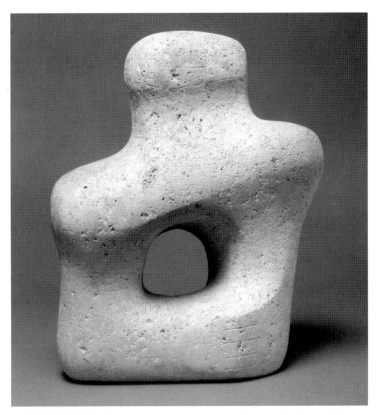

74 *Carving (Figure)*, 1933, Roman Travertine marble, H. 40.64 cm,
Private Collection (LH 137)

entire figure is caught up in an organic, upward thrust. A hollow appears between the breasts and the head, its concavity emphasised at the point of transition to the hole in the head, which can be read as an orifice for breathing or as an eye. Combining concise, internally coherent volumes with the suction effect of the small piercing in the head, Moore gave the whole a strangely introverted, unsettling quality that recalls the surrealist penchant for contradition.

The sculptures shown by Moore at the 1936 Surrealist exhibition thus testified, on the one hand, to a biomorphic approach to form that had progressed beyond its basis in the work of Picasso, Arp, Giacometti and Lipchitz and, on the other, to a conception of emotional space[90] that, developed out of the material, could 'have as much shape-meaning as a solid mass'.[91] In November 1936, as a postscript to the exhibition, Read published a miscellany entitled *Surrealism*. Moore was represented by four illustrations. The double-page spread containing Figs. 58 and 59 showed the 'biomorphic Moore' in the shape of the reinforced concrete *Reclining Figure* and the complex 1933 wood *Carving* (fig. 77) illustrated in three positions (fig. 78). A second spread – Figs. 60 and 61 – presented the artist more from his *Square Forms* side, juxtaposing a

stone *Carving*[92] with the powerful motifs in a drawing that will be discussed in detail below.

Remarkably, Moore went beyond his contribution to the exhibition by including a strikingly surrealist wood carving. In conversation with the author,[93] he confirmed that *Carving* (later called *Composition*) was based on *Studies of Bones* (fig. 76). The drawings, which once more bear witness to the artist's intensive study of anatomy, all revolve around the subject of hollows and holes. The top four sketches show details of the human shoulder: sections of the scapula with the articular facets of the collarbone (clavicula – not depicted as a whole) and the bone of the upper arm (humerus). The two studies in the third row represent sections of an elbow joint: the olecranon on the ulna and the head of the radius (capitulum radii). The drawings at the bottom show details of the elbow joint, rotated through 180 degrees and focusing on the olecranon itself. Here, in the turning movement implicit in the joint, Moore discovered a dynamism that he sought to preserve in the sculpture, developing it fully on all sides. He underscored this by placing the carving on a disk-shaped base with a circular groove, a feature reminiscent of Giacometti's *Circuit* of 1931, likewise made from wood.[94]

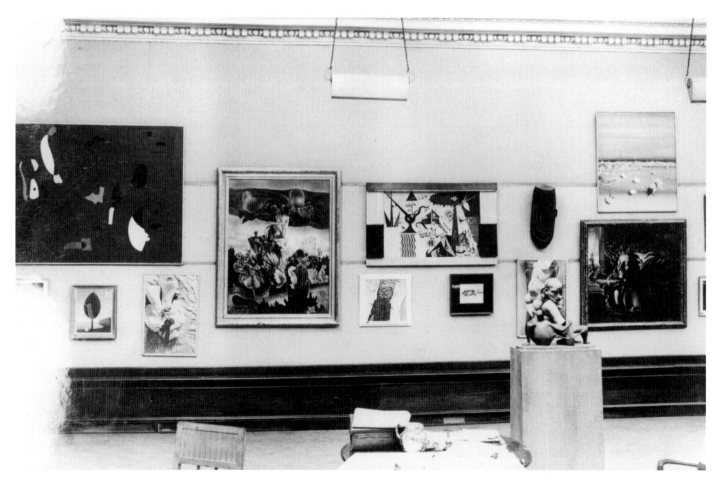

75 View into the International Surrealist Exhibition, Burlington Galleries, London 1936

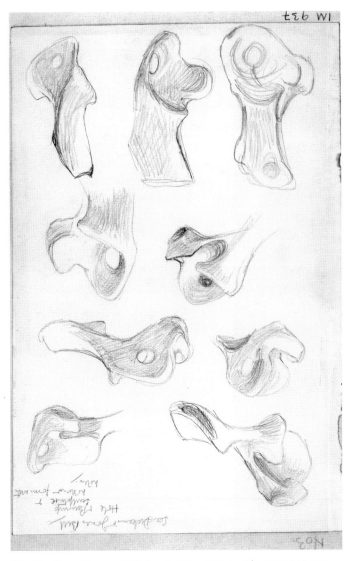

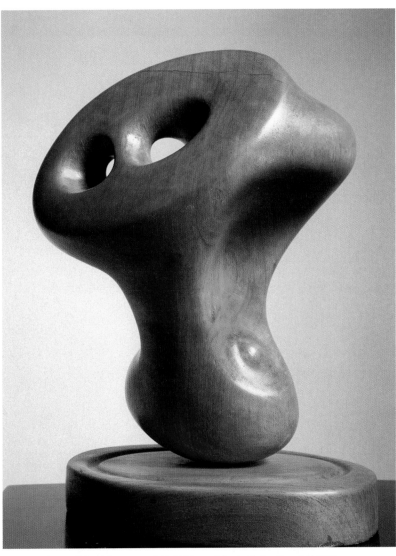

76 *Studies of Bones*, 1932, Pencil, 27.3 x 18.1 cm, The Henry Moore Family Collection, AG 32.48 (HMF 938)

77 *Carving*, 1933, Walnut wood, H. 35.6 cm, Private Collection (LH 132)

The many-sidedness inherent in *Carving* was emphasised in Read's book by Frances Joseph Bruguière's photograph (fig. 78).[95] This both reproduced and interpreted the sculpture, combining the three main views in such a fluid way that the carving almost seems to be revolving, drawing attention to the interdependence of form and space in the work. Moore here used holes (suggesting eyes in a head) to interweave external and internal energies dynamically and thus to grant the sculpture a sense of latent movement. The carving, then, is invested with that 'continuous movement' which Christian Zervos rightly saw as an essential feature of surrealist sculpture.[96] *Studies of Bones*, and the head evoked in the carving derived from it, inhabit the same world as Moore's *Transformation Drawings*, discussed in detail in the previous chapter.

Further evidence of the artist's distanced association with Surrealism comes from the exhibition *Surrealist Objects and Poems*, held at the London Gallery in late 1937, in which his

contribution was included in the 'Constructed Objects' section, and not among the 'Found Objects Interpreted'. That contribution consisted of *Sculpture to Hold* (then titled *Object to Hold*) of 1936 (fig. 79), a programmatic work. Moore explained to the present author that his aim in this small wooden piece was 'to connect touch with sculpture'.[97] He wanted viewers to put their hands in the cavity and grasp the 'stem'. In other words, he wished to combine primary tactile experiences – exploration by touch both inside and out, both unseen and seen – in one and the same sculpture. The 'object' of the original title was thus defined in sculptural terms. Unlike Giacometti in *Suspended Ball* (1930–31),[98] which likewise sought to involve the spectator physically, or in *Point to the Eye* (1931),[99] he was not concerned to evoke sexual arousal or violence. Instead, *Object to Hold* was self-sufficient. Feeling their way around the interior and exterior, beholders were to expand their sensory perception of three-dimension-

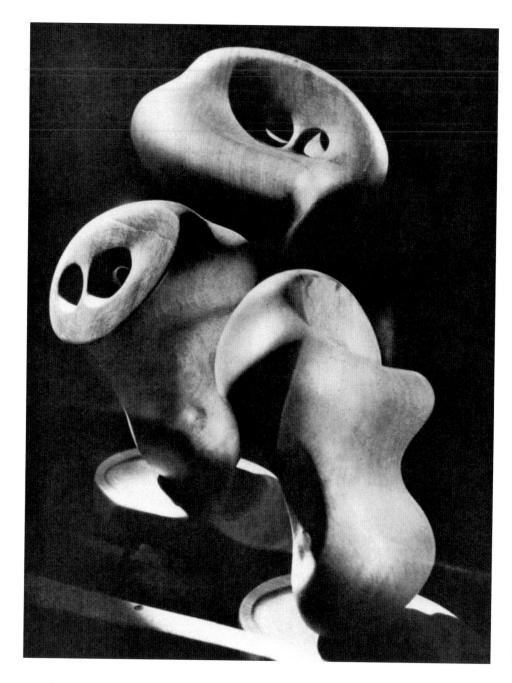

78 Frances Joseph Bruguière, *Henry Moore. Carving in three Positions*, 1933. In: *Surrealism*, ed. by Herbert Read, London 1936, fig. 59

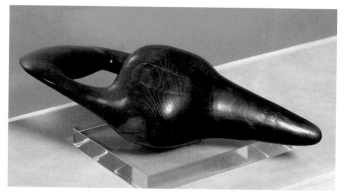

79 *Sculpture to hold*, 1936, pine wood, L. 33 cm, Private Collection (LH 173)

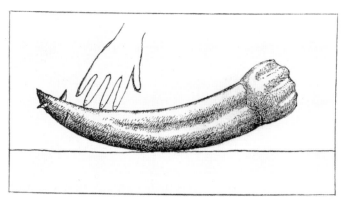

80 Alberto Giacometti: *Objet désagreable*, 1931–32, pencil, 10 x 14.5 cm, Musée national d'art moderne, Centre Georges Pompidou, Paris

al forms. Increasing visitors' awareness in this way was the only instructive goal that Moore shared with the organisers of *Surrealist Objects and Poems*.

Moore's stance here becomes clearer if the didactic aim of *Object to Hold* is compared with that of Giacometti's marble *Objet désagreable* of 1931.[100] Giacometti included a drawing commenting on his object among the illustrations to his well-known text 'Objets mobiles et muets', published in issue no. 3 of *Le Surréalisme au Service de le Révolution* in 1931 (fig. 80). The drawing shows that he, too, was concerned with touch – but by preventing it. As a Surrealist, he rejected tactility, anticipating a statement of his old age in which he declared that his works were created 'solely for the eyes'.[101] The drawing shows a hand with fingers touching an object with spikes at its tip. Grasping the object would be painful – 'disagreeable'. Like Moore's sculpture, Giacometti's drawing revolves around attraction and repulsion, but at a subversive, sexual level, rather than in a tactile way: its sharply focused wit has more in common with the surrealist aesthetics of cruelty, as embodied in Dalí and Luis Buñuel's film *An Andalusian Dog*. Self-destructive tendencies of this kind, noticeable in other surrealist works by Giacometti, were utterly foreign to Moore. His avowed aim was to promote tactile investigation that balanced the 'external' and the 'internal', the 'full' and the 'empty',[102] and encouraged the sculpture to be perceived in what might be called 'anthropological' terms.

Relationships to Alberto Giacometti's Surrealistic Sculpture

Such dissimilarities testify to a fundamental difference of approach between Moore from Giacometti. This did not prevent Moore from admiring Giacometti all his life, whatever his reservations,[103] and other parallels between the 'Surrealist' Moore and Giacometti certainly exist. Both artists first visited Paris around 1922. Both attempted to come to terms in their own ways with the omnipresent influence of Picasso, Brancusi, Archipenko, Henri Laurens and Lipchitz. Both arrived at an inidividual style by studying non-European sculpture in museums. Both shared the traditional view that drawing was a *sine qua non* of artistic activity. And both focused primarily on the human figure.

Giacometti's 'artistic socialisation', however, had taken place in Paris, where the variety of his innovative sculptural ideas and his literary curiosity led him to the heart of surrealist activity, both to Leiris and Battaille and to Breton.[104] Whereas Moore in 1929 found compelling expression of his personal archaism in the heaviness conveyed by his *Reclining Figure* in Leeds, Giacometti in the same year enticed visitors to his first successful exhibition, at the Galerie Jeanne Bucher, with the airy quality of his reliefs *Gazing Head* and *Man (Apollo)*. From 1929 to 1938 Giacometti produced one major surrealist work after another, focusing on a kind of 'object art'. Breton was

81 *Head and Ball*, 1934, Cumberland Alabaster, L. 51 cm, The Henry Moore Foundation (LH 151)

82 Alberto Giacometti: *Homme, femme et enfant*, c. 1931, Wood and metall, 41.5 x 37 x 16 cm, gift of Marguerite Arp-Hagenbach, Kunstmuseum Basel

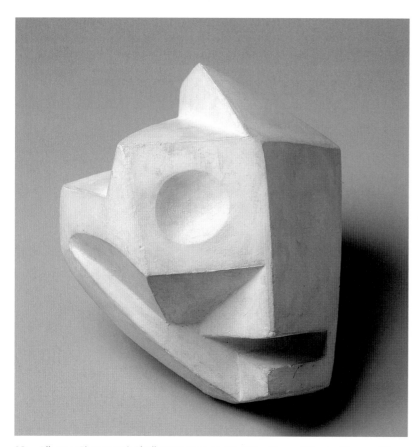

83 Alberto Giacometti: *Skull*, 1934, Bronze, 18 x 21 x 19 cm, Alberto Giacometti-Stiftung, Kunsthaus Zürich

to cite them as examples of 'modern poetic magic'[105] in 1941. Since then scholars have acquired more extensive knowledge of the complex web of experience that lay behind such outstanding pieces as *L'Heures des traces* (1930), *Suspended Ball* (1930), *Cage* (1930), *The Palace at 4 A.M.* (1932), *Model for a Square* (1930–31), *Woman with her Throat Cut* (1932), *The (Surrealist) Table* (1933) and *Hands holding the Void (Invisible Object)* (1934).[106]

As a surrealist, Giacometti undermined preconceived notions of sculpture as 'embodying' something. He relied instead on simple signs or symbols, suspended in cages, spread out on disc-shaped surfaces or, as in *Woman with her Throat Cut*, trampled on the floor. At the mercy of the space they inhabit, they all reflect the artist's fears and inhibitions.

Avant-garde artists and collectors were fascinated by Giacometti's existential diagrams, which accommodated dreams, sex, magic, cruelty and the sort of interpretative ambiguity that permits shapes to be read as a head or a landscape, say, or as an insect or a woman. Moore was no exception. Yet unlike Picasso and Hepworth, who both made wholesale adaptions of *Suspended Ball*,[107] he borrowed only individual features from Giacometti. In the spirit of the latter's referential *pars pro toto* method, he focused on conceptual details, as indicated by the bars in the reinforced concrete *Reclining Figure* (fig. 72), the circular groove in *Carving* (fig. 77) or the groove in the recessed area of the base in *Head and Ball* of 1934 (fig. 81),[108] which symbolises the pyschological link between the 'head' (mother) and the 'ball' (child) and is clearly related to Giacometti's *Man, Woman and Child* of 1931 (fig. 82).[109] Moore certainly also noted the masterly juxtaposition of extreme emotion – the screaming mouth – with cool, hard-edged Cubist faceting in Giacometti's 1934 *Skull* (fig. 83).[110] His small, contemporaneous *Carving* (fig. 84) possesses a similar double charge.

Moore seems to have been especially attracted to the formal vocabulary of Giacometti's 'table' sculptures, which show objects protruding from a flat surface. A drawing of 1934, for example (fig. 86), includes borrowings from his *Model for a Square* of 1931/32 (fig. 85).[111] Yet whereas Giacometti's signs for 'tree', 'woman' and 'serpent' suggest an interpretation of his work as the Garden of Eden,[112] Moore's drawing refers to nothing more than an 'architectural' setting. In fact, it recalls the megaliths of Britain.[113] The pierced disc, for instance, brings to mind the well-known *Mên-an-tol* in Cornwall (fig. 87)[114] and recurs in the reinforced concrete *Composition* of 1934 (fig. 88), with its splintered structure reminiscent of bones. Viewing *Composition* in terms of the drawing and of its megalithic associations, the suggested parallel with Giacometti's *Woman with her Throat Cut* appears problematic,[115] not least because Moore remained unreceptive towards the aesthetic of cruelty promoted by Bataille and his associates and apparent in this and other pieces by Giacometti.[116]

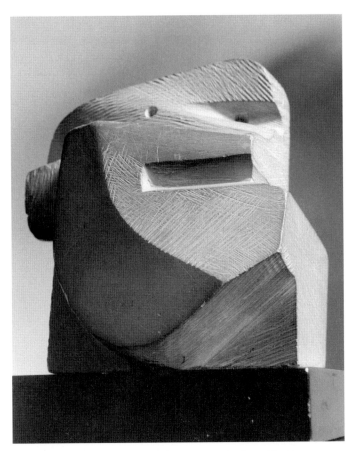

84 *Carving*, 1934, African Wonderstone, H. 10.16 cm, The Henry Moore Family Collection (LH 142)

Further reflections of Giacometti's 'table' sculptures in Moore's work – for example, in the various *Drawings for Wood Constructions*[117] – likewise transform the sources in abstract terms. In all his dealings with Giacometti's art Moore can thus be said to have adopted the Swiss artist's ideas only if they extended spatial potential in the context of his own, primarily formal interests.

Non-European sculpture and magic

Two Upright Forms (fig. 89)[118] was surely an outstanding contribution to the *International Surrealist Exhibition* of 1936. At 49,5 x 35,3 centimetres, this highly finished gouache, which once belonged to Kenneth Clark, is relatively large. Stylistically, it resembles the monolith-like *Square Forms* that Moore began drawing in the context of his 'pictural settings' in 1934.[119] A mask appears against the patchy background between two abstract shapes as though floating in front of a wall, its mischievous expression contrasting with the impersonal, idol-like character of the vertical forms. The sources of this composition are revealing in more than one respect. Moore took the motifs – the two forms and the mask – from a 1935 sheet of

studies (fig. 90),[120] in which the figure on the right is clearly female. With the exception of the two reclining figures at the top and the mask itself, the sketches constitute a rare instance of *Transformation Drawings* based on photographs. These had appeared in a special issue of the surrealist periodical *Minotaure* (no. 2, 16 June 1933), accompanying reports of an expedition from Dakar to Djibouti undertaken by the ethnological institute of the Université de Paris.[121] Among other things, the issue contained copiously illustrated accounts of the customs and rituals of the Dogon people in Sanga. The Surrealists' fascination with the authentic nature of this culture was doubtless increased by the fact that one of their friends, the young Africanist and writer Michel Leiris, had taken part in the expedition. Each of the motifs that Moore copied from the periodical was to prove enormously rich in potential.

From page 10 (fig. 91) he jotted down two motifs: a shrine (*kono*) for ritually sacrificed animals and a sacred cave near Barna in Sanga, Sudan, housing 'mother masks'. The masks can be seen in a second photograph (fig. 92), their staff-like extensions reaching far into the cave. In his drawing Moore upended them and transformed their faces into the legs and lower parts of his figures' bodies. Next to them he sketched a grass mask (fig. 93) from the ethnological museum in Basle that had been reproduced in the first number of *Minotaure* (February 1933, p. 1), accompanied by a text by Eluard. As so often was the case, Moore added notes to his sketches indicating possible uses. In the sacrificial shrine and the masks, for example, he saw 'Statues'. A sketchbook of 1936 (with additions from 1942) preserved at the Henry Moore Foundation includes a two-part drawing of 1936 in pen and ink, pencil and wash (fig. 94) that closely anticipates the final version of the

85 Alberto Giacometti: *Model for a place*, 1931–32, Wood, 19.4 x 31.4 x 22.5 cm, Peggy Guggenheim Collection, Venice

86 *Monoliths*, 1934, Pencil, crayon, pen and ink, watercolour, wash on cream medium-weight wove, 27.8 x 18.3 cm,
Henry Moore Foundation, AG 34.69 (HMF 1127)

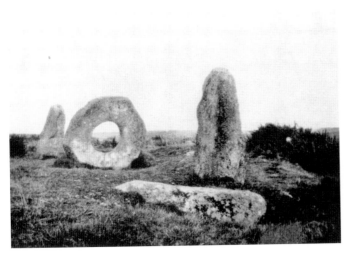

87 *Mên-an-tol*, Cornwall

states in *Two Upright Forms*. The transition from a swift record of the photograph in *Minotaure* to an independent composition takes place in this drawing. In the final gouache (fig. 89) Moore homed in on the forms derived from the masks in the upper section of the two-part drawing. He both transformed them into mysterious beings and brought them into line with his more abstract *Square Forms*. Their 'eyes' are the focus of that psychological content that he expressly wished his works to possess.[122]

A similar combination of ritual object and spellbinding expression was to be found among the illustrations to Leiris's article on Dogon masks in the African number of *Minotaure* (pp. 45–51). Moore was probably struck by the formal structure of the animal masks in particular, with their deep eye sockets, the continuous straight lines of their noses contained within a vertical rectangle and, in one *Antelope Mask* (fig. 95), the concave facial area. By the late 1930s he had developed this formal vocabulary along independent lines, as shown by a sketch of 1939 for the lithograph *Spanish Prisoner* (fig. 96),[123] produced in reaction to the Spanish Civil War. Much later, in 1968, he was to bring together the masks' features in simpli-

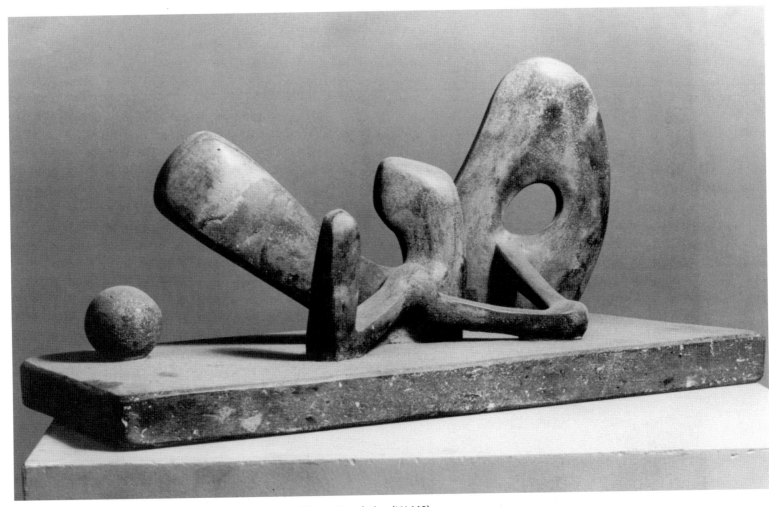

88 *Composition*, 1934, Iron concrete, L. 44.5 cm, The Henry Moore Foundation (LH 140)

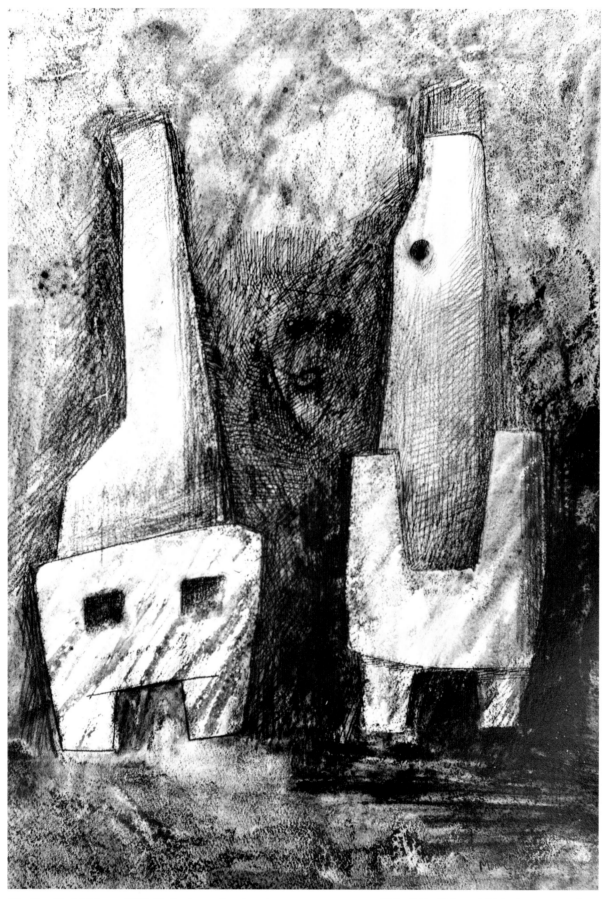

89 *Two Upright Forms*, 1936, Chalk, charcoal, watercolour, wax crayon, pen and ink, 49.5 x 35.3 cm, British Museum, London, AG 36.18 (HMF 1254)

90 *Ideas for Sculpture*, 1935, Pencil, pencil (rubbed), pen and ink, wash on cream lightweight wove, 27.3 x 18.1 cm, The Henry Moore Foundation, AG 35.94r (HMF 1183)

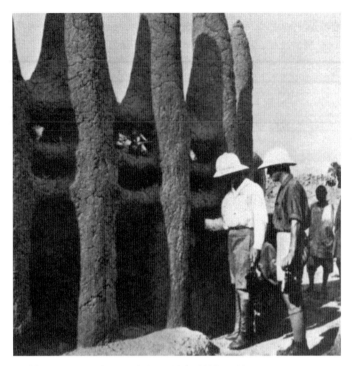

91/92 MINOTAURE, No. 2, June 16th, 1933, p. 10

92 MINOTAURE, No. 2, June 16th, 1933, p. 19

fied form in *Large Totem Head* (fig. 97).[124] This shows the vertical framing rectangle as an oval, the eye sockets enlarged and the long bar of the nose as a dominant component. *Large Totem Head*, then, can be said to have had its origins in the artist's surrealist phase of thirty years earlier.

The figures and heads that Moore developed from African sources do not conceal their origins in the world of spirits and magic. Rather, that world forms an integral – and compelling – part of the message conveyed by these modern concretions. The sheet of studies containing the initial idea for *Two Upright Forms* (fig. 90) shows at lower left a figure described in the annotation as 'Bird cage sculpture with wood & plaster'. It was taken from illustrations on page 19 of the African number of *Minotaure* showing rooftop structures made from bamboo and straw (fig. 98). Moore jotted down one of these in pencil, then drew over this sketch in pen and ink to fashion a figure with a face. He will have learnt from Leiris's text accompanying the reproductions that the Africans themselves viewed some of the structures in anthropomorphic terms.

Moore made straightforward copies of ritual staffs with animal heads illustrated on pages 28 and 29 of the same issue of *Minotaure*, objects that possessed apotropaic significance for the Africans (figs. 100, 101). Many years later the shape of these staffs, stepped and with one form apparently inserted into the next, were to inspire the artist's 'organic columns'. The intensely evocative drawing *Animal Head* of 1935 (fig. 102) belongs in the same context. Turned to face the viewer, this head would seem to underlie the type shown in *Spanish*

93 *Grass-Mask*, Afrika, Ethnological Museum, Basel, MINOTAURE, No. 1, February 1933, p. 1

94 *Ideas for Stone Sculpture: Statues*, 1936, Pencil, chalk (part-washed), pen and ink, 25 x 17.8 cm, The Henry Moore Foundation, AG 36-72.2 (HMF 1277)

95 *Antelope-Mask*, Dogon

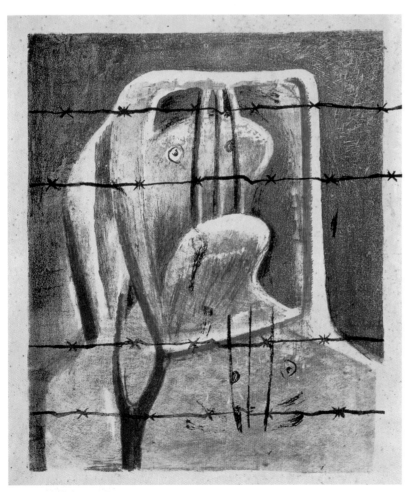

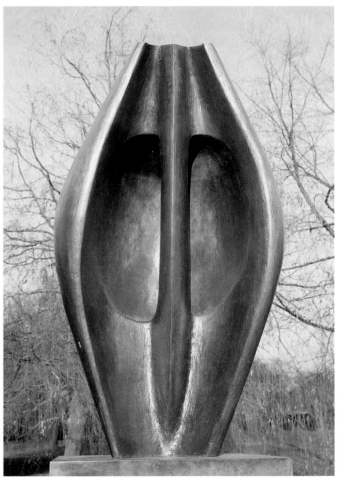

96 *Spanish Prisoner*, c. 1939, Lithography, 36.5 x 30.5 cm, The Henry Moore Foundation (CGM 3)

97 *Large Totem Head*, 1968, H. 244 cm, The Henry Moore Foundation (LH 577)

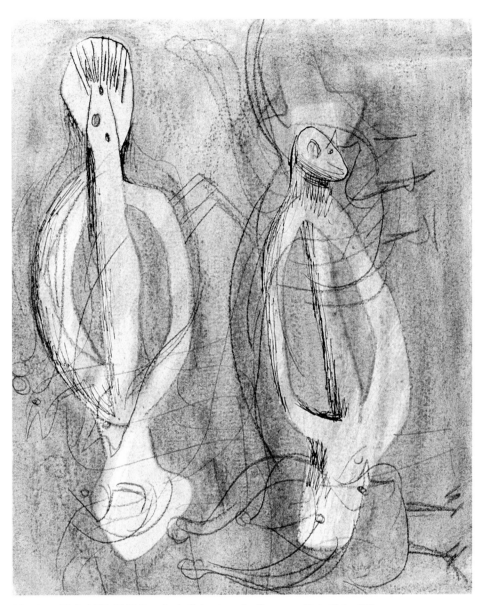

98 *Rooftop,* Bamboo and straw, Sudan, MINOTAURE, No 2, June 16th, 1933, p. 19

99 *Lyre Birds*, 1936, 1942, Pencil, chalk (part washed), pen and ink, 21.6 x 17.8 cm, The Henry Moore Foundation, AG 36-72.11 (HMF 1287)

Prisoner. It is as if Moore wished to depict the inhumanity of the prisioner's treatment by means of a face distorted along animal lines. He thus solved the problem of how to depict opposition to violence in basically the same way as Picasso, Miró and others had before.[125] They too had denounced the use of force by means of violent imagery, as repelled by the monstrous in human terms as they were attracted to it creatively.

Finally, Moore sketched an anthropomorphic *vessel* from Dahomey reproduced on page 59 of *Minotaure*. The handles end in a depiction of a child's head, and the top of the vessel suggests comparisons with the unbroken curve of the noses in some of the artist's later heads, with the forms capping them.[126]

The motif of the 'Bird cage sculpture with wood & plaster' (fig. 90) that he had derived from Sudanese models acquired crucial significance for Moore. It tied in with the birdcage imagery that had started appearing in his drawings in around 1932.[127] In the wake of his *Minotaure* drawings he addressed it directly in *Lyre Birds* (fig. 99)[128] from the sketchbook of 1936/42 cited above. Beginning in 1939, the motif recurs in the internal figures of the *Helmets*[129] and, in 1950, in a bronze *Standing Figure*.[130]

Moore shared this interest in bird cages with many surrealist artists. His predecessors here included Marcel Duchamp, Giacometti, Ernst and Nash; from 1936 they were joined by René Magritte, Penrose, Kurt Seligmann, André Masson and (outside the context of Surrealism) Max Beckmann. In their

100/101 *Ritual staff with animal head*, Sudan, MINOTAURE, No 2, June 16th, 1933, p. 28/29

retaining its lop-sided stance. His impressions of the model apparently still fresh, he constructed a figure swiftly and boldly, its flower-like head granting it a vegetative aspect.

Moore shared a long-lasting interest in Oceanic sculptures with certain Surrealists. Breton, Eluard and Louis Aragon owned Malanggan figures, and sculptors such as Lipchitz and Arp also derived inspiration from Oceanic art. Moore's relationship to it differed from theirs in that his imagination worked on the forms of Oceanic sculpture with undiminished intensity over long periods, constantly adapting them and using them as a springboard. In doing so, he both objectified and internalised the principle of metamorphosis[133] espoused by the Surrealists.

When the present author showed Moore the Oceanic figure and his sketches side by side in 1980, he confirmed that the transformation marked the inception of an idea that was to crystallise in the course of a number of drawings and eventually to take on three-dimensional form and be developed further in the *Internal/External Forms*. This formal innovation resulted in several major works and will be discussed in detail in Part Two.

individual ways all these artists adopted a *topos* of classical antiquity that saw the bird in a cage as a symbol of the soul confined to life on earth and frequently appropriated the bird as an image of alienation. By contrast, Moore viewed the bird-and-cage motif in purely sculptural terms. It gave him the opportunity of pursuing his interest in the formal and substantive dialectics of the internal and the external, a concern apparent at many points in his work in the 1930s. From this vantage point, it seems only natural that the pierced, bird-cage configurations in his sketchbooks of 1932 to 1939 should repeatedly be accompanied by notes to himself to 'remember New Ireland sculpture'.[131]

The pencil drawing *Internal/External Forms* of 1935 (fig. 103) can be related to a specific Oceanic model. At the lower left Moore sketched part of the body of a richly ornamented Malanggan female figure in the British Museum that is carved from a single piece of wood (fig. 104).[132] The drawing at upper left suggests a similar source, although none has been identified. He omitted the characteristic base with its fish's mouth, the hands (which clasp the long breasts) and the head. His concern was with 'forms within forms', with the correspondences between the body and its framework, and he emphasised the latter by means of thick lines. In the figure on the right – an invention of the artist's – he developed and strengthened the 'scaffolding' of his *malanggan* model while

102 *Animal Head*, 1935, Pencil, chalk, 13.8 x 22 cm, The Henry Moore Foundation, AG 35.45r (HMF 1234)

turns
inside
forms

103 *Internal/External Forms*, c. 1935, Pencil, 13.8 x 22 cm, The Henry Moore Foundation, AG 35.37r (HMF 1226)

104 *Standing Female Figure*, Wood, H. 338 cm, New Ireland, British Museum, London, Inv.-No. 1884, 7-28.2.

105 *Ideas for Drawing Subjects*, 1937, Pencil, crayon, wash, 26 x 19.9 cm, The Henry Moore Foundation, AG 37.72 (HMF 1365)

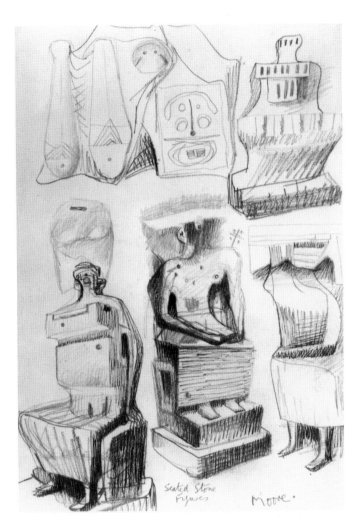

106 Salvador Dalí: *Visage paranoiaque.* From: Le Surrealisme au service de la révolution, 3, 1931, p. 40.

107 *Seated Stone Figures*, 1940, Pencil, ink and wax crayon on cream wove, 27.3 x 18.4 cm, British Museum, London, AG 40.63 (HMF 1546)

Double Images – Strategies in the Circles of Dalí, Brassaï and Miró

Moore's adoption of double images represented a further borrowing from the Surrealists that was to bear fruit in his oeuvre for a long time to come. *Ideas for Drawing Subjects* of 1937 (fig. 105) addressed the topic directly, as the inscriptions indicate. That at the top reads: 'Try some drawings in full solidity – see torso photos of Brassaï [*sic.*]'. This doubtless refers to the photographs of nudes that Brassaï had published in the winter 1935 issue of *Minotaure* (no. 6, p. 5), in which reflections of a female torso turned it into a double image recalling a landscape. Below this, Moore noted: 'Sculpture head and mountain top with figure walking up steps'. To the left of the sketch thus described, he drew an upright, semi-abstract figure in the style of his *Square Figures* that, rotated clockwise through 90 degrees, shows a flat piece of land with houses. This type of double image had been used by Dalí in 1931 in the *Visage paranoiaque* (fig. 106) he had published in issue no. 3 of *Le Surréalisme au Service de la Révolution* (p. 40), with which Moore was familiar.[134]

Moore's notes and sketches in *Ideas for Drawing Subjects* continue in the same vein. Further down, on the right, he wrote 'Make some drawings from architecture in wonders of the past and turn them into figures', and below this, next to a landscape sketch, 'steps up to a reclining figure'. To the right of this appear the words 'Rosetta Stone'. The artist's sketch of this renowned object embodies his aim of breathing life into 'wonders of the past' by turning them 'into figures',[135] making the central section of the stone, with its demotic inscription, protrude so far that the whole acquires an anthropomorphic character. Similar formal combinations occur later in Moore's œuvre, for example in the drawing *Seated Stone Figures* of 1940 (fig. 107).[136]

A different kind of object with human associations appears in *Sculptural Ideas, Hollow Form* of 1938 (fig. 108), a drawing in pen and ink and chalk with wash[137] that clearly resembles empty mummy cases. In the surrealist context of Moore's work in the 1930s the term 'sculptural ideas' often involves a mental switch. The present drawing may have been based on an Egyptian model. The striking array of distorted figures, which seem to have assembled to perform some mys-

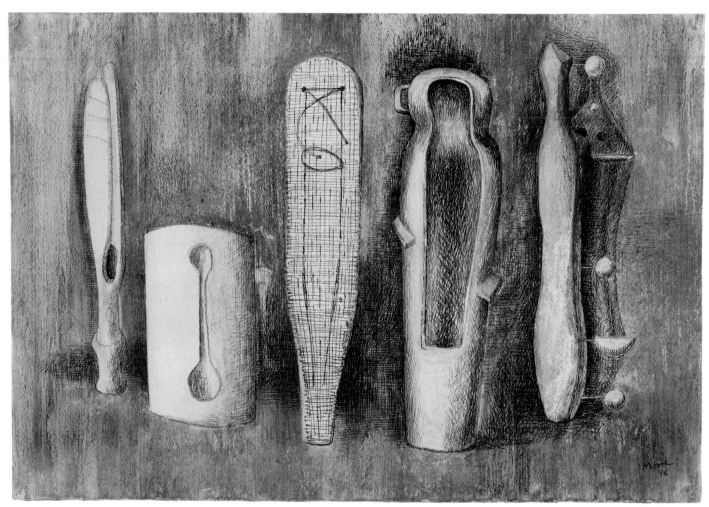

108 *Sculptural Ideas, Hollow form*, 1958, Chalk, pen and ink, watercolour, 38.1 x 55.9 cm, Art Gallery of New South Wales, Sydney, AG 38.45 (HMF 1378)

109 Howard Carter, *Tut-Ench-Amon: coffins and mummies of the still-born children*, Private Collection, UK

111 Joan Miró: *Tilled Earth*, 1923, Oil on canvas, 66 x 92.7 cm, The Solomon R. Guggenheim Museum, New York

110 Cover Design for *Contemporary Poetry and Prose*, Pencil, pastel (washed), pen and ink, brush and ink, 21.6 x 14 cm, Private Collection, UK, AG 37.20 (HMF 1350)

112 *Figures in an Interior*, 1938, Pencil, charcoal washed, 36.8 x 54 cm, Collection Joan and Lester Avret, AG 38.43 (HMF 1376)

terious ballet, may constitute a visual reminiscence, conscious or unconscious, of Howard Carter's report on his sensational discovery in 1926 of the tomb of King Tutankhamen. The third volume of Carter's widely read account, with which Moore must have been familiar, contains illustrations of the king's anthropomorphic mummy cases and of those presumed to have held the bodies of his two children who died at birth. The artist's drawing may represent a free variation on the pictorial arrangement in a reproduction such as that included here, which probably shows the mummies and cases of the children (fig. 109).[138] Moore added a base to his mummy case, and the arms, which appear on New Kingdom examples to underscore the portrait character of the whole,[139] are attached to the outside. In this way he fashioned a 'mummy human' that took the form of an empty husk. His death-space has nothing in common with the cult of the dead practised in ancient Egypt. Egyptian mummy cases echoed the shape of the mummy's contents: accommodating the image of the deceased within that of the god Osiris was thought to secure everlasting life. Moore, as a sculptor of his time, contented himself with the outer form alone, which acquired the ghost-like presence of an empty substitute body. Self-contained and self-sufficient, the anthropomorphic cavity developed an uncanny spell of its own through the absence of a fully three-dimensional form. This kind of depth of visual utterance was one of Surrealism's most important legacies to Moore.

The artist's drawings of 1937 show how intensely he pursued his interest in the surrealist landscape-figure duality. That year he produced nine designs for the cover of the periodical *Contemporary Poetry and Prose*.[140] One of them (fig. 110), made with a few strokes of the pen, shows an enigmatic face drawn as a single line and emerging from a curving shape that can be interpreted either as the ground or as a chain of hills. As in a diagram, landscape and figure interpenetrate in this free, ambiguous image. The head points upwards to the title of the periodical, with two ears and a closed mouth suggesting listening. The image as a whole presumably evokes readers 'listening' to surrealist writings. Stylistically, the design obviously owes much to Miró. Moore borrowed the sign-like symbols for 'ear' and 'mouth' placed against a monochrome background from such paintings by Miró as *The Tilled Field* of 1923–24 (fig. 111)[141] and *Harlequin's Carnival*[142] of 1924–25. In addition, the swelling lines and their ornamental character recall Miró's 'drawn paintings' of 1929.[143] Moore had become closely acquainted with Miró's work in Paris, before the latter's exhibition at the Mayor Gallery, London, in July 1933. That a painting like *The Tilled Field* stayed in his mind is indicated by the fact that he took up one of its most striking motifs – the fig tree with a signpost and a large thorn. A first variant of this appears in a drawing of 1937 executed partly in pastel, *Figures in an Interior* (fig. 112).[144]

The *Stringed Figure* – Dynamic Interaction between spaces

Investigation of Moore's varied engagement with surrealist content and modes of representation would be incomplete without discussion of the *Stringed Figures*. Produced from 1937 to 1939 in the form of both drawings and sculptures, they display remarkable powers of invention. Their genesis is closely bound up with surrealist concerns, and the poetic quality of the figures reflects the aesthetic aims of the Surrealists.

The development of the *Stringed Figures* began with the artist's discovery of the expressive potential of mathematical demonstration models during his student days in London. In 1962 he explained in an interview how at the Science Museum in South Kensington he had been 'greatly intrigued by some of the mathematical models; you know, those hyperbolic paraboloids and groins and so on, developed by Lagrange in Paris, that have geometric figures at the ends with coloured threads from one to the other to show what the form between would be. I saw the sculptural possibilities of them'.[145] But not until 1937 did he create his first *Stringed Relief* (fig. 113),[146] and it would seem more than likely that his decision to do so was prompted by personal acquaintance with Naum Gabo[147] and by knowledge of certain photographs by Man Ray. Moore will have seen work by Man Ray in an issue of *Cahiers d'Art*[148] published to mark the surrealist exhibition *Objets* at the Galerie Charles Ratton, Paris. The periodical contained three starkly lit, 'sculptural' photographs titled *Studies of Mathematical Models* as illustrations to Zervos's article 'Mathématique et l'art abstrait' (Mathematics and Abstract Art).

A decade previously, in August 1926, Picasso had drawn three identical views of a model demonstrating aspects of differential geometry, probably taken from a book (fig. 114).[149] The similarly turns mathematical aspects into biomorphical: His organic shapes find their counterpart in the earliest embryonic stage of human development resp. that of higher vertebrate animals. The cone in this drawing consists of 'threads': lines run from the framing strokes to two openings, creating an inner and an outer space. This dynamic interaction of two regions fascinated Picasso and in 1927 it became the basis of studies for the first metal model of his monument to Apollinaire.

Moore will thus have found stimuli for his experimental *Stringed Figures* in the work of Picasso, Gabo and Man Ray, not forgetting the rod 'implantations' in some of his own sculptures, themselves stimulated by Lipchitz and Giacometti.[150] He can scarcely have known Picasso's drawing of 1926, but his own approach comes closest to this view of two interwoven spaces. His overriding concern was precisely this interaction of transparent, immaterial volumes and their integration in figurative contexts. Hence, he stressed the sculptural

113 *Stringed Relief*, 1937, Beech wood and strings, J. C. Pritchard, Esq., London (LH 182), Wood: Private Collection, Bronze: The Henry Moore Foundation

character of his *Stringed Figures* by creating an interplay between three-dimensional solids and the strings. With Moore the contrasting interrelation of mass and line, of solid matter and translucent form, of organic roundness and the geometry of spheres, of inner space and outer space, generated a series of formal 'events' whose field of reference was never exclusively abstract. On the contrary, he aimed to distil the psychological essence of 'living creatures'[151] from a contrasting physical reality, be it in a mother and child (fig. 432),[152] a conflation of a reclining human figure with a musical instrument,[153] a bird's basket[154] or a bride's veil.[155] This, too, was part of Moore's 'Surrealism'.

It was only logical, then, that *Stringed Figure* (fig. 116), a major wood sculpture of 1937, should have been titled *Surrealist Sculpture* in the organ of British Surrealism, the *London Bulletin* (nos. 4 – 5, July 1938, p. 24). A sketch (fig. 115) shows that it was originally conceived as a horizontal piece, and it was in fact exhibited as *Reclining Figure* at the Guggenheim Jeune Gallery, London, in 1938. Not until 1944, in the first volume of the catalogue raisonné of Moore's work, did the artist decide on the vertical option. The change was decisive.

114 Pablo Picasso, *Sketchbook*, begun in August 1926 in Juan les Pins, sheet 20, Pen and ink, 21 x 16 cm, Museé Picasso, Paris

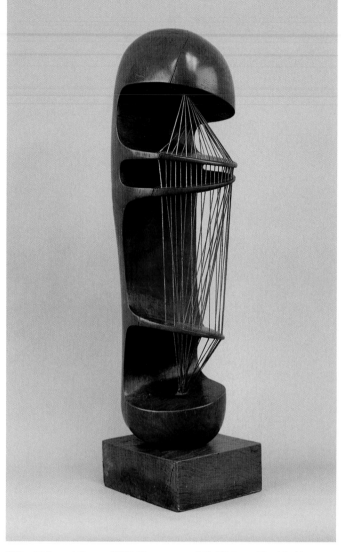

115 *Ideas for Sculpture for Lubetkin's Flat: Stringed Figures*, 1938, Pencil, 27.8 x 18.4 cm, The Henry Moore Foundation, AG 38.14 (HMF 1400)

116 *Stringed Figure*, 1937, Cherry wood, H. 50.8 cm, The Hirshhorn Museum and Sculpture Garden, Washington (LH 183)

In the horizontal position three thin 'slices' overarch the space bounded by the strings so that it appears as an independent, floating, transparent 'body'. Only in the vertical position does the unity of solid and immaterial volume become clear. The strings now articulate the 'empty' space as a fully fledged shape, in accordance with the artist's notion that 'space and form are one and the same thing'.[156] In the 1937 drawing *Five Figures in a Setting* (fig. 117) the diaphanous stringed volume of the piece on the far left possesses similar independence. Forming a kind of column of air, its immateriality is protected by the hollow shape that enfolds it, the inside of which is coloured red. The *Stringed Figure* of 1937 strengthened the contrast between a bold, solid form and the elusive volume that it holds and protects and whose shape it helps to determine. 'Top-heavy' when displayed vertically, *Stringed Figure* also emphasised the sculpture's human connotations.

To recapitulate, Moore's engagement with Surrealism in the 1930s helped him to discover a wide range of biomorphic forms and to subsume them in rhythmic configurations, in a 'continuous movement' of organic masses. The influence of Surrealism is also evident in his granting hollow spaces an emotional and a phantasmagorical charge, in his immaterial articulation of space by means of strings, in his espousal of metamorphosis as a subject and underlying principle of his art and in his use of double images.

The above account has shown that, in addition to his previously documented acquaintance with French surrealist publications, Moore explored intensively and fruitfully articles published in *Minotaure* prior to the major surrealist exhibition in London in 1936. He seems to have studied the periodical's special ethnological issue of 16 June 1933 particularly closely, which is scarcely surprising in view of his long-standing inter-

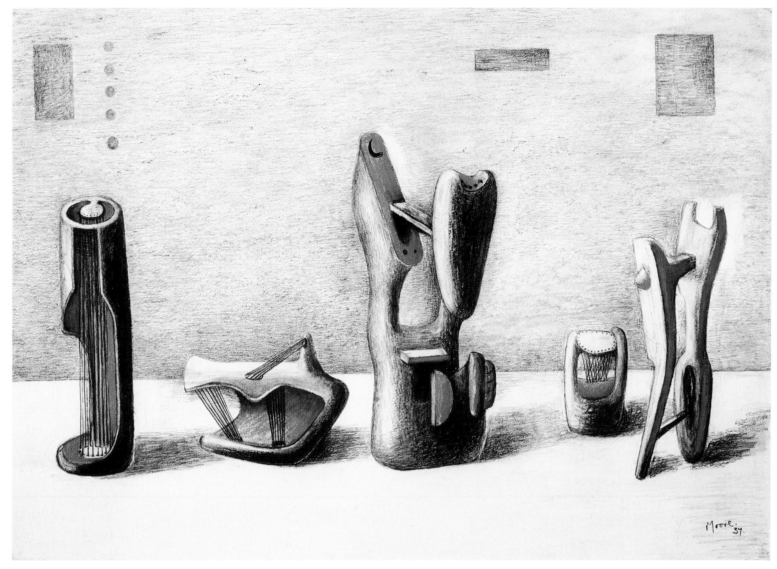

117 *Five Figures in a Setting*, 1937, Charcoal rubbed, pastel, crayon, 38 x 55.5 cm, The Henry Moore Family Collection, AG 37.47 (HMF 1319)

est in non-European art, an interest he shared with the Surrealists. Motifs derived from the African art discussed in *Minotaure* became part of his formal repertoire and he varied them over a strikingly long period. The bird-cage motif, for example – popular with artists at the time – combined with the influence of oceanic Malanggan figures to help him formulate one of the central concerns of his ouevre, the juxtaposition of internal and external forms. Finally, his treatment of surrealist-style double images shows him placing surrealist modes of

pictorial invention at the service of his aim to 'present the human psychological content of my work with the greatest directness and intensity'.[157]

Surrealism prompted experiments that resulted in some immensely rich veins of form and content that he quarried in his future work. In a sense, it also returned him to his roots in English Romanticism by redirecting his attention to nature and magic. It is thus scarcely surprising that Moore later stated that this was a 'fortunate period for me'.[158]

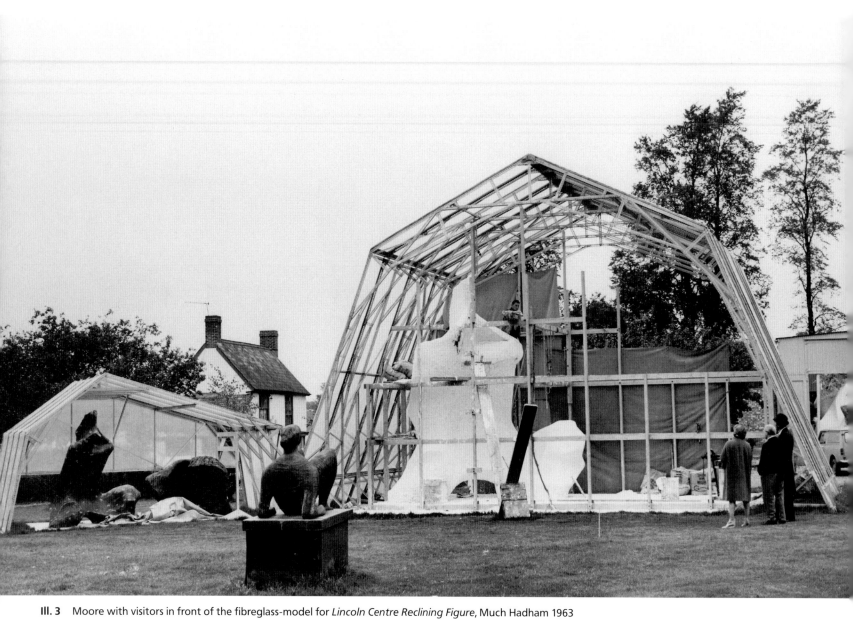

Ill. 3 Moore with visitors in front of the fibreglass-model for *Lincoln Centre Reclining Figure*, Much Hadham 1963

3. The Dominance of the *Reclining Figure* Theme

Some of Moore's drawings of 1937 discussed above were based on the type of surrealist double image that exploited ambiguities between landscape and human figure. An analogy between the two had led the artist in 1930 to call one of his reclining figures *Mountains*. Subsequently, stimulated by the work of Brassaï, Miró and Dalí, he explored the quintessentially British theme of the marriage of landscape and figure in ever bolder ways within the inexhaustible field of experimentation represented by his own reclining females.

In 1968 the critic David Sylvester noted that reclining figures accounted for two thirds of Moore's sculptural output.[1] What lay behind this exceptionally intensive focus on a single subject, which persisted for almost sixty years until the artist's death in 1984?

Moore himself offered several explanations for what he called an 'absolute obsession'. He stressed that the reclining figure, compared to one standing or seated, 'gives the most freedom, compositionally and spatially. [...] A reclining figure can recline on any surface. It is free and stable at the same time.'[2] Yet what counted in the context of this oft-invoked freedom was the 'form-idea'. Incorporating as many aspects as possible, it was this notion that focused and ordered the various forms into a unified statement. Moore made a systematic, but instructive comparison with Cézanne, saying: 'The vital thing for an artist is to have a subject that allows [him] to try out all kinds of formal ideas – things that he doesn't yet know about for certain but wants to experiment with, as Cézanne did in his *Bathers* series. In my case the reclining figure provides chances of that sort. The subject-matter is *given*. It's settled for you, and you know it and like it, so that within it, within the subject that you've done a dozen times before, you are free to invent a completely new form-idea.'[3]

The reclining figure, then, formed a kind of vessel into which Moore poured his most important poetic, compositional, formal and spatial discoveries. The farthest-reaching developments in his art are thus reflected in such figures. In the early period, they demonstrated his belief in the doctrine of direct carving. Later, they embodied his espousal of the surrealist emotionalisation of figure and space. And finally, they became a focus for the analogies between figure and landscape that will be discussed below. One further innovation explored in the context of this basic theme was the artist's discovery of rhythm as a constituent force in the generation of form. This will be examined in Part Two, in a discussion of the semantics of Moore's wooden reclining figures in relation to his aesthetics as a whole. The reclining figures that belong to his engagement with internal/external forms will likewise be examined in the theoretical section of this book.

Hills, caves and cliffs form a metaphorical context for Moore's reclining figures. He addressed this imaginary extension of his field of visual awareness in conversation with the critic Gert Schiff in 1954: 'All experience of space and of the world starts with one's attitude towards one's own body. That's how the deformations in my figures can be explained. They are not so much distortions of a given body shape. I rather believe that through the image of the human figure one can also express non-human issues, such as landscape – corresponding to when we relive mountains and gorges through the experience of our body. Or think of the basic element in poetry, the metaphor: there we also express one thing through the image of another. It seems to me that in such poetic examinations of the world I can express more about the world as a whole than with the human figure alone'.[4]

The large *Recumbent Figure* of 1938 (figs. 119, 120) was commissioned from the artist during the fruitful creative period he spent at Burcroft, the house in the Kent countryside where he lived from 1935 to 1939. Carved from green Hornton stone, it was to grace the garden terrace of the house 'Bentley Wood' of the Russian architect Serge Chermayeff at Halland in Sussex, which he has recently built for himself.[5] The house was an excellent example of modernistic building in England. Chermayeff was a member of his Hampstead circle of friends.[6] Working with him, he made acquaintance with some more renowned Avantgarde architects as for example Marcel Breuer, Martin Gropius, Michael Rosenauer and Ieoh Ming Pei. Tey all shared Moore's deep rooting conviction of a sculpture not being a decorative part of a building but, due to an own formal identity capable of complementary emendment and enheigtenment.[7] Moore explained that the sculpture was to form a 'kind of focal point of all the horizontals' amidst the rise and fall of the Downs, adding: 'it was then that I became aware of the necessity of giving outdoor sculpture a far-seeing gaze.' Sculpture should become 'a mediator between the modern house and the ageless land.'[8]

Both statements are important for an understanding of *Recumbent Figure*. In making the figure assimilate the undulating hills in the way that a magnifying glass collects the sun's rays, the artist not only responded to the rhythmic call of the landscape, but also provided an internal focus for the sculpture itself.

One sheet of preparatory studies for the sculpture is especially striking (fig. 118). In all four sketches of the whole figure an upright upper body and raised, slightly parted legs emphasise its undulating rhythm, the chief components of which were subsequently accentuated with black chalk. The eyes show the artist addressing the figure's gaze. At lower centre, overlapped by chalk lines belonging to the figure below it, there appears a three-quarter view of a woman's head that largely corresponds to the head as seen in the main view of the final sculpture. The artist ignored such detail when sketching the figure in its entirety: his concern here was with the overall conception, with the flow of open yet concise forms. He evidently found the uppermost version to be the most

118 *Ideas for Sculpture: Reclining Figures*, 1938, Pencil, crayon, 27.5 x 19 cm, Private Collection, Canada, AG 38.13 (HMF 3813)

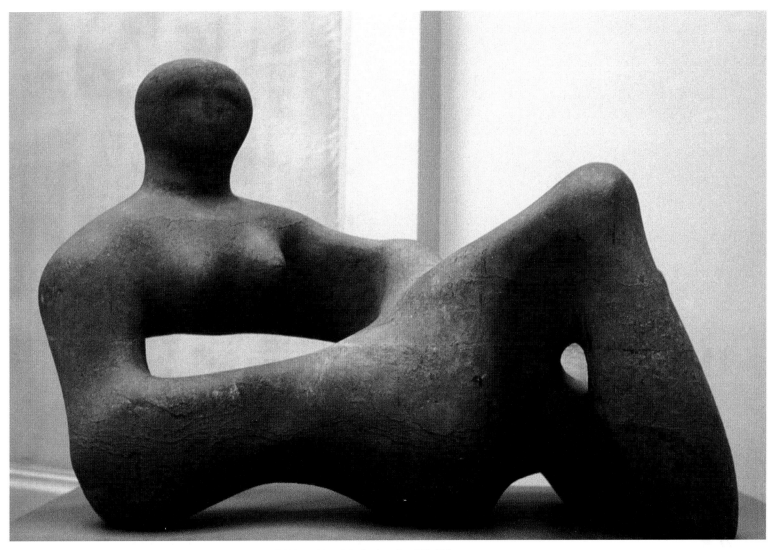

119 *Recumbent Figure*, 1938, Green Hornton stone, L. 132.7 cm, Tate Britain, London (LH 191)

compelling. Eschewing distinctly articulated arms, he merged them with the rest of the body to form an animated arrangement of condensed, balanced masses that exudes a sense of self-sufficient harmony. Nothing disturbs the grand progress of forms in the final work, not even the two openings. The flow of kinetic energy is constant and self-contained: it sweeps down from the head to the powerful right shoulder, rises steeply to the right knee, falls away to the rear into the trough formed by the lower legs, proceeds in an undulating, diagonal motion to the left elbow and thence back to the head. This spherical head forms a three-dimensional entity of its own. Rising above the broad 'bar' of the shoulders and arms, it opposes the horizontality of the rhythmically undulating sequence of forms with a strong vertical. The 'life force' transmitted to the figure via the rise and fall of the surrounding hills seems to be returned to the landscape by the head's enigmatic gaze. This indicates that Moore viewed the exchange of three-dimensional energies between landscape

and figure in a specific location in quite concrete terms. *Recumbent Figure* is thus an exceptionally vivid example of him accomplishing his aim of making landscape and figure 'enhance' one another.

Moore realised this goal in three further reclining figures created at Burcroft between 1935 and 1939. These wood sculptures, all carved from the trunk of a single elm, attained a progressively greater degree of landscape character and 'Weltdurchdringung' (in the sense of 'penetration of the surroundings'), culminating in the work of 1939 in Detroit (figs. 121, 290–292)[9] and are discussed together in Part Two of this book. Elmwood has a particularly striking grain, and the artist, by feeling his way into the vegetative processes that cause this, aimed in the Detroit figure to maximise both the animation of the masses and the variety of the openings and cavities. He himself referred to this sculpture – at 205 centimetres long, the largest of the three – as 'my most opened out wood carving' and recalled: 'This was a moment of great excitement

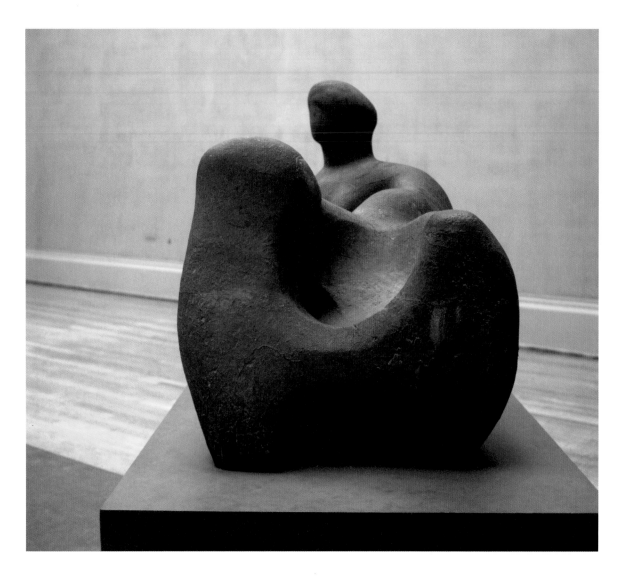

120 *Recumbent Figure* (LH 191)

in my work. This piece for me represented a special stage in my development; it was an advance in wood carving and a great struggle to do'.[10]

Moore expanded the composition of the Detroit sculpture in comparison with the two previous figures, which had consisted of two parts balanced rhythmically like a lemniscate.[11] In addition he substituted an asymmetrical arrangement for the two circular elements that had previously balanced each other. Forming bridging elements that mark the lateral limits of the figure like rolling waves, the legs initiate three scroll-like motions that eventually either sweep into the breast or curve up and round into the vertical section containing the shoulder and head. Stemmed at several points, a single horizontal movement passes through the entire body and opens it up on all sides. Moore had never, and would never again, create a reclining figure in wood that possessed such a richly articulated inner life and that used a freely rhythmical arrangement to balance solid forms and openness in such a masterly fashion.

The artist must already have been aware of the sculpture's exceptional importance at the time he produced it. Some of the drawings made while he was working on the project[12] relate its forms to the surrounding hills in Kent, as though he wished to integrate the figure into the landscape particularly closely. These drawings evoke the kind of response to the carving recorded much later, in 1985, by its first owner, the British painter Gordon Onslow-Ford (significantly, a member of the French Surrealist group): 'The surface was subtle and invited the touch. As one walked around the carving, one could catch the essence of well loved rolling landscapes that had been transposed into anthropomorphic forms. I felt that I was in the Presence of the Mother Earth Goddess.'[13] This last remark, especially, captures something of the charm that this figure, drawing on the 'mysterious fascination of caves', must have exerted on Moore and on the few people then well-disposed towards his art. Onslow-Ford also possessed a marvellous sheet of drawings by Moore, *Pictural Ideas and Setting for Sculpture* of 1939–40 (fig. 122), in which the artist 'quotes'

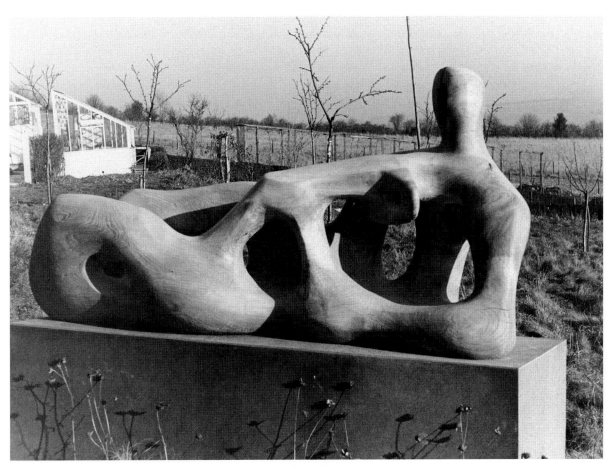

121 *Reclining Figure*, 1939, Elmwood, L. 205.7 cm, The Detroit Institute of Art (LH 210)

122 *Pictural Ideas and Setting for Sculpture*, 1939/40, Pencil, chalk, wax crayon, watercolour wash, pen and ink, 21.5 x 13.7 cm, Private Collection, USA, AG 39-40.13 (HMF 1415)

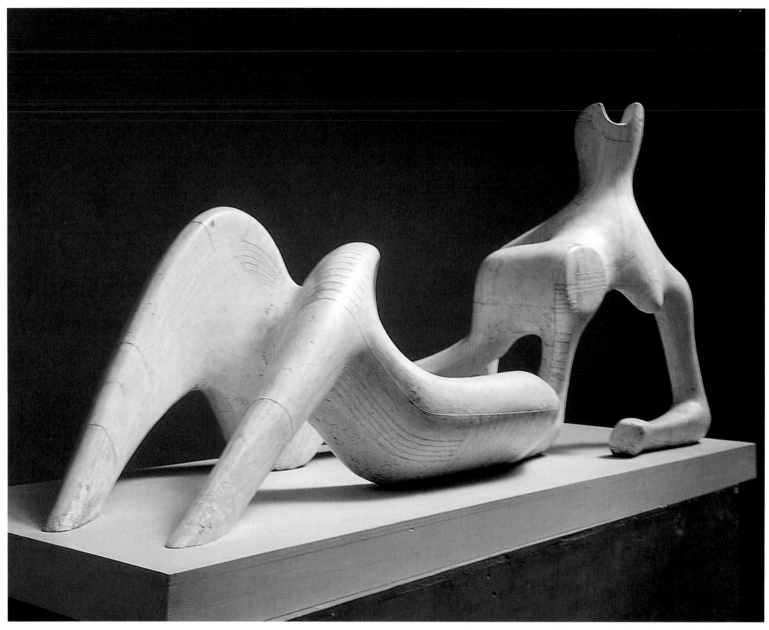

123, 124, 124a *Reclining Figure: Festival*, 1951, Plaster, 105.4 x 227.3 x 89.2 cm, Tate Britain, London (LH 293)

his own figure, embedded in the Kent countryside, as a sketch among sketches.

Soon after the end of the Second World War, after having found back to sculpting in working out his Northampton Madonna (fig. 203), Moore achieved a breakthrough in his beloved theme. *Reclining Figure: Festival* (figs. 123–124a) was commissioned by the Arts Council of Great Britain at the end of 1949 for the Festival of Britain, scheduled to take place on London's South Bank in the summer of 1951 to mark the centenary of the Great Exhibition of 1851. The Arts Council initially suggested a family group of the kind the artist had recently produced,[14] but Moore eventually responded to the Festival motto of 'Discovery' with a semi-abstract bronze reclining figure with a fantastical aspect. It perplexed the majority of the

8.5 million visitors, who failed to see the point of this skeletal monster with its split head. Criticism was widespread, one writer even claiming: 'It is sadly reminiscent of the pitiful human remains found after the Hiroshima bomb explosion and among the dreadful discoveries at Bergen-Belsen.'[15] Neither was Moore's figure in accord with the latest artistic trends in Britain, which went by the name of 'post-war realism'.[16] Hence, very few people were capable of recognising in this reclining figure a new, compelling image of humanity.

Judging by contemporary photographs, *Reclining Figure: Festival* was displayed on a higher base (approximately 1 m tall) than has since become customary. In other words, the viewer was meant to look through the piece rather than down at it. As Moore never tired of explaining, form and space were of

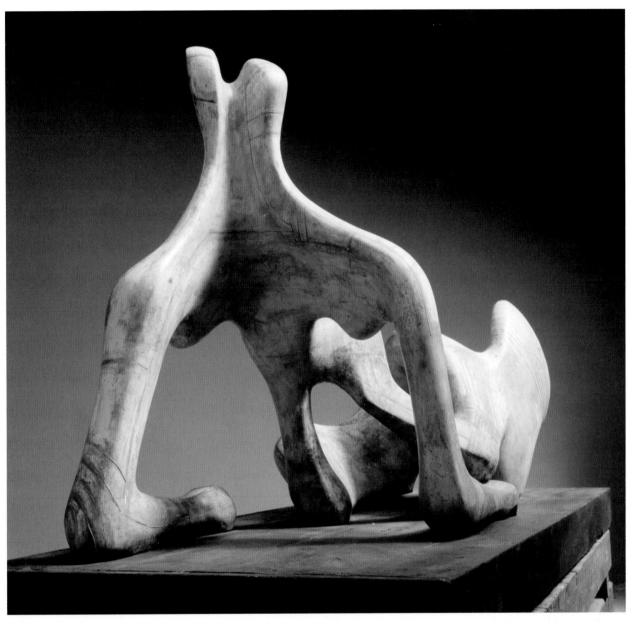

124

equal importance in his sculptures: looking through them was thus just as important as viewing their exteriors. In the present case, the artist found the inseparability of mass and space 'perhaps most obvious if this figure is looked at lengthwise from the head end through to the foot end and the arms, body, legs, elbows, etc. are seen as forms inhabiting a tunnel in recession. Seen in plan the figure has "pools" of space... Hardness projecting outwards, gives tension, force, and vitality.'[17]

These ideas, which had been expressed in very similar terms by Rodin,[18] were realised in a particularly striking manner in the *Reclining Figure: Festival*. Close inspection reveals that the decisive spatial impulse within the figure as a whole comes from the head. This towers above the bridge-like construction of the upper body, the long forearms resting on the base and

reaching further back than usual. Standing behind the head, the viewer senses a powerful thrust passing from it to the upper arms and down through the rest of the figure. The energy embodied in this thrust moves forwards, renewing itself from cavity to cavity and seemingly pushing the chest towards the middle of the body. Pressing onward like a ship's prow, it solidifies into the largest mass in the figure, at the area of the chest. From here two elements descend on either side, one vertically, the other diagonally, and lead to the lower body. The thrust passes to the relatively solid legs, placed diagonally to the upper body, and eventually subsides in two simple, broad, wave shapes. A sequence of firm support, upward movement and release of tension thus governs the spatial composition of the figure. Almost paradoxically, the dyna-

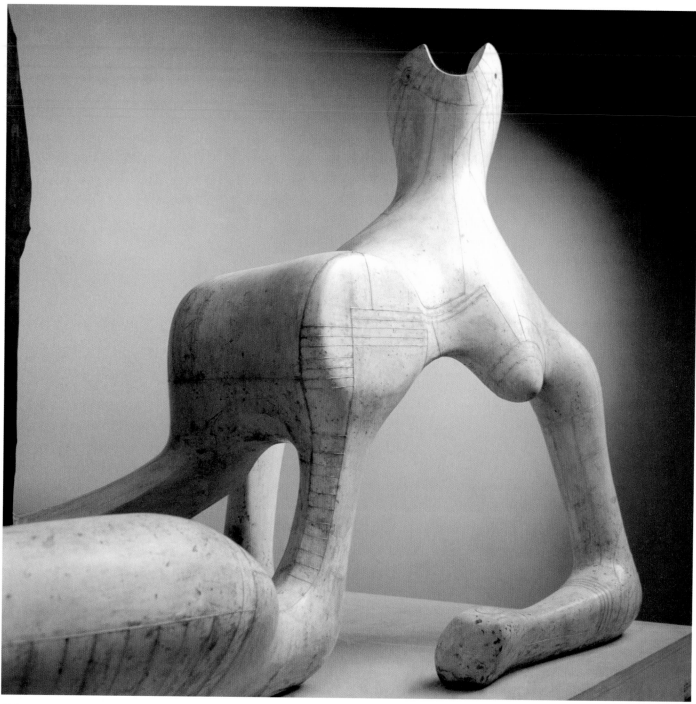

124a

mism of this progression underscores the prevailing impression of tense yet majestic repose. Particularly in the area of the head and chest, the sculpture evinces a new confidence.

Moore sought to produce 'tension, force, and vitality' by means of forms 'straining or pressing from inside'.[19] During his work on *Reclining Figure: Festival* he gave visual expression to these forces in a way unusual even for him. He stuck lengths of string to the plaster model in arrangements that partly suggest intentions going beyond the 'sectional lines' he had drawn on his maquettes and models on previous occasions.

Like them, the string traces the three-dimensionality of the forms and stresses the tension at their joins, but it also generates forms and meanings of its own. The gaze of the eyes is intensified, for example, by 'rays' issuing from the pupils. Or again, the edge of the head is surrounded by a band of long and short lines, possibly indicating the split head's psychological openness to influences 'from on high'.[20]

The lines, the forms and the new, dynamic, interpenetrating articulation of space in Moore's 1951 sculpture evoked a humanity that, strange though its outward aspect may have

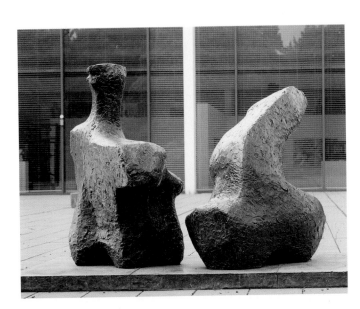
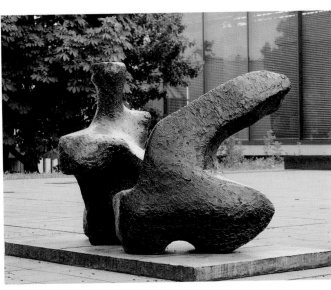
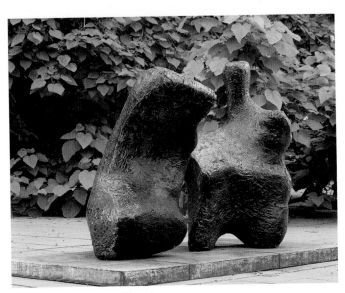

125 *Two Piece Reclining Figure No. 1*, 1959, Bronze, 143 x 215 x 138 cm, 6 views, Wilhelm Lehmbruck Museum, Duisburg (LH 457)

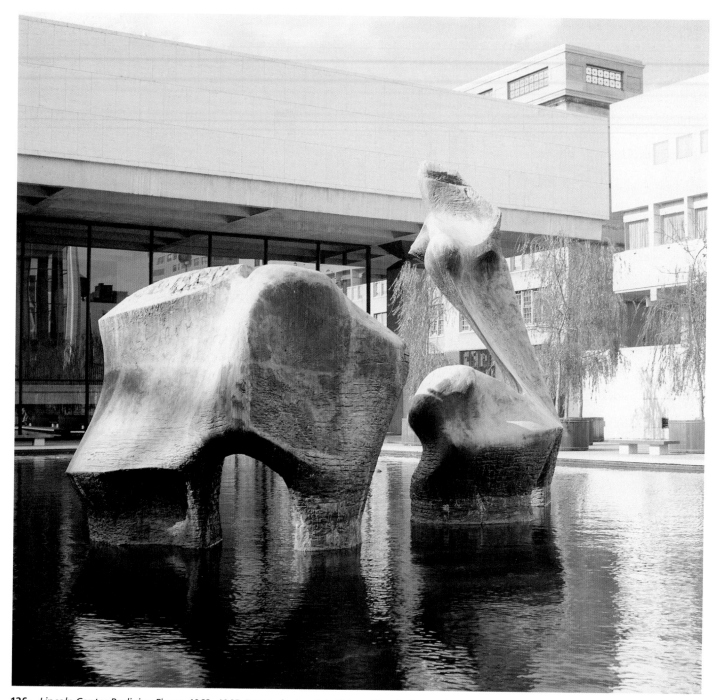

126　*Lincoln Center Reclining Figure*, 1963–1965, Bronze (unique), L. 854 cm, Lincoln Center for the Performing Arts, New York (LH 519)

seemed, was at one with itself in its openness to the world and its inner strength. In this sense, it offered hope to receptive viewers in the turbulent post-war world. It was thus a focus of attention at the exhibition *Mensch und Form unserer Zeit* (Man and Form in our Time), mounted in 1952 as part of the prestigious Ruhr Festival in Recklinghausen. The importance of this exhibition for Moore's reputation in Germany will be discussed in Part Three.

Around the time he was working on *Reclining Figure: Festival*, with its extensive use of negative volumes, Moore made an increasing number of statements about the role of space in

sculpture. This was a flourishing period for sculpture in Europe and the USA that focused on this issue in the wake of Julio Gonzalez. Names that spring to mind include David Smith, Naum Gabo, Antoine Pevsner, George Rickey, Reg Butler, Hans Uhlmann, Norbert Kricke, Eduardo Chillida, and Brigitte and Martin Matschinsky-Denninghoff. By 1954 Moore felt compelled to admonish sculptors: 'You have to be careful: the interest in space could push to the fore and ultimately become an end in itself, with the effect that, in the end, you have no form left anymore. You mustn't forget that sculpture is fundamentally form. The young like to overlook this, when

they start with complex structures without having previously shown that they are able to understand a simple shape as well.'[21] For him, 'the understanding of space is only the understanding of form... If you hold your hand as I am doing now, the shape that those fingers would enclose if I were holding an apple would be different from the shape if I were holding a pear. If you can tell what that is, then you know what space is. That is space and form. You can't understand space without being able to understand form and to understand form you must be able to understand space.'[22]

Moore's conception of space as dependent on form took him down completely new paths. This is nowhere clearer than in the large number of multipartite reclining figures that he began creating in 1959. These form a separate, immensely varied field of experimentation within the artist's exploration of his favourite basic theme. Starting with a series of figures divided in two, he moved on to examples consisting of three parts and then even more than three. These series were all governed by the notion of 'dismemberment' or fragmentation and how to overcome it. Breaking up the figure into distinct volumes, Moore related its parts spatially and formally to one another in such a way that their multiplicity appears subsumed into an overall, and higher, unity.

The sculptor explained the genesis of, and the ideas involved in, this 'dismemberment' thus: 'As long ago as 1934 I had done a number of smaller pieces composed of separate forms, two and three-piece carvings in ironstone, ebony, alabaster and other materials. They were all more abstract than these. [...] I did the first one in two pieces almost without intending to. But after I'd done it, then the second one became became a conscious idea. I realised what an advantage a separated two-piece composition could have in relating figures to landscape. Knees and breasts are mountains. Once these parts become separated you don't expect it to be a naturalistic figure; therefore, you can justifiably make it like a landscape or a rock. If it is a single figure, you can guess what it's going to be like. If it is in two pieces, there's a bigger surprise, you have more unexpected views.'[23]

For the first work mentioned by Moore, a bronze two-part reclining figure of 1959 (fig. 125), readers are referred to a separate publication by the present author.[24] Discussion here will concentrate on a late two-part reclining figure, a work in which the landscape associations were uniquely accommodated to urban surroundings: *Lincoln Center Reclining Figure* of 1963–65 in New York (fig. 126). It was based on two found bones. Bypassing drawing, the artist worked over these for the first maquette in plaster, a procedure that encouraged him to view the piece from all sides at all times.[25] Taking his cue from the almost tangible, volumetric tension generated between the two elements in the previous two-part sculptures, Moore created a reclining figure for New York of an unparalleled, almost aggressively dramatic quality. Perhaps the most 'American' of all his figures, it strikes a distinctive note among the four surrounding buildings of the Lincoln Center for the Performing Arts[26] and its grandeur invokes a characteristically American feeling of openness and expansiveness with regard to the human body and to space.[27]

At a length of 8.54 metres, the figure lay in an area of water the size of a tennis court. The water extended the artist's experience of 'landscape' points of reference for his sculptures. He wanted the bronze figure to 'make you think that it goes down to a bottom, like rocks'.[28] In other words, he aimed for forms that appeared in the oasis of the arts represented by the Lincoln Center as if they, "like rocks" had been rooted to the ground of the earth. Their bottomless permanence was to oppose the ceaseless fluctuation of the water. Consciously or unconsciously obeying the *genius loci* of Manhattan as an island of rock, Moore developed the formal vocabulary of his bronze from this basic contrast between this and water. The elements of this vocabulary – a shooting up, a surging, a breaking against – seem to be captured in solid form as bodily movements. In addition, the hardness of the shapes, their sinewy power and their bold silhouettes (the main lines of which continue across the intervening space) reveal how profoundly the conception of this two-part reclining figure was influenced by the artist's empathy with the structural language of the bones that formed its starting point.

With its triple reference to bones, rocks and water, *Lincoln Center Reclining Figure* offers a major testimony to Moore's personal natural aesthetic. Moreover, the sculpture's compelling expansiveness and its clear emphasis on visibility from all sides make it a prime example of the artist's late style, the phenomenology of which will be the subject of a separate discussion in the present volume.

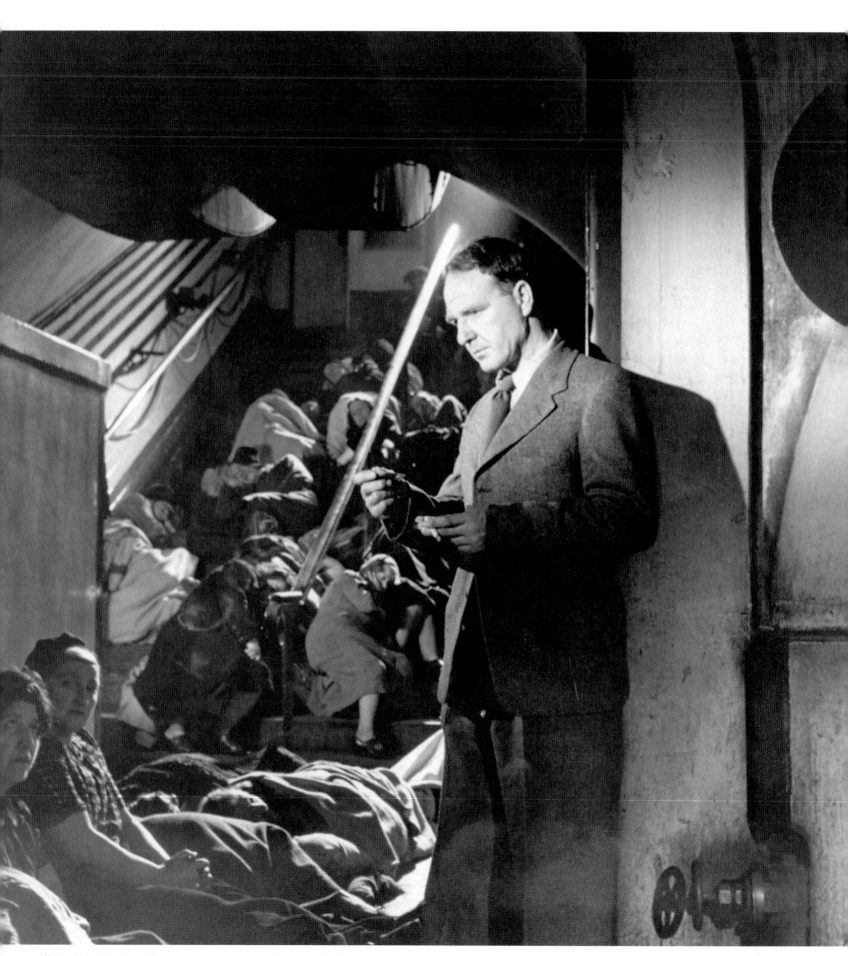

Ill. 4 Tube-Station Holborn: Henry Moore 1944 photographed by Lee Miller during the preparation of the film *Out of Chaos*

4. The *Shelter Drawings*: Moore and the Reality of War 1940 – 42

Having already strayed some way into the future, let us return to 1939 when Moore had reached the high point of his surrealist phase, only to find – with the outbreak of the Second World War – that his life, like that of so many others, was to be overtaken by a social and political reality whose cruelty would soon far outstrip any surrealistic fantasy.

We know how Moore first heard of the outbreak of hostilities.[1] At 11.15 on the morning of Sunday 3 September, he tuned into the radio broadcast during which Prime Minister Neville Chamberlain announced that Great Britain was at war with Germany. At the age of forty-one Moore was no longer eligible for military service, and there was a question mark over whether, and for how long, he would be able go on teaching at the Chelsea School of Art in London. Still, the Moores refused to panic and instead went swimming with their assistant Bernard Meadows. They went to a beach near Dover in sight of the Shakespeare Cliffs and Moore recorded the moment in a picturesque drawing entitled 'Sept. 3rd/1939' (fig. 127). The bathers, who might normally have made the most of the moment with abandon, are seen almost motionless in the water. They are looking directly towards the enemy and seem paralysed by the dangers they can now expect. The hopelessness of their situation is underlined by the impenetrability of the cliffs rising up in the background. Their inner rigidity is reflected in their faces, held fast by masks, rods and planks. It is as though Moore's arsenal of surrealist forms suddenly had a very different basis — in real life.

With its mixture of realism and fantasy, resistance and helplessness, this drawing paved the way for a singular group of works that was to become known as the *Shelter Drawings*, one that was to establish Moore on the world stage. The historical circumstances, the genesis and motifs of these drawings, and Moore's state of mind during the Blitz, have all been examined in depth by Julian Andrews. His heartfelt account[2] is moving indeed – not least to the German reader.

In the early days of the war Sir Kenneth Clark, Director of the National Gallery and a collector and friend of Moore,[3] had already suggested that he should accept an appointment as an Official War Artist. But Moore declined because, as Andrews puts it, he had the 'feeling that his work was unsuited to war subjects. Privately, however, he worried about how to find an artistic role for himself, and by the summer of 1940 was making sketches of possible war subjects, including crashed German aircraft, ruined buildings, and victims of air raids trapped under debris – these last purely imaginary'.[4]

Moore's correspondence from that time leaves the reader in no doubt as to the strength of his reaction to the war: 'I hate intensely all that Fascism and Nazism stands for, & if it should win it might be the end in Europe of all the painting, sculpture, music, architecture, literature which we all believe in.'[5] Or, elsewhere: 'I hate the war! Apart from its most terrible side, all the maiming and killing it's going to bring, it blinds people to all the real values in life, holds back the progress of all those activities in life one believes worth while… I'm still in the process of trying to get my attitude to the war clear and satisfactory, even to myself.' But of one thing he was certain, as he wrote in the same letter to his friend Arthur Sale on 24 April 1940: 'I still think the war could have been avoided if we'd had a government less terrified of socialism and more sympathetic and ready to work with Russia. The Chamberlain Government I think is the worst in our history, it helped rear the Hitler Germany.'[6]

In the summer of 1940 the Moores moved into the studio in Hampstead that had previously been occupied by Barbara Hepworth and Ben Nicholson.[7] In mid-August London saw its first air raids. The level of attack soon intensified and in the night of 18 – 19 September alone enemy aircraft dropped 350 tons of bombs on the city. Casualties were particularly high among the civilian population, and by the end of September 1940 10,000 people had already lost their lives. The onslaught continued unabated until the end of May 1941. Somewhat to the discomfiture of the authorities, Londoners took matters into their own hands and solved the problem of insufficient space in the official air-raid shelters by taking refuge from the nightly bombing raids in the underworld of the tube system. Cut off from life above ground and wracked by uncertainty as to whether or in what condition they would find their homes the next day, night after night they made do, as best they could, on the bare platforms, in a suffocating atmosphere and with wholly inadequate sanitary arrangements. There was no hope of even the slightest privacy for the individual. By definition those seeking shelter had to become a community of sorts and the time-honoured British capacity for fairness, sang-froid and humour all came into their own.[8]

It was by chance that Moore first saw for himself what he likened to 'a huge city in the bowels of the earth'.[9] On 11 September 1940 he and Irina had, by way of an exception, gone into town to visit friends using the tube rather than by car. On their way home later that evening, as they travelled along the Northern Line, Moore saw 'for the first time… people lying on the platforms at all the stations we passed… When we got out at Belsize Park we were not allowed to leave the station because of the fierceness of the barrage. We stayed there for an hour and I was fascinated by the sight of people camping out deep under the ground. I had never seen so many rows of reclining figures and even the holes out of which the trains were coming seemed to me to be like the holes in my sculpture. And there were intimate little touches. Children fast asleep with trains roaring past only a couple of yards away. People who were obviously strangers to one another forming tight little intimate groups… I had a permit which got me into any Underground I wanted to visit. I had my favourites. Sometimes I went out to the station at Cricklewood, and I was very interested in a huge shelter at Tilbury, which wasn't a tube

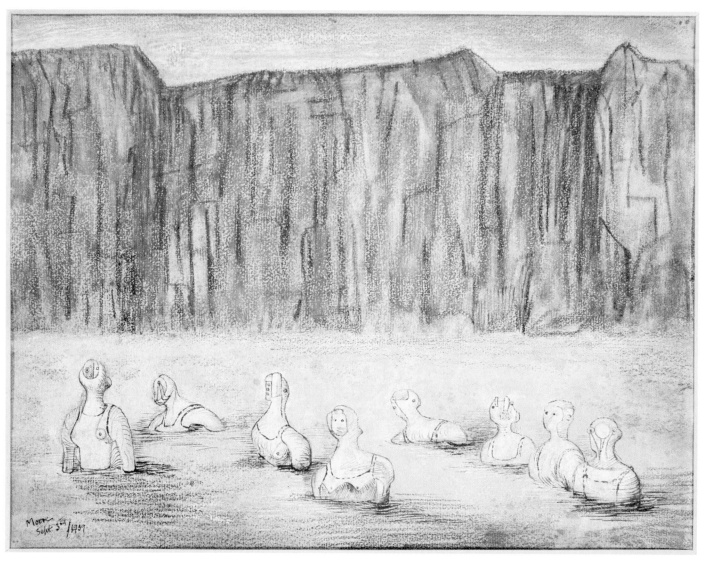

127 *September 3rd, 1939*, Pencil, wax crayon, chalk, watercolour, pen and ink on heavyweight wove, 30.6 x 39.8 cm, The Henry Moore Family Collection, AG 39.35 (HMF 1551)

station but the basement of a warehouse. But the shelter which interested my most of all was the Liverpool Street Underground Extension. A new tunnel had been bored and the reinforcement of the walls completed but there were no rails, and at night it was occupied along its entire length by a double row of sleeping figures.'[10]

'I began filling a notebook with drawings – ideas based on London's shelter life. Naturally I could not draw in the shelter itself. I drew from memory on my return home.[11] But the scenes of the shelter world, static figures – "reclining figures" – remained vivid in my mind, I felt somehow drawn to it all. Here was something I couldn't help doing. I had previously refused a commission to do war pictures. Now Kenneth Clark saw these and at once got the War Artists Committee to commission ten. I did forty or fifty from which they made their choice. The Tate also took about ten. In all I did about a hun-

dred large drawings and the two shelter sketch books… I was absorbed in the work for a whole year; I did nothing else.'[12]

The intensity with which Moore devoted himself to this task speaks for itself. Ultimately the *Shelter Drawings* not only marked a watershed in his artistic and stylistic development, they also eloquently bear witness to the extent to which he was moved by the 'pity and abandon'[13] of those affected by the bombings. At the same time, he also admired their acceptance of their fate. However acclaimed an artist, he had not lost touch with his fellow human beings and was impressed by the population's stoic refusal to succumb to the enemy's attempts to demoralise them.

From the outset – and to this day – the *Shelter Drawings* have received due recognition from leading scholars ranging from Herbert Read to Julian Andrews to Andrew Causey.[14] In view of the sheer diversity of the drawings' subject matter, in

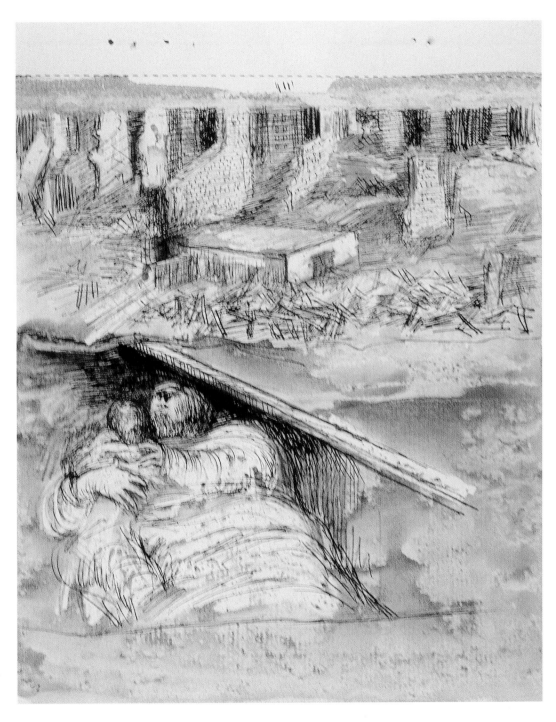

128 *Blitzed Buildings and Woman Holding Child*, 1940–41, Pencil, wax crayon, watercolour, pen and ink, 20.4 x 16.2 cm, British Museum, London, AG 40-41.65 (HMF 1623)

the following I shall focus on Moore's perception of the social reality of the day, artistic leitmotifs – such as tunnel, drapery and sleep – and his reference to mythical, phantasmagorical themes.

The order in which these aspects of Moore's work are considered here largely reflects the development of the artist's own interests. Initially the drawings are dominated by portrayals of the real violence of the air raids, seen in collapsing houses, destroyed terraces on the horizon, crashed Heinkel bombers, burning cows and the suffering of the victims of the air raids.[15] Comments in letters and notes on sketches attest

to the artist's fascination with unusual polarities, such as the 'contrast of peaceful normal with sudden devastation' (…) composite picture of devastated buildings + shelterers + London skyline'[16] which can be seen, for instance, on p. 65 of the first sketchbook (fig. 128).[17] Here it is certainly Moore's aim to create a *mixtum compositum*. The close juxtaposition of ruins and maternal protection is wholly programmatic. There is a clear distinction between the chromatic daytime situation and the non-colours of the maternal scene below ground. Imagined images such as this rub shoulders with scenes taken straight from life, such as the dual image on p. 64 of a rescued woman,

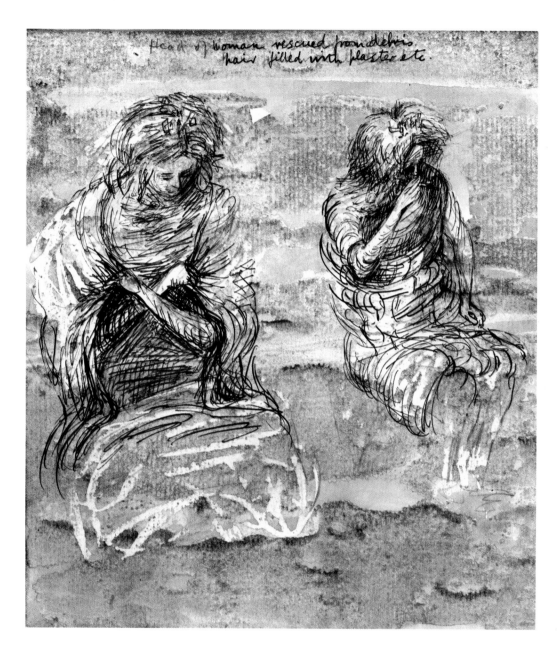

Head of woman rescued from debris hair filled with plaster etc.

129 *Woman with Hair Filled with Plaster*, 1940–41, Pencil, wax crayon, coloured crayon, wash, pen and ink, 20.4 x 16.2 cm, British Museum, London, AG 40-41.64 (HMF 1622)

still with pieces of debris in her hair, and who has been given a cigarette to help to calm her shattered nerves (fig. 129).

Aside from the purely representational observations of the destructive impact of war on everyday life – with a level of realism that is very unusual in his œuvre – most of the other sketches and large drawings are dominated by themes that allow Moore to pursue his own sculptural interest in the human figure. This alone can explain the concentration with which he worked on the *Shelter Drawings* for an entire year. With his experience of creating holes in stone and wood sculptures, he felt drawn to the tunnel-openings as motifs.[18] Prepared by his experience, as it were, to handle these forms, he was able to convey a sense of the lines of sleeping figures in this unfinished tunnel at Liverpool Street Station (fig. 130)[19] being locked together inextricably in an immense, eerie vault. Once again the 'hole' was to serve as a symbol, albeit now

filled with the madness of real life. Having already been very much alive, three years earlier, to 'The mystery of the hole – the mysterious fascination of caves in hillsides and cliffs',[20] he now used this same response to encapsulate the reality observed underground in an even more intensely mysterious cavern scene. Empirical reality fired Moore's imagination to the point where it seems that these tunnels have an energy of their own, devouring human beings as they are sucked at ever greater speed into a constantly revolving vortex.[21] By raising this possibility, Moore heightened the sense of hopelessness inherent in the image: at any moment the curved sides of this negative space could close in, consuming and burying all its occupants.[22]

It was only because Moore had already spent years making drawings and sculptures of reclining figures in every imaginable (and unimaginable) pose, and in astonishing sizes, that he

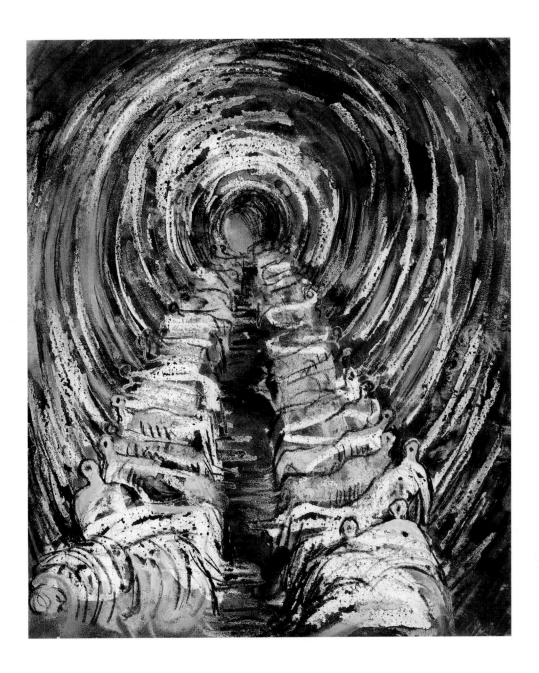

130 *Tube Shelter Perspective*, 1941,
Pencil, wax crayon, coloured crayon,
watercolour, Gouache, 17.8 x 25.4 cm,
The Henry Moore Foundation,
AG 41.13 (HMF 1773)

could now retain a mental image of the sleeping figures in
their blankets – singly and in groups – and work them into
compositions, or even elevate them into more mythical realms
of expression, once at home. The unexpected, somehow
unreal impressions of the underworld of the tube system that
Moore observed and absorbed night after night[23] stimulated
and extended his imaginative powers both at the time and for
years to come. Above all it was the sight of the many individu-
als seeking shelter that first inspired a concentrated explo-
ration of drapery, which impelled him to draw images of sleep-
ing figures and to create an almost demonic image of human-
ity. This always against the background of the palpable
tension of the time and constant existential threat facing the
population – including himself – when it seemed that every-
thing was at the mercy of some very tangible, but higher
fate.[24]

Let us look now more closely at the three main pictorial
innovations that feature in Moore's *Shelter Drawings*: Drapery,
Sleep and Myth.

Drapery

Empirical reality,[25] as we have seen, heightened the intensity
of Moore's imagination. And it was particularly in the *Shelter
Drawings* that he achieved a singularly ambivalent combina-
tion of everyday reality and fantastic exaggeration and enno-
blement. In the process, he had to confront an ancient sculp-
tural issue that he had so far – with some notable exceptions
– scarcely engaged with: the business of drapery. Now, how-
ever, the sight of hundreds of people wrapped up in their
blankets meant that the question of how exactly to portray
drapery constantly preoccupied him. He set out to find his

131 *Reclining Figure*, 1933, Pencil, chalk, wash, pen and ink, 41.9 x 35.6 cm, Private Collection, UK, AG 33.10 (HMF 990)

own solution and to allow it to take him into new realms of expression. This whole process did not happen without Moore drawing on earlier experiences.

It was in Italy in 1925 that the young Moore first engaged in serious studies of the handling of drapery, specifically in paintings by Giotto and his contemporaries.[26] And in 1946 he expressly pointed out to his New York curator, James Johnson Sweeney, that it was not until he embarked on the *Shelter Drawings* that he fully appreciated the value of his early experience of the Mediterranean tradition.[27] Before that, in the late 1920s and 30s, his handling of drapery was primarily guided by a more archaic understanding of pure forms. Just occasionally, for instance in 1928 under the influence of Picasso, he became more daring: witness the playful aberration in *Three-Quarter Figure* (fig. 47),[28] where he opened up the figure's 'reinforced' outer shell. In 1933, when he was developing his biomorphic motifs, he made a number of drawings where drapery is inseparable from the human form and thus becomes a dynamic component in the organic rhythm of a reclining figure. It is interesting to compare the strikingly lucid example that was once in the Helen Sutherland Collection (fig. 131), with a late *Transformation Drawing* of 1935 (fig. 132), in which Moore similarly used drapery to accentuate the forwards position of the knee. However, the lineature in the *Transformation Drawing* – seen in close conjunction with an anthropomorphic study of a bone – is very much looser.

132 *Bone Form: Draped Reclining Figure*, 1935, Pencil, chalk, 13.8 x 22 cm, The Henry Moore Foundation, AG 35.28v (HMF 1217)

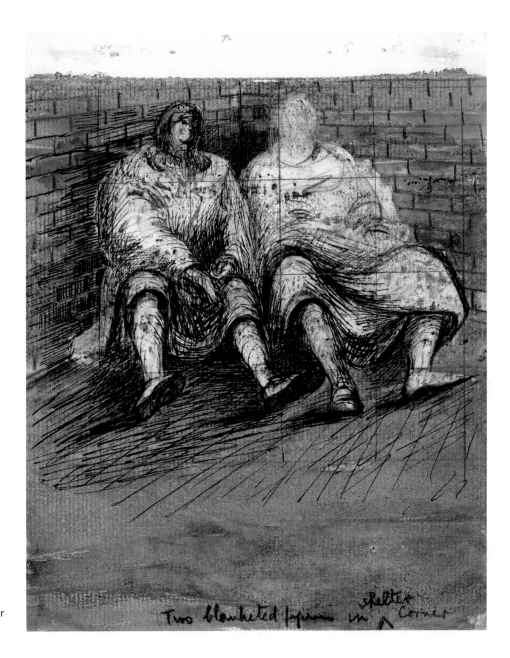

133 Study for *Two women wrapped in blankets*, 1940–41, Pencil, wax crayon, watercolour, pen and ink, 20.4 x 16.2 cm, The Henry Moore Foundation, AG 40-41.134r (HMF 1691)

The free-flowing style of the 1935 drawing clearly anticipates that of the *Shelter Drawings*, where the drapery no longer merely serves to underline the sculptural weight of the body but – as an almost independent shell – becomes a mode of expression in its own right. This is seen very clearly if one takes the looser rendering of the drapery in the 1935 drawing, for instance, and compares it to the image of two figures seeking refuge in a bunker (p. 66 of the second sketchbook; fig. 133). Here, as elsewhere, Moore makes a point of the sheer amount of fabric in the coats and blankets. What was still seen clinging closely to the core of the body in 1935 has now extended outwards to become a single, large-scale undulation, which in turn decisively accentuates the weight of the two seated figures, their legs spread wide. In another drawing, entitled *Group of Shelterers During an Air Raid* (fig. 134),

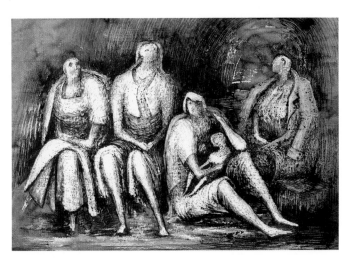

134 *Group of Shelterers During an Air Raid*, 1941, Pencil, wax crayon, coloured crayon, watercolour, pen and ink, 38 x 55.5 cm, Art Gallery of Ontario, Toronto, AG 41.62 (HMF 1808)

135 *People wrapped in blankets*, 1940–41, Pencil, wax crayon, coloured crayon, watercolour, pen and ink, 20.4 x 16.2 cm, British Museum, London, AG 40-41.6 (HMF 1619)

136 *Sea of Sleepers*, 1940–41, Wax crayon, watercolour wash, pen and ink, 20.4 x 16.2 cm, The Henry Moore Foundation, AG 40-41.130 (HMF 1687)

137 *Transformation Drawing* and Study for *Composition*, 1932, Pencil, chalk, collage, 23.8 x 19.8 cm, Art Gallery of Ontario, Toronto, AG 32.84v (HMF 973)

the clothing of the individual figures is more readily identifiable. Yet here, too, it is used to lend weight to the sculptural effect. The figures very much look as though they have been carefully packed. Shawl, waistcoat, headscarf and coat offer them protection and reinforce the impression of tense sitting and listening.

In other drawings Moore increased the impression of near-mummification to the extent that the figures almost become as one with their wrappings. Typical of these is the drawing *People Wrapped in Blankets* (fig. 135) from p. 61 of the first sketchbook. The rhythm of the folds leaps from figure to figure – a throng of veils and fabrics that, with no more than the merest indications of the heads and bodies below them, seems to dissolve into a dance of interconnected movements. A drawing of this kind (here bathed in an unreal pinkish hue)

benefits considerably from the mixed media technique that Moore frequently used in the *Shelter Drawings*. The first layer of the composition is drawn in wax (in white or some other colour) which repels the watercolour wash that is applied next. Lastly the forms are defined using a pen and black ink – a process that in this case heightens the impression of figures hovering in mid-air.[29]

The vitality of this, and similar scenarios with multiple shrouded figures, is even more intense where the moving mass of hundreds of people wrapped in blankets in the underground shelters looked to Moore, above all, like a fantastic image of a 'sea of sleepers'. On p. 62 of the second sketchbook, he splits this pictorial idea into two fields (fig. 136). The waves of blankets become an absolute and in the crowd of sleeping figures the heads look like the foam on breakers. In

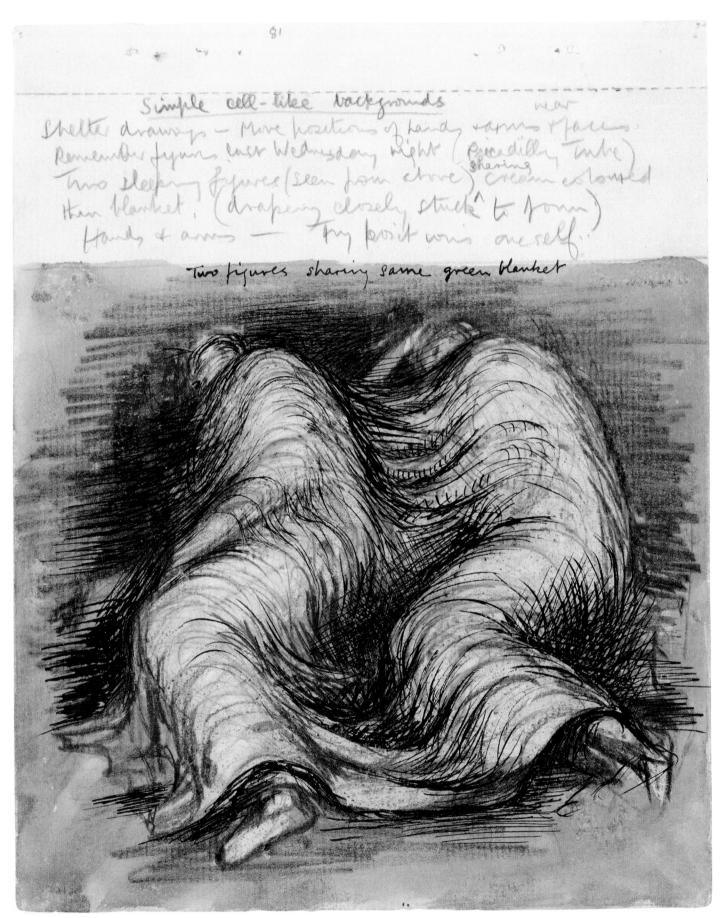

Simple cell-like backgrounds

Shelter drawings — Move positions of heads + arms + faces. near

Remember figures last Wednesday night (Piccadilly Tube)

Two sleeping figures (seen from above) sharing cream coloured thin blanket. (drapery closely stuck to form)

Hands + arms — try point was one self.

Two figures sharing same green blanket

138 *Two figures sharing same green blanket*, 1940–41, Pencil, wax crayon, watercolour, pen and ink, 20.4 x 16.2 cm, The Henry Moore Foundation, AG 40-41.148 (HMF 1705)

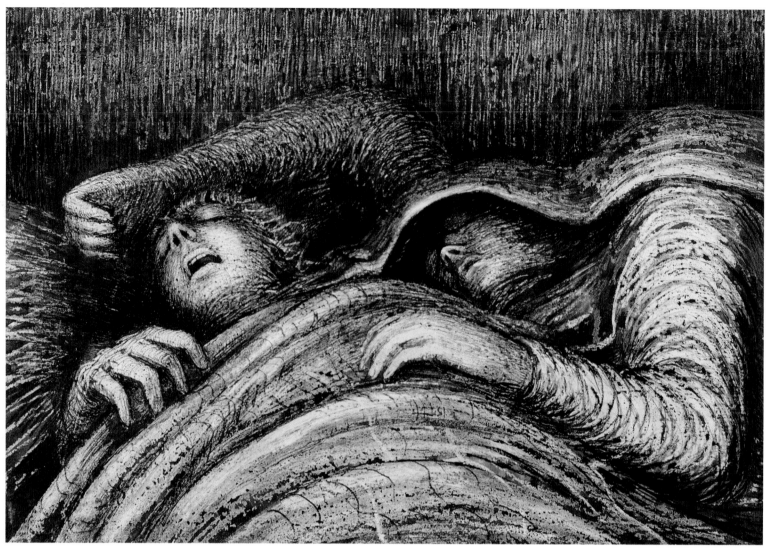

139 *Pink and Green Sleepers*, 1941, Pencil, wax crayon, coloured crayon, chalk, watercolour, pen and ink, 38.1 x 55.9 cm, Tate Britain, London, AG 41.92 (HMF 1845)

the upper left of the same page, Moore has also dashed off a side view of a heavily shrouded woman. This drawing provides food for thought, for it can be seen from a comparison with a sketch of 1932 (fig. 137), that the way the various fabrics seem to flow around the woman's right arm (her hand is resting in the small of her back) has echoes of the *Transformation Drawings*. Whereas, in the latter, the flowing linear forms of a bone gradually mutated into the biomorphous concrete sculpture *Composition*,[30] now the process is reversed: the liquid nature of the drapery around the body relieves it of its own weight.[31] The same effect is seen to an ever greater degree in the sleeping figures.

Thus Moore was able to take the element of drapery, which he first added to his vocabulary in the *Shelter Drawings*, and use it to serve his imagination in a whole variety of ways. The two main functions are, firstly, as an outer shell for the body that will protect it from all dangers[32] and, secondly, to dissolve the weight that normally attaches to a body and to

de-individualise it in the sea of sleeping figures – in that situation where numerous souls yield to their collective fate.

Sleep

While bombs were bringing death and destruction to London night after night, life continued unabated in the underground labyrinth of the tube system. People from all walks of life were thrown together and Moore was one of them. Leaving aside his own military service at a young age, it seems he now saw things that must ultimately shake the foundations of his hitherto closeted artistic existence. But he took this lesson to heart and later – to repeat – remarked on the effect it had had on him: 'Without the war, which directed one's direction to life itself, I think I would have been a far less sensitive and responsible person – if I had ignored all that and went on working just as before. The war brought out and encouraged the humanist side in one's work.'[33]

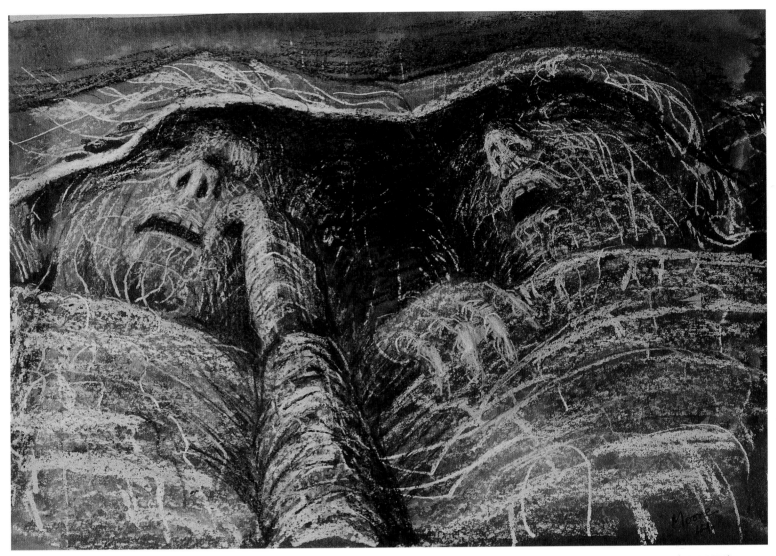

140 *Two Sleepers*, 1941, Pencil, wax crayon, watercolour, 31 x 46.5 cm, Pallant House Gallery, Chichester: The Walter Hussey Bequest, AG 41.10 (HMF 1853)

It was no doubt also partly his new-found humanist sensibilities that accounted for Moore's novel interest in sleep. It is probably fair to say that the only other artist to have dealt with this theme so extensively was Picasso. On the basis of tiny sketches that he had discreetly executed from life, Moore created a whole series of finished drawings celebrating the sleeping figure. In the exceptional circumstances of wartime London at night, he saw human beings pitifully exposed and yet still capable of gestures of affection and care. On one occasion he observed 'two figures in sleeping embrace',[34] and in notes next to another drawing (fig. 138) from the second sketchbook, he wrote: 'Two sleeping figures (seen from above) sharing cream coloured thin blanket (drapery closely stuck to form)'.[35] The drawing closely adheres to these notes, which in fact summarise the artist's sculptural interest in the figures. You are looking from above on two sleepers enveloped in one blanket this time a green one. The harmony of the positions of the shelterers lying on their sides is enlivened by the asymme-

try of the rhythmic steps of the sunken folds between them. The shared blanket both unites and separates.

Moore achieved an even more compelling image through the cocoon-like blanket in the drawing *Pink and Green Sleepers* (fig. 139). This, alongside the tunnel pictures, is the most famous *Shelter Drawing* of all. He developed the motif from a small sketch with three figures[36] and another four preparatory studies.[37] The two sleeping figures are seen from below, 'as if we were kneeling at their feet'.[38] Consequently we, as viewers, are drawn into the rhythmic dynamics of the composition and come very close to their 'sleeping embrace'. The blanket, which the woman has drawn up to her chin, also protects the eyes and shoulder of the man, like an outspread wing. Under the blanket the man sleeps cuddled close to the woman, his arm tenderly resting on her body. The two give and receive the same level of protection from each other. With its flowing folds it is as though the blanket plays a role in its own right, embodying the couple's deeper sense of non-conscious be-

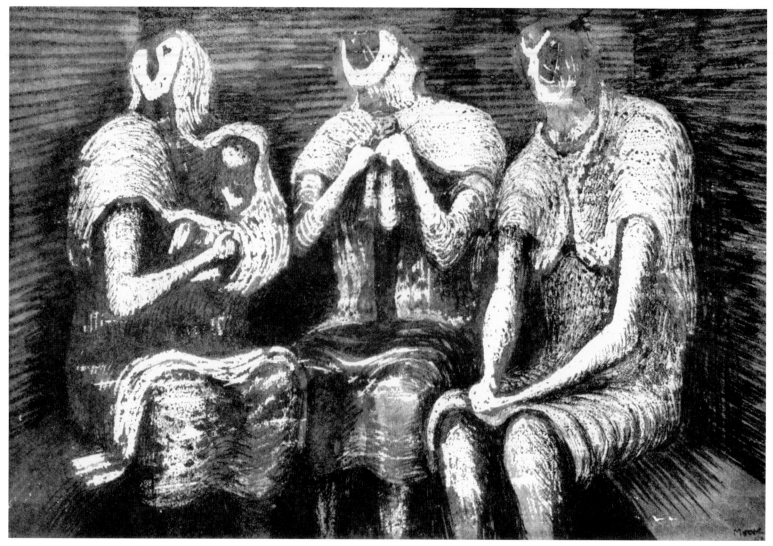

141 *Shelter Drawing: Three Fates*, 1941, Pencil, wax crayon, coloured crayon wash, pen and ink, 38.1 x 55.9 cm, Brighton Museum and Art Gallery, Brighton, AG 41.80 (HMF 1830)

longing. The fluid covering signifies the living oneness of these two souls that even extends into that other mode of being we enter when we sleep.

From time to time Moore even touched on the ancient concept of death as the brother of sleep. In the 1941 drawing *Two Sleepers* (fig. 140) the two levels of existence seem to be inextricably linked. Julian Andrews has aptly pointed out that the figures' mouths gaping 'in a hideous manner' seem more likely to be emitting the death rattle of a dying human being than slow breathing or even snoring.[39] In the otherworldliness of this scene Moore's *compassio* is at its most moving. Where else in the history of modern art to date would one have been confronted so directly and existentially with the dividing line between sleep and death? Picasso created numerous images of figures asleep, but these are generally – and magnificently – erotic in their content.

To my knowledge Moore only later produced one other similarly intense depiction of sleep, namely in his sketch of his

sleeping grandson Gus[40] – once again revealing his deep understanding of real life and the extent of his human empathy.

The Mythical Dimension

Alan Wilkinson talks of the outstanding 'visionary intensity'[41] of the *Shelter Drawings*, and this could be said to apply particularly to the drawings in which Moore transposes the figures into a different, mythical dimension. This is epitomised in the *Three Fates* of 1941 (fig. 141). Although in this case Moore only makes indirect reference to the traditional iconography of the Fates,[42] it was not by chance that he came up with this image set underground in the tube system. In the drawing we see three seated women whose heads appear deformed and strangely divided. The women on the left holds a child on her arm, the central figure is knitting and the woman on the right merely gazes fixedly into space. These *Three Fates* conform to

art-historical tradition in that they are seated around an open space and that they are strikingly ugly; in addition to this they make their portentous appearance in a cave-like setting and two are active, while the third is wholly inactive.

According to Hesiod, the three Parcae (in Roman mythology) or the three Moerae (their Greek equivalents) controlled the mortal lives of human beings.[43] As the daughters of Night, they are also the sisters of Death and Sleep. Generally they are described as living underground in a cave, from where they affect the lives of humans: 'Clotho is the "spinner", who spins out the thread of mortal life, Lachesis is the "drawer of lots" who measures out the thread of life, and Atropos is the "unturning one" who cuts that same thread. Each human being has the thread of their life spun for them. And the Fates not only determine the length of a person's life, they also decide on its quality, allotting both good and bad to the mortals on Earth.'[44] While Clotho and Lachesis are actively concerned with furthering life, Atropos ends it with death. Accordingly, in late-medieval miniatures she is sometimes portrayed as a skeleton. More often than not, she was portrayed as old, ugly and with withered breasts. In the *Roman de la Rose* she has three breasts in order to slake the thirst of the three-headed Cerberus.[45]

Moore adapted this age-old material to his own needs. The element of birth is represented in the woman with the baby in her arms. The thread is in the hands of the knitter and the third figure, gazing straight ahead, has the ugly, pendulous breasts of Atropos, as she was so strikingly portrayed in the Middle Ages when she would take on the appearance of a witch, so that she should above all inspire terror. When Moore, too, heightened the foreboding nature of the figure of Atropos, he was simply replicating the medieval, demonic image of this third Fate. In 1940–41 her role as a *memento mori* was all too relevant. During those wartime nights, Death could not have been closer, and it seems that Moore's Atropos is only waiting for him to strike.

Within Moore's artistic development as a whole, the *Shelter Drawings* play a pivotal role. In one sense they advance important aspects of his prewar output, such as his greater interest in colour and preference for reclining figures (informed by his 'Etruscan' memories[46]). In another sense they allow the artist to work up entirely new themes: the clothed figure and use of drapery (which took him in the direction of Classical Greek sculpture), the family,[47] that was to preoccupy him after 1945 when the country was struggling to recover, and not least his development of idol-like, demonically expressive figures.[48]

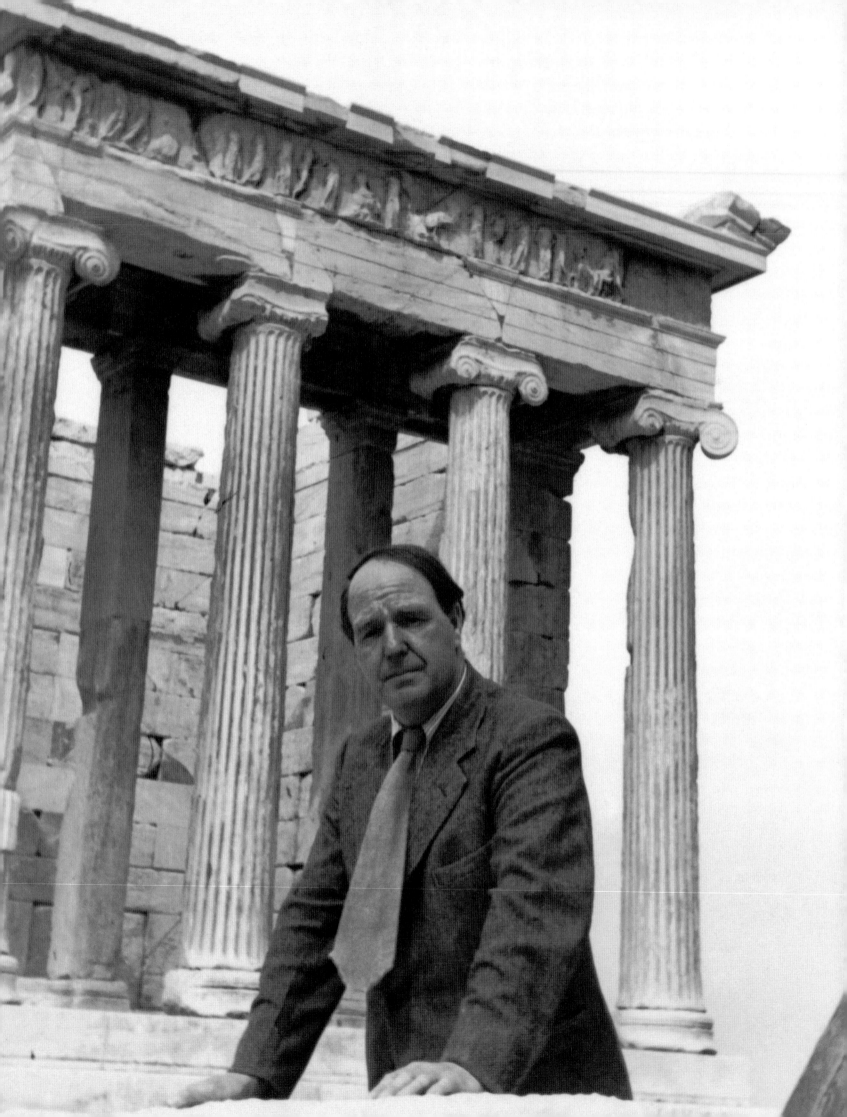

5. Under the Banner of Humanism: A Dialogue with Tradition

Henry Moore and Greek Antiquity

An exchange with classical precursors cannot be separated from any history of Western sculpture.[1] This art, which was to become of the utmost significance for man's perception of himself, had culminated in the works of Phidias and Polyclitus in the fifth century BC. Werner Fuchs described this achievement as 'the classical' *Daseinsform* (form-existence) that restricts man entirely to himself and yet exalts him, that discovers a grand rhythm, that permeates all the parts of a figure and organises it into a new unity determined by the intellect, by volition and the soul. [...] The sacral compactness of archaic representation dissolves into a free religiosity. The manifestation, the representation of pathos and passion, of strength and grace becomes the aim of the late classical period and of Hellenism. In Hellenistic art the *Daseinsform* becomes the *Wirkungsform* (form-effect). Here sculpture conquers the entire range of human representational possibilities and defines unique bodily gestures, which, as applicable formulae, are available to all later art: Roman, Early Christian, Byzantine, even Medieval and particularly Renaissance.'[2]

At the beginning of this century, sculptors strove resolutely to free themselves from these 'applicable formulae' which had dominated the entire Baroque period, were redefined in the Neoclassicist epoch, and were repeated again and again in the various 'classical revivals' of the nineteenth century. Not least in order to escape the ubiquitous presence of Rodin, but also to resist cultivating the degenerate heritage of salon sculpture, they gave priority to the Egyptian and pre-classical Greek. During the first third of the twentieth century the acknowledgement of, for example, archaic Kouroi and the Severe Style pedimental sculptures from the Zeus temple at Olympia, accompanies the awakening of modern art, under the banners of truth to material and new tectonics. Wherever archaism surfaces – whether under the auspices of the neoclassical (Bourdelle, Maillol, Ludwig Kaspar), of expressive archaism or primitivism respectively (Brancusi, Nadelmann, Modigliani, Zadkine, Eric Gill, Gaudier-Brzeska, Jacob Epstein), of Cubism (Laurens, Lipchitz, Zadkine) or of constructivism (Schlemmer) – it concerns the justification and objectiveness of *sculpture pure*[3].

As a young 'modern' sculptor, Moore as a matter of course joined this pioneering opposition.[4] He discovered a wealth of stimuli, particularly in African, Eskimo, Columbian and Aztec sculpture: these 'encouraged' him 'to be more adventurous and experimental'[5] and to search for the true figurative expression of the form in stone and wood. Yet Moore was not only fascinated by sculpture from outside Europe at this point.

Simultaneously he was taking note of numerous Cycladic idols, prehistoric evidence of the so-called Aegean culture from the second half of the third millennium BC, which represent an early phase of Greek art.

If one wishes to outline the real importance of Moore's connection with antiquity for his entire œuvre, this is where it has to begin, for only on the basis of an historical perspective can it become clear to what extent Moore, in immersing himself in the avant-garde 'archaic', forsook the well-trodden paths of the conventional reading of antiquity. That he also discovered new approaches became evident in the 1940s and 1950s when, first through drawing, then through sculpture, he made an intensive study of major works from the Greek Antique collections in the British Museum. Now, working from his own aesthetic premises, he virtually succeeded in blending Phidias' *Daseinsform* back into nature, thereby undoubtedly effecting a most significant turning point within the more recent intellectual history of the appreciation of antiquity. He achieved something similar in 1961, as will be discussed later, in his *Large Standing Figure: Knife Edge* (figs. 185, 186), except that here it was the Hellenistic *Wirkungsform* of the Samothracean *Nike* which Moore sought to penetrate, using the language of his analogy with nature. The path leading to this work was, however, to be long and one that lasted fifty years.

The Big View of Sculpture – The World Tradition

At the start of his academic training in autumn 1919 Henry Moore, as we have seen already, was not spared the agonizing exercise of copying drawings from poor quality plaster casts, yet this did not deter him from studying antique sculpture privately in the library. In a dated and signed notebook of 96 pages from 1920, the so-called 'Bushey Sketchbook', he compiled for himself a 'History of Sculpture'. On 39 written pages and in 26 drawings Moore made his selection of Chaldean, Babylonian, Assyrian, Greek and Roman sculpture, and worked over the artistic ideals of Michelangelo, his longstanding model. He also attempted to acquire an overall view of Greek, Roman, Byzantine, as well as Gothic and Renaissance architectural forms.[6] Thus it was with remarkable care that the 22-year-old assimilated a basic art historical knowledge which, significantly, extended beyond the traditional curriculum of classical and Hellenistic antiquities. This 'universalist' readiness to learn not only clarified his perspective of the confusingly rich British Museum collections, but was also to lay the foundation for his broad interests as a collector in later life.

In those formative years of the 1920s, Moore's early, cross-cultural encounters with antiquity were augmented by intimate knowledge of authoritative private collections, as well as the relevant holdings of the British Museum.

Ill. 5 Moore in front of the east-frieze of the Athena Nike temple on the Akropolis in Athens, 1951

143 *Notebook No. 3: Figure Studies*, 1922–24, p. 131, Pencil, pen and ink, 22.5 x 17.2 cm, The Henry Moore Foundation, AG 22-24.48r (HMF 132)

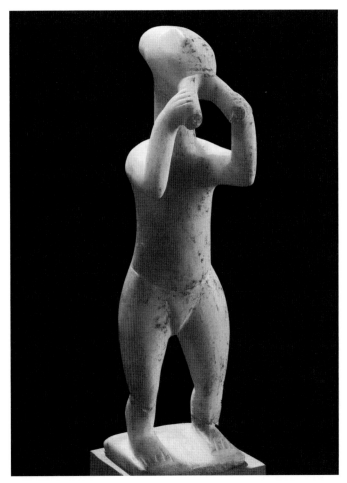

144 *Double-Flute Player on a Grave* on Keros, Cycladic, 2000 BC, Marble, H. 20 cm, National Museum, Athens

The Cycladic Approach

Moore's authentic search for the 'big view of sculpture – the world tradition'[7] for universal 'form-ideas' in the sculpture of all epochs is reflected by the diversity of ideas in his studies in *Notebook No. 3* of 1922–24. Here one discovers, in addition to the above-mentioned copies after Giotto, Cézanne, Archipenko, Zadkine and Picasso, that there are sketches of African woodcarvings, a statuette from British Columbia and a first reference to the Mexican rain god Chacmool, as well as unexpected drawings of Cycladic idols (p. 126 and p. 131). Thus we find a standing female figure with folded arms (figs. 142, 143) and beneath this, in two sketches, the back view of the *Double-flute Player* from the National Museum in Athens, which Moore must have known from a reproduction (fig. 144).[8]

On several occasions Moore described his marked preference for this prehistoric Aegean art. 1969 he wrote: 'I love and admire Cycladic sculpture. It has such great elemental simplicity. (I'm sure the well-known Cycladic head in The Louvre influenced Brancusi and was the parent of his sculpture… *The Beginning of the World*).'[9]

In 1981 Moore stated for his memoirs, which recapitulated his visual experiences in the British Museum: 'If I was asked to explain to students what it is I mean by a sense of form perhaps I would start off with the Cycladic Room of the British Museum, for what the Cycladic sculpture has got is an unbelievably pure sense of style, of unity of form. It's as though they couldn't go wrong, but always arrived at a result which was inevitable from the beginning. Another attraction for me of Cycladic sculpture was that most of it is in marble. Around 1910 to 1920 a strong belief came to be held by a few sculptors that they should carve directly in the material rather than casting their work into different material, such as bronze.'[10] Simplicity, purity, unity of form, intellectual logic in the conception of form and its suitable translation into marble – Moore recognised these qualities in Cycladic idol sculpture and never tired of extolling them, particularly after he himself came to own two originals.[11] Speaking of a Cycladic marble jar in the British Museum, he reminds us of an old aesthetic maxim: 'This piece is strongly figurative with a body, neck and head, and two little breasts at the front. There is no doubt our

sense of form comes from our own bodies. If we didn't have a head and body, two arms and two legs, feet and hands, the whole basis of plastic art would be quite different.'[12]

Accordingly Moore found in Cycladic art an understanding of physicality within the creation of sculpture. For him, one of the ideals of classical Greece was therefore already inherent in its prehistoric prototypes. This early insight testifies once again to Moore's need to clarify for himself the historic connections within the 'world tradition of sculpture'. 1976 he recalled this lifelong curiosity: 'All along I was learning… I believed then that it was a duty, (it was also great pleasure and excitement) to get to know as much as possible of the past history of sculpture – just as a scientist, say, is helped in his special subject if he knows how it has reached its present stage – or that a writer should know something of the history and practice of the language he uses (why ancient poetry has a power that much new poetry does not have).'[13]

This sense of a cognitive obligation towards the world history of sculpture stands fairly isolated in the practice of avant-garde sculpture of the time. Certainly, other sculptors also passed wide-eyed through the ethnological museums: where would Picasso, Brancusi, Giacometti, Gonzalez and many others have been without the Musee de l'Homme? Moore's thinking, however, is unusually historic. As his early notes in Leeds have shown, he had to compile for himself a historical development of plastic art – and in those days that for him meant primarily sculpture – in order to know where he stood in terms of specific related 'form-ideas'. His need to work from this historical tradition, indeed, to establish himself within it, coincides with his general work ethic of a morphogenetic derivation of form.

In the 1920s, Moore's marked interest in the early forms of Greek art was also theoretically consolidated by a clear refusal of the educational ideal (*Bildungsideal*) of mature Greek classical and Hellenistic art.

145 *Notebook No. 6: Study after 'Venus of Grimaldi'*, 1926, p.71, pencil, wash, 22.2 x 17.2 cm, The Henry Moore Foundation, AG 26.36v (HMF 461)

Mycenaen Tombs

With this in mind, one is not surprised to see Moore's sketch of Mycenaen architectural detail in his *Notebook No. 6* of 1926 (fig. 145). The artist related how he drew from memory an entrance to one of the Mycenaen tombs.[14] It is conceivable that what he saw here in his mind's eye was the often reproduced portal of the so-called *Treasury of Atreus* (fig. 146).[15] Should this comparison hold, then Moore would not only have remembered the characteristic facade, with its portal flanked by half-columns and its triangular pediment (yet omitting the technically important door lintel), he would also have expressed his particular appreciation of the building blocks of this architecture – the great, rectangularly hewn monoliths. As suggested by the tilt of the ashlar masonry, one also seems to see some hints of the uncovered, narrowing approach to

146 *Treasury of Atreus*, Mykene, 1300 BC, height oft the portal: 540 cm

the hidden tomb. Besides the massive 'stoniness' of the ashlars, which Moore accentuates more than in the original, the vortex effect of the portal (in reality 5 metres high) seems to have occupied him most. Moreover, as a sculptor, he sees the famous portal layout as formal sculpture, as an entirety in a spatial context, with its mighty approach in the foreground, its 'hole' and its shadowy promise of depth in the rear. The Mycenaen theme makes its appearance in Moore's work for the first time with this sketch. It was to become significant for him in many ways, not only with regard to the culture's sculpture itself, but also concerning the palace as the site of action for Homer's heroes, and finally in the sense of Mycenaean culture being altogether representative of the concept of 'tragic' Greece. These aspects were to occupy him with increasing regularity, particularly from the beginning of World War II.

The 'West Wind Relief' and its Antique Sources

Within the chronological sequence of events that spans Moore's encounter with antiquity, 1928 marks the year that the young sculptor was given a prestigious commission for a monumental relief on the headquarters building of the London Underground, alongside Eric Gill, A.H. Gerrard, Allan Wyon, Eric Aumonier and F. Rabinovitch.[16] The search for the correct formal solution led him for a while remarkably close to the supposedly discredited Hellenistic sculpture. In the final outcome, however, he clearly dissociated himself from it. After he had overcome his initial antipathy towards making a relief at all, he applied himself with great earnestness to the 'West Wind' commission. He threw himself with growing enthusiasm – in over 100 sketches contained in a special notebook[17] – into this new venture: a horizontally extended female figure in relief which needed to remain visible from below and from a considerable distance. It had to suggest swift flight and nevertheless remain 'sculpture' in the required sense – that is, it was to communicate by virtue of its masses alone. This was the challenge he faced.

The first 20 preparatory drawings show how Moore at first lingered over more static poses, thereby orientating himself to his model drawings of reclining female forms. In doing so, he stayed on the tracks of Maillol, among others (see figs. 28, 29). Then, following the theme, he tried to make the figure fly. The raising of the plastic masses and the necessary accompanying impression of lightness created obvious problems. In this conceptual stage he made use of an all too time-honoured device of high classical and later Greek statuary: drapery as an expressive means.

On the page of studies shown, for example (fig. 147), he experiments with three views of a reclining figure. Pulling at a large cloth from beneath its thighs, it holds this up horizontally with outstretched hands, inside the given relief panel. The figure, or more specifically its heaviest actual part, the volup-

147 *Ideas for West Wind Relief*, 1928, "Underground" Relief-Sketchbook, p. 21, pen and ink, 36.5 x 22.5 cm, The Henry Moore Foundation, AG 28.10r (HMF 620)

tuously protruding buttocks, seem almost as if protected within a swing-like loop of cloth.

In Hellenistic sculpture, the occurrence of this type of 'swing' in conjunction with an openly displayed and naked rear view is often found in the different versions of sleeping maenads or hermaphrodites. Moore had certainly encountered this type, which was quite common in the second century BC, already. Here we see his central nude back view juxtaposed with the terracotta of a *Sleeping Maenad* from Tarento (fig. 148). Equally obvious, it appears to me, is a reference to the well-known reliefs on the so-called 'Tower of the Winds' in Athens. Already widely known in England through Stuart and Revett's catalogue of engravings of 1762, these topological precursors to the London figures were probably familiar to all the participating sculptors. Thus Moore's lower 'flying' nude (fig. 147) may also be compared to the *Zephyr* on the Horologium of Andronicus, from the first half of the first cen-

148 *Sleeping Maenad*, c. 130/120 BC, Terracotta, L. 30 cm, Museo Nazionale Archeologico, Tarent

149 *Zephyr, Tower of the Winds,* Athens, first half of the first century BC, Engraving in: Stuart/Revett: The Antiquities of Athens, part 1, London 1762

150 *West Wind Relief*, 1928, Portland stone, L. 243.8 cm, London Transport, St James's Park Underground Station, Westminster (LH 58)

151 *Seated Figure*, 1930, alabaster, H. 38.1 cm, Art Gallery of Ontario, Toronto (LH 92)

152 *The Harpist* from the Cycladic island Amorgos, Cycladic, 2300 – 2000 BC, marble, H. 22.5 cm, National Museum, Athens

tury BC (fig. 149).[18] If one disregards the difference in gender, the *en face* position of the wind god and his flower-filled, looped cloak constitute a similar arrangement of figure and drapery.

Naturally, Moore is not copying here in any direct way. Yet he does consciously or unconsciously take up a dialogue with the 'applicable formulae' of major Greek works while seeking to resolve the technical problem of 'flight'. He would not have been the pragmatist and self-conscious artist he already was at thirty, had he not side-stepped, when it seemed appropriate, his avowed abstinence from the Greek ideal of beauty. In the final executed version of the relief, however (fig. 150), Moore triumphs with an individual solution, one which endorses the aesthetics of *sculpture pure*.[19] Here again archaic massiveness guarantees 'simplicity of form',[20] and there also emerges an intensity of spiritual expression unexpected in the young sculptor. One might almost be looking at an – admittedly hefty – successor to the Shakespearean spirits of the elements and of air. The listening attitude characterising her broad countenance, the large ear, the animated look, the pointed open hand – all indicate future events, towards which the Wind-woman strives unerringly.

The Cycladic Construction Principle

In the following comment Moore again puts the viewer – as was the case with the Mycenaean portal – on a helpful track. He remarked to Alan Wilkinson that his admiration for a specific Cycladic figure, the *Harpist* from the National Museum in Athens, which he knew from a reproduction (fig. 152), had influenced the *Seated Figure* which he carved in alabaster in 1930 (fig. 151).[21] Wilkinson correctly saw in this figure a culmination of those motifs which Moore had gleaned from his studies of Mexican sculpture.[22] Susan Compton has also pointed out the internal twist of the upper part of the body as against the lower part: 'This Mannerist approach, perhaps derived from Michelangelo, is surprising in view of the conflicting influence of primitive art'.[23] Finally, Wilkinson saw in the multiple piercings of the marble block, the *tertium comparationis* of the Cycladic seated figure. Moore accordingly admired in the National Museum alabaster work 'the remarkable way in which the carver opened out the stone, hollowed out certain areas, completely freeing the chair and the figure from the original block of marble'.[24]

The question remains, how much of Moore's above-mentioned aesthetic criteria regarding Cycladic sculpture – 'sim-

153 *Stones in a Landscape*, 1936, Charcoal, watercolour, pen and ink, 55.9 x 38.1 cm, Private Collection, London, AG 36.23 (HMF 1259)

plicity', 'pure sense of form' and 'unity of form' – is relevant to the specific alabaster prototype of his figure. The *Seated Figure* of 1930 is certainly not 'simple' in the manner of the clear frontality and construction of Cycladic idols. It nevertheless preserves the 'pure sense of form' in a sense in which the alabaster is made smooth, right up to each small bodily detail. Finally, as far as the 'unity' or inner logic of the whole form is concerned, this is definitely shared with the Cycladic *Harpist* in several major points, such as the multiple right angles in the handling of arms and legs, which also predominate in Moore's work. These right angles throw the figure into spatial separation and simultaneously bind it to the initial shape of the marble block.

Thus, through examining the principles of construction in the Cycladic *Harpist*, Moore is spurred on to create a sculpture which ventures three-dimensional openings without forfeiting its strong material character.

Stones in a landscape

Encouraged by Surrealism to extend his imaginative faculties, Moore immersed his sculpture designs of about 1933 in large-scale dream landscapes built up of densely washed layers of colour. From 1937 onwards we also find sculpturally reshaped and anthropomorphic views. Moore discovered another use for the idea in the drawing *Stones in a Landscape* 1936 (fig. 153). Here the scene, with its unreally interspersed white temple facades, forms a pendant to the exaggerated sculptural motifs of the Square Forms. They appear to be embedded in a narrative, picture-like drawing, the whole of which is intended to be read schematically.

In another context, Wilkinson has associated 'square forms', pictorially arranged in a similar manner, with 'ancient weather-worn menhirs'.[25] What the consequences of this precise subject (together with Stonehenge) were for Moore, in the light of emerging Neo-Romanticism in England, will be discussed later on in the Chapter I.7.[26] One thing here becomes apparent, however: Moore uses the temple props as an ambiguous yardstick – literally at first, in that he uses their smallness to accentuate the colossal size of the monoliths, then spiritually, in that the pale temple fronts, in contrast with the dark, puzzling witnesses of a mythical prehistory, evoke an historic tension. He consciously keeps the depiction of the Attic forms shadowy, in contrast to his pronounced 'square forms'. At most, they are permitted to heighten *ex negative* the mythical presence he would like to bestow on his abstract stones.

Kenneth Clark rightly regarded *Stones in a Landscape* as a 'magnificent and unique example' of Moore's special aptitude for dramatic pictorial arrangement. This talent was further expressed by drawings in which he placed his figure designs on the front edge of a sort of stage and extended their shadows into the space behind. In this way the sculptor established 'ghostly relations' between the front and rear layers of figures.[27]

The Mycenean Idol in the 'School Print'

After 1936 and for almost thirty years, Moore again and again practised in these pictorially conceived drawings, with their staggered, chromatically subdued and 'ghostly' figure projections, an artistic device which activates the narrative component of other drawings by twentieth-century sculptors. With this in mind his quotations from antiquity are also given an extended narrative function. This is made particularly clear by several drawings which belong to the group of works called 'sculptural objects' (1934 – 49). Moore made a lithograph with this title for the series of so-called *School Prints* in 1949 (fig. 154).[28] It was preceded by three drawings of the same year, in which the 'sculptural objects' were elaborated in two variations, both referring to forms invented in the 1930s.[29] It is worth retracing their genesis in detail.

The initial idea for the whole group is rooted in a brief sketch from 1934 (fig. 156). Here Moore drew, probably from a published reproduction, a clay idol from the thirteenth-century BC Mycenaean culture and, adjoining this to the right, a structure that is reminiscent of a butterfly chrysalis. Decades later Moore was himself to possess such a Mycenaean cult object, similar to the one he had seen in the British Museum (fig. 155),[30] a terracotta statue about 12 cm tall. Moore liked to point out how it originated from the hand which modelled it. He underlined, by vividly repeating the shaping movement, how the Mycenaean sculptor pulled the disc-shaped torso up from the column-like base, thereby creating the plastic swellings of the bust and finally giving the head a bird-like appearance.

Scholars have several explanations for the meaning of these idols: 'They are interpreted as gods, because they were found in sanctuaries, as godly nannies, since one mostly finds them in the graves of small children, but also as simple votive offerings or as toys.'[31]

Moore based his sketch from 1934 on an idol of the Phi-type, whose folded arms are hidden beneath the wavy decoration of the drapery. Next to this condensed, abstracted body-image with its undulating silhouette, the still-closed chrysalis with its similarly schematised 'vein' decoration seems like an organic off-shoot of the figure itself.

The close proximity of both shapes may at first appear coincidental, yet it is definitely not without meaning or sensitivity. Rather, it seems to me here that Moore – whether through study or intuition – still sensed in the Mycenaean clay idol its historic origin in the organic-stylistic prerequisites of Minoan art, and therefore experienced both shapes as vital characters that belong together. The consistency, too, with which Moore links the Mycenaean Phi idol, wherever it

154 *Sculptural Objects*, 1949, Chromolithograph, 49.5 x 76.2 cm (CGM 7)

155 *Mycenian Idol in Phi-Type*, 13th century BC, Terracotta, H. 12 cm, British Museum, London

appears, with the themes of 'nature' and 'life' supports this thesis, as we shall see. The next phase of development of the 'sculptural objects' took place in 1938 when Moore designed two stage scenarios in the same manner, prosaically calling them *Drawing for Metal Sculpture* (figs. 157, 158). The first shows two abstracted multi-level sculptures, which could well have been constructed using a soldering technique. In shades of dark violet, black and blue, they flank a Mooresque armillary sphere. With its black bars she gives the impression of a cage, enclosing a pierced red disc. To the right Moore places his Mycenaean idol, slightly raised above the accessible stage floor and removed to a diffuse blue misty area.

In the pendant drawing (fig. 158), the figure scenario is now forced on to a continuous stage floor, showing the contrast between metallic instruments and naturalistically modelled statues in the foremost plane. To the left one recognises a frame, on the crossbars of which hang various shapes. On closer examination, these strike one as being suspended letters from the Greek and Etruscan alphabets: phi and delta above and, between three 'O' shapes, the Etruscan sign for 'Th' (seventh to fifth century BC).[32] A shape leans against the foot of the frame which, together with the armillary sphere,

could be derived from Moore's stringed figure *Head*, also from 1938 (fig. 159).

Seen in this light, the message of the drawing seems clear: the modified idol and monumentalised 'chrysalis' in the centre stand in opposition to the lateral symbols of intellectual rationality. Spatial opening and density of form, rationality and antiquity/nature – out of this balancing act and from the 1930s onwards, Moore consciously tried to work in both a surrealist as well as an abstract direction.[33] Continuing this clarifying process, he returned in the next chalk drawing to an idea first seen in 1934 (fig. 160). Here he lets the Mycenaean idol and the 'chrysalis' appear in a familiar relationship once again as witnesses to mathematical rationality. In this dialogue of figures that includes Mycenaean Greece, Moore seems to want to refer to his redoubled striving towards a balanced interaction of form and space.

In the version of the idea which became the *School Print* lithograph (fig. 154), Moore modifies the direct quote from antiquity, inasmuch as he utilises the individual shape developed in 1938 but retains its bluish shade. He also displays his antique alphabet-frame with extreme care, as if to say to the children: Spell out archaic antiquity – it's worth it! Against the

156 *Ideas for Sculpture*, 1934, pencil, crayon, 27.3 x 18.1 cm, The Henry Moore Foundation, AG 34.73v (HMF 1139)

157 *Drawing for Metal Sculpture*, 1938, Chalk (part-washed), crayon, watercolour, 38.1 x 55.9 cm, The Henry Moore Foundation, AG 38.47 (HMF 1381)

158 *Sculptural Objects*, 1949, Pencil, chalk, watercolour wash, 48.3 x 73 cm, Ralli Foundation, Geneva, AG 49.2 (HMF 2520)

159 *Head*, 1938, Elmwood and string, H. 20.3 cm, Collection Ursula Goldfinger and Family (LH 188)

background of the long development of the work shown here, his 'idol figure' thus retains its inherent traditional Greek context. For Moore the historical dimensions of the 'universal form-language' must be preserved in this deliberate aesthetic self-representation.

Wartime: Reflections on Homer and Severe Archaic Form

During the years 1941–42, while Moore was busy with the *Shelter Drawings* and thus sharing in the war experiences of his countrymen (accordingly, a period when his art exuded a deepened social responsibility), a new and more complex relationship with Greek archaism was ripening within his representation of figures.

Moore's borrowings now had a different existential urgency. It is almost as if the severity of the archaic depiction of man also armoured his figures anew and strengthened them against the ever-present threat of death. The plastic shape was imbued with an ethos based on its own humanist resources – the antiquity of Homer.

160 *Sculptural Objects*, 1949, Chalk, watercolour, gouache on wove, 38.7 x 49.5 cm, The Henry Moore Family Collection, AG 49.1 (HMF 2519)

Moore's intensified learnings from Homer during the war introduce a significant chapter into his reading of antiquity. Here the foundations are laid for his rapprochement with classicism later in the 1950s which in itself was prepared by his *Shelter Drawings*. This becomes clearly visible for the first time in a number of pictorial drawings from 1943, as well as in Moore's illustrations for the publication of Edward Sackville-West's radio play, *The Rescue*.[34]

The Rescue was published in May 1945, just before the end of the war, and contained six drawings by Henry Moore, some reproduced in colour. This 'Melodrama for Broadcasting, based on Homer's Odyssey' had first been aired by the BBC in two parts on 25 and 26 November 1943. The play, ingeniously interwoven with music by Benjamin Britten, recounts freely, after Homer, the homecoming of Odysseus to Ithaca and the heroic fate of Penelope and her son Telemachus; thus marking an exceptional event in the history of English radio. The publication of the book also gave Moore's drawings an airing and was the first time that the sculptor became widely known as an illustrator.[35]

Moore's striving for intelligibility is unmistakable. He makes clear demands on his protagonists, Odysseus, *Penelope and Eurynome* (fig. 161), on the poet *Phemius* and on *Telemachus*, by attempting to make them speak via their three-dimensional presence and psychological tension. One sees that these pictorial drawings and the adjoining studies in *The Rescue Sketchbook* were done at a time when Moore, through his commission for the *Northampton Madonna*,[36] was able to revert to sculpture after a long break caused by the war. His new sculpturally haptic drawing style, together with an intensified consideration of drapery, is introduced in a remarkable sketch for the *Rescue* illustration *Phemius Points out the Gods to Telemachus* (fig. 165). If one compares this with the final maquette for the *Northampton Madonna* of 1943 (fig. 162), Moore's attempt to accentuate the massive, tensed corporeality of his figures by means of generously moulded drapery becomes clear. Heavy folds of cloth cling to the body and portray its vigorous appearance with a few rhythmic lines.

Moore may have adapted this moulded drapery, which is virtually 'sketched' onto the monumental body, from the simi-

161 Illustration for *The Rescue: Penelope and Eurynome*, 1944, Pencil, chalk, wax crayon, wash, pen and ink, 47 x 31.8 cm, The Henry Moore Foundation, AG 44.43 (HMF 2301)

162 Maquette for *Madonna and Child*, St Matthew's Church, Northampton, 1943, Bronze with green patina, H. 15.3 cm, Utermann Gallery, Dortmund (LH 224)

larly unified features of the high archaic *Seated Figures from Didyma*, near Miletus, which he had seen in the British Museum. These votive statues, which lined both sides of the Holy Way to the Apollo sanctuary (figs. 163, 164),[37] appeal to the modern viewer because of 'a large uniform mass, the weighty volume of which makes for the imposing formation of aloof restfulness and power in the archaic *Seinsform*'.[38] The figures are dressed in chiton and cloak, the latter enveloping the shoulders, arms and legs in almost relief-like layers, thus further heightening the impression of dense corporeality. These majestic east Ionian stone figures had fascinated Moore since the 1920s:[39] now that it was necessary to emphasise the positive heroes from Sackville-West's play in their mightiness and

richness, he remembered their expressive power. Naturally, in the 1940s, borrowings from their 'strength of character' signified much more than just a formal adaptation. Together with the author, who addressed this question directly in his preface,[40] Moore must have been aware of the underlying topicality of the Odyssey in connection with the recent German occupation of Greece and the resistance in that country – indeed, of Fascism in Europe altogether. This was why his protagonists had to be visually strong in such a convincing way at that time.

We find a corresponding encapsulation of 'archaic' power as proof of inner moral strength in Moore's *Northampton Madonna*, in *The Rescue* illustrations and in the sculpture

Three Standing Figures (fig. 168).[41] It is in this female group, particularly, that the politico-ethical dimension of Moore's 'archaism' of the 1940s may be perceived.

The idea for a three-figure group on the other hand (a familiar theme in sculpture since the 'Three Graces' configuration), dates back to the *Shelter Drawings*. It meanders through Moore's graphic œuvre from 1942,[42] first takes plastic shape in a maquette of 1945,[43] thence to be carved over life-size out of hard English Darley Dale stone in 1947–48.[44] What is of interest for our discussion is the fact that Moore himself placed this sculpture next to the previously mentioned seated figures from Didyma. Without adding any comment, he confronts the head and shoulder section of the woman on the left of his group with the only remaining *Branchidae figure* in the British Museum that still retains a head (figs. 166, 167). His comparison shows how he picks out the shallow relief carving of the seated figure and then, over the right shoulder, gradually deepens this. Moore later explicitly pointed out in reference to his archaic model: 'Look how poised yet relaxed that simple head is, it's the very essence of a head on a neck and shoulders.'[45] He tried to retain in his figures this impact of the dense, gently curved handling of volume, while dramatising the masses in his own way. His heads do not however, from a psychological viewpoint, look exactly relaxed, but seem to be filled with a dignified alertness. Moore makes them look tensely upwards – a frightened communal glance from six piercing eye sockets. The pose of each figure makes them appear somewhat perplexed. John Russell may have correctly interpreted the message intended here.

He saw the *Three Standing Figures* as guardians or witnesses, and so remarked on the relevant *Zeitgeist*: 'The man or woman who watches the skies has a particular emotional meaning for anyone who, from the Spanish Civil war onwards, has looked on the skies primarily as a potential source of catastrophe, and in carving this group Moore drew, whether consciously or not, on the stored memories of millions.'[46] It seems that Moore had again managed to come up with an accurate portrayal of the times, with his configuration fusing archaic expressive power with the moral claim to strength, or in this case, to bearing witness.

The same sympathy, permeating and humanising the timelessness of the archaic *Seinsform*, is also diffused by the splendid drawing *The Three Fates* of 1948 (fig. 169). An general mood of archaicism also prevails over these women and their massive unity of body and drapery. There is also a disturbing moment of individual expression animating their hieratic severity.

The owner of the drawing, the late Walter J. Strachan, writer, friend and interpreter of Moore, must have had similar thoughts when he wrote at that time: 'The figures represented The Three Fates of classical legend, suitably impersonal, but I always see a slight likeness to Irina [the artist's wife] in one of the figures and Sybil Thorndike [an English actress] – in tragic mood – in the central figure, "Atropos".'[47]

There were already hints in the Shelter and related pictorial drawings of the theme of the three goddesses of fate, prompted by the war. Yet nowhere in Moore's work does it reach such a pronounced and profound form as in this draw-

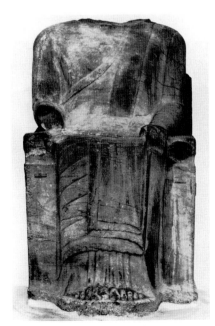

163 One of the *Branchides* from Didyma near Miletus, 600/580 BC, Marble, H. 155 cm, British Museum, London

164 *Group of Branchides*, from Didyma near Miletus, c. 575 BC, Marble, H. 149 cm, British Museum, London

165 Illustration for *The Rescue: Phemius Points out the Gods to Telemachus*, 1944, Pencil, wax crayon, coloured crayon, pen and ink, 21 x 14 cm, The Henry Moore Foundation, AG 44.33 (HMF 2294)

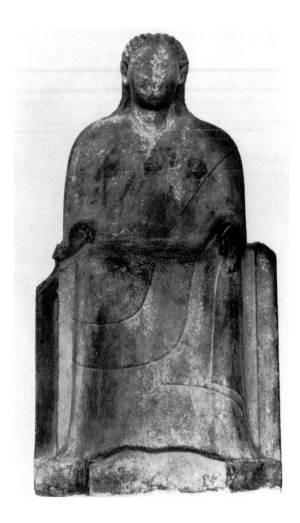

166, 167 One of the *Branchides* from Didyma near Miletus, detail, 600/580 BC, Marble, H. 149 cm, British Museum, London

168 *Three Standing Figures*, 1947/48, Darley Dale stone, H. 213 cm, Battersea Park, London (LH 268)

169 *The Three Fates*, 1948, Pencil, charcoal, white wax crayon, watercolour, wash, coloured crayon, pen and black ink on medium weight wove, 40 x 58.5 cm, Collection W. Strachan, UK, AG 48.27 (HMF 2163)

ing. Chromatically fused with their unreal, pale violet and blue-grey background, the Three Moerae emerge large, grave and of equal stature, one beside the other. Clotho holds up the distaff from which she draws the thread of life. She looks at Lachesis, who keeps the thread taut regardless of the circumstances and at the same time allots destiny with her right hand, letting the spindle hang, plummet-like, with a noticeably cautious gesture. Between the two, Atropos watches. She holds the antique, one-piece arc scissors at the ready. Calculating the end of the thread, she looks back to Clotho at the beginning – the wheel comes full circle, the cycle of life is measured and complete.

Besides the examples we have just seen from the 1940s, it is in this subtle and dramaturgically composed drawing that one is best able to understand how completely Moore had plunged into antiquity as the scene of action – right up to the detail of the 'correct' scissors. A consciously experienced history of the times provided the backing for such an identification. Moore was well aware of what the conflict had changed in him: 'Without the war, which directed one's direction to life

itself, I think I would have been a far less sensitive and responsible person – if I had ignored all that and went on working just as before. The war brought out and encouraged the humanist side in one's work.'[48]

Humanism: A Strategy of Hope in the First Post-War Era

With simple words, as was his nature, Moore here addresses a phenomenon of the post-war epoch, and *humanism* was the international catchword of the time.[49] It crossed all boundaries and was valid from a Christian as well as from an agnostic perspective.[50] Humanism, in the sense of taking out a reinsurance policy with antiquity – that is, with the beginnings of Western thinking and its art – embraced at the time a strategy of hope for all those who, after Auschwitz, Coventry, Dresden and Hiroshima, pressed for an intellectual *renovatio*, largely in vain, as was to be seen.

This search for a cultural reconstitution, assisted by the creative heritage of antiquity, permeated all art forms at the time. In terms of sculpture, the preference for mythical figures

170 Scene from Centauromachie of the frieze of the *Apollo Sanctuary in Bassai*, c. 410 BC, Marble, H. 64 cm, British Museum, London

and themes, starting with Prometheus, Orpheus, Phoenix, Amphion, Daphne, the siren and the sphinx, springs to mind.[51] Moore did not participate in this variety of imaginative figurative scenes. None of the themes mentioned – with the exception of Goethe's Prometheus, which he illustrated in 1949 – stimulated him. Instead, and this seems significant, he kept to antique man as he knew him from Homer, the ideal. Thus he conceived the idea of the warrior form, or the 'prototype of the warrior, who has been defeated and mutilated in a murderous battle such as Homer sings of, who has lost his left arm and left leg and right foot, who has no weapon left but his shield […] A figure from the Mycenean epoch'.[52] *Warrior with Shield* 1953/54 (figs. 171–173),[53] described in this way by Will Grohmann, definitely harbours memories of World War II, as we shall see. Moore's *Warrior with Shield*, belongs to the very few representations of male figure in the artist's work. As David Mitchinson pointed out: 'Moore's treatment of male subjects followed a clear pattern. In sculpture, as in the drawings and lithographs, they were never aggressive, militaristic, or bombastic. In the familiy groups they appeared as supportive figures, and in *King and Queen* as stoical, contemplative, even domestic. All three of Moore's large bronze warriors have shields, a classic item of defence, but no weapons of attack such as swords or spears. The shields when viewed as a traditional form of protection can be compared to the helmets in the *Helmet Heads*, or the exterior elements of the internal / external forms – hard, defensive barriers safe-

guarding what lies beneath. Male forms are unthreatening and male flesh is perceived as being just as vulnerable as female'.[54]

The artist tells us that a pebble was the forerunner of his bronze and that its irregular, rough shape had helped him to develop the idea of an amputated leg.[55] He reworked the pebble using plaster and, starting from the leg stump, modelled the torso of a man lying down. But there was not enough action in this first design. Because Moore found lacking the balanced exchange between this accumulation of inner force and spatial development, he changed the pose to that of a seated figure, which, armed with a shield, defends itself against the enemy attacking from overhead. In doing so, he specifically included memories of recent aerial warfare.[56] Head and torso bend far backwards, while the narrow pelvis and the inwardly turned lower leg support the body.

This active moment of defence is what is essential in the *Warrior with Shield*. It determines the entire course of the figure's shape, as well as its content. The body seems to be enclosed within a semicircular arc, from its split crown over the rounded shield to the shank curving backwards. The warrior seems to seek shelter underneath this arc. As a result all shapes, including the corresponding back section, are made rounder. Only on this right, active side of the figure does Moore accentuate the joints – in the protruding shoulder, the hand and the perfectly modelled knee. He always spoke of the joints as the 'key points' for building up a figure.

171, 172, 173 *Warrior with Shield*, 1953/54, Bronze, H. 152 cm, Kunsthalle Mannheim (LH 360)

172

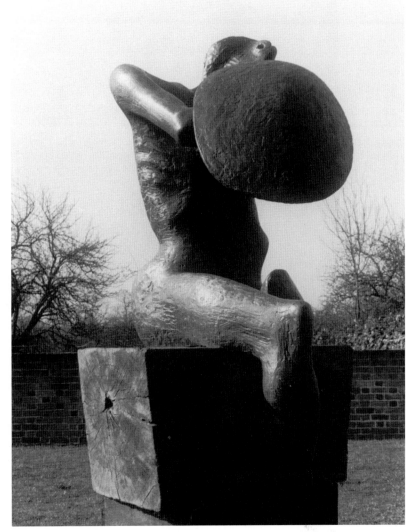

173

The active right side is diametrically opposed in meaning to the left. Here suffering dominates. The flow of forms is interrupted by many deep crevices; the volumes appear singly 'inflicted'. The thorax and ribs emerge separately and the leg and arm stumps protrude starkly from the body. Splitting and segmentation to the left, spherically arched form continuum to the right; it is through this artistic contrast that the tension between 'wounding' and 'challenging' is first seen. Action and suffering, alertness and mutilation express themselves as plastic sensations over the forms themselves.

In line with the further economy of Moore's figure, he allowed these formal contrasts to culminate in the head: in the outsized, bulging eyes and the suspicious pose on the one hand and the deeply cleft nose on the other. The genesis of this outrageous deformation of the head begins with Moore's helmeted figures of 1939 and the subsequently derived studies of the 1940s.[57] There the helmet cavities are continued into the heads themselves. Head and helmet fuse. Yet in the

head of this warrior there are expressive components, which Moore himself defined as 'bull-like' and 'bestial'. This touch of bestiality is present in many of his drawings. He had already sketched fantastic animal heads in 1950 which showed similarities, for example in the 'splitting' motif. On one of these studies he noted down his keyword – 'vitality'.[58] In the warrior, the animal-like conception of the head also heightens the vitality of the whole figure.

This procedure corresponds with Moore's central aesthetic of what he called 'spiritual vitality' which will be discussed below in Part II. As a founding member of the group Unit One, an important movement in the English avant garde, he had already made this clear in 1934: 'For me a work must first have a vitality of its own. I do not mean a reflection of the vitality of life, of movement, physical action, frisking, dancing figures and so on, but that a work can have in it a pent-up energy, an intense life of its own, independent of the object it may represent. [...] Between beauty of expression and power of expres-

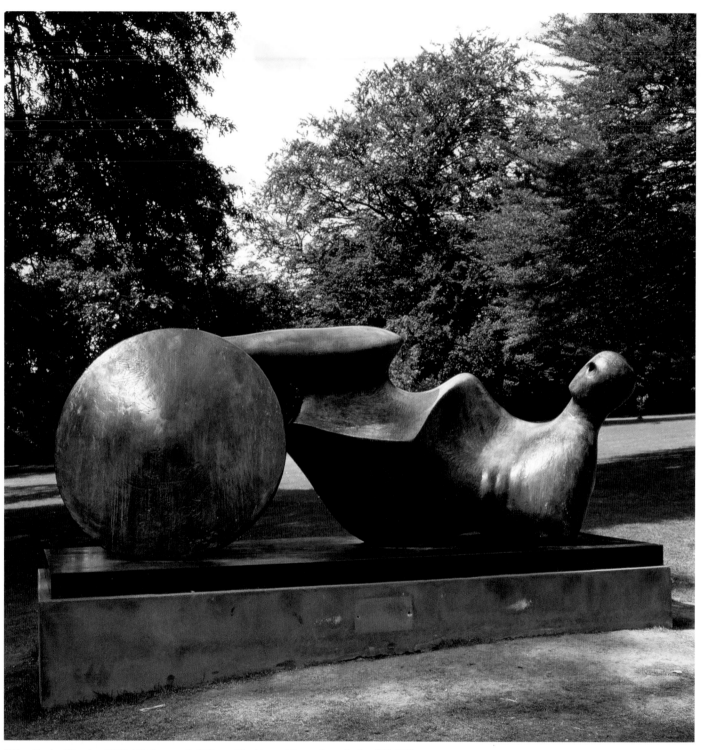

174 *Goslar Warrior*, 1973–74, Bronze, L. 249 cm, The Henry Moore Foundation (LH 641)

sion there is a difference of function. The first aims at pleasing the senses, the second has a spiritual vitality which for me is more moving and goes deeper than the senses.'[59]

When one looks for the link between the *Warrior with Shield* and antiquity, a remark of Moore's takes on significance, one which points to the unconscious influence of his trip to Greece.[60] Moore set foot on Greek soil for the first time in 1951, at the age of 53, on the occasion of an exhibition of his work in Athens.[61] In an interview with Vera and John Russell ten years later, he reported how strongly he was impressed by the Acropolis in Athens, and by Delphi and Olympia, but above all by Mycenae.[62]

He experienced the fortress layout of Mycenae as 'colossal', and continued; 'I felt that I understood Greek tragedy and – well, the whole idea of Greece – much, much more completely than ever before.'[63] Through this inner link with his earlier analysis of Mycenaean art and of Homer, the essence of Greece manifested itself to him in the ancient city, in the residence of Agamemnon as celebrated by Homer, as being identical with Greek tragedy. Against the intellectual horizon of this fusing of Greece with tragedy, one can understand why Moore employed antique motifs in order to impart the necessary 'vitality' to the tragedy of his wounded yet defensive hero. This is so not only in the shield, but also in the pose of the warrior in general. Eduard Trier has pointed out the possible influence of the Belvedere Torso;[64] there may have been another inspiration besides.

In Greek painting and relief sculpture from early classical times to the Hellenistic, one can observe an almost uniform basic pose for the fighting warrior; the athletic body is depicted frontally in attacking position. He usually lifts his shield up on the side of the outstretched leg. On the other side he supports himself on his knee, the viewer often only seeing the foreshortened thigh. This stereotyped fighting pose could not have escaped Moore's notice. It is to be found for example in great numbers on Etruscan cinerary urns showing relief scenes of the fighting Achilles,[65] or on the famous frieze from the Apollo sanctuary in Bassai (410 BC).[66] On the British Museum relief slab shown here (fig. 170) a lapith props itself up on the sunken equine back of a centaur in order to strike the final blow. If one imagines this frieze figure reversed in the opposite direction (an optical exercise that would be second nature to a sculptor), one has a revealing perspective of Moore's *Warrior with Shield*: the knee motif has become the leg stump and the dynamically rising diagonal of the body (together with the same missing foot) is restrained and forced into a seated pose.

So Moore incorporated precise antique reminiscences into his *Warrior with Shield*, while further dramatising them through his depiction of brutal mutilation. Given the reality of aerial warfare, he links the 'modern' motif of upwardly directed defence to a classical antique warrior theme. The real war

experience mingles with this inner image of Greece, which to him seemed the essence of tragic heroism.

The later portrayals of warriors, which he made in the 1950s and again in 1973 and 1974, prove just how far-reaching this dual experience must have been for Moore. Comparisons with antiquity could be made for each one of them. Here only the last version of 1973–74 is discussed. At this late stage Moore exchanged the 'naturalism' of his *Fallen Warrior* (fig. 405)[67] and *Falling Warrior* (fig. 369)[68] for an unusual, highly creative amalgam of figuration and abstraction. In doing so he exaggerated even further the dramatic quality and the generally constrained three-dimensionality of his late works.

The *Goslar Warrior* (fig. 174)[69] was named after the siting of the first cast in Germany. Resting diagonally on a narrow rectangular plinth, the body of the stretched out figure is modelled in large, faceted planes. Although he has fallen, his body still appears to be in full possession of his powers of defence. With firm, lifted head he pushes himself up from his torso. The warrior seems intact as far as his raised rib cage. But then one discovers a large, hollowed, amputated section on the one flank at the base of the leg; above this the undam-

175 *Apulian Volute Krater* with scenes from the Fall of Troy, 380–370 BC, British Museum, London

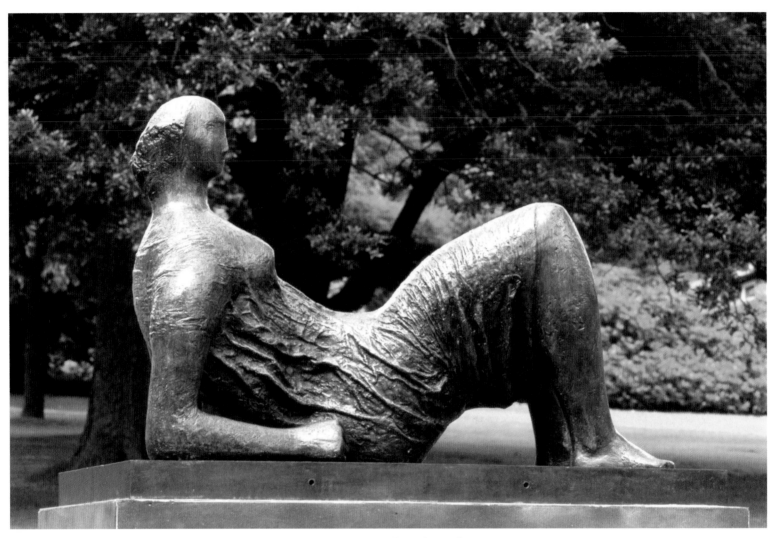

176 *Draped Reclining Figure*, 1952/53, Bronze, L. 157 cm, The Henry Moore Foundation (LH 336)

aged limb with its outflung, horizontally extended shin. The circular shield leans against his heel. The angle of the shield corresponds with the slant of the abdomen and thus, in spite of its daring position, appears well connected to the body via the parallel axes. It testifies to all that is left to the warrior: the understanding of his own existence. The shield is therefore depicted as a veritable status symbol.

Both the daring balance of the shield against the leg, as well as the act of representation, may have been inspired by a painting on the large *Apulian Volute Krater* in the British Museum (fig. 175).[70] Depicted on this vase, by the Iliupersis Painter of 330–370 BC, are scenes from the Fall of Troy – a Homeric theme, in other words, which must certainly have interested Moore. In the main scene to the left Polyxena is struck, to the right Cassandra flees to the protection of Athena's altar. The latter looks down worriedly at Ajax, son of the king of Locris and captain of forty Locrian ships on the voyage to Troy. His long spear distinguishes him as one of the most skilful spear throwers of the Greek army. He turns to

Cassandra with a mischievous, coveting glance. Soon he will commit the sacrilege for which he will pay the gods with his own life: he will drag Cassandra from the altar and rape her. He is about to lay down his large circular shield. The Iliupersis Painter finds an impressive solution for this transitory event: the shield continues the slant of the body and seems to pull the warrior figure to the left towards Cassandra. Such an eloquent detail could hardly have slipped the untiring attention of Moore the museum visitor.

'How Wonderful the Elgin Marbles Are.'

At the age of 62 Moore commented in retrospect on his perception of antiquity. His remarks, which confirm the previous observations, contain valuable references to the Greek sculpture that, having overcome his academic traumas, he was able to turn to ever more freely with advancing age.

'There was a period when I tried to avoid looking at great sculpture of any kind. And Renaissance. When I thought that

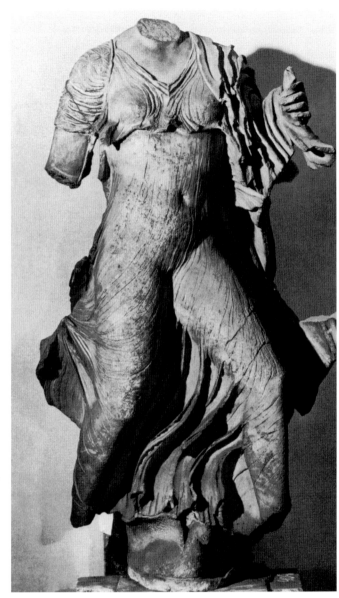

177 *Nereid*, originally placed between columns of the *Nereid Monument*. From Xanthos in Lycia, c. 410 BC, Marble, H. 141 cm, British Museum, London

178, 179 *Draped Torso*, 1953, Bronze, H. 89 cm, Staatsgalerie Stuttgart (LH 338)

179

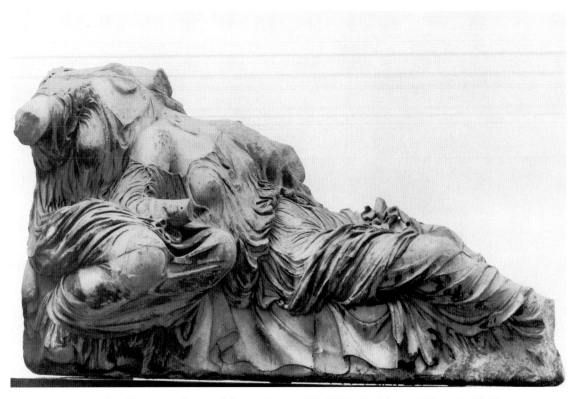

180 *Dione und Aphrodite*, east pediment of the Parthenon, 438–432 BC, Marble, L. c. 230 cm, British Museum, London

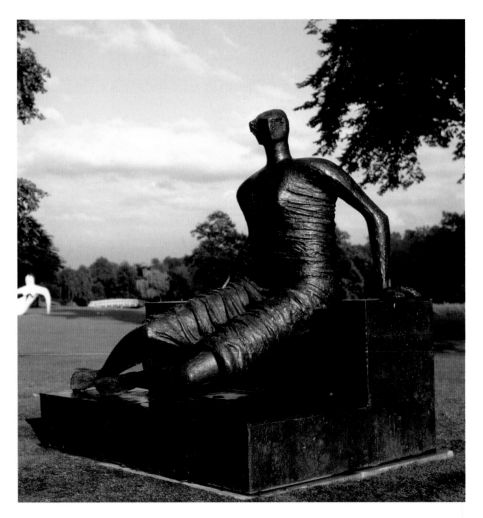

181 *Draped Seated Woman*, 1957–58, Bronze, H. 185 cm, The Henry Moore Foundation (LH 428)

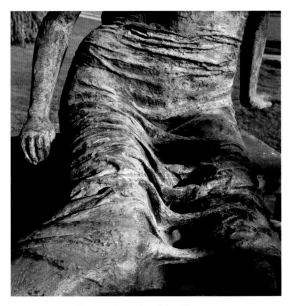

181a *Draped Seated Woman* (detail)

182 *Illissos*, west pediment of the Parthenon, c. 435 BC, Marble, H. c. 90 cm, original length more than 200 cm, British Museum, London

183 *Fragment Figure*, 1957/58, Bronze, L. 19 cm, The Henry Moore Foundation (LH 430)

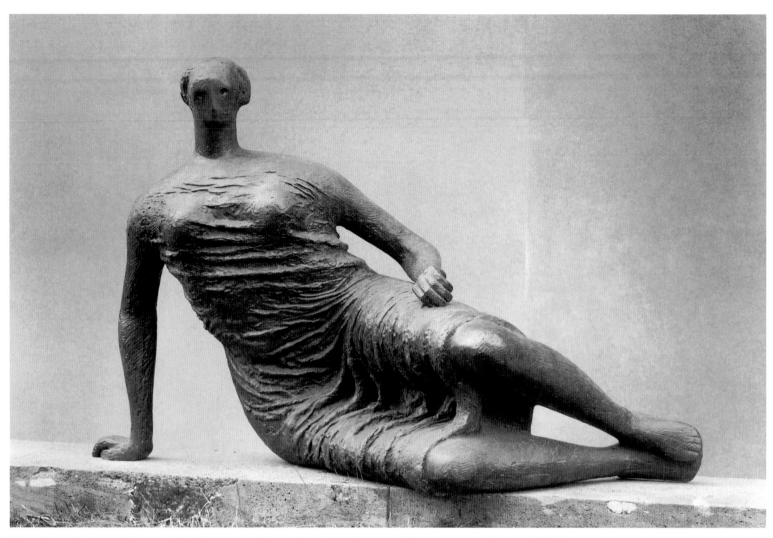

184 *Draped Reclining Woman*, 1957/58, Bronze, L. 208.5 cm, Bayerische Staatsgemäldesammlungen, München (LH 431)

the Greek and Renaissance were the enemy, and that one had to throw all that over and start again from the beginning of primitive art. It's only perhaps in the last ten or fifteen years that I began to know how wonderful the *Elgin Marbles* are.'[71]

In fact, Moore was thoroughly well prepared for an appreciation of the *Elgin Marbles*. Only after he had made the Homeric image of archaic Greek man his own was he able fully to value the Parthenon sculptures exhibited in the British Museum, showing Phidias' idealising style at its peak.[72] His long journey through the history of antique sculpture, from its Cycladic beginnings when Moore was in his twenties, was of such historic consequence because, in his basic understanding of sculptural form, he thought in first terms of developments and then realised these in sculpture. This is why the mature classical style of the *Elgin Marbles* and related pieces were not only to be cited, but analysed step by step on the basis of the artistic and historical prerequisites for their origins – and that meant linking them to the concerns of his own work.

So we see Moore, from the 1950s onwards, increasingly taking up the challenge of the plastic authority of Phidias and his successors. He does so first with his long-tested theme of body drapery, secondly from the morphogenetic perspective[73] of his experiencing of nature, and thirdly because of his increasing need for movement and an all-round view. This complex orientation towards fifth century high classical Greek sculpture is described here by using a few chronological examples.

Animated by his experience of Greece, Moore set to work in 1952 to find a new approach to the drapery theme. If, in his own words, drapery played a very important role in the depiction of the refugees wrapped in blankets and coats in the Shelter drawings, teaching him 'about its function as form',[74] in 1952–53 he sought an expressive unity of body and garment, which he could then realise three-dimensionally, in the *Draped Reclining Figure* (fig. 176). Regarding this work, a cast of which is now in the hall of the Museum Ludwig in Cologne,

Moore wrote in 1954: 'Drapery played a very important part in the shelter drawings I made in 1940 and 1941 and what I began to learn then about its function as form gave me the intention, sometime or other, to use drapery in sculpture in a more realistic way than I had ever tried to use it in my carved sculpture. And my first visit to Greece in 1951 perhaps helped to strengthen this intention – so… I took the opportunity of making this draped figure in plaster (for bronze). Drapery can emphasise the tension in a figure, for where the form pushes outwards, such as on the shoulders, the thighs, the breasts, etc., it can be pulled tight across the form (almost like a bandage), and by contrast with the crumpled slackness of the drapery which lies between the salient points, the pressure from inside is intensified. Drapery can also, by its direction over the form, make more obvious the section, that is, show shape. It need not be just a decorative addition, but can serve to stress the sculptural idea of the figure. Also in my mind was to connect the contrast of the sizes of folds, here small, fine and delicate, in other places big and heavy, with the form of mountains, which are the crinkled skin of the earth.'[75]

With this text and with his characteristic metaphorical outlook, Moore makes it very plain that for him the garment does not lead its own calligraphic life but is an instrument with which to accentuate the 'sculptural idea of the figure'. Drapery 'serves' the expression of the body. It is so fused with the body that it looks like 'the crinkled skin of the earth'. Undoubtedly, Moore has here not only brought his perspective of nature into play, but has also learnt from the high classical conception of drapery shown by Phidias and his immediate school. This is evident, to begin with, from the connection he himself made for his *Draped Torso* 1953 (figs. 178, 179). The reworked, partial cast of the trunk of *Draped Reclining Figure* (fig. 176) makes up a section of this bronze. In his book *Henry Moore at the British Museum*, the artist placed the erect fragment beside one of the Nereid torsos from the Xanthos tombstone, without making an issue of the comparison as such.[76]

He admired the 'sensitive' handling of the stone in the drapery of the marine goddess from around 410 BC (fig. 177) because it 'gives the impression of light, flimsy material, wet with spray, being blown against the body by the wind.'[77] The atmospheric merging of this Nereid, hurrying lightly across the sea with her fluid, flowing wrap, could hardly be given a better description. His *Draped Torso* offers the same sensual unity, but is more strongly dependant on mass. Here the folds of the drapery bulge forth like powerful arteries, as if modelled along the body. In *Draped Seated Woman* (figs. 181, 181a) made four years later, Moore has at his disposal an even freer vocabulary of folds which, for its part, reacts to a heightened movement and elasticity of the body.

I would like to compare the whole seated pose with the *Dione* from the group of three goddesses on the east pediment of the Parthenon (fig. 180). In both cases there is the same pulling away of the shins and accentuation of the knees, between which are stretched the hard ridges of the folds. Which other twentieth-century sculptor – the question must be permitted at this point – has ever achieved such independent proximity to Phidias? The sovereignty distinguishing Phidias' interplay of 'drapery-life and existential behaviour of the body'[78] is inherent in Moore's seated and reclining female figures from the years 1957–58. In spite of their 'modern' shifts in proportion (keeping the head small in favour of the powerful nature of the body) and in spite of their anology with nature ('the crinkled skin of the earth'), a comparable breadth and majesty of spatial fulfilment speaks from these figures.

Even where Moore becomes more strongly involved in the 'analogous creation' of rocks and cliffs, as in the invention of the *Two Piece Reclining Figure No. 1* (fig. 125),[79] Phidias' powerful image of man still remains before him: the outflung leg section of this piece is reminiscent of, among other things, the torso of the river god *Illisos* from the west pediment of the Parthenon (fig. 182).[80] The fragment of his upper leg thrusts freely and aggressively into space in a similar way. To my eyes, the small *Fragment Figure* (fig. 183), which developed out of the reduction of the maquette into the large *Draped Reclining Figure* (fig. 184), certainly shows the greatest closeness to the *Illissos*. In it Moore has even increased the free, gliding effect of his majestic seated motif. The small figure attains a spatial fullness and openness through the formation of the torso, which ties it directly to the flowing movement and free atmosphere of the *Illissos*.

The Romantic Synthesis: Transformation of Antiquity into Nature

In 1961, in the *Large Standing Figure: Knife Edge* (figs. 185, 186), Moore reached a new and in itself unique synthesis of his three compelling endeavours of the 1950s: drapery, analogy with nature, and the all-round view. The oft-made comparison with the *Nike* of Samothrace (fig. 187) is instructive in connection with this figure. In order to understand it more fully, we first need to look at the genesis and dynamics of Moore's discovery of form.

The sculptural problem on which the artist embarked was one of structure and mimetics: how to transfer the cohesion, elegance and sharpness of a bone – more precisely a bird's breastbone – which has, in Moore's words, 'the lightweight fineness of a knife-blade',[81] to a bronze figure, in which the same thinness, lightness and sharpness remain inherent.

Moore implanted such a *Bird Bone*[82] into his first small model, using its individual shape to develop the sculpture further. He added the head, arm stumps and the base in clay. The found object with its jaggedly profiled edge, along which the lamellae of the bone protrude visibly, indicated the decisive

185, 186 *Large Standing Figure: Knife Edge*, 1961 (cast: 1976), Bronze, H. 358 cm, The Henry Moore Foundation (LH 482a)

diagonal movement which was to determine the whole fig-ure. Moore orientated his intermediate model along the lines of this bone-maquette in 1961, completing a version 1.62 m high in the same year. Seven bronze casts were made from this 'working model'.[83] One of these is placed on a revolving base in the foyer of the Neue Oper in Frankfurt am Main.[84] In 1961 Moore enlarged the working model to 2.84 m, a cast of which is owned by the City of Essen.[85] He risked a further enlarge-ment to 3.58m in 1976, but due to the changed dimensions, felt the need to smooth out several areas of the surface. He had six bronze casts made of this last version, one of which crowns the hill in the park at Greenwich, London.

At this ideal site, the sculpture has everything it requires for its full spatial development. The large space all around per-mits one to circle the figure and so perceive the staggered development of its planes at front and back, as well as the thin, 'knife-edge' sharpenings of the sides. Natural light underlines the calculated modulation of the forms with their

rhythmic exchange of soft hollows and sharp-edged crevices and fractures. Finally, the lofty position permits a view of the figure from below, thanks to which the eye may consummate the wonderful upward swing which sweeps through the fig-ure. This upward thrust was so important to Moore as the quintessence of the entire composition that he bent the torso to the rear: 'the top half of the figure bends backwards, is angled towards the sky, opens itself to the light in a rising upward movement – and this may be why, at one time, I called it "Winged Figure".'[86]

Moore tellingly speaks of the strongly poetic and musical expressive dimensions of this piece.[87] It appears as if winged: its thin, predominantly concave sweeping surfaces make the form seem as if caught up in a fleeting breath which comes from far away, possessing it before flowing past. The figure moves in this draught with a dancer's grace, achieved by the sculptor in this alone of all his large works. None of his figures is so vitally free and sure in the airy element. The drapery is

transformed as the figure merges with its raiments. In *Large Standing Figure: Knife Edge* Moore was thus able to carry the inner congruence of the bird bone as the primary motivation for the form of his sculpture through all the phases of the work. Given this so extensively realised analogy with nature, the closeness to the *Nike* of Samothrace of 200 BC, detected by Moore himself and independently by many viewers, is astonishing (fig. 187). Every visitor to the Louvre has climbed the broad staircase to where she has stood impurturbed since 1884.[88] What features, then, are precisely comparable to Moore's figure? The 'winged' movement, the diagonally conducted fracture, evocative of the puffed-out drapery between the Nike's legs, and the torso shape in general of course, but it hardly needs stressing that there is much which is not in any way related. A decisive difference with regard to content, however, should be cause for reflection: the radiant, eminently sensual marble sculpture in Samothrace depicted the descent of the goddess. Nike alights in rushing flight on the ship's bow of those whom she will lead to victory: 'A new image of the goddess of victory, of truly element-like and simultaneously primitive cosmic strength, is evoked by the impetus of the energy-laden body and its manifold movements', wrote Ernst Buschor. Behind this was 'a new, in the third century still unknown, experience of Nature as a cosmic omnipotence, in which lonely man can flee, can pour out his soul. This is the meaning of the new vitality of form, of the new chisel stroke.'[89]

We see Moore arriving at the *Wirkungsform* of Hellenistic sculpture between 1961 and 1976 in *Large Standing Figure: Knife Edge*. If, in the traumas of the 1940s, he had allowed himself to be guided and strengthened by the sacrally defined *Seinsform* of Greek archaism, and if he succeeded in the independent approximation of Phidias' *Daseinsform* at the beginnings of his international fame in the 1950s, then the late Moore opened himself up completely to the elemental, overpowering movement of the Hellenistic representation of the gods. All enthusiasm aside, however, his 'Winged Figure' does not incarnate a goddess! With Moore it is man as such (gender remaining intentionally undefined) who raises himself and strives up and out of himself, towards the light and the heavens.

There is confirmation of this transcendant approach of the late Moore in two pastel drawings from the year 1979, one of which is illustrated (fig. 188 and AG 79.74). Here he places his sculpture – probably orientated by photographs – in the front picture plane, in order to direct it animatedly towards a landscape scene with a lake and hills respectively. Through the medium of drawing he is able to let antique gracefulness mingle with the atmosphere of nature.

This romantic, indeed ultimately religious message of the *Large Standing Figure: Knife Edge* is diametrically opposed to the exulting power of the antique *Nike*. Moore's figure should

187 *Nike of Samothrake*, c. 190 BC, Marble, H. 245 cm, Louvre, Paris

188 *Figure in Imaginary Landscape*, 1979, pastel, chalk, watercolour, 17.2 x 24.3 cm, The Henry Moore Foundation, AG 79.75 (HMF 79 (48a))

189 *Niobe with her daughter*, 300 BC, marble, H. 228 cm, Uffizi Gallery, Florence

190 Maquette for *Mother and Child: Upright*, 1977, Plaster, H. 59 cm, The Henry Moore Foundation (LH 731)

be perceived, as he once mentioned in conversation, as a means 'to direct the viewer to experience'.[90] What exactly that meant may perhaps only be correctly assessed today, now that simulation and manipulation threaten ever more to supplant the value of autonomous experience. The modesty with which the artist himself addressed his comparison with antiquity fits this open-ended conception: 'somewhere in this work there is a connection with the so-called Victory of Samothrace in the Louvre – and I would like to think that others see something Greek in this Standing Figure.'[91] This 'somewhere' should be kept in mind for the following and last comparison.

In 1977 Moore created the Maquette for *Mother and Child: Upright*, only 22 cm high. The subsequently enlarged working model, a light green tinted plaster, is still in the artist's studio in Much Hadham (fig. 190). This piece made me think involuntarily of the Florentine *Niobe and her Daughter*. The *Niobe Group* (fig. 189), probably a copy of the original from around

300 BC which is among the most important pieces from antiquity in the Uffizi. In the story of the death of the Niobeans, as told in Ovid's *Metamorphoses* (VI, 146-312), one sees above all a testimony of maternal love. Niobe puts her arm protectively around her youngest daughter, who has fled into her lap. She tries in vain to ward off Apollo's and Diana's deadly arrows with her cloak.

The heavy pathos of this group has never failed to impress, right up to the twentieth century. Giorgio de Chirico, for example, borrowed Niobe's head on several important occasions,[92] and of course Moore also knew this work well. Some of its main characteristics are echoed in his *Mother and Child: Upright*. The encircling arm on the right, the curving, separated fold lines around Niobe's right shin, repeated in Moore's horizontally terraced plateau of folds as well as the cloak motif, are modified into a similarly contoured unit, together with the erect standing child. I doubt whether Moore was truly thinking of the *Niobe Group* while working on his

maquette, but it does seem as though its power had worked its charm on him.

Many examples in this chapter have shown that Moore was by no means in need of direct, dependent relationships in order to bring 'something Greek' into his work. The fact that the artist did not simply assimilate this or that prototype, but that his gradual reconciliation with antiquity over the decades traced a more general voyage towards a reconquering of its precepts shows, to my mind, how strongly the Grecian element was alive in him. It began in his youth with copies of Cycladic idols and ended with free variations on themes of the high classical and succeeding periods.

The essential consequence of this long passage through the history of antique sculpture refers, as suggested above, to the way Moore's mind worked as a sculptor in relation to the development of forms. It is on this morphogenetic basis that the increasing interlocking of antique gracefulness and analogy with nature (such as rocks, bones or the 'crinkled skin of the earth'), a process unique to Moore, is achieved. Where he brings together the life-giving aesthetics of nature with the antique form, he has forged his own language as part of the long journey to self-discovery.

Italy, Michelangelo and Christian Motifs

In 1972, when the City of Florence decided to present a major retrospective of the work of Henry Moore, he wrote a lengthy letter of thanks to the Mayor. In it there was a sentence that could well stand at the head of this chapter as a motto: 'Florence – I feel it is my artistic home.'[93]

What exactly did Moore mean by this? Was it just a politely formulated expression of gratitude to the city that was proposing an unusual, historic location – the Forte di Belvedere – for an exhibition that would most probably attract large numbers of visitors? What does it mean when a cosmopolitan like Moore describes Florence and Tuscany, with its long tradition of art, as his 'artistic home' even though one is well aware of the extent to which he had drawn inspiration from non-European and Western art alike – Sumerian, African, Mexican, Egyptian, the art of the Cyclades, the early Greeks, Phidias, and many more? All these queries amount to one main question: What were the roots of his identification with Italy? In order to answer this we would do well to examine in detail Moore's lifelong interest in Italian art per se. For it seems that already during his training as an artist the seeds were sown that would continue to bear fruit far into his old age.

The first contact with the south came when the young Moore was studying original works of art in London's great museums. Wherever he went – to the National Gallery, the British Museum, the Victoria & Albert Museum, the Wallace Collection, the Royal Academy – his avid gaze was met by masterpieces of Italian art. In 1923, as a student at the Royal College of Art, Moore was instructed to sculpt a theme of his choice in marble (fig. 191). He chose an Early Renaissance, Italian marble relief that had impressed him in the rich collection of Italian sculpture in the Victoria & Albert Museum. The piece in question was by Domenico Rosselli (1439–1498), a lesser-known master who worked in the same circles as the Pisani in Pisa and whose work is closest in style to that of the Florentine Antonio Rossellino.[94] The carving portrays *The Madonna and Child with Three Cherubs' Heads* (fig. 192). It is one of a substantial series of reliefs featuring the Virgin Mary that Ulrich Middeldorf described in terms of 'lyrical mildness', 'naïve, reserved simplicity' and the 'charm of the archaic'.[95] This characterisation makes Moore's choice more readily understandable in that it is confirmation of the fact that his internal compass was already set towards 'simplicity' and the archaic. In addition to this, Rosselli's subtle handling of the stone may well also have captivated Moore. For his college exercise he worked *en taille directe*, that is to say, without using a point to point transfer device. It was only when he had in effect finished the piece that he added measuring points, in order to comply with the college's rules.[96] His copy all but perfectly replicated the subtleties of the faces and drapery in Rosselli's relief. Moore liked this early work of his and over the years it was the first exhibit on display in numerous retrospectives.[97]

The crucial factor that led to Moore's ultimately extremely fruitful relationship with Italy was the scholarship he received in 1925 from the Royal College of Art, which specifically provided him with the funds for a five-month stay in Italy. In February Moore set off from Paris. Unfortunately he left no personal account of this trip,[98] but his route took him to Turin, Genoa, Pisa, Rome, Siena, Florence (where he stayed for three months), Assisi, Padua, Ravenna, Venice and Munich before he returned to the French capital. As his letters tell us, the overwhelming impression of the works of art he saw on his travels plunged the young artist into not inconsiderable turmoil. At first his gaze was obscured by his already wide-ranging interest in the art of early civilisations. He had to struggle to appreciate the art of Graeco-Roman Antiquity and of the Renaissance as he was expected to. Thus it seems entirely logical that – having already studied the history of classic Italian art in 1920 in the well-stocked art library in Leeds[99] – he should now review its development by starting at the beginning. In this he pursued a similar approach to his study of Antiquity.

New research by David Ekserdjian into the detailed sketches that have survived from that trip (mainly in *Notebook No. 3*) has shown precisely which works and artists Moore found most compelling. These were Giotto in Assisi, and – in the Pinacoteca in Siena – his sublime afterlife in the works of Ambrogio and Pietro Lorenzetti, Bartolo di Fredo, Niccolò di Segna, the Maestro di S. Lucchese (Cennino Cennini?), Taddeo di Bartolo and Andrea Vanni.[100] Moore's sketches of these

191 *Head of the Virgin*, 1922–23, Marble, H. 53.2 cm, The Henry Moore Foundation (LH 6)

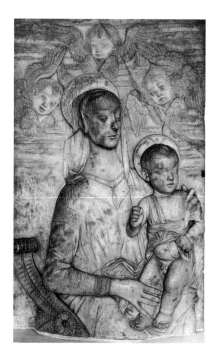

192 Domenico Rosselli: *Madonna with Child with Three Cherub's Heads*, 15th century, Marble, gilded relief, 104.1 x 65.4 cm, Victoria and Albert Museum, London

works are mainly expressive studies of individual heads, gestures, horses and draped figures. In addition to this, in the Collection of Prints and Drawings in the Uffizi, Moore asked to see anonymous drawings after originals by Giotto and after Mantegna's *Crucifixion* from the predella of the St Zeno altarpiece; no doubt he had already studied these in the Louvre. He was also very struck by the work of Masaccio.

The surviving study materials from Moore's Italian journey of 1925 reflect the young sculptor's interests and show his attitude to the art he saw. He described some of this in a letter to his mentor, the Director of the Royal College of Art, Sir William Rothenstein, albeit not without a touch of youthful arrogance: 'In Italy the early wall paintings – the work of Giotto, Orcagna, Lorenzetti, Taddeo Gaddi, the paintings leading up to and including Masaccio's are what have so far interested me most. Of great sculpture I've seen very little – Giotto's painting is the finest sculpture I met in Italy – what I know of Indian, Egyptian and Mexican sculpture completely overwhelms Renaissance sculpture – except for the early Italian portrait busts, the very late work of Michelangelo and the work of Donatello, though in the influence of Donatello I think I see the beginning of the end – Donatello was a modeller, and it seems to me that it is modelling that has sapped the manhood out of Western sculpture'.[101]

The extent and intensity of Moore's encounter with Giotto's painting – which he called the 'finest sculpture' – is very evident from a masterful drawing (fig. 194)[102] in which he reworks figures from a copy of a Giotto painting in the Collection of Prints and Drawings in the Uffizi. The copy in question, by an anonymous artist in the fifteenth century (or earlier?), was of Giotto's *Visitation* from the lower church of Assisi (fig. 193), now often attributed to the School of Giotto. Moore abandons the narrative connections within the scene. Mary (fourth figure in profile from the left) and Elizabeth (profile in the upper right, gowned figure in the lower left) were separated from each other. Instead he focused on the outer,

193 Anonymous Florentine: *The Visitation*, 15th century, Uffizi, Florence

194 Copies of Figures from *The Visitation* of Giotto, 1925, pen and ink, wash, 33.8 x 24.5 cm, Art Gallery of Ontario, Toronto, AG 25.93r (HMF 355)

195 *Memory of Giovanni Pisano*, 1964, pencil, coloured crayon, pastel, felt-tipped pen, watercolour wash, 24.5 x 22.8 cm, The Henry Moore Foundation AG 64.17 (HMF 3102)

accompanying figures. Intuitively, in all his figures he sought to achieve that 'perfetta dignità' and 'misure' that Ghiberti had expressly referred to in his discussion of Giotto's work: 'For he [Giotto] did much to ensure that art should appear more natural, without overstepping existing boundaries.[103] In this drawing Moore, with his sculptor's eye, also conveyed very clearly the characteristic upright stance of Giotto's figures. Like Giotto's, his are also firmly rooted within themselves.[104]

So it is not surprising that Moore was also drawn to the work of Giovanni Pisano, the great contemporary and possible source of inspiration for Giotto. We know for certain that Moore saw his sculptures on the pulpit in the cathedral in Pisa, completed in 1311. Later on he recalled his reaction to Giovanni's figures for the facade of the Baptistery: 'I must only have been able to admire, or try to admire… with struggle and

effort, for when I could only see them at such a distance above me it was impossible to feel the true three-dimensional, face-to face relationship which I need from sculpture. I wanted to see them as Giovanni made them… It was only after the war, when the big figures from the niches were taken down and put inside the Baptistery, that I saw them near-to, and then I was at once struck by the tremendous dramatic force of what I would call the hallmark of Giovanni's sculptural quality, style, or personality. It was also after the war that I saw properly the small life-size figures which, for their preservation, have been removed from the architecture and put into the Pisa Museum.'[105]

As long as he lived Moore was fascinated by the dramatic intensity of Giovanni's work, the great naturalness of his figures and the strength of their emotions. In the last twenty years of his life, he even had the opportunity to be physically

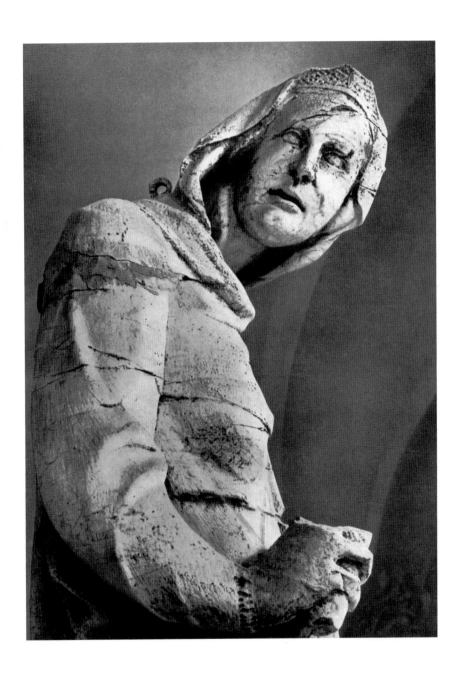

196 Giovanni Pisano: *Miriam*, from the façade of Duomo di S. Maria in Siena, Marble, c. 1296, Museo dell' Opera del Duomo

closer to where his idol had lived and worked. In 1965 the Moores had a house built in Forte di Marmi. On their regular visits there, when Moore often took the opportunity to go to the quarries in Carrara, he also frequently went to Pisa.

In 1964 Moore drew a figure which he entitled *Memory of Giovanni Pisano* (fig. 195). The power of the extended upper body and the abrupt turn of the head are reminiscent both of the figure of *Miriam* (fig. 196) on the façade of the cathedral in Siena (*c.* 1296) and of the fragment of a tombstone for Margaret of Luxembourg in Genoa (1312).[106] In this work Moore echoes details of Giovanni's art, which he must already have seen in 1925 and which had already born fruit in his *Warrior with Shield* of 1953/54 (figs. 171–173),[107] where there is a similarly sharp movement of the neck.

In 1969, at Moore's suggestion, Thames and Hudson published a book on Giovanni Pisano. This was the first scholarly English language publication on the artist and is still a standard work. Under Moore's guidance, new photographs of his art were taken specifically for the occasion. The painter and sculptor Michael Ayrton, a good friend of Henry Moore's, wrote the main text, while Moore provided the introduction. Written very much from the perspective of a practising sculptor, this text is not only highly informative from a purely art-historical point of view, it is also valuable for what it reveals of Moore's own concept of sculpture.[108]

Moore's main aim in this text is to convey something of the astonishing impact these figures had on him, and thus to whet the reader's curiosity and interest. He gives a detailed account of the achievements that raised Giovanni Pisano's art above that of his father, Nicola, and – in Moore's view – helped to pave the way for the Renaissance. His first observation concerns Giovanni's ability to introduce a hitherto unseen

197 Giovanni Pisano, She-*Wolf with Romulus and Remus*, from the façade of Duomo
di S Maria in Siena, Marble, c. 1296, Museo dell' Opera del Duomo

level of drama into his sculptural figures. Moore was very struck by the way that Giovanni Pisano shaped the line of the neck, as can be seen in the drawing illustrated here: 'Then I saw in so many of them the thrusting-forward neck, the neck that goes forward at an angle of forty-five degrees or even more (but with the head itself left upright). It has been said that he carved them like that to avoid a squat, foreshortened appearance when the figure was to be seen high up in perspective, but you get the same urgent, thrusting attitude in some of his figures which are meant to be seen at eye-level, such as the Caritas on the Pisa Cathedral pulpit. This thrust, I think, was something Giovanni felt about the urgency of human communication. He simply felt that the figure needed this tremendously potent gesture forward to "give the message". These sculptures are absolute presences and they made a lasting, most powerful impression on me.'[109]

Moreover, no Italian sculptor before Giovanni had conveyed such a sense of movement: 'I think it was Giovanni Pisano's excitement over articulating the human body in sculpture, in a way that we know from our own physical experience that it can't articulate…'[110] The following passage from Moore's introduction shows how Giovanni's understanding of three-dimensionality related to his own work: 'We know that the head is a separate movable unit, the neck is another unit, the shoulders are another, the pelvis is another, the legs can bend at the knees and then bend at the feet. There are about sixteen individual units in the human figure: head, neck, thorax, pelvis, thighs, lower legs, feet, arms and hands all of which can bend at angles to each other… I have said that by making the pieces of the human body seem movable and articulated with one another, you give sculpture intensity, but by this I do not mean the portraying of actual physical movement such as

walking, running etc. For Giovanni gets drama into his figures when they stand still, as Masaccio did later. In Masaccio's *The Tribute Money* you feel, when Peter hands over the money, that there is a kind of electric charge in the air and this is created not by strong physical action but by a dramatic tension, something that both Masaccio and Giovanni could give in their work. The late Michelangelo has the same thing… It's the huge difference between using anatomy for its own sake and using a knowledge of the human figure to express one's philosophy, one's interpretation of life generally – and this is what surprises me: that Giovanni had done this so early.'[111]

Moore also attributed to Giovanni an extraordinary 'sensitivity of form'[112] and virtuoso craft skills that he used to 'let the inside of the stone come out; he freed something from the inside… Giovanni was one of the first Italians to feel the bone inside the sculpture.'[113] Here Moore was thinking above all of the lion on the pulpit in Pisa Cathedral and the she-wolf with Romulus and Remus on the cathedral façade in Siena (fig. 197).[114] In both of these the inner structure is palpably present in the final form.

The emphasis that Moore put on these points underlines the affinity he saw between Giovanni's sculptural approach and his own concept of spiritual vitality[115] in sculpture. Equally telling, with regard to his own view of art, is the way that his remarks are not confined to Giovanni's work alone: 'I feel terribly strongly that he was a great man because he understood human beings and if you asked me how I would judge great artists it would be on this basis. It would not be because they were clever in drawing or in carving or in painting or as designers; something of these qualities they must naturally have, but their real greatness, to me, lies in their humanity.'[116]

Last but not least, there is the fact that in his old age, Moore bought a slightly damaged marble angel (fig. 198). It was his firm belief[117] that he had before him a work by Tino di Camaino, one of Giovanni Pisano's most important pupils.[118] In close contact with this piece, as part of the fine collection of works of art with which Moore surrounded himself, he became so familiar with it that he in effect appropriated it in his last drawings. Witness, for instance, a chalk drawing of 1982 that was first published by Max Seidel in 1987 (fig. 199). In his comment on this memorable image Seidel writes: 'In this drawing we see the transformation of a Gothic angel; it is also still recognisable, partly identifiable, in one of Henry Moore's sculptural projects.'[119]

After this excursion to Pisa and the work of Giovanni, let us now return to Florence where Moore spent three months in spring 1925. During that stay, he started each day by visiting the chapel of Santa Maria del Carmine. Forty-seven years later, he looked back at this time in his letter of thanks to the Mayor of Florence: 'At first it was the early Florentines I studied most, especially Giotto, because of his evident sculptural qualities. Later Masaccio became an obsession, and each day I paid an

198 School of Tino di Camaino, *Fragment of an Angel*, Marble, H. 86 cm, The Henry Moore Foundation, Hogland, Much Hadham

199 *Figure of an Angel (Study after Italian Sculpture)*, 1982, chalk, ballpoint pen, gouache, 35.5 x 22 cm, The Henry Moore Foundation, AG 82.10 (HMF 82(2))

early morning visit to the Carmine chapel before going any-where else... Towards the end of my three months [in Flo-rence], it was Michelangelo who engaged me most, and he has remained an ideal ever since.'[120]

On his daily visits to the chapel, Moore also travelled back in time to the early days of the Renaissance. Around 1427 the Florentine nobleman Felice Brancacci commissioned the artist Masolino and his pupil Masaccio to paint a series of frescos in his family chapel. Masaccio's almost Grecian figures intro-duced a new *gravitas* and emotional intensity into Italian art. As in his encounter with the work of Giotto, Moore was already prepared for Masaccio's new pictorial language by his studies in London. A year earlier, in 1924, he had already made a series of studies of female nudes (fig. 200)[121] whose mod-esty and strikingly homogenous lineature have a close affinity with the figure of Eve in Masaccio's almost sculptural painting of *The Expulsion from the Garden of Eden* in the Brancacci

Chapel (1427–28). On a sheet of studies from 1925,[122] there is a note by Moore at the upper right: 'for head see Masaccio'. This could well refer to the firmly rooted female figures in Ma-saccio's *The Distribution of Goods* in the Brancacci Chapel.[123]

Furthermore, the female figures in the *Shelter Drawings*, who are seen as the real representatives of *humanitas* in dan-ger, seem to owe something of their rigorous solidity to the human forms constructed by Masaccio. This connection is par-ticularly striking in the case of the so-called *Northampton Madonna* of 1943–44 (fig. 203),[124] which Richard Cork has rightly compared to the *Madonna and Child* by Masaccio in the National Gallery in London (fig. 201).[125] This comparison is further justified by Moore's own preparatory drawings for the *Northampton Madonna* (fig. 202), which Cork does not take into account.[126] The study illustrated here shows that in the early stages of this project, Moore was directly referencing Masaccio's painting. It was only as the work progressed and in

200 *Standing Women*, c. 1924, pen and ink, chalk, 55.9 x 21.6 cm, Private Collection, UK, AG 24.39 (HMF 248)

view of the constraints that arise from working with stone, that Moore abandoned the halo and the throne. In contrast to Masaccio's painting, in the finished sculpture the Madonna's hand is raised in a protective gesture. This could, however, be read as an echo of Rosselli's Madonna relief where – albeit much more tenderly – the Madonna's hand rests on the Child's shoulder (fig. 192). And the border around the neckline of the Madonna's gown also recalls the *decorum* seen in the sacred sculptures from Rosselli's time and earlier. There are many examples of this style in the collection of Italian sculpture at the Victoria & Albert Museum in London.

The representation of the Mother and Child in Moore's *Northampton Madonna* has a rare nobility, dignity and spirituality. By now it would be impossible to imagine twentieth-century sculpture without it. In this piece Moore reached new heights in his mastery of the art of stone sculpture. With consummate skill, he was also able to incorporate the different coloured strata of the Hornton stone into his composition: dark grey predominates in the centre of the figure and at knee level; a reddish layer colours the folds below the knees only to reappear in the chest and head areas. Meanwhile, a gentle reddish hue suffuses Mary's youthful features.

Preceded by eleven different bozetti,[127] in the final version the group is animated yet firmly rooted in the stone. The Christ Child is enveloped in maternal warmth and the figures connect on every level. The Child's left hand rests trustingly in that of Mary, while the line of her lower arm is related to the angle of the Child's legs. The dynamism of this movement comes to rest in the horizontal line of the Child's lower right arm and the Madonna's right hand. This sense of calm is reflected in the inward serenity of the expression on the Child's face.

With the war still continuing unabated, it seems that Moore poured all his longing for peace into this work. And he found this peace in his representation of the balance between powerful solid forms and their spiritual content, between dynamism and stasis, between the fixed configuration of the bodies and the nuanced wealth of expression in their faces. It is this grave harmony that marks out the *Northampton Madonna* as the legitimate successor to the Madonnas of Giotto and Masaccio, despite the intervening centuries.

Moore was naturally also impressed by Mantegna's extremely foreshortened figures, although more for their artistry than for the poses, as in the works of Giotto, Giovanni Pisano and Masaccio. And it is very evident that Moore did not use foreshortening for the same reason as Mantegna. In the case of the latter, as we see in the painting *Christ in Gethsemane* (fig. 204), the striking perspective is used to underpin the narrative function of the painting, for instance in the way that the position of the disciple on the right leads the viewer's eye to the group of approaching soldiers, and hence to the imminent Passion of Jesus Christ.[128]

In the case of the previously discussed *Pink and Green Sleepers* of 1941 (fig. 139), one of the most important *Shelter Drawings*, Alan Wilkinson makes the connection with this painting by Mantegna.[129] He compares the unusual physiognomies of the figures with those of Mantegna's sleeping disciples. In both cases there is a similarly extreme degree of foreshortening (showing the figures' nostrils) which Moore had also seen in Mantegna's depiction of Jesus Christ in death, in the so-called *Cristo in Scurto* in the Brera in Milan.[130] In his own drawing, Moore concentrates entirely on the psychological expression which is sustained by the form and the undulating flow of the covers.

Few artists, however, moved and inspired Moore as did Michelangelo. Even as an eleven year-old miner's son, he knew that he wanted to be a great sculptor 'like Michelangelo'.[131] At the age of twenty-three, in his *Notebook No. 1*, which he probably used for visits to the British Museum, he copied various motifs from late drawings by the artist.[132] Not long after this the name of Michelangelo appears on a drawing along with a note that reads 'individuality of form conception'.[133] In an interview conducted in 1964 Moore commented, with a sideways glance at Nietzsche, that he 'still knew that as an individual he [Michelangelo] was an absolute superman.'[134] Moore frequently made reference to Michelangelo in connection with his own work and it is highly likely that he was encouraged to pursue his interest in the work of the Italian by his friend and sometime mentor Kenneth Clark, the Renaissance scholar and former Director of the National Gallery. Even a cursory glance into his library and its rich stock of books on Michelangelo shows how seriously Moore studied his work. Amongst other things he owned a copy of Tolnay's standard text and Frederick Hartt's study of the drawings. With a total of twenty-three books on the subject, his collection would have done any private scholar proud.[135]

It was not arrogance – as some have wrongly suggested – that led Moore to refer to Michelangelo so often in conversation. Rather, his boundless admiration was founded in the similarity of their approaches to the craft of sculpture and in his recognition of Michelangelo's intellectual stature. For Moore, with his strong sense of tradition, all the most important sculptural values came together in the work of Michelangelo.

On the basis of the said interview of 1964,[136] we shall now identify the main features of Moore's evaluation of the work of Michelangelo: reclining figures and movement as a potential source of strength, *nonfinito*, the expression of the inner spirit, and – yet again – 'humanity'.

With reference to Michelangelo's *Night* in the burial chapel of the Medici in the new sacristy of San Lorenzo, Moore spoke of 'a grandeur of gesture and scale that for me is what great sculpture is'. And he attached particular importance to Michelangelo's 'over-life-size vision' and the 'tremendous monumentality' of his work.[137] He also expressed huge admiration for Michelangelo's new concept of the reclining figure in the Medici chapel – a view that was no doubt coloured by his own overriding interest in this theme. In the figures representing the *Times of Day*, Michelangelo increased the range of expression of the moving figure, but always with a view to the overall effect of the composition. To this end he was careful to balance weight, strength, gestures and rhythms. The reclining figures on unstable sarcophagus lids seem to be drawn into their own centres of gravity. By their implied movement they embody strength and, as Hans Kauffmann has said of *Giorno* (fig. 205), they are filled 'with an inner movement that passes from limb to limb'.[138] And as such they become 'innately active organisms'.[139] The tension they convey 'arises from the conflict between strength and weight, or rather between the balance of power between the two'.[140] And it may be that Moore sensed this same potential for power in the innate movement of Michelangelo's reclining figures.

Moore certainly knew the two surviving models of river gods that Michelangelo intended for the tombs of the Medici. One was on show in the British Museum, the other in Florence (at first in the Accademia del Disegno; in 1965 it was moved to the Casa Buonarroti).[141] In the case of the latter clay model (fig. 206), it is worth noting that in the sixteenth century it was wrongly mounted by its owner, the sculptor and architect Bartolomeo Ammanati. Originally the right elbow and right leg were to have been in contact with the plinth.[142] In this position the raised left leg would have appeared all the more powerful. In addition to this, the contrast between the different lines of the upper body and the raised leg would have been even more effective.

Moore created a very similar sense of tension in 1959 in his bronze *Two Piece Reclining Figure No. 1* (fig. 125).[143] Once again there is a concentration of power in the raised leg. It is almost as though Moore has reworked Michelangelo's 'innately active organism' as one of his own biomorphous, autonomous compositions. For his part, Michelangelo had largely abandoned any allegiance to *contrapposto*. As has been shown elsewhere,[144] this new freedom allowed him to enter the terra incognita of precise, natural-looking figures. With regard to the power and volumes of the components of *Two Piece Reclining Figure No. 1*, Moore expressly associated them with the thrusting force of a branch veering away from a tree trunk or with a rock formation standing free of the cliffs behind it. The human form and Nature are as one in this piece, with each heightening the impact of the other. This openness to Nature on Moore's part by definition went further than Michelangelo's anthropomorphism. For, in Moore's opinion, the unprecedented suffering and upheavals of the twentieth century meant that the modern sculptor could no longer cling to the ideal of human beauty that had prevailed during the Renaissance. As he said in 1934: 'Beauty, in the later Greek or

Renaissance sense, is not the aim of my sculpture. Between beauty of expression and power of expression there is a difference of function. The first aims at pleasing the senses, the second has a spiritual vitality which for me is more moving and goes deeper than the senses.'[145]

The importance of 'spiritual vitality' to Moore may also have led him to appreciate Michelangelo's use of *nonfinito*. With his particular admiration for Michelangelo's figure of St Matthew and his unfinished *Slaves*, Moore was raising a Modernist issue that had concerned artists before him (also influenced by Michelangelo) – Rodin and Brancusi – and of his own time, such as Alfred Hrdlicka and Lorenzo Guerrini.[146] Moore's position was very clear. When David Sylvester asked

202 *Madonna and Child Studies*, 1943, pencil, wax crayon, coloured crayon, watercolour, pen and ink, 18 x 17.2 cm, Private Collection, USA, AG 43.96 (HMF 2181a)

201 Masaccio, *Madonna with Child*, 1426, Wood, 135.3 x 73 cm, National Gallery, London

him during the course of the same interview in 1964, 'But what is it that makes you like the unfinished *Slaves* better than the finished ones?', Moore did not hesitate:

'I prefer them because they have more power in them, to me, much more power than the finished ones. That one in the Louvre is much too weary and sleepy and lackadaisical.'

Sylvester: 'Well, it's meant to be dying.'

Moore: 'I know, but I mean you can have a thing that's dying and yet it has the vitality of the sculptor in it.'[147]

Moore's *Warrior with Shield* and his *Falling Warrior* memorably supported this view.

However, there are in fact only a small number of large-format pieces in which Moore specifically focuses in terms of form and content on the practice of *nonfinito*. In the late works it is mainly seen in small-format sculptures. By far the most compelling example is his over-life-sized, wooden *Upright Figure* of 1956–60 (fig. 207). This piece originated in a reclining figure that was later executed in bronze.[148] An early, interim photograph shows the elmwood figure and the small bozzetto.[149] While Moore was working on the piece, he discovered that he could raise the figure into an upright position: 'I put it upright, and it became instead of a static figure one that was actually climbing – a figure in action. I altered some little bits and it has remained an upright figure ever since, even though it began as a reclining figure. It's an ascending figure going up into the sky.'[150]

203 *Madonna and Child*, 1943–44, Brown Hornton stone, H. 149.9 cm, St Matthew's Church, Northampton, Gift of Canon J. Rowden Hussey (LH 226)

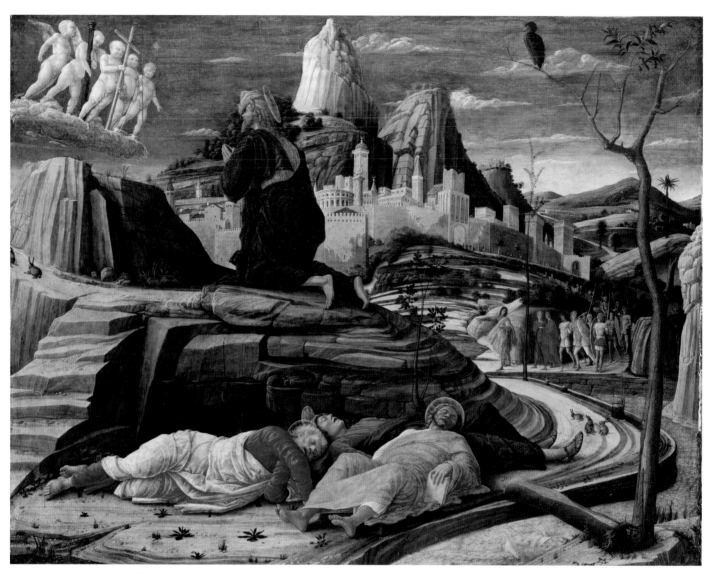

204 Andrea Mantegna: *Christ in Gethsemane*, c. 1480 (?), Tempera on wood, 62.9 x 80 cm, National Gallery, London

205 Michelangelo: *The Day*, 1526–31, Marble, L. 194 cm, St Lorenzo, Florence

206 Michelangelo: *Rivergod*, c. 1524, wood, clay and wool, L. 180 cm, Casa Buonarroti, Florence

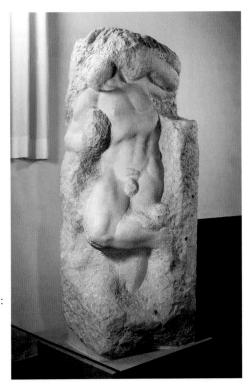

208 Michelangelo: *Wakening Slave*, c. 1530–34, Marble, H. 267 cm, Galleria dell'Academia, Florence

207 *Upright Figure*, 1955–60, Elmwood, H. 274.5 cm, Salomon R. Guggenheim Museum, New York (LH 403)

In order to reinforce the impression of a figure climbing upwards, which is above all conveyed by the raised right leg, Moore also allowed the head to extend well above the back wall. It is as though the figure were exerting itself, working its way upwards, but ultimately not able to free itself from the block, as we can tell by the fact that the feet are not fully visible and the left arm is no more than a fragment. The tension between the figure's determination to climb higher and the fact that it is prevented from doing so by being not quite fully formed (not entirely detached from the tree trunk it is made from), is reminiscent of Michelangelo's unfinished *Slaves* in the Galleria dell'Accademia in Florence. In Joachim Poeschke's view, Moore's *Upright Figure* shares the same 'bodily torsion and the lateral angles of the limbs', 'vertical movement' and crosswise horizontals above and below. Nevertheless, while the movement in Michelangelo's *Atlas* and *Captive* (fig. 208), for instance, seems to be prevented from rising upwards and

209 Michelangelo: *Rondanini Pietà*, Marble, 1552/53–64, H. 195 cm, Museo di Castello Sforzesco, Milano

210 *Study after Giovanni Bellini's Pietà*, 1975, Pencil, wax crayon, watercolour wash, gouache, charcoal on wove, 42.8 x 32.4 cm, The Henry Moore Foundation, AG 75.34 (HMF 75 (14))

211 Giovanni Bellini: *Dead Christ with Mary and John the Evangelist*, *(Pietà)*, c. 1470, Wood, 86 x 107 cm, Pinacoteca di Brera, Milano

is already interrupted by the 'angle of the head',[151] Moore achieves the opposite effect in the figure's fully-formed head, flung defiantly backwards. His *Upright Figure* is aware of its relationship to the heavens above and exudes a sense of confidence; typically for Moore this strength and self-confidence is associated with a female figure.

If there were any piece that, in Moore's opinion, even outdid the Florentine *Slaves*, then it was only the *Pietà Rondanini* (fig. 209) that Moore first saw in 1952 in the Castello Sforzesco. As he said in conversation with David Sylvester: 'And for me Michelangelo's greatest work is… *The Rondanini Pietà*. I don't know of any other single work of art by anyone that is more poignant, more moving. It isn't the most powerful of Michelangelo's works – it's a mixture, in fact, of two styles… The top part is Gothic and the lower part is sort of Renaissance.[152] So it's a work of art that for me means more because

it doesn't fit in with all the theories of critics and aestheticians who say that one of the great things about a work of art must be its unity of style.'[153]

In the case of the *Pietà* 'the thin expressionist work [is] set against the realistic style of the arm. Why should that hand, which scarcely exists, be so expressive? Why should Michelangelo, out of nothing, achieve that feeling of somebody touching another body with such tenderness? I just don't know. But it comes, I think, from the spirit. And it seems to me to have something of the same quality as the late *Crucifixion* drawings.

Sylvester: They are certainly the other works by Michelangelo to which *The Rondanini Pietà* relates. For one thing, they have the same stark up-and-down movement.

Moore: Yes I think that towards the end of his life he was someone who knew that a lot of the swagger didn't count.

212 *Study after Crucifixion Sculpture*, 1954–56, Pencil, bush and ink, 27.3 x 24.2 cm, Crane Kalman Gallery, London, AG 54-56.12r (HMF 2844)

His values had changed to more deeply fundamental human values.'[154]

Moore's sympathetic artist's view has its roots in the Romantics' reception of the work of Michelangelo. Nevertheless, compared to the narrative homages of artists such as Fuseli, Blake and Delacroix,[155] it is striking to see the more sculptural nature of Moore's response plus his emphasis on the fact that he saw his own ethical approach to art reflected in the similar 'human values' of Michelangelo's work.

And it was this approach that also led him to the work of Giovanni Bellini. In 1975 Moore made three sketches (fig. 210) after Bellini's *Pietà* (fig. 211) in the Brera in Milan.[156] What could it have been in particular that drew him to this epoch-making work, painted around 1470? No doubt Moore was struck by the 'intensity, cohesion and heightening of individual forms'[157] and by its use of the three-figure composition that had its roots in the tradition of icon paintings. Intuitively he absorbed the monumental simplicity of Bellini's pictorial form, only to simplify it yet further. His full attention is on the close juxtaposition of the two heads, which is at the very heart of Bellini's composition. According to Bellini's own inscription, his main concern was the 'eloquence' of his painting.[158] And it is at precisely this point that Moore takes up the baton: he is interested to discover how it is that Bellini manages to create the impression that, despite her Son's closed eyes, Mary still appears to be searching for His life and His divine soul. It is as though Christ were still talking to her alone, and even smiling at her in death. This closeness, this affection

is for His mother alone. And she is the only one who can still feel it. The face of Christ is no longer of this world. And it seems that death is transcended in His face. He can only communicate this anticipation of His own Resurrection to His mother; meanwhile John is still seen in his role as the Evangelist. His thoughts – evident in his gaze and in the angle of his head – are already on the outside world that is yet to be told of these events.

The intensity of Moore's empathy for Bellini's *Pietà* is, ultimately, entirely in keeping with his own religious outlook. With all due respect, it seems to me that Moore's Christianity is largely apparent in the way that he engages with artistic themes such as love for one's fellow human beings and *compassio*. The first is seen, in the wider sense, in his two statues of the Madonna and in his many moving mother-and-child compositions. Meanwhile his Crucifixion figures explore the question of *compassio*. Between 1954 and 1956 Moore made a number of drawings (from photographs) after a Styrian figure of the Crucified Christ from around 1520 in the National Museum in Ljubljana. In the example illustrated here, the *Study after Crucifixion Sculpture* (fig. 212), once again we sense the intensity of Moore's empathy for the figure. In 1982 he made a mixed-technique drawing of an image of the Crucified Christ that reminded Wilkinson of Masaccio's fresco of the Holy Trinity in Santa Maria Novella in Florence.[159] Moreover, Moore himself made the connection between a group of three *Upright Motives* and Golgotha.[160]

Let us linger a little longer with Bellini and Moore's reception of his work, and recall a personal experience in the Städel-museum in Frankfurt. In 1978 Klaus Gallwitz, the then Director of the Städelmuseum, was keen to purchase a relatively large bronze work by Henry Moore, which unfortunately in the end proved impossible. As his assistant, it was up to me to look after the artist during his stay in Frankfurt. Before flying back home, Moore wanted to take a tour through the museum, with which he was not yet familiar. And that's when the adventure began. He paced rapidly through the rooms, seeking out exactly those artists that had always been important to him: Bellini, Grünewald, Rembrandt, Courbet, Degas, Cézanne and Picasso. He stopped at each painting and addressed it like a friend, sometimes using his hand to point out this or that detail that mattered to him. It was immediately obvious that Moore knew 'his' artists very well but that he nevertheless approached them with characteristic humility. In the case of Rembrandt's *Blinding of Samson* and Bellini's *Madonna and Child with St John and St Elizabeth* (fig. 213),[161] he was fascinated above all by the hands. I remember how he immediately homed in on the joined hands in Bellini's painting and demonstrated to me the trusting gesture of the small Child's hand in the larger one of His Mother. Later I realised why this discovery had given him such pleasure: in 1952 he had addressed a very similar theme in two *Hand Reliefs* which

213 Giovanni Bellini: *Madonna and Child, St John and St Elizabeth*, c. 1500, mixed media on poplar, 72.3 x 90.2 cm, Städelsches Kunstinstitut, Frankfurt a.M.

show his daughter's hand lying in that of her mother's.[162] His wider interest in forms 'fitting together' was also met in this piece. And an interesting comparison could be made with his large bronze *Locking Piece* of 1963–64 (figs. 218–220) which will be discussed in the next chapter. Details of this kind were enduringly fascinating to Moore.

One may assume a similar attraction to have prompted his late copy of *Four Standing Women (after Pontormo)* (fig. 214), made after Pontormo's fresco of the *Visitation* (1514–16), a work that Moore will of course have known from the Church of SS. Annunziata in Florence. In this case the eighty-three year-old chose a photograph (he often drew from book illustrations at this stage in his life) that showed the group as a rhythmic composition of the kind that had variously interested him since 1944, generally in connection with the sculpture *Three Standing Figures* (fig. 168) discussed earlier here. Be it with two, three or four elements, Moore's interest was not so much in the two divine pregnancies (in the typology of the *Visitation*), but in the rhythmic juxtaposition of a number of people connected by their gestures and by the spaces between them (fig. 215).[163] It was in compositions of this kind that Moore had honed his eye for the harmony he found in Pontormo's group composition.

To come back to our original question, what was the source of Moore's identification with Italy and Italian art? As we have seen, it was founded above all on his proven preference for artists such as Giotto, Giovanni Pisano, Tino di Camaino, Masaccio, Rosselli, Ghiberti,[164] Bellini, Mantegna, Michelangelo and Pontormo. In the work of all these artists he found confirmation for his own aspirations. Thus in Giotto's

214 *Four Standing Women (after Pontormo)*, Charcoal, chalk, pencil (rubbed), 43 x 32.9 cm, The Henry Moore Foundation, AG 81.103 (HMF 81 (109))

work he discovered figures rising up in an expression of a new alertness and human self-determination, in Giovanni Pisano's art he saw implicit movement and dramatic expression, in that of Masaccio he saw the rootedness of an image of humanity founded in Classical Antiquity,[165] in Bellini's work he saw the Christian victory over death and in that of Michelangelo the individual coming into his own amidst a fine balance of force and weight.

Florence, his 'artistic home', where all his favourite artists were gathered together, had always been a place where they had reflected on aesthetic questions. The founding fathers of

modern-day art history were Florentine scholars: Cennino Cennini, Lorenzo Ghiberti, Leon Battista Alberti and above all Giorgio Vasari. Moore may well have sensed the innate potential of a city that is still now at the forefront of developments. And there can be no doubt that he will have been fascinated by the architecture, as elsewhere in Italy. The perfect balance of simple forms and proportions seen in so many Florentine buildings must have made a lasting impression on a sculptor whose deepest roots were in stone sculpture.

Moreover, there was also Moore's interest in Etruscan Antiquity as I showed in 1994.[166] Here, too, was an art form –

215 *Draped Standing
Figures in Red*, 1944, Pencil,
wax crayon, watercolour,
pen and ink, 40 x 31.1 cm,
Coll. John Cochrame,
AG 44.67 (HMF 2253)

with its spiritual funerary sculptures – that professed the same 'human values' that Moore found above all in Florence and in Tuscany, in the work of artists ranging from Giotto and Pisano to Michelangelo.

And it was also the humanity that he found in his many encounters with 'his' art, that – as we have seen – also gave him access to Christian themes. Ultimately, Moore's concept of 'humanity' is closely bound up with the forming of the individual personality through art. And it seems that it was particularly in this area that Italian art was to be important to him at various, crucial stages in his life – in 1925, in 1943–44 and in his

old age. Other than in the case of works from far distant Antiquity and, even more so, that of non-European sculpture, Moore found himself very much in tune with Italian art, both intellectually and emotionally. And it was Italian art that touched him most readily, with the result that he truly identified with it.[167]

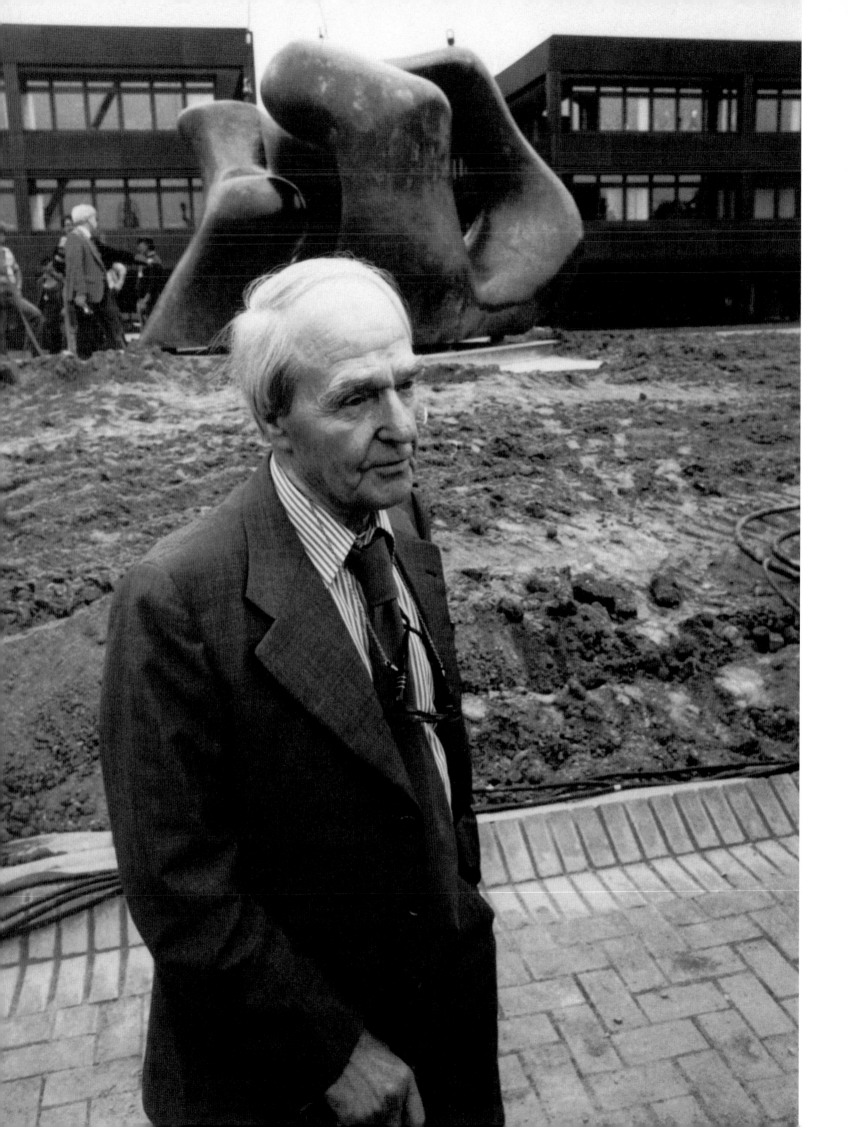

6. The Late Work: Some Insights

Moore's artistic career progressed through four clearly defined periods. The first covers his early studies and self-discovery as an artist, and concludes in 1929 with the making of the *Reclining Figure*, now in Leeds. This was followed by a time of prolific and far-reaching invention when Moore became a leading exponent of avant-garde Surrealism and Abstraction in England. This period, which also saw Moore's international breakthrough, lasted until 1939. In the course of the third period, which covers the 1940s and 50s, Moore came into his own as an artist, in full command of both his Classical and anti-Classical visions. The fourth and last period, during which Moore produced his mature work, commenced in 1959/60. However, having completed his monumental *Reclining Figure* for the UNESCO Headquarters in Paris in 1958 (fig. 1), which paved the way for future monumental sculptures, Moore – already over sixty years of age – now extended his range to include a whole new variety of sculptural approaches. Much of this work could be described as either fantastical-figurative or biomorphous-abstract. In his last twenty years, now with several full-time assistants, new, spacious studios and in being constant contact with his most important foundryman, Hermann Noack[1] in Berlin, Moore produced a body of work that was both new and forward-looking. This final period can rightly be seen as a separate entity in its own right. With a growing reputation worldwide, a demand for major commissions and having amassed a considerable fortune – undreamt of by sculptors before him – Moore was now a free agent. There was no end to his artistic inspiration. So what were the new forms he was exploring, what was the new content?

It was in 1959 that Moore started to produce the first of his numerous multi-part reclining figures.[2] The late *Lincoln Center Reclining Figure* of 1963–65 (fig. 126), discussed earlier here, perfectly exemplifies a monumental version of the principle of a two-part piece where the space between the two parts has a vitality all of its own. Three- and four-part figurations followed in the wake of increasing abstraction. As Alan Bowness wrote in 1977: 'The coming together of two or more parts of a sculpture is perhaps the essence of Moore's later work, both in form and subject. In his own words: "When dividing up a single figure the space between the pieces is not a blank, but a missing part to be imaginatively filled".'[3] At the same time Moore was developing new, thinner-skinned, sharper-edged pieces or free compositions, such as *Knife-Edge Two Piece* of 1962 (figs. 216, 217).[4] In addition to this, he was also working on the process of 'interlocking' or 'fitting together', which was itself no less innovative and open to use in an even greater variety of ways.

In his discussion of the artistic criteria that governed Moore's late work, Alan Bowness identifies a 'strong sense of internal action',[5] a growing confidence in the natural object as formal inspiration and a heightened interest in all kinds of human relationships. As Bowness says, these 'had always been a major preoccupation, from the earliest *Mother and Child* sculptures, but it seems to me that what we are offered in the late works is a paradigm of the human relationship, with figures groping, touching, embracing, coupling, even merging with each other.'[6] In Bowness's opinion this 'basic humanism'[7] also occasionally has sexual connotations, although any more detailed investigation of these might be likely to create confusion rather than illuminate the work. It seems to me that this reserve on the part of an author who was close to Moore and his work for many years is still to be recommended. For even when Moore's forms are distinctly male or female and have sexual overtones,[8] they are subsumed into the organic whole by the innate coherence of the composition. And particularly in the late period, Nature is the all-embracing principle forming the backdrop to all of Moore's artistic output.

In addition to this, in his late work Moore took a much greater interest in different surface tensions within one and the same piece. More than ever before, there are moments when hard and soft, smooth and rough come into direct contact with one another. David Sylvester makes this very point: 'Underlying this new concern is a new extreme concentration and tactile and motorical rather than visual sensations… The hard-and-soft figures are haptic images: they make bodies look the way they feel, from outside, and, still more perhaps, from inside. To the eye they can seem dislocated, awkward, uncouth. They asked to be looked through rather than looked at.'[9] And the concomitant 'growing acceptance… of imperfection, incompleteness'[10] is in fact seen in the number of torsos and fragments Moore made during this final stage of his artistic career.

At this point, we would do well to focus on the term 'late work' with reference to Henry Moore. In what sense, if at all, did it differ from the late work of other great artists? For a start there are few sculptors who could similarly be described as having really set out to explore new artistic shores in their late work. To do so requires innovative potency. A body of late works of this kind can only be created by those with a constant inner drive, who 'manage to produce astonishing new forms, as though new energy were welling up from unknown inner depths, and as though new artistic aims had loomed into sight'.[11] These are the terms used by Josef Gantner with reference to the late work of Michelangelo, Rembrandt and Goya. This list could easily be extended to include Rodin and Moore. Rodin's extended concept of *modelé* as seen in *Balzac* (1898) and his declared intention to attain in this figure 'a simplification that is truly great',[12] his *Homme, qui marche* of 1907, which introduces the autonomous torso into Modernism, his revolutionary *Assemblages*[13] and Symbolist figurative allegories in his late watercolours – all this and more set

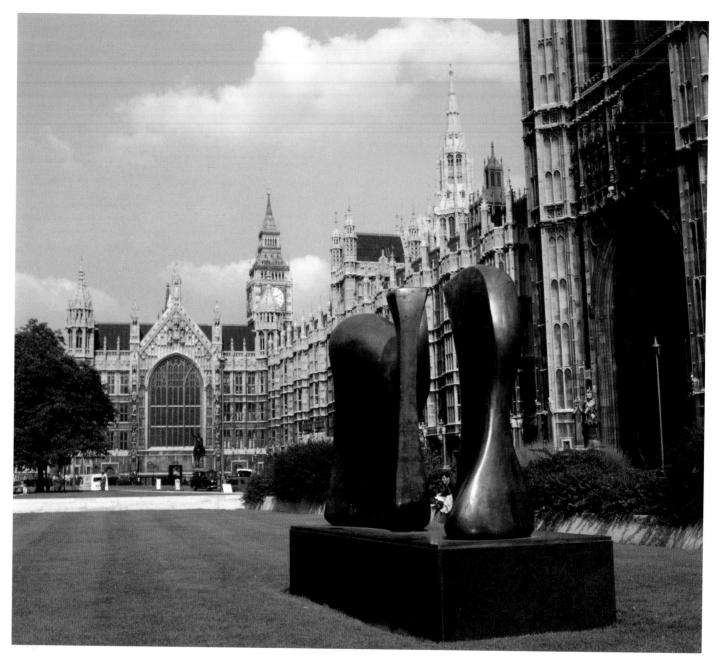

216, 217 *Knife-Edge Two Piece*, 1962–64, Bronze, L. 366 cm, Abington Street Gardens, Parliament Square, London (LH 516)

Rodin's late work apart from his earlier production. And one might also cite Maillol's final version of his *Harmonie*,[14] or the intensified gaze of the figures in Giacometti's late portraits and his negative figure in *Apparition*,[15] or Chillida's late works that lock space inside themselves, as in the *Besarkada* series or the last simplified pieces, such as *Buscando la Luz I*.[16]

All these artists – Rodin, Maillol, Giacometti, Chillida and Moore – make their own contributions to what could be described as a 'phenomenology of late sculptural works'. Moore, for one, enriched this phenomenology in astonishingly diverse ways. Like that of Rodin, Moore's late work is filled with self-evident paradoxes. In Moore's case these originate in the polar opposites of complexity and heightened simplicity.

The complexity of his late production is typified in works such as *Locking Piece* of 1963/64 (figs. 218–220),[17] *Spindle Piece* of 1968/69,[18] *Hill Arches* (fig. 222)[19] and related works which are all designed to contain space within them. Meanwhile the heightened simplicity of other works is exemplified by pieces such as *Large Torso Arch* of 1963–69 (fig. 449),[20] *Three Rings* of 1966 (fig. 447),[21] *Bridge Form* of 1971[22] and *Sheep Piece* of 1971–72 (fig. 414),[23] which all manage to fill more ample forms with inner tension. Both qualities – the greater complexity of Moore's output in conjunction with the greater simplicity of its appearance – come into their own on three levels: in the monumentality of the sculptures, in their enduring debt to the morphology of natural objects and in

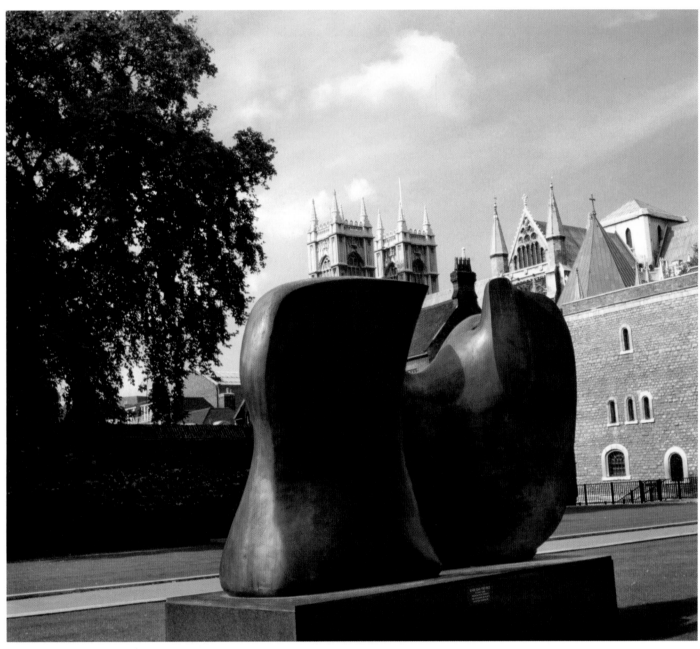

217

the unmistakable impact they make out of doors thanks to the autonomy of their organic forms. We shall now examine in more detail a number of bronzes – in both architectural and landscape settings – to see how these fundamental characteristics variously impinge on each other, act in concert with one another and, in so doing, are able define the interplay of complex intensity and highly-strung simplicity.

It is, perhaps, worth pointing out that when it came to making a piece to be placed outside – which applied to many of the late works because of their sheer size – Moore never compromised a sculpture to suit a particular architectural situation. In his view, the sculpture had to hold its own as a three-dimensional structure. As a rule, he would choose a piece (or a maquette) that was already in existence so that he could assess in advance how it would work in the space and what its effect would be. Ideally, the sculpture would enter into dialogue with the built edifice as an equal. At the same time, of course, Moore did take the architecture into account when necessary. Richard Cork and Anita Feldman Bennet have made studies of his commissioned works in public spaces and have shown that Moore was not only in close contact with leading architects from Gropius to Ieoh Ming Pei, but also included numerous architectural motifs in his own work.[24] It goes without saying that even when he was commissioned to create a piece for a specific architectural setting – as in London, Rotterdam, Paris (UNESCO), New York and Chicago[25] – he

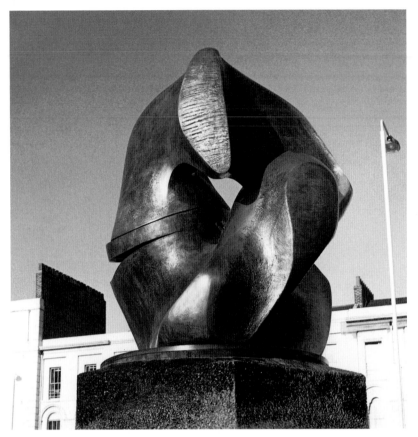

218, 219, 220 *Locking Piece*, 1963/64, Bronze, H. 293.5 cm, Riverside Walk Gardens, Milbank, Tate Britain, London (LH 515)

218a *Locking Piece*, 1963/64, Fibreglass version (LH 515) seen at the 1976 exhibition in Zurich

never lost sight of his own artistic aims. Thus Moore was not troubled by the much discussed question as to whether and how a sculptor creating a work for a public space can resolve the fundamental conflict between architecture and sculpture. Moore trusted in the coherence and self-sufficiency of his sculptures. And it was only from this position of strength that he was both able and willing to enter into dialogue with architecture and/or urban spaces. As he wrote in 1952: 'I am sure the time has come for architects and sculptors to work together again.'[26]

Let us now conduct our brief survey of late works in architectural settings by analysing the following four works: *Knife Edge Two Piece*, *Locking Piece*, *Divided Oval: Butterfly* and *Hill Arches*.

The large-format *Knife Edge Two Piece* of 1962–64 (figs. 216, 217) exists in three versions.[27] Moore was inspired to explore the notion of a 'knife edge' by the sight of birds' bones, whose elegance, delicacy and sharp edges had originally led to his high-spirited, draped *Standing Figure: Knife Edge* (figs. 185, 186), discussed earlier here. In *Knife Edge Two Piece* the thin shapes of bird bones are seen in the form of a two-piece sculpture which itself is transposed into the abstract. It is only when the viewer walks round the work that the connection between the two pieces makes visual sense, and it is only then that the work connects with the viewer's sense of space and of touch. With this many-sidedness Moore introduces into the work an ever greater level of nuance and a wealth of intrinsically transient aspects. These qualities are typical of Moore's late work as a whole.

In effect there are two characteristics that account for the innate tension of *Knife Edge Two Piece*: the apparent convergence of the two parts, and their unequal proportions. It is as though the two sections, travelling infinitely slowly towards each other along a narrow, invisible track, have halted to greet each other. The form that narrows towards the centre takes up the most space along its leading edge and looks at that point rather like a question mark. Its counterpart, with its anchor-like bulge, answers with a calmer, grander movement. Opening out at its narrow edge into two points, the 'question mark' seems to be thrusting forwards. Accordingly, as soon as viewers fully take into account the internal space, they have a sense of both parts of the sculpture pushing inwards. If, on the other hand, the composition is viewed as a whole, the overwhelming impression is of two parts gliding past each other. This is largely due to the parallel rhythms of the 'footprints' of the parts, their matching heights and the pointed, active leading edge of the narrower form. The ultimate direction of this movement is determined by the site where the sculpture is placed.

The connection between the sculpture and its surroundings is seen to advantage in London at its site outside the

Houses of Parliament on a peaceful lawn in Abington Street Gardens. In the bustling context of Parliament Square, at the heart of British political life, *Knife Edge Two Piece* is the only non-political 'monument'.[28] All around it weightily symbolic portraits of rulers and political leaders look down from their plinths of various heights: *Richard the Lionheart* (1157–1199, ruled 1189-99), *Oliver Cromwell* (1599–1658, Lord Protector 1653–58), *George V* (1865–1936, ruled 1910–36), *Winston Churchill* (1874–1965) and *Margaret Thatcher* (born 1926). Naturally one is moved to wonder about the spirit, or the epoch that is reflected in Moore's work. Perhaps an era that made it possible for an artist to explore fundamentally new ground in the realms of sculpture that would ultimately extend our perception of space and time? It is interesting to note that the nation credited with first establishing democratic government should have chosen to place an abstract sculpture in this highly political setting. In such close proximity to Parliament House, the fine leading edge of this piece seems to echo the sharp-edged neo-Gothic features of the architecture. The sharpness of Moore's forms, their vertical edges and the sense of gliding motion are a perfect match for the rippling architectural backdrop.[29] The connection between the two opens up a very individual aesthetic dialogue: while the metric sequence of the articulation of the façade could be express as a mathematical system, the rhythm of the organic forms in *Knife Edge Two Piece* demonstrates a new sense of freedom that emanates from within the piece. Perhaps, in this particular location, this points to the innately political meaning of the sculpture.

Locking Piece (1963–64), a large work measuring 293.5 cm in height, is also one of three. It was preceded by a preparatory model (107 cm high) made in 1962.[30] The artist described the genesis of the sculpture in the following terms: 'The germ of the idea originated from a sawn fragment of bone with a socket and joint which was found in the garden.'[31] In 1968 Moore commented with disarming candour: '*Locking Piece* is certainly the largest and perhaps the most successful of my "fitting together" sculptures. In fact the two pieces interlock in such a way that they can only be separated if the top piece is lifted and turned at the same time.'[32]

This sense of twisting and turning is very much intrinsic to the basically circular piece. In Volume 3 of the catalogue raisonné, Moore includes no less than ten views of the preparatory model (figs. 218–220).[33] It was important to Moore that the reader could imagine walking round the sculpture. And the many different aspects of the piece were equally important in real life: visitors walking from Tate Britain towards the banks of the Thames find themselves proceeding anticlockwise round the sculpture, thus exactly following the sequence of ten images chosen by Moore for the catalogue raisonné. It is almost as though the sculpture were functioning as a turntable, guiding visitors around it and towards the river.

221 *Large Divided Oval: Butterfly*, 1967, Bronze, L. 800 cm, Haus der Kulturen der Welt, Berlin (LH 571b)

Locking Piece can be seen from afar in Riverbank Gardens. With a row of Victorian buildings behind and a high-rise block at right angles to that, this once relatively unattractive site now has a clear view of the Thames. The whole area around the sculpture has recently been renovated. Originally, as can be seen from the old photographs reproduced here, the sculpture was placed on a hexagonal plinth which echoed its circular form. On this polygonal base, *Locking Piece* rose up like a heavy, yet balanced ring composed of interlocking organic forms and with a readily visible internal space. If one walks around it as described above – with one's back to the Victorian buildings – one is drawn into a process of increasing form individuation. This perusal of the work culminates in a bipolar view (fig. 220). While one form, thickening towards the top, screws inwards, another rotating form – in the shape of a large wing – is released out of the centre. The formal process inherent in this piece comes to a climax in the contrary motion of these elements. Systole and diastole, contraction and expansion, closing and opening all come together. It is at this point that the sculpture is at its most expansive and, as

such, opens out towards the panoramic vista of the Thames and, with its own internal logic, draws the infinite space of the river into itself. Correspondences of this kind are entirely deliberate on Moore's part. With the rotating, rhythmic alternation of introversion and expansion he succeeded in creating a form that reveals itself over time, a form that – in the relative confinement and spaciousness of its setting – crucially helps to define the space.

A very different relationship to architecture is seen in the eight-metre long *Large Divided Oval: Butterfly* of 1967 (fig. 221). This was installed in 1987 in Berlin, outside the Kongresshalle (now Haus der Kulturen der Welt), to mark the city's 750-year anniversary. The artist did not live to see the work in place. Preceded by a smaller version in white marble (91 cm in length),[34] the monumental bronze was placed in the water so that its shape – and the reflection of that shape – would act as a counterpoint to the architectural sweep of the roof behind it. Without the water, the large version of *Large Divided Oval: Butterfly* looks as though it has been derobed. It is only possible to fully appreciate the dialogue of its forms in situ.

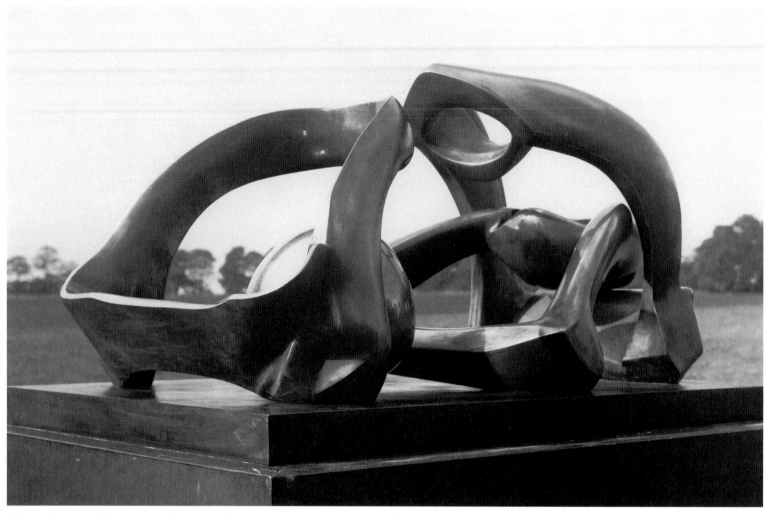

222 *Hill Arches*, 1973, Bronze, L. 550 cm, The Henry Moore Foundation (LH 636-36)

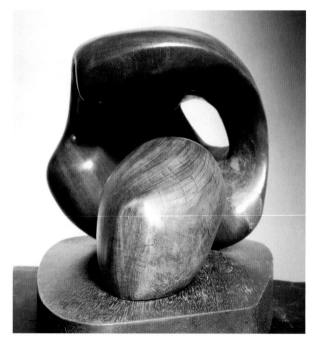

223 *Two Forms*, 1934, Pyncado wood, basis: oakwood, H. 53.34 cm, Museum of Modern Art, New York (LH 153)

Photographs inevitably draw the curves and countercurves so closely together that the work is dominated by an alien beauty of line. In reality, in the changing play of the light and with the invigorating effect of the reflecting water, it is as though the sculpture grows beyond the limits of its own form. With their unerring wit, Berliners registered this fact and were soon referring to it as 'Heaven's Ear'. The artist's own butterfly metaphor is embodied in the shape of the wings extending outwards and in the central protuberance which calls to mind the chitinous body of an insect.

The sculpture *Hill Arches* of 1972–73 (fig. 222) also went through the process of maquette, interim model and final monumental version.[35] The piece had already been preceded in 1969 by a preparatory etching entitled *Projects for Hill Sculpture*.[36] However, ultimately – as Susan Compton has pointed out[37] – in its formal disposition this sculpture has its roots in *Two Forms* of 1934 (fig. 223). This abstract wood sculpture already anticipates the defining movement of the large form in *Hill Arches* which seems to be leaning protectively forwards over a smaller form. Similarly, the earlier work already includes the hole through the back of the leaning

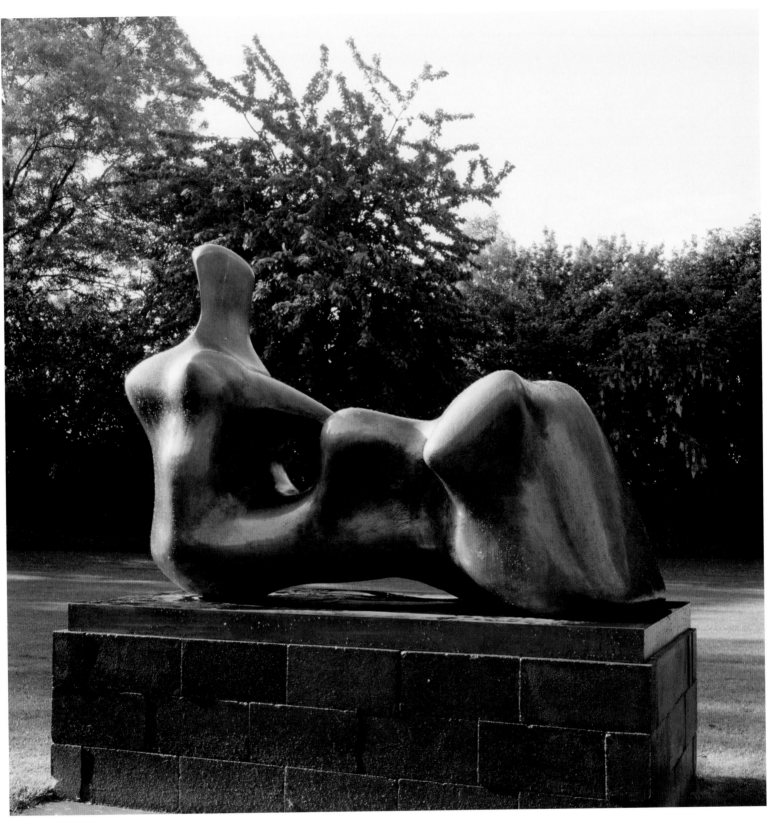

224 *Reclining Figure: Hand*, 1979, Bronze, L. 221 cm, The Henry Moore Foundation (LH 709)

form. Moore himself described this work in terms of a mother and child composition, with the larger protective form the upper body of the mother and the ovular form in front of it – indebted to Brancusi – representing the child.

In *Hill Arches* Moore repeated the configuration of sheltering form with a smaller, round form below it in the other half of the piece. But now he transmuted the solidity of the form into bands, and elongated the whole piece. This in turn resulted in two arched lines that together almost form a semicircle. Any mother-and-child allusions have long disappeared. Instead the piece is devoted to an abstract interplay of above/below and internal/external. The indented sphere down below answers the 'eye' in the highest point of the arch rising up opposite it. The loop at the bottom repeats the direction of the movement of the second arch on the other side.

Thus the inwardly rich interweavings appear calm on the outside, thanks to the 'hill-shaped' arches. They so memorably dominate the overall impression of the sculpture that one could describe the work as a 'landscape in itself'.[38] Thus one can readily imagine how, in the right setting – be it a spreading canopy of leaves (during the 1992 Paris exhibition in the Bagatelle Park), or the dome of the Karlskirche in Vienna – this very distinctly curvilinear sculpture would appear even more eloquent. The defining feature of this late work could be said to be that given an analogous, matching form either in the landscape or in the architecture, the impact of the sculpture is not only increased, but singularly developed.

Let us now turn our attention to the late works in landscape settings. Moore never let there be any doubt about the fact that a landscape setting was always his preferred option for his sculptures. He welcomed the sculpture parks that were growing in popularity in his day but, even then, would still insist on the autonomy of the sculpture. As he was already saying as early as 1962, things should not be taken to the point where sculpture was demoted to the status of merely an 'ornament' in the landscape or in a garden design. As he saw it, everything depended on the correctly chosen setting: 'a good setting is one in which the right conditions are present for a thorough appreciation of its [the sculpture's] forms, but a setting cannot *alter* it.'[39]

Even more than in an architectural context, the sculpture placed in the landscape has to be self-sufficient, in view of the far greater wealth of formal associations found in the latter. The artist has to bear in mind that 'landscapes, clouds, the sky, impinge on the sculpture & reduce its bulk – Thin linear forms tend to get lost. – It seems that in the open air a certain minimum bulk is needed, to contrast with the great spaces of the sky & large distances.'[40] How Moore handled these truths (in fact known to all sculptors), thereby allowing his late monumental sculptures to respond to Nature, will now be shown in a few, select examples.

Reclining Figure: Hand, where one arm demonstratively crosses the space between the upper and the lower body, measures 2.21 m in length (fig. 224).[41] If one has the chance to view the bronze in Moore's meadows at Much Hadham, or against the extended backdrop of the hills of the Yorkshire Sculpture Park, it is impossible not to notice its dialogic dimension – although at first sight everything would seem to point to the opposite. Is this heavy body with its ponderous movement not in fact shutting itself off from the world? And does not the very smoothness of its surface create the impression of dismissive self-absorption? That the opposite is true becomes apparent as soon as the sculpture is seen exposed to the air and the gentle hills of the English landscape. In this context, its generous forms resonate with the expanses of Nature and come into their own. The smooth epidermis extending over large areas proves to be the perfect surface to reflect the rapidly changing natural light. It seems that the sculpture is at one with the temporal processes of Nature. It appears invigorated and clearly has a soul. With its oversized dimensions, it exudes a power that allows it to hold its own with the landscape. It can even stand up to it. As viewers take in its forms, they feel lifted out of themselves, elevated, literally empowered. And it is precisely this that appears to be the secret of Moore's late monumental works.[42] The artist himself took a very pragmatic view of what was needed: 'Incised relief, or surface scratchings won't show in dull English weather. Only your big architectural contrasts of masses – real sculptural power, real sculptural organisation – will tell at all on a dull day. Therefore if one gets used to working out-of-doors, to be satisfied with it one will be challenged into making a sculpture that has some reality to it – like the reality of nature around it.'[43]

That this impression of 'reality' goes hand in hand with the sense of a 'soul' is very much the preserve of Moore's late figurative works, as long as the light and the specific landscape setting allow. Two examples come immediately to mind:

With its vertical stance *Upright Motive No. 9* of 1979 (fig. 225) appears to be at odds with the gently undulating, hilly English countryside as Moore knew it from various important stages in his life in Yorkshire, Kent and Much Hadham. But the torso of this standing figure also changes radically, before the viewer's very eyes, in different light conditions. This effect is all the more powerful when the sculpture is diagonally lit by the rising or setting sun. When the natural light is at its intensest, the figure's chest seems to expand and it is as though the sculpture starts somehow to breathe. Moore gave this work a generous *modelé*, so that the light can enter deeply into it. The head is turned up like a vessel, indeed everything in this ascendant piece strives upwards, taking the viewer with it.

Connotations of this kind, which are ultimately designed to engage the viewer's spirit, are even more evident in Moore's last oversized mother and child representation: *Mother and Child: Block Seat* of 1983–84 (fig. 226). The relevant plaster

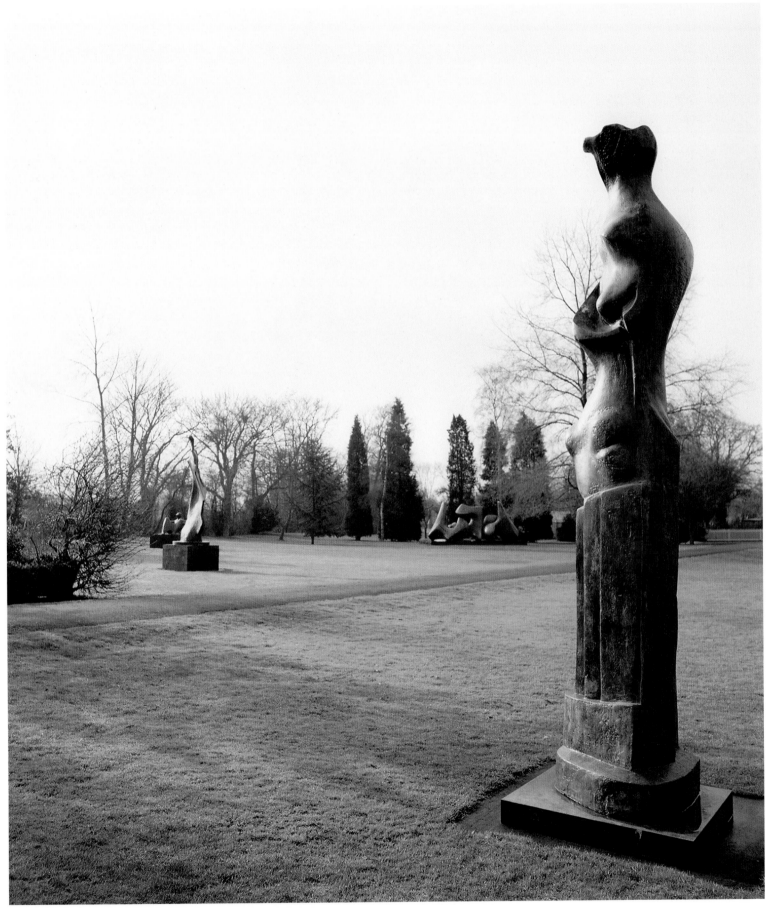

225 *Upright Motive No. 9*, 1979 , Bronze, H. 335.5 cm, The Henry Moore Foundation (LH 586a)

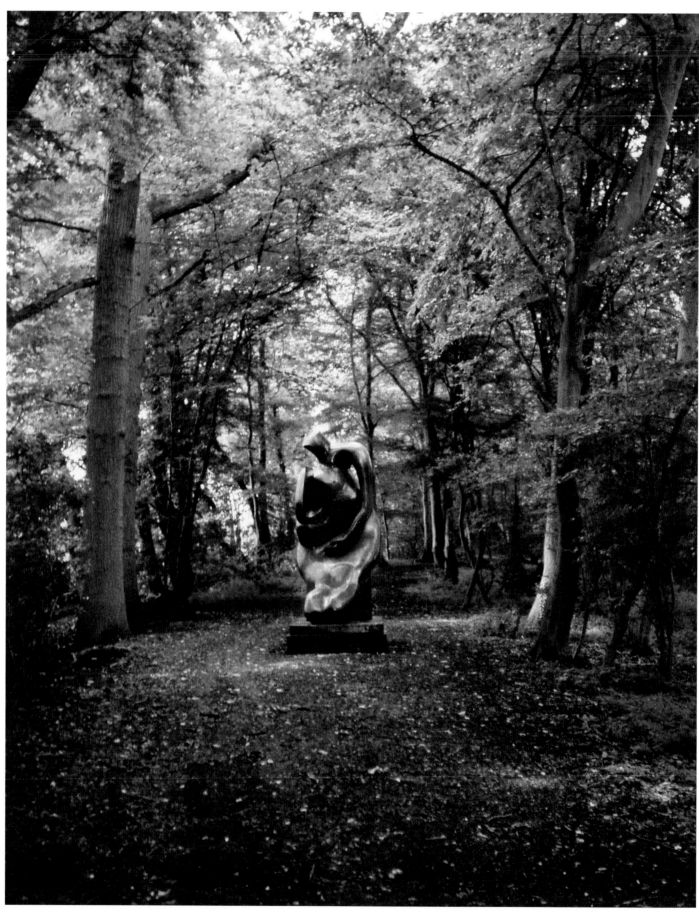

226 *Mother and Child: Block Seat*, 1983–84, Bonze, H. 244 cm, The Henry Moore Foundation (LH 838)

maquette, presumably developed from a pebble, is still on view in the studio in Much Hadham as is the monumental bronze in the grounds of the Henry Moore Foundation, perfectly placed in an avenue of trees: the branches of the tall trees meet up above the figure. In this situation the majestic motif of a gateway of trees,[44] familiar from Romantic painting, becomes reality and in a sense ennobles this late work. Once again the natural surroundings are at one with the internal processes of the sculptural form: the inward, actively protective gesture that runs from the head through the elongated left arm into the child is taken up and paraphrased by the sheltering arc of the trees.

In *Mother and Child: Block Seat* we also see clearly the way in which Moore, in his late works, was able to use biomorphic transformation to make the connection between the human figure and Nature. And this interplay with Nature only works on a deeper level because the forms have their morphological origins in the maxim 'as in nature'.

Monumentalisation, the delimitation of forms and extended contextualisation are not only all characteristic of the aesthetics of Moore's late works, they are of the essence of 'late works' per se. Joseph Gantner has suggested that in the consciousness of the finest ageing artists, 'their own demise is no longer of any consequence, and that with age and in an artist's late works, the last stage – enduring fame – has already begun. Death has lost its finality, and this explains the truly sublime relationship certain artists have to death. Untrammelled by boundaries, they live in the future.'[45]

This sense of being 'untrammelled by boundaries' was characteristic of Moore. It is in keeping with the fact that his late work is 'sublime' in the original sense of the word (Lat. *sublimare* = to raise up), and it is very evident even in his old age when he was suffering severe ill health. In those last years each afternoon the artist would have someone take him in his wheelchair on an outing through his extensive grounds, which had been transformed into parklands under the expert supervision of his wife, Irina. What he wanted above all was, as he himself said, 'to see nature, the countryside, the trees, the sky, to be renewed and refreshed'.[46] For Moore lived very much in trusting harmony with Nature and its cycles of growth and dying. And this uniquely characteristic sense of trust is what still gives his so deeply 'natural' work an ever more precious quality: confidence in life.

7. 'Englishness'? A Matter of Definition

'After all, as a Briton, Moore comes from ornament
and proceeds towards ornament like the ancient Irish.'
Gerhard Marcks[1]

Following the overview of Moore's work from the point of view of its history and particular issues in the previous chapters, we will now embark on a more detailed exploration of the question as to whether there is a specifically English ingredient in his art. And if so, of what exactly does it consist?

In the first place, it is clear that the main fruits of Moore's British upbringing are the same elements that connect him to the English Romantic movement – his empathy for Nature and the landscape, his reverence for Stonehenge, his admiration for the sacred carvings of Medieval England and his special affinity for the work of Turner, Constable and Blake. All these elements will be individually examined in the second half of this chapter.

Besides his English-Romantic heritage, in Moore's work there are also aspects of form and content that point to a specifically Irish-Celtic connection. In order to shed greater light on these aspects, we will begin by first considering the hallmarks of English art, which were in fact a topic of discussion amongst Moore's friends and fellow artists. It was the same question of 'Englishness' that nowadays – in the light of developments at home and abroad – is currently fuelling a debate on cultural self-definition. In Moore's day the self-imposed task of defining 'Englishness' was largely shouldered by Herbert Read and Nikolaus Pevsner. From the outset Read regarded this as a political issue; Pevsner, the German immigrant and architectural historian, took a broadly material approach intended to pinpoint the salient features of English art history. Moore and Read were friends from Yorkshire and enjoyed each other's company and conversation, and Moore will also certainly have known of Pevsner's famed Reith Lectures for BBC radio on art and national character in which he himself was described as the leading sculptor in the world.

In early 1934, barely a year after Hitler's rise to power and the proclamation of his racist cultural politics, the Royal Academy took a stand and, in its grand, historic premises, presented a lavish exhibition that highlighted the specific qualities of English art from the early Middle Ages to Turner.[2] In response to this self-analytical exhibition of Britishness, in December 1933 Herbert Read published an article in praise of 'English Art' in the *Burlington Magazine*.[3] It goes without saying that Moore will have read this thoughtful, at times speculative essay by his friend, and it is also highly likely that he visited the exhibition.

Read starts his survey in the early Anglo-Saxon era, which he credits with 'a certain calligraphic or linear freedom'[4] that has its roots in earlier Irish-Celtic designs (although he does

not specifically make this point). And in connection with the late tenth-century illustrated manuscripts of the Winchester School, he writes that in those days English art stood 'for freedom and for grace; and these qualities were expressed as only they can be expressed in the plastic arts – by the infinite inflections of line, the line which alone is capable of giving plastic expression to rhythm'.[5] Read further suggests that this tendency towards the liberated line goes hand in hand with a love of the burlesque. By the eleventh century a growing ability to observe Nature in all its forms was leading illustrators towards a new level of realism where the subtly inflected lineature was enriched by an 'earthly instinct'.[6] Between the fourteenth and eighteenth centuries, these two main directions of English art were affected and influenced to the point of unrecognisability by foreign styles, particularly those emanating from Italy and the Netherlands. In Read's view it was only with the arrival of William Hogarth that English art started to find its way back to its own origins. While this revival culminated in the mastery and closeness to Nature of one such as Gainsborough, it was taken to the next level by the Romantics William Blake, John Constable and William Turner.[7]

Prompted by the present discussion of globalisation, national cultures and identity, in 1998 Kevin Davey turned his attention to Read's early defence of 'Englishness'. Bearing in mind the close friendship between the influential art critic and the sculptor, it is worth looking more closely at Davey's findings. Davey sees Read as 'a thinker who tried to define, transform and mobilize the nation's sense of itself, the Anglo-British national-popular will, through his literary anthologies and surveys of the visual arts, political critique and founding of institutions'.[8] Read 'celebrated "Englishness as an ideal, a dynamic vision"'.[9] As such it was to transcend mere nationality. In the wider context of a revival of the arts and above all of Romanticism, Read spoke out strongly against the 'combination of puritanism and capitalism'[10] that had prevailed in his native land since the nineteenth century. In 1936, Read was to see the emphatic arrival of Surrealism in London as entirely in keeping with a tradition that began with Shakespeare and continued in the work of Swift, Shelley, Swinburne, Lear, Walpole and, most notably, Blake, Lewis Carroll and Wordsworth.

It seems that Moore and his fellow artists broadly agreed that the main characteristics of Celtic art laid the foundations for certain aspects of English art. As Paul Nash wrote in 1934 in his essay for *Unit One*: 'English art has always shown particular tendencies which recur throughout its history. A pronounced linear method in design, no doubt traceable to sources in Celtic ornament. Or to a predilection for the Gothic idiom. A peculiar bright delicacy in choice of colours – somewhat cold but radiant and sharp in key...'[11] With his wide-ranging interest in the art of early civilisations, it is not surprising that Moore was also attracted by early Irish-Anglo-Saxon art.[12] And, in anticipation of what is yet to come, it is worth recalling the Pre-

Ill. 7 West Portal of St Andrews, Much Hadham, Hertfordshire

227 *Book of Kells*, St Matthew, Detail from the Four Evangelists, Opening of the Gospel of St Matthew, Vellum, c. 800, MS 58, fol. 27v., Trinity College, Dublin

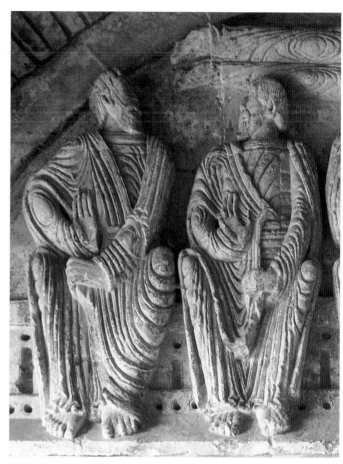

228 *Two Apostles*. Detail from the tympanum, south porch, Malmesbury Abbey, Wiltshire, 1160–65. Stone relief

Raphaelites' love of Celtic motifs which had survived into the Art Nouveau that the young Moore grew up with.[13]

Nikolaus Pevsner's standard work, *The Englishness of English Art*, was published in 1955. In preparation since 1941, its discussion of outstanding themes covers many of the same

229 William Blake: *Jerusalem* (Bentley Copy E) 1804–1820, Pl. 35: The Creation of Eve (Detail), etching with ink und watercolour, 22 x 16.1 cm, Private Collection/ The Bridgeman Art Library

areas as the 1942 study by the Viennese art historian Dagobert Frey, *Englisches Wesen in der bildenden Kunst*, to which we shall return later with reference to Henry Moore.[14] Pevsner identified rationalism and realism as the main characteristics of English art.[15]

All three of these authors were in agreement that English art has a unique, very strong sense of the expressive power of the line and that this is evidence of the continued existence of certain fundamental aspects of Celtic art. As Frey put it: 'Typical of the English approach to form is the line, ebbing and flowing, streaming through forms and dissolving again. And the line was already in evidence as a constitutive formal element by the Carolingian era in the image of St Mark in the Canterbury Gospel and still lingers on in the edgy drawing style of the Utrecht Psalter.'[16] The gaze of the Nordic artist, as Frey goes on to explain, 'does not take in the form, but glides along the linear sight lines.'[17]

Leaving aside the unfortunately loaded and undeniably dubious generalisation in the use of the term 'Nordic', and the later reference to a racial-cultural opposition between the 'Mediterranean-Celtic and the Nordic-Anglo-Saxon character'[18] Frey did, however, identify a pictorial reality that certain-

230 *Shelter Scene: Two Swathed Figures*, 1941, Pencil, wax crayon, coloured crayon, watercolour wash, pen and ink, 27.7 x 38.2 cm, Manchester City Art Galleries, AG 41.76 (HMF 1825)

ly applies to Moore's work. For his Celtic heritage is very much alive in his liberated lineatures, in the agility and rhythms of his vocabulary of biomorphous forms and in his grounding in the expressive power of the fantastic. Witness the *Shelter Drawings* with their evocations of forms where 'dynamic formal energies' speak through the said 'linear sightlines' (fig. 230).[19] With the independent flow of his own compositional lines, Moore is firmly rooted in the English tradition. I am thinking here, for instance, of the miniatures in the *Book of Kells* (c. 800), and specifically of the image of the symbol of St Matthew (fig. 227).[20] Here the bodily presence of the angel is largely suggested by the drapery which, for its part, is articulated in a rhythmic sequence of contrary-motion folds. What appears, in 800, as a well-ordered pattern in the image of an angel, apparently weightless and matterless, reappears almost 400 years later – bound by the same principle but incomparably more intense – in the flowing folds of the garments of the Apostles (fig. 228) in the tympanum in the Norman porch of Malmesbury Abbey (1160–65).[21] A similar heritage can be

traced in the work of William Blake, and Pevsner pointed out the inner affinity of some of his images with certain illuminations from the thirteenth century.[22] But Blake's extremely dynamic lineatures also have certain aspects in common with those in Moore's *Shelter Drawing* (fig. 230). One need only compare his image of God the Father from his *Jerusalem* cycle (fig. 229) with Moore's drawing.[23] Blake's figure seems to be attracted by the flames. Moore's 'linear sightlines' are freer in their formation.

What connects all these four examples spanning 1200 years is their non-corporeality, or rather the impression they give of 'not-yet-being-in-a-body'. In 1940, in Moore's drawings showing the caverns of the London Underground as the bombs fell above ground, this common feature turned into 'no-longer-being-in-a-body'. And when Rudolf Huber visited Moore in Much Hadham in 1958, he already saw 'in the uninterrupted, flowing lineature of Moore's figures something eminently English'. Furthermore: 'Moore is the first artist of our time who, leaving aside pure abstraction, has made the line sculp-

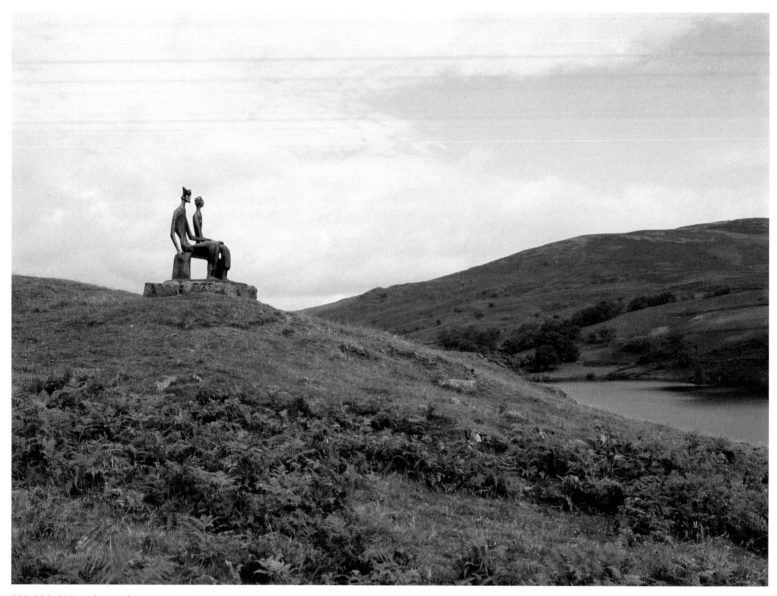

231, 232, 233 *King and Queen*, 1952–53, Bronze, H. 163 cm, J. W. Keswick, Shawhead, Dumphries, Scotland (LH 350)

ture-worthy, by creating palpable tension between the line and the space around it. He does not juxtapose volumes, thereby avoiding issues of proportion just as the architects of English Gothic cathedrals once did when they continued the linear system right down to the ground and left columns and pilasters free of capitols and entablatures. At the sight of some of Moore's sculptures one is reminded not only of the figures on the façade at Wells, of St Faith in Westminster Abbey or of the Canterbury Gospel, but also of the vertical articulation in English half-timbered houses. Moore took the line, actually tied into the plane, and extracted it from there by interweaving and interlocking it with the third dimension and, in so doing, turned it into a viable sculptural element. Lehmbruck pursued a similar course. When I put this idea to Moore he agreed and remarked that he certainly felt that there was a connection between Lehmbruck's work and English art.'[24]

As we have seen, early Irish-English art has much in common with the rhythmic linear art of the Celts, which was also the source of its particularly supple, convoluted linear patterns as seen, for instance, in the extravagant decoration interspersed with fantastic hybrid creatures favoured in Irish-Anglo-Saxon illuminated manuscripts or in the Irish-Scottish high crosses made between the tenth and the twelfth centuries. As Rudolf Huber correctly observed, Celtic elements even linger on in the organic growth of English cathedral architecture.

It seems that Moore, the draughtsman, tapped into this Celtic tradition and developed his own forms from the free-flowing lines he found there. Beyond this there are also individual sculptures – significantly, mostly bronzes – or whole groups of works where even the contents reflect his Celtic-tinged Englishness. I am thinking here above all of the bronze

King and Queen (1952–53), other fantasy compositions in Moore's sculptural output and drawings, and the well-known *Glenkiln Cross* (1955–56) with its very evident connections to the traditional Irish high cross.

King and Queen – Imagination and Identification

In Moore's output as a whole, *King and Queen* (figs. 231–233) is undoubtedly a key work. While some of Moore's own contemporaries took objection to the 'animal head' of the King and regarded it as a travesty of the traditional image of the human being, nowadays – more than ever – viewers are struck by the coherence of the piece's formal invention, its stupendous imaginative range and its 'identificatory' power. There is scarcely another work where Moore's language is both so personal and so comprehensively mythological. In a sense *King and Queen* works as a form of sculptural substitute, like Picasso's *Man with a Lamb* (1944) or Max Ernst's *Capricorne* group of 1948.[25]

As it happens, Moore's *King and Queen* turned out to be one the most important examples of the postwar phenomenon of 'idol sculpture'.[26] The word 'idol' derives from the Greek *eidolon* meaning picture or cult image. Contemporary images of idols – as seen in the work of artists such as Germaine Richier, Alberto Giacometti, Picasso, Barbara Hepworth, Marino Marini, Karl Hartung, Lynn Chadwick, William Turnbull, Wilhelm Loth and Lothar Fischer – play with the alien, hierarchical appearance that is typical of sculptures used in cult rituals. They also favour the powerful axial structures and frontality of these cult images. In the idol sculptures that proliferated so strikingly in the 1950s and 60s, there are echoes of the cataclysmic upheavals and attempts at reorientation that shaped the sculptural image of humankind after the Second World War.

How did the *King and Queen* come about? How does it connect with the rest of Moore's work from the period; what was its inspiration, what did it mean for the artist, and how does it relate to his Englishness? We are indebted to Anthony Caro for his eyewitness account of its making. He was present when Moore fashioned the maquette of *King and Queen* directly from pieces of wax. Both assistants – Caro and Alan Ingham – had to be ready to react in an instant: 'First we boiled up the wax and poured it out on to flat sheets, so he'd got wax roughly the thickness of a casting. Then... he'd cut out the shape of the figure he wanted – in this case the bodies of the King and Queen – and he did it exactly like a tailor cutting cloth into shape. He worked on a very small scale, he was comfortable working very small, the whole figure about six or eight inches (15–20 cm) high. He'd get this little figure and bend the warm wax into a seated position, then he'd make a little wax seat for it and give it legs and arms made up of thin elements of wax which he'd model. He was good at modelling hands or feet on a tiny scale. When it came to the head he'd make the head out of small wax parts, weld them together

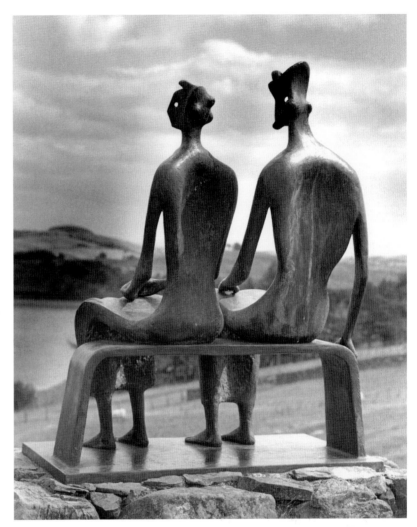

232

and dip the whole head into hot water, so the shapes would melt a little and cohere and the parts of the head would run together... it was fascinating to watch him working... In the tiny sketch the sculpture was already there, even the detail, eyes and hands.'[27]

The work process, described in such detail here by Caro, was the same for the figure of the *Queen*. Moore's skill in working at speed with the warm wax and in modelling minute details was in evidence in all his maquettes, be it from clay, wax or plaster. Once they were finished, he looked after them like precious jewels and shielded them from prying eyes at home in Hoglands by keeping them in a room of their own, next to the bedroom.

There can of course be no doubt that the process described here, where the figures were cut and formed from sheets of warm wax, facilitated the ribbon-like shape of the figures' torsos. As a concept this may have partly originated in an exhibit in the British Museum that would perfectly have complemented the image of an Egyptian married couple from the Middle Kingdom which Moore himself cited as an influence (fig. 234).[28] The exhibit in question is an archaic portrayal of

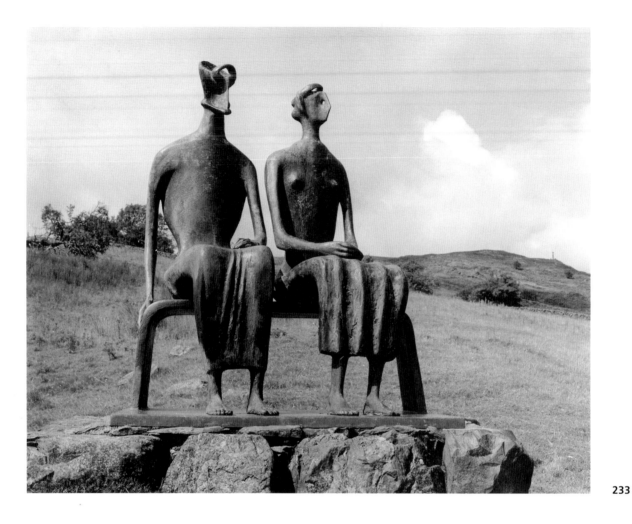

233

234 *Egyptian effigy of a married couple*, late 18th Dynasty, c. 1340 BC, White limestone, H. 130 cm, British Museum, London

235 *Demeter and Persephone in a Wagon*, late 7th century BC, Terracotta, H. 16.5 cm, British Museum, London

two Corinthian goddesses, which may have been made from similarly thin, curved sheets of clay (fig. 235).[29]

In *King and Queen* the two figures are not only united by their ribbon-like structures. There is also the correspondence in their poses (from the front both appear to be looking to the right) and the supple elegance of their physiques, which have no hint of earthbound bulk. This impression is further reinforced by their hollowed out backs and by the deep folds undulating across the front of the Queen's gown. As Peter Anselm Riedl has said: 'Her legs take no account of these undulations: on the contrary, there are distinct valleys where her thighs must be under the material.'[30] The impression of non-corporeality is further enhanced by the many scratches on the surface of the piece that preclude any thoughts of skin. Despite all of this, however, the figures' anatomies seem perfectly logical and realistic: 'The arms may be thin and overly long, but they are anchored in the powerfully formed shoulder joints and exude a sinewy energy around the elbows'[31] – much the same could also be said of the finely formed hands and feet.

Thus the piece as a whole is imbued with an enigmatically buoyant combination of naturalness and immateriality. Both figures have an air of suprahuman detachment that culminates in the 'regal' heads, each of which is topped by a diadem. These adornments grow like hoops out of the cartilaginous, stepped hairdo of the Queen and out of the bony, more animal-like head of the King. In both cases the diadem and the head form a single, organic entity. This and the overall coherence of the cranial structures – facilitated by the suppleness of the wax – crucially contribute to the impression of naturalness that emanates from the hybrid figure of the King. According to Moore himself, the King and Queen are creatures from the world of English fables and fairytales that he was reading to his daughter at the time.[32] As the tales brought back to life old stories and legends, there arose in him the imagined reality of a mythical regal couple from the distant past. Moore also talked of the 'power in primitive kingship'[33] that he wanted to express in this work.

This comment also relates to the drawings of 1950, in which he dreamt up heads of *Fabulous Animals*. One of the drawings is marked with the word 'vitality'[34] which, for Moore, was an essential component of these heads. That these are not real, but imaginary, fantastical creatures is confirmed by the abstract frameworks of lines that interconnect and encircle the heads, the eyes and the mouths. On the sheet of *Fabulous Animals* illustrated here (fig. 236), the artist is mainly exploring the idea of a horned animal with an elongated snout. It seems that it was on the basis of drawings such as these that Moore first came up with the *Goat's Head* of 1952 (fig. 240) and, not long afterwards in 1952–53, the *King's head* (fig. 241). One cannot help but be struck by the internal geometry that underpins the biomorphous formation of the latter.

236 *Fabulous Animals*, c. 1950, Wax crayon, coloured crayon, watercolour wash, whereabouts unknown, AG 50.34 (HMF 2626)

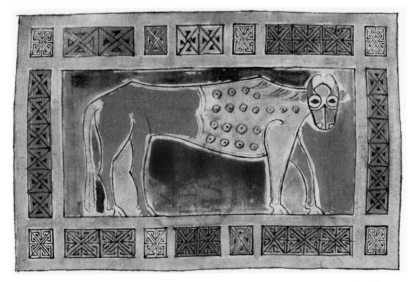

237 *Symbol of St Luke. Book of the Evangelists of Armagh* (Northern Ireland), Detail from the Opening of the Gospel of St Luke, Harley Armagh Gospels, Vellum, 1138, MS Harley 1802, fol. 86v., British Museum, London

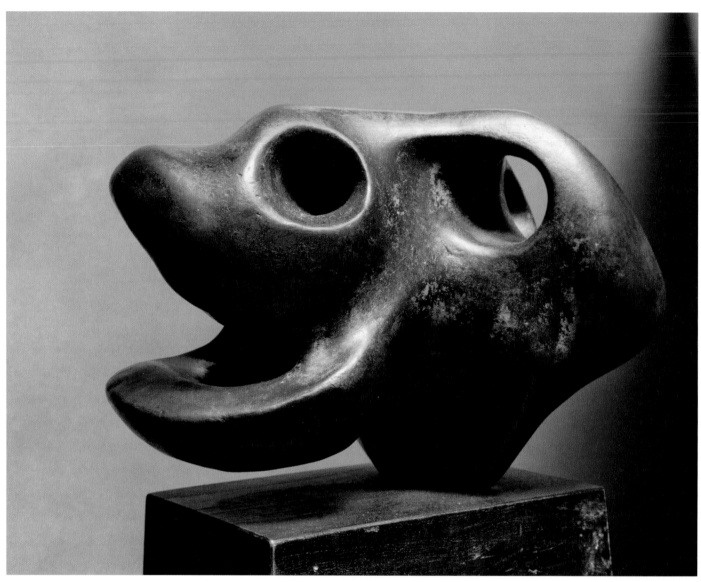

238 *Animal Head*, 1951, Bronze, L. 30.5 cm, Tate Britain, London (LH 301)

The line of the nose and the hole for the eye rise straight up from the triangular, jutting beard. Next comes the high forehead which, hollowed out like a bowl, allows the crown above it to curve outwards all the more freely.

The basic components of the highly complex, interlocking elements of the King's head – triangle, straight edge and circle – had already been prepared in the drawing of *Fabulous Animals*. Looking more closely at the head at the far right of the second bottom row, it seems that this geometric form may well have its roots in Irish imagery. It is interesting to compare this head and that of the calf illustrated at the beginning of the Book of Luke in the mid-twelfth century *Armagh Gospels* (fig. 237)[35] which is held in the library of the British Museum, where Moore might well have looked at it. The miniaturist abstracts St Luke's symbolic animal in his own way. The animal's horns almost form an arc above the creature's head – reminiscent of the crown on the King's head. Although one would not wish to suggest a direct influence here, it is fair to say that Moore's King and the ideas he was working out in the *Fabulous Animals* come close to the lucid diction of early Medieval images of animals in Irish art.

A similar affinity may also be seen between Moore's bronze *Animal Head* (fig. 238) and an illuminated initial in an Irish missal (fig. 239) produced between 1126 and 1134 and now in the library of Corpus Christi College in Oxford.[36] In both instances we see the open jaw and the large, round sunken eye. The tautly rhythmic lines of this planar image of an Irish monster – one of many such creatures – seems to live on, imbued with a new sculptural intensity, in the rhythms of Moore's resonant forms.

The suggestion here that particularly the head of the King stands out as a product of a deep-seated Celtic-Irish heritage is not unconnected to the only comment on the King that the artist himself made public: 'The "clue" to the group is perhaps

the head of the King which is a head and crown, face and beard combined into one form and in my mind has some slight Pan-like suggestion, almost animal, and yet, I think, something Kingly.'[37] Here Moore is alluding to the mythical, imaginative aspect of the King's head, which is ennobled by its connection to the animal world.[38] It has within it a numen, like Egyptian animal deities. But also present in this piece is Pan, who in ancient Greece symbolised the all-embracing divinity of Nature.[39]

This intrinsic oneness with Nature and the regal aura of the couple are nowhere seen to better advantage than on the Scottish hillside that is part of the estate owned by the late Sir William Keswick (1903–1990), who bought the work as early as 1953.[40] A year later the artist visited Keswick's collection and was deeply moved by the naturalness of the way that the figures gaze regally out over the sweeping landscape. For the first time he saw one of his sculptures completely and utterly integrated into a natural setting.

In this situation the sculpture displays the 'essential characteristics' of English art that Herbert Read had already identified in 1933. He took the view that wherever English art placed its trust in the freedom of the line and particularly where it (since Romanticism) was at one with the landscape, it could attain a unique 'magic, beauty and grace'. Moreover, it developed 'a capacity to express almost the inexpressible (or as we might say, the divine)'.[41] Moore's special skill was to anchor this transcendental moment in a powerfully empirical image. This ability to keep his 'feet on the ground' – which Read described as his 'earthly instincts' – comes to the fore in the relaxed yet alert pose of the couple, in their sensitive hands and feet, and in their penetrating gaze.

But there also appears to be a very different kind of empiricism at play in this piece: it seems to me that by unostentatiously referencing the body language of his wife Irina and his own body language, he has in effect created a monument to their closeness. Irina's slim, brittle phenotype – in 1952 she was forty-five years old – the clasped hands we see on drawings (fig. 242)[42] and photographs of her where she is shown seated, her invariably upright posture, her profile and her wholly unpretentious yet highly intelligent aura – all of these are found in Moore's Queen. As Stephen Spender once commented, at her husband's side she was always the 'spectator'.[43] Her reliability was legendary. Whenever friends wanted to purchase one of Moore's drawings, they were always glad of her advice. Yet in conversation she avoided airing her own views on more general art issues.

Irina was born in Kiev into a wealthy Russian family that had been hit hard by the Revolution. She was twenty-one years old and a student of free painting in London when Moore – nine years her senior and already an assistant professor of Sculpture – came into her life. As Moore told his biographer Roger Berthoud in 1978, up to that point he had taken

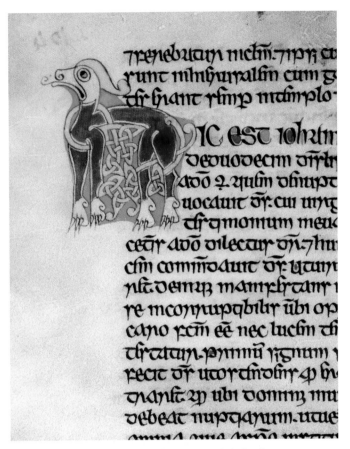

239 *Initial from the Gospel of the Corpus Christi College,* MS. 122 folio 103v, between 1126 und 1134, Corpus Christi College, Bodleian Library, University of Oxford

the view in conversation with his friends, that really serious artists should not marry. It was their duty to be married only to their art, like Michelangelo and Beethoven. 'After meeting Irina I began to say Rembrandt was married, Bach had twenty children.'[44] Throughout his life Moore paid thankful tribute to their long union and to Irina's quiet, yet ever watchful, critical involvement in everything he did. As he wrote in 1968, when his wife was in hospital and complications had arisen in her condition: 'I was terribly distressed and worried, – and completely disorganized in all my routine. I hadn't realized how much my peace of mind for work is based on Irina's help in the background, – but now she is home and daily improving, we are both much happier.'[45] And visitors to the Moores' home could see that Moore was always a little more relaxed when Irina was by his side.

This relationship between Henry and Irina Moore comes across very movingly in a photograph from 1954 that shows the couple seated together in a manner closely related to that of the *King and Queen* (fig. 243). While he is more open and more restless in his manner, Irina appears concentrated and self-contained. His head is slightly bowed, hers slightly raised. Intuitively Moore echoed these poses in *King and Queen*.

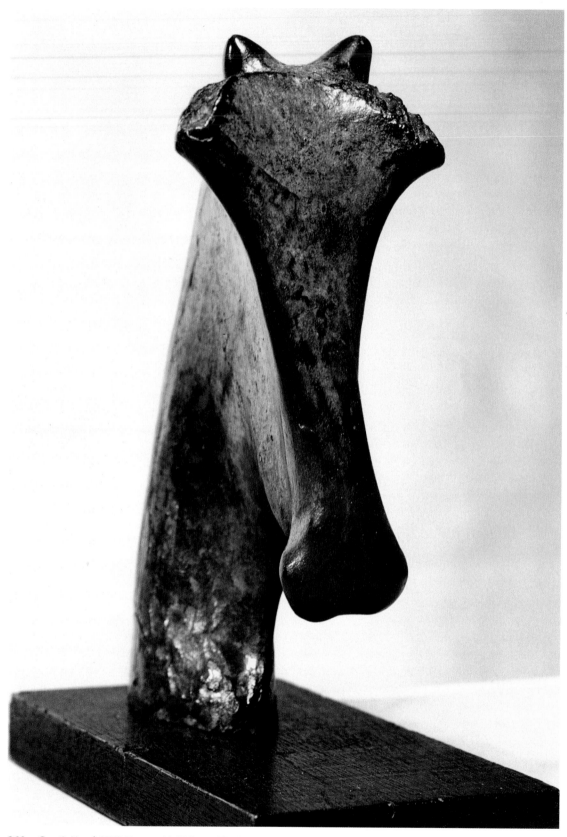

240 *Goat's Head*, 1952, Bronze, H. 20.3 cm, The Henry Moore Foundation (LH 302)

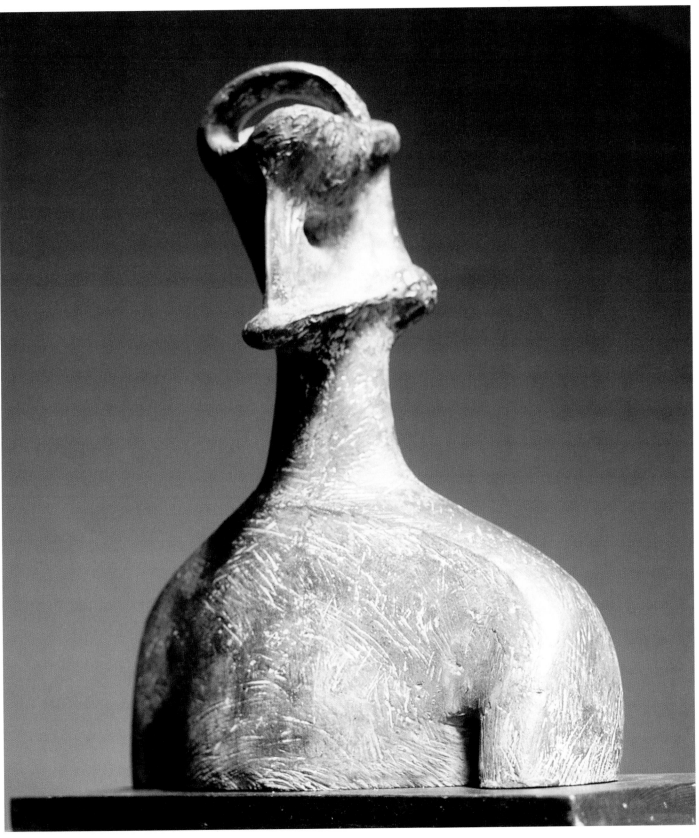

241 *Head of King*, 1952/53, Bronze (unique), H. 57 cm, Arts Council of Great Britain, London (LH 351)

242 *Seated Female Nude*, Oil paint, charcoal, chalk, 56.5 x 38 cm, Contemporary Art Society, Whitworth Art Gallery, Manchester, AG 29.11 (HMF 698)

With so many identificatory connections, it is not unreasonable to suggest that in his alter ego of a King with an animal's head, Moore was not least making an important statement regarding his own approach to art, in particular his allegiance to the notion of constant metamorphosis – of which there is ample evidence in the flowing transitions in his work between figures and the landscape, rocks, stones, shells and bones. And there is one more symptomatic feature in this work: In *King and Queen* Moore drew on the processes of pictorial formation that are also typical of Irish-Anglo-Saxon civilisation and its hybrid creatures. The primitive power, the primordial nature of the faerie world that Moore expressly sought to tap into in his figures, came to him in *King and Queen* from the pictorial origins of his own Englishness.

Fantastic Transformations: Leaf Figures

The fantasy-filled potential for transformation that appeared in a concentrated form in *King and Queen* is also found in other works by Moore. With regard to his sculptural works, one's thoughts turn immediately to the playfully humorous *Leaf Figures* (figs. 244, 245). These were made in 1952, that is to say, they were concurrent with *King and Queen*. They had been preceded by numerous preparatory studies in which the artist gave free reign to his sculptural interest in leaves.[46] How he turned his sculptural eye to the observation of leaves emerges indirectly from a remark made to Vera and John Russell: 'I could get into such a state of looking that the whole of this room and every object in it could become the starting points for a new sculpture. Take those dahlias – you could do a sculpture based on the rhythm of their leaves, and an entirely different one based on that plant over there…'[47] In one of the studies simple, markedly ribbed leaf-forms look as though they have been stuck into a body bandage. In the bronzes Moore turned this cumulative structure and the leaf texture into two- or four-part three-dimensional compositions. Leaves and the human figure interrelate so closely that although it is possible to identify female figures (with breasts and skirts), the structural characteristics of the leaf – its flatness, its gentle curves and the pattern of its ribs – are still completely recognisable

Using these elements, Moore made the *Leaf Figures* so that, in keeping with the human anatomy, more highly differentiated plastic features are evident from the front view. The figure on the left has a concave back. Bolstered by an axial rib, she can stand up straighter than her companion. As we can see from the side view, it is as though this second figure were still learning to walk upright. The idea that Moore was indeed making a humorous play on the process of standing fully upright is also supported by the fact that, to my knowledge,

243 Henry and Irina Moore at Home, Hogland, Much Hadham, 1954

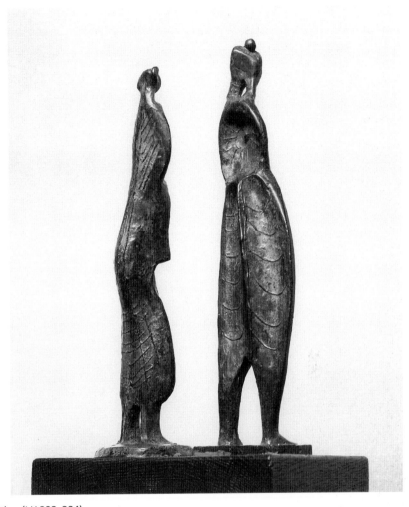

244, 245 *Leaf Figures*, 1952, Bronze, H. 49.5 cm, The Henry Moore Foundation (LH 323, 324)

he always exhibited these two figures together. It may well be that by placing them side by side he was demonstrating to the viewer the sequence of moves involved in gradually standing up straight.

But this still leaves the knobbly shapes of their heads unaccounted for. In order to understand these, it is perhaps useful to be aware of the sculptural status the head generally occupied in Moore's thinking. Its particular importance has been evident time and again in the preceding discussions of certain works. In addition, Moore's own words on this subject to John Hedgecoe should not be overlooked: 'In a figurative sculpture, the head is for me the vital unit. It gives scale to the rest of the sculpture and, apart from its features, its poise on the neck has tremendous significance.'[48]

In what sense, in the *Leaf Figures*, are the heads the 'vital unit'? Their rounded protuberances are at odds with the flat, modelled leaf structures. Where the figures merely imply spherical structures, the heads elevate them into a qualitatively different realm of fully-modelled forms. Thus it is in the head that we see an intensification of the metamorphotic inclinations of the leaf figures towards human being, which is

also manifest in their striving to stand upright. In this 'vital unit' the implication is that the metamorphosis of plants is proceeding in the direction of the human. While Ovid tells of the metamorphosis of mortal beings into elements of the natural world, here – vice versa – in the sculptor's hands the human being reigns supreme. With regard to the fairytale-magical or humorous undertone that permeated Moore's transformations of animals and plants, there are some smaller, playful bronze variations on this theme, such as the female *Standing Figure: Shell Skirt* of 1967,[49] in which the imprint of a shell becomes a pleated skirt out of which the small, armless figure is gracefully rising.

In the years before this, Moore had already been developing his eye for the effects to be achieved by structural mimesis of this kind, which had notably been introduced into the world of sculpture by Picasso with his *Femme au feuillage* of 1934.[50] Amongst the preparatory studies for the large *Two Piece Reclining Figure, No. 2* (fig. 357) there is one example where the shape of the torso is striking for its particular, very individual structural awareness. The piece in question is the second maquette (fig. 246). The hollowed out, female upper

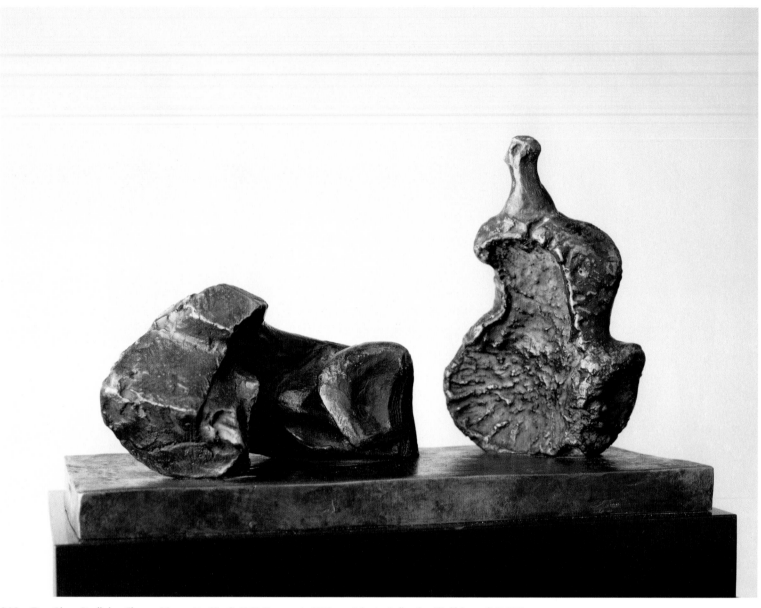

246 *Two Piece Reclining Figure, Maquette No. 2*, 1961, Bronze, L. 25.5 cm, Private Collection Wolfsburg (LH 474)

body has its own amorphously structured inner life that derives from the imprint of a bone. The restless surface relief draws the eye to itself and enlivens the impact of the hollow. This gives the upper body its own innate weight, which it in fact needs to hold its own against the multiple layers of the separate lower body. The heightened vitality of the hollow creates the impression that the lower body, stretched out on the ground, had only just separated from the upper. It was from complex tensions of this kind that Moore developed the robust 'landscaping' of his *Two Piece Reclining Figure, No. 2*.

A comparable level of metaphorical meaning also occurs in the 1964 work on paper, *Gourd Women* (fig. 247). For all the humour of these figures, there are also more fundamental issues in play here. The sheet is marked at the top with the words 'Fruit Women'. The breasts and arms of the generously

proportioned *Gourd Women* – painted in warm yellows and oranges – are one with the upper body. Underpinning an image of this kind are Moore's thoughts from 1937; written in the middle of his surrealist period, he talks here of the associative content of certain shapes: 'It might seem from what I have said of shape and form that I regard them as ends in themselves. Far from it. I am very much aware that associational, psychological factors play a large part in sculpture. The meaning and significance of form itself probably depends on the countless associations of man's history. For example, rounded forms convey an idea of fruitfulness, maturity, probably because the earth, women's breasts, and most fruits are rounded, and these shapes are important because they have this background in our habits of perception. I think the humanist organic element will always be for me of fundamental importance in sculpture, giving sculpture its vitality.'[51]

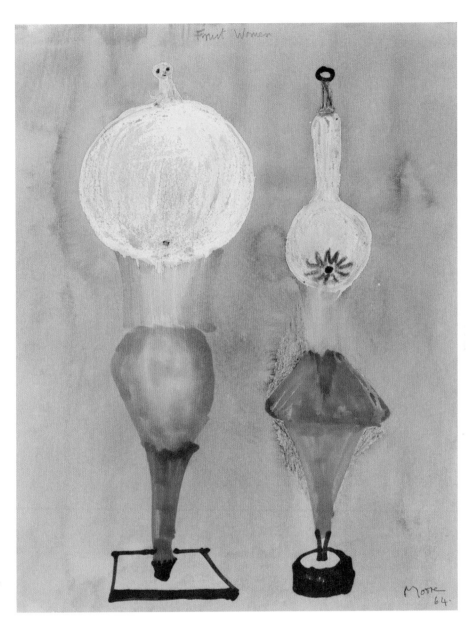

247 *Gourd Women*, 1964, Wax crayon, coloured crayon, pastel, felt-tipped pen, watercolour wash, The Henry Moore Family Collection, 29.2 x 22.9 cm, AG 64.16 (HMF 3104)

On the evidence of the examples discussed here, it is clear that Moore's introduction of a human-organic element to the 'form in itself' could at times take him into the realms of pure fantasy, although never to the detriment of his fundamental interests and concerns with regard to form.

The Glenkiln Cross and the Semantics of Irish High Crosses

A very different, much more puzzling – intrinsically ambivalent – level of meaning is found in the group of *Upright Motives* of 1955–56 (fig. 248). In order to understand them in their Englishness rather better, it is necessary to take a closer look at these pieces. Their story gets off to a somewhat complicated start, with two completely separate commissions for sculptures. Initially, as Moore later recalled, in 1945 he was asked to create a sculpture for the courtyard of a new office building for the Olivetti company in Milan. In his view, the sculpture would have to hold its own against 'horizontal rhythm of the building' and 'for contrast... should have an upright rhythm'[52] or 'upright motives'.

For the purposes of this commission, which was not to come to fruition, Moore made thirteen maquettes between twenty-three and thirty centimetres in height. Some of these he chose to take further as sculptures in their own right and realised Nos. 1, 2, 5, 7 and 8 in full size, up to two or three metres in height. Of these, No. 1 was the crowing glory of the group as a whole. It was soon bought by the Scottish collector Sir William Keswick and, following its installation on a hillside above a loch at Glenkiln Farm (Shawhead, Dumfries), it was named the *Glenkiln Cross* (fig. 248).[53]

The work on the *Upright Motives*, which increasingly became independent entities, was preceded by another com-

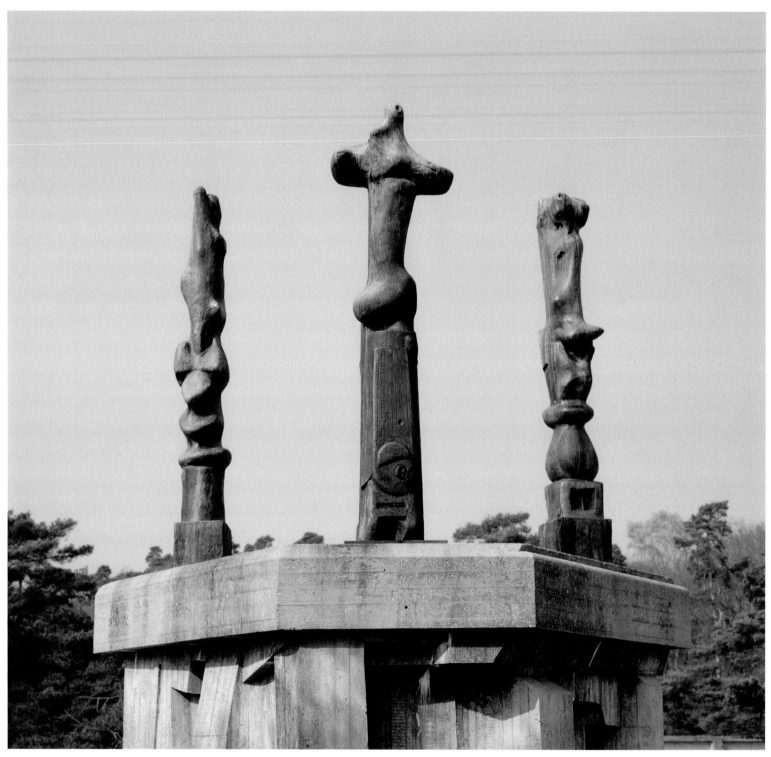

248 *Upright Motive No. 7*, 1955–56, Bronze, H. 320 cm, *Upright Motive No. 1: Glenkiln Cross*, 1955/56, Bronze, H. 335.5 cm, *Upright Motive No. 2*, 1955–56, Bronze, H. 320 cm, Tate Britain, London (LH 386, 377, 379)

mission, first identified in 1988 by Peyton Skipwith.[54] From research carried out in Linz into the estate of the Austrian-English architect Michael Rosenauer (1884–1971), the present author has been able to bring to light yet another commission issued to Moore in 1954. Moore and Rosenauer had already successfully collaborated in 1952–53 on the construction of

a screen for the *Time Life Building* (fig. 411)[55] in London's Bond Street. In 1954 Rosenauer submitted a competition entry for offices for the English Electric Company, with a sculptural design by Moore. The plans show six *Upright Forms* along the main façade (fig. 249), which were to extend above the height of the second floor windows. Unfortunately this project, too,

249 Michael Rosenauer/Henry Moore: Photography from the model of *Fassade English Electric Company Building,* London 1955. Whereabouts of the original plan are unknown, Nordico – Museum der Stadt Linz, Michael Rosenauer Estate

250 *Sketchbook B. Ideas for sculpture,* c. 1935, Pencil, 13.8 x 22 cm, The Henry Moore Foundation, AG 35.47 (HMF 1236)

was not to be successful. The maquettes for the six mighty column-figures are now on show in the Leeds City Art Galleries.[56] The vocabulary of these figures is consistently abstract. Predominantly geometric elements are piled one on top of the other. Blocks and irregularly placed cubes or discs articulate the verticals, which vacillate between pillar and column. Only two of the maquettes look as though they may terminate in biomorphous tips. What is seen here in an inchoate form was to bear fruit in the intenser biomorphism of the slightly later Milan maquettes. So far it has gone unnoticed that in the bindings of the six maquettes for the English Electric Company building there are two occurrences of a characteristic relief image which then reappears on the plinth of the *Glenkiln Cross.* It is above the motif that Moore later described as a 'ladder'.[57] In this feature – with strings over a relief-like 'half moon' which itself curves above an 'eye' – Moore is citing an as yet unexplained motif from an Oceanic sculpture of a head or fragment of a door, which he copied from a book illustration in 1935[58] and later used as a cover design for the

magazine *Poetry London.*[59] On the first drawing of 1935 (fig. 250) Moore wrote the words 'New Ireland Strings'.[60]

Given that at the base of the *Glenkiln Cross* Moore expressly used the Oceanic string motif (which was incorporated into an abstract pattern on the maquettes for Blumenauer), he must have attached some special meaning to this musical motif. But what could the meaning be? In our search for an answer to this question, we have to bear in mind that Moore himself saw the *Glenkiln Cross* as a representation of a crucifix. As he later recalled, the *Upright Motives* became increasingly organic, 'and then one in particular (later to be named The *Glenkiln Cross*) took on the shape of a crucifix – a kind of worn-down body and a cross merged into one'.[61]

The *Glenkiln Cross* itself consists of a lower, rounded column section out of which grows the strikingly elongated torso, starting at the hips. At chest level the biomorphous body divides into two horizontal, outstretched arm stumps, above which there is a curtailed head. An easily identifiable

251 *Upright Motive: Maquette No. 1*, 1955, Bronze, H. 30.5 cm, The Hirshhorn Museum and Sculpture Garden, Washington (LH 376)

When Will Grohmann embarked on the first detailed discussion of the *Upright Motives* in his 1960 monograph, he was able to draw on his own experience of conversations with Moore and his friends: 'They are sometimes known as… "Scottish crosses", after the tall crosses in Scotland, Ireland and Wales dating from the early Middle Ages.'[63] This information, which Grohmann does not elaborate upon, seems to me worthy of note. The *Glenkiln Cross* does indeed have certain features in common with Irish high crosses, such as the division into a lower section and a cross.[64] In addition to this, in a sense the body adopting the shape of a cross recalls a particular type of Irish cross where it is as though the body of Christ had become one with the cross, as in the case of the anthropomorphic Celtic cross on the Island of Skellig Michael[65] or the Kilbroney Cross in the northeast of the same island (fig. 252).[66] Both of these crosses date from the fifth to the seventh centuries. And the taut strings on the column also have specifically Irish connotations, for relief images of David with his harp, as a forerunner of Christ, and other aspects of David's life were regularly included in the imagery adorning Irish high crosses.[67] Moreover, the 'ladder motif' that Moore himself alluded to in the context of a Crucifixion scene, was also widely found on Irish high crosses.[68]

So it seems that Grohmann's reference to possible connections between the *Glenkiln Cross* and early medieval Irish-Scottish high crosses was well founded. Seen against the sky on a lonely hillside, with its triumphant gesture and the vitality of its biomorphous forms, this work vividly calls to mind hope-filled images of Christ on Irish high crosses, where He is always shown as a still living figure. And in many instances He is even encircled by sunrays, symbolising the coming Resurrection of the crucified Christ.

eye at the front and another at the back of the head convey a sense of an all-seeing being.

Moore later found that the *Glenkiln Cross* and two other *Upright Motives* looked to him like the Crucifixion scene at Golgotha (fig. 248).[62] In the case of the crosses bearing the two thieves, the forms are less obviously human. In *Upright Motive No. 7* one has a sense of arms being stretched out above the figure's head and in *Upright Motive No. 2* it is as though the head had sunk deep into the shoulders. Both of these forms create the impression of coercion and torment, whereas the *Glenkiln Cross* (fig. 251), placed in the centre, appears to relish its own spatial freedom. A very different, singular existence triumphantly makes its presence felt in this work.

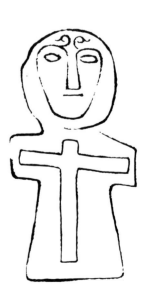

252 *Cross Stone of Kilbroney*, Irland, 5th.–7th. century

The Legacy of Stonehenge

The paths that the sculptor Henry Moore followed to Stonehenge on Salisbury Plain were many and varied, but the goal was always the same: to absorb what he could of Stonehenge for his own artistic work. For him it was only the stones themselves that mattered; he was less interested in the story of the lengthy construction work that went into making this sacred site or in the astronomic calculations that may have determined its layout. Above all, Moore was fascinated by the mystery of the greyish-green sandstone giants that so eloquently stood as evidence of a prehistoric cult or burial site. Through them, Moore was able momentarily to experience the sublime. We will later come back to his response to the Romantic notions of Stonehenge in the work of artists such as Blake, Turner and Constable.[69]

The long story – lasting many decades – of Moore's contemplation of Stonehenge began in a way that he was never to forget: in late September or early October 1921 he travelled from Chelsea to visit the stone circle, or rather its surviving fragments, on the lonely expanses of Salisbury Plain. There he found a site measuring some thirty metres in diameter; the remaining stones – some toppled over, some still standing – 'are each around a metre in depth, roughly two metres wide and a good four metres high. The stones are placed roughly one metre apart. These standing stones were originally all topped by horizontal lintels, of which only six are still in place… The stone used for these blocks is a type of sandstone known as sarsen. Originally a reddish-brown, the Stonehenge sarsens have taken on a grey-green tinge from the moss that covers their surfaces.'[70] As Moore will no doubt instantly have realised when he touched them, the stones have been very carefully worked. What else would he have seen? Let us stay with Bernhard Maier's description: '…the upright sarsens that make up the stone circle and the horse shoe are not hewn as exact rectangles but narrow slightly towards the top, possibly to create the illusion of even greater height. Neither are the long sides of the lintels straight, but are instead curved to follow the perimeter of the circle. As one can see in some places – for instance in the case of the large standing stones in the central trilithons and the lintels, now lying on the ground – the lintels do not simply lie on the standing stones but, as in joinery work, are secured in place by tenons (on the standing stones) and mortises (in the lintels).'[71]

It is likely that Moore did not see all the relevant details of the structure on that initial visit in 1921 because he first arrived there on a moonlit evening. The site could not have made a greater impression on the twenty-three year old. Even in his old age he remembered every detail: 'Moonlight is a great enlarger. The forms were simplified. It was a great emotional impact.'[72] In conversation with the present author, he remarked that at the time he had no knowledge of its 'symbolic meaning for Druids and so on'. For him, the impact of the

mighty blocks was enough. In his view, this level of 'solidity' and 'personality' was only to be found in stones, not in plants (pointing out towards the garden at Much Hadham as he spoke). And it was for this reason that in the past people had often given special names to stones and revered them. 'Only what is larger-than-life, can be worshipped above us. It's a question of scale. I am always very aware of this.'[73] This experience, where the huge stones appeared to have their own 'personalities' and the magic of the place was heightened by the light of the moon – these two seminal moments were to become constants in Moore's creative engagement with Stonehenge. Remarkably, he only found an independent visual form for these experiences when, in the midst of his surrealist period, he started to think about the transformations that could be effected in objects. Moore's surrealist response to Stonehenge, which first emerges in 1933, was also coloured by two other factors. Firstly, in 1930 the journal *Documents* (no. 7), produced in Paris. Georges Bataille, Carl Einstein and Michel Leiris – all three champions of Surrealism – had already published an article on Stonehenge by Adama van Scheltema: 'Le centre féminin sacré. On Stonehenge and ritual circles'.[74] Clearly the mystery of Stonehenge also preoccupied the Surrealists in Paris. Secondly, there was a keen interest in Stonehenge and British megaliths in general amongst other artists in Moore's circle of friends.

Since late 1932 Moore had been working closely with Paul Nash, preparing materials to be published by the group Unit One.[75] Nash knew Stonehenge and was also particularly fascinated by the stone avenues at Avebury. He photographed everything that had what he called the 'primal magic of the stones.'[76] Later, in 1934, from the photograph 'Stone Personage' he derived a number of motifs for paintings that were to become very well known, works such as *Druid Landscape*, *Stone Tree* and *Landscape of the Megaliths*[77]. Looking back at that time, Nash himself remarked that 'The beauty and mystery of the megaliths was something peculiar in a different sense, I think mainly a formal sense, their coloring and pattern, Dream.'[78] In the same way that Nash wanted to replicate these poetic moments in his surreal landscapes, Moore also wanted – and had the skill – primarily to engage with Stonehenge with regard to the artistic issues he was dealing with at the time. A useful light is thrown on this by a passage from a letter (replying to a longer letter from Paul Nash) written on 15 September 1933, in which he describes the stones at Avebury that he had photographed in July of that year. Moore writes: 'I've read somewhere that certain primitive people coming across a large block of stone in their wanderings would worship it as a god – which is easy to understand, for there's a sense of immense power about a large rough-shaped lump of rock or stone. A mechanical rectangular block bought from a stone merchant hasn't this power but begins to get it after the first two or three days carving & it's always a

253 *Ideas for Sculpture*, 1933, charcoal (washed), pen and ink (washed), 55.1 x 38.1 cm, The Henry Moore Family
Collection, AG 33.39 (HMF 1008)

disappointment to go from this first hacked out stage on to the next nibbled stage – the third and finishing stage brings more subtlety of shape & if the carving is any good as sculpture something of the first power comes back too… A great wish I have is to build (and design) my own place to work in and to have it big enough to set up in the middle of it a large rough-axed monolith much as one of the Stonehenge pieces, and near it, & of about the same size a part of the trunk of a big tree (such as some there are near here, in Waldershare Park). Working with them in sight there'd be less risk of being sidetracked so often from real sculpture.'[79]

These lines show what direct use the thirty-five year old sculptor wanted to make of his memories of the carefully hewn stones at Stonehenge and other sacred sites. His comment that it is only after some days work that a new block begins to exude something of the power of the monolith but that this then progressively diminishes as the work proceeds, and will only return – in the best case scenario – when the sculpture reaches completion, describes a creative work process that steadily spirals to a higher level. Picasso is also known to have observed something similar. And in the years leading up to this point, as we have seen, when Moore was working on a stone block he wanted above all to retain its 'stoniness'. Now the same aim is overlaid by the mystery of Stonehenge, that is to say, the pure aesthetic of the material is enriched by a new sense of magic.[80]

The extent to which the notion of Stonehenge served as a formula of sorts for Moore, is evident from a drawing made in 1933, possibly at much the same time as Moore's comment to Nash (fig. 253).[81] Left of the throng of sketches – unified by layered washes – there is a semi-abstract, standing figure on its own, marked with the word 'Stonehenge'. If anything, the head of this figure resembles the image of a recumbent figure that stands out in the centre of this diaphanous mass. In other words, this Stonehenge figure is also associated with the notion of a shrouded human form.[82]

The following year, in 1934, Moore included similar Stonehenge forms in a drawing entitled *Monoliths* (fig. 86). We have already referred to this drawing in Chapter I.2 in connection with Moore's response to Giacometti's table sculptures. Moore's 'architectonical setting'[83] was imbued with memories of prehistoric monuments. In the centre of the bottom of the sheet he sketched, as we have seen, is a megalithic ring with a menhir resting on it, reminiscent of the well-known *Mên-an-tol* in Cornwall, a burial site from 2400 BC (fig. 87). This explicit reference to an important prehistoric site predates similar works by Barbara Hepworth. A contemporary critic, reviewing her 'single form' sculptures of 1937–38 and her earlier ring-shaped works, was in no doubt as to the connection with *Mên-an-tol* and menhirs.[84]

In 1935, in Moore's wilder, surreal imagination the figure and the 'architectonical setting' interconnected in such a way

254 *Ideas for sculpture and Artist's notes*, 1937, Pencil, pen and ink, chalk, 27.2 x 18.4 cm, Sotheby's London 1989, AG 37.67r (HMF 1341)

that on one of his drawings he made a note reminding himself to 'do some architectural stonehenge ones'. It is also significant that in 1937, when he was making notes with page numbers from Leo Frobenius's standard work *Kulturgeschichte Afrikas* of 1933, he added the instruction to himself: 'Try also stonehenge drawing' (fig. 254).[85] To the lower left of this comment is a figure which, with multiple angular hollows, is reminiscent of one the *Monoliths* of 1934.

This drawing with its reference to Stonehenge did not exist in an artistic vacuum. In 1937, in the avant-garde journal *Circle*, when Barbara Hepworth published her seminal article 'Sculpture' in the cause of a better understanding of constructive sculpture, she illustrated the text with photographs of

255 *Stonehenge XI: Cyclops*, 1973, lithography, 45.1 x 28.9 cm (CGM 218)

256 *Stonehenge XIII: Arm and Body*, 1973, lithography, 29.2 x 45.5 cm (CGM 220)

Stonehenge.[86] This indirect utilisation of Stonehenge in support of her pure, tectonic, abstract sculpture came after Moore's drawings of 1933. Moore's interest in Stonehenge was concerned with the duality of figure and architectural monument. And it is highly likely that his surrealist reflections on a newly invigorated form of architectural sculpture played a part in this.[87]

It was precisely this ambivalence between invigorated figure and monument that coloured his later – one might even say, more important – engagement with Stonehenge. This culminated in 1972–73 in the publication of his *Stonehenge Suite* – a series of fifteen lithographs plus an etching for the standard edition and sixteen lithographs and three etchings for the luxury edition.[88] The finished works were preceded by drawings in either chalk or pen and ink.[89] Having made numerous studies (drawings and photographs) in situ – according to Moore's own estimate he must have visited Stonehenge somewhere between twenty and thirty times[90] –

in the end he relied mainly on detailed photographs that his assistant, Michel Muller, had specifically taken for him.[91] While the etchings portrayed a more distant view of parts of the stone circle, the softer tones of the lithographs were particularly suited to depictions of the eroded surfaces of the stones.[92] By means of carefully chosen viewpoints and surprising angles, Moore devised a special dramaturgy for the stone monsters. On each sheet he explored anew their 'personalities', at times approaching very close to their huge forms and finding correspondences with aspects of his own work. Under his gaze fissures in the stone came to represent the profound depths of the uncanny,[93] interstices closed up into caves (see *Moonlit Blackness*), gigantic heads almost seem to rub up against pillars, with his old motif of almost-touching[94] making an appearance in *Cyclops* (fig. 255), and, in *Arm and Body* (fig. 256), the sucking navel-hole opens up positively primal insights into the distant phenomenon of the human being. In all of these works, Moore never lightened the sombre mood

of the Stonehenge sarsens nor did he lessen their innate magic that he was always alive to after that first unforgettable visit by moonlight. In his very useful introduction to the *Stonehenge Suite*, Stephen Spender rightly talks of these lithographs and etchings as an 'autobiographical series'.[95]

The Romantic View of Stonehenge

This personal reaction to Stonehenge, that is to say, the way in which Moore the sculptor introduced 'his' stones into the magical ring in 1972–73, was only the latest stage in a long line of pictorial responses to Stonehenge in English art. In concentrating fully on his own individual sculptural understanding of the stones and their sublime nature, Moore was in his own way adopting a Romantic attitude to Stonehenge, in keeping with that of artists such as Blake, Turner and Constable. All three had advanced far beyond the earlier tradition of topographical representations of Stonehenge by the introduction of the sublime into their own compositions. A few select examples should suffice to illuminate this point.

Whenever William Blake made reference to Stonehenge in his images, he would cite characteristic architectural elements. Generally this would be a trilithon, sometimes two or three that he would show side by side on a hillside as in the illuminated books *Milton, a Poem* (1804–10/11)[96] and *Jerusalem* (1804–20). In *Jerusalem* alone the Stonehenge motif appears four times and is once specifically referred to in the text (p. 94D).[97] In the spirit of *pars pro toto*, these motifs stand for all things sacred. Blake regarded Stonehenge primarily as a source of national identity, as a ritual site for Druids and, as such, a place associated with atavistic cult practices that he, as a Christian, wanted to see halted. In one of the best known illustrations for *Jerusalem* (fig. 257),[98] Blake depicted a positively gigantic megalithic gateway. Stepping through it is the prophetess Vala in her threefold beauty. Whether this gateway in fact had its origins in an eccentric representation of Stonehenge published in an important study from that period by William Stukeley (1740),[99] and whether it was from here that Blake drew his now revised interpretation of the prehistoric complex as a ritual site for the Druids (supposedly constructed between the fifth and first centuries BC), two particular aspects of Blake's Romantic images of Stonehenge were to be of importance for the future of this pictorial tradition: the broken, moonlit sky heightening the pathos of the scene and the dramatic view from below of the roughly hewn stone blocks. Both of these elements intensify the sense of the sublime and, as we have seen, were to directly influence later artists up to and including Moore.

Unlike Blake, Turner and Constable, later on, only ever portrayed Stonehenge in its entirety in their views of the ruins of this ancient sacred site. And in so doing, they were seeking to emphasise the lonely, sublime nature of the area and the

257 William Blake, *Jerusalem* (Bentley Copy E) 1804–20, Pl. 70, etching with ink, 21.9 x 15.9 cm, Yale Center for British Art, Paul Mellon Collection, USA

'grandeur of idea'[100] it embodied. This was further intensified by scudding clouds and a skyscape that seemed to play an active part in the whole, its vast expanses arching over the ruins and dramatically reinforcing the artistic effect. Thus Stonehenge is seen to have a mysterious, atmospheric focus which is in turn permeated by the sublime. Having visited Salisbury Plain in 1820,[101] Constable later described how powerfully its mysteriously alien nature affected him. In a text written in 1835 to accompany his most famous image of Stonehenge – a watercolour showing the site backed by a double rainbow (fig. 258) [102] – when it was included in an exhibition at the Royal Academy, he set the scene: 'The mysterious monument of Stonehenge, standing remote on a bare and boundless heath, as much unconnected with the events of past ages as it is with the uses of the present, carries you

258 John Constable, *Stonehenge*, 1835, Watercolour, 39 x 59 cm, Victoria & Albert Museum, London. Bequeathed by Isabel Constable

back beyond all historical record into the obscurity of a totally unknown period.'[103]

Moore, heir to Constable's Romantic view of Stonehenge with connotations of the sublime, also brought out the stones' inherent mystery in his compositions. But unlike Constable, he never embarked on a painterly overview. Instead he went in much closer. As we have seen, in his eyes the monoliths had personalities and what Nash had referred to as 'primal magic'. And with the discovery – in this configuration of stones that meant so much to him – of connections to his own sculptural interests and themes, they became benchmarks for his own sculptural ideals.

Moore and the English Romantics

Moore's Englishness[104] is seen yet again in his relationship to the Romantic art of his native country. Peter Fuller has rightly identified elements of this Romantic tradition in Moore's sculptural analogies to the landscape.[105] We discussed this topic in some detail in Chapter I.2 with reference to specific *Reclining Figures* made between 1938 and 1965. In these cases, Moore's interest in merging notions of landscape with the human figure derived primarily from his engagement with surrealist ideas. As we saw, it was through certain 'Surrealist'

drawings exploring, amongst other things, the 'double image' developed by Brassaï, Dalí and Miró, that Moore arrived at corresponding three-dimensional forms. In these the human figure became one with the forms found in hillsides and rock formations. In this context Moore's invention of his multi-part reclining figures took on a special significance. As he himself said of his key work of 1959, *Two-Piece Reclining Figure, No. 1* (fig. 125): 'I realised what an advantage a separated two-piece composition could have in relating figures to landscape. Knees and breasts are mountains. Once these two parts become separated you don't expect it to be a naturalistic figure; therefore, you can justifiably make it like a landscape or a rock... As I was doing it, I kept being reminded of *The Rock at Etretat*, the picture by Seurat... It is this mixture of figure and landscape. It's what I try in my sculpture. It's a metaphor of the human relationship with the earth, with mountains and Landscape. Like in poetry you can say that the mountains skipped like rams. The sculpture itself is a metaphor like the poem.'[106]

In view of Moore's surreal reference to such a Wordsworthian metaphor,[107] it is worth remembering that in 1939 Moore was regarded as a Surrealist by other members of the London art scene.[108] In 1940 he participated in the group exhibition *Surrealism Today* at the Zwemmer Gallery in London.

Many felt that the Romantic movement lived on in the aims of the English Surrealists. In his compendium, *Surrealism*, published in November 1936 following the major Surrealism exhibition in London, Herbert Read made the point that in many respects, where English Surrealism was at odds with Naturalism, it was in line with Romantic poetry and painting. Both movements, Surrealism and Romanticism, valued the imagination and all that is wondrous. In this connection Read made specific reference to Byron, Keats, Shelley, Wordsworth, Coleridge, Blake, Constable and Turner.[109] In the same publication Hugh Sykes Davies declared: 'In all the essentials of romanticism, Surrealism continues the earlier movement.'[110]

Moore did at least once refer directly to Wordsworth, that great visionary who yearned for harmony between Nature and humankind. In 1941, in conversation with Kenneth Clark and Graham Sutherland he alluded to Wordsworth in connection with his own approach to the landscape. In this short exchange, Clark speaks first: 'And that is that the art of landscape did develop comparatively recently in the history of painting precisely because it took a long time for the old painters to realise that landscape could be made to express all the qualities of moral grandeur and human destiny and so forth… I do believe that great landscapes must be painted with a pervading sense of human values… That's why, to my mind, a painter must know his landscape intimately. He must belong to it, and it to him… Yes, in a way it's a Wordsworthian relationship with nature, isn't it?' To which Moore replies: 'Yes, Wordsworth often personified objects in nature and gave them the human aspect, and personally I have done rather the reverse process in sculptures. I've often found that by taking formal ideas from landscape, and putting them into my sculpture I have, as it were, related a human figure to a mountain, and so got the same effect as a metaphor in painting.'[111]

1949 saw the publication of Clark's book on the history of landscape painting, *Landscape into Art*. In it Clark discusses in detail two artists – Constable and Turner – whose influence is seen in some of Moore's late drawings from the 1970s and 80s. Ignoring chronology, we will look first at these two artists in this discussion of Moore's relationship to the Romantic movement, since their influence is sporadic and predominantly evident in the late works. This will be followed by a much closer examination of Blake's importance for Moore. Blake preoccupied Moore on a much deeper level, as a freethinker in terms of his politics, as a daringly experimental artist and as a great poet, but also for his attitudes and the visionary ideas embedded in his ever fluid vocabulary of lines and forms.

John Constable

In the drawings he made in his old age, Moore not only sought to deepen his understanding of forms through his study of an elephant's skull or of the lives of the sheep that grazed on his land; between 1975 and 1981 he devoted equal attention to his study of the trees that flourished in his grounds in Much Hadham. All these drawings are executed in charcoal, some with a wash or additional touches in watercolour. Three main themes predominate in these drawings: firstly, wider views of woodlands or fruit trees (always with visible gaps between the trees); secondly, the networks of branches in the crowns of trees; thirdly, root formations with the lower section of the trunk leading upwards from the roots. This third motif occurs with the greatest frequency. Evidently Moore was fascinated by the accumulation of energy in the roots and the constrained, bodily movement of the trunks growing upwards and into the branches.

In a particularly memorable drawing of this type (fig. 260), which was based on a coloured lithograph,[112] it seems that Moore is taking the Wordsworthian path. For here, where a thinner ivy plant is seen climbing up a massive oak tree trunk, Nature serves as a metaphor. It evokes the human situation of a couple, with the tree appearing all the more solid in comparison to the finer ivy; its mighty upwards progress is underlined by the fluidity of its bark formation.

In a comparable composition, Constable portrayed a similarly powerful three-dimensional presence in his small oil painting, *Study of the Trunk of an Elm Tree* (c. 1821; fig. 259). This study is in the collection of the Victoria & Albert Museum, where Moore will certainly not have missed it in amongst the many innovative sketches by his predecessor.[113] Above all he will not have failed to observe Constable's 'ecstatic love of trees'.[114] In the *Study of the Trunk of an Elm Tree* we see not only all the various elements that are associated with Constable's vibrant interplay of light and shade, which he himself called his 'chiaroscuro of nature', but also the way that his natural scenes seem to live and breathe. And, to judge by Moore's later highly charged landscapes and cloud scenarios, it appears that he had observed and adopted Constable's avowed determination to preserve the 'first sensation'[115] of the pictorial idea that leads to the final work.[116]

Joseph Mallord William Turner

In a slightly daring formulation, one might say that the Moore's drawings began and ended with Turner. His earliest surviving drawing (fig. 261), made when he was seventeen years old in the National Gallery in London, is a watercolour copy of Turner's masterpiece, *Ulysses Deriding Polyphemus – Homer's Odyssey*, of 1829 (fig. 262).[117] And as an old man, in 1982–83, in a series of seascapes and cloud compositions,[118] Moore still has an eye to his predecessor and his dissolution of forms in his late, atmospheric works.

In the early copy by the aspiring artist, one detail already stands out: whether deliberately or not, the young Moore has turned the 'reclining figure' of the giant Polyphemus into a

259 John Constable, *Study of the Trunk of an Elm Tree*, c. 1821, Oil on paper, 30.6 x 24.8 cm, Victoria & Albert Museum, London. Bequeathed by Isabel Constable

260 *Tree with Ivy (Oak and Ivy)*, 1978, Charcoal, watercolour on blotting paper, 28.3 x 22.1 cm, The Henry Moore Foundation, AG 78.5 (HMF 78(5))

mountain or cloud formation. In this he adds a pictorial element that Turner had intentionally left in a state of some ambiguity. It seems that in this composition Moore is already anticipating a later theme of his Romantic-Surrealist output, when he was exploring analogies between the human figure and the landscape.

In his old age, Moore was able to acquire a late watercolour by Turner. The setting sun is reflected in the water at the lower left of the sheet, while banks of mist and a bright cloud of light pass across and obscure the adjoining rocky landscape. Moore must particularly have liked the atmospheric nature of the composition.[119] A comment by the artist himself explains what mattered to him in a work such as this: 'Turner – whether on canvas or paper – can create almost measurable distances of space and air – air that you can draw, in which you can work out what the section through it would be. The space he [Turner] creates is not emptiness, it is filled with "solid" atmosphere.'[120] Evidently Moore saw in Turner's handling of space an affirmation of his own efforts to give solidity to the space that interacted with his sculptural forms.

In the 1982 watercolour *Rock, Sea and Sky* (fig. 263) phosphorescent light and glowing air above the water is clearly related to Turner's *Staffa, Fingal's Cave* of 1832.[121]

Similarly, *Mountain Landscape with Clouds* (fig. 264) also has an affinity with Turner's work. In this sheet Moore is starting to reflect on the calculable spatial distances that he had seen in the work of his predecessor. Moore's mountains are cloudier and the rolling clouds more solid than in the incomparably more ethereal works by the Romantic painter. In this mutual appropriation of substance, or rather, in this qualitative transition from rock to cloud, Moore the sculptor was taking a wholly contemporary approach to Turner's late openness regarding the relationships between different forms.

In 1936, when Herbert Read declared that it was time to reassess Turner's work, the latter had already completed his triumphal progress through the ateliers of artists in continental Europe. The work of Monet, Moreau and Signac would have been unthinkable without Turner's influence, and the same can be said of the work of Max Ernst, Mark Rothko and even Jackson Pollock later on.[122] Amongst all the many reci-

261 *Sketch after J. M. W. Turner's Ulysses Deriding Polyphemus*, 1916, watercolour, 7.7 x 12.7 cm, Wakefield City Art Gallery, AG 16.1 (HMF 16 (1))

262 William Turner, *Odysseus taunting Polyphem – Homers Odyssee*, 1829, Oil on canvas, 132.5 x 203 cm, National Gallery, London

263 *Rock, Sea and Sky*, 1982, Charcoal, pastel, watercolour, chalk, ballpoint pen, 19.2 x 28.2 cm, The Henry Moore Foundation, AG 82.367 (HMF 82(376))

pients of Turner's work, Moore is probably the only sculptor who for decades took very much the same compositional approach as Turner.[123] This alone should be enough to remove any lingering doubts as to Moore's innate Romanticism. But it is only in his response to the work of William Blake that we see the full extent and depth of his Romantic leanings.

William Blake

Blake's metaphysical pictorial work, his lonely struggle against the supremacy of reason, his rebellious artistic nature, his insistence on the reality of his visions, his passionate renewal of the essence of the imagination – all these qualities together placed the artist whom Herbert Read called the 'Superrealist' in the front rank of the Romantic forefathers of the English avant-garde. It was not only the London Surrealists and their continental counterparts,[124] but also those English artists who, between 1935 and 1955, were counted amongst the Neo-Romantics, that were ardent champions of Blake's work.[125] Unlike today, when Blake's much-loved poem 'The Tiger' has achieved the 'status of a worldly hymn'[126] amongst the wider

British public, in the early decades of the twentieth century it was only the artists, poets and writers who respected and admired him.

Before embarking on a closer examination of Moore's interest in the work of William Blake, it is perhaps useful to sketch in responses to Blake amongst Moore's contemporaries, that is to say, Herbert Read, Paul Nash, Graham Sutherland and John Craxton. From the sources available to us today, it is clear that these artists also forayed into the same Blake-continent that Moore explored in its many aspects. It is all the more useful to form a picture of these contemporary responses since Moore left behind so little written evidence of his own thinking. Despite this paucity of material, however, there can be no doubt as to his great admiration for Blake's work. It was central to his own artistic approach.

As a young poet Herbert Read was already drawn to Blake, and his *Songs of Chaos* of 1915 are clearly influenced by both Blake and W. B. Yeats. Looking back at those early years, Read wrote: 'It was then that the poetry of William Blake descended on me like an apocalypse. Tennyson had chimed in with my moods and shown me felicity. Blake shook me to the depths

264 *Mountain Landscape with Clouds*, 1982, Charcoal, pastel, watercolour wash, ballpoint pen, pencil on wove, 21.7 x 15.3 cm, The Henry Moore Foundation, AG 82.434 (HMF 82(443))

265 Paul Nash: *Monster Field*, 1939, Photography, Paul Nash Estate

266 William Blake: *Pity*, c. 1795, colour print and finished in pen and watercolour, 42.5 x 53.9 cm, Tate Britain, London

of my awakening mind... there is no poet with whom I would more readily identify the poetic essence. For me Blake is absolute.'[127] Another writer who frequently cited Blake was Geoffrey Grigson, the author of a popular volume on Henry Moore in the well known series of *Penguin Modern Painters* (1946) and founder and editor of the journal *New Verse* (1933–39). Furthermore, in 1947 he published a highly regarded book on the influential Blake-pupil Samuel Palmer, whose pictorial world had a singular fascination for the Neo-Romantics.[128]

Paul Nash also felt powerfully drawn to Blake,[129] whose name repeatedly crops up in Nash's writings. In 1934, he declared in *Unit One* that Blake had an awareness of the 'hidden significance' of England, the country that he called 'Albion'. In Nash's view, Blake had credited this country with a 'great spiritual personality'.[130] In 1937, in his essay 'Surrealism and the Illustrated Book', he specifically located the roots of English Surrealism in the 'genius of Shakespeare, the vision of Blake, the imagination of Coleridge... all belong to Surrealism'.[131] And again in 1937, Blake is co-opted in defence of Surrealism when Nash writes that Surrealism lived 'in the world created by the poetry of Coleridge, and of Wordsworth, a world which inherited the songs and visions of William Blake'.[132] Two years later in 1939, in his essay 'Monster Field' – a reference to his own painting of the same name – Nash suggests that this composition was inspired by Blake. This painting, one of his most important works,[133] was made in 1939 after a photograph of one of his best known *objets trouvés*, a huge, rootless, bizarre-looking tree trunk (fig. 265). In order to capture its magic on canvas, Nash followed Blake's lead. Explaining this, he wrote: 'The one now could have but one equivalent. The horse in William Blakes's interpretation of the "sightless couriers of the air"'.[134] Interestingly, Nash assumes his readers will know the relevant picture by Blake and does not give its name. The work in question is the large colour print *Pity* (fig. 266),[135] and the phrase he cites is taken from Shakespeare.[136] It was Blake's ghostly horses racing across the sky that Nash had in mind when he created this composition from his *objet trouvé*. Having placed his found trunk facing in the opposite direction and having raised it up, it is as though he has launched it on its own ghostly journey.

Graham Sutherland, whom Moore valued very highly both as a painter and a man, expressly referred to Blake's importance for his own work. In 1936, in the journal *Signature*, he cited Blake as a 'prototype', as an artist who developed ideas 'which well up from his subconscious mind'. Above all Sutherland admired the late Blake's illustrations for Dante's *Divine Comedy* and his wood engravings to illustrate Ambrose Philips's eighteenth-century imitation of Virgil's first *Eclogue*. In the same article, it is also clear that Sutherland regarded Henry Moore as an heir to Blake's legacy. In his view Moore's drawings did not merely adhere to Nature, but had – like com-

267 Holman Hunt, *The Light of the World*, 1851–56, Oil on canvas, 122 x 60.5 cm, The Warden and Fellows of Keble College, Oxford

positions by Blake – 'a self-contained vitality of their own... a poetic reality.'[137]

A similarly open declaration of allegiance to Blake was made by John Craxton looking back at the early 1940s: 'I was very taken with Blake... and found that he endorsed my feelings in many issues. I especially felt a sympathy for Blake's attack on sfumato, the popular pictorial technique of his day'.[138] Craxton's specific mention of Blake's striving for linear clarity[139] would have struck a chord with Moore. Precisely this

268 William Blake: *Jerusalem*, (Bentley Copy E) 1804–20, Frontispiece, Pl. 1, line engraving, printed in relief, 22.3 x 16.2 cm (sheet: 26 x 19.5 cm)

study[144] shows that the figure of the Saviour was originally taller and thinner. In this respect Hunt's figure was reminiscent of Blake's majestic, elongated, ethereal image of Christ.[145] In addition to this, the striking portrayal of the light shed by the lamp has echoes of Blake's well-known figure of a man carrying a lamp on the frontispiece of his *Jerusalem* (fig. 268).[146] It has been suggested that a secular descendant of Blake's lamp-bearer stepping through a dark entrance way, is seen in Moore's 1942 drawing of a *Coal Miner Carrying Lamp* (fig. 269).[147] The pose is different, but deep under ground in the mine, this figure is surrounded by a comparable dark zone against which the light of the lamp appears similarly intense.

The next evidence we have of Moore's admiration for Blake comes in the shape of a picture postcard that Irina and Henry Moore sent to Jocelyn Horner in Leeds on 23 December 1935. The card shows one of Blake's illustrations for Canto 25 of 'Paradise' in Dante's *Divine Comedy*.[148]

Still looking at that same period, it could also be said that Moore's friendship with Graham Sutherland (1902–1980) was indirectly reinforced by Blake. The two artists' paths crossed early on. Sutherland had been appointed to a teaching post at the Chelsea School of Art shortly before Moore and the two often talked, discussing the London art world. Looking back in 1982 during a BBC interview, Moore recalled that in those days Samuel Palmer was Sutherland's 'god' and added, clarifying the situation for himself, 'I admired the Palmer things, mainly through liking Blake.'[149] In the same breath Moore goes on to describe how he and Sutherland had both opposed the 'Royal Academy domination of art in England'.[150]

On 1 May 1937 Moore and Roland Penrose took part in a march organised by the group Artists International Association in protest at the British government's plans for rearmament and its policy of appeasement towards the Spanish Republic. As we have already noted, the marchers carried a banner through the streets with a quote from Blake: 'A Warlike State Cannot Create'.[151] It could be said that many of the leftist, artistic avant-garde in London identified with William Blake.

The extent to which Moore in particular looked to Blake as an authority is evident from an undated drawing and notes that Will Grohmann published in 1960 in his monograph.[152] This artist's notes reflect the inner tensions he felt within himself: 'For it seems to me now that this conflict between the excitement & great impression I got from Mexican sculpture & the love & sympathy I felt for Italian art, represents two opposing sides in me, the "tough" & the "tender"… Blake for example was torn between the two – his tender "Songs of Innocence" & lyrical watercolours – & his tough muscular "Nebuchadnezzar eating grass"… Perhaps an obvious & continuous synthesis will eventually derive in my own work – I can't say – I can only work as I feel & believe at that time I do the work. I can't consciously force it to come.'[153]

sentiment comes across in instructions to his printer on some of his state proofs: 'strengthen lines'.[140]

Moore's admiration for Blake never diminished, and it is possible to identify moments throughout his life where it was either a tangible factor or present by implication. The first instance comes in the fact that in Moore's parental home there was a reproduction of Holman Hunt's *The Light of the World* (fig. 267)[141] – a well-known devotional image in the Anglican community, painted in 1851–53 in three versions, held in Oxford, Manchester and London (St. Paul's Cathedral). Mass-produced as an etching, and later by the photogravure process, it gained widespread popularity and hung in homes not only throughout the British Empire but also in continental Europe and North America.[142] As a member of the Pre-Raphaelite group that rediscovered Blake,[143] it seems that Hunt's depiction of Christ, standing and knocking at the door, has its origins in Blake's repertoire of figures. A preparatory

269 *Coalminer Carrying Lamp*, 1942, Pencil, wax crayon, coloured crayon, watercolour wash, pen and ink on wove, 48.1 x 39 cm, The Henry Moore Family Collection, AG 42.84 (HMF 1986)

270 *Illustration for a poem by Herbert Read*, 1945, Pencil, wax crayon, water-colour wash, pen and ink, gouache, 28.5 x 22.7 cm, The Piccadilly Gallery, London, AG 46.81 (HMF 2324a)

271 William Blake: *Ode on a Distant Prospect of Eton College*, from *The Poems of Thomas Gray*, 1797–98, watercolour and black ink on paper, Yale Center for British Art, Paul Mellon Collection, USA

It should become clear from what follows how accurate Moore was in diagnosing his own affinity with Blake.

In 1946 Moore created twenty-six sketches[154] for an aquatint etching to illustrate Herbert Read's poem *1945* (fig. 270), which was to be published in the second issue of the quarterly *Arts* with an image by Moore. The poem, which Read sent to the artist in October 1945, describes children with 'golden eyes' running across 'perilous sands' and finding samphire against the backdrop of cold waves breaking 'without resurrection'.[155] It was always intended to be 'a modern version of Blakes's illustrated poems: that at any rate, is the historical precedent.'[156] In June 1946, Read wrote again to Moore, mildly inquiring as to progress on the illustration and including a small sketch with his letter.[157] Moore now set to work. He first tried various ways of adopting the layout in Read's drawing which leaves an area free for the text of the poem, as for example in Blake's *Ode on a Distant Prospect of Eaton College*, 1797–98, from *The Poems of Thomas Gray*

(fig. 271). However, as the work progressed, Moore increasingly concentrated on how to represent the running children, which in turn reflected the main message of Read's poem, where they are seen as bearers of new hope for the future. Perhaps both Read and Moore were aware that this in itself was comparable with the trust that Blake, as a believer, put in children. Moore's interest in the subject matter may have been all the keener for having become a father just three months before embarking on these sketches.

Besides intermittent artistic references to Blake, from 1946 onwards a much deeper kinship with Blake becomes evident in Moore's works on paper whenever he uses more colour. So far there has been no study dedicated to Moore's very particular use of colour. As Grigson already pointed out in 1944: 'Moore's colour, as in Blake's *Newton* [fig. 272] is a free, personal, expressive colour, which... fills out the design'. Mainly with reference to examples of Moore's work from the 1930 and 40s, Grigson also adds that his use of colour is 'full of sur-

272 William Blake: *Newton*, 1795, Colour print finished with pen and watercolour, 46 x 60 cm, Tate Britain, London

prise'. In these circumstances, colour becomes 'an indivisible part of the total effect' reinforcing 'the total meaning' and Blake's 'entire view of the "wonder and mystery" of life.'[158]

Grigson's comparison with Blake's *Newton* was a felicitous choice, for this large coloured monotype, finished with watercolour, perfectly demonstrates Blake's ability to use a rich palette of layered colours to create an intense, luminaristic impact.[159] Moore tapped into this in his own way. More often than not his best coloured works owe their intensity to a varied range of mixed techniques. Shortly before the outbreak of war, Moore discovered what a range of expressive possibilities could be achieved by combining wax crayons and watercolours, to which he would also often add pencil, charcoal, pen and ink or gouache.[160] Peter Cannon-Brookes has described the effect of Moore's highly developed use of colour: 'The depths and transparencies of Moore's colour, produced, usually, by the most deft handling of a combination of gouache, water-colour and greasy chalk, are the source of the

instantaneous attraction of his pictures. As a sculptor whose first concern is with the expression of form, he has achieved the feat of animating his shapes, in themselves austere if not impassive, with a subtle emotional complexion, of presenting them in an atmosphere almost of passion that is the result of an instinctive colour sense operating not only dramatically but also as an organ of taste, so that his drawings provide at first sight, before we have penetrated their details, a sensuous stimulus. They have an assurance of execution, and an impartiality – almost priestly because it is not careless – in the human sympathies they express.'[161]

It is often precisely these 'depths and transparencies', plus passionate commitment, that link Moore's coloured compositions with those of William Blake. And Moore, too, was capable of transporting the viewer into imaginary worlds, although (with the exception of his late, free drawings), he always took the human figure as his starting point. He was very well aware that every 'smudge' and every area of 'shad-

273 *Landscape with Figures*, 1938, Pencil, charcoal, pen and ink, 38.1 x 55.9 cm, Private Collection, UK, AG 38.55 (HMF 1388)

ing' broke up the picture surface and opened up the possibility of creating new 'space'.[162]

The suggestions, indications and evocations of irrational spaces in Moore's drawings are persuasively exemplified in the following three examples: *Landscape with Figures*, 1938 (fig. 273), *Two Figures in a Setting*, 1939 (fig. 274) and *Reclining Figure: Bunched* (fig. 275). In these sheets Moore achieved a level of translucence that is entirely in Blake's spirit. And it was precisely in his idealistic determination to imbue forms with a new 'spiritual vitality' that Moore was following in Blake's footsteps.

But Moore is also connected to Blake in another respect. Both artists greatly admired English medieval sculpture, particularly as found on tombstones and graves. In his youth, when he was apprenticed to the London copper engraver James

Basire in 1774–75, Blake was given the rather unusual task of copying medieval tombstones and other works of art in Westminster Abbey. Credited to his master, they were later published in two large antiquarian reference works, very much in keeping with the Enlightenment spirit of the age.[163] For Blake this was a magnificent opportunity not only to immerse himself in the flowing lines of the Gothic style that was later to energise the Classicism of his own figures, but also – most importantly – to engage on a deeper level with religious imagery. Legend has it that, one day in Westminster Abbey, Blake had a vision of a procession of monks.

For his part, Moore variously referred to the strong impression that the tombstones at St Oswald's Church in Methley, near Castleford, made on him.[164] No less significant is the short essay by Moore included in 1975 in a publication issued by

274 *Two Figures in a Setting*, 1939, Pencil, pastel, watercolour wash, charcoal, pen and ink, 55.5 x 38.6 cm, David and Alfred Smart Museum of Art; The Joel Starrels Jr. Memorial Collection, University of Chicago, AG 39.3 (HMF 1442)

275 *Reclining Figure: Bunched*, 1961, pastel, felt-tipped pen, watercolor wash, 39 x 53.6 cm, Private Collection, UK, AG 61.1 (HMF 3025)

Chichester Cathedral. He opens with a confession: 'Perhaps the single period in past art which I love most is the Romanesque – when sculpture and architecture had such complete unity and religious sincerity. Of Romanesque art in England I think of Durham Cathedral, the crypt of Canterbury, also Chichester.'[165] Moore continues with an account of his first visit to Chichester Cathedral in the early 1920s and his surprise at the reliefs he came across in the south quire aisle, depicting *The Raising of Lazarus* (fig. 276) and *Christ Arriving at the House of Mary and Martha*. Both had survived from the earlier Norman church on that site, where they presumably decorated the choirstalls and probably date from the period 1125–35.[166] Moore: 'I stood before them for a long time. They were just what I wanted to emulate in sculpture: the strength of directly carved form, of hard stone, rather than modelled flowing soft form.

'A year or two later I got the same satisfaction and sustenance at Malmesbury when first seeing the tympanum and reliefs in the porch of the Abbey. For me the Chichester and Malmesbury sculptures are the two finest and most complete works of Romanesque art in England – and equal to the greatest French examples.

'In the Chichester sculptures there is deep human feeling. I think the sense of suffering and tragedy is chiefly given through the heads. Look particularly at the head of Christ in the *Raising of Lazarus*. The eyebrows and the eyes are sloped steeply downwards from the centre line of the face expressing intense grief.

'And in the mourning heads of Mary and Martha there is the same tragic feeling. These two heads should be studied on their own, photographed life-size – or casts made of them – and examined as we do with close-up details of old master

276 *The Awakening of* Lazarus. Detail from the south aisle of the choir, Chichester Cathedral, c. 1125–1135. Stone relief

paintings so that we respond to their strong sculptural quality and deep religious sincerity'[167]

It seems to me that Moore's detailed study of the Chichester reliefs stood him in good stead when he himself was commissioned to sculpt sacred subjects for a medieval church. In 1953 he made the heads of a *Queen* and a *King* for the main west entrance to St Andrew's Church in Much Hadham (figs. 277, 278).[168] These two heads form the starting and end points of the protruding, upper section of the outer frame of the entrance. They visibly benefit from Moore's observations in Chichester. Like their predecessors, they have deep-set eyes and eyebrows sloping 'steeply downwards'. Yet the facial expression of Moore's heads is very different. With much smoother surfaces, their gaze is wider and less personal. The purity of their aspect in conjunction with their (almost Gothic) elongated features rising up above a narrow chin very

much recalls Blake's Westminster Abbey drawings.[169] But even if Moore had not known these pencil drawings, there is a self-evident affinity between his own highly spiritual sculptures and Blake's studies of Gothic subjects in Westminster Abbey.

As early as 1936, in his introduction to the compendium *Surrealism*, Herbert Read was exhorting his contemporaries to recognise the 'superrealist character' of medieval art.[170] In Read's view, this art proved, as far as the Surrealists were concerned, that before the Age of Enlightenment art had been 'supernatural'. In addition to this, we also have evidence that as early as 1934, Moore was already making specific reference to the 'spirituality' of Gothic sculpture. In his essay for *Unit One* he writes: 'I want to make sculpture as big in feeling & grandeur as the Sumerian, as vital as Negro as direct & stone like as Mexican as alive as Early Greek & Etruscan as spiritual as

277, 278 *Heads (of Queen and King)*, St Andrews, Much Hadham (LH 356a/b)

Gothic.'[171] In 1943, on a study for the *Northampton Madonna*, he wrote, 'Big simple grandeur of Chichester romanesque'.[172] The same sense is conveyed by the heads made for St Andrew's Church in Much Hadham.

Yet another instance in which the experience of visiting Chichester still resonated, as Karen Coke has shown, concerns the three medals that Moore made in 1975 on the occasion of the nine hundredth anniversary of Chichester Cathedral.[173] In these he did not hesitate to virtually replicate the main motifs of the two reliefs – Christ's head in the *Raising of Lazarus*, and Mary, Martha and a disciple from the second relief. It may have

been in connection with this commission that Moore made the plaster copy of the head of Christ on the first relief. Later on he kept this piece in his print studio, hanging on the wall next to where he worked.

For all the omissions that may come to light in any discussion of a theme that is as central to an artist's work as Moore's innately English interests and legacy, [174] this brief survey has nevertheless led us to the heart of his artistic life. As though under a burning-glass, a variety of crucial influences and interests coalesce. Having grown up in a home with a print of Hunt's *The Light of the World* – a seminal, Pre-Raphaelite, reli-

278

gious image that reinforced his own openness to Celtic linea-tures and to Blake's imagery – with a fascination for Stone-henge and drawn to English medieval sculpture ever since childhood, Moore's Englishness was probably at its most evi-dent in his affinity for the Romantics. Coleridge, Keats,[175] Wordsworth, Walter Scott, Thomas Hardy[176], Turner, Constable and, above all, Blake shaped his deepest understanding of Nature and of human beings. That he also seriously engaged with non-European art, with Greek Antiquity, with Giotto, Giovanni Pisano, Masaccio, Bellini and Michelangelo is a telling reminder of the sheer breadths of his artistic cosmos, that also encompassed an Irish-Anglo-Saxon constant which we have sought here to assess and to present in light of its lasting influ-ence on the artist Henry Moore.

Ill. 8 Moore, together with his assistant John Farnham, photographing Rodin's *Torso l'Homme qui marche*.

8. Moore's Encounter with Rodin

In many ways the position that Henry Moore occupied for over two generations invites comparison with that of Auguste Rodin. While his French predecessor enjoyed an international reputation unrivalled by any living sculptor before him, Moore – born into the media age – was known the world over. And, as this study shows, Moore's work – albeit for different artistic reasons – was to make a similarly global impact. Consequently, the most logical move in any attempt to locate Moore in the history of sculpture is to explore his attitude to Rodin's work. Both his admiration for certain aspects of Rodin's art and his resistance to others help to define his own attitudes. In what follows we shall examine these in the light of some new findings.

When Moore was around sixteen years old, his father showed him some photographs of sculptures by Rodin. He was never to forget these.[1] As a twenty-one year old student at Leeds School of Art (1919–21) he made two figures in the style of Rodin: a standing figure of an old man (influenced by Rodin's famous sculpture of an old woman, *Celle qui fut la Belle Héaulmière*) and an old bearded man, inspired by Rodin's *John the Baptist*. However, neither of these early pieces by Moore has survived.[2]

Also in 1919, Moore came across a copy of Paul Gsell's book *Auguste Rodin: L'Art. Entretiens réunis* (first published in 1911)[3], in which Rodin, by now an old man, talks of his working methods, his attitudes to movement, to dance, to Greek Antiquity and to other fundamental matters of aesthetics. Decades later, Moore looked back at this time in conversation with Alan Bowness: 'I read this book with great interest. I remember in it somewhere Rodin saying that when he got stuck with modelling a clay sculpture, he would sometimes drop it on the floor and have another look. Now this was for me as a young sculptor a revelation of how you can take advantage of accidents, and how you should always try and look at a thing over again, with a fresh eye.'[4] A similar flexibility was in fact frequently evident in Moore's work. Even although he may never intentionally have thrown a piece on the floor, he nevertheless was not afraid to make radical changes when a work was still in progress. To name but three examples: *Stringed Figure* (1937), the seated *Warrior with Shield* (1953–54) and the wooden *Upright Figure* (1956–60) were all originally reclining figures.[5]

In 1921, when Moore enrolled at the Royal College of Art in London, he found in the Director of the College – Sir William Rothenstein – a man of the world who had been personally acquainted with Rodin (and other artists, such as Whistler and Degas). The young Moore also heard Eric Maclagan, Director of the Victoria & Albert Museum, talking about Rodin. These accounts meant a lot to him at the time: '...to know that somebody like Rodin had been in London and had walked these same little streets that I was walking – that was a very real thing for me. And I saw the works that he'd given to the

Victoria and Albert Museum, and could study them. I had a great admiration for them at the time, though I never made any conscious study of Rodin'.[6]

How are we to understand this last, slightly throwaway remark? Most probably, Moore was just making the point that he never slavishly followed Rodin's lead in his own work, for as an artist, it is certainly clear that he engaged with Rodin's sculpture on a very serious level. This is evident not only from his detailed analyses of pieces by Rodin, but also by the presence in his library of no less that nineteen books on the Frenchman.

Rodin's gift of a total of twenty-one works to the Victoria & Albert Museum, mentioned by Moore, occurred in October 1914.[7] This generous gesture by Rodin was in part an expression of his gratitude to his numerous English clients who had not only commissioned portraits from him early on but who, from 1911 onwards, had also supported the purchase and installation of his *Burghers of Calais*. Besides three important portraits, this group of twenty-one sculptures also included key works such as *John the Baptist* (1879–80) and *The Prodigal Son* (1885–87).

In the eyes of younger artists in England around the turn of century, Rodin epitomised Modernism. His sculpture was visibly at odds with the officially approved academic style that abounded in the streets and squares of London. In 1915 the *Burghers of Calais* was installed in Victoria Tower Gardens – a masterpiece for all the public to admire. With the work located in close proximity to the Victoria Tower itself, Rodin approved a five-metre high plinth.[8] Over forty years later, as a member of the Royal Commission of Fine Arts, Moore found himself in a position to consider the question of this very plinth, and was happy to have been largely responsible for having it lowered to the height of just one metre, so that the piece was both more visible and more accessible to the public.[9] It seems that Moore had not been informed of Rodin's original views on the height of the plinth, and was no doubt mainly concerned to achieve that proximity to the viewer that the sculptor expressly referred to in connection with the *Burghers of Calais* in conversation with Paul Gsell.[10]

Not infrequently, Moore's comments on Rodin's achievements convey a sense of the degree to which he identified with the aims of his great predecessor. Witness his description of Rodin's detailed study of the human body: 'And Rodin is as universal in his fragments as in the big figures, because he understood the human body so well. This is in my opinion the greatness of Rodin, that he could identify himself with and feel so strongly about the human body. He believed it was the basis of all sculpture. He understood the human figure so well and loved it so much that this is the universal quality in him. And out of the body he could make these marvellous sculptural rhythms.'[11]

And in conversation with Albert Elsen, Moore is very specific about Rodin's particular skills: 'Rodin taught me a lot about the body; its assymmetry from every point of view; how to avoid rigid symmetry; where were the flexible parts of the body such as those in the head, neck, thorax, pelvis, knees and so on, and that these axes should not parallel each other. These are ways of giving the figure vitality. Rodin perfectly understood Michelangelo... Rodin had great sensitivity to the inner workings and balance of the body... He could make you feel his modelled feet gripping the ground as in the *Walking Man*. Rodin helped give me that insight into empathy, feeling in to his sculptures. In my own works I have to feel the disposition of their weights, where the pressures are, where the parts make contact with the ground... I like in Rodin the appearances of pressures from beneath the surface... Rodin may not have been able to make sculpture for architecture, but he certainly knew the architecture of his body.'[12]

These are remarkable observations. Added to which, Moore repeatedly talked of the fundamental difference between his own work and that of Rodin. For, just as Rodin was primarily a modeller, Moore's heart was always in carving. Even if this distinction arose solely from their different attitudes to materials, nevertheless there are echoes here of Moore's insistence on the autonomy of the sculptural form. Whatever the case, he certainly did not share Rodin's primary interest in an 'art dynamique'.[13]

Moore's plea for a tectonic sculptural approach – implicitly anti-Rodin – reveals an inner confidence in his own stance that also meant he did not shrink from precisely elucidating the issues that stood between himself and Rodin. The question of movement was one such issue, to which the two sculptors had diametrically opposed attitudes. When asked by Alan Bowness, '...how far do you think that the representation of movement is a proper concern of sculpture?', Moore came straight to the point: 'This is one of the ways in which my generation does stand for a reaction against Rodin. One of my points is that sculpture should not represent actual physical movement. This is something I have never wanted. I believe that sculpture is made out of static, immovable material.'[14]

Bowness also raised the question of the all-pervasive eroticism of Rodin's work: 'There's another aspect of Rodin we haven't mentioned, that is his erotic side. This is something that matters very much for Rodin – he can revel in sensuality in a quite uninhibited way. What is your reaction to this?' Once again Moore did not hold back in his reply: 'It is certainly very important for Rodin, though it doesn't excite or interest me very much, perhaps because one knows the human figure so well. But for Rodin I think this erotic excitement was a part of his rapport with the human figure. And he was unlike Cézanne who had his erotic side but who suppressed it. This doesn't make Cézanne less of a physical artist, and I don't think you ever need this obvious erotic element for a person

to understand the human figure. You don't get it in Rembrandt, and I would say that Rembrandt understands the human figure and the human character and the whole of its dignity and everything else.'[15]

In this response, Moore is indirectly touching on the fact that, from the outset, the corporeal sensuality of his own work had little to do with Rodin's 'erotic excitement' – his was a more distanced sensuality that is less about the drives troubling the human psyche and more about life itself, the natural forces that are constantly growing and forming. Yet despite these obvious differences, Rodin and Moore did share certain aesthetic and theoretical beliefs. Closer scrutiny of these can help to define Moore's place in the history of sculpture. And in this respect considerable weight has to be given to Moore's reading – at the age of twenty-one – of Rodin's conversations with Paul Gsell, the most important source for Rodin's views on art. It is hardly likely that he only read this publication once. So it is not surprising that there are many links to Rodin in Moore's attitude to art and to his own sculptural praxis. We shall therefore look in greater detail at those aesthetic views expressed by Rodin that either coincide or contrast with Moore's own thinking.

Drawing from All Sides / Many-Sidedness / Modelé

In order to arrive at the 'all-sided development of a moving organism',[16] Rodin made studies of his model from a variety of different angles. His guiding principle – 'drawing from all sides', that is to say, finding the clay outline,[17] allowed him to capture the intended expression of a figure as completely as possible. Rodin's 'drawing from all sides' was echoed in Moore's own striving for many-sidedness, which he pursued with all the more determination from the 1950s onwards, when he started making small plaster maquettes of his pieces, which he could turn around and over in his hands and work on with a file and a chisel.

In Rodin's case, as well as the viewing the subject from different angles, he would also make a model, where the mobile ups and downs of protrusions and hollows would always be worked 'from deep within a shape..., never from the surface.'[18] Moore may well have read the relevant passage in the book by Paul Gsell: 'Instead of imagining the various parts of the body as more or less flat surfaces, I represented them as projections of interior volumes. I endeavoured to express in each swelling them as projections of interior volumes. I endeavoured to express in each swelling of the torso or the limbs the presence of a muscle or a bone that continued deep beneath the skin. And so the trueness of my figures, instead of being superficial, appeared to grow from the inside outward, as in life itself.'[19]

This attitude to modelling coincided with Moore's own certainty regarding the necessity of a form that originates

from within, which he could then relate to his detailed knowledge of bone structures, mentioned earlier here. However, Moore went further than Rodin: 'It's the bone that pushes out from inside; ...and it's there that the movement and the energy come from... so that in this way you get a feeling that the form is all inside it, and this is what also makes me think that I prefer hard form to soft form. For me, sculpture should have a hardness, and because I think sculpture should have a hardness fundamentally I really like carving better than I like modelling.'[20]

But even when Moore was making a model, he sought to imbue the form with the same sense of an inner energy pushing outwards.

Nature

Rodin repeatedly commented that his unwavering faithfulness to Nature required a mode of seeing where the eye, by means of a real connection,[21] was able to penetrate from the external reality to the internal reality of creation.[22] As Rodin himself said to Gsell: 'The artist has only to look at a human face to decipher a soul; no feature fools him. Hypocrisy is for him as transparent as sincerity. The slope of a forehead, the slightest knitting of the brows, a fleeting look reveal to him the secrets of the heart. He scrutinizes the spirit enfolded in the animal. He perceives in glances and gestures the entire, simple inner life of the beast – half-formed feelings and thoughts, hidden intelligence... He is likewise the confidant of inanimate Nature. Trees, plants speak to him like friends. The gnarled, old oaks tell him of their good will toward humanity, whom they protect with their spreading branches. Flowers converse with him through the gracious bend of their stems, the lilting hues of their petals. Each corolla in the grass is an affectionate word addressed to him by Nature... for him everything is beautiful because he walks ceaselessly in the light of spiritual truth.'[23]

While Rodin's attitude to Nature is permeated by the sense of a pantheistic-Symbolist global embrace, two generations later Moore's approach was incomparably more measured and precise. When he scoured the landscape for pebbles and rocks, bones, trees and shells – displayed in their hundreds in his maquette studio and constantly re-examined time and again – he was searching for the 'principles of form and rhythm'[24] that underpin the natural world. Unlike Rodin, Moore took each 'word addressed to him by Nature' and examined and probed it with infinitely greater determination in the hope of discovering its underlying structural principles. To put it in a nutshell: where Rodin was content to appreciate and admire, Moore turned himself into a fully-fledged 'morphologist'.

Contra Rodin: 'Form against Space'

When Rodin saw a great artist seeking 'the entire truth of Nature, not only the truth of the outside, but also... that of the inside',[25] and when that same artist also 'listens to the spirit answering his own spirit',[26] then it seemed to Rodin that he could discern a fundamentally religious approach in that person. As Moore may have read in Paul Gsell's *Conversations*: 'Every artist who has the gift of generalising forms, that is to say, of stressing their logic without emptying them of their life, expresses a similar religious emotion.' This is in keeping with the fact in his efforts to perceive the logic of such a generalised form, he was also pursuing an 'idea for the entire composition'.[27] And this he would always try to have 'strongly and clearly in mind [so as to] always compare and closely relate the smallest details of his work to it.'[28] In other situations, Rodin relied on Nature – correctly observed – to give a work of art its innate coherence: 'Nature unifies details because it is simple; it binds together all planes and all outlines in a single unity.'[29] This both philosophically and sculpturally grounded theory of oneness and wholeness, in which every detail makes sense, was very much in the spirit of Moore's own work. In his divided figures he consciously focused on the functioning of the piece as a whole, regardless of the fact that it was divided into two or more sections.[30]

While Rodin achieved unity through the skilful binding together of different elements, Moore pursued the same aim through a dialogic interplay of form and space, where the two would pull together. As early as 1958, he made a significant comment in this connection, in conversation with Rudolf Huber, when he specifically describes his approach as being quite the opposite of Rodin's. Whereas Rodin pits form against form [in his models], Moore pitted form against space and then connected the two.'[31]

Hands

Although much more could be said of Moore's relationship to Rodin, I will concentrate here on the pronounced interest in hands that the two artists shared. Between 1922 and his old age – even more so in his last years – Moore drew around one hundred studies of hands,[32] which form an important group in his output of life drawings. That they are predominantly studies is confirmed by the artist's own words: 'If one likes drawing hands, as I do, the nearest model is one's own two hands. These drawings were made to study hands generally. Hands, to me, are – after the head and face – the most expressive part of the human figure... Hands have always been of interest to me and, as a student, it was a hand I modelled, which helped to win me a scholarship to the Royal College of Art'.[33]

Moore's earliest known studies of hands (for a sculpture) have survived in *Notebook No. 3* of 1922–24 (fig. 279). The

279 *Notebook No. 3, p. 25, Studies of Hands*, 1922–24, Charcoal, 22.4 x 17.2 cm, The Henry Moore Foundation, AG 22-24.11 (HMF 95)

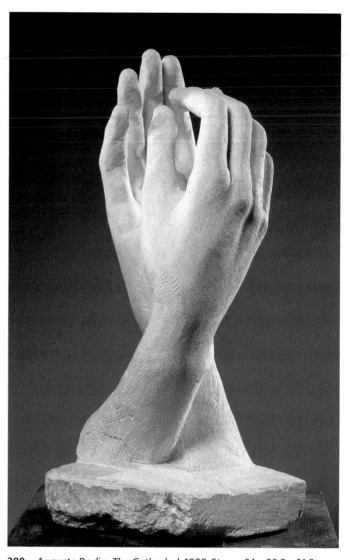

280 Auguste Rodin: *The Cathedral*, 1908, Stone, 64 x 29.5 x 31.8 cm, Musée Rodin, Paris

hands are raised up, with the left hand grasping the thumb of the right hand.[34] Looking back, Moore commented that he was 'probably influenced by Rodin'[35] in this study. And it is true that the powerfully expressive motif of the raised hands does call to mind Rodin's *La Cathédrale* (fig. 280), the most important of his hand sculptures.[36] At the sight of this stone sculpture, where two casts of a right hand enclose a space – with the 'structure of the jointed fingers'[37] suggesting the title of the piece – the writer Schmoll gen. Eisenwerth was moved to describe it as a 'Symbolist-religious "abstract" gesture of reverence and, at the same time, and perhaps better… a gesture of reverential protection afforded to a mysterious core'. In his view, Rodin was thinking here of a 'vessel for the divine'.[38]

Moore's drawings of hands are naturally mostly of his left hand, with some of both hands. In addition to this there are also studies after Carlo Crivelli and Giovanni Bellini (from 1974–75)[39] and one of the arthritic hands of the Oxford professor (and winner of the Nobel Prize) Dorothy Hodgkin (fig.

281).[40] The latter directly reflect the impression made on the young Moore of Rodin's *Main crispé* of 1880–85 (fig. 282). This monumental hand-torso – a study for the *Burghers of Calais*[41] – was known to Moore from a series of photographs by Eugène Druet that he had come across in 'Rodin et son œuvre'– a special supplement issued by the journal *La Plume*, to mark the retrospective of Rodin's work presented in Paris in 1900. The young artist had bought his own copy, which he signed and dated with 'Henry Moore 1924'[42] This same supplement also included an article by Gustave Kahn on Rodin's portrayal of hands.

Amongst Moore's late studies of his own hands, a striking number show both hands stretched out, feeling a pebble or a bone,[43] or a single hand with a brush.[44] Although both topics must have had a programmatic element in the sense that they reflect his ongoing interest in organic forms and his special feel for colour, Moore never sinks to the level of stylised pathos. On the contrary, these sheets retain the air of studies

281 *Dorothy Hodgkin's Hands*, 1978, Charcoal, pencil, 25 x 32.9 cm, The Henry Moore Foundation, AG 78.41 (HMF 78(41))

of natural acts of feeling, clasping and the like. In these draw-ings Moore is trying to remain as faithful as possible to the hands as sculptural elements and to the expression of the hands, with their slim appearance and sensitive movements. The predominant movements involve touching – where the hands are at rest or clasping each other, closed over each other, or with the fingers tentatively intertwining. Moore generally heightened the highly-charged three-dimensionali-ty of his images of hands by hinting at a background, against which they stand out, in light and shade, like monuments in their own right.

Even more so than the late drawings of hands, Moore's three-dimensional hand-torsos are very much open to inter-pretation. The works in question are two reliefs[45] and three fully-modelled hand montages: *Study for Hands of Queen* of 1952 (fig. 283), *Hands of King*[46] and *Mother and Child: Hands* of 1980[47]. In the latter three works, Moore addresses two main themes: the first concerns the Queen from the piece *King and*

Queen (figs. 231–233). Even separated from the arms and body, these hands are still filled with the sense of a human spirit. The second concern the mother-child relationship, in the sense that here the left hand of the Moores' daughter Mary is inclined towards her own mother's left hand.[48]

In these hand sculptures Moore was deliberately accen-tuating the role of space. In the *Study for Hands of Queen* – one upright and one lying down – there is yet another echo of Rodin's work, namely the plaster study *Mains d'amants* of 1904 (fig. 284).[49] In this piece the right hands of a man and a woman – one lying down, one rising up – touch tenderly thumb to thumb.

None of Moore's three-dimensional hand-torsos has any-thing even remotely comparable to the vessel imagery of some of Rodin's hands. And there is nothing to compare with the symbolism of an empty, sacred core to be sheltered and protected, as in *La Cathédrale*. Although Moore's hands do also have a protective tendency, more often than not they

282 Auguste Rodin, *Main droite crispée, Study for the Citizens of Calais*, 1880/85, Bronze, 46.5 x 30.5 x 19.5 cm, cast 1913, Kunstsammlungen Chemnitz

283 Study for *Hands of Queen*, 1952, Bronze, L. 20.5 cm (each), The Henry Moore Foundation (LH 353)

transmit a palpable energy, with the innate tension of the forms connecting with the space around them. And the active togetherness of the two hands of the Queen seems to reflect her singularly alert sensibilities. While Rodin – in a Symbolist spirit of suggestion and vagueness[50] – celebrates the ennobling, indeterminate, intrinsically open gesture of reverence, the English artist – the more empirical of the two – focuses on the communicative togetherness that is so typical of ordinary life. Rodin's lyrical pathos, on one hand, real-life human relationships on the other.

Sketch

With regard to Moore's relationship to Rodin, it should not be forgotten that he owned three bronzes and an original pen and ink drawing by the artist,[51] and that throughout his life he was interested in Rodin's working methods. He was particu-

larly taken by his fragmented forms, and no less important to him was Rodin's elevation of the three-dimensional sketch. In 1966 he paid his respects to Rodin for this achievement in his lithograph *Hommage à Rodin*,[52] in which a row of demonstratively sketchy reclining figures recall the way that Rodin used diffuse light to make connections. In addition to this, both artists greatly admired the work of Michelangelo and both were collectors, mainly of old sculptures. While Rodin's preference was for the sculpture of Greek Antiquity, he also had an interest in Egyptian, Etruscan and non-European works.[53] Moore, having worked his way through Primitivism, was much more open to the world tradition of sculpture. And he found a similarly rich seam of life in the inexhaustible variety of forms in the natural world. One of his highest aims was to promote a 'universal understanding' of all these interconnections. This incomparably wider openness to Nature and to art history sets him apart from Rodin, who never abandoned the

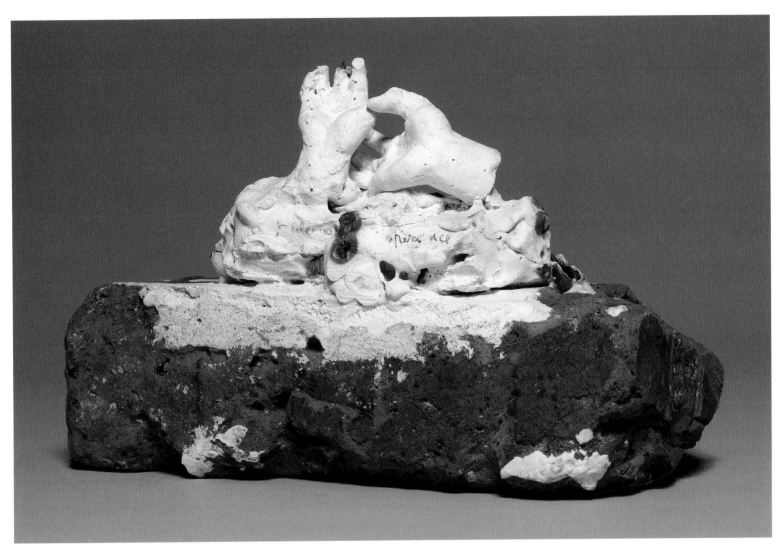

284 Auguste Rodin: Study of *Mains d'amants*, c. 1903, Plaster on brick, 13 x 21.4 x 10.6 cm, Musée Rodin, Paris

image of the human being as it had been defined by the nineteenth-century Romantics.

It was Moore's much greater range of interests that shaped his innate abilities and his legacy to future generations. Included amongst these interests were the ethical demands he made not only of his own art, but also of art in general. Unlike Rodin, Moore had first-hand experience of two World Wars, and he never shied away from the ideological conflicts of his own time. His youthful empathy with Communism gave way after the war to active support for individual Christian humanism. The extent to which ethos and form were two sides of the same coin for Moore is clear from the preceding survey of selected works. And when he spoke of the humanity that, in his view, must be evident in all great art, he was not talking in empty platitudes. In his willingness to help younger artists (see Part III), in his widely varied activities in the cause of the arts in England and the wider world, but above all in his love of life that shines through his work with its deep-rooted connections to the natural world, Moore embodied the humanism he strove for.

Theory

Goethe
Maximes
+Reflection.

Moore

Ill. 9 Two Shut-Eye Drawings ('Goethe/Maximes and Reflection'), 1980, ballpoint pen, 16.5 x 21.1 cm, The Henry Moore Foundation, AG 80.283r (HMF 80 (246))

Humanity and Form

All his life – in notes, texts and conversations – Henry Moore never tired of explaining that it was the human content that mattered to him most in his work. As early as 1925, when he turned his attention to primitive art for confirmation of the particular strength of sculpture compared to painting, he specifically distinguished between 'humanity and form' as opposed to 'abstraction as pure abstraction'. The notes to this effect were made in 1925 on p. 155 of Notebook No. 4 (fig. 285).[1] They also show that in Moore's view, in addition to 'humanity and form', 'simplification' and 'austerity' also heightened the 'emotional expression' of a work of art. Furthermore: 'The individual medium in the greatest works of sculpture & painting gives the works of each an organic existence and beauty peculiar to itself.'

The extent to which Moore sought to anchor his works in their own individual 'humanity' could readily be demonstrated from numerous similar statements. Later in life, he identified the same trait of humanity in the works of Giovanni Pisano, Masaccio, Bellini, Michelangelo and Rembrandt. Looking at the achievements of these artists Moore saw their work as the expression of a genuine personality filled with intense empathy and warmth.[2] In 1937, in his text 'The Sculptor Speaks', he had already indicated that when he was creating a sculpture in wood or stone, the emerging form seemed to him like a human character that could influence the progress or the final shape of the work.[3] And in the mid-1950s, at the sight of an Egyptian bust of a female figure from the 18th Dynasty in the archaeological museum in Florence, he wrote, 'I would give everything, if I could get into my sculpture the same amount of humanity & seriousness; nobility & meaning & experience, acceptance of life, distinction, & aristocracy. With absolutely no tricks, no affectation… no movement, but more alive than a real person.'[4] In this determination not to resort to 'tricks' or 'affectation' we still hear the younger artist's belief in 'simplification' and 'austerity.'

Although the concept of humanitas was ultimately defined by the Romans and included by Cicero in a canon that was to hold good for centuries to come, it originated in the Greek mind. It was closely connected with the self-recognition and ethical responsibility towards other free human beings that were so highly rated in Greek civilisation. And it seems to me that this is the terrain that nurtured Moore's own pairing of 'humanity and form'. It in effect sums up his highest aim, or what Herbert Read called his 'transcendental purpose'.[5]

Regardless of the diverse results that modern anthropologists and philosophers have arrived at in their attempts to define 'humanity', Moore never strayed from his pursuit of humanism in his own work. In his view, humanity always relates to art and, as such, is connected with visual reality. By contrast, anthropologists are quite unable to say with any certainty what 'humanity' might be. In our own time, philosophers have also tried to differentiate notions of 'human': is it to be found in the human being content with his own lot, or rather in the creative homo faber? Are human beings, as Friedrich Nietzsche suggested, 'still undetermined animals',[6] or do they have the ability to develop and attain a higher level of being?

As an Englishman, Moore grew up in a cultural climate where ethical values had been observed and respected ever since David Hume had founded the Anglo-Saxon, moral-sense tradition of practical philosophy.[7] Coming from this background, it was Moore's highest aim that his artistic production should not only relate to human beings – to their bodily, mental and spiritual faculties of perception – but that it should also reinforce their moral fibre. As his career progressed, this humanist approach took him ever closer to Nature. What initially appealed to his playful side – the discovery of the Surrealists' interest in the objet trouvé – soon turned into a challenge, as he sought to explore in ever greater depth the possibilities of transformation that could affect different natural realms. And it seems that the studies he made of such phenomena gave him a deep-seated sense of security that prevented the upheavals and loss of humanity that he personally witnessed in two World Wars from ever really diminishing his creative powers. Although he was very well able to give powerful expression to the physical destruction, the fear and the dehumanisation of war – for instance in his helmet figures and in his falling and fallen warriors – the image of the human being he created in his Shelter Drawings and in the heroic female figures of the 1950s embodied a a sort of resistance. This was underpinned, above all, by the forces of facticity that, for two main reasons, he himself felt to be immutable: the omnipresence and influence of art through the ages, and the presence of Nature. Specifically the second of these two factors could offer human beings a level of purity and vitality that modern men and women very much needed to preserve and nurture their own humanity. Thus Moore's supreme interest in Nature also had a human side. And when he saw organic forms as entities in motion, it was his intention to take the next sculptural steps in these processes of three-dimensional growth affecting fragments of Nature (pebbles, bones, roots, shells etc.) and guide them through different stages of transformation to the human form, into which they would ultimately be integrated.

This creative connection to the natural world means that Moore's union of humanity and form contains within it everything that can be described, in his own terms, as 'organic existence', 'organic form' and as an 'organic whole'. By the same token, his concept of space is inextricably bound up with organic forms. This complex framework also includes the factors that Moore himself referred to as vitality, internal/external forms, balance, size, rhythm, variety, intensity and metaphor –

285 *Notebook No. 4*, 1925,
Pencil, 22.8 x 18 cm, p. 155,
The Henry Moore Foundation

all of which are crucial to a view of art that he himself never committed to paper.

Of course Moore himself would never even have contemplated the idea of devising and defending an identifiable aesthetic. On his own admission, he studiously avoided any kind of doctrinaire theories and insisted that all he wanted was freedom.[8] Nevertheless, with hindsight we can see very clearly that his approach was supported by a coherent framework of principles that mutually reinforce and explain each other. Moreover, in the sense that it was important to him that a work of art should reflect an individual, personal vision and should be in a position to imbue matter with life – that it should itself be a 'miracle of life'[9] – it is fair to say that in themselves these views define a theoretical position. They are in keeping with specific guiding principles that – as soon one takes into account their place in the history of aesthetics – prove to be based on a recognisable system of references. It is only from this springboard that Moore's key concepts come together on a metalevel of which he himself will certainly not have been aware. However, it is without doubt essential to examine these in more detail if one is to have any hope of doing justice today to the singular qualities and enormous impact of his notion of organic form and space. It is only through a more active awareness of the philosophical and aesthetic parameters of the basis of Moore's artistic outlook that we can pinpoint the coherence and internal logic of that outlook.

Moore's artistic interests are firmly rooted in the vast cosmos of the history of ideas. And it was these origins that gave Moore's message of 'humanity and form' its innate power.

The Aesthetics of 'Organic Form'

'Form – the shape of things – is the most exciting side of my life. Through it I express my visions and my reactions – I think in shapes.'[10]

'To observe, to understand, to experience the vast variety of space, shape and form in the world, twenty lifetimes would not be enough. There is no end to it.'[11]

Moore's ready declarations of his lifelong fascination with form – the plastic essence of things – his unrelenting efforts 'to observe, to understand and to experience' all kinds of space and form in their endless variety, becomes all the more significant if one takes into account the range of meanings that is implied in the English words 'form' and 'shape'. The German *Gestalt* does not have the same associations as 'shape', which is poised somewhere between contoured form and schematic being. Compared to the tangibility of *Gestalt*, shape has greater flexibility and a wealth of other potential.

In the history of aesthetics, the identification of form and forming as artistic activities first emerged in the early eighteenth century in the writings of the English philosopher Anthony Ashley Cooper Shaftesbury. His definitions laid the historical foundations for Moore's understanding of the potential humanity of form. In his overview of concepts of form (from Plato, Aristotle and Plotin to the present day), Klaus Städtke looks at Shaftesbury's contribution to the field: 'Taking Plotin's *endon eidos* as read, he [Shaftesbury] regards form as a creative, primal force. He extols the form-giving power of the divine spirit that appears in both Nature and art as "this" third order of beauty, that forms not only what we simply call form, but also the forms that are themselves engaged in the process of forming. The "forming power" that inspires the artist as "inward form", in conjunction with the "moral sense" within his own soul, is what ultimately gives rise to the form of the work of art.'[12]

While Shaftesbury suggests that the artist's idea takes on an "inward form", the German Idealists take this same view yet further. Now the inward form relinquishes its role as a 'general regulator for the behaviour of individuals within society',[13] that Shaftesbury still attributed to it, and – with the advent of Gottfried Herder and Johann Wolfgang von Goethe – increasingly starts to become associated with the work of art. In his *Briefe zur Beförderung der Humanität* (1793–97), Herder declares that it is the artist's soul that 'makes form into form, and reveals itself in that form as it also does through his

body. Remove the soul, and the form becomes no more than a mask.'[14] Only the 'original genius', only the real artist can imbue the form with a spirit and a soul. And if he is able to do this, then – in an entirely organic process – the inward form will manifest itself in the outer form of the work of art. And that work will develop a level of 'coherence, independence and dynamism like that of natural organisms.'[15] The classicist rules, derived from the empty legacy of the French *doctrine classique* that can only lead to a form-mask,[16] are now countered by the 'laws of form-giving Nature, which the artist, too, obeys'.[17]

Working both within these laws and on his own account, the artist now creates a second 'Nature'. Goethe described this same situation: 'The artist, thankful to Nature who gave him life, gives her a second Nature back, moreover in so doing he follows the rules… that Nature herself prescribed for him.'[18] Very much in this spirit, in Germany luminaries such as Herder, Goethe and Karl Philipp Moritz (see *Über die bildende Nachahmung des Schönen* of 1788) evolved a concept of organic form with which the creative artist could answer Nature on her own terms.

At around the same time Friedrich Wilhelm Joseph Schelling went a step further in his *Philosophy of Art*: 'The complete forms generated by the *plastic* arts are the objectively portrayed archetypes of organic nature itself.'[19] In this statement, we see how close Schelling's approach was to Goethe's. From detailed discussion of natural philosophy with Goethe, Schelling had assimilated the latter's concept of the organism and of the law of polarities (from his theory of metamorphosis) which were to become important building blocks in his own thinking.

More so than any other twentieth-century sculptor, when Moore was creating his organic forms he sought to maintain his own free connection with the laws laid down by Nature. The way that he investigated different natural forms (as in his treatment of bones), the way he delved as deeply as possible into various techniques for articulating forms, and the way that he transferred the potential for movement in the living process of their development into his own artistic forming, meant that he had all he needed to advance the philosophical and aesthetic tradition of creative organic forms that had started with Shaftesbury. Consequently, Moore's biomorphous forms were to make a unique contribution to the long tradition of organic forms in the history of ideas and civilisation. This tradition goes right back to Antiquity (Plato, Aristotle, Cicero, Vitruvius) and was reinvigorated in Renaissance art theories by Leon Battista Alberti for one; after this it continued to make an impact in Romanticism, Jugendstil and above all in the work of great architects ranging from Gottfried Semper to Frank Lloyd Wright (or Frei Otto, today).[20] Meanwhile Classical Modernists – of every stylistic persuasion – also engaged with the shapes, structures and potential for meta-

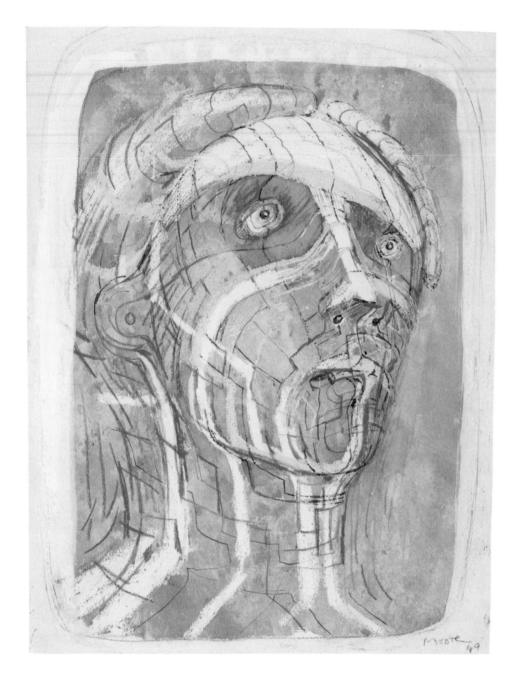

286 *Head of Prometheus,* c. 1950,
Pencil, wax crayon, coloured crayon,
watercolour wash, pen and ink, gouache,
Bridgestone Museum of Art, Ishibashi
Foundation, Tokyo, 35.6 x 27.4 cm,
AG 50.4 (HMF 2577)

morphosis in natural forms.[21] In this context, what sets Moore apart from other sculptors, such as Brancusi, Arp, Hepworth and Naum Gabo, is the fact that he did not deal merely with the basic forms of nature, but avidly explored a huge variety of mineral, botanical, animal and human forms. As we have shown above, this versatility went hand in hand with his development and dynamisation of the essence of Brancusi's form-giving. In the company of the artists listed here, Moore looks more like a morphologist. And it seems to be on this level that he comes closest to Goethe, who himself was following in Shaftesbury's footsteps.

While Moore's widely documented reading of Goethe was something of an exception in the response to Goethe in twentieth-century England, it is very much in the mould of the

open admiration of Goethe professed by such figures as Percy Bysshe Shelley, Lord Byron, Thomas Carlyle and Walter Pater.[22] At the same time it is also an important element in the strikingly wide-ranging influence that Goethe had on artists in the twentieth century.[23]

Morphological Discoveries: Moore and Goethe

The author has already shown elsewhere that Moore was already indirectly drawn to Goethe's morphological observations in the 1930s.[24] This came through his introduction to D'Arcy Wentworth Thompson's renowned study *On Growth and Form.*[25] This classic in the field of morphological research

was first published in 1917 and much admired in the artistic circles Moore moved in. In Chapter I–2 of this present volume, we have already seen that the principles underlying Moore's *Transformation Drawings* – exemplifying metamorphotic processes – have a striking affinity with Thompson's theory of transformation.[26] Moreover, in his reading of *On Growth and Form* Moore will also have come across two important tenets of Goethe's morphological theory. In his discussion of the sizes of cells, Thompson comments that '...the life of the body is more than the *sum* of the properties of the cells of which it is composed: as Goethe said, "Das Lebendige ist zwar in Elemente zerlegt, aber man kann es aus diesen nicht wieder zusammenstellen und beleben."'[27] Without citing his exact source, here Thompson is alluding to a point fundamental to Goethe's thinking, namely that the living whole is an entity in its own right which can no longer be seen as such once it has been broken down into its constituent parts. A similar sentiment is aired in *Faust I*: 'To docket living things past any doubt / You cancel first the living spirit out: / The parts lie in the hollow of your hand, / You only lack the living link you banned.'[28]

In another passage, where Thompson is discussing the 'composite whole' of each individual animal, he cites Goethe's law of compensation in natural growth processes, which he describes as 'the fundamental truth'[29] in biology. He is referring here to Goethe's belief that in the various animal species different organs develop according to the function they are to fulfil, which in itself is a perfect example of the economy of natural processes.[30] Goethe addressed the same theme in his *Metamorphosis of Animals*:

'So if you see that a creature possesses a certain advantage, / Put the question at once: What is the fault that afflicts it / Elsewhere? – and seek to discover the defect, always inquiring; / Then at once you will find the key to the world of formation. //

'For there has never existed an animal into whose jawbone / Teeth are pegged that had a horn sprout out of its forehead; / Therefore a lion with a horn the Eternal Mother could never / Possibly make, though she drew on all her potent resources; / For she has not measures sufficient to plant in a being / Rows of teeth, complete, together with horns or with antlers. //

'May this beautiful concept of power and limit, of random / Venture and law, freedom and measure, of order in motion, / Defect and benefit, bring you high pleasure...'[31]

All Thompson's references to Goethe's writings concern the living whole, which the morphologist Goethe also liked to describe as the 'spiritual organic whole'.[32]

The next period when Moore encountered Goethe's writings and ideas came in 1948–50, when he made a series of colour lithographs to illustrate Goethe's dramatic fragment *Prometheus* (fig. 286). Interspersed with numerous quotes from Goethe's text, these images bespeak Moore's special sense of identification with this subject matter.[33]

In 1962 Moore's friend W. H. Auden (with Elisabeth Mayer) translated Goethe's *Italian Journey* into English.[34] Particularly in view of Moore's love of Italy, he must have become aware of this text in 1962 at the latest. During an interview on 12 October 1977, Moore spoke of his relationship to Goethe. Without hesitation he declared that he particularly admired Eckermann's conversations with Goethe for their 'universal understanding', adding that he had read them several times. Eleven days later he returned to the same topic in conversation with his bibliographer, Alexander Davis, and commented, in something of an understatement: 'No, I have never read much Goethe. I have not read Faust all the way through, but ten years ago I read Eckermann's Conversations which gives Goethe's attitude to life, and it's a marvellous book, a wonderful book. I have read it four times since and read it again recently because it is so wise, it's so full of digested experience that he's thought over and over, and so for me, that is the kind of book and that is the kind of influence that is most important.'[35]

In addition to this reliably documented interest in Goethe on Moore's part, there is yet another telling document to take into account. It is a drawing, made around 1980, that is expressly marked 'Goethe/Maximes & Reflection' (ill. 9). In other words, besides his reading of Eckermann's conversations, in his old age Moore was also interested in Goethe's *Maxims and Reflexions*, and – by definition – in Goethe the universalist. This collection of aphorisms and observations reflects the full range of Goethe's views as comprehensively as only *Faust* and *Wilhelm Meister* were able to do.

In view of Moore's evident acceptance of Goethe as a poet and serious student of art and Nature, the similarities in their views on the theory and aesthetic practise of artistic production are all the more striking. At first sight their common ground is fairly general in nature. But the connections become ever more specific the deeper one goes, until it is clear that they share a very similar notion of organic forms taking shape and changing shape according to a series of natural laws. Let as look at individual instances connecting the two.

In their artistic outlooks, both men, Goethe and Moore, always took the human being as their main point of orientation. Goethe, too, turned his attention to making detailed anatomical studies. He attended anatomy lectures at the university in Jena and discovered the intermaxillary bone in the human jaw. Even drawings of an elephant's skull have survived[36]: as it happens Moore, in his old age, never tired of making drawings of a similar specimen.[37] In June 1784 Goethe wrote to Frau von Stein: 'To my great joy the elephant skull has arrived from Kassel, and the part I was looking for [the intermaxillary bone] is much more visible than I had expected.'[38]

Goethe also studied and modelled human anatomy from life. That the powers of one's imagination are increased by the firsthand study of natural forms was evident to both Goethe

and Moore from their own experience. The two men (Moore, as we have seen, only after a time) appreciated what Italy had to offer and admired the art of Antiquity. Moreover, both had the same optimistic approach to life, although not to the extent that their confidence could not be shaken. They also shared a sense of the spiritual and physical totality of existence; yet both were also equally well aware that this existence could, in Goethe's eyes, be shattered by demonic forces or, in Moore's eyes, by destructive, uncanny powers, compelling human beings to struggle to restabilise their lives. Goethe would no doubt have agreed with the following statement by Moore: 'I personally believe that all life is a conflict… One must try to find a synthesis, to come to terms with opposite qualities… All that is bursting with energy is disturbing – not perfect. It is the quality of life. The other is the quality of the ideal. It could never satisfy me… To be an artist is to believe in life. Would you call this basic feeling a religious feeling? In that sense an artist does not need any church and dogma.'[39]

In addition to the parallels mentioned above, there is also the fact that in his own way Goethe had already touched on the notion of an aesthetic of artistic materials. In October 1788, he published a short essay in the literary periodical *Der Teutsche Merkur* entitled 'Zur Theorie der Bildenden Künste' ['On a Theory of the Visual Arts']. In this essay he devoted a whole section to the materials used in the visual arts, pointing out that every material has its own innate value and that however much an artist (architect or sculptor) 'may become the master of the material he is working with, he can never alter its nature'[40] True success will only come to those artists 'whose invention and powers of imagination connect directly with the material that he is working with.'[41] Goethe then goes on to remind his readers that Egyptian obelisks may well owe their characteristic form to the crystalline structure of the granite used to make them, and that 'people are guided to art by the material'.[42]

The ground for this surprisingly early focus on the artistic material *an sich*, and the influence it has on the finished work, had already been laid by Goethe in his essay 'On Granite'.[43] This essay takes on even greater significance when one traces its influence on Goethe's writing and the subsequent deep consideration he also gave to the symbolic value of different metals.[44]

The many-faceted affinity between Moore and Goethe (which is by no means restricted to their shared – strictly limited – classical inclinations) takes on a particularly interesting aspect when one compares the efforts of each to capture the essence of form. With his investigations into the metamorphosis of plants and animals, into morphology and into the science of meteorology, Goethe was seeking to understand the processes of constancy and change, of formation and transformation found in the natural world. In Goethe's view, the formative laws of polarity and strengthening (leading to metamorphosis) that he established also applied to the visual arts.[45]

Moore, too, never tired of observing the productive energies at work in Nature and the laws that controlled them. When he studied the 'principles of form and rhythm' to be found in pebbles, rocks, trees, plants, shells and bones and extrapolated from these his own three-dimensional forms, he was in fact pursuing the 'ideal empiricism'[46] advocated by Goethe.

Further to this, there is another striking similarity between Goethe's notion of the 'minted form that lives and living grows'[47] and Moore's own attitude to natural forms. In the spirit of Classical hylomorphism, Goethe always sought to distinguish the noble from the unformed, that is to say, from that which is merely material. His notion of form contained within it the preliminaries of his morphology. In Dorothea Kuhn's assessment of Goethe's Nature studies, 'form occupies a superior position to the individual parts and, as the opposite pole to the material, instigates forming and shape'.[48] Goethe presents the same point in his *Fairy Tale*, where the 'mixed king' – a statue made from gold, silver and brass – stands for unclassified, unpurified material. And 'forming and shape' were only to be generated by the three other statues, the beautiful and perfectly formed 'sacred' columns that had the power of speech and stood for 'wisdom', 'appearance' and 'power'. The forming sculptor is on their side. Filled with inspiration, he allows the forming energies within him to become active and in effect continue the formative processes of Nature. Without his morphological studies and his theory of metamorphosis, Goethe could in all likelihood not have arrived at the view that in his own act of forming, the inspired artist is continuing the divine creation of Nature on a higher spiritual level. As it is, when Wilhelm Meister finds himself in the Pedagogic Province, he sees that '…the sculptor stands at the very side of the Elohim, when they fashioned that magnificent figure from formless, repulsive clay.'[49]

When Goethe talked of the 'minted form that lives and living grows' he was tapping into the ancient notion of the essence of form, according to which form functions in a similar manner to the stamp used to mint a coin (*forma* = minting stamp). But Goethe did not stop at this ancient concept of form, at the *typos*.[50] As the good student of Leibniz that he had become through Herder, he saw an active energy within form – a *vis activa*. Taking Leibniz's teachings as his starting point, Goethe took the old notion of form through his own morphology and theory of transformation and, by this means, categorically extended its application. In the sense that Goethe's form 'living grows', it obeys the laws of entelechy and, hence, those of constant metamorphosis that Goethe believed applied to plants, animals and human beings alike. In what Goethe described as form, 'order in motion'[51] has the

upper hand over chaos. And in it creation is continually evolving into new forms.

In his readings of Eckermann's conversations with Goethe, Moore will have found repeated references to Goethe's *Metamorphosis of Plants*.[52] What Goethe presented here as the laws of polarity ('expansion and contraction' or 'systole and diastole') and 'enhancement,' ['Steigerung'][53] that in his view governed the metamorphosis of plants, would not have been unfamiliar to Moore from his own artistic work. As we shall show in what follows, his experience led him to the position where Goethe's laws of polarity and enhancement became a natural part of his own artistic praxis.

Polarity and Enhancement: The *Reclining Figures* Carved in Wood

The group of six monumental *Reclining Figures* made in wood, that Moore produced at widely spaced intervals between 1935 and 1978, are without doubt some of his most important works. Initially Moore had approached this material with some trepidation. The demands it would make on the artist seemed to him too complex, and he feared that it was too great a risk to embark on a large-format piece in wood.[54] Despite this, Moore's handling of this 'characterful'[55] material ultimately greatly enriched the art of wood carving. As an art form, wood carving had been in a process of evolution ever since Gauguin and the Nabi sculptor Georges Lacombe; it made very considerable advances in the wake of Primitivism in the hands of Picasso, Brancusi, the Brücke artists and also of Barlach. Moore, in his turn, was able to expand this new terrain by virtue of his willingness to actively engage with the 'principles of form and rhythm' that were intrinsic to the original tree.

By definition a tree trunk and its elongated, organic form already embodied one of the main features of Moore's reclining figures. Over the years he steadily developed this feature, both in terms of size and composition. Balance and rhythm became increasingly subtly interconnected. With the wisdom of those who think with their hands, Moore allowed his theme to develop of its own accord and thus retained his own instinctive feel for wood, which he particularly valued for being a living, growing organism: 'What wood can do that stone doesn't is still give you a sense of it having grown, whereas stone doesn't grow – it's a deposit. Also for me the grain of the wood plays a part and makes it alive.'[56]

Reflecting his belief that the principles of natural growth should above all be apparent in a wood carving, the developmental line that can be traced through these six reclining figures shows that at every stage Moore was striving for a more harmonious interplay of solid forms and open spaces. The intrinsic rhythm of the forms and holes is crucial to this. It is only when one contemplates these six figures as an extended

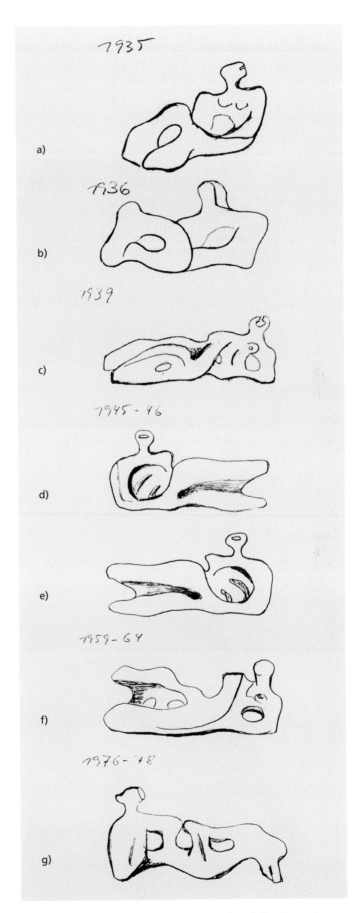

287 Schematic view on the development of *Reclining Figures* in wood 1935 – 1978

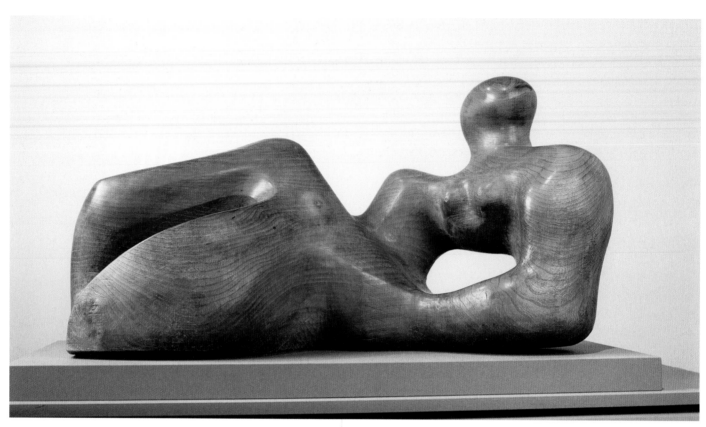

288 *Reclining Figure*, 1935–36, Elmwood, L. 93.3 cm, Albright-Knox Art Gallery, Buffalo (LH 162)

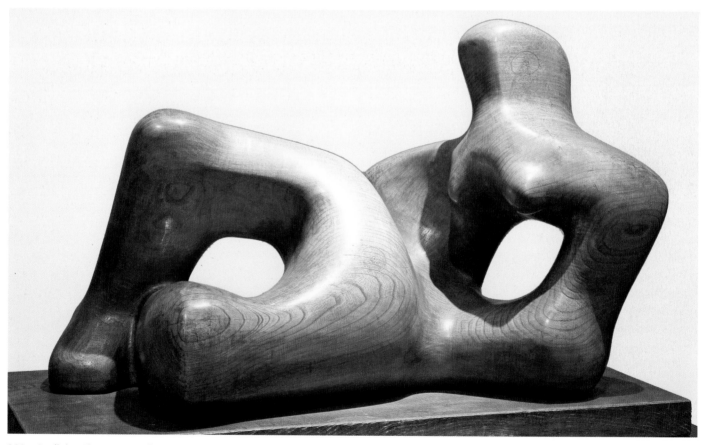

289 *Reclining Figure*, 1936, Elmwood, 64 x 115 x 52.3 cm, Wakefield Art Gallery and Museums (LH 175)

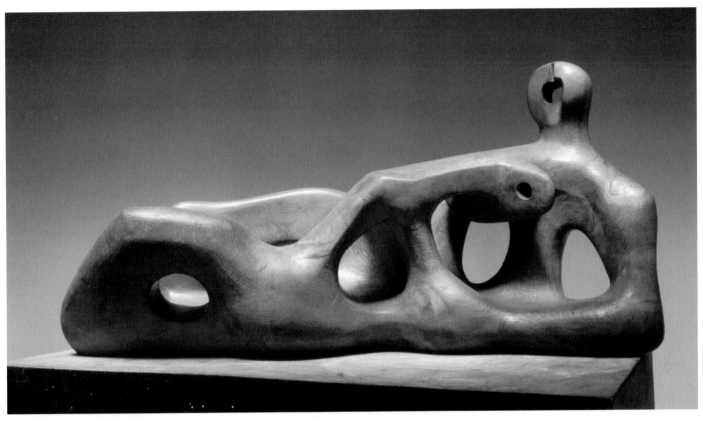

290, 291, 292 *Reclining Figure*, 1939, Elmwood, L. 200 cm, Detroit Institute of Arts, USA (LH 210)

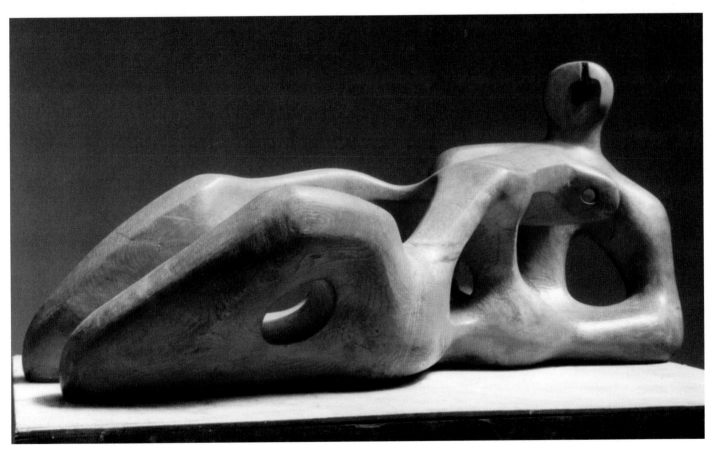

291

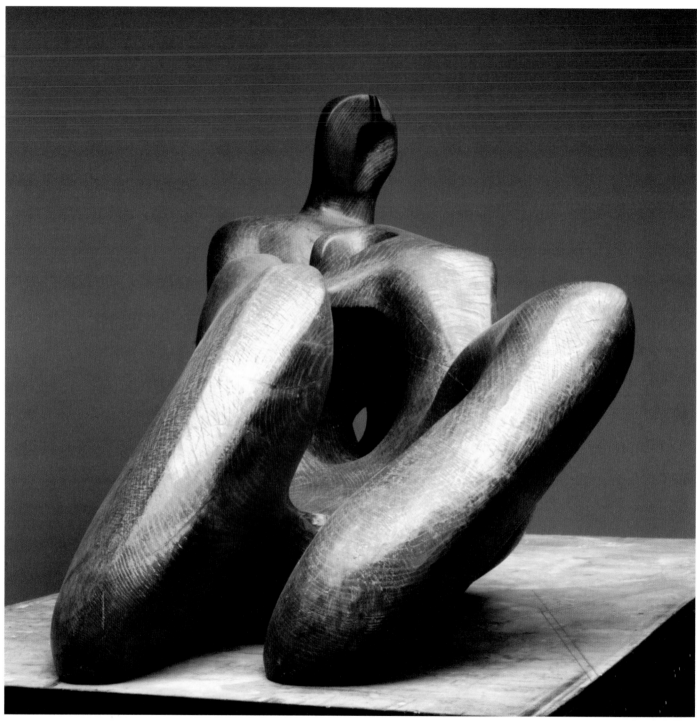

292

group, that one can have a proper sense of the way in which Moore subjects his reclining figures to the laws of systole and diastole, of contraction and expansion, of solid forms and open vistas, of self-assertion and self-denial. In the sixth and last version, he arrived at a new synthesis that, with regard to its form and content, stands as the high point of the series as a whole.[57]

In 1935–36 Moore started his series of reclining figures carved in elmwood with a two-pronged approach. In terms of the date of their conception and realisation, the second ver-

sion followed very closely on the first (fig. 288 and fig. 289). Both works, now in Buffalo and Wakefield, are based on a binary rhythm and, as such, perform what could almost be described as a rocking balancing act. In each case the opening between the schematically bent legs is countered by the chest. As in Bernoulli's lemniscate, the line of the form seems to circulate solely within itself.

In the third of these reclining figures in elmwood – at two metres now twice as long – made in 1939 (figs. 290–292, see

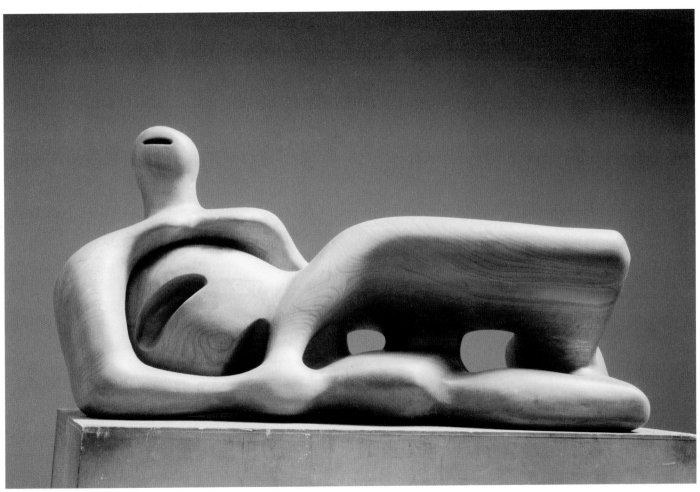

293 *Reclining Figure*, Autumn 1945 – October 1946, Elmwood, L. 190.5 cm, J. B. Speed Art Museum, Louisville (LH 263)

also fig. 121) Moore abandons this strikingly closed composi-
tional form which seems to represent a systolic gathering of
strength. Now a single, horizontal, interrupted and compact-
ed rhythm runs the length of the body, in effect opening it up
on all sides. In his old age to repeat it Moore explained the
particular significance of this figure in his own estimation:
'This was carved in Kent. The wood was obtained from a tim-
ber merchant in Canterbury. It was for me my most "opened-
out" wood carving – you can look from one end to the other
through the series of tunnels. It was also the most ambitious
carving in wood I have ever done… This was a moment of
great excitement in my work. This piece for me represented a
special stage in my development; it was an advance in wood
carving and a great struggle to do.'[58]

In this work Moore elongated the shape as a whole. The
two elements of the first two figures circulating within them-
selves and mutually sustaining each other are replaced by
asymmetry in the third. Looking at it from its main viewing
side (fig. 290), one can readily see the extended wave move-
ment that runs through the raised legs. This is followed by
three separate undulations that work their way through the
chest before finally curving upwards into the vertical head

and shoulders. Moore was quite right when he described this
as his most 'opened-out' wood carving.

In the fourth version of 1945–46 (fig. 293), which was
carved from a rectangular block, Moore produced a power-
fully expressive, self-contained piece. The raised legs seen in
the 1939 version are now turned to the right and on their
side. The front view is dominant. Although still retaining the
asymmetry of the third figure, the sweeping curves that
define this version recall those in the first two examples. Two
sources of movement, directed towards each other, balance
each other. The upper body curves protectively above a form
that runs from the feet, through the forked motif of the legs,
into a rounded form, and finally comes to rest below the
broad bridge of the chest. Above this spherical form there is a
wide slot that echoes the space-creating energy of the legs –
it almost looks as though Moore's primary interest was in
these two directional thrusts within wholly different forms of
movement, for which he then had to create the necessary
sense of balance. In this piece Moore's main focus was on the
drama of the forms, although this is not to say that he was
indifferent to the contents and psychological implications of
the figure. Taking into account Moore's imminent fatherhood

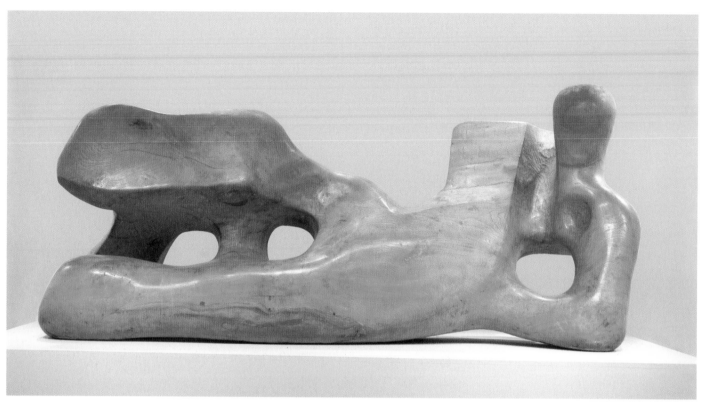

294, 295, 296, 297, 298 *Reclining Figure*, 1959–64, Elmwood, L. 261 cm, The Henry Moore Foundation (LH 452)

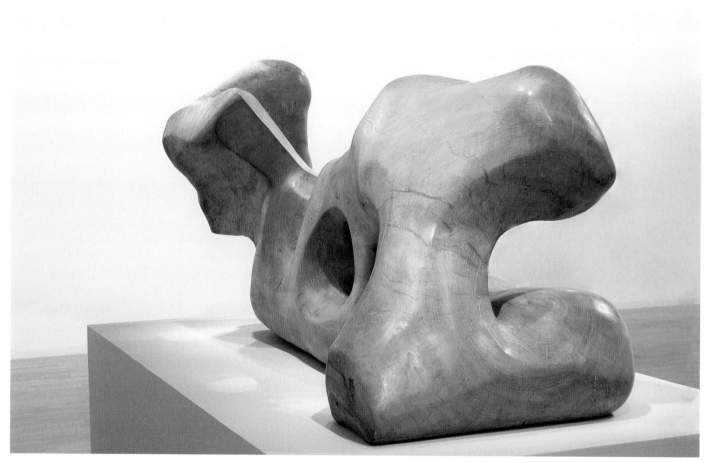

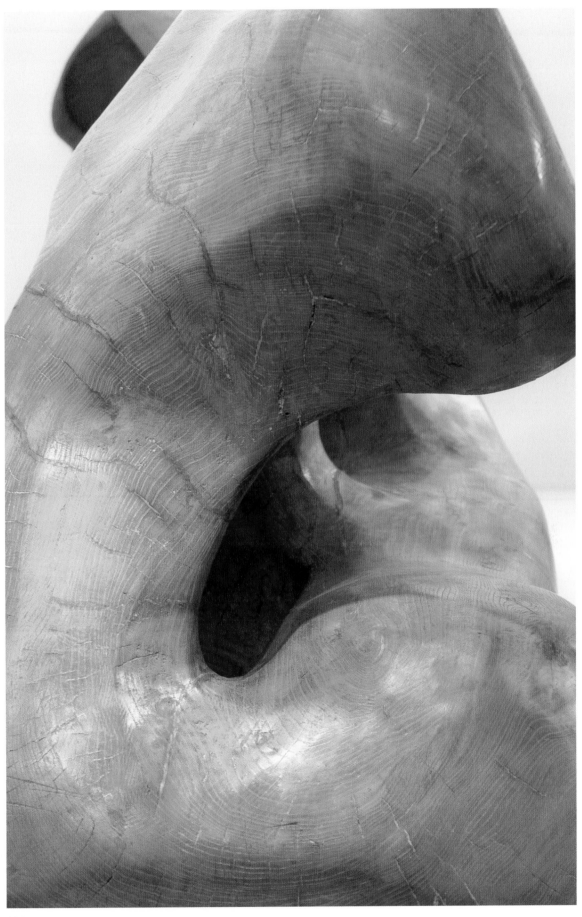

296

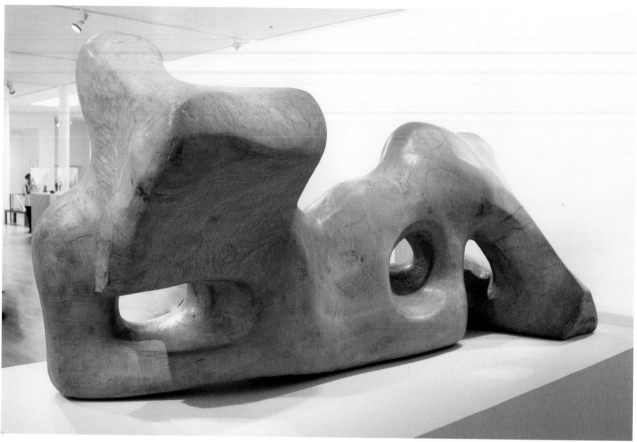

297

(the Moores' daughter Mary was born on 7 March 1946), in her interpretation of this piece Clare Hillman has suggested that '…both mother and foetus have only deep grooves for eyes… The mother looks towards the sky and her body is literally knotted up with anxiety for her child'.[59] Moore himself commented on the content of this most expensive of his elmwood reclining figures (sold at auction in 1983) in an interview at the time of the sale: 'For me it had great drama with its big heart like a great pumping station.'[60]

If one were to mentally reverse the main view of the fourth *Reclining Figure* (see fig. 287e), one would arrive at the basic form of the fifth figure, made in 1959–64 (figs. 294–297), albeit much more opened out and extroverted. It is as though this were Moore's Heroica. There are now three openings in the legs and their surface undulates noticeably. A new addition is the 'shield motif' rising up from below in front of the right shoulder and catching the light. This motif is a development of the rising diagonal in the third *Reclining Figure* of 1939 (figs. 290–292); now more markedly opened out, the two are connected in the manner of a further diastole. Moore loved this outstanding figure for its through-composed buoyancy and, in the company of friends, cited the comparison with Michelangelo made by an art critic at the time.

It was only in his last large-format reclining figure made in 1976–78 from a mighty, unusually contorted elm trunk (fig. 298–299a),[61] that Moore created a clear middle section. The two directional thrusts – one descending from the head and the other ascending from the feet – meet half way. The protuberance in the upper right recalls the fourth figure in the sense that it tips up and fills out the space between the legs. A coming together of this kind was already hinted at in the fourth figure of 1945–46. Meanwhile the many holes echo the fifth and third figures, and the distinctly upright head in profile reiterates a motif from the first figure.

In this grand finale, which Moore produced at the age of eighty, he draws together a whole number of threads from the preceding figures. And it was only here – thanks to the sharp angle of the original tree trunk – that the upper body could describe an actual curve. This also encouraged Moore to create more powerful solid forms and, in so doing, he arrived at a perfect balance of mass and space. In this and in the great equilibrium of stasis and motion that is achieved in this piece, Moore concludes the progress of his six reclining figures – through two changes of systole and diastole – with a mighty enhancement and synthesis. It is only when one analyses the six reclining figures carved in wood as a group and traces the movements and directional thrusts as they pass from piece to piece, that it becomes clear that, in effect, in this unique series of works Moore was giving visual form to Goethe's laws of formation and transformation that guide the artistic concept

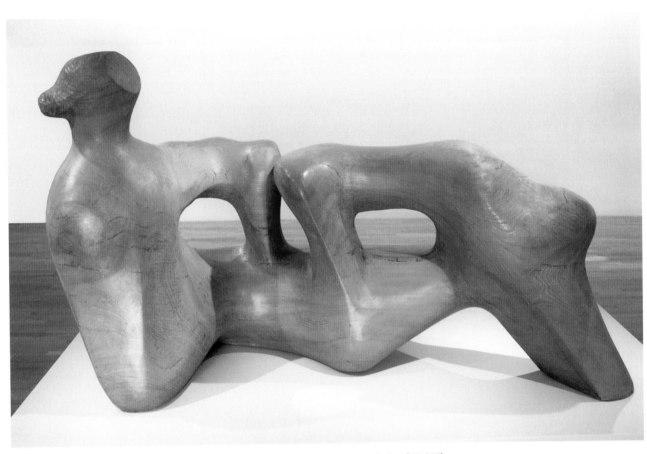

298 *Reclining Figure*, 1976–78, Elmwood, L. 222 cm, The Henry Moore Foundation (LH 657)

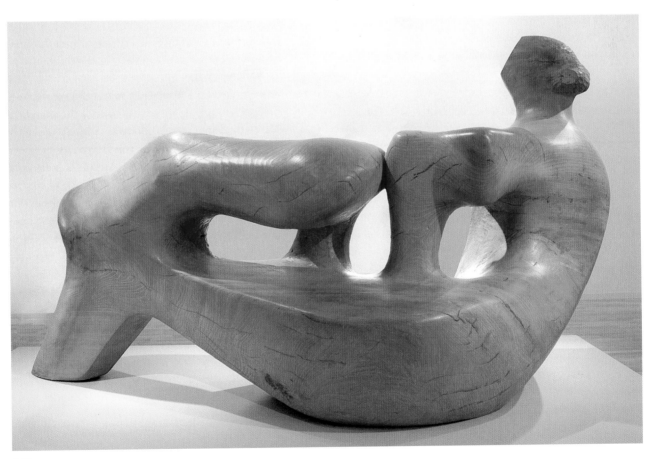

299

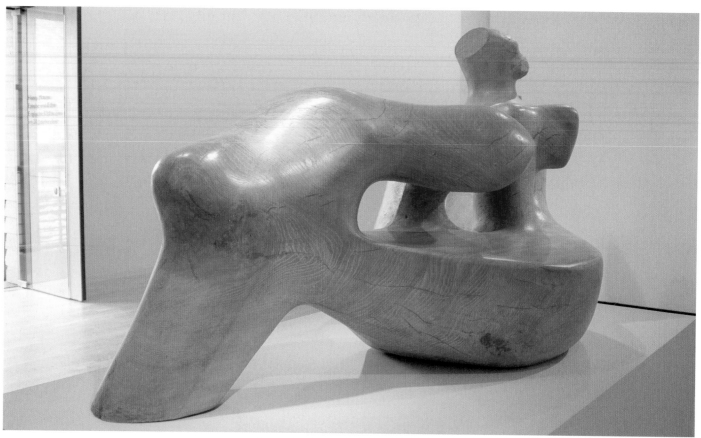

299 a

through polarity and enhancement to completion. No other group of Moore's works demonstrates so rigorously and lucidly what he himself described as the 'organic whole'.

Coleridge and the Organic Whole

It was in 1937 that Moore specifically chose to use the term 'organic whole' in order to distinguish his own position from that of Brancusi. At the time of the making of the first two elmwood reclining figures, he wrote his relatively comprehensive text 'The Sculptor Speaks'. At its heart there is the passage that we have already cited with reference to Brancusi: 'Since the Gothic, European sculpture had become overgrown with moss, weeds – all sorts of surface excrescences which completely concealed shape. It has been Brancusi's special mission to get rid of this overgrowth, and to make us once more shape-conscious. To do this he has had to concentrate on very simple direct shapes, to keep his sculpture, as it were, one-cylindered, to refine and polish a single shape to a degree almost too precious. Brancusi's work, apart from its individual value, has been of historical importance in the development of contemporary sculpture. But it may now be no longer necessary to close down and restrict sculpture to the single (static)

form unit. We can now begin to open out. To relate and combine together several forms of varied sizes, sections and directions into one organic whole.'[62]

Following this important declaration of his own intent with regard to the organic whole, Moore talks of his ever-present interest in forms that constantly attracts his attention anew to bones, shells, pebbles and all the many different forms found in the natural world. When working in stone, for instance, his aim was that the material should 'be turned from an inert mass into a composition which has a full form existence, with masses of varied sizes and sections working together in spatial relationship'.[63] Elsewhere Moore described this 'full form existence' as 'whole': witness the moment when he attributes a 'whole personality' to his elmwood figure of 1945–46 (fig. 293) with contrasts that go 'beyond the confines of a single personality'.[64] Rather different and yet not unrelated is Moore's description of the fragmentary form of his *Draped Torso* of 1953 (figs. 178, 179) whose proportions and sizes create the same effect as the whole figure.[65]

Thus Moore was always seeking to create a harmonious connection between 'the whole' – the full form existence including 'his' space – and its constituent parts. For Moore the whole needs to be viewed actively, from all sides. It makes its presence felt in different equivalents from form to

300 *Four-Piece Composition: Reclining Figure*, 1934, Cumberland Alabaster, L. 50.8 cm, Tate Britain, London (LH 154)

form and from space to form as an operative component in the formal interconnections and tensions within the space. As a living web of varied relationships it is a non-tangible *concretum*.

Moore also described this web of connections as 'one unit'. Take for instance his reference to the sense of unity that links the components of the multi-part reclining figures he first made in 1959 (fig. 125): 'They are still one unit, not two or three separate figures… If somebody moved one of these parts one inch, straightaway I'd know. The space would be different, the angles through here, there. All the relationships would be changed.'[66] In keeping with the exactitude of these relationships, in *Two Piece Reclining Figure No. 1* (fig. 125), as we have already seen, the space between the two parts – between the upright upper body and the raised legs – functions as an imaginary bodily space.

For Moore space and form were inseparable. In his eyes they were equal partners that – regardless of a figure's dismemberment – together form a highly charged, organic entity that does not exist in material terms. In addition, this entity promotes a mode of seeing that is open to dynamic-plastic configurations. From Moore's point of view, and in light of his keen study of bone structures, this interstice can be read as an extended 'joint' or interarticular space that does

not interrupt, but rather intensifies, the dynamic link between two sections.

As early as 1934 Moore was already considering the question of organic unity in his *Four-Piece Composition: Reclining Figure* (fig. 300).[67] In conversation with Richard Morphet, Moore pointed out that in this work he started from a 'mental conception' that he had previously worked out on paper as a drawing. All the elements (rounded, elongated, convex, closed) relate to each other both in their shapes and in their distribution in the space. The curved void of the head/upper body, with its inscribed eyes and breasts, corresponds with the bent leg fragments – one raised, one lying flat. The solid sections to the right and the left enclose the space between them which can be read as an imaginary torso, with the small ovoid shape as its navel. Thus, as the viewer engages with the work, it is as though a meta-figure materialises, uniting the various parts as one greater, single entity. This entity is, in turn, reinforced by the formation of the original parts in the sense that their irregular forms underpin the composition and its interconnections. Thus the pointed tip on the right-hand piece by definition accentuates the spherical form of the head/upper body rising up above it. In every area of the piece there are interlinking correspondences. Summing up this piece, one could say that Moore primarily orients the variety

of plastic forms towards natural forms, with the result that the piece as a whole becomes a vigorous, animated, carefully articulated entity.

With this concentration on the 'organic unity' of the work of art, Moore is following in a long-established aesthetic tradition that goes back to the research into Nature and natural forms instigated during the Enlightenment. Having found a footing in the wide-ranging philosophical foundations of German Idealism, it then extended its reach to philosophy, poetology and architectural theory in England. In view of Moore's significant statement, setting himself apart from Brancusi, it is worth filling in some of the historical detail pertaining to the notion of the 'organic whole'. The concept as such originated in Geneva in the work of the natural scientist and philosopher Charles Bonnet. In 1762, on the basis of his studies of insect life, he proposed the hypothesis that 'every organic body already exists before fertilisation, which does nothing more than prompt the development of what already existed in the seed or in the egg as a miniature whole (procurer le développement du tout organique)'.[68]

It was Bonnet's friend, the Zurich-based poet Johann Caspar Lavater, who in 1770 preceded his translation into German of Bonnet's Philosophical Palingenesis, Or Ideas on the Past and Future States of Living Beings with a foreword in which he introduced the term 'organic whole' into the German language, with a recommendation that the reader should 'study the whole system, all the author's main points, which together bear such a similarity to an organic whole'.[69] Taking the work done by Bonnet and Lavater as his starting point, Georg Germann has shown the extent to which the organic whole infiltrated architectural theory in the age of Goethe. In his discussion, Germann cites figures such as Alois Hirt, Karl Friedrich Schinkel, Friedrich Weinbrenner, Franz Kugler and others, before turning his attention to the English scientist, university reformer and methodologist William Whewell, who in 1835 used the term in a study of German ecclesiastical architecture.

Of the leading figures of this time, Hirt, Schinkel and Sulpiz Boisserée could all have been introduced to the notion of the organic whole by Goethe, with whom all three were personally acquainted.[70] By 1799 Goethe was already equating the existence of an organic whole with beauty. In the novella Der Sammler und die Seinigen, jointly conceived by Goethe and Schiller, we read that 'The human character is to beauty as the skeleton is to the living person… The bone structure… determines that person's form but is not that form in its entirety; even less does it affect the ultimate appearance of a person, which – as the epitome and outer shell of an organic whole – we call beauty.[71]

Here beauty is seen as the essence of the organic whole. In this notion of beauty attached to the living organism there are echoes of the young Goethe's attitudes to Nature. Thus the twenty-three year old wrote in his text 'On German Archi-

tecture': 'Art is creative long before it is beautiful. And yet, such art is true and great, perhaps truer and greater than when it becomes beautiful. For in man there is a creative force which becomes active as soon as his existence is secure. When he is free from worry and fear, this demigod, restless in tranquillity, begins to cast about for matter to inspire with his spirit.'[72] This fundamental notion of an active, creative force in human beings that produces works of art as its second nature, is taken up by the young Schelling in his Philosophy of Art (1802), when he, too, turns his attention to the organic whole: 'That person is still lagging far behind for whom art has not yet appeared just as unified, organic, and in all its parts necessary a whole as does nature. If we feel perpetually moved to view the inner essence of nature and to discover that fertile source that generates so many great phenomena with eternal consistency of form and regularity, how much more must it interest us to penetrate the organism of art, which generates the highest unity and regularity and reveals to us far more directly than does nature the miracles of your own spirit?'[73]

In Schelling's view, anyone wishing to grasp the organic whole of a work of art must 'cultivate the ability to comprehend the idea or the whole as well as the mutual relationships between the various parts and between those parts and the whole'.[74] Tapping into the traditions of Antiquity, here Schelling is touching on the powerful interplay of whole and parts that operates within the organic whole.[75] Schelling posits the presence of this interplay in the perfectly finished work of art and wants to see those contemplating the work perceive it in the activity that pervades the organic whole.

In Hegel's thinking, the organic whole fulfils a similarly comprehensive function. He makes this point in the foreword to his Phenomenology of Spirit: 'This movement of pure essences constitutes the nature of scientific method in general. Regarded as the connectedness of their content it is the necessary expansion of that content into an organic whole.'[76]

The first Englishman to engage with this topic was the Romantic poet, philosopher and critic Samuel Taylor Coleridge (1772–1834). From his firsthand knowledge of the discourse amongst artists and philosophers on the subject of the organic whole (a discourse to which Karl Philipp Moritz and August Wilhelm Schlegel also contributed), Coleridge came to his own conclusions and introduced notions such as 'organic unity' and 'organic whole' to his compatriots and founded his own aesthetics on these. Anyone brought up in the English education system knows of Coleridge. Moore mentioned him at least once to John Hedgecoe.[77] In 1948 Herbert Read wrote an essay entitled Coleridge as Critic[78] which he included in his book on Romantic literature in England, published in 1953.

In his philosophically founded poetology and in his critical lectures, above all on Shakespeare, Coleridge provided ample evidence of the extent to which his thinking had been informed by his study of the writings of Kant, Schelling, August

Wilhelm Schlegel, Lessing, Goethe and Schiller.[79] He was in Germany from September 1798 until July 1799. And as James Benziger has rightly pointed out, Coleridge's encounter with these German thinkers and his modified absorption of their views shaped his own philosophical development.[80]

In Coleridge's philosophy and theory of poetry, 'organic unity' and 'organic whole' are deemed to be central to the functioning of both philosophy and poetry. Coleridge specifically uses the term 'organic whole' in his *Bibliographia Literaria*, Chapter XII. Here the poet exhorts the reader to take account of the whole of the chapter, and illustrates his point with a colourful metaphor: 'The fairest part of the most beautiful body will appear deformed and monstrous, if dissevered from its place in the organic whole.'[81]

Even if Moore can scarcely have known of these connections – although it is far from impossible that he and Herbert Read might have discussed Coleridge – there are nevertheless astonishing parallels between his working methods and Coleridge's poetology. Once again we see Moore's inherently Romantic inclinations coming to the fore.

The most important evidence as to Coleridge's understanding of the terms 'organic unity' and 'organic whole' occurs firstly in his *Bibliographia Literaria*, which offers the reader an introduction to his planned magnum opus, 'Logosophia', on the divine and human logos,[82] and secondly in his lectures on Shakespeare. For Coleridge, the term 'organic' was associated with the imaginative powers of the inspired poet who had progressed beyond the 'mechanical regularity' of normative poetry as prescribed by the Classical doctrine of the three unities. In his view, the imagination of the true genius could rely on its own innate 'understanding' insofar as that imagination was the outcome of the individual human being's connectedness with the living creativity of the universe. Coleridge regarded this form of imagination 'as a living power and prime Agent of all human Perception, and as a repetition in the finite mind of the eternal act of creation in the infinite I am'.[83] Through the inspired genius of an artistic ego, that – in the spirit of Fichte and Schelling's transcendental Idealism – is its own first principle,[84] an imagination can become creatively active, in the awareness of its origins in the entirety of the divine basis of being: 'sum quia in deo sum'.[85]

Thus Coleridge's notion of 'organic unity' originates at a high philosophical and religious level, as a higher form of the Romantic imagination which he sees best exemplified in the lyric poetry of William Wordsworth and in the plays of Shakespeare. In his observations on *The Tempest* – a drama that he felt particularly drawn to for its supernatural elements – Coleridge declared that Shakespeare was 'the vital writer, who makes men in life what they are in nature, in a moment transports himself into the being of each personage, and, instead of cutting out artificial puppets, he brings before us men themselves.'[86] And it was as a result of this vitality, as Coleridge

writes elsewhere, that Shakespeare's dramas were composed as though they had grown like plants. 'No ready cut and dried [structure]; and yet everything <u>prepared</u> because the preceding involves or was the link of association.'[87] In Coleridge's view this closeness to nature and its natural processes of growth – reflected in the dynamic progress of Shakespeare's writing – is what makes his plays inherently organic.

By the same token, Coleridge sees in Wordsworth's poetry a 'seminal principle' of the imagination in action.[88] And in his own poetological deliberations, organic unity again looms large. As Günter H. Lenz has shown, Coleridge sees 'an organic entity underpinning the production and reception of poetry; but this entity is both realised and reified in reflection as a union of contrary, necessarily opposed forces… such as the sublime and the majestic, thinking and feeling'.[89]

From his analysis of Coleridge's lecture *On Poesy or Art*, Lenz concludes that 'Coleridge regards the poem and the work of poetry, by virtue of its structure, as an organic form, that connects the various parts to create a single, living whole, although he explains this whole by citing numerous reference points outwith the work itself and does not see it as a harmonious balance but rather as a web of heterogeneous elements, as an entity that is articulated according to the essence and significance of its various components, in which the effect of the living power of the imagination is particularly evident in its most outstanding passages.'[90]

Before this, Lenz had suggested that 'only if the work is the produce of the "organically" functioning creative powers of a genius, will it be a living whole; its structural balance, however, is the outcome of the activities of its maker's powers of "judgement and taste" and – in contrast to genius – consciously developed talent. And it will appear to the reflective mind as a "reconciliation of opposites", an internal unity, albeit a unity that is the product of a unified will made up of heterogeneous elements and moments.'[91]

According to Lenz, a fully-fledged work of art 'is the outcome of an organic process, in which conscious intention, unconscious creativity and the innate characteristics of the chosen medium are inextricably bound up in each other'.[92] And it is in this work of art that organic form comes into its own. As Coleridge himself said: 'The organic form… is innate, it shapes as it develops itself from within, and the fullness of its development is one and the same with the perfection of its outward form. Such is the life, such the form.'[93]

In Coleridge's view, organic form can be achieved by those poets who tap into the same source as Nature herself and who take from Nature 'living and life producing ideas' for their own work.[94] These poets put their faith in the beauty of Nature which is found in the unity of the manifold, the coalescence of the diverse. In other words 'it is the union of the shapely (formosum) with the vital… The sense of beauty is intuitive. Believe me, you must master the essence, the natura

naturans, which presupposes a bond between nature in the higher sense and the soul of man'.[95] As long as the artist does not break this Spinozist bond, then – according to Coleridge – he will be able to preserve the 'moral reflexions' that are intrinsic to organic form, and he will be able 'to make the external internal, the internal external, to make nature thought, and thought nature – this is the mystery of genius in the Fine Arts'.[96]

Even this brief insight into Coleridge 'organicist thinking'[97] may suffice to indicate its similarity with Moore's own organoid aesthetic. The connections between Moore's artistic thinking and methods and Coleridge's theoretical writings are self-evident. And although the two were involved in very different art forms – poetry and sculpture – nevertheless Moore could be said to share Coleridge's philosophical and theological definition of organic unity and organic form, because he, too, believed in the divine foundations of existence. Moreover, achieving an exact correspondence between the part and the whole was one of Moore's primary artistic aims. Moore need only have replaced the word 'poem' with 'sculpture' for the following statement by Coleridge to be a true reflection of his own thinking: 'a legitimate poem… must be one, the parts of which mutually support and explain each other; all in their proportion harmonizing with, and supporting the purpose and known influences of material arrangement'.[98]

The Conjunction of Space and Form

However incredible it may seem, it was only in the twentieth century that sculptors first gave serious consideration to sculptural space.[99] The ground had previously been laid by art historians, most notably Jacob Burckhardt, Alois Riegl and Heinrich Wölfflin, who had variously turned their attention to the treatment of space in different architectural styles. In 1938, in a lecture entitled 'Über den kunstgeschichtlichen Raumbegriff' at the Munich Academy, Hans Jantzen summed up the main developments. With particular regard to painting, he made the point that artists had only begun to refine their understanding of space when they 'relinquished the principle of imitation'.[100] Kurt Badt took up this issue in 1963 in his study *Raumphantasien und Raumillusionen. Wesen der Plastik*: 'However, the rise of abstract art went hand in hand with the dominance of the concept of abstract space in art history.'[101]

More recently, it is clear that since Picasso, sculpture has adopted a range of very different spatial perspectives. New sculptural articulations of space were successively developed by the Cubists, Futurists, Constructivists and Biomorphists. Picasso's Cubist layers articulating the space in his *Guitar* (1912), Archipenko's almost representational replacement of the head by an equivalent space in *Woman Combing Her Hair*

(1915), Boccioni's boldly progressive opening-out of space in *Development of a Bottle in Space* (1912), Pevsner's transparent allusions to the universe, Naum Gabo's late visions of space flooded with light, and lastly, the magical formation of space as a processual, plastic event in Laurens's *Amphion* (1937) – all these treatments of space confirm an observation made by Carola Giedion-Welcker: 'A new and fundamental sense of space seems to be manifesting itself. Figures and objects are no longer placed in self-contained isolation; the sculptor's aim is to animate the space surrounding the form and emanating from the form. He uses every possible means of bringing space to life as an emotional stimulus.'[102]

In the midst of all these different ways of activating space, one main issue can be identified: starting with Julio Gonzalez, artists now seek to reduce the overall mass of their works and to all but do away with the traditional emphasis on gravity and on permanence.[103] Typical of this tendency towards dematerialisation, was Pevsner and Gabo's declaration in their *Realistic Manifesto* that they wanted to express the universal, vital principle in their abstract visions of space. Oskar Schlemmer at the Bauhaus went a stage further when his dancers enacted a plastic animation of the stage space in an attempt to extend its reach into the realms of metaphysics. Meanwhile, under the banner of Suprematism, Malevich launched an impassioned defence of the thesis that 'we can only perceive space if we break free from the Earth, if our foothold no longer exists'.[104]

However, this major current in modern sculpture, willing to countenance the irrational in its striving for the extremes of space, was completely at odds with Moore's approach. His scepticism regarding this level of unworldliness resonates unmistakably in a comment he made in 1953 to the effect that space in sculptural works should never become a fetish, for that would only weaken and diminish the form.[105] And this was not the only trend in modern sculpture that Moore staunchly resisted. There are no occasions when he could be said to have entered into an 'unconditional connection to the tangibility of place'.[106] Heidegger's 1951 axiom of space collected in the place that the human being and the work of art 'inhabit' – that was to be so important to Chillida, for instance, with his Mediterranean background – never captured the English sculptor's imagination.

If, however, it was not a striving to reach out into unlimited space, and if the work was not tied to a specific place, what was it that distinguished Moore's indubitable contribution to a new sense of sculptural space? The answer lies halfway between the two extremes outlined above: in the universality of a rhythmic formation of space that is itself embedded in the Here and Now of an organic form. It lies in the instigation of a spatial dialogue through the medium of the sculptural hole, in the conversation between inside and outside, in the coming together of form and space.

In her speech at a memorial ceremony for Henry Moore at the Akademie der Künste in Berlin on 23 November 1986, Brigitte Matschinsky-Denninghoff aptly pinpointed Moore's treatment of sculptural space: '...one of his great achievements was to redefine negative space in sculpture. He attached as much importance to it as to volumes. In his figures this negative space is not only created by virtue of the positions of the limbs, it permeates the very body of the figure and generates a new form within a form. How he enriched sculpture, taking a hitherto unheard of liberty, that we now treat as perfectly natural! And what a decision, what an effort to destroy a stone or a tree trunk in this way! What a moment when two parts of a body connect through this act of destruction and the air can pass freely between them like the water when a lock is opened... Henry Moore often spoke of the excitement that gripped him every time he reached that point.'[107]

As we will see, Moore also released the *spatium*, the interstice, from its functional architectural role and developed its three-dimensional aspect.

In a nutshell, one could say that Moore introduced into twentieth-century sculpture a modern concept of space that operates in the realms of organically alive forming. And he had only one aim for the complementary nature of his version of form and space, namely to achieve the highest level of three-dimensionality. This in turn requires the processual togetherness of both components: the fluid form enters into space and successfully eludes the fixed boundaries of a 'kernel sculpture'.[108] By the same token, space – as an active agent – is incorporated into the material of the sculpture. This interplay of different components is posited on the transparency and fluidity of space and form which, for Moore, only exist in conjunction with each other. No other sculptor has set such store by the mutual interaction of these two elements.

Whenever Moore talked of sculptural space, he always pointed to this fundamental relationship. His two most important statements on this subject were made, firstly, in 1937, when he could already look back at his early, opened-out, biomorphous sculptures and, secondly, in the early 1950s in a discussion of the handling of space in his *Reclining Figure: Festival* (figs. 123–124a).[109]

Remarkably, in his 1937 article, 'The Sculptor Speaks', written for *The Listener*, he comes to the matter of 'opening out' sculpture in the same breath as he describes Brancusi's very concentrated shapes as 'almost too precious': '...it may now be no longer necessary to close down and restrict sculpture to the single (static) form unit. We can now begin to open out. To relate and combine together several forms of varied sizes, sections and direction into one organic whole'.[110] This is followed by a short discussion of the universal shapes of bones, shells and pebbles with Moore expressing his particular admiration of what Nature does with pebbles, some of which have

holes right through them. However, this does not necessarily harm the stone: 'A piece of stone can have a hole through it and not be weakened – if the hole is of a studied size, shape and direction. On the principle of the arch, it can remain just as strong.'[111] Moore then turns his attention to the meaning of holes and caves:

'The first hole made through a piece of stone is a revelation.

'The hole connects one side to the other, making it immediately more three-dimensional.

'A hole can itself have as much shape-meaning as a solid mass.

'Sculpture in air is possible, where the stone contains only the hole, which is the intended and considered form.

'The mystery of the hole – the mysterious fascination of caves in hillsides and cliffs'[112]

Here Moore connects the sculptural meaning of the hole with the innate, poetic mystery of the cave. Long before this, Rodin had also talked of the mysterious attraction that caves in the landscape had for him. However, in Rodin's case – as a Symbolist – the actual nature of the attraction was not defined more precisely than as a vague feeling that captivates the sensitive artist. In contrast to Rodin, Moore registers the cave and the hole as shapes in their own right, and he goes on to develop his own cave metaphors. From his original, authentically Surrealist interest in magic and ritual, Moore comes to see caves and holes in terms of masks, birth and the grave.[113]

Having achieved new heights in his dialogic form-and-space configuration in the bronze *Reclining Figure: Festival* (figs. 123–124a) in 1951, with its very considerable openings and holes, he penned some notes, in a sense justifying what he had done. And it is only now that he talks of the necessary 'distortion' of the form: 'If space is willed, a wished-for element in the sculpture, then some distortion of the form – to ally itself to the space – is necessary.'[114] This, precisely, is what he did so audaciously in *Reclining Figure: Festival*.[115] Not only did he create identifiable spatial zones within the centreless, distorted figure, he also allowed the line to come into its own on the surface of the piece. In this work Moore combines the three basic elements – line, form and space – to create a fully-formed, three-dimensional organism. This piece presents a new plastic analogy to an open image of a human being that is entirely harmonious in the coherence of its forms.

Shortly after finishing this incunabula of organic spatial sculpture, Moore noted down some more thoughts on the interdependence of form and space he had already postulated. For him the relationship between the two worked differently depending on whether the piece was modelled in clay or sculpted in stone. In the case of the model, the initial presence of a finely wrought armature meant that space was the dominant element; little by little the emerging form would work its way into it and, as such, clothe the space. However, when the

301 *Two Part Reclining Figure, No. 2*, 1960, Bronze, L. 257.8 cm, The Henry Moore Foundation (LH 458)

sculptor was working with a block of stone or wood, which is after all pure mass, he would have to be very sure of what he was doing if he wanted space to become an element in its own right within the sculpture.[116] Yet in his own praxis, the two working methods are by no means always completely distinct from one another. After 1936, for instance, the reclining figures carved from wood or stone (the UNESCO *Reclining Figure*) were preceded by clay maquettes, which only goes to show that all Moore was really concerned with was the final form of the work, that is to say, with balancing form and space.

Aside from the importance given to the hollows and holes that underpin Moore's notion of the interdependence of form and space, the old concept of *spatium* – the interstice – is unexpectedly imbued with new life in his works. Originally the preserve of architecture – for Vitruvius *spatium* was the space between two columns[117] – in Moore's hands it becomes

the interval between two forms. The real space between the two parts of a work becomes an active component in the work to the extent that the two forms relate to each other. In terms of the composition as a whole, the space is crucial, for as the vehicle that transports and mediates the energy emanating from the forms, it is the *constituens* of the organic whole.

Moore first stumbled on this fertile ground in 1959, when he pulled the maquette of a reclining figure apart and, as a result, conceived his *Two Piece Reclining Figure. No. 1* (fig. 125).[118] (This piece is one of a group of four two-part reclining figures, and was followed in 1961–63 by a number of other three- and four-part reclining figures.) In 1959 Moore placed the two sections on a turntable and later described how 'one form gets in front of the other in ways that you can't guess'.[119] The forms generate a rhythm of their own and have a potential for movement that feeds into their final positions. Moore knew that he had found the correct positions for the separate

parts when they did not overstretch the overall dimensions of the reclining figure and when the constituent parts and the whole were clearly connected.

At the same time, the interstices in multi-part reclining figures could fulfil an important metaphorical function: 'I realised what an advantage a separated two-piece composition could have in relating figures to landscape. Knees and breasts are mountains. Once these two parts become separated you don't expect it to be a naturalistic figure; therefore, you can justifiably make it like a landscape or a rock.'[120]

In his next work, *Two Part Reclining Figure, No. 2* (fig. 301) of 1960, Moore developed this landscape connection even further. At 257.8 cm in length, this piece is considerably longer than its predecessor of 1959 (fig. 125). It is as though Moore had drawn the two sections further apart, reducing its figurative allusions. Now the two sections appear to have sunk into the ground as 'rocks' and 'cliffs', which here – with much rougher surfaces – form the torso and the legs. Only the head seems to have escaped being incorporated into the rock-formations of the rest of the figure and, as such, draws attention to the level of alienation in this piece that involves not only the interstice but also the spatial notions of cave and hole that are familiar from earlier works by Moore.

This many-faceted interplay of the two spatial features that meant so much to Moore continues to develop in myriad ways in subsequent multi-part reclining figures and in later abstract compositions.

Spiritual Vitality as a Founding Principle

Ever since Antiquity – and especially since Ovid's *Pygmalion*[121] – inner vitality together with the look and the aura of life have been the sculptor's highest aims, which were never more sensually achieved than in Falconet's famous *Pygmalion* group of 1763. However, if one takes away everything that continued to keep these aims uppermost in sculptors' mind, right up until and including Rodin – that is to say, if one removes the allegory of the loving artist, reflections on the transition from inanimate to animated matter, the inspiration of beauty, the adornment of the mimesis of Nature[122] – then, even after modern artists have crossed the Rubicon of abstraction, they are still left with the time-honoured striving to breathe life into their work. And although in some languages the notion of 'vitality' – in German for instance – can tend towards rude good health, in English it has more to do with activity and movement in the sense of being animated, strong and capable of continued development. The idea of 'vitality' was so important to Moore that for him it was also intrinsic to his definition of beauty, as we see from his early programmatic contribution to the publication *Unit One* in 1934. Here he pledges his allegiance to a form of beauty that has a power of

expression that is not merely about pleasing the senses, and that has 'spiritual vitality, which for me is more moving and goes deeper than the senses'.[123]

At the time when he made this statement, Moore was in close contact with his fellow-artists and friends, Barbara Hepworth, Ben Nicholson, Paul Nash and, above all, their theoretician-in-chief Herbert Read. The latter was very much in favour of an organicist aesthetic, which he felt was perfectly exemplified in Moore's work. As early as 1933, when he published his book *Art Now*, Read was already able to identify two underlying trends in the art of his own time: abstract Formalism and subjective Idealism. The second of these relied heavily on natural organic forms. Later on Read was to see Surrealism as part of the same lineage.[124] In his 1934 monograph on Henry Moore, Read again referred to the dialectics of the order he had earlier identified: 'In one direction the artist tends to create a work whose aesthetic significance resides in formal relations and in qualities of texture; in the other direction the artist combines these relations and qualities with a reflection or representation of qualities typical of living things or, at least, qualities due to natural processes. The first type of artist is a purist, and makes no kind of compromise with any world outside the ideal world of subjective creation; he merely gives outer and solid form to conceptions that are as abstract as any conceived by the mathematician... In modern sculpture Brancusi is the foremost representative of this type of artist. The second kind of artist does not wish to limit his function in this way. He feels that if he can link his formal conceptions with the vital rhythms everywhere present in natural forms, that then he will give them a force altogether more dynamic than the force of abstract conceptions. Henry Moore, though he does not exclude exercises in the abstract mode, and, indeed, finds such exercises a considerable aid to his development, belongs essentially to this second type.'[125]

Read distinguished clearly between 'abstract' and 'living' forms. And in his view, those who addressed the second in their pictorial language in effect subscribed to a philosophy of life that he explained in the following terms: 'Mr. Moore, in common with artists of his type throughout the ages, believes that behind the appearance of things there is some kind of spiritual essence, a force or immanent being which is only partially revealed in actual living forms. Those actual forms are, as it were, clumsy expedients determined by the haphazard circumstances of time and place. The end of organic evolution is functional or utilitarian, and spiritually speaking a blind end. It is the business of art, therefore, to strip forms of their casual excrescences, to reveal the forms which the spirit would evolve if its aims were disinterested.'[126]

Although these sentiments might have benefited from some further elucidation – Aristotle and Kant are looking on from afar[127] – and hardly do justice to Moore's love of Nature, nevertheless it is worth inquiring as to why Moore's friend

and closest interpreter makes such a point of Moore's belief in a 'spiritual essence'. With his description of Moore's determination to create purer forms (as in Nature), Read affirmed Moore's notion of spiritual vitality. And in his book on Moore, he made a similar remark in connection with Moore's intense study of Nature and the natural world: '…the artist makes himself so familiar with the ways of nature – particularly the ways of growth – that he can out of the depth and sureness of that knowledge create ideal forms which have all the vital rhythm and structure of natural forms. He can escape from what is incidental in nature, and create what is spiritually necessary and eternal'.[128]

In Read's theoretical deliberations, he later summed up these qualities as 'organic vitalism'.[129] And in his 1965 book on Henry Moore, he repeatedly makes reference to the latter's vitality. However, in the end when he blatantly generalises this term, it is clear that by now he has thrown in his lot with Carl Gustav Jung: 'The modern artist has dared – and no one has been more explicit than Moore about his intentions in this respect – to abandon the ideal of beauty and establish in its place the ideal of vitality. But vitality is but a provisional word which serves to disguise the fact that we do not know and cannot measure the nature of life. Beauty is no mystery: it can be represented by geometrical formulas, by calculated proportions. But the vital process is intangible, and can be represented only by symbolic forms – forms symbolic of the essential nature of living organisms and forms symbolic of the racial experiences that have left an impress on our mental constitution – the archetypal patterns of birth and death, of social conflict and tragic drama.'[130]

In fact – to return momentarily to Coleridge – Moore sought out 'life producing ideas' that he would then strive to realise in his forms. As such – as ideas – they owed everything to his inner convictions. And this approach also had its origins in the Romantic movement in the sense that Schelling always had his sights on the ability to develop spiritually, an ability that he regarded as the defining feature of human beings. It was from this Romantic perspective that Moore's maxim of spiritual vitality that goes deeper than mere beauty came into its own.[131]

Internal and External Form

There are very similar parallels to Moore's thinking in the notion of the reconciliation of opposites that Coleridge extrapolated from the notion of the organic whole. And when Coleridge makes the connection between this and the moral responsibility of poetic forms 'to make the external internal, the internal external', it is as though he were anticipating Moore's much later artistic praxis. The fundamental importance of this mutuality to Moore is well exemplified in

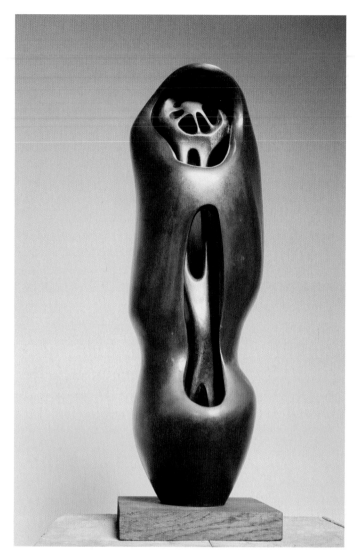

302 *Internal/External Form: Flower*, 1951, Bronze, H. 76.5 cm, The Henry Moore Foundation (LH 293b)

three major works from the period 1951–54. The three pieces in question – bronzes made one after the other – are *Internal/External Form: Flower* (fig. 302),[132] *Upright Internal/External Form* (figs. 303, 304)[133] and *Reclining Figure: Internal/External* (figs. 305–307).[134] The form and content of these three works is best understood if they are viewed as variations on a single conception. The maquettes for these sculptures were all made in 1951, thus the history of their making suggests that they should be viewed as a group of three, as does their self-evident role as the threefold exploration of the *same* idea, namely the mutual interaction of inner core and outer casing. In this we also encounter Moore's outstanding sense of balance – which, as we shall see later, was as important to his immanent aesthetic as were organic form and the concept of an organic whole. This close connection of inside and outside is also the theme of Goethe's late poem, *Epirrhema*:

'Science of nature has one goal: / To find both manyness and Whole. / Nothing "inside" or "Out There", / The "outer"

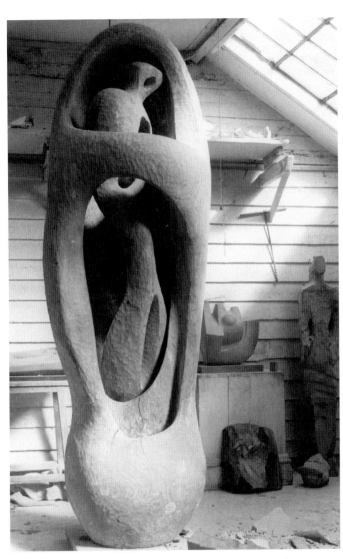

303 *Upright Internal / External Form*, 1953–54, Elmwood,
H. 261.5 cm (photography of the studio), Albright-Knox Art Gallery,
Buffalo, USA (LH 297)

world is all "In Here"./ This mystery grasp without delay, / This
secret always on display. / The true illusion celebrate, / Be joy-
ful in the serious game! / No living thing lives separate: / One
and Many are the same.'135

The first work of this group listed in the catalogue raison-
né is *Upright Internal/External Form: Flower*, in which the
internal figure terminates at the top like a 'stamen' of sorts, as
Moore himself called it. The external form in this first piece is
differently handled to that in the next major work, *Upright
Internal/External Form*, which was always recognisably the
image of a mother and child.136 In the first case it looks like a
part-human, part-fruit hybrid; the second tends more to the
human. In both works the dominant impression is of a column
with two openings at the front and an external contour that
flows rhythmically in and out. Of the two, the *Flower* con-
tracts and expands more dynamically than the calmer mother
and child which, with an almost completely flat back, seems
if anything to be stretching upwards. The different tempos

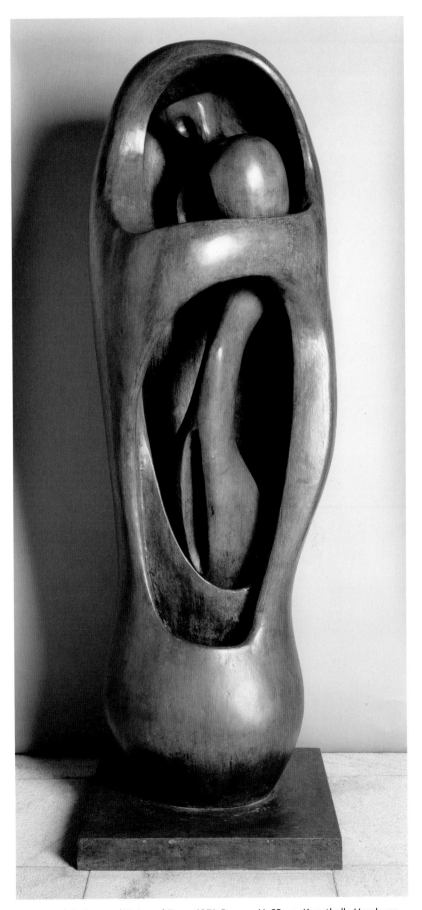

304 *Upright Internal/External Form*, 1951, Bronze, H. 62 cm, Kunsthalle Hamburg
(LH 295)

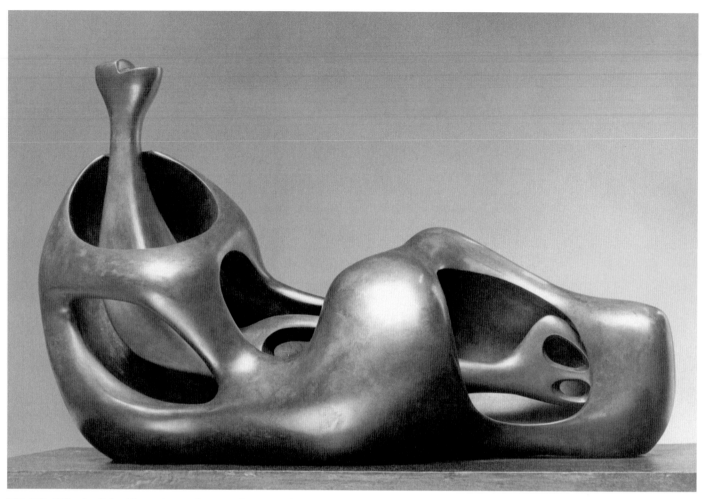

305, 306, 307 *Reclining Figure: Internal/External*, 1951, Working model, Bronze, L. 535 mm (LH 298)

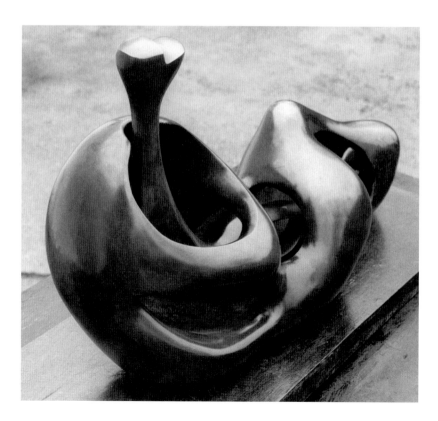

306

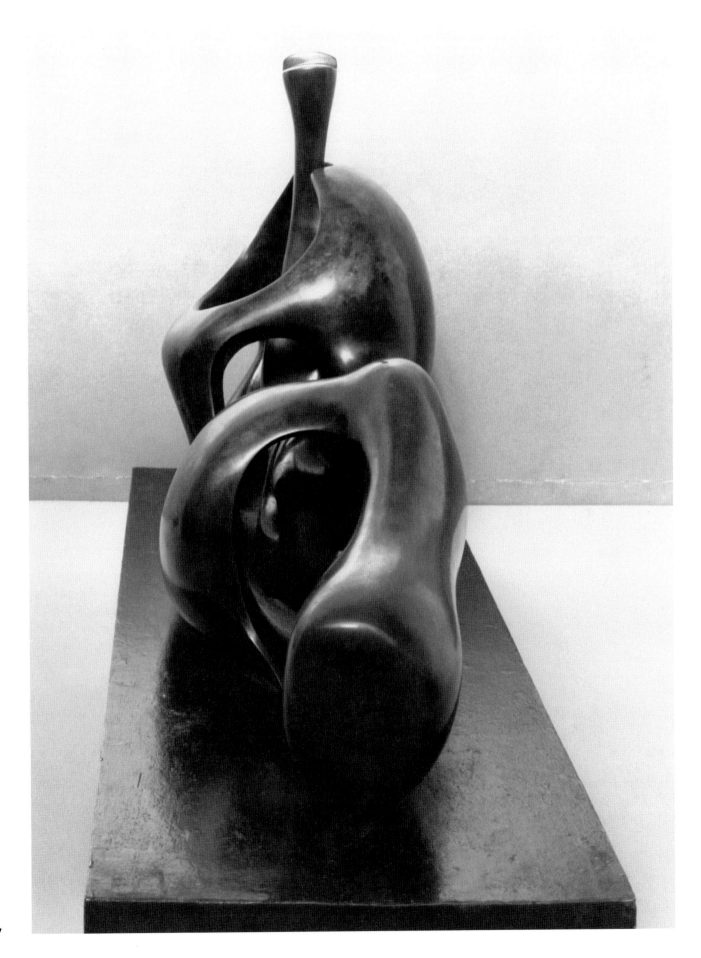

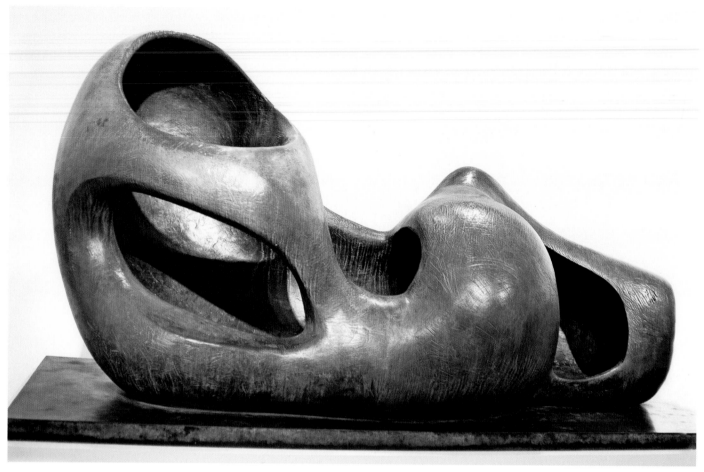

308, 309 *Reclining Figure: External Form*, 1953–54, Bronze, L. 213.5 cm, Europaplatz, Freiburg i. Br.

of the two outer casings also determine the formation of the internal figures. In the more sketch like *Flower*, the internal figures is more delicately formed, whereas in the other piece, the thicker casing encloses a more substantial 'child' with a will of its own, twisting and flexing its limbs.

Ever since it was first shown, viewers have marvelled at the inspired manner in which Moore gave life to the notion of internal/external forms in this dual figuration (figs. 303, 304), creating a telling, harmonious dialogue that elevates the work as a whole to the level of an existential metaphor. The front view of *Upright Internal/External Form* is dominated by a sense of growing movement. And it is only in this piece that the lower section of the casing leads stepwise into the centre. At the same time, these bodily layers as it were contain more space – witness the spaciousness of the casing in *Upright Internal/External Form*. In order to demonstrate the greater roominess of this internal space, it is said that in the company of his friends in 1953–54 Moore would even climb inside the casing himself.[137] The artist left it to others to try to put into words the evident symbolism of this important sculpture. In 1961 Erich Neumann – well schooled in C. G. Jung's theory of

archetypes – came to the following conclusion: 'What we see here is the mother bearing the still un-born child within her and holding the born child again in her embrace. But this child is the dweller within the body, the psyche itself, for which the body, like the world, is merely the circumambient space that shelters or casts out. It is no accident that this figure reminds us of those Egyptian sarcophagi in the form of mummies, showing the mother goddess as the sheltering womb that holds and contains the dead man like a child again, as at the beginning. Mother of life, mother of death, and all-embracing body-self, the archetypal mother of man's germinal ego conciousness – this truly great sculpture of Moore's is all these in one. And just for that reason it is a genuine bodying forth of the unitary reality that exists before and beyond the division into inside and outside, a profound and final realization of the title it bears: *Internal and External Forms*. Outside and inside, mother and child, body and soul, world and man – all have been made "real" in a shape at once tangible and highly symbolic.'[138]

The third example, *Reclining Figure: Internal/External* (figs. 305–307)[139] represents a figure inside a casing, and is only

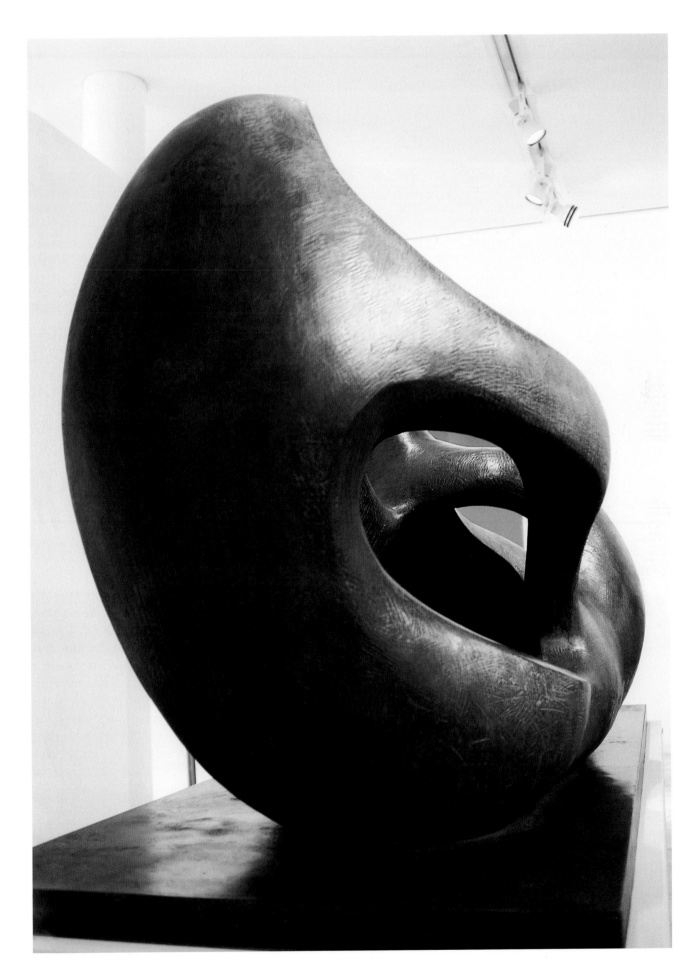

310 *Standing Figures*, 1940, Pencil, chalk, watercolour, pen and ink, 432 x 254 mm, Collection Jeffrey H. Loria, New York, AG 39-40.43 (HMF 1494)

known as a working model. It was intended as a preparatory study for a larger version, measuring 2.13 metres in length and made in 1953–54. However, the internal figure was not included in the final, large-format example. Was it too dramatic for Moore? Whatever the case, the final version[140] was clearly of lasting interest to Moore and he never tired of photographing its tunnel-effects, holes and swinging outer casing (figs. 308, 309).[141]

And yet, in the working model, it seems that Moore was perfectly satisfied with the relationship between the internal and external forms. But why only at this size? Presumably because at a length of 53.3 cm, the piece is more comprehensible as the viewer looks at it or down on it. And it is only then that the close interconnection of the movement of the internal figure and that of the casing can properly be seen in the round as intended. The multiple correspondences within the overall internal-external composition only come into their own when the piece is seen as a whole. Taking a closer look at the movements of the reclining figure and at the casing actively enclosing it, we can see Moore's attitude to the human figure and its anatomy. The feet, part of the lower section of the figure, are enclosed more tightly by the casing. In the upper curved section the pelvis stands out clearly on the right-hand side. And at the point where the figure becomes active and gains height by sitting upright, the casing recedes and gives the internal figure all the room it needs in three large openings. Ultimately it is only the head, as it were rising up out of the neck, that is free to break through the outer casing. The head rises up from the vertical line of the neck. Remarkably, here Moore retains the functional, anatomical unit of the backbone and skull we find everywhere in the natural world.

If one looks down on *Reclining Figure: Internal/External* from above (fig. 306) or directly from the side (fig. 307),[142] one can again see the extent to which Moore had the human form in mind when he was creating the flowing casing, where the full-length closed rear clearly echoes a human back. In that sense, in this reclining figure the internal and external forms could not be more closely related. One complements and energises the other.

Let us now look individually at the developments in terms of form and content that are revealed in these three sculptures. As we saw in Chapter I.2, the germ of the idea of the internal/external forms was first articulated in 1935. At the time, when Moore was in his thirties and working through his early, experimental Surrealist phase, he made the drawing illustrated here, in which he had expressly set himself the task of depicting 'forms inside forms' (fig. 103).[143] In the lower left he takes his inspiration from an Oceanic sculpture – an ornamental malanggan column – that was on display in the British Museum (fig. 104).[144] It takes the form of a highly embellished female figure carved from a single section of a tree. Moore did

not include the gaping 'fish mouth,' nor the head, nor the hands holding the pendulous breasts that are typical of these ritual figures. His interest was in the carefully calibrated juxtaposition of the body and the open framework around it which he accentuated with heavier pencil lines.

The figure on the right is a free invention, but still has obvious Oceanic roots. Within an open system of supports, an upright fragile form is sketched in with rapid, brittle lines. The pelvis is an abstraction of the upwards curved fish mouth. The dominant sternum and the bent legs recall the framework of the malanggan column. Finally, the flower head – with an additional stamen – gives this ephemeral form a plant-like feel. In this transformation of one of the forms-inside-forms motifs, which was itself derived from a ritual Oceanic figure, into a plant-like hybrid image, Moore was in effect taking the first step towards *Upright Internal/External Form: Flower* (fig. 302). But before the final figure could be realised sixteen years later, it had to progress through a whole series of preparatory drawings.

In a drawing of 1938–39 (fig. 63),[145] Moore has transformed, draped and stabilised the delicate figure. The idea of adding drapery, as the top left figure clearly shows, came from his *Stringed Figures* of 1937 (fig. 116).[146] While the latter was characterised by the dichotomy of an abstract, concave body and a 'veil' of strings, in this sheet of drawings Moore has solidified the protective body. It appears firmer. Consequently, in the next sketches the body was able to cope with bone-like internal figures instead of the strings. In addition to this, the standing figure at the lower right has a pattern of holes that Moore himself once described in conversation as 'roots'.[147] Clearly the notion of plant-based metamorphosis had lasted beyond 1935. That it was not abandoned in the immediate future either, is evident from the next drawings. On a sheet of studies dated 1939–40 (fig. 310), Moore built separate 'storeys' into open casings around the internal elements (distinctly plant-like in the lower left study). Now the relationships start to settle down. In the upper left part of the sheet, Moore is exploring the sculptural *helmet* motif that he had come up with in 1939.[148] With an internal figure inside the head, this motif was to be crucial to the development of the *Upright Internal/External* sculptures. Another important feature of the further evolution of the internal/external forms is seen in the small study in the upper right of the sheet from 1939–40. Here a single spar crosses in front of a hollowed-out body.

Eight years later, after Moore had digested the impact of World War II in his *Shelter Drawings*, he once again returned to the notion of internal/external forms; now, with a sure touch and an entirely new level of certainty, he guided the motif towards its final, three-dimensional formulations. The two sheets of studies for *Internal/External Forms* illustrated here (figs. 311, 312) come from a sketchbook Moore used in

311 *Sketchbook 1947–49*, p. 38, *Ideas for Internal and External Forms*, c. 1948, Pencil, wax crayon, coloured crayon, watercolour, pen and ink, gouache, Smith College Museum of Modern Art, Northhampton, Mass., AG 47-49.13 (HMF 2408)

312 *Ideas for Sculpture – Internal / External Forms*, 1949, Pencil, wax crayon, coloured crayon, watercolour wash, pen and ink, 29.2 x 23.8 cm, Private Collection, London, AG 47-49. 71r (HMF 2458)

313 *Three Figures: Internal/External Forms*, 1948, Pencil, pen and ink, chalk, watercolour, Private Collection, USA, AG 48.8 (HMF 2481)

1947–48. These studies are astonishingly advanced versions of the three finally realised sculptures, with the most attention – in terms of drawn detail – being paid to what would become *Internal/External Form: Flower*.

A similar level of attention is paid to the same motif in a sheet from 1948 with three variations on the *Flower* theme (fig. 313). Here the motif is drawn as statues, prefiguring the bronze realised three years later. In 1948 Moore still had a real flower-head in mind, as he had already done in the first sketch of 1935 (fig. 103). But he finally relinquished this idea so that the figure should be more completely self-contained, which in turn heightens the intensity of the dialogue between the internal and the external form. While the central statue approximates most closely to the 1951 bronze, the statue to its right also deserves closer examination. Here Moore abandons the ring-like stamens and hints at a more human anatomy instead. For here the top section of the internal figure calls to mind a schematic representation of a human heart with blood vessels branching off it, while, lower down in the same figure, the relatively free, relocated bifurcation of two large blood vessels recalls the arteries and veins in the lower body – an astonishingly concrete connection is made here between Moore's internal figure and the inner, invisible human being.

The care with which Moore developed his sketches of the *Flower* version suggests that when it came to realising the three bronzes in 1951, Moore started with this plant-like, humanoid conception and only then – or possibly concurrently – turned his attention to the two other versions.

In the sketches of statues in the sheet from 1948, the outer figures undulate in a manner that is highly evocative of thrusting, organic life. It was only in the mother-and-child version that Moore calmed this active force and instead opened up a spiritual dialogue of sheltering and being sheltered, of giving protection and of pent-up internal energy. In the third version, he turned the spotlight away from the inner figure and outer figure, from the core and its casing, to the conditions pertaining to a semi-raised reclining figure, and used the flowing transitions between stasis and motion, between mass and space, to unleash a more intensely dynamic overall rhythm.

Balance: Equilibrium and Synthesis

The group of *Internal/External Forms* demonstrates something of the spectrum of meaning contained within the notion of balance – a term that Moore repeatedly used, forcefully yet also perfectly naturally. It is not only one of the cornerstones of his aesthetics, it also reveals an important side of Moore's personality.

Anyone who looks up the entry for 'balance' in the *Oxford English Dictionary* will find references ranging from Shakespeare and Milton to Dickens and Ruskin, all writers with whom the widely-read Moore will have been very familiar. In a figurative sense 'balance' is defined as 'The metaphorical balance of justice, reason, opinion, by which actions and principles are weighted or estimated'. On a generative level it is 'That which balances or produces equilibrium' – as in a well-considered counter-argument in a discussion. Further to this, there is also the term 'balanced condition', where the dictionary explanation seems very much in the spirit of Moore's work: 'Balance = General harmony between the parts of anything, springing from the observance of just proportion and relation; especially in the Arts of Design.'[149]

A sense of the properties of 'balance' described here, particularly with reference to harmony between parts arising from the overall proportions of the object in question, was in Moore's blood, both through his native language and through his cultural upbringing as an Englishman. The first two meanings cited here are concerned with the carefully judged consideration one might give to actions or principles and with 'equipoise of mind, character or feelings.'[150] Both of these remind me vividly of the man Henry Moore in our conversations in 1977, 1978, 1980 and 1982 in Much Hadham, walking together in his sculpture park, and in 1979 in the Städelmuseum in Frankfurt. Fêted the world over, at that time Moore was

still young enough to work at a furious pace and yet he was already aware of his place in history. I myself witnessed firsthand how naturally and openly – in his determination to come up with a balanced, fair answer – he would respond to questions about the extent to which he and his contemporaries might have discussed and exchanged ideas. Of course Moore must always have had the capacity to freely recognise other people's achievements. One need only recall the help he gave to Jewish immigrants during the war – such as the German sculptor Theo Balden – who were trying to have their work shown in London. Recollecting his meetings with artists such as Picasso, Giacometti and Miró, Moore spoke warmly of these occasions and of the horizons that they had opened up for him, and concluded with a wide smile: 'Yes – I was influenced.'[151]

Moore's self-confidence tempered with modesty had to impress and shame all those who met him. To take just one example: on one occasion, in order to put an important question as clearly and quickly as possible – the time allowed for interviews was always strictly adhered to – I had taken a number of sketches with me. "Did I do that?' was his surprised inquiry – although of course the question was immediately answered at second glance.

The fact that, despite his own increasing workload in the postwar years, Moore played his part in the reconstruction of the country, in part by becoming an honorary curator at the National Gallery and at the Tate Gallery, points to the steadiness of this character. On the other hand, he was no saint; he could lose his temper and normally balanced outlook like anyone else if, for instance, an assistant had allowed minimal inaccuracies to creep into the larger version of a bozzetto.

In 1949, Moore was not above creating lithographs for use in schools, although he never let his own artistic standards slip. As we saw in Chapter I–5, in the colour lithograph *Sculptural Objects* (fig. 154) of 1949[152] he presented his young viewers with a picture parable, in which he shows that in life it is important to find a balance between *ratio* (represented by a counting device and an armillary sphere at the edges of the picture) and participating in the living processes of Nature and art (represented in the togetherness of the butterfly doll and the Mycenaean clay idol).[153]

The aesthetic value of balance in Moore's work is perhaps best described with reference to the notion of 'balanced condition' cited in the *Oxford English Dictionary* and the quotation from Ruskin. In the volume 1 of his *Modern Painters* (1843–60) Ruskin – the 'Luther of the arts'[154] who, most importantly for Moore, instigated the 'historicisation of the observation of Nature and natural forms[155] – writes that 'In all perfectly beautiful objects, there is found the opposition of one part to another, and a reciprocal balance.'[156] And Moore made a plea for a very similar 'reciprocal balance' with respect to different trends in art in his early essay 'The Sculptor Speaks': 'The violent quarrel between the abstractionists and

the surrealists seems to me quite unnecessary. All good art has contained both abstract and surrealist elements, just as it has contained both classical and romantic elements – order and surprise, intellect and imagination, conscious and unconscious. Both sides of the artist's personality must play their part.'[157]

It may have been while he was working on this essay of 1937 that Moore came up with the following outline of balance in the history of art and his own work. He starts by making a list of opposites:

'The classical tendency	The romantic tendency
order	surprise
unity	variety
design and formal relations for their own sake	content expression
conscious, intellectual, logical, calculated	intuitional, emotional, imaginative
symmetrical	asymmetry
static	dynamic
squareness, – rectilinear	curves & roundness
geometric	organic & biomorphic
hardness, tenseness	flowing softness
ordered shape, abstract non-representational	surrealist

'My work may be balanced on the second side but it also contains some of the other elements – but I believe it has some element of order & unity, some design, even balance & abstract qualities, some tenseness.

When its [sic] all classic, its too obvious & cold & deadly perfect, when its all romantic, its too loose uncontrolled wildly chaotic & shapeless – But in my opinion – Gothic sculpture – Mexican, all primitive sculpture, Shakespeare, Beethoven, Tintoretto, El Greco, Rubens, Michelangelo, Masaccio, are all more romantic than classic.'[158]

In this telling statement, Moore 'dehistoricised' the standard notions of 'classic' and Romantic to the extent that he defined their characteristics in such a way that they fitted his current view of his own praxis and also his own art-historical preferences. In his own work he saw both 'classic' and Romantic elements.

In the 1950s, Moore took this not-only-but-also approach to mean that in the artist there could well be 'two conflicting sides': 'the tough and the tender'. In support of this he cited figures such as Blake, Goya, Shakespeare, Michelangelo and Picasso before, with his characteristic, honest reserve, coming to his own situation: 'And really I see no difficulty in appreciating both sides & finding them in the same artist.

Perhaps an obvious & continuous synthesis will eventually derive in my own work. – I can't say – I can only work as I feel & believe at the time I do the work. I can't consciously force it to come.'[159]

In the 1970s he embraced the notion that he had this ability to create a synthesis of opposites when he told his favoured photographer, David Finn, '…some critics see as two opposing sides in my work – the "tough" and the "tender". I am happy to think I may have these two sides. To understand or feel anything deeply, you must know its opposite.'[160] The underlying balance in Moore's work becomes very noticeable when one considers his working methods, his specific observation and exploration of forms and his openness to often very diverse cultural traditions from all over the world.[161] This approach is itself reflected in the mutual interdependence of opposites that he often spoke of and implemented in his own output by combining abstraction and figuration, figure and landscape, calm and movement, mass and space, inside and outside. For the sculptor Henry Moore, his study of the human body was the basis of all he did. He pursued this interest as long as he lived. Moore himself advocated drawing from life in order to acquire an exact understanding of human anatomy. Talking to his biographer John Russell and the latter's wife, Vera, in 1961, Moore described the demands that he made of himself in his *Life Drawings*: 'And the human figure is both the most exacting subject one can set oneself and the subject one knows best. The construction of the human figure, the tremendous variety of balance, of size, or rhythm, all those things, make the human being much more difficult to get right in a drawing than anything else. It's not only a matter of training – you can't understand it without being emotionally involved, and so it isn't just academic training: it really is a deep, strong, fundamental struggle to understand oneself as much as to understand what one's drawing.'[162]

While this fundamental determination to understand human morphology for the sake of its sculptural aspects depended on the artist's perception of the endless examples of balance in the human form, it also depended on his precise observation of size and rhythm.

Scale: A Measure of the Artist's Inner Vision

With regard to questions of size, that is to say, correct scale, Moore went into the greatest detail in his article 'The Sculptor Speaks': 'There is a right physical size for every idea. Pieces of good stone have stood about my studio for long periods, because though I've had ideas which would fit their proportions and materials perfectly, their size was wrong. There is a size to scale not to do with its actual physical size, its measurement in feet and inches – but connected with vision. A carving might be several times over life size and yet be petty and small in feeling – and a small carving only a few inches in height can give the feeling of huge size and monumental grandeur, because the vision behind it is big. Example, Michelangelo's drawings or a Masaccio madonna – and the Albert Memorial.

Yet actual physical size has an emotional meaning. We relate everything to our own size, and our emotional response to size is controlled by the fact that men on the average are between five and six feet high… If practical consideration allowed me, cost of material, of transport etc., I should like to work on large carvings more often than I do. The average in-between size does not disconnect an idea enough from prosaic everyday life. The very small or the very big takes on an added size emotion.'[163]

Moore wrote these lines in 1937, and they read like a projection into the future. For in the years to come, especially after his breakthrough to the five-metre UNESCO figure of 1957–58 (fig. 1) and his use of polystyrene at the modelling stage,[164] Moore increasingly found opportunities to realise ideas on a 'very big' scale that broke out of the confines of ordinary life. But at times he also enjoyed working on a very small scale, which could potentially appear nothing short of monumental. The success of both scales depended on the strength of the artist's inner vision, which – in Moore's late works – took them into the realms of the sublime.

Rhythm: Dynamic Form

None could fail to notice the emphasis on balance and rhythm in Moore's comment to the Russells in 1961. How important these were to Moore is also evident in the emphasis he placed on them in 1930 in his modernist survey of 'The Nature of Sculpture'. Here he declares that there are no limits on the scope of the present-day sculptor, who is able to recognise 'the intrinsic emotional significance of shapes' and who understands the material he is working with. 'His inspiration will come, as always, from nature and the world around him, from which he learns such principles as balance, rhythm, organic growth of life, attraction and repulsion, harmony and contrast… It has a life of its own, independent of the object it represents.'[165]

In this essay, Moore credits the principles of balance and rhythm with all the qualities that were identified in connection with the 'organic whole' and in the thinking of Goethe and Coleridge. It is clear that, for Moore, rhythm and balance, in conjunction with each other, were the vehicles that conveyed the vitality of the artistic form. He deliberately sought out forms and rhythms in Nature that he could use, in a mediated form, in his own artistic creation. And if it is true to say that in his work form is rhythmic and rhythm is fully-formed, then this is due to the equivalence of form (mass) and space. For rhythm only emerges from the movement of forms in space and, vice versa, from the movement of space with and in forms. The rhythmification of the articulation of the form and space within a figure gives that figure a sense of direction, a beginning and an end, and hence a life of its own. It is only

rhythm that secures its position in the organic interconnections of its flowing changes of direction. In Moore's eyes, rhythm follows close on the heels of balance as the most powerful guarantor of vitality.

These connections can be seen in many of Moore's figures, such as the well known lead *Reclining Figure* of 1939 (fig. 314).[166] At only 33 cm in length, a coherent rhythm runs through it from end to end. The fluid articulation of its forms and spaces starts in the parallel, raised lower legs. The elongated hollow of the lower body is crossed above the hips by a bar set at a right angle to the rest of the piece. Beyond this the body continues through a horizontal plane before rising up vertically. The upper body is also divided at its half-way point, in this case by the back of the pelvis and the breast piece at the front. Both elements run through the fluidly modulated lines of the breastbone and the arms into the powerful horizontal of the shoulders. Out of this rises the divided head. The opening in the head echoes the opening in the leg section. Thus this *Reclining Figure* of 1939 has a beginning and an end and, as such, functions as a coherent whole. The flowing rhythm is firmly anchored with in it, and the marked caesuras articulate the proper motion of the organic whole.

This fluid yet in itself sustained interrupted notion of rhythm in Moore's work occupies a special position in the history of aesthetics. As a rule, rhythm – as a way of organising time – is recognised and described in music, poetry and dance. But in the visual arts, too, and today in film, video and web art, it can be of crucial significance when the dynamic repetition of certain equivalent elements is a major factor in the composition of the piece.[167]

From its origins in Classical Greek proportions, through its association with the laws of a divine order in the Middle Ages, it was only in the Renaissance that rhythm became an artistic means in its own right and a constituent in the portrayal of the human form.[168] Thanks mainly to the increased autonomy of pictorial means since Cézanne, rhythm played a very important part in the art of the twentieth century. In Cubism it primarily served to articulate the composition – reinforced by the Cubists' awareness of the rhythmic lines and planes in African carvings. By contrast, in Surrealist-influenced Biomorphism – seen in Picasso's biomorphic constructions from around 1930 – the emphasis is on rounded or bone-like formations whose pent-up, implosive rhythms move in sweeping curves and have more to do with the animal kingdom.

Moore was of course fully aware of all of this. And he would certainly have been interested in an article entitled 'Rhythm' by the painter and avant-garde filmmaker Hans Richter. It was published in English in 1926 in the well known periodical *The Little Review*. Here Richter is indirectly referring to his own avant-garde films in which specific structural units – squares, rectangles, abstract forms and objects – are seen in rhythmic motion. Richter's organicist thinking is astonishingly

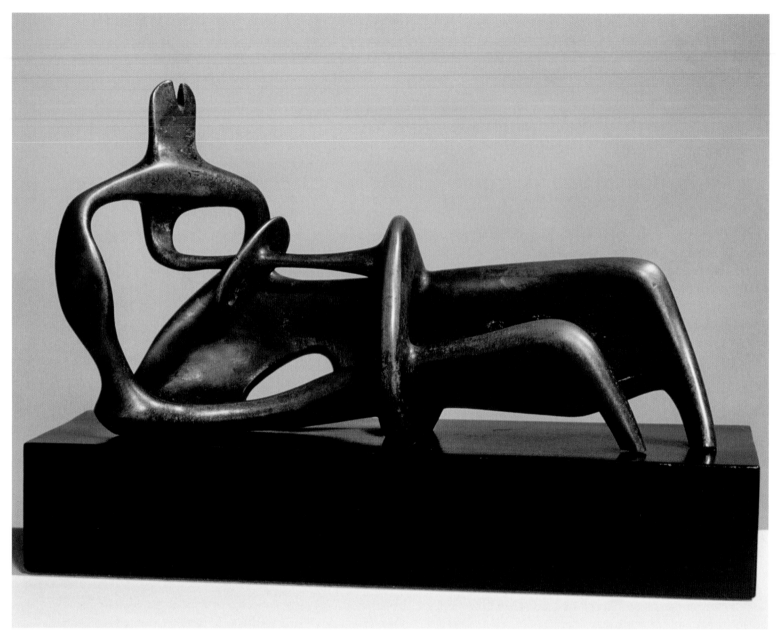

314 *Reclining Figure*, 1939, Lead, L. 33 cm, former Collection Gordon Onslow-Ford (LH 208), 1959, 9 versions cast in bronze, The Henry Moore Foundation

closely related to Moore's ideas on the same subject: 'The Rhythm of a work is equal to the idea of the whole. Rhythm is the thing that informs ideas, that which runs through the whole: sense – principle, from which each individual work first gets its meaning. Rhythm is not definite, regular succession in time or space, but the unity binding all parts into a whole… Just as the path of the intellectual formulating power leads to thought, as a justifying moment of intellectual activity, so the emotional formulating power leads to rhythm as the essence of emotional expression. Just as thought gives the value to an abstract work, so rhythm gives a meaning to forms…

'Rhythm expresses something different from thought. The meaning of both is incommensurable. Rhythm cannot be explained completely by thought nor can thought be put in terms of rhythm, or converted or reproduced. They both find their connection and identity in common and universal human life, the life principle, from which they spring and upon which they build further.'[169]

Moore could certainly only have agreed with this remarkable passage, for he too regarded rhythm as a life-giving force when he spoke of its contribution to sculpture. Indeed, he even went so far as to suggest that each artist expresses his own individual rhythm in the forms he creates, although it is to his advantage if he should consciously remain unaware of this, so that it can come into its own unhindered in his artistic production.[170]

In his view of rhythm as a life-giving principle, Moore was not thinking merely of musical rhythm that is generally understood as a mathematically constructed means to order time. Moore – importantly – utilised rhythm as a dynamic component of the organicity of the parts and the whole. And it was also to the rhythm that he looked for the spiritual vitality of a work of art.

In Moore's hands, the rhythm of a work could also breathe life into the relationship between a sculpture and its architectural setting. In his explanation of the screen he designed in 1953–54 for the Time Life building in London's Bond Street (fig. 411)[171] he expressly declared that the aim was 'to give a rhythm to the spacing and sizes of the sculptural motives which should be in harmony with the architecture'.[172] He only felt that he had achieved this aim at the fourth attempt: 'The fourth maquette I thought was better and more varied and so this became the definitive maquette…'[173] The four reliefs were originally intended to be installed on separate pivots and to regularly rotate. However, this was deemed unsafe and the idea was abandoned. As it is, the four reliefs sit in the rectangular framework of the screen in such a way that the rhythmic variety and carefully balanced openings of individual forms are seen to best advantage.

Varietas

For Moore variety and rhythm were closely interconnected. Early on, in *Unit One* he wrote: 'There is in Nature a limitless variety of shapes and rhythms.'[174] And much later, in the 1960s, he remarked to John Hedgecoe in connection with his study of bones and the collection of bones in the Natural History Museum: 'The wonderful collection of bones with such a variety of structures… From objects like this, I have learnt to approach varieties and textures, even rhythms.'[175] Studying these objects enriched the sculptor's imaginative powers, which in turn generated the rich variety of spatial aspects from the organic unity of the sculptural conception.

Moore's 'variety' profited from its close interconnections with the life-giving principle of rhythm. It also enhanced the viewer's experience by drawing on the traditional, aesthetic concept of *varietas*. Basing his argument in Classical rhetorics, specifically in that of Cicero, it was the early Renaissance scholar Leon Battista Alberti who crucially introduced the concept of *varietas* both into his discussion of the composition and reception of history paintings and into his thoughts on architecture.[176] For Alberti *varietas* – alongside *copia* (wealth) – was a primary formal element that 'arouses the interest of the viewer and moves and delights him to an equal degree.'[177]

In the realms of sculpture, the Classical rhetorician Quintillian already specifically identified variety in Myron's *Discus*

Thrower (c. 450 BC),[178] the same work that the young Moore was compelled to copy at art school in Leeds. In the Renaissance Donatello and, most notably, Michelangelo set new standards. Now variety in sculpture concerned the various aspects of a piece, the connections between different spatial layers, in short everything that by means of variation, repetition and transformation would interest and inspire the viewer.

When Moore connects this concept of *varietas* to form and rhythm, he concentrates mainly on movement. This combination is seen to particular advantage in his late works where two forms echo each other and communicate with each other in dual figurations such as *Moon Head* (1964),[179] *Two Forms* (1964–69) and *Large Two Forms* (1966–69; fig. 315), *Double Oval* (1966; fig. 316) and *Two Heads* (1976).[180] In the rhythmic sequences in these pieces the variety arises from repetition and transformation. And as one walks around these dual figurations, the two elements reveal the many facets of their formal and spatial presence as they are juxtaposed,[181] interposed,[182] stand in parallel at one remove[183] and approach each other.[184]

Keats, Expressive Intensity and Psychological Truth

While balance, rhythm and variety were intrinsic to the organicity of Moore's concept of vitality, there was another important aesthetic criterion in this mix, namely intensity. In Moore's hands this was mainly achieved through the nature of the expression. Therefore it is not surprising to find the young sculptor referring to it in the context of the expressive force of primitive sculpture As he said in an interview in 1932: 'The primitive simplifies, I think, through directness of emotional aim to intensify their expression.'[185] And even earlier he had already made the following note on a drawing: 'Remember Mexican Mother & Child… simple power / & intensity – and Negro figure – for vitality & pick of life.'[186] And on another drawing, from 1934, there is a note to the effect that it is pointless trying to imitate the ancients (that is to say, the art of Classical Antiquity). Instead the work had to have 'life & vitality, intensity & power of sensitiveness & emotional fullness to be able to stand up to it / 3dimensional.'[187] In 1937, in 'The Sculptor Speaks' Moore made the following statement: 'My sculpture is becoming less representational, less an outward visual copy, and so what some people would call more abstract; but only because I believe that in this way I can present the human psychological content in my work with the greatest directness and intensity.'[188]

When Moore talks of intensity of expression as a means to reveal the essence of the subject, he is once again firmly rooted in the aesthetics of the Romantic tradition as exemplified in the work of the poet John Keats for whom intensity was the main quality that he was striving for in his own work.

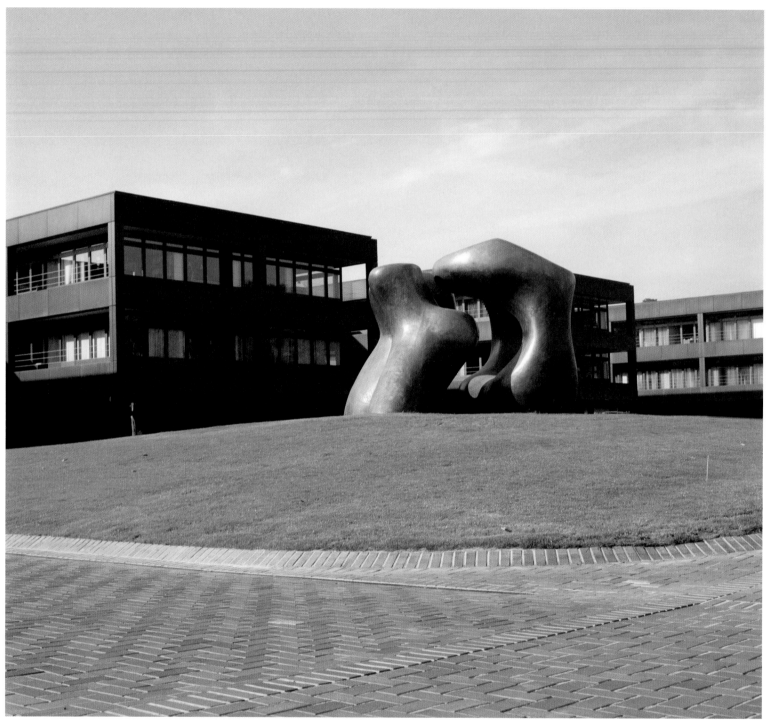

315 *Large Two Forms*, 1966/69, Bronze, L. 610 cm, Bonn (LH 556)

In 1817 Keats wrote in a letter 'The excellence of every art is its intensity, capable of making all disagreeables evaporate from their being in close relationship with Beauty and Truth.' Commenting on this in his standard work on Keats's poetry, Helmut Viebrock remarked: 'To illustrate what he means by the word intensity, Keats chooses an image from chemistry… Intensity is the outcome of combining beauty and truth, a process during which all that is disagreeable "evaporates". As in the process of smelting, the given facts are purified to

produce truth and beauty and everything that runs counter to its powerful effect is removed.

'This process of artistic purification is equivalent to the "purifying electric fire" in the realm of morals. Intensity and purity have similar effects… "Purity" is visible innocence and modesty; it blurs the boundaries between real and ideal Nature; above all it is an attribute of the sublime nature of poetry. "Pure" is one of the highest attributes in Keats's estimation. The effect of purity is intensity. And in Keats's work,

intensity arises through the concentration on the beautiful and the true in all that is experienced.'[189]

For Moore and his contemporaries, the Platonic maxim of the mutual conditionality of truth, beauty and goodness that was still accepted as the natural canon of values in the nineteenth century no longer held good. Nevertheless – in the spirit of Keats – Moore still regarded intensity as a compound of truth and purity. And it is only when one becomes fully aware of the way that Moore's 'fine, serious'[190] character was dedicated to expressing the psychological truth of the human mind that it is possible to understand the deeper implications of his striving for intensity.

Metaphor: Extended Associations

Moore repeatedly turned to the time-honoured poetological concept of the metaphor to clarify the relationships between his figures and Nature. We will concentrate here on four instances and in so doing, one cannot help but notice that Moore's approach to metaphor coincides markedly with Picasso's description of his sculptural work as a plastic metaphor. Each in his own way made a productive connection between the metaphor and modern sculpture.

In 1932, when Moore was fully occupied with his *Transformation Drawings* and reading Thompson's morphological standard work *On Growth and Form*, he remarked in an interview with Arnold L. Haskell: 'As with the flints I have studied the principles of organic growth in the bones and shells at the Natural History Museum and have found new form and rhythm to apply to sculpture. Of course one does not just copy the form of a bone, say, into stone, but applies the principles of construction, variety, transition of one form into another, to some other subject – with me nearly always the human form, for that is what interests me – so giving, as the image and metaphor do in poetry, a new significance to each.'[191]

Here Moore associates the act of copying or transposing (Greek *metaphora* from *metapherein* = to transfer) the form of a bone into a stone sculpture with the principles of 'construction, variety and transition of one form into another'. In the following statement Moore discusses the pictorial content of his two-part *Reclining Figures* of 1959 and 1960: 'Well, I would rather move round it. No, I think that sculpture should remain still and the person should go round it. The sculpture is a mixture of the human figure and landscape. From one point of view the leg end is like a mountain rock. As I was doing it, I kept being reminded of *The Rock at Etretat*, the picture by Seurat… It is this mixture of figure and landscape. It's what I try in my sculpture. It's a metaphor of the human relationship with the earth, with mountains and landscape. Like in poetry you can say that the mountains skipped like rams. The sculpture itself is a metaphor like the poem.'[192]

In the above case Moore specifically made the connection between his *Reclining Figures* and the landscape. And in so doing he alluded to the same level of chthonic meaning that was already present in his *Shelter Drawings*.

In 1962 Moore once again referred to the use of metaphor in sculpture: 'The whole of nature – bones, pebbles, shells, clouds, tree trunks, flowers – all is grist to the mill of a sculptor. It all needs to be brought in at one time. People have thought – the later Greeks, in the Hellenistic period – that the human figure was the only subject, that it ended there; a question of copying. But I believe it's a question of metamorphosis. We must relate the human figure to animals, to clouds, to the landscape – bring them all together. There's no difference between them all. By using them like metaphors in poetry, you give new meaning to things.'[193]

This statement is particularly important because in it Moore displaces the Classical emphasis on imitation with his own interest in metamorphosis – which had been very much in his thoughts ever since his work on the *Transformation Drawings*.[194] He felt that, compared to Hellenistic art, there had been a sea change in artistic aspirations: with the new relationship of the human figure to the landscape, the human form was no longer dominant. Accordingly, it is not surprising to find the sculptor going a step further in this comment from 1970 and directly comparing his work with that of the poet William Wordsworth: 'Yes, Wordsworth often personified objects in nature and gave them the human aspect, and personally I have done rather the reverse process in sculptures. I've often found that by taking formal ideas from landscape, and putting them into my sculpture I have, as it were, related a human figure to a mountain, and so got the same effect as a metaphor in painting.'[195] In making this comparison between his own work and that of Wordsworth (1770–1850), one of the great English Romantics, a close friend of Coleridge and much admired by Moore, the sculptor restates his allegiance to the prime importance of the human figure in his work. By taking the human figure as his starting point, he was able to arrive at formal concepts and motifs that could, for instance, make the connection with a mountain in the landscape.

Looking at these statements, it is clear that the range of the metaphors that Moore marks out around his figures is always ultimately rooted in Nature and the landscape. The tone in his comments is if anything lyrical and free-flowing, allowing the suggested new meanings to float at will in their own imaginary open terrain. Not so Picasso. It was around 1950, when he was working out his assemblage sculptures and how these accommodate objects that he developed his own theory: 'The material itself, the form and texture of those pieces, often gives me the key to the whole sculpture. The shovel in which I saw the vision of the tail-feathers of the crane gave me the idea of doing a crane. Apart from that, it's not that I need that ready-made element, but I achieve reality

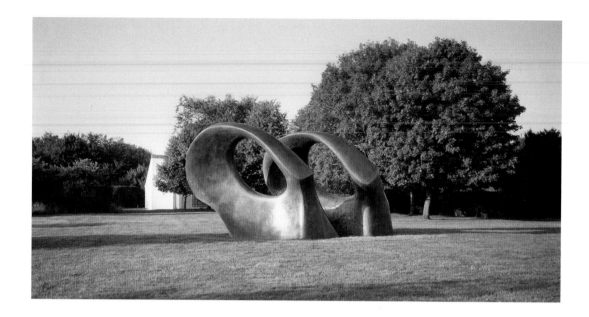

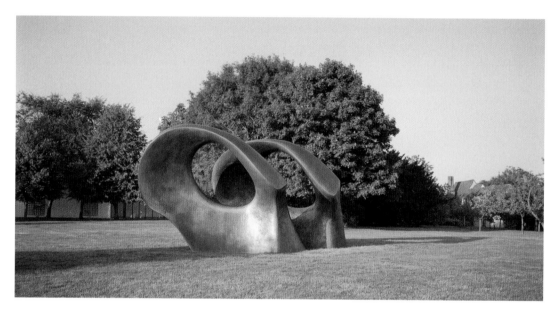

316 *Double Oval*, 1966,
Bronze, L. 550 cm, The Henry
Moore Foundation (LH 560)

through the use of metaphor. My sculptures are plastic metaphors. It's the same principle as in painting. I've said that a painting shouldn't be a *trompe-l'oeil* but a *trompe-l'esprit*. I'm out to fool the mind rather than the eye. And that goes for sculpture, too. People have said for ages that a woman's hips are shaped like a vase. It's no longer poetic; it's become a cliché. I take a vase and with it I make a woman. I take the old metaphor, make it work in the opposite direction and give it a new lease of life. It was the same way, for example, with the thoracic cage of the goat. One could say the rib cage resembles a woven wicker basket. I move from the basket back to the rib cage: from the metaphor. The form of the metaphor may be worn-out or broken, but I take it, however down-at-the-heel it may have become, and use it in such an unexpected way that it arouses a new emotion in the mind of the viewer, because it momentarily disturbs his customary way of identifying and defining what he sees. It would be very easy to do these things by traditional methods, but this way I can engage the mind of the viewer in a direction he hadn't foreseen and make him rediscover things he had forgotten.'[196]

Picasso's *trompe-l'esprit* method plays with the pictorial potential of found objects. Implanted into the rump of the *Goat*, the rib cage becomes a deconstructed metaphor. Picasso's intellectual ploy is intended to enhance the reality of the piece. Plastic metaphor and structural mimesis impinge on each other. Thus Picasso's deconstructed metaphor returns the *Goat* to the realms of imitation.

By contrast, Moore's work was far removed from mimesis with the result that, with its figurative poetic allusions, it was able to retain a greater level of openness and freedom. Appealing to the viewer's active imagination, his forms would embrace both the figure and any related clouds, land and mountains. As such it would also release internal pantheistic moments. And in this respect Moore's work calls to mind Hans Blumenberg's conclusion that with metaphysics going into a decline, it is increasingly being replaced by metaphor.[197]

In terms of the history of ideas and of sculpture, Moore's unquestioning acceptance of the poetic power of the metaphor is grounded in the work of the Symbolist Rodin. The same could not be said of Picasso, who provocatively dismembered the metaphor and, with the sudden awakening prompted by his *trompe-l'esprit*, heightened the viewer's sense of the object. Picasso was ever the realist. Meanwhile, in his very different approach to the metaphor, Moore was always the Romantic.

Conclusion

In Part II of this study, the intention was to identify the historical background of Moore's main aesthetic aims and – where appropriate – to trace their English roots. Yet none of this was

intended to suggest studiously learned intentions on the part of the sculptor. Moore did not fit the normal mould of the intellectual. It was neither his wish, nor would it have been possible for him, to leave behind him a carefully worked out aesthetic theory. Above all he was an artist whose prime interest was in the spiritual equilibrium of his work and in finding the optimal physical form for his ideas. Added to which, he had an enduringly inquiring mind. Having originally trained as a teacher, as a young man he set about studying the history of all art genres throughout the ages; no doubt these studies enriched his own teaching at two London art schools in succession.

All his life Moore enjoyed talking to friends, students, collectors and patrons. He was an avid conversationalist and glad to explain his ideas – partly for the sake of art, but also from a natural need to make himself understood to others. At the same time, he was not interested in theory in the narrower sense.

In the history of sculpture in the twentieth century, there are a number of sculptors who formulated their intentions as sculptural programmes or produced manifestos of various kinds – artists such as Boccioni, Balla, Depero, Tatlin, Gabo, Pevsner, Rodchenko, Schöffer, Le Parc and Sol LeWitt.[198] As Futurists, Constructivists, Utilitarists and exponents of Minimal Art, these artists took to the written word either in order to enlighten their fellow men or to change society – neither aim would have appeared alien to Moore, although he never published an artistic programme as such.

Between 1930 and 1937 – at the time of his most diverse artistic experiments, when he was a member of the inner circle of English Surrealists – Moore wrote four essays that in effect outline the theoretical basis of his work. The titles are 'A View of Sculpture' (1930), 'On Carving' (1932), 'Unit One' (1934) and 'The Sculptor Speaks' (1937).[199] In these texts Moore touched on the seven main points in his attitude to art; these can be summed up as follows:

– An awareness of sculpture the world over, outwith the Classical-Western academic tradition. This includes an interest in Palaeolithic and Neolithic art, in the art of the Sumerians, Babylonians, Egyptians, early Greeks, Etruscans, Indians and Mayans, stone works in Mexico, Peru, the history of the Romanesque period, Byzantium, Gothic art, the art of Black Africa, of the South Sea Islands and of Native Americans.

– Truth to material in the strictly Modernist sense (only up until the early 1950s).

– An openness towards the inspiration to be found in the forms of the human anatomy and in Nature in general. In his detailed study of the morphology of forms, Moore's interest was in metamorphosis, balance, rhythm, organic growth, attraction and rejection, harmony and contrast.[200] These determine the very different characteristic

forms of pebbles, rocks, bones, trees and shells. By engaging with these with 'exact sensual fantasy',[201] the sculptor can discover his own forms, although these only exist within the life-currents of Nature.

- The avoidance of perfection and symmetry in favour of a form-organism that has movement within it.[202]
- The all-round spatiality of a sculpture that radiates energy and its own immanent dynamics on all sides. Through these dynamics in combination with the articulated form of the piece, the work can open out to the space around it (by means of holes) and draw that space into it.
- The participation in the sculpture of the psychological moment and of the unconscious, such that abstract and surrealist modes of expression can be combined and are equally valued.

- Spiritual vitality, power of expression and intense life are the qualities that were to replace notions of beauty and mimesis inherited from Classical Antiquity. In this sense Moore's sculptures were intended to create added anthropological value. They were 'an expression of the significance of life, a stimulation to greater effort in living'. [203]

These seven core issues founded and sustained Moore's overriding interest in the 'humanity of form'. It has been our aim to show here that despite Moore's declared scepticism regarding art theory, there was a coherence to their interconnection and interaction and that together – against the backdrop of Moore's idealistic, Romantic mindset – they ensured that, through his work, he would become the modern champion of organic form and the organic entity.

Impact

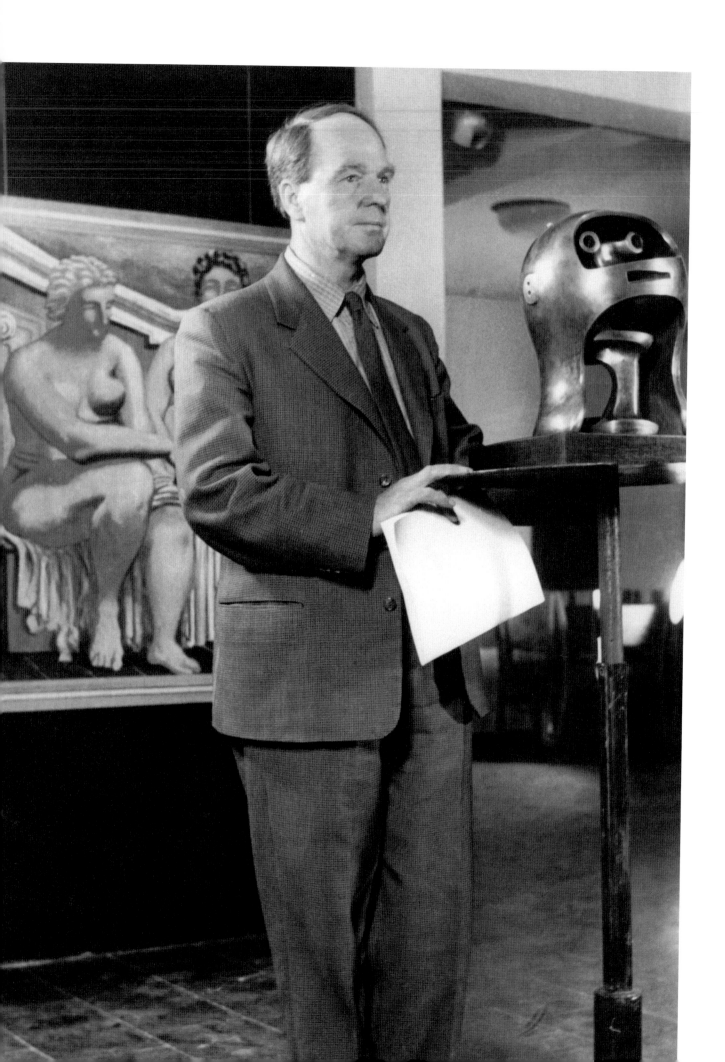

In the history of sculpture the impact of the work of Henry Moore is little short of unique. At the age of forty-eight, in 1946, he made his breakthrough on the international stage with a solo exhibition at the Museum of Modern Art, New York. This presentation, which also travelled to Chicago, consisted of eighty-five sculptures and forty-seven drawings. With its main focus on the *Shelter Drawings*, the exhibition firmly established Moore's reputation as a humanist.

The statistics alone speak for themselves. Over a period of seventy-five years (1928–2007) Moore's work was shown in 760 exhibitions worldwide: 272 in Great Britain, 199 in the USA, 80 in Germany (four in the former GDR), 54 in Japan, 46 in Switzerland, 29 in Italy, 27 in Canada, 25 in Denmark and 21 in France. Germany comes in at third place, after Great Britain and the USA – all the more interesting in view of the fact that the first important themed exhibitions of Moore's work took place there. Bearing in mind the provenance of this book, we beg leave to start with Germany.

Henry Moore in Germany

The Ruhrfestspiele (festivals) at Recklinghausen step straight into the limelight with two events, in 1952 and 1955. On the first occasion, Moore's brand new *Reclining Figure: Festival* (figs. 123–124a) of 1951[1] was included in the groundbreaking exhibition *Mensch und Form unserer Zeit*. This exhibition set out 'to make visible the FORM of our own time – through outstanding examples of the visual arts and literature, technology, furniture and household goods.'[2] It was the brainchild of the highly respected Rhenish art critic Albert Schulze-Vellinghausen. Moore's sculpture was illustrated twice in the catalogue and juxtaposed with a 'sun rotor'. The accompanying commentary in no sense contradicts our own analysis of the work earlier in this study: 'Like the sun rotor on the opposite page, the large *Reclining Figure 1951*… seems to gather into it the radiant energy of the light, only to send it back out into the surrounding space as elemental reflections from the curvilinear surface of its *stucco lustro* finish.'[3] In 1955 the theme of the Recklinghausen Festival was *Das Bild des Menschen in Meisterwerken europäischer Kunst*. This exhibition, curated by the painter Thomas Grochowiak, included Moore's *Helmet Head, No. 2* of 1950 (fig. 317) placed next to a Medieval relic of a head.[4] The proximity of two such pieces raised the question of the sculptural use of open spaces and voids in the past and the present alike. Once a vessel for sacred contents, now a disquieting, uncanny space. Moore enjoyed comparisons of this

kind. He relished them, as he told Eduard Trier, who summed up Moore's thoughts on the matter: 'He [Moore] regards the juxtaposition of old and new art as a potentially productive idea, which could be important for both artistic and educational reasons. He knows of no similar endeavours in England.'[5]

Since 1968 the firm of Rosenthal in Selb produced the first examples of Moore's work in bone china. In 1978 Erich Steingräber and his young assistant Michael Semff in Munich turned the spotlight on Moore's handling of found natural objects and demonstrated their importance for his maquettes.[6] That same year saw a small, but important exhibition of Moore's *Notebooks* in Ermatingen. In 1984 in Marl, there was an exhibition on the theme of mother-and-child. In 1992 Nele Lipp at the Lola Rogge-Schule, a dance school in Hamburg, presented a performance of 'dance sculptures' and 'sculpture dances' based on four works by Moore, entitled *Fließender Stillstand: Tanzskulpturen und Skulpturentänze zu vier Werken des Bildhauers Henry Moore*. In 1997 Martina Rudloff and her team of writers explored the theme of 'animals' in Moore's work in hitherto unseen breadth and depth.

To take an active interest in the work of Henry Moore in postwar West Germany was to declare one's intention – now that the Hitler blockade was over – of finding one's cultural feet again, opening one's mind to what was new and seeking contact with world-class art.[7] The circumstances of any such interest within the free democracy of the Federal Republic in the west – with the unhindered and gladly received support of the British Council[8] – were rather different to those in the German Democratic Republic in the east where art professionals were tyrannised by a different political dictatorship. In the West, even when the country was still coping with major economic challenges, there were soon no less than twenty-four of Moore's large-format sculptures in public spaces in nineteen towns.

In 1998 Anita Feldman Bennett of the Henry Moore Foundation described Moore's own feelings towards Germany: 'The artist maintained a unique relationship with this country, not least because the majority of his bronzes for over thirty years were cast by the Noack foundry in Berlin. [9] The same year [1977] that the Foundation was established, Moore was visited by Chancellor Helmut Schmidt… their friendship led to the presentation of the monumental sculpture *Large Two Forms*[10] to the city of Bonn two months later. Moore continued to be recognized within Germany through a number of prestigious honours and awards, culminating with the final tribute in 1980 of the Grand Cross of the Order of Merit, which he received at the age of 82.'[11]

No doubt the best evidence of the success of Moore's art was the unmistakable influence it had on artists in West and East alike. We shall outline the main features of where, how, in which respect and under which auspices this influence made itself felt in artists' studios in both parts of Germany. Ultimate-

Ill. 10 Henry Moore speaks on the Opening of the Exhibition *Das Bild des Menschen in Meisterwerken europäischer Kunst*, Ruhr-Festspiele Recklinghausen 11th June 1955

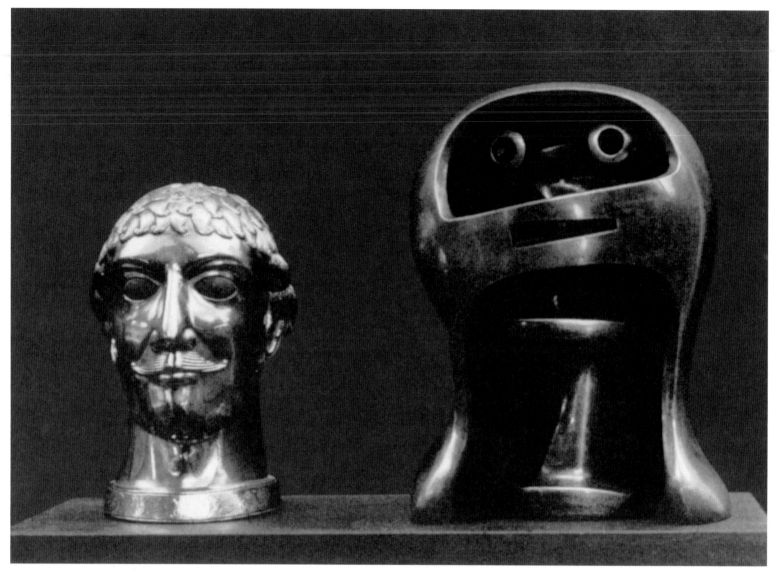

317 *Helmed Head, No. 2*, 1950, Bronze, H. 34 cm, The Henry Moore Foundation (LH 281) next to a *head-reliquary with relics of* St. Candidus or St. Vitalis, Aachen (?), c. 1170, St. Lambertus, Düsseldorf

ly we shall show that despite the broad-based, strikingly multi-faceted response to Moore in Germany, his influence in German studios mainly stemmed from a small number of particularly outstanding positions in his art. As though in a rear view mirror, we can see in these pieces the main essence of Moore's contribution to art in the twentieth century. But before we come to that, let us look at the historical background and the prevailing art-critical positions that were to determine the reception that met Moore's work in Germany.[12]

Moore's Presence in West Germany

Hamburg has always had excellent cultural contacts with the British Isles, and in many ways it was to be a happy port of arrival for Moore's work in Germany. In 1931, Max Sauerlandt, Director of the Museum für Kunst und Gewerbe in Hamburg

bought a small sculpted head from Moore, which we will return to later. Unfortunately, this first purchase of Moore's work by a museum (when the artist was thirty-two) was confiscated by the National Socialist authorities and has never come to light again. Yet the purchase was a gesture by a German institution that he was not to forget. As it was, Moore reciprocated with great generosity in 1970 when the Hamburg Museum was buying two models of a wall for the Rotterdam Bouwcentrum.[13]

The first German artist whose work – very early on, in 1934–35 – was to be visibly influenced by Moore's sculpture, was the Hamburg-born sculptor Karl Hartung (1908–1967). Moore's first solo exhibition on German soil, organised by Carl-Georg Heise with the support of the British Council, opened in the Hamburger Kunsthalle in 1950. During the first week of the exhibition a mere 297 visitors came through the doors.[14] The exhibition then travelled to the Städtische Kunst-

sammlungen in Düsseldorf. That same year, Moore's work was also on show in Munich, when he participated in *Werke europäischer Plastik*, a group show at the Haus der Kunst. 1951 saw an exhibition in Berlin, for which the British Council selected ten small sculptures and sixty-eight drawings; the exhibition ran for three weeks at the prestigious Haus am Waldsee. Now the visitor numbers reached 1,771. This was followed in 1954 by a highly regarded solo exhibition at Schloss Charlottenburg in Berlin (3,181 visitors). By 1960 the ice had been completely broken and 22,747 visitors went to see the Moore exhibition in the Hamburger Kunsthalle.

In January 1949 the well-known art critic and writer Will Grohmann invited his English colleague Herbert Read to a lecture he was to give, in the Hochschule für Bildende Künste, on new sculpture in England. Grohmann had known Read since the 1930s. In 1949 the two men went to visit Henry Moore in England. It was this and subsequent visits to Much Hadham that led to Grohmann's profound, much read monograph on Moore, published by the Rembrandt Verlag in Berlin in 1960. Grohmann had had a chair of Art History at the Hochschule für Bildende Künste since 1948 and made a point of referring the young sculptors in his care – such as Bernhard Heiliger and Otto Herbert Hajek – to the work of Henry Moore.

Besides Will Grohmann, Carl Georg Heise and Werner Doede (Director of the Städtische Kunstsammlungen, Düsseldorf), there were numerous influential art historians in West Germany who actively championed Moore's work, figures such as Alfred Hentzen, Werner Hofmann, Gert Schiff, Eduard Trier and Peter Anselm Riedl. In the early 1970s Riedl delivered one of the first lectures on Moore at the University of Heidelberg.

As one would expect, the seeds sown by this wealth of exhibitions, lectures, books and articles first bore fruit in artists' studios. What were the values that young artists absorbed from Moore's work? It should not be forgotten that, with the Cold War at its height, Moore found himself confronted in Germany by two very different systems that by no means responded to him in the same way. And he was to find the same situation, magnified, in the different responses of the Eastern Bloc and the West.

It is worth examining in more detail here the line taken by art critics in West Germany who were so well disposed towards his work, and the arguments presented in the GDR where he was officially shunned for decades as a 'Formalist'. Even a brief outline of these different stances is very telling.

Art Critics

The very first reviews of Moore's work in West Germany already set the tone for what was to follow. Between 1958 and 1960, the main critics discussing his work were Werner Hofmann, Will Grohmann and Eduard Trier. Each had his own view of the Englishman. Werner Hofmann, still in Vienna at the time (1958), reflected the thinking of the young, Austrian postwar Surrealists when he divided Moore's work into a 'first and second Surrealism', discerned 'magic' and a '*Gestalt* oracle' in his work, and took the same approach as the Jung-disciple, Erich Neumann.[15] At the same time, however, Hofmann recognised, very early on, Moore's prime interest in 'form simply as form'.[16] He also observed that with his highly educated eye, Moore – unlike the Expressionists and Cubists – was able to perceive Primitive Art 'as an intrinsically coherent, global phenomenon'.[17] Hofmann's subtle analyses of Moore's work, written in 1959, are as compelling today as ever. Just as important as these at the time, was his publication of twelve key texts by Moore.

The leading art critic in West Germany after the war was Will Grohmann, who has already been mentioned several times here. His 1960 monograph of Henry Moore marked a new departure with its opulent production. In his assessment of Moore's work, Grohmann concluded that his 'strength lies in the continuity of his creative powers and their gradual intensification'.[18] In addition to this, he saw in Moore's sculpture a 'multiplicity of modes of expression'. These included 'the combination of antitheses' such as Naturalism and Classicism on one hand, and Abstraction on the other.[19] He was also very struck by the way that Moore, as an individual, was constantly alert to the past history of his chosen genre and to the world of symbols. Like Hofmann, Grohmann was also convinced by Jung's views on archetypes, and this comes through very clearly in his description of Moore as a 'herald of motherhood and chtonic deities'.[20] In addition to this, with reference to the *Upright Motives*, Grohmann commented that twentieth-century art had been enriched by Moore's important introduction of the Celtic idiom into his own work[21] – a remarkably apposite observation, which this study would certainly support. (See Chapter I,7).

Grohmann's analysis is particularly interesting when – in his discussion of the bronze *Standing Figure* of 1950 (fig. 373) – he compares Moore's work with that of Paul Klee (the subject of an earlier monograph by Grohmann) and reflects on the question of 'the absolute'. He finds the association with an angel (which he adopts from Neumann's writing) 'not altogether far-fetched, when we think of the requiem with many angels Klee made during the last year of his life. The only difference is that Klee called up the angels, fashioned and named them; transcendency of form marched hand in hand with transcendency of his imagery into the realm of the eschatological. Moore's situation is different; transcendency of form flows back into the figure and fills it with a multiplicity that belongs to the realm of the spiritual, but is not something outside existence.'[22]

More so than either Hofmann or Grohmann, Eduard Trier had long been professionally involved with sculpture.[23] His practised eye and the acuity of his analytical mind gave him an

unusual ability to handle artistic concepts, which in turn distinguishes his rich body of writing on modern sculpture.[24] As one of the main curators at documentas II, III and IV it was Trier who introduced the German public to the first international sculptural avant-garde, including the work of Henry Moore, in 1959 and 1964. In 1960, in an exhibition entitled *Figur und Raum*, he presented a profound overview of modern sculpture, which also included work by Moore.[25]

Trier gained considerable respect amongst artists in 1971 when he discussed Moore's work in his *Bildhauertheorien* ['Sculptor's Theories'] and presented his views in the context of a whole range of artists' opinions regarding the art of sculpture. Thus the reader was able to learn what had drawn Moore, and others, to Primitive Art, above all to Mexican art,[26] how he felt about Nature and about installing sculptures out of doors[27]; they could read about his ultimately tolerant attitude to *taille directe*,[28] how – unlike Archipenko, Lipchitz, Laurens and many others – he had found in the question of internal and external forms a leitmotif for his life's work and how he insisted on the mutual interaction of form and space,[29] how he dealt with the matter of scale[30] and how the human form was always his point of reference; how he insisted that the art of sculpture should enjoy the same independence as architecture[31] and, finally, how he appreciated photography as a visual aid in his efforts to understand three-dimensional forms.[32]

On the basis of the ground laid by Hofmann, Grohmann and Trier, the critical response to Moore's work in West Germany was enthusiastic. In the postwar years he was seen as an artist who was primarily concerned with questions of form and the history of ideas. The positions adopted by the three writers discussed here are supported by numerous statements made by Moore in interviews.[33] And it is worth adding that the lively, liberally wide-ranging interest of West German critics in Moore's work was easily matched by the response of West German artists.

Moore's Impact in West German Artists' Studios – Individual Case Studies

The questions asked of Moore's work in artists' studios were generally concerned with pictorial matters. And the answers were then more or less assimilated into individual artists' own praxis. This in turn led to creative responses to Moore's work that for years to come were to be met with mockery and derision from the public at large – criticising Moore's figures for their small heads, the supposedly clichéd heaviness of his female figures, and his use of sculptural holes. Unbothered by this, artists always returned to the core issues in Moore's art: *taille directe*, holes and tunnels, the interdependence of form and space, internal/external forms, biomorphous abstraction, the adoption of principles of form and rhythm from Nature,

the expressive potential of reclining figures, the relationship between the landscape and the human figure, images of war, martyrdom and death.

Karl Hartung

As we have already said, Karl Hartung – even before the Second World War – was one of the first to draw inspiration from Moore's work.[34] Always determined to let the material speak out as purely as possible – and increasingly interested in coming up with simple, organic forms – Hartung could not have been better prepared to enter into artistic dialogue with the English sculptor.

From late 1932 to 1936 Hartung worked in his native city of Hamburg. Here he came into contact with Max Sauerlandt, Director of the Museum für Kunst und Gewerbe and an inspired champion of Modernism[35] who actively supported artists such as Moissey Kogan (1879–1942), Gustav Heinrich Wolff (1886–1934) and Richard Haizmann (1895–1963). The latter had already made a detailed study of the work of Brancusi. His animal sculptures and his *Plastische Komposition. Auffliegender Vogel* of 1931 crucially influenced Hartung's breakthrough to abstraction.[36] Haizmann and Hartung also shared an interest in the ideas of Rudolf Steiner, which Hartung had already come into contact with as a young man.[37] In 1935 Peter Lüders presented work by both Haizmann and Wolff alongside that of Hartung in the Hamburger Kunstraum.[38]

It is likely that Sauerlandt may have had a not inconsiderable influence on Hartung's reception of Moore's work. He had been on friendly terms with Herbert Read since 1923,[39] and it was on his recommendation that Read arranged for Wolff to visit Moore in his studio. Following this visit, Wolff wrote enthusiastically to his mentor on 23 January 1931: 'The sculptor Moore should certainly not be ignored. You must look him up, such a fine, serious character. I would like to see some of his work coming to the attention of the public in Germany. His drawings are magnificent… Please let me know if you are coming to London soon, otherwise I will ask Moore to send you some. He's got a wonderful bronze bird, not unlike Haizmann's work. He is very uneven – very naïve – London must be somewhat provincial in its intellectual life.'[40]

In April 1931 Sauerlandt and Read went together to visit Henry Moore in Hampstead, at 11A, Parkhill Road. Not long after this, Moore's second, very highly regarded solo exhibition opened at the Leicester Galleries.[41] At this exhibition Sauerlandt bought a stone sculpture for his museum, as well as four drawings and three watercolours – all for a grand total of £20 15s. In his report detailing new acquisitions for the year 1931, he wrote: 'In one instance we ventured beyond the borders of Germany, when we bought a number of works by the young English sculptor Henry Moore (b. 1898), in which one can see, very characteristically, his determination to cut the

ties with the formal conventions of recent decades and, in his own free way, to make contact with developments in the art of continental Europe. We bought from Henry Moore a female head in profile, carved from haematite (N.B. for £5) and seven sheets of studies with different aspects of the same plastic motif – drawings, some coloured: very characteristic and significant with regard to the artist's preparatory work, instantly revealing the sculptor's hand.'[42]

However, very soon these works and other new acquisitions that did not have the approval of the National Socialist authorities were impounded and in 1933 Sauerlandt was removed from office.[43] On 27 July 1933, as though to underline the sacked Director's good intentions, Read wrote to Moore, expressly mentioning that 'Sauerlandt sends you his best from Germany.'[44]

It seems highly likely to me that in his conversations with the young sculptors of his acquaintance – Kogan, Wolff, Haizmann and, of course, Hartung – Sauerlandt will have talked of Moore's work and naturally have afforded them access to his new acquisitions and to any other visual materials. In summer 1932 – at Sauerlandt's suggestion – the Hamburger Kunstverein presented an exhibition entitled *Neue Englische Kunst*. This was overseen by the Anglo-German Club in collaboration with the Foreign Office in London and ran from 28 June until 31 July 1932. In the introduction to the catalogue Moore, who was represented by seven sculptures and five drawings, was described by R. H. Wilenski as the leading sculptor amongst his young English contemporaries. A similar view was put forward by the critic writing in the *Hamburger Echo*, who saw in Moore's work a 'grandeur of form that is rare in art today'.[45]

There is no reason not to assume that Karl Hartung saw this exhibition, the first presentation of Moore's work on German soil. And it is also highly likely that he will have known, through Sauerlandt, of the monograph Read was currently working on. Sauerlandt's death in January 1934 came before the publication of Read's study, but it seems that, in all probability, Hartung will have seen it while he was still in Hamburg.

In his first completely abstract work, *Durchlöcherte Form (Abstrakte Form) [Perforated Form (Abstract Form)]* of 1935 (fig. 318),[46] there is a very clear connection to Moore's work. And although its biomorphous forms may also owe something to Haizmann, Moore's presence is unmistakable. Above all the intrusion of space into the piece recalls Moore's *Carving* in walnut wood of 1933 (fig. 77).[47] The preparatory drawings for this piece, discussed in Chapter I–2, underline its origins in Moore's studies of bones with their suggestions of potential movement.[48] Hartung, too, was fascinated by the implicit motion in the sculptural representation of circling and whirling spaces and – as the title indicates – dared to create a 'perforated' form. Nevertheless, compared to Moore's sharply ascending diagonal motion, Hartung's piece is calmer and more settled.

318 Karl Hartung: *Perforated Form (Abstract Form)*, 1935, Bronze, H. 42 cm, Private Collection, Germany

A clear affinity with the undulating rhythms of Moore's reclining figures is evident in Hartung's pencil drawing of a *Liegende Figur [Reclining Figure]*, dated 1936 (fig. 319).[49] Starting anew time after time, he encircled the rounded forms, raised up the left shoulder in a steep wave movement and marked the hiatus between the two legs with a narrow, modest gap. While this drawing, dated 1936, already provides ample evidence of Hartung's awareness of Moore's work, this is conclusively confirmed by another – as yet unpublished – drawing, this time of a *Büste [Bust]* (fig. 320).[50] It seems to me that Birk Ohnesorge is right to date this work (for stylistic reasons) to 1936. This

319 Karl Hartung: *Reclining Figure*, 1936, Pencil, 30 x 46 cm, Hartung Estate

320 Karl Hartung: *Bust*, c. 1936, Pencil, 46 x 35 cm, Hartung Estate

321 *Composition*, 1933, Concrete cast, H. 58.4 cm, British Council, London (LH 133)

sheet was most probably inspired by Moore's biomorphous *Composition* (fig. 321),[51] illustrated in Read's monograph.

The smooth, organoid forms that Hartung arrived at in 1936 in both of these drawings become even intenser in the bronze *Liegender [Reclining Figure]* (fig. 322), which has possibly been dated too early, at 1935–38.[52] This work, too, would be aptly described by Markus Krause's comment that 'Hartung's anthropomorphic figures… are never as distant from Nature as those of Henry Moore.' And, as Krause rightly points out: 'Sculptures such as this were far and few between in Germany in the 1930s… The seemingly soft, evenly modelled and polished body undulates in an uninterrupted flow. Nevertheless, one is aware of the framework supporting the piece; the constant, gentle pressure that seems to have been induced by the proportional shifts has not reached the tectonic core of the form. The human figure reveals the organic power play of Nature.'[53]

Unfortunately, just one photograph has survived of Moore's head of a female figure of 1930, bought by Sauerlandt (figs. 323, 324); once again it is fair to assume that it was known to Hartung. The work itself is lost. The structure and forms of this reddish-brown, ironstone piece – approximately fifteen centimetres in height – are similar to those of other heads that have survived from the same period.[54] The characteristics of the lost sculpture can be clearly identified from the photograph: rising up out of the neck (which is rounded at the base) is a narrow, elongated head, thrown right back. The head itself is dominated by its powerfully expressive profile. Running from the chin, over the open mouth, up the nose and the forehead, this line creates a continuous arc encompassing the whole head. The continuity of this line was clearly of im-

322 Karl Hartung: *Reclining Figure*, 1935/38, Bronze, L. 42 cm, Sprengel Museum, Hanover

portance to Moore. This unique piece is notable for the angle of the head; considerable significance also attaches to the fact that the plane of the face is perforated by a single eye-hole.[55]

If one is to assume that Hartung was indeed aware of this work, bought for the Hamburg museum in 1931, then it may well be that this perforated face was the inspiration for some of his own sculptural solutions, which were to become an independent motivic thread in his subsequent work. The first instance of Hartung engaging with Moore's work is a strong charcoal drawing of 1945 (fig. 325).[56] The image here is still clearly informed by Hartung's experience of wartime, in the sense that it veers between notions of death and art. Body parts – like pieces of sculpture – are seen lying on the ground

323, 324 *Head of a Woman* standing on the desk of Max Sauerlandt, Kunstgewerbemuseum Hamburg, 1931–33

325 Karl Hartung: *Untitled*, 1945, Charcoal, whereabouts unknown

in a battlefield. The profile is similar to that of the Moore's *Head*, acquired for Hamburg, only here the eye-hole seems to be turning its horrified, relentless gaze on the viewer.

A year later Hartung had made his will-o'-the-wisp of a drawing into a fully-fledged sculpture entitled *Unheimlicher Kopf I [Uncanny Head I]* (fig. 326).[57] And the main vehicle for the uncanny is clearly the hole. Three years later, with his *Janus* head of 1949 (fig. 327),[58] Hartung found yet another solution for this uncanny aspect of Moore's legacy. The enlarged eye-hole now serves two heads and imbues the highly polished, purified double head with a strikingly unreal presence.

In ancient Rome, Janus was the god of beginnings, doors, gateways and passages.[59] His double head looks both to the inside and the outside. Hartung's image is a continuation and sublimation of the Classical motif. In his hands the double profile has female traits and the interior and exterior are differentiated. On the main viewing side[60] we see a noble, Classical face gazing straight forwards and connected with the outside world. By contrast, the rear, 'inner' head is more steeply angled,

326 Karl Hartung: *Uncanny Head I*, 1946, Bronze, H. 39 cm, Private Collection

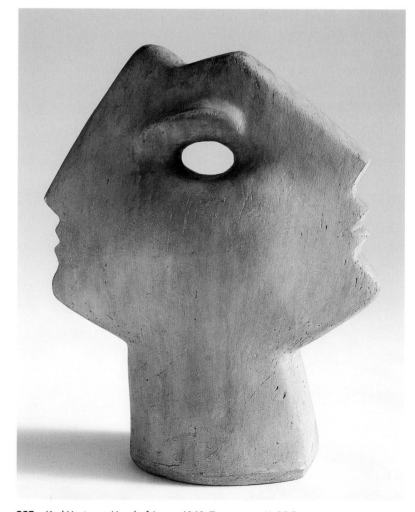

327 Karl Hartung: *Head of Janus*, 1949, Terracotta, H. 35,5 cm, Private Collection, Berlin

which makes it appear to take up more space. Exterior and interior, connected at the pivotal point of the eye-hole, thus point to the two realms of existence that meet in the human mind: external reality and our internal, mental perceptions.

The extent to which Hartung was reflecting on his own artistic intentions is evident from the following notes to himself: 'Search for the level of interconnections. Mighty. Tremendous. The depths of the world behind things. The level of associations. Shattering the superficial.' (1953). Or: 'Make the invisible visible and the visible transparent.' And later: 'If sculpture is perforated and draws space into itself, this is an indication of a particular mode of behaviour, perhaps of a longing for the transcendental.' (1963)[61]

Space as a vehicle for the transcendental – ultimately it was this use of space that, in Hartung's view, constituted the new value of modern sculpture. In an undated note (c. 1945?), he writes, 'Sculpture can no longer use the old means to say what has to be said. (Like the other arts). Frontality is a thing of the distant past. Take command of space (not just mechanically), incorporate into the three-dimensional form the things that, coming from below, can hold their own against space. Once again the cosmic is an experience. Cosmos and microcosm yield new revelations. At least in sculpture, dare to create and make the most of the three dimensions, without the inhibitions of representationalism. Create a new thing that lives a new nature from within itself.'[62]

The comments here regarding space caught between above and below are somewhat clarified by an earlier diary entry (1940): 'Space (by which I mean cosmic space) is no longer alien and hostile to us. The current from above and the response from the Earth are the emotions and experiences of people today, which prompt artists to create new works.'[63] Further to this, Hartung's African-wood Kugelform [Spherical Form] (fig. 328)[64] of 1948 and his own accompanying notes point to the metaphysical foundations of his image of Nature and the human being. Here sculpture is about meditation. The viewer senses that the gradual opening of the sculpture is bound up with progressive growth towards light.

In Hartung's case, this sense of the metaphysical connotations of the cosmos that can fill the openings in plastic forms, is rooted in philosophy.[65] Whether consciously or not, Hartung sought to extend the range of ideas that attach to Moore's interdependent forms and spaces. His efforts in this direction are reflected in his diary entries during the war. In 1940, for instance, he wrote: 'A higher form of existence wants everything from the artist, that is his task and his duty.'[66] And on 22 February 1941: 'Every deed by a creative person enriches our spiritual heavens. It is like a refuge that people create here on Earth, storing up energy; the achievements of artists and creative minds are the true wealth of this world.'[67] Finally, undated: 'We artists are now truly fighting for a realm that is still far away in the clouds and whose expanses and splendour

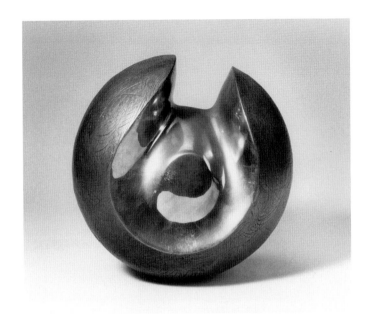

328 Karl Hartung: *Spherical Form*, 1948, African wood, H. 15.5 cm, Private Collection

are very rarely seen by any of us. A new land,[68] where there are still many provinces to be conquered, even if no-one is in the slightest interested. But we have to fight for the sake of the cause, without glancing to right or to left.'[69]

Markus Krause arrived at c. 1937–38 for the date of the *Sitzende Figur [Seated Figure]* (fig. 329)[70] that was shown as a plaster piece in 1946 in the 'chamber' exhibition at Godebuscher Weg and illustrated in the accompanying catalogue. As elsewhere, space defines the form, disappearing into the distance between the rump and the bent arm. This particular configuration echoes Moore's *Figure* (fig. 330) of 1932, reproduced in Read's monograph of 1934. Once again the comparison shows that the young Hartung was aiming for calmer surface movement. Moore's *Composition* was founded on his studies of vertebrae, which gave his forms a more angular appearance.

In 1939 and 1945, Hartung worked on an irregular, abstract form with a crenellated opening at the top spanned by metal rods. This *Abstrakte Form mit Stäben [Abstract Form with Rods]* [71] did not progress beyond the experimental stage. In it Hartung abandoned Moore's biomorphic forms and holes, and – as Krause has observed – engaged instead with his *Square Forms* with rod, as in *Sculpture* of 1934.[72] By definition, the comparison shows that Hartung's main interest in Moore's work lay in his biomorphic abstraction. Like Moore, Hartung effortlessly accommodated both abstraction and figuration in his work. And Hartung was also at home with Constructivist methods.[73] In this respect, he was as unwilling to be pinned down in any one style as Moore. At the same time, this was entirely in keeping with his belief that it was the artist's duty to honour the multiplicity of Nature in his work.[74]

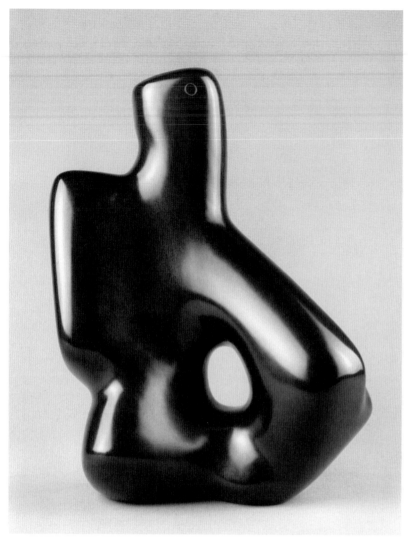

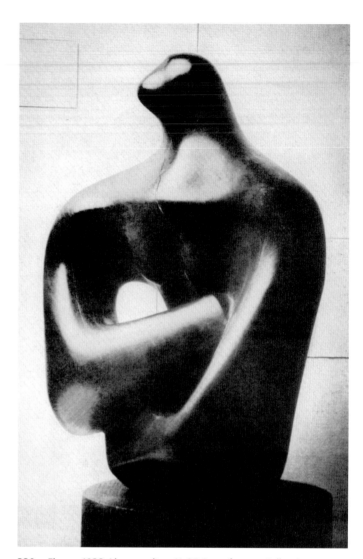

329 Karl Hartung: *Seated Figure*, 1937/38, cast, H. 35 cm, Private Collection

330 *Figure*, 1932, Lignum vitae, H. 25.4 cm, former Collection Mrs. Fanny Wadsworth, London (LH 127)

Whenever Moore talked of Nature, he always spoke in concrete terms. His study of the principles of natural forms and rhythms was underpinned and accompanied by his own ongoing visual and haptic awareness of Nature – rocks, trees, bones, shells, pebbles. Although this is not to say that Hartung – a similarly avid collector of *objets trouvés*[75] – was any less familiar with Nature. But, revealing his grounding in a very German tradition, when Hartung talked of the relationship between his art and Nature, he talked in terms of fundamental, even philosophical issues. In the early 1940s, he made a note to himself: 'Nature is always the same, it is only our way of seeing that changes. The human intellect is foundering on all sides today. Nor does it get you anywhere in the art world. We need a different organ. New forms come from new organs. You only discover in Nature that which is already within yourself… How could it be otherwise? We are Nature and ultimately cannot do anything else, it is just that we always see a different side. Should we not, at long last, express some-

thing like gratitude to Nature's vegetation? A monument to vegetation.'[76]

Hartung's implicit exhortation to the creative artist to replace his intellect with another organ and to make reference to plant life, coincides both in its vocabulary and content with certain anthroposophical concepts with which he was certainly familiar.[77] Rudolf Steiner's teachings amounted to one overriding plea that we, as human beings, should exercise our higher mental faculties, seen in the imagination, inspiration and intuition. In one of his most important publications, *Theosophy: An Introduction to the Supersensible Knowledge of the World and the Destination of Man*, Steiner specifically talks of 'higher organs'. In his view, when human beings develop these organs, they can draw on them to learn to perceive the separate 'soul and spiritual worlds'.[78] A diary entry by Hartung from January 1941 reveals the similarity of his and Steiner's thought processes: 'It is quite extraordinary to see what new realms we are discovering in human beings. The

human being cannot be thought of as in the past, he now appears much more differentiated, and so to speak with many more "bodies". Our seeing seems no longer to be confined to our actual eyes. Our sense of the body extends beyond the limits of our own physical form, even the dimensions are no longer fixed. But above all it is the sense of the loosening, the detaching of so many mysterious things within us that is so significant.'[79]

Here Hartung makes direct reference to Steiner's *Theosophy* and the description there of the seven different 'bodies' of the human being.[80] In Hartung's 1922 copy of the text, there were four sheets of paper, closely written on both sides: an exact copy of the first section of the chapter 'Body, Soul and Spirit'.[81] To judge by the handwriting, it was copied out by the young Hartung, who made a particularly close study of anthroposophy between 1929 and 1939. The surviving manuscript copy concentrates on Steiner's explanations of the 'ether body'. Hartung made a note of two sections in particular: 'In each plant, in each animal, he perceives, besides the physical form, the life-filled-spirit-form; in order to have a name for this spirit form let it be called the ether-body, or life-body.'[82] And: 'To the investigator of spiritual life, this matter presents itself in the following manner. The ether-body is for him not merely a product of the materials and forces of the physical body, but a real independent entity which first calls forth these physical materials and forces into life.'[83]

Against this background it is all the more important to bear in mind that Hartung – more than any other artist after 1945 – drew his ideas and subject matter directly from his contemplation of the 'life-filled-spirit-form' of Nature and its creative forces. Between 1946 and 1952 alone, Hartung produced twenty-three works with the title *Organische Form*. These are then followed by *Vegetative Form, Kleine Knospe [Small Bud], Meeresformen [Marine Forms], Bergkräfte [Mountain Forces], Druse [Geode], Wurzel [Root], Kristalline Form [Crystalline Form]* and *Wachsende Flügel [Growing Wings]*. And then there are major works such as *Engelskopf I [Angel's Head I]*[84] and *Thronoi*[85] that tell of structure-creating life processes – visualised in a manner reminiscent of the patterns of bark on a tree trunk – that transcend the mere corporeality of the model. With reference to his work *Schreiten (Torso) [Walking (Torso)]* of 1950 (fig. 331),[86] Hartung made the following comment: 'When it came to the Torso of 1950, it was important to me to try to send the movement out in all directions into the surrounding space. In this work there was no longer to be a rear view and a viewing side, just the liberated action transposed into the simplest form that was sculpturally viable. It must have been around 1934 that I felt very intensely drawn to tree forms. For years I tried to replicate the way that the trunk and branches grow so naturally from one form into another.'

At the time he had been particularly struck by 'a huge beech tree outside Hamburg, where I was living in those

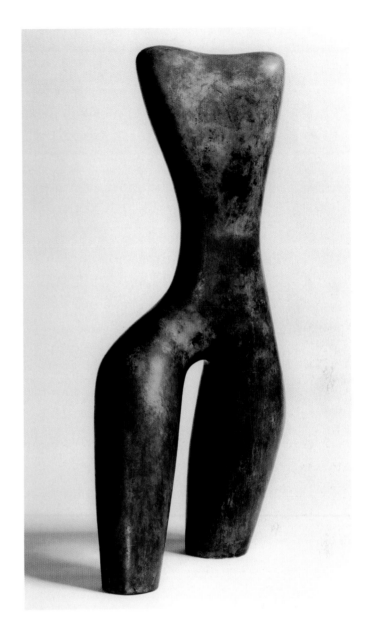

331 Karl Hartung: *Walking (Torso)*, 1950, Bronze, H. 140 cm, Private Collection

days'.[87] And it is true that if one imagines turning the sculpture *Walking (Torso)* around, one will see the pronounced bifurcation that is so characteristic of the beech tree. Hartung brings the upwards motion of the tree back down to earth. Evidently he had such an empathy with the processes of natural growth that he was able to come up with pertinent analogies in human movement.

It was Steiner who proposed that form arises from life-filled formative forces od the *ether-body*.[88] This view seems to have been especially important for Hartung's late works. After his *Engelskopf II [Angel's Head II]* he broke open the surfaces and accentuated the vertical, 'ethereal' flow of the form. This in turns adds special significance to Hartung's use of key concepts in Goethe's thinking, such as his *Urform* (see Hartung's magisterial *Urgeäst [Ur-branches]*)[89] and 'metamor-

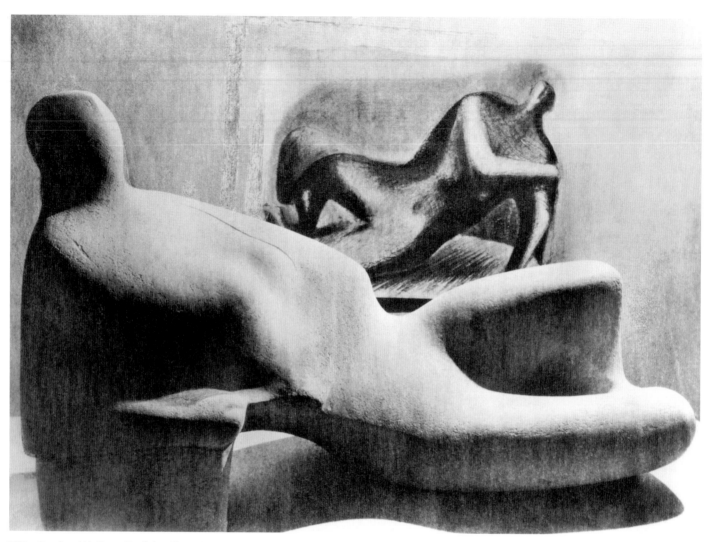

332 Bernhard Heiliger: *Reclining Figure I*, 1948, Cast concrete, L. 70 cm, whereabouts unknown

phosis', which were also central to Steiner's work.[90] A very telling remark was made by Hartung's student Günter Grass, who passed on some of his teacher's artistic maxims in 1967: 'Keep the material cold.[91] Think with the stone. Always seek out the simplest form, the ur-form.'[92] And in the mid-1940s Hartung was already making a note that reads: 'Goethe. The human being is Nature, how could he create anything other than Nature. Metamorphosis. New senses.'[93]

Thus, with his grounding in Nature, ur-forms and their metamorphoses gleaned from his reading of the works of Goethe and Steiner, Hartung was free to enter into dialogue with Moore's own view of Nature. And although independently of Steiner's terminology and thinking, Moore was always striving for the same forms of movement found in Nature. From 1932/33 onwards – in his *Transformation Drawings*, then in many of the *Shelter Drawings*, above all in the series of reclining figures carved in wood and in numerous other organic-abstract works – Moore was able to create a visible sense of 'life currents'[94] flowing through his forms. Ulti-

mately Hartung's understanding of Nature is closely related to Moore's own aesthetic of the natural world. No German artist after Hartung trod such a very close path to Henry Moore.

Bernhard Heiliger

In the immediate postwar period, the Berlin constellation of Hans Uhlmann, Karl Hartung and Bernhard Heiliger and the members of the highly active sculpture scene in Munich formed the German sculptural avant-garde. Bernhard Heiliger (1915–1995) was the youngest of the three and soon in receipt of the most public commissions. In conversation with the present author, he played down any influence Moore had had on his work – by contrast to his attitude to Arp, whom he readily acknowledged as a role model.[95] Assessing the situation in 1976 (with reference to Will Grohmann, who had identified their concurrent progress), Heiliger insisted that his early works had merely appeared in parallel to that of the English sculptor. And he substantiated his view by citing Grohmann's

introduction in the catalogue for his Berlin exhibition at the Haus am Waldsee in 1950: 'A kindred approach took his work into similar territory to that of Henry Moore, whose work at that time was only known in Germany from the occasional illustration… What would have impressed Heiliger, were the large forms, the swelling shapes, the sensitively calibrated proportions according to the distribution of weights and balances – all features that were common currency in the European approach and vocabulary of that time.'[96]

Almost four decades later, Siegfried Salzmann unquestioningly accepted Heiliger's account of events, namely that his first acquaintanceship with Moore's work was at the latter's Berlin exhibition in the Haus am Waldsee in 1951.[97] However, there are works made from 1947/48 onwards that would appear to suggest otherwise. In addition, there is also the recent biographical research by Marc Wellmann and above all, historical fact. For a start it is entirely possible that in postwar Berlin, Heiliger might very well have come across early publications mentioning Moore through fellow artists, such as Jan Bontjes van Beek, or through Will Grohmann. Looking back at the immediate postwar years, the photographer Gerda Schimpf – who took a portrait photograph of Heiliger in 1948[98] – remembers that he had been greatly impressed by Moore's *Shelter Drawings*.[99] It should not be forgotten that in certain circles of the Berlin avant-garde, and not least in those that Grohmann frequented, Moore was definitely 'in'. The academy professor had taken Heiliger under his wing, and his high opinion of Moore and certainly reports of his visit to Moore's studio in Much Hadham in summer 1949, could very well have been known to his protégé.[100] In this connection Katharina Schneider comments: 'All the new ideas and news from abroad must have come to Heiliger's ears, for artists and art historians were working closely together on Heiliger's first retrospective, presented in the Haus am Waldsee in 1949–50.'[101]

Writing in an exhibition catalogue to accompany the work of Marino Marini in 1950, Alfred Hentzen may well have been quite correct in his assessment of Moore's status: '…long before his first exhibition in Germany [1950] his style had already started to make an impression. Soon everyone had heard that a new sculptor had stepped onto the European stage. Books about Moore passed from hand to hand, were keenly studied in artists' studios and handed on to the next reader.'[102] Hentzen's view coincides with that of others from the same period. Witness a comment by Richard Scheibe in a letter of 17 February 1950 to his friend Gerhard Marcks: 'The entire guild is mooreing'.[103] And on 28 March 1950, in a review of Moore's exhibition in Hamburg, Albert Buesche wrote in the *Berliner Tagesspiegel*: '…even as the outlines of his life's work emerge for the first time, certain German sculptors are already greeting him as the Messiah. The most dedicated Mooreans – Hans Uhlmann, Karl Hartung and Bernhard

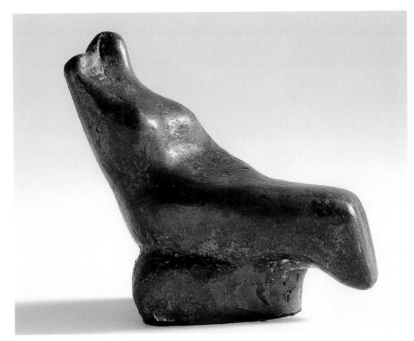

333 Bernhard Heiliger: *Small Seated Figure*, 1949, Bronze, 13.5 x 14 x 8 cm, Private Collection, Berlin

Heiliger – have gathered together in Berlin.'[104] On 29 March 1950, Adolf Frisé was even more direct in his article in the *Deutsche Zeitung und Wirtschaftszeitung*: 'The German viewer does not approach the work of Henry Moore entirely unprepared. He knows the highly simplified sculptures of Mataré. And he has already detected the influence of Moore in the work of the Berlin sculptors Hartung and Heiliger.'[105]

In the meantime, we now know that in spring 1950 Heiliger went to see Moore's Hamburg exhibition, which was on view from 5 February until 2 March. As Marc Wellman has shown, a letter written by Heiliger detailing his reaction to Moore's work indicates his unease at what he saw. In this letter Heiliger 'describes Moore as an artist of immense ability whose experimentation with form can at times become an end in itself, at the expense of the work's expression and inner substance'.[106]

Another very telling episode was described to the present author by Wieland Förster. In spring 1954, when Förster went to visit Heiliger at the Hochschule für Bildende Künste in Berlin, the latter insisted on arranging an out-of-hours viewing for the visiting students from Dresden of Moore's exhibition in Schloss Charlottenburg.[107] When Förster visited Heiliger again, at a later date, in his studio in Hardenbergstraße, it seems that Heiliger – with unusual bluntness – declared that he had no time for the very figurative conception of the *Draped Reclining Figure* of 1952–53 (fig. 176).[108] He 'accused him [Moore] of betraying abstract art, the only possible path'.[109]

In fact Heiliger did clearly prefer Moore's abstract, biomorphous forms. The importance of this work to Heiliger is immediately evident in a series of reclining figures he made in

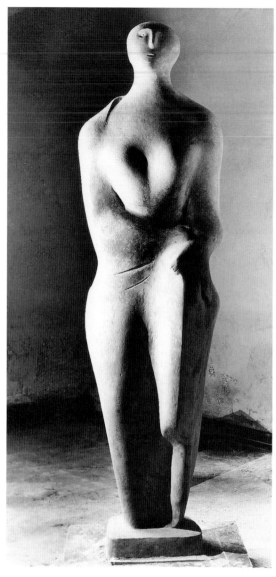

334 Bernhard Heiliger: *Large Figure*, 1949, Plaster, H. 180 cm, whereabouts unknown

335 *Sixteen Heads*, c. 1932, Pencil, chalk, wash, pen and ink, 38.1 x 31.7 cm, Private Collection, Israel, AG 32.44 (HMF 935)

1947–48, exemplified here in his cement *Liegende Figur [Reclining Figure]* (fig. 332),[110] which conflates motifs from Moore's *Reclining Figures* of 1929 and 1935–36. Thus the arm at a right angle, supporting the body, recalls the *Reclining Figure* in Leeds (fig. 2),[111] and the flow of the shapes (arising from the cement casting) – opened legs, the deep hollow in the region of the hips, the swelling upper body and the ovoid head – all point to the typology and rhythms of Moore's first *Reclining Figure* carved in wood in 1935–36 (fig. 288).[112] Nevertheless, the young Heiliger was not going to risk any actual holes in this piece.[113] Here, as in his other early reclining figures, the human body is seen as an abstract figure, drawn out into a roundly modulated, organoid form. The epidermis is smooth and the shapes merge gently into each other. Indeed, the *Kleine Sitzfigur [Small Seated Figure]* (fig. 333), only fourteen centimetres wide,[114] could easily serve its owner as a 'palmstone'.

Another instance of Heiliger indirectly reflecting Moore's work is seen in his *Große Figur [Large Figure]* (fig. 334) of 1949 (stucco, height: 180 cm, location unknown).[115] This distinctly frontal statue is a variation of an earlier version made in 1948,[116] in which Heiliger took his lead from the draped statues of ancient Greece. The 1949 version retains the motif of the left hand, grasping and lifting a fold of the garment, but now it merges into the undulations of the figure as a whole. As Katharina Schneider has aptly said: 'The individual elements now merge more clearly into a single entity. Breasts, arms and the stylised drapery folds have become protuberances that appear on the surface as though something is pushing out from within the work. With its soft contours, drawn together tightly at the ankles, the footless figure comes up against an irregularly formed plinth, set at right angles to it. With the contrapuntal distribution of the shapes, in this sculpture we see

the first instance of that asymmetry that Moore had already formulated in his *Half Figure* [117] in 1929.'[118]

It was in 1950 that Heiliger first created non-functional holes in an object, in two versions of his *Freie Form [Free Form]*.[119] At the same time he also produced drawings, including one entitled *Figur abstrakt [Abstract Figure]*[120] in which he created a surrealist exaggeration of the motif.

By 1951, in his standing and reclining *Muses* in a twenty-eight metre relief for the Schillertheater in Berlin,[121] Heiliger had developed his own idiom from the repertoire of forms seen in Moore's work in the 1930s and 1940s. However, in the beauty of their gliding lines, his harmonious, rhythmic sequences of planes never convey the same tension that is intrinsic to Moore's figures.

Even in his outstanding abstract portraits, Heiliger's work still seemed indebted to that of Henry Moore. There are studies of heads by Moore – nothing to do with portraiture – that freely play-out the principle of the 'dynamic organism'.[122] Heiliger could well have seen an example of just such a piece in Herbert Read's early monograph (fig. 335). It is interesting to compare the head at the far right end of the top row with Heiliger's famous portrait of *Hofer* of 1951 (fig. 336).[123] It seems that Moore's drawing prefigures the striking motif of the eye sockets set into a single arc in Heiliger's head. It was presumably at Grohmann's suggestion that Moore visited Heiliger in his studio in 1959 on his first trip to Berlin. And Heiliger sought to maintain the connection in 1962 when he sent his students to Much Hadham, although without accompanying them himself.[124]

It was in 1961–62 that Heiliger – working on his *Drei Parzen [Three Fates]*[125] – was preoccupied with Moore's *Three Standing Figures* of 1948 (fig. 168),[126] even taking into account their title. They were illustrated in Grohmanns 1960 monograph, where they are interpreted as the Three Fates. In 1964 Heiliger produced his *Etuden [Etudes]* (fig. 337),[127] which were to be very important for his subsequent development. Their starting point is clearly human vertebrae, which are then paraphrased as small, autonomous sculptures. In this process, Heiliger was unmistakably following in Moore's footsteps and the way he used his maquettes from the mid-1950s onwards.[128] Individually, these *Etudes* develop a high level of energy and power in the way they reach out to the space on all sides. And there are some related forms in the nine-metre *Vegetative Säule (Lebensbaum) [Vegetative Column (Tree of Life)]* of 1964–65.[129] In 1966–67 Heiliger used fragments of this for his series of three partly polished *Vertikale Motive [Vertical Motives]* (fig. 338).[130] In these pieces the legacy of Moore's *Upright Motives* (figs. 248, 251) is used in a highly intelligent manner. Retaining the principle of storeys, developed by Moore, these stacked forms become ever lighter and more vibrant as they rise upwards. And it is in this lightness, and in his increasing tendency to break open forms and to halt

336 Bernhard Heiliger: *Hofer*, 1951, Bronze, H. 44 cm, Akademie der Künste, Berlin

337 Bernhard Heiliger: *Etude II*, 1964, Bronze, 14 x 12 x 20 cm, Private Collection, Berlin

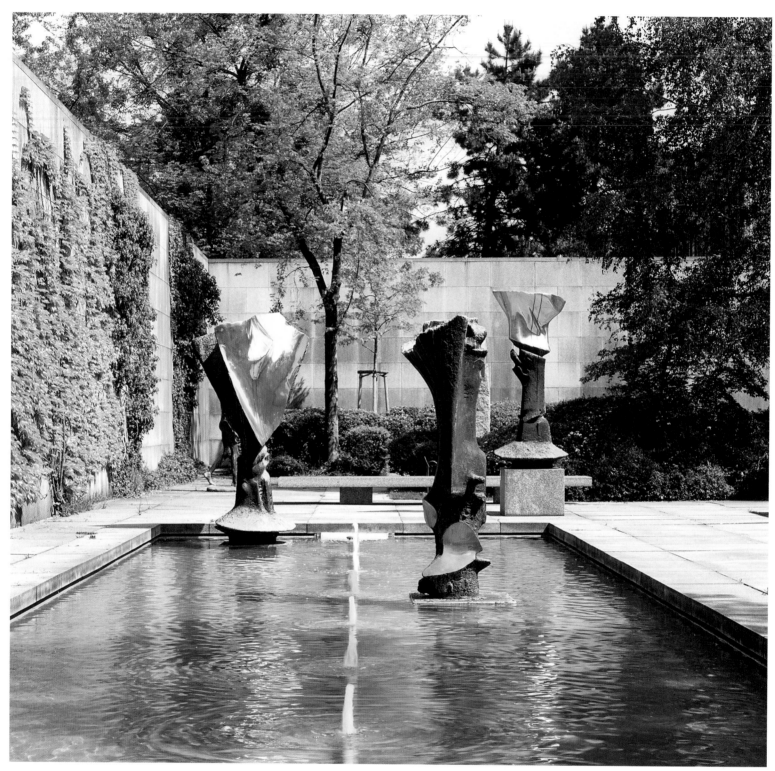

338　Bernhard Heiliger: *Vertical Motives I–III*, 1966–67, Bronze, I: 214 x 61 x 84 cm, II: 232 x 90 x 100 cm, III: 262 x 116 x 140 cm, Staatliche Museen zu Berlin, Nationalgalerie, Berlin

339 Brigitte Matschinsky-Denninghoff: *Stonehead I*, 1949, African Wonderstone, 16 x 6 x 16.7 cm, Private Collection

340 Brigitte Matschinsky-Denninghoff: *Steinkopf*, Pencil, 29.5 x 21 cm, Collection of Brigitte und Martin Matschinsky-Denninghoff, Berlin/Schönfeld

them in moments of stormy or floating movement, that we see Heiliger's main aim, namely to stay closely in touch with the genesis of his forms.

Looking at the surprising number of instances where Heiliger took his lead from Moore – his biomorphous figurations, the incorporation of voids and holes into sculptural composition, his study of vertebrae and their plastic transformation, and lastly his *Upright Motives* – we see very clearly the length of the shadow that the English sculptor cast across him for a good twenty years.

Brigitte Matschinsky-Denninghoff

Brigitte Matschinsky-Denninghoff (née Meier-Denninghoff, b. 1923) was just lucky. Early in her adult life, in 1947, when she was a discontented student in the class of Toni Stadler[131] at the art academy in Munich, she met the British Consul, John Anthony Thwaites (later well known as an art critic).[132] He handed her a book about Henry Moore, which 'made nonsense' of her as yet unclear understanding of sculpture and gave her her first 'inkling of a possible path to follow'.[133] The book in question was the lavishly produced first volume of the catalogue raisonné of Moore's work with an introduction by Herbert Read (first published in 1944).[134]

And then something happened that was very unusual in that postwar period. On Thwaites's recommendation, in autumn 1948 – not long after the war had ended – Henry Moore took on the young German as his assistant for two months.[135] Thwaites had sent Moore photographs of her work, including her *Skizze in Terrakotta [Sketch in Terracotta]*

of 1947[136] – a semi-abstract, astonishingly independent figuration. The first project she worked on with Moore was his *Madonna and Child* in Hornton stone for St Peter's Church in Claydon, Suffolk (now in the Church of St Mary and St Peter, Barham, Suffolk). This piece was based on a model from the studies made in 1943 for the *Northampton Madonna*. Following this, the young artist then had the pleasure of helping to restore two *Square Forms* of 1936.[137] 'We laughed a lot.'[138] There was certainly no other German artist that Moore wrote to so often between 1947 and 1958.[139] Eleven letters have survived from this correspondence; they reveal Moore's natural warmth, but also his unfailing support and encouragement.

Brigitte Matschinsky-Denninghoff, Anthony Caro and Phillip King were Moore's most successful assistants. In the long list of assistants, still detailed in the records of the Henry Moore Foundation, she was the first woman and followed by only two others, Deborah Scott and Esther La Pointe.[140] Once her time as an assistant was over[141] the agreement was that Brigitte would send drawings and photographs of her work to Much Hadham, and that Moore would return them with his comments. How well this worked can be seen from the following instance. In late 1948, Moore gave his assistant two small African wonderstones, which she soon made into two stone heads.[142] She then made two drawings of the first of these, *Steinkopf I [Stone Head I]* of 1949 (fig. 339), and included a note to the addressee (fig. 340): 'That is the little wonderstone-piece you gave me. I'm rather pleased with it – not so much with these drawings. But you may be able to imagine what it looks like.' When he sent this and other drawings back on 21 February 1949, Moore commented on this

341 Brigitte Matschinsky-Denninghoff: *Tower III*, 1956, Brass and tin, H. 180 cm, Private Collection, Meerbusch

piece in particular: 'I like the look of what you've done with the little wonderstone piece (though the drawing of it isn't as good as some of the other drawings).'

Executed in pencil, pen and ink, this drawing clearly relies on Moore's 'sectional-line method', as do other drawings made by Brigitte in 1949–50. In the finished *Stone Head*, Brigitte Matschinsky-Denninghoff alienated the profile by following the natural outlines of the existing wonderstone. In addition, the tunnelling in the mouth area shows her attempting, in her own way, to emulate Moore's daring holes and spaces; the sharp incisions and edges recall the harsh diction of the *Square Forms*.

In his letters to his former assistant, Moore not only reported on his work, he also talked of family life. The tone is understandably relaxed. There are also passages of particular interest with regard to Moore's own ides, as in the letter of 21 February 1949. Here Moore is discussing Brigitte's drawings: '...keep on criticising them yourself as scientific drawings, that is whether they work three-dimensionally. I am sure now that you can see yourself where things go wrong. Sometimes not immediately but quite easily if you look at the drawing again two or three days after you've done it… It was a good idea to try some drapery. Try doing some more… The bone drawing is quite good. Don't forget to make the near parts of the drawings come at you stronger than the far away part which can be quite faint. Keep on trying with the colour drawings too. I shall expect the next batch in about a fortnights time. It was very nice to get such a long letter from you enclosed with the drawings, I am glad you are working hard. I am too…'

The last sentence is typical of Moore in these letters. He is always encouraging his younger colleague to keep on working as hard as possible.

For all his empathy, Moore could also report quite naturally of his own successes, such as his Paris exhibition which prompted him to write, on 7 January 1950, that 7,000 visitors came to see it – three times as many as had visited the Matisse exhibition, '…which all surprises me – for one thing, I thought there was less interest in sculpture than painting anyhow.'

In these letters Moore often expressed the wish not only to look at photographs of Matschinsky-Denninghoff's works, but also to see the originals. The letter of 1 February 1957 is particularly telling in this respect. Brigitte Matschinsky-Denninghoff translated it and it was printed in the catalogue for her exhibition at the Otto Stangl Gallery in Munich. In this letter Moore declares that he was 'most impressed' with the works she made in 1956, and names *Turm III [Tower III]* (fig. 341),[143] *Ausdehnung [Extension]*[144] and *Aufgelöste Struktur [Dissolved Structure]*.[145] 'It is very nice to see you are always developing and I'm delighted to know that your last exhibition in Berlin[146] was quite a success and that your reputation is growing.' One year later both artists were represented at documenta II in Kassel.

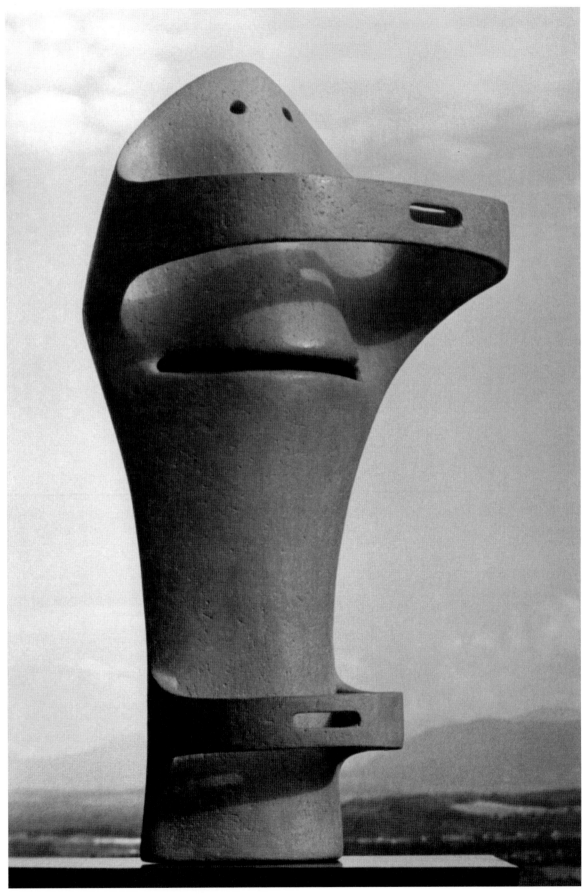

342 Brigitte Matschinsky-Denninghoff: *Moby Dick*, Terracotta, H. c. 80 cm, former Private Collection, München, now whereabouts unknown

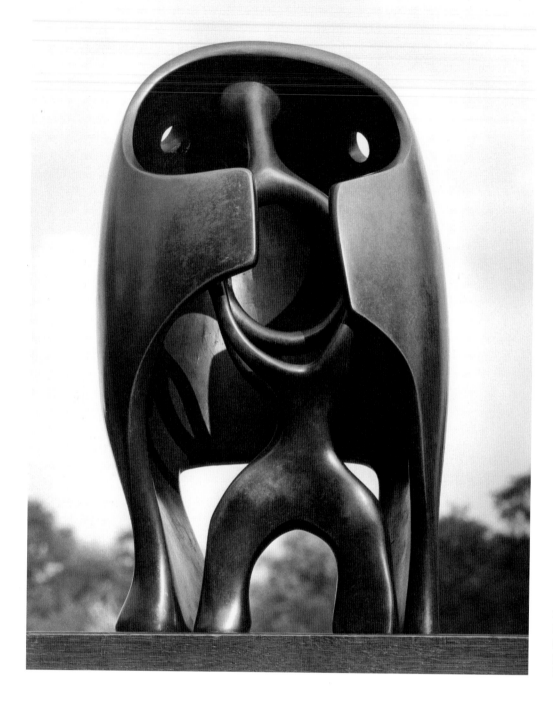

343 *The Helmet*, 1939, Lead, H. 29.2 cm, Scottish National Gallery of Modern Art, Edingburgh/Bronze: The Henry Moore Foundation (LH 212)

1959 was also the year that Brigitte Matschinsky-Denninghoff was awarded the newly founded Prix Bourdelle – partly on the strength of Moore's recommendation[147] – which included an exhibition in the Musée Bourdelle. In her letter of thanks to Moore on 7 August 1960, she also told Moore of her marriage to Martin Matschinsky.[148] The two had been collaborating since 1955, and in 1970 they went public with their new joint name.[149] The artist-duo Matschinsky-Denninghoff remained close friends with Moore. Whenever Moore flew to Berlin to see Hermann Noack at his foundry, he liked to take the opportunity to meet up with the couple.[150]

In her contribution to the memorial service for Henry Moore at the Akademie der Künste in Berlin in 1986, Brigitte Matschinsky-Denninghoff spoke movingly of Moore, as none other could have done: 'We had the great good fortune to know him, and I hope you will allow me a few personal words… his criteria were humanity, dignity, naturalness and vitality – by which he meant the inner energy in things, that he always strove to make visible… In his view, fame came with responsibility, which he treated with great care as a strict yet positive observer and critic, never ill-willed, but always respectful of others' efforts and of all that serves the cause of

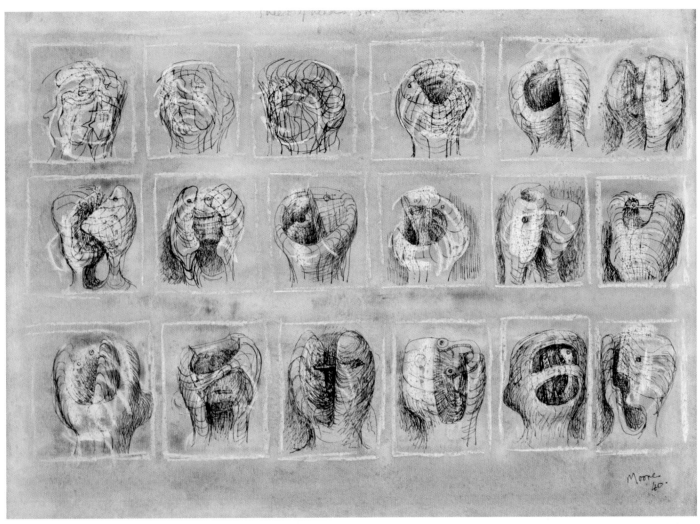

344 *Sheet of Heads Showing Sections*, 1940, Pencil, wax crayon, watercolour wash, pen and ink, 27.9 x 38.1 cm, Private Collection, AG 40.35 (HMF 1508)

art. When he visited us in our studio, we felt that he accepted and approved of what we were doing. And he used to say "we", very often it was "we", taking sides with his conversation partner. "Is it not marvellous", he said to us not long ago, "that we do what we want all our life and get away with it?"… When we last saw each other here in Berlin, a few years ago, he spoke – as he often did in his later years – about drawing, about the kind of reality that he associated with drawing, about acuity of observation. "We don't try hard enough", he said – [again that we] – "we still don't try hard enough. None of us makes enough of an effort!" Yet he didn't say it with an air of resignation, but like someone who is very determined to try harder from now on.'[151]

What exactly were the aspects of Moore's work that influenced Brigitte Matschinsky-Denninghoff? At first there were identifiable motifs. Later the dialogue between the two became more of a free discussion of shared artistic principles and theories.

Following on the abovementioned *Stone Head I* (fig. 339), her second clear response to Moore's work, in 1949 – *Moby*

Dick (fig. 342)[152] – is surprising for its humorous originality. With a broadly grinning mouth the terracotta dolphin rises vertically upwards, its fins joined together in front of its body. It is an admirably confident assimilation of the vocabulary of forms in Moore's lead *Figure*[153] and *The Helmet* of 1939 (fig. 343), even down to the symbolism of thin-skinned eye holes.

Matschinsky-Denninghoff would have had access to the catalogue raisonné with illustrations of both of Moore's works. *The Helmet*, like the many martial variants that followed it up until 1975,[154] is rightly seen as Moore's protest against the inhumanity of the Second World War and all wars since then. *Moby Dick*, however, although drawing on a similar set of forms, seems to reverse the fearful introversion of the helmet head, as if it were responding in a playfully narrative manner to the new advances in Moore's internal/external forms. And it is reasonable to assume that she will have seen for herself the relevant studies by Moore in the widely distributed softback publication of 1943, in which Geoffrey Grigson provided a first introduction to Moore's coloured works on

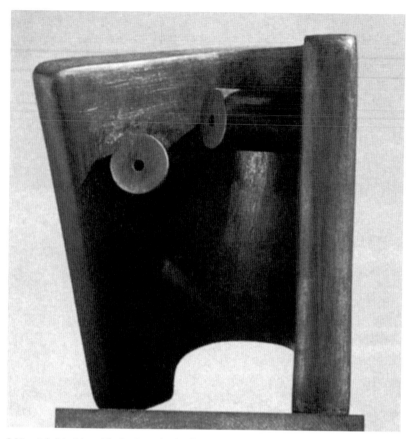

345 Brigitte Matschinsky-Denninghoff: *Lead-Figure*, 1949, Lead on wooden pedestal, 24 x 20 x 20 cm, Private Collection, Mayen

above this one, she must also have been struck by the hollowing out of the head, which has now hardened into a single, concave shell. A similar shell enclosing an interior space – albeit more abstract and more pointed, with protruding eyes turned to each other – is seen in Matschinsky-Denninghoff's *Bleifigur [Lead Figure]* of 1949 (fig. 345).[156]

But even when both were independently active, there are still parallels to Moore's work. Thus, for instance, the steel sculpture *Naturmaschine [Nature Machine]* of 1969 (fig. 346)[157] reflects her interest in another theme that was central to Moore's artistic aims. As Johannes Langner has shown,[158] the three-part, horizontal sequence of raised cubes and curved, tubular forms has clear echoes of Moore's *Three Piece Reclining Figure, No. 1* of 1961–62 (fig. 347). Moreover the three elements in the *Naturmaschine* were an abstract demonstration of the oneness of constituent parts and the whole, whereas in Moore's hands a similar configuration seems rather to operate in the realms of an imaginative coalescence of the human being and the natural world.[159] Even today, for both artists this connection with the landscape in so many of Moore's *Reclining Figures* is still 'the most exciting thing he ever did'.

During her time as an assistant in Much Hadham, the young artist – surrounded by Moore's works and able to observe firsthand his approach to Nature – found her own instinctive, close connection to the landscape reinforced. She and her husband have always been able to draw intuitively on their impressions of Nature and the natural world as a source of inspiration. After the overwhelming experience of the mountains as a young woman,[160] the brass and steel sculptures that she and her husband later collaborated on reflect the formation and inner energies of water, sea and air that urged them to work in three dimensions. As her work matured it seems that it was increasingly imbued with a sense of Nature similar to that felt by Moore, adding a rich sensuali-

paper.[155] Here Brigitte would have come across a sheet of eighteen sketches (fig. 344) tracing the gradual opening of a human head. In this sheet Moore was experimenting with new ways of splitting the head, internally and externally, and with fencing and locking in the outer shell. The penultimate head in the lowest row could certainly have been the inspiration for her *Moby Dick*. And, looking at the study directly

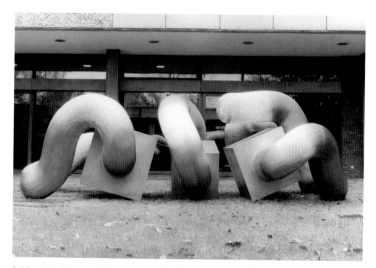

346 Brigitte and Martin Matschinsky-Denninghoff: *Nature-Machine*, 1969, Chromenickelsteel, 510 x 230 x 160 cm, City of Marl

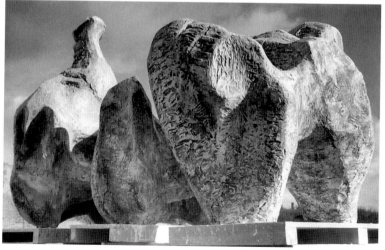

347 *Three Piece Reclining Figure, No. 1*, 1961–62, Bronze, L. 287 cm, Tate Britain, London/Los Angeles County Museum for Art/Meadows Museum, Dallas (LH 500)

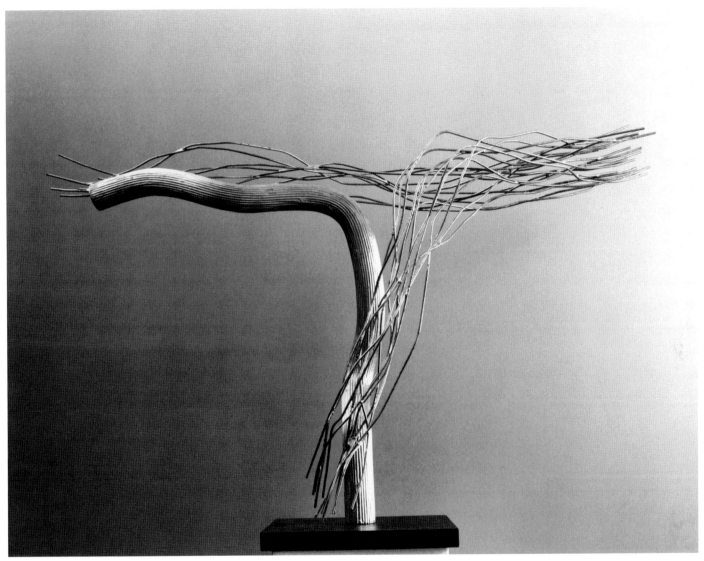

348 Brigitte and Martin Matschinsky-Denninghoff: *Kreuzbaum I*, 1984, Brass and tin, 45 x 80 x 23 cm (pedestal: 20 x 20 cm),
Collection Lars Kistner, Nürnberg

ty[161] to the legacy of abstract forming she had inherited from Pevsner.[162] The better the two artists came to understand the types of movement that are specific to different elements, to the forms and growth patterns of plants and vegetation, and to the gestures of animals and human beings, the more confidently they were able to develop their own dynamic artistic forms. While Brigitte's view of Nature was founded on persistent observations, Martin's was also substantially influenced by his extended study of the writings of Rudolf Steiner. With each having his or her own intense sense of connection to Nature, they ultimately arrived at a different concept of space to that in Moore's work. Using bundles of flowing lines to create rounded or open forms, it is as though they set the surrounding space in motion. Primarily based on the line, the relationship of their forms to space is about partaking of space. In a work such as *Kreuzbaum I [Cross Tree I]* of 1984 (fig. 348)[163] it is as though the space were articulated in the wind, con-

stantly in motion and not, as in Moore's work, either kept in balance by perfectly through-modelled plastic forms or steadied from within.

Brigitte Matschinsky-Denninghoff expressly discussed this concept of space, as described in Part II, in the memorial speech at the Akademie der Künste in Berlin: '...one of his great achievements was to redefine negative space in sculpture. He attached as much importance to it as to volumes. In his figures this negative space is not only created by virtue of the positions of the limbs, it permeates the very body of the figure and generates a new form within a form. Single-handedly he enriched sculpture, taking hitherto unheard of liberties, in a way that we now treat as perfectly natural!'[164]

In their astonishing late works, the Matschinsky-Denninghoffs' 'acceleration' of space has undergone yet another transformation. Since the mid-1990s their work has grown taller even as the forms dissolved. Space – flickering yet stand-

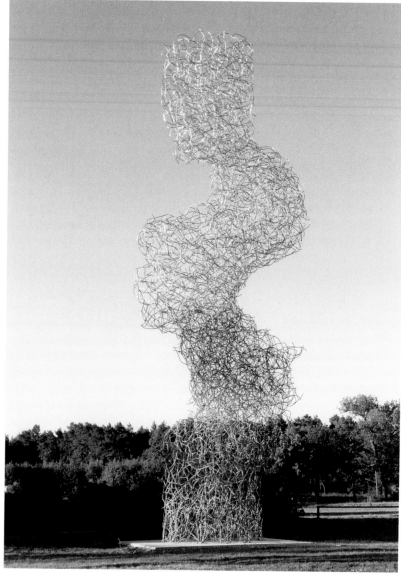

349 Brigitte and Martin Matschinsky-Denninghoff: *Large Column*, 2004, H. 1500 cm, Collection of Brigitte and Martin Matschinsky-Denninghoff, Berlin/Schönfeld

ing – seems to suck light into itself. In a work such as the fifteen-metre *Große Säule [Large Column]* of 2004 (fig. 349), with its organic-looking, fluctuating lightness and transparency,[165] we see how far they have moved away from Moore's earthbound, even chthonic interdependence of form and space.

Wilhelm Loth

Wilhelm Loth (1920–1993) is another artist who was to be crucially influenced by his early encounter with Moore. Looking back in 1982,[166] he wrote, 'I first came across the name Henry Moore when I was still a prisoner of war in England [1944–46]. One day the head officer brought me a slim Penguin book[167] with drawings by Moore (in gratitude for my good work, as he wrote inside it – I had put on a small exhibition of my draw-

ings in the camp chapel). I had never seen anything like these drawings by Moore, they were completely new to me (even although I was already twenty-four years old). My artistic ideals still tended towards the works shown in the exhibition *Degenerate Art*, although I was more strongly drawn to Dix (*Kriegskrüppel*) than, for instance, Schwitters' (*Merzbild*). My most enduring impressions of sculpture to date were of Lehmbruck's *Sitzender Mann* (Städel Museum, Frankfurt) and Barlach's *Zweifelnder* (Galerie Buchholz, Berlin). Both before 1939. When the first Moore exhibition in Germany was presented in Düsseldorf in 1950, I had to see it. It made a huge impression on me. So it is all the more astonishing that it only had a relatively negligible effect on my own sculptural endeavours at the time. You can only see traces of Moore in some of the woodcuts.'[168]

Loth's detailed recollections speak for themselves. And it is true to say that his *Holzschnitte [Woodcuts]* of 1950 do have an affinity with Moore's work, as this single example should demonstrate (fig. 350).[169] It depicts a biomorphic, looped female upper body, in which the young artist has adeptly implemented the impression he gleaned from the Düsseldorf exhibition catalogue where there was an illustration of Moore's *Composition*[170] of 1931 in Cumberland alabaster (fig. 351). In Loth's woodcut the rounded arms, protecting the deep space around the breasts, encircle an empty white plane. In the same catalogue Loth also found his inspiration for the split head in the small, lead Surrealist *Reclining Figure* of 1939.[171] And there were also later heads by Moore[172] that caught Loth's eye – as we see in the terracotta *Kopf nach Clementine H. [Head after Clementine H.]* of 1952, in which he adopts Moore's motif of a powerfully modelled hair knot, which destroys the otherwise serene outline of the head.[173]

So much for the few visible traces of Moore in Wilhelm Loth's œuvre. Yet in his mind he engaged very actively with Moore. This is evident in that same letter of 7 May 1982. In it he expresses his fascination at the thought of Moore's connections to Surrealism, and adds in the same breath: 'I myself feel that these connections are more likely to have come from outside, than to have arisen within his own being. It seems to me that Henry Moore is a highly intelligent, but not an intellectual artist (as I imagine Max Ernst to be). He – Moore – was led by the determination to combine the new possibilities of non-representational sculpture with his own anthropomorphic interest, to break out of the limited possibilities of traditional figurative sculpture and to find unusual formal definitions (for the human being). I have used the term 'formal definitions' quite deliberately here because I feel that he was not concerned with new spiritual definitions, not like Giacometti with regard to the existential situation of the human being. His – Moore's – *Family Group*, for instance, is a clichéd, albeit formally alienated, image of parents and a small child in harmony with each other.'[174]

Loth's view of Moore as an artist who was solely interested in new 'formal definitions' could have been refuted repeatedly by this present study. Interestingly, he tends to this view precisely in the areas where he himself profited from Moore's theories on art. It is fair to assume that he will have paid due attention to Geoffrey Grigson's introduction to the Penguin book mentioned earlier. And this would have been the first time he came across statements by Moore that were to be of importance to him later on. Looking at his own work, Moore declared: 'The most striking quality common to all primitive art is its intense vitality. It is something made by people with a direct and immediate response to life.'[175] And: 'I don't want to see the original realities – as optical effects, that is. I want to see the deeper reality underlying the scenic, the expression of what are sometimes called abstract imaginings.'[176]

Both statements cut to the quick of Moore's art: intensity and vitality,[177] an abstract vision of the human body as an expression of a deeper reality – these were his aims. The phrase 'intense vitality' seems to have stayed with Loth throughout his artistic career. All of thirty-eight years later, in a long conversation with the present author, he commented: 'today intensity is our beauty'.[178]

Toni Stadler

The determination with which the aged Toni Stadler (1888–1982) engaged with the work of Henry Moore, ten years his junior, marks a significant watershed in the history of German sculpture. Stadler had been personally acquainted with Adolf von Hildebrand and, through him, had come to understand Hans von Marées' world of para-antique forms; he had internalised the work of Maillol, and understood better than anyone the importance of Greek archaism for Modernism; it was Stadler who took up the legacy of the Etruscan Kuroi and Stadler who always remained faithful to the figure and – in his weightless torsos – treated it as a vessel.[179] And it was this same artist who, late in life, took Moore as his role model. At a crucial moment in his long, highly complex development, he very deliberately turned his attention to what the English sculptor was doing. And he had cogent artistic reasons for doing so.

Around 1956 Stadler started to discover what he could do with the human torso[180] by deliberately opening up the existing gaps (around the arms and the neck). At the age of sixty-eight, after many long years, he abandoned the closed forms and brittle saturation of the figurative style he had evolved from Maillol's art. Now the element of fragmentation in his work corresponded more closely with his sense of the time he was living in. Once his figures had been cast in bronze, he would start work on them again with an embossing hammer, adding new details and repeatedly adjusting the patina. Thus Stadler's sculptures started to develop a whole new

350 Wilhelm Loth: *Woodcut*, 1950, 28 x 25.5 cm, Loth Estate, Galerie Schlichtenmaier, Stuttgart

351 *Composition*, 1931, Cumberland alabaster, H. 33.27 cm, The Henry Moore Foundation (LH 102)

352 Toni Stadler: *Marshall Fountain*, 1961, Bronze and stone, Length of the figures ca. 220 cm, diameter of the round basin 625 cm, positioned in front of the Old Opera, Frankfurt a.M.

353 Toni Stadler: *Marshall Fountain* 1961 *(Detail)*

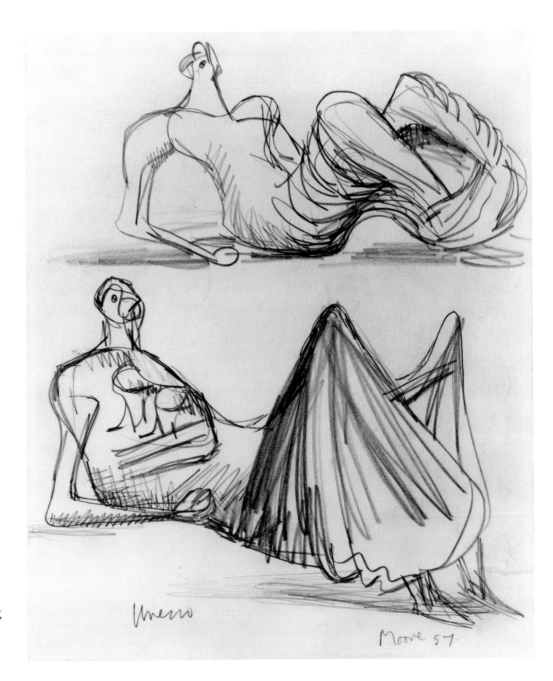

354 *Two Reclining Figures*, 1957, Pencil, 29.2 x 23.8 cm, British Museum, London, AG 57.3 (HMF 2957)

surface life. The bodies of his young, boyish male figures, his dancers and bathers, took on a fragmented air, defenceless, vulnerable, and with their roughened skin seemed to be filled with the all-pervading vibrancy of their alert, taut corporeality.

It is one of the outstanding features of Stadler in this late period that he was able to sustain this *outré* style of artistic forming in a complex commission depicting three reclining figures, and even took it a stage further in other large-format bronzes. In the present context it has to be interesting to discover how he did this – consciously avoiding any form of monumental pathos and with an ever greater capacity for allusions to Nature, which in itself took his work all the closer to that of Henry Moore.

In 1961 Stadler was commissioned to design a memorial to George C. Marshall outside the Frankfurt Opera. Living in Rome at the time – as a guest of honour at the Villa Massimo – and greatly impressed by the city's magnificent fountains, he designed a water feature, the so-called *Marshall-Brunnen [Marshall Fountain]* (fig. 352).[181] With reference to this work, Thomas Weczerek wrote: '...a rounded pool with three female, reclining figures, with stone benches around the edge that invite people to linger for a while... The trio of figures in the bubbling water calls to mind water-creatures born of a Mediterranean spirit: nymphs at a water source. One need only think for a moment of the symbolic meaning of the water source and the reason for this memorial, for one to remember with gratitude how significantly the Marshall Plan

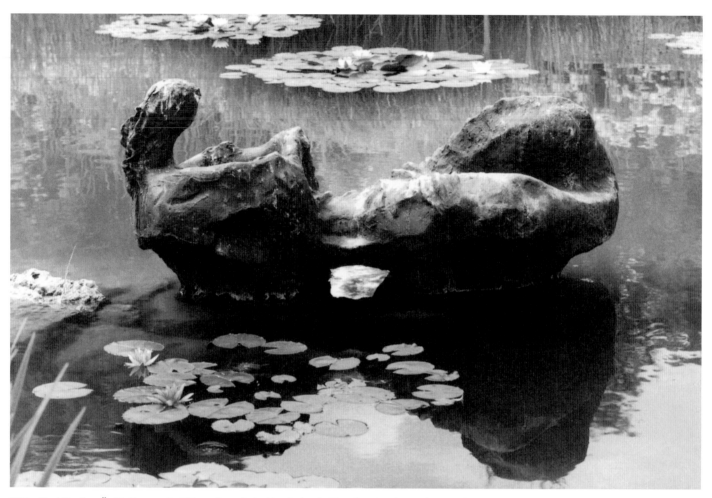

355 Toni Stadler: *Ägäis*, Bronze, L. 195 cm, Bayerische Vereinsbank, München, Tucherpark, München

helped to set in motion the reconstruction of Germany after the war, which in turn illuminates the lines from *Faust Part II* that the artist cites in conjunction with this work:

> Aglaia: Grace we bring as flower of living; Let fair grace be in your giving.
>
> Hegemone: Grace be in your glad receiving; Heart's desire is sweet achieving.
>
> Euphrosyne: Closed in tranquil time and place, Thankfulness has special place.'[182]

With this reference to Goethe, to Aglaia, Thalia, Euphrosyne and Classical literary traditions, it seems that the humanistically educated and widely read artist was tapping into the myth of the Graces.[183] And this is not insignificant in this piece. For wherever the Graces appear in the context of visual art – as they still do in the twentieth century in works by artists such as Robert Delaunay, Picasso, Arp, Marino Marini to name but a few – they are invariably portrayed in terms of the harmony of their upright forms, resonating with and around each other. Stadler, however, depicts them as horizontal figures, turning them into reclining water nymphs,[184] although in their gestures and poses he retains the harmonious togetherness that typifies the iconography of the Three Graces. His

conception of the figures' mutually complementary positions is best seen from the main viewing side. From this angle, Hegemone is the dominant figure, facing the opera house in a relaxed pose with her arms stretched out far behind her head.

Approaching the work from the city centre, the first of the reclining figures one encounters is *Aglaia* (fig. 353). With her closed legs drawn up to her body and her arms resting around the centre of the body, this slim figure is perfectly at peace in her own, dignified composure. Not so her opposite number, Euphrosyne. As the third of the figures, Euphrosyne combines elements of the poses of the other two: Hegemone's more relaxed legs and Aglaia's arms.

While Goethe's humanist-symbolist lines portray the three figures as the epitome of 'grace' – giving, receiving and offering thanks – Stadler's water nymph-Graces sacrifice their feminine charms for a threefold interplay of closed, opened and almost-closed bodily attitudes. The element of water is crucial to these three figures.[185] It is as though Stadler's reclining figures were floating in the water, their forms and garments as one with the fluid movements around them. Hence the undulating, circular, never ending ebb and flow of their poses and, above all, the uncontrived liveliness of the lie of the drapery. It

356 Toni Stadler: Drawing after Moores bronze
Two Piece Reclining Figure, No. 2

is clear that in this figurative expansion, in the rhythm of the forms (up and down) and in the play of the drapery, Stadler was taking his lead from the draped reclining figures that Moore first made in 1952 (see figs. 176, 183). It seems, however, that he also learnt as much from a related, drawn study that he had seen illustrated in the catalogue for the exhibition in Munich in 1960 (fig. 354),[186] where the flowing line of the upper figure anticipates his Euphrosyne.

In 1963, in conversation with Hans Kinkel, Stadler had cited Moore, Marino Marini and Henri Laurens as his possible, modern sources of inspiration. On the same occasion, he also remarked that 'specifically in the cases of the figures around the fountain, I would readily admit that I found much of Moore's work very stimulating'. And as Kinkel observed, while he said this he 'tenderly, gently ran his left hand along the length of a reclining figure…'[187] which showed once again that in the Marshall memorial, in the subsequent reclining figures and above all in his *Ägäis* (fig. 355),[188] his main concern was precisely this animated flow of forms and shapes.

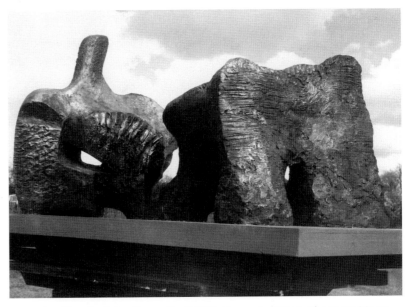

357 *Two Piece Reclining Figure, No. 2*, 1960, Bronze, L. 259 cm, The Henry Moore Foundation (LH 458)

358 Toni Stadler: doublepage with photo-collage, 1965–70, Stadler Estate, Deutsches Kunstarchiv im Germanischen Nationalmuseum, Nürnberg

Ägäis, a major work from 1963, seems to have captured within it all the energy of powerfully flowing movement. The words of Henri Laurens could as easily have been uttered by Stadler: 'I don't form shapes, I form movement'.[189] The level of autonomy evident in this movement and in the merging of figure and drapery transposes *Ägäis* into the realms of natural forms and hence to the same regions as Moore's landscape metaphors. That Stadler was particularly open to precisely these metaphors is confirmed by some of his later drawings in which he copied *Two Piece Reclining Figure, No. 2* of 1960 from different angles (figs. 356, 357).[190] Here, too, he was fascinated by the reciprocity of human and natural forms.[191]

Stadler's own indication of the importance of Moore's work as a source of inspiration for the *Marshall Fountain* in

359 Reclining Figures, 1942, Pencil, wax crayon, watercolour wash, pen and ink, Private Collection, Taiwan, AG 42.137 (HMF 2035)

360 Three Reclining Figures, 1942, Pencil, wax crayon, watercolour wash, pen and ink, 22.5 x 17.5 cm, The Henry Moore Family Collection, AG 42.149 (HMF 2041)

361 Joseph Beuys: *Sculpture by Henry Moore by Beuys*, 1961, Gum, cardbord, glas, L. 23 cm, Museum Schloss Moyland

Frankfurt is further reinforced by materials in his estate. One such is a small, undated, fragmentary notebook with no binding that he used between 1965 and 1970. He seems to have pasted reproductions of works of art that mattered to him into this book, and there are two particularly remarkable double pages (fig. 358).[192] On the left there is a photograph of Stadler's *Woge [Wave]* of 1967; on the right is a reproduction of Moore's *Draped Reclining Figure* of 1952–53 (fig. 176). The next double page has details of reproductions of drawings made by Moore in 1942. On closer examination, these two images turn out to be rudimentary versions of two larger drawings, each with several reclining figures, one above the other (figs. 359, 360).[193] In each case Stadler had selected the lower of the three reclining figures. He specifically chose the versions whose multiple layers created the liveliest effect. And in these drawings by Moore he found that breathing openness that was to be so important for his own flowing pictorial style.

Joseph Beuys

In the same year that Stadler – his eyes on Moore – embarked on a new form of reclining figures with echoes of the natural world, the much younger Joseph Beuys (1921–1986, Moore's junior by thirty-three years) created a 'plastic image', which he rather self-confidently entitled *Plastik von Henry Moore von Beuys [Sculpture by Henry Moore by Beuys]* (fig. 361). While the older artist, with his highly animated late work, re-established himself in the present through Moore, in 1961 the younger rebel – sidestepping each and every tradition – took his lead from a motif in Moore's work that was both related to his own thinking and had a programmatic significance for his work as a whole.[194] Beuys's seemingly unremarkable piece, a mere twenty-three centimetres from end to end and set in a white box – mounted on a firm back plate and with a glass front panel – is formed from a pale rubber band which has been rolled so that the flap in the upper right stands up like a head. The rubber band was twisted in on itself, pulled through in the middle and knotted twice so that it forms two unequal loops. Finally Beuys placed the piece on a sheet of pale brown paper so that it is embedded in its own coloured space.

This last move confirms – if it were not already clear – that this piece is more than just a game with a rubber band, the way anyone might toy with one. Indeed Beuys may have started by doing just that, only to discover a 'plastic image' in what he was doing and to have developed that into the final work. What was important to him in this piece is evident from the

362 *Reclining Figure: Snake*, 1939/40, Lead, 28.6 cm (bronze, cast 1959), The Henry Moore Foundation (LH 208a)

title: *Sculpture by Henry Moore by Beuys*. In his own unique manner, Beuys created a work after Moore. No more than that, and no less than that.

Which Moore did Beuys have in his sights? To what extent is this nevertheless very much a plastic image by Beuys and – despite its apparent *pauvreté* – to be taken seriously? How exactly did this plastic image contribute to the West German reception of the work of Henry Moore?

Although, as far as we know from existing sources, Beuys only once mentioned Henry Moore – in 1984 in a conversation with Mario Kramer,[195] it is reasonable to assume that he will himself have seen Moore's first exhibition in Germany, in Düsseldorf in 1950, and that – as one would certainly expect – Moore will have been a topic of lively discussion and debate amongst the young artists studying under Mataré. As it happens Mataré was not entirely persuaded by Moore's art,[196] which is not to say that his students could not form their own opinions.

How closely Beuys had studied Moore's work, and how well he had understood the latter's compositional aims, is apparent from his 'plastic image' of 1961. In it Beuys was clearly paraphrasing those reclining figures by Moore which, con-

ceived with a particular spatial generosity, live by the linear rhythms of the energies flowing through them – perfectly exemplified in *Reclining Figure: Snake* (fig. 362), and other works, generally in bronze or lead, that energetically develop the biomorphic abstraction of the *Recumbent Figure* (figs. 119, 120). Beuys's inspired handling of a rubber band has a particular affinity with the biomorphic liquefaction and dematerialisation of these works. This Moore is his Moore – rhythmic, boldly energetic and filled with life.

In his own unsystematic way, Beuys makes it clear that he was well aware of Moore's aesthetic of *spiritual vitality* and his striving for an organic whole. Organic whole? This notion, so important to Moore as we have already seen,[197] was by no means alien to Beuys. After all, like Moore, he too strove for the same end in his own plastic image: his elastic band turned from a circle (!) into a recumbent lemniscate with a clearly identifiable centre – surely the neatest formulation of 'unity in multiplicity' – a concept that Beuys was later to return to in connection with his political aims as a member of the environmentally aware Green Party.[198]

It is in the lemniscate of the *Sculpture by Henry Moore by Beuys* that we see the real point of contact between these

363 Joseph Beuys: *Bees and Metamorphosis*, 1952, pencil, 25.1 x 38 cm from "Secret block for a secret person in Ireland", No 71, Collection Marx, Hamburger Bahnhof, Nationalgalerie, Berlin

two artists. With his asymmetrical-symmetrical rubber version of a figure of eight – loosely knotted in the middle and lying on its side – Beuys was referencing the formal essence of some of Moore's best *Reclining Figures* as well as his own familiarity with this symbol.

Moore based numerous reclining figures on the shape of a figure of eight, and at the exhibitions of his work in Düsseldorf (1950) and Essen (1960), Beuys would have been able to see examples that would have appealed to his own artistic eye. In many of these pieces, Moore used a binary rhythm. In the abovementioned *Reclining Figure: Snake* of 1939–40 (fig. 362),[199] the gap between the raised legs is balanced by the rib cage. In a recumbent lemniscate the form circles in and around itself.[200] Beuys tapped into the notion of the organic whole, as it occurs in Moore's aesthetic, and incorporated this into his own phenomenology of the lemniscate. This in turn was founded on Beuys's declared intentions to raise the general level of awareness of his fellow human beings, which of course also shaped his small *Sculpture by Henry Moore by Beuys*.

This is not the place to enter into a detailed discussion of Beuys's phenomenology of the lemniscate. A few pointers will have to suffice. In the figure of eight we see a line that, so to speak, only once crosses its original path as it returns to its starting point, a line that sets out with rhythmic verve, only to double back on itself, a line that can circle, stop, pass through a crossing point, stretch and contract. Everything in the unbroken course of the figure of eight veers in a harmoniously controlled manner between renunciation and reassurance – a line that is as much about being at one with itself at the crossing point as about communication, interconnecting associations and rhythmic movement.

For Beuys the two fundamental qualities of the figure of eight – its rhythmic, flowing movements and the moment of concentration at the crossing point had a particular significance for very different but equally important reasons. This can be seen from two examples from the period preceding the plastic image of 1961: *Bienen und Metamorphose [Bees and Metamorphosis]*, 1952 (fig. 363).[201] In view of this well-known drawing, the following comments by Beuys seem very relevant to the notion of a figure of eight.

'These queen bees all have something powerfully organic about them. In the middle there is a heart of sorts; the forms move away from the point where the heart is and circle back round it. It is actually a very organic form that has associations

364 Joseph Beuys: *Lemniskatenschwingung um einen Kern (Grauballemann, version I)*, 1953, brasswire and rosewood, measures and whereabouts unknown

with the things that Christianity talks of – heart, love, giving oneself up. This is what I have tried to put into this piece and to represent in a directly organic manner, like a kind of psychological process. In this respect the queen bees are nothing other than moving crosses… the cross is organic and moves to right and to left like a form pursuing an asymmetrical course. One movement goes down and the other goes up. There is a kind of heart shape in the middle and usually there is a head shape making its way upwards.'[202]

In 1953 Beuys made his *Lemniskatenschwingung um einen Kern* (fig. 364).[203] The third version of this work, entitled *Grauballemann*, is on view in the Beuys Block in Darmstadt.[204] Moreover, in the drawings that he used to explain discussion points in the 1970s, Beuys variously used the infinity sign to explain the basis of the anthropological reforms he was striving for in the art world.[205] Thus the dynamic sign of the figure of eight was always rich in connotations for Beuys. Most particularly where – as in the abovementioned plastic image – it was laid out before the viewers' eyes, encouraging them to trace its dynamic movements. And Henry Moore had precisely the same intention for his own work. His sculptures and three-dimensional pieces, filled with potent life, are designed to nurture and reinvigorate the viewer's plastic sensors.

So it turns out that, in his experimentation with a rubber band, Beuys was standing on Moore's shoulders. This conclusion is confirmed in other connections between the two artists. For a start there is the importance of Ireland. Both artists incorporated the imagery of Irish high crosses into their work. Both were washed by the 'current' (to use Beuys's own terminology) of the legacy of Celtic civilisation – Moore only instinctively at times, Beuys more consciously. Both were fascinated by

Stonehenge. Both felt especially drawn to the work of William Blake. Both were prepared to work for the good of society – the older of the two produced work for schools, was willing to do what was asked of him by UNESCO, major London galleries and other cultural institutions; the younger, taking the initiative on a non-institutional basis, was tirelessly active in his support of a whole range of cultural and political causes.

The only question still to be answered concerns Beuys's contribution to the reception of Moore's work in Germany. In the end it is clear that he went beyond the purely formal response of some of his predecessors. He focused on the symbolism of Moore's intrinsically rhythmic reclining figures, and created his own version of a figure of eight as an analogy of the energies within the human being that are there to be mobilised. In so doing he accentuated the loosely sweeping knot in the heart region of his rubber configuration. He certainly knew of the deeper significance of such knots.[206] More so than for Moore, it is clear from Beuys's teaching that the cognitive human being implied by the figure of eight was always of importance to him.

Reviewing this small selection of sculptural responses to Moore's work in West German artists' studios, it is clear that they encompass a wide spectrum of interests. Above all it was his use of organic abstraction and inherent connections to the processes of metamorphosis – as seen in the various *Reclining Figures* and *Upright Motives* – that attracted attention in West Germany. Meanwhile other artists were fascinated by the connections Moore made between the figure and the landscape, his fluid use of drapery, the rhythmic juxtaposition of solid forms and open spaces, and the effects of negative space in general. In each individual case where an artist is seen

to have assimilated certain ideas, one senses something of the extent to which Moore unleashed new experimental energies in West Germany.

Moore's Presence in East Germany

Henry Moore's impact was nowhere so multi-faceted and varied as in the divided Germany. Although the two cultural systems within Germany were founded on the same artistic legacy (Neo-Classicism, Expressionism, New Objectivity) – albeit corrupted by Hitler – they were now at odds with each other on the frontline of the Cold War. In this volatile mix, Moore fulfilled the role of a steady constant and one of the most important exponents of modern sculpture. Unlike in the West, where it was not hard to seek and make personal contact with the English artist and where individuals could openly declare their allegiance to particular artistic trends, in the East access to Moore was much more difficult. In addition to this, not least because of cultural and political pressures, any attempt at access was viewed very differently. Nevertheless, despite the constant indoctrination they had to contend with, visual artists in the East still, admirably, managed to maintain certain pockets of freedom. Catalogues of Moore's work, that had somehow found their way into the East, were keenly studied and copied in secret. At the same time, in the West, the situation was dominated by political interests and the business of commissioned works of art. Yet with regard to the two different social systems, the fact remains that in the West, where artists were completely free to engage with Moore and his innovations, the reception of his work was much more varied than in the East, where artists were still in the trenches fighting for the principle of abstraction to be accepted.

Even before the founding of the German Democratic Republic in 1949, the Soviet Union was already trying to regulate art production in East Germany according to its own ideological belief in Socialist Realism. Anything that did not fit the mould of the propagandist art that was deemed to be close to the people, was classified as formalistic, and banned. And anyone who was either not able or not willing to desist from Formalism[207] was excluded from the official association of visual artists, that is to say, cut off from a range of material benefits and not considered for public commissions.[208] In East Germany power initially lay in the hands of the Soviet cultural officer Alexander Dymschitz, who ruthlessly implemented the doctrine of Formalism that had been introduced by Stalin in 1932. In a statement made in 1949, he declared that 'Formalism in art is a typical expression of the bourgeois decadence that is threatening to degenerate art, that is a direct attack on the nature of art, that destroys the true nature of art and will ultimately cause its own self-induced demise."[209] In her overview exhibition *Picasso in der DDR [Picasso in the GDR]*,

Brigitta Milde rightly pointed out that 'the Formalism-Realism debate was hugely detrimental to art and artists in East Germany. Anything that did not conform to the aesthetics of Menzel and Repin was Formalist.'[210]

Moore could never have been forced into this Procrustean bed. Accordingly, during the first anxious years when the GDR was still trying to consolidate its position (albeit dependent on the Soviet Union in all areas of life), Moore's work had to be portrayed as a Capitalist, late-bourgeois aberration. The ferocity of the onslaught on his work is very evident in a deliberately misleading article published by *Neues Deutschland*, the main mouthpiece of the SED [Socialist Unity Party of Germany]. On 15 July 1950, in response to the exhibitions in Hamburg and Düsseldorf, readers were told that 'his misanthropic "works" represent the human being as no more than an ugly lump, with grossly exaggerated, swollen limbs, with not a trace of a human mind. Henry Moore appeals to the bourgeoisie because he portrays people the way they like to see them: as robots with animal strength and dully submissive. And the same aims are pursued by American Formalist art, which seeks to divert the people's attention… to the abstract and the mystical, and to make everything real appear repulsive.'[211]

Few artists in the East will have been taken in by this. Yet the same applied here as elsewhere: *semper aliquid haeret*. It took fifteen years before the journal *Bildende Kunst* (the journal of the Association of Visual Artists in Germany and a state-sponsored forum for all aspects of art in the GDR) first struck a more objective note.

Enemy – Testator – Socialist Comrade in Arms –
The Changing Image of Henry Moore in Bildende Kunst

The first significant consideration of the art of Henry Moore came at a time when the Party and the Regime in the GDR had gained a new sense of security following the building of the Berlin Wall on 13 August 1961 and the consequent lessening of tension in the nation's political life. By now the lead role of the workers had been established and the efforts designed to promote the internal development of a socialist society were well under way. This latter aim involved nurturing a socialist, national identity with the arts being expected to play their part by propagating a 'historically founded image of the epoch'.[212] Now for the first time bourgeois Modernism was countenanced as a 'possible source of a usable legacy,[213] with the result that in 1965 an exhibition was presented in the Nationalgalerie in East Berlin entitled *Von Delacroix bis Picasso [From Delacroix to Picasso]*. Clearly, in their own work, GDR artists were expected to 'advance beyond"[214] the art trends on display and to develop their own positions.

At this important moment in the state's cultural politics, the leading art journal in the GDR, *Bildende Kunst,* published a critical yet thorough, ten-column article by Jutta Schmidt entitled

'Lernen bei Henry Moore?' ['Learning from Henry Moore?'].[215] The point of departure for Schmidt was that in response to the journal's survey of role models, younger sculptors[216] in the GDR had 'almost unanimously named Barlach, Maillol, Blumenthal, Arp, Marini and, above all, Henry Moore'. When asked why, 'they spoke of a particular ability Moore and just a few others had to give visual form to certain sculptural laws'. In their view Moore could 'induce in the viewer an awareness of the relationships between forms.'[217] But hot on the heels of these views came the stern ideological proviso: the young sculptor still had to keep his feet on the ground as a realist, and he would not get his money's worth in Moore's company: 'No, it's not enough merely to establish the upwards-striving force of one of these reclining figures or to convey a sense of its relaxed vegetative forms extending into the space around it... These most general aspects of human existence – detached from any historical connections, with no links to a concrete individual and his or her class-bound status – do not convey an artistically conceived image of the human being, they do not represent contemporary personas and their responses to the various phenomena of our own time. This applies not only to Moore's many different reclining and standing figures but also to his family groups, his warriors and some of his mother-and-child sculptures.'[218]

It was not the interesting conflict between different forms that mattered, it was what a work of art said about reality, that is to say, about the reality of everyday life in a socialist society. There was just one hint of tolerance: 'It may be that, despite this, some may place a high artistic value on Henry Moore's work', only to be followed by the exhortation to 'say something meaningful to the people that make up our socialist present'.[219] With these words in 1965, Jutta Schmidt continued the Formalism-Realism debate in a tone that held out little hope of reconciliation.

In 1975 *Bildende Kunst* published two articles in quick succession that made waves in the official East German attitude to Moore because of the extent to which they contradicted each other. Since Erich Honecker had become Head of State in the GDR, the situation had relaxed a little for the first time. In June 1971, at the Party Conference of the SED, the Minister for Culture had spoken up in favour of allowing artists to tackle a wider range of themes and for a greater variety of artistic styles. This paved the way for greater individuality in the work of GDR artists. In addition to this, Honecker opened the doors to a new level of engagement with the nation's artistic legacy. Now it was even sometimes possible for artists to travel abroad to non-Socialist countries and to extend their range of experience.

This new openness was too much for some art critics. Ingrid Beyer's 1975 essay on 'Artists and Society' follows a strictly Marxist line and she comes straight to the point: 'In 1975 the leading English sculptor Henry Moore wrote in an article "So-

ciety and the public cannot have a voice in art matters. Because they are incapable of artistic creation, they don't know what is going on in the artist's head." This is a view shared by countless late-bourgeois art professionals and theorists; it has proved to be extremely tenacious and has not even been entirely eradicated in certain socialist scenarios.[220]

This tortured article continues to struggle with these opening lines. When Moore calls for the freedom needed in the process of artistic creation, Beyer accuses him of taking a line that is incompatible with the Marxist demand that the artist should embody real-life historical progress, that is to say, the aims of a socialist society.

Business as usual? Hardly. Three months later the same journal reported on a number of artists' responses to the legacy of art history in light of their own personal, creative perspectives. Of the six who were asked to participate in this enquiry, three referred to Moore by name. These were Fritz Cremer, Theo Balden and Gerhard Lichtenfeld. The relevant passages from this article are deserving of closer examination.

Fritz Cremer

The length of the artists' contributions is already indicative of the importance the journal's editors attached to them. First, and at greatest length, there is the statement by the highly decorated Official Artist of the GDR, Fritz Cremer (1906–1993).[221] It is worth starting at the end of his statement: 'In my view an artist's critical acceptance of this legacy can only lead to truly innovative, creative results if each individual – taking into account his own radius – consciously decides to believe in human common sense and, in so doing, chooses life. Then, like ballast that has been weighing us down, standards that we have been struggling with, such as "sculpture *per se*" and the famous-infamous flirtation with timelessness, just fall away from us.'[222]

Here, and throughout the statement, we hear the voice of the committed Marxist. The recipient of numerous large-scale commissions to design some of the most important monuments in the GDR, notably the memorials to those who suffered and died in the concentration camps at Buchenwald, Ravensbrück and Mauthausen, Cremer was feted and often quoted. Nevertheless there were moments when Cremer struggled with the official cultural politics of the GDR. To be precise, there were times when he took inspiration from the same art whose ideology he publicly rejected. To take just one example, quoting Fritz Jacobi: 'As an artist he was fascinated by Barlach's earth-bound, understated figures sustained by the simplest of forms... Barlach's originality and the connections he was able to make between suffering and inner greatness influenced Cremer in a number of works, particularly in his mother figures.'[223] One can only agree with this. So it is all the more astonishing to read Cremer's tirade against Barlach

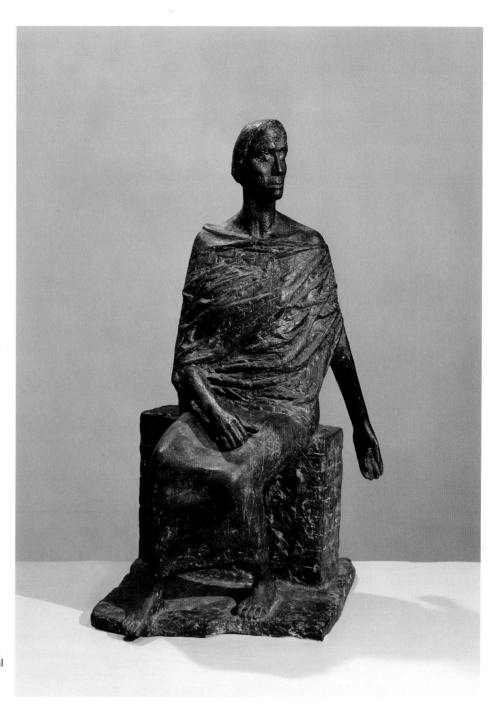

365 Fritz Cremer: *O Germany, pale mother*, 1961–65, Bronze, H. 230 cm, for the Memorial former Conzentrationcamp Mauthausen, Austria

in the statement we are looking at here. Now he accused the older artist of 'intellectual camouflage'. According to Cremer, Barlach's art was 'caught up in absolutist thought patterns and idealist art traditions, even although it was also on the threshold of a fundamentally new dialectic spirit. The intellectual small-mindedness and limitations of his art have their roots in his anachronistic striving for eternal relevance and end in his famous-infamous notion of timeless art.'[224]

When it came to Henry Moore, Cremer concentrated his critical attention on a clearly defined problem. Unfortunately without further explanation, he asks if it is acceptable for a Communist artist to declare his allegiance to the attitude to tradition adopted by Moore, namely the 'view that the Greeks had stood in the way of the development of the art of sculpture. Instead of taking as their starting point the innate values of plastic forming, they [in Moore's view] had replicated the human form in bronze or stone so to speak as a curiosity cabinet exhibit. In addition to this, Moore is also of the opinion that today's modern means of communication afford us a comprehensive, deep insight into pre-Greek and prehistoric art, which at last gives the twentieth-century sculptor the chance to partake of the true, original power of plastic form-

ing. I regard this view as undialectic and, for that alone, as pre-historic, because art made on this basis cannot be distinguished from the prehistoric spirit it expresses.'[225]

Cremer's simplistic rhetoric and his barely concealed support for the party line[226] could only miss the mark in his criticism of Moore. At no time was Moore of the opinion that the Greeks had hindered the development of sculpture. In Part I of this study, precisely the opposite was seen to be true. And as far as his interest in early art is concerned, he was specifically searching for a world language of forms. Typical of this are his comments on Mesopotamian art, when he makes the point that it is not at all necessary to know the history of the Sumerians in order to relate to their art. For, wherever and whenever a sculpture is made, it has its own reality and is always part of life for those people who are open to it.[227] Naturally Moore supported a notion of 'art *an sich*'[228] (which Cremer also took exception to) that had to be strong enough to reach out into life and to reconcile Nature and humankind with each other. This, too, Cremer dismissed as idealistic.

Despite his objections to Moore's thinking, although he did credit him with being 'one of the most interesting and inspiring sculptors of our time',[229] Cremer did not baulk at drawing directly on Moore's legacy This is evident in one of his major works, the monumental memorial to the victims of the former concentration camp at Mauthausen in Austria, *O Deutschland, bleiche Mutter [Oh Germany, Pale Mother]* (fig. 365)[230] of 1961–65. The way that the cloth is drawn around the figure's shoulders shows very clearly that Cremer is certainly indebted to the draped figures Moore started making in 1952 (figs. 176, 183). In the strong relief of the all but autonomous flow of the folds, Moore was metaphorically recalling 'the crinkled skin of the earth',[231] in line with his own aesthetic founded in Nature and the natural world. Obviously aware of the comparable works in Moore's œuvre, Cremer sought to remain 'concrete',[232] with the metaphor of the cloth in this piece calling to mind barbed wire or the ropes used to tie up the mothers.[233] In this much narrower, representational function of the drapery there was no real point of contact between Cremer's work and the ultimately pantheistic approach taken by Moore, discussed here in Chapter I,5.

Theo Balden

Theo Balden (1904–1995), whose dialogue with Moore – as we shall show – ranged wider than that of any other East German sculptor, also recognised his debt most openly in the said article in *Bildende Kunst*. His contribution, entitled 'Erbe im Dienste eines streitbaren Humanismus' ['Legacy in the Service of a Debatable Humanism'], was largely filled with reflections on his own development and influences, namely Lehmbruck, Barlach, music and Nature. During the course of this, he made the following comment: '…I also found Moore's sculptures

inspiring and enriching – above all in the secure congruence of form and content, an important and, in my view, often neglected artistic principle. My relationship to Moore's work derives from the usability of this principle and not from Moore's philosophical position'. Having covered his back, Balden could allow himself the following: 'Of course there are people who categorise Picasso and Moore as Formalists, but simply to dismiss individual artists or what we call Modernism is a poor substitute for in-depth differentiation and analysis.'[234]

Balden's brief, largely positive reference to Moore does not even begin to hint at the extent to which his output – major commissions for monuments and a retrospective, in 1971, in the Nationalgalerie[235] – was in fact indebted to the English sculptor. But more of that later.

Gerhard Lichtenfeld

In 1958 Gerhard Lichtenfeld (1921–1978) succeeded Gustav Weidanz as Head of the Sculpture Class at the Hochschule für Industrielle Formgestaltung Burg Giebichenstein. Having been appointed to the Chair of Sculpture in 1966, Lichtenfeld remained at the same institution – a highly successful teacher – until his untimely death in 1978. His lively, masterfully animated nudes were in the best tradition of German figurative sculpture. He often cited Maillol as an influence, although there are also echoes of Gerhard Marcks.[236] In his statement for *Bildende Kunst*, he maintained a strictly historical perspective: 'Almost thirty years ago, when I ventured to make my way in sculpture at Burg Giebichenstein in Halle (one of the least tradition-laden art schools) it was the four great "M"s – Maillol, Marcks, Marini and Moore – that were regarded as the most accomplished exponents of pure sculpture. At the time Rodin was shamefully ignored. The four "M"s were the pillars of our training. My teacher, Weidanz, defended their cause in the area of applied sculpture. Thirsting for knowledge, as we were, …we soaked up every comprehensible, instructive comment and immersed ourselves in the images of art presented to us. With the help of works by the four great "M"s, armed with an overview of past centuries and encouraged by the fact that we could see his own work and that of Grzimek coming into being, we gained from Weidanz a well-founded understanding of sculpture as a creative art. Principles that you should not have to think about while you are working, but that you should also never forget.'[237]

Lichtenfeld did not go into any more detail, and did not list which works by Moore had played such an important part in his training. In his own work there are no obvious connections. Bearing in mind the rather constrained situation at Burg Giebichenstein, the constant presence of Gerhard Marcks who had already been a leading figure there before 1933, and the short time that Waldemar Grzimek taught there, it is clear that

at least neither of these two would have kowtowed to Moore. And Weidanz never took his lead from Moore. Accordingly, Moore's elevated status at Burg Giebichenstein may have been founded on a more general admiration for his craft skills and his utterly incorruptible approach to art.

With these references to Moore in 1975 in *Bildende Kunst*, these three artists' voices paved the way for a sweeping change of public opinion. Just a few years later, in 1979, *Bildende Kunst* published an article by Raimund Hoffmann with ten illustrations in which he gave a straightforward, well informed introduction to Moore's work and main strengths. In the introduction Hoffmann briefly reviewed the reception of Moore's work in the GDR to date. Taking a mildly critical stance, he points out that Jutta Schmidt's essay 'Lernen bei Henry Moore' ['Learning from Henry Moore'] 'provided more than enough material for a meaningful debate which unfortunately never came about. But things have changed now, ever since the early 1970s when both artists and art historians started to pay greater critical attention to how we deal with the legacy of the past.'[238] On the artists' side, Hoffmann cites Cremer's favourable assessment of 1975 (minus his criticisms of Moore) with its comment that Moore was one of 'the most interesting and inspiring sculptors of our time'. On the more recently converted art historians' side, Hoffmann found himself having to cite the 1975 edition of the Leipzig *Lexikon der Kunst*, which had an entry for Henry Moore: 'Nevertheless, the artist's humanist convictions makes itself felt time and again in his insistence on the human body as the fundamental substance of sculpture, in his open allegiance to humanist traditions in art and in his expression of human suffering in the face of destruction and in the attacks on man's inhumanity conveyed in many of his works... In view of all this, socialist artists have also productively engaged with various aspects of his work.'[239]

In effect, this officially approved view established the positive image that Moore enjoyed in the coming years in the GDR, where he was seen as a humanist in touch with real life, and as a defender of human dignity (in his *Shelter Drawings*). And now that Moore had achieved this level of acceptance, socialist artists were free to engage with his work and ideas.

This change took on another, rather different hue in 1982 following the publication of an article on 'Volumen und Raum' ['Volume and Space'] by the Moscow art historian Natalja Poljakowa.[240] Given the prevailing tone of Soviet art criticism, this essay was quite astonishing in that it embarked on a serious discussion of artistic forms. Poljakowa's study of the relationship between plastic volumes and the surrounding space as seen in sculpture through the ages, going right back to the freestanding menhirs of the distant past, was not innovative as such, but it did add the names of various Russian sculptors to the history of the emancipation of space, which had long been common currency in the West.

Assuming the existence of two parallel strands of development – with space tending to become ever more independent on one hand, and solid volumes coming into their own on the other, Poljakowa saw both strands coming together in the work of artists as diverse as Giacometti, Wotruba and Moore: 'The intersection of these trends became the tragic content of their art.'[241] And with specific reference to Moore: 'Thus the true meaning of Moore's art cannot properly be understood without taking into account the law of the active relationship of plastic volumes to space. It is as though Moore's reclining women are pinned down by a mighty wave of space in attack mode. Like a rushing torrent, in many places this energy has forced its way through the solid body and has left gaping holes in its wake. But these huge women simply rest all the more firmly on their massive elbows, hips and legs, their rounded heads rising up above the ground. And it is the heroism of the human struggle with the elements that constitutes the genuine pathos conveyed by the art of this English sculptor... He polishes surfaces, scratches others and bores holes through them as though he were leaving traces of the plastic form's resistance against the attacks of space and time. In his subjectless, abstract sculptures this struggle is all the clearer and the volume-space structure is openly on view for all to see.'[242]

While Natalja Poljakowa discerned a tragic, basically combative stance in Moore that could be best seen in some of the realistic, draped figures, at the same time she also saw a new spiritual dimension in the interplay of space and volumes in Soviet sculpture. It must have seemed to her readers that, although Moore did not yet know of the blessings of socialism, nevertheless he was significantly in touch with new diverse volume-space connections. His inclusion as a player in a wider, sculptural process and, as such, the approval he now enjoyed from a highly regarded Russian source, will not have gone unnoticed by the cultural authorities in the GDR.

By 1984 the time had at last come for a British Council exhibition of Moore's *Shelter and Coal Mining Drawings* together with four small bronzes (1939–46) to be shown in the Nationalgalerie in Berlin, before travelling to Leipzig, Halle and Dresden. The catalogue has 104 entries, all of which are illustrated. To my knowledge this was the first opportunity for artists east of the Wall to become acquainted with original works by Moore. Visitors to the exhibition avidly examined the works on display.[243]

Once connections to England had been re-established, in 1987 *Bildende Kunst* took from *Art Monthly* an overview of Moore's work by Anthony Barnett,[244] which crowned *Bildende Kunst*'s socialist assimilation of Moore with the declaration that his work represented the situation of the British working classes.[245]

Having surveyed the evolution of attitudes to Moore in the official art press of the GDR, we shall now turn our attention to his impact on artistic praxis in East German studios. We

shall start by looking at the work of Theo Balden, an émigré and the best known East German sculptor after Cremer.

Moore's Impact in East German Artists' Studios

Theo Balden

No other East German artist was as deeply affected by Henry Moore's work as Theo Balden (1906–1993). When he emigrated to England in 1939 he was thirty-five years old. By then he was already marked by the battle that he, a staunch Communist, had waged against the National Socialist regime and by the ten months that he had been held in prison by the Gestapo. Although he was basically a self-taught artist, in 1923–24 he attended the foundation course at the Bauhaus in Weimar where he had fallen under the spell of Moholy-Nagy and Schlemmer. Having managed to escape via Prague to London, he was only able to start work as a creative artist in 1941, after some time as an internee in Canada. As Ursula Feist has shown, the rich experiences that now filled his life were 'deeper and had a more enduring effect on both his personality and work than all that had happened to him in pre-Fascist Germany and in exile in Czechoslovakia'.[246] According to his own account of that time it seems that – leaving Moore aside – he was most impressed by the work of Graham Sutherland, John Piper, Paul Nash and Jacob Epstein,[247] all of whom were friends of Moore.

Since the early 1930s Moore had been an active member of the leftist Artists International Association (AIA), which also counted Nash, Piper and, later on, Balden amongst its members. Moore was personally involved in putting on exhibitions, writing petitions and taking part in public demonstrations, such as the protest against Mussolini and against the policy of appeasement towards Republican Spain being pursued by the British government.[248] In 1938 he also became a member of the Artists Refugee Committee. Following the Munich Agreement between Hitler and Chamberlain, the members of this committee devoted their efforts to helping German colleagues in Czechoslovakia to gain entry to the United Kingdom. In addition to this, Moore was amongst those who – in the middle of the war (!) – assisted German exiled artists in their efforts to have their work shown in exhibitions. In February 1945 Moore, 'whom Balden sometimes saw setting up exhibitions'[249] and Epstein participated in a group exhibition at the Whitechapel Gallery in East London, which also included a number of works by Balden.[250] However, there are no records of Balden – unlike his fellow exile, the sculptor René Graetz[251] – ever visiting Moore in his studio.

In an obituary for Moore, Balden described just how powerfully he was drawn to the art of Henry Moore, who was only six years his senior. With the improving cultural climate in the GDR, he was now able to declare: 'I gladly admit how much

366 Theo Balden: *Mother with Child*, 1946, Pencil and red ink, 33.5 x 19.5 cm, whereabouts unknown

I love his work'. Balden's article in the liberal Berlin newspaper *Sonntag* demonstrated his detailed knowledge of Moore's work. Rightly – and in agreement with Moore's approach – he spoke in particular of Moore's overriding interest in the human form: 'It was the human form that was the object of his intense, enormously productive attention, energy and curiosity… He replaced figurative narrative with sculptures born of a sensual and aesthetic grasp of the processes of growth and development. He had a creative empathy and relationship to

forms caught up in processes of various kinds. These are the forms that ensue from an inner vitality, succinct forms that act rather than report, because they are alive. And logically, it was the ideal of vitality that became Moore's replacement for the ideal of classical beauty.'[252]

With this reference to vitality, a key concept that Moore himself used extensively, as we have already seen, Balden showed that he was very much aware of Moore's aesthetic views.

While Balden was able to make a close study of original works by Moore up until 1947, while he was still in England, there are few accounts of later direct contacts with Moore's work.[253] The first traces of Balden's artistic engagement with Moore's sculpture date to the period when he was preparing his sculpture *Sitzende [Seated Woman]* (fig. 367)[254] of 1948. A number of preparatory studies have survived, which initially explore a mother-and-child theme. The example illustrated here, *Mutter mit Kind [Mother with Child]* (fig. 366),[255] made in 1946, may have been included by Balden in his solo exhibition that same year in Derby. The later bronze *Sitzende [Seated Woman]* is already anticipated here in the broad base of the seated figure, in the hypertrophied swelling of the draped legs and knees, the marked angle of the head turned left and the inward-looking, internal perspective of the main body of the piece tapering towards the top. This alignment – heavy at the base, light at the top – creating a greater sense of movement, is also seen in a sculpture with a similar body position, *Knienden [Kneeling Figure]*, whereas it is noticeably softened in *Sitzende [Seated Woman]*. Thus the drawing connects the two sculptures.

In the early part of his career – up until the early 1940s – Balden practised *taille directe* in a variety of works in wood or stone. Hence it is hardly surprising that in the drawing illustrated here (fig. 366), he took his lead from the stone sculptor Moore, or more precisely, from the *Madonna and Child* (fig. 203) he made for St Matthew's Church in Northampton (1943–44).[256] In this drawing Balden portrays the mother on a similarly plain bench. And, again reminiscent of Moore's approach, he deftly accentuated the layers of drapery encircling the powerful knee, creating a similarly wedge-like upper arm and drawing attention to her strikingly upright pose. Not found in Moore's sculpture are the hands, the much smaller standing child (no more than sketched in), the pronounced breasts and the more acute angle of the smaller head.

While Moore's sculpture was purely about the protective pose of the Madonna and the resonant togetherness of mother and child, with the stone form tamed in praise of the immutable majesty of the Virgin Mary, Balden's main interest was in the woman and her erotic appeal. In the emphatic fluctuations of her swelling limbs, breasts and head, he created a sense of continuous mass that flowed through the piece and already anticipated his *Sitzende [Seated Woman]*. From the

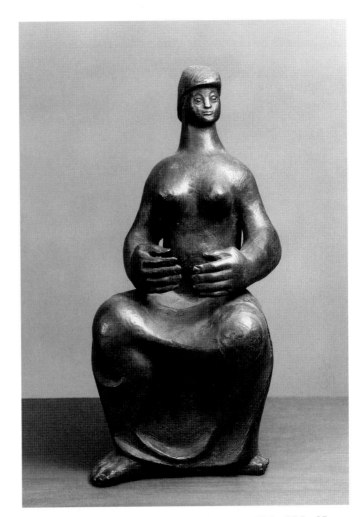

367 Theo Balden: *Seated Woman*, 1948, Bronze, 50.5 x 25.5 x 25 cm, Nationalgalerie Berlin/Kunstmuseum Magdeburg

overall composition of the drawing, it is understandable that in the final version of the sculpture, he abandoned the child and, hence, the woman's role as a mother. Now the seated woman's powerful, heavy hands move towards each other in front of her midriff. However, they do not touch, but come to a halt at the last moment, as though asking a question.[257]

The role of the outsider, which was immediately thrust upon Balden in the GDR, had its roots not least in the international air of his work, and above all in the vocabulary of forms he had learnt from Moore. How could he remain faithful to the affinity he felt with Moore,[258] without being accused of Formalism? From the late 1960s onwards he did this by creating a niche for himself with small-format pieces, which may also have brought him solace from his own much weaker, propagandist works. In a work such as *Kleine Büste [Small Bust]* of 1970,[259] his style approaches that of Moore's biomorphous works, such as his Cumberland alabaster *Composition* (fig. 351) of 1931.[260]

We know of Balden's respect for Moore's ability to create animated, organic forms. And amongst his very interesting studio notes, there is the comment: 'I have tried – no doubt

368 Theo Balden: *Torso eines Gemarterten*, 1961, Bronze, 9 x 24.5 x 14 cm, Nationalgalerie, Berlin

369 *Falling Warrior*, 1956/57, Bronze, L. 147 cm, Bayerische Staatsgemäldesammlungen, München (LH 405)

370 Theo Balden: *Herz und Flamme der Revolution – Karl Liebknecht*, 1979/83, Bronze, H. c. 560 cm, Lustgarten, Potsdam

subconsciously at first – to form my shapes according to the same principles that apply to mountains, trees and blades of grass.'[261] And, echoing Moore's views, he adds: 'There has to be a law of forms.'[262] As early as 1971, Balden had already outlined the nature of such a law: 'For me sculptural forms are not just forms, but expressions of active forces, forces that drive from the centre outwards and from outside inwards. Everything has to be expressed by dint of the form. It by no means diminishes the work to say that a sculpture consists of convex and concave elements. From the most extreme hollowing-out

to the most dramatic swelling, there is a range of expression that allows for the highest degree of subtlety and variety. There are forms that the sculptor's hand can soothe to sleep and others that he fuels to the point of extreme agitation and excitement. Everything in keeping with the plastic meaning. The human eye sees the forms, but the ear should also hear them – the shrill, sharp ring of pain or the dark, warm minor tones of a maternal gesture. In fortuitous yet rare moments, form and sound are as one, to me… I strive for a form that is all movement and movement that is all form.'[263]

Balden's terracotta *Schwarzer Torso [Black Torso]* of 1968[264] is particularly powerful in its expression. In it he even radicalised Moore's concept of an opened-out torso. A useful comparison may be made with Moore's *Draped Torso* of 1953 (figs. 178, 179)[265] with its arm stumps pointing backwards. While this torso ultimately has connections with the Classical Greek draped figures of eurhythmy,[266] the full vitality of Balden's torso-shell derives from the fissure dividing the bust – a motif that he returned to time and again. In *Schwarzer Torso [Black Torso]*, as elsewhere, the sight of the opened body hits the viewer like a scream.

Balden achieved a similar intensity of dramatic expression in his various versions of *Torso eines Gemarterten [Torso of a Martyr]* (fig. 368).[267] Here the sinewy convulsion of the out-stretched body is powerfully reminiscent of Moore's *Falling Warrior* of 1956–57 (fig. 369). Even although Balden's bozzetti of 1961 and 1972 are no larger than statuettes and what he called his 'form passages' are smoother, nevertheless the figure has a highly convincing innate monumentality and pathos. Similarly, the large-format version of *Torso eines Gemarterten [Torso of a Martyr]*[268] of 1990 is extraordinarily powerful in its expression.

It was in 1971 that Balden, step by step, started working out versions of his *Vogelbaum [Bird Tree]*[269] which was to pre-occupy him until 1983. Rarely did he make a more peaceful sculpture, and there is no mistaking the influence of Moore's internal/external forms.[270] It seems that Balden must have given very careful consideration to the interdependence of space and form that Moore achieved in his internal/external sculptures. In his own *Vogelbaum [Bird Tree]* of 1978,[271] Balden turns this interdependence into a metaphor. The open crown of the tree functions as a casing that the birds can fly in and out of. With its spherical form, it also calls to mind thoughts of the cosmos. In this upper section of the sculpture, Balden may also have had Moore's bronze *Atom Piece* (fig. 69)[272] in mind, which he had seen in London in 1965.[273] As we saw in Chapter I,2, Moore arrived at the morphology of its dominant rounded form and convoluted internal forms through his detailed study of an elephant's skull. In Balden's hands, this level of complexity was reduced to the narrative associations of birds and tree. At the same time, his feeling for Nature led in this work to an unusually harmonious image of existential confidence.

At around the same time that he was exploring ideas in his *Vogelbaum*, Balden was also working on his most innovative political monument, *Karl Liebknecht – Herz und Flamme der Revolution [Karl Liebknecht – Heart and Flame of the Revolution]* (fig. 370)[274] for Potsdam. Here the artist once again took the principles of form he so admired in Nature and deployed them in a symbolic image. Where previously he had focused on the protective role of the crown of a tree, now he turned his attention to organic flames rising and doubling over, as old

metaphors for revolution that he now revitalised and differentiated. He himself referred to the fact that the flames were to signal the continued active presence of the concept of socialist revolution.[275]

As he grew older and more relaxed, Theo Balden found a new use for the principles of form that underpin the natural world. In the 1980s he started on his astonishing late work. Birk Ohnesorge has researched its particular connections to Nature.[276]

Over the years, Balden – as we have seen – familiarised himself with important aspects of Moore's sculptures. These included the mother-and-child theme, biomorphous abstraction, the opened-out torso, motifs of martyrdom and war, internal/external forms and the application of the principles of form found in Nature. In his old age, however, he made very direct reference to Moore's reclining figures. Thus, in his bronze *Kleine Sitzende [Small Seated Figure]* of 1980,[277] be it consciously or subconsciously, he echoed the undulating rhythms of Moore's *Recumbent Figure* of 1938 (figs. 119, 120).[278] While the movements in Balden's figure are more compressed and less abstract, nevertheless there is a similarity in the overall composition of the piece – the arm, the raised knee and the exposed head.[279]

Balden's many different responses to Moore also reflect the fascinating progress of his own work. While he spent his early years creating powerful, swelling yet perfectly balanced sculptural forms, in the works he produced in his old age, the forms flow with an almost lyrical tenderness. And it was in his late work that his innate musicality particularly came to the fore. Perhaps this was what gave him the capacity to remain close to Moore's animated, organic forms – despite all the difficulties he had to contend with.

René Graetz

René Graetz (1908–1974) made a name for himself in the history of art in the GDR as a multi-talented sculptor, painter, draughtsman and ceramicist. Yet he is all but forgotten today. Rightly so? Surely not. Whatever the case, he merits a place of his own in the East German reception of Henry Moore. It is not only that when he was in exile in England in 1939 he had a number of opportunities to visit Moore in his London studio in Parkhill Road,[280] he also – as we shall show here – variously made reference to Moore in some quite remarkable works.

Born in Berlin in 1908, Graetz grew up in Geneva and, at a very early stage, received a socialist education, before going to the Art Academy in Cape Town where he trained as a sculptor. In 1935, still in Cape Town, he demonstrated his sculptural talents in portraits reminiscent of the late work of Jacob Epstein. He was one of the first to voice his opposition to the National Socialist regime in Germany and to speak out against Franco's advance into Spain, distributing flyers (that he had

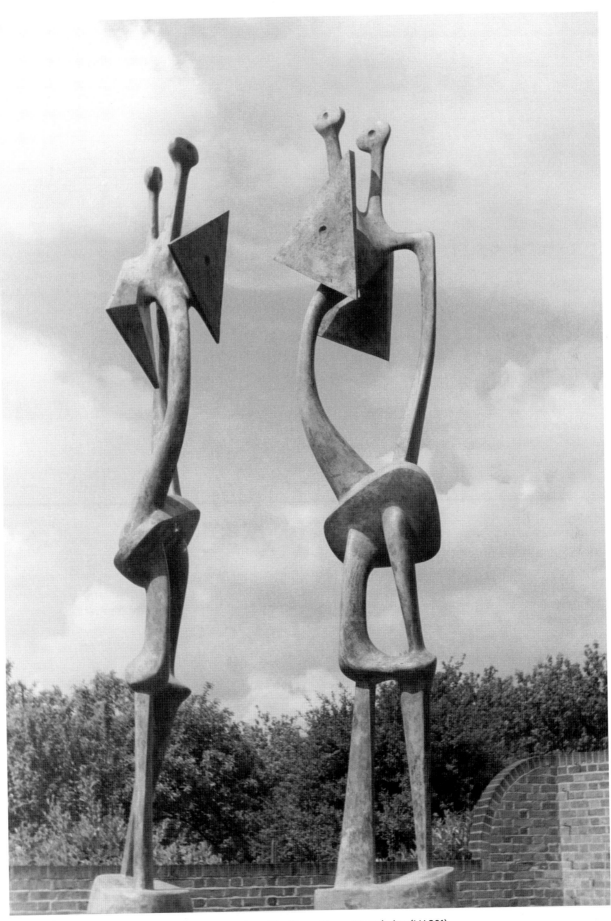

371 *Double Standing Figure*, 1950, Bronze, H. 218 cm, The Henry Moore Foundation (LH 201)

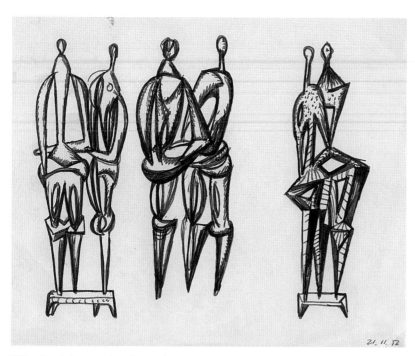

372 René Graetz: *Ideas for Sculpture*, 21.11.1956, Feltip pen on paper,
20.5 x 26.5 cm, Archive Graetz, Berlin-Buch

co-written) on German vessels in the Cape Town harbour and scattering others on the German battleship, the Scharnhorst. He only escaped arrest by fleeing to Paris, from where he travelled on to London in 1939. During the twelve months he spent in an internment camp in Canada, he met Theo Balden. Like Balden, after his release in 1941 and return to London, Graetz became a politically active Communist member of the Artists International Association and the similarly leftist Freier Deutscher Kulturband. In 1946 he and his young wife, the well-known Irish artist Elizabeth Shaw, arrived in Germany and had their first sight of the destruction there. Graetz immediately became a member of the SED.

Andreas Schätzke has written about the situation that awaited the by nature cheerful artist[281] at the hardened ideological frontline in Ulbricht's Germany: 'A unreserved supporter of the nascent socialist state, politically active, certain of the value of art to society, open in his style of discussion, willing to experiment and ready to change, Graetz also had a fundamentally positive attitude to his party's policies in the realm of art.'[282] And indeed there are statements by Graetz that leave no doubt as to his loyalty to the SED.[283]

However, with his cosmopolitan background Graetz must have been something of an enigma to the authorities. In the 1950s and 60s, he was subjected to a ruthless smear campaign, partly because of his tolerant attitude towards the Expressionists and partly because he courageously resisted the blinkered Formalism doctrine and made the case for a concept of form that had more to it than mimesis.[284] On friendly terms with Fritz Cremer and Waldemar Grzimek, he

was nevertheless commissioned by the state to create works such as the memorials in Sachsenhausen and Buchenwald.[285]

During his highly eventful career, the sculptor Graetz – committed neither to Realism nor Abstraction – never had the chance to develop his sculpture uninterrupted. It was only in the last years of his life that he engaged on an intenser artistic level with the work of Henry Moore, who had influenced his sculpture as much as Picasso had influenced his drawings and paintings. The dialogue had started as far back as 1950 with a small bronze of a mother and child,[286] conceived in a manner that has clear echoes of the Northampton Madonna.

In amongst his sketches there are a number of studies of figures, from 1956 and 1969, that clearly relate to Moore's *Double Standing Figure* of 1950 (fig. 371). In this work and in the subsequent *Reclining Figure: Festival* (figs. 123–124a) Moore had broken new ground. In contrast to the previous highly figurative, heavily three-dimensional family groups, in *Double Standing Figure* and the related *Standing Figure* he achieved a new lightness and openness. John Russell has very aptly described these pure figures, with their stepped frames made up of a minimum of vertical lines, as 'fleshless signals of a new idiom'.[287] In each case the two supporting legs set the piece in motion. Subdivided at the knee joints and the pelvis, the legs continue upwards to become the frame of the upper body, before terminating in two feelers.[288] The puzzling appearance of these two figures, only compounded by the prominently separate, triangular shoulder blades, even suggested to Erich Neumann that they might be representations of angels.[289] Whatever the case, with their insubstantial grace, these creations – understandably – were particularly admired by Giacometti.[290]

In the sheet of 1956 illustrated here (fig. 372), Graetz made three studies of different aspects of Moore's *Double Standing Figure* (fig. 371), notably the rising verticals and the plates articulating the composition at knee and pelvis level. In the third sketch, he transferred the triangular shoulder motif into the lower body. Graetz's pairs of figures are turned much more distinctly towards each other in a more lifelike manner, sidestepping the riddle of Moore's spirit beings.[291]

A similar change is seen in the 1960 sheet, when Graetz responded in an even freer series of sketches to Moore's *Standing Figure* (figs. 373, 374). Graetz took the airy figure, subdivided into three sections, and released a different triple time rhythm: in the pelvic area, at shoulder height and in the upwards movement of the bird, he altered the vertical rhythm of Moore's piece, once again turning it into a genre scene, or more precisely, incorporating it into his future *Frau mit Vogel [Woman with Bird]*, that was later installed posthumously in the park at Berlin-Rummelsburg in 1980.[292] What was to turn into a realistic figure in the finished large-format sculpture, was much closer to Moore's original vision in the very considerably freer sketches. It is therefore not surprising that it was

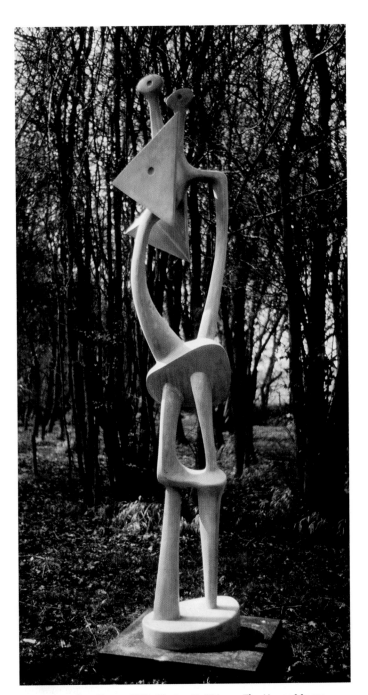

373 *Standing Figure*, 1950, Plaster, H. 221 cm, The Henry Moore Foundation (LH 290)

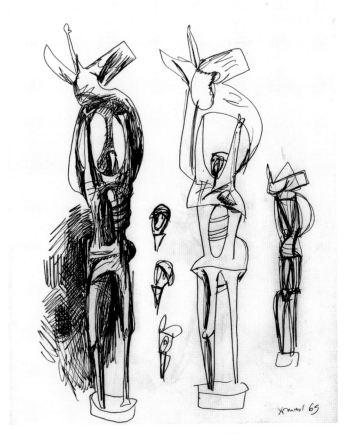

374 René Graetz: *Ideas for Sculpture*, 1969, Feltip pen on paper, 24.5 x 21 cm, Archive Graetz, Berlin-Buch

specifically in his sketches that Graetz engaged on a deeper level with the questions of form raised by Moore's sculptures.

This is very clear in the case of Graetz's abstract sculpture with the English title, *Inborn Power*, of 1970 (fig. 376) and the many richly inventive studies that preceded it.[293] These bear English inscriptions such as 'One Form Entering Another' (fig. 375)[294] and 'Struggling Forms'. In all these cases there is a conflictual relationship involving a star-like shape trying to penetrate a second form, more organic and partially opened. It seems that here Graetz is exploring Moore's internal/external forms as well as his holes and tunnels.

In 1970–71 Graetz produced a series of works, throughout which he immersed himself more deeply than anywhere else in Moore's vocabulary of forms. Graetz called these pieces *Upright Figures*, with even the title indicating their indebtedness to Moore. While the latter chose the name *Upright Motives* for his 1950s columns on the basis of their organic-abstract formal content, now Graetz – in his own abstract series of ten large figures with some smaller variants – underlined their figurative nature, which he maintained in the stepped, measured arrangement of the compartments stacked one above the other. While he was working on this series, he was glad to feel that he was making progress towards 'new form-relations'.[295] If one retraces his steps in detail, it seems that he was discovering the coherence of form-compositions that operate according to their own logic. Graetz gradually worked his way towards this new insight by relating what he was doing to Moore's own singular achievements and by adapting Moore's holes and tunnels, but also by exploring his ongoing torsion and many-sidedness.

Right at the beginning, in *Upright Figure No. 1A* (fig. 377),[296] made in March 1970, there is already a very clear echo of the upper section of Moore's *Upright Motive No. 1: Glenkiln Cross* (fig. 248). In Graetz's hands Moore's motif of a

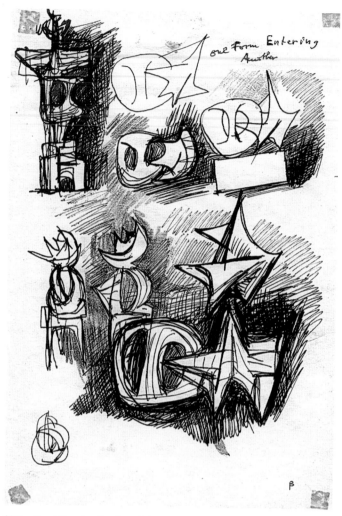

375 René Graetz: *Study to Inborn Power*, Pen and ink on paper, n.D., 21 x 14.5 cm, Archive Graetz, Berlin-Buch

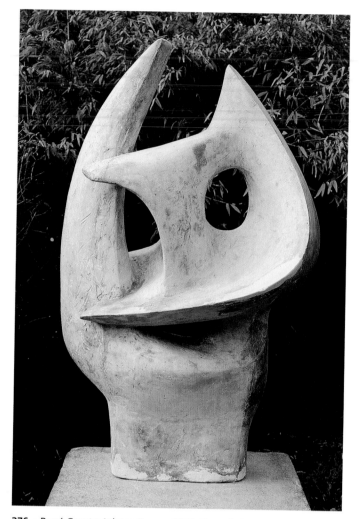

376 René Graetz: *Inborn Power*, 1970, Ceramic, H. 70 cm, Archive Graetz, Berlin-Buch

narrow head above outstretched arms has a greater number of parts and is more loosely attached to a shape behind it.

In the next version, *Upright Figure No. 2*,[297] the head comes forward more freely, although still the dominant impression is of an organoid, polished human torso. Following this, in the next version known to me, *Upright Figure No 4.* (fig. 378), the form becomes clearer all round. This piece calls to mind a three-quarters figure, starting just above the knees. Below the pelvis and in the centre of the body, Graetz made openings in the figure, for the first time; at chest height he added rounded plates that appear to echo the upper section of *Upright Motive No. 8* (fig. 379). Meanwhile, the split head with a crown can only be a homage to the English artist.[298]

The formal confidence that Graetz demonstrates in his series of nine *Upright Figures*, developed in an intense engagement with Moore's forms,[299] was also based on an incisive mental dialogue with his role model. In Graetz's diaries from the period 1970–72 there are various notes, some of which are readily identifiable as notes made from his reading

of texts by Moore. In Graetz's library, which contained numerous books about Moore, there was also a copy of the anthology of texts by Moore himself that was published by Philip James in 1966. The following principles, by which Graetz lived, chime with Moore's own ideas: 'We have to learn to understand forming as forming. It is a language' (1971).[300] Or: 'A work of art conveys a spiritual vitality that is much more moving and goes much deeper than the beauty of harmony and peace' (1972).[301] Also written in 1972, there is an entry that refers directly to Moore: 'Some of Moore's figures have an incomparable nobility, which is what gives his work its humanity. Distortions are not important. Humanity, the human being always dominates. Some of his works are like metamorphoses. A figure as landscape or a landscape as figure, making use of the big, heavy shapes of the mountains, the gentle undulations of the valleys, folds, etc.'[302]

Finally we come to Graetz's innate resistance to the Leninist maxim 'Being determines consciousness', when he writes, in 1972, 'Poetry and dreams – that is what humanises the

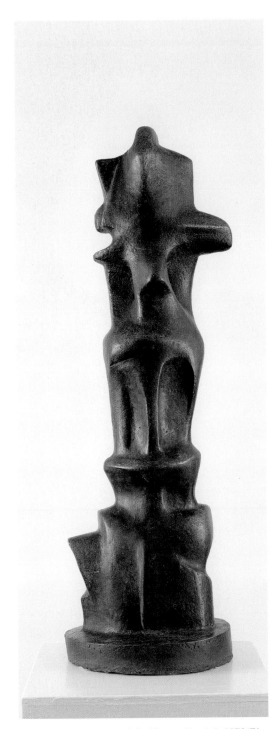

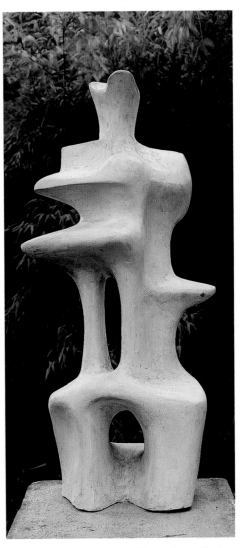

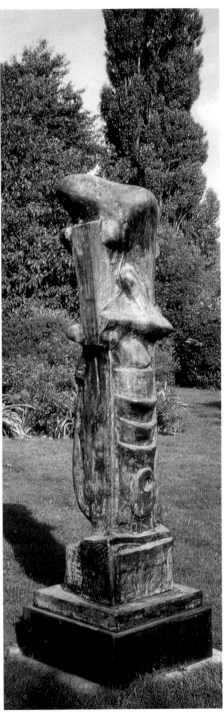

377 René Graetz: *Upright Figure, No. 1 A*, 1970/71, Bronze, H. 72 cm, Archive Graetz, Berlin-Buch

378 René Graetz: *Upright Figure, No. 4*, Plaster, H. 84 cm, Archive Graetz, Berlin-Buch

379 *Upright Motive, No. 8*, 1955–56, Bronze, H. 198 cm, The Henry Moore Foundation (LH 388)

material world. Without art we will all descend into a new kind of barbarism that will wipe us out.'[303]

But in the last months of his life, Graetz was troubled by doubts. Obliged to return to realistic figuration in his latest commission – an accessible but finely conceived full-length portrait of *Rosa Luxemburg*[304] for the municipality of Greater Berlin – on 20 August 1973, as though justifying this recent change of heart, he wrote, 'I would like to avoid suffocating in an aesthetic Formalism that is becoming increasingly sterile. I must make a break with this side of my work and go back to Nature.'[305]

This relapse into the old enemy terminology is shocking. Graetz's escape into abstraction, which – as it were guided by Henry Moore – had produced remarkable results, was over almost as soon as it had got off the ground. As recently as 1970, when the artist was at his creative height and working

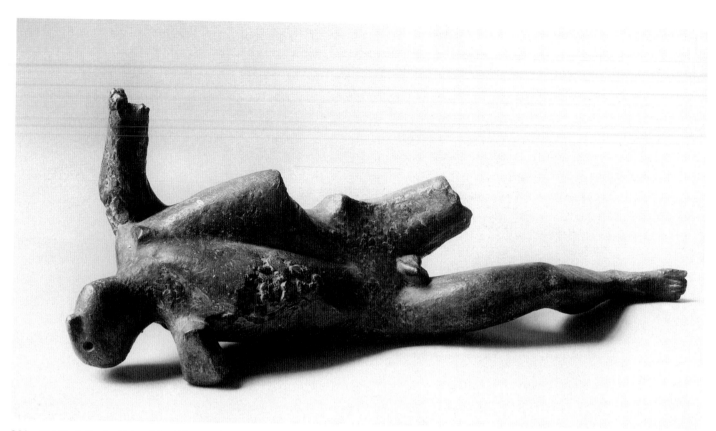

380 Gustav Seitz: *Reclining Man (The War)*, 1960, Bronze, B. 46 cm, Gustav Seitz Stiftung, Hamburg

on his *Upright Figure No. 7*, he had made a very different note to himself: 'Now I feel that I am standing on my own – perhaps for the first time since 1950. There is no turning back. Actually a wonderful feeling! To take distance + feel independent from all these false compulsions which in fact mean so little to artistic production. There are so many duties, meaningless, except… as a means to rule over others.'[306]

Amongst the representatives of the next generation, signs of Moore's influence are much more muted. Unlike the situation that Balden and Graetz had found themselves in – which was to be so crucial to their work – for the younger sculptors born around 1930 and socialised entirely within the system of the GDR, there was no hope of personal contact with Moore. Instead the younger artists had to rely on their teachers' greater or lesser understanding of Moore's work. This was clearly the case for both Werner Stötzer and Wieland Förster.

Werner Stötzer

When the young Werner Stötzer (b. 1931)[307] became a Master's student in the class of Gustav Seitz (1954–58), he was introduced not only to all his teacher's favourite artists – Pablo Picasso, Aristide Maillol, Marino Marini, Henri Laurens, Germaine Richier, Julio Gonzalez – he also encountered the work of Henry Moore.[308] Seitz was a great admirer of Moore's work. On 20 December 1959 Seitz wrote to Karl Albiker about

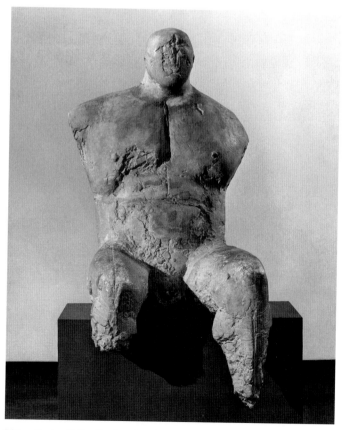

381 Gustav Seitz: *Beaten Catcher*, 1966, Bronze, H. 198 cm, Kunsthalle Mannheim

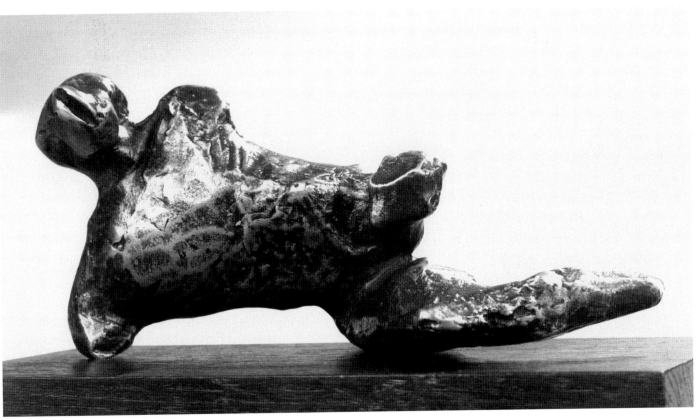

382 *Reclining Warrior*, 1953, Bronze, L. 19.5 cm, Art Gallery of Ontario, Toronto (LH 358 b)

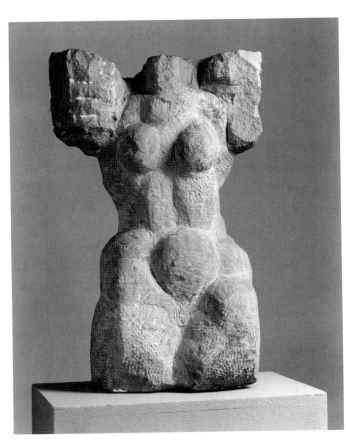

383 Werner Stötzer: *Torso*, 1974, Limestone, H. 56 cm, Convent Unser lieben Frauen, Magdeburg

the latter's as yet unpublished text *Das Problem des Raumes in den bildenden Künsten*,[309] saying that he felt that Albiker's 'concept of the space-creating task of sculpture was very definitely also shared'[310] by Marino Marini and Henry Moore. It is clear that Seitz was already well aware of Moore's concept of space and that he was also familiar with the variations on the torso that Moore had been producing in the 1950s. Both his *Liegender Mann (Der Krieg) [Reclining Man (The War)]* of 1960 (fig. 380)[311] and one of his most important works *Geschlagener Catcher [Defeated Catcher]* of 1963–66 (fig. 381),[312] would not have been thinkable without Moore, or more precisely, his *Warrior with Shield* (figs. 171–173) of 1953–54.[313] As it happens, Seitz's *Liegender Mann (Der Krieg)* has striking similarities with Moore's original reclining version of his warrior (fig. 382). In 1960 Moore visited Seitz and his students at the Hochschule für Bildende Künste in Hamburg, and on 15 June 1960 Seitz wrote to the Director of the Mannheim Kunsthalle: 'It was splendid! And plenty to tell about it.'[314] Although Seitz's interest in Moore is only documented for the time he was in Hamburg, there is little doubt that he will also have discussed Moore's work in detail before that with his students in Berlin.

Stötzer's comments on Moore, which as far as they go were only published after the Berlin Wall came down, tend in two different directions. In response to a question from Karin Thomas, for instance, when she asked whether he had taken

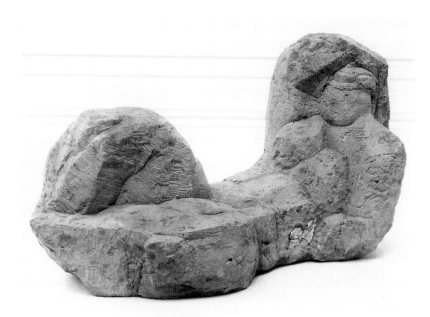

384 Werner Stötzer: *Reclining Werra*, 1981, Limestone, 62 x 34 x 29 cm, Kunstmuseum Dieselkraftwerk Cottbus

any interest in Western abstract art in the 1950s and early 60s, Stötzer replied, 'Yes, of course, above all Henry Moore and his free forms, and Max Bill. Since I was a Master's student with Gustav Seitz in Berlin, I had access to all the news. What was still banned in Dresden, was available to us in Berlin in the sense that we could make photographs from books in the American Library. I used to take those photos with me to my friends in Dresden.'[315] In all likelihood Stötzer had Moore's abstract works in stone and wood in mind in his reference to 'free forms'.

On another occasion, in a text written in 1984,[316] Stötzer talked of the perfect mastery of the stonemason's craft that he had seen particularly in the work of Wotruba, but also in that of Brancusi, Arp, Zadkine and Moore. No doubt – as a born sculptor himself – he especially admired Moore the *tailleur*, which is also how Moore saw himself.

Stötzer's response to Moore's work was not so much a matter of motivic or stylistic borrowing as an appreciation – sculptor to sculptor – of his craft skills and artistic approach. As exponents of *taille directe*, both sought a close rapport with the block, endeavouring at all times to preserve the elemental character of the stone and to realise the artistic concept in a process of creative interaction with the material.

Unlike Moore, Stötzer has provided some detailed accounts of his working methods and his experience of handling stone. In an article published in *Bildende Kunst* in 1975 he wrote: 'Guided solely by the flow of ideas, I start by carving out the first shapes with a chisel, not improvising, but constantly keeping control of the idea. Shapes created in this way are then pared away to allow others to emerge. Stored experi-

ences of forms are realised in bodies and spaces. The effort expended during the work is rewarded by the constantly changing state of the stone. But this "effort" has nothing to do with physical exertion. It is required to maintain the constant concentration with which I have to observe the stone, and it requires a considerable effort to persistently review ideas and their application. By now there are some hours and days when I almost feel a sense of companionship with the stone, little by little you get to know each other; I tell it of my fears and hopes. And after some months, we know each other well, and a new reality has come into being.'[317]

Here Stötzer describes the making of a work in terms of reaching maturity, as a giving and taking. The stone is personalised and becomes the addressee of the artist's own physical actions. In light of this process of mutual, increasing transformation and animation, in 1972 Stötzer wrote in a poem, 'Stone leads us to the essence.'[318] Moore would have been in full agreement with a statement of this kind. More than that: Moore's own stone carvings often attained a level of intensity where the essence of the expression comes close to the hieratic and supra-individual. Stötzer, for his part, remained firmly rooted in the Here and Now and, as such, always in touch with his fragmented, burgeoning, life-filled layering of shapes and forms. As Fritz Jacobi observed, it was to the credit of Stötzer that 'in a certain sense… stone was rediscovered by sculptors in the GDR… Stötzer articulates the body, creates contrasts within the sequence of sculptural forms and generates the greatest possible tension between agglomeration and elongation. It is as though we are seeing body-landscapes: disjointedly rustic, tautly layered, cheek-by-jowl or rhythmically dispersed. The total plastic effect of each configuration becomes the decisive criterion.'[319]

Not so Moore. He was less interested in configurations and visual combinations[320] than in allowing the stone or wood to fully come into its own in the forms and spaces of the organic whole.[321] And in this process Moore was specifically interested in the creation of negative spaces – which was not one of Stötzer's artistic aims.

While Moore worked towards the totality of a piece, Stötzer developed a heightened awareness of the possibilities of the torso. What he achieved in this area is amongst the finest work by German sculptors in the last third of the twentieth century. His rudimentary, condensed anatomies, for instance his *Torso* of 1974 (fig. 383) and his *Liegende Werra [Reclining Werra]* of 1981 (fig. 384), thrive on the audacity of their roughly hewn planes and the abrupt transition from sensually swelling to tectonically exaggerated forms. Stötzer used the stone to give visual form to ideas that mainly came to him from the sight of the female body, the vocabulary of forms of certain landscapes[322] and the sounds of certain words. 'Ultimately a stone that has been treated with sensitivity should be like a poem.'[323]

385, 386 Wieland Förster: *Friendly Nations*, 1961–62, Bronze, H. 230 cm and 185 cm, hall of residence for students, Technische Universität, Dresden

Thus it is clear that Stötzer's appreciation of Moore's mastery of *taille directe* was deeply rooted in his own artistic makeup. Everything he created retained a sense of eruptive motion. He specifically wanted to 'break the stone open in such a way that it constantly develops new strength'.[324]

Wieland Förster

Wieland Förster's (b. 1930) response to Henry Moore has in effect taken him in two directions. On one hand, in his early work there are isolated incidences of concrete sculptural and motivic borrowings and affinities. On the other hand – particularly in his late period – the author Wieland Förster writes quite remarkably of circumstances that indicate important similarities of outlook.

As we have already seen,[325] it was Bernhard Heiliger, who made it possible for the twenty-four year old – one of a group of students from Dresden visiting Heiliger in his studio in West Berlin – to see the Moore exhibition in Schloss Charlottenburg in somewhat unorthodox circumstances. The exhibition made

a deep impression on him, and he was particularly gripped by the monumental works he saw there.[326] Förster left the Art Academy in Dresden in spring 1958 and transferred to Berlin. On the recommendation of his teacher Hans Steger, he enrolled in the class of Fritz Cremer; Gustav Seitz could not take him because he was already preparing to move to Hamburg. However, it soon became clear to Förster that he was not comfortable with Cremer's dogmatic approach to art, with the result that his time as one of Cremer's Master's students was relatively short.

It was during this phase in his development that he first actively engaged with Moore's work. The outcome can be seen in a pair of bronzes of 1961–62, with the official title *Völkerfreundschaft [Friendly Nations]* (figs. 385, 386), although the artist privately called it *Freundschaft unter Studenten [Friendship between Students]*. This pair was made in response to an open competition for a sculpture to be placed outside a hall of residence for students at the Technische Universität, Dresden (this piece is now located at the TU student residence not far from the main railway station). The competi-

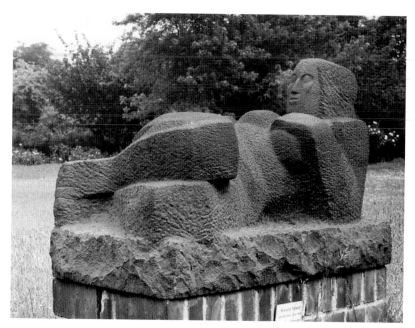

387 Wieland Förster: *Reclining Woman*, 1965–67, Diabas, H. 74 cm, L. 114 cm, Staatliche Galerie Moritzburg (Sculpture Garden Halle/Leuna)

tion remit issued by the authorities described the usual cliché: three students on a high plinth – one African, one Chinese, one German – hand in hand, bearing aloft a flag as a symbol of the worldwide socialist revolution. With a certain amount of professorial support and dicing with the danger of being officially disbarred from working as an artist, Förster managed to give the ideological theme a much more personal air. Taking his inspiration from a small photograph in a students' newspaper produced in Krakow, showing students walking and sitting on the steps of the old university, he decided to create the two female figures we now see on a five-metre long plinth. In the plans this also originally included a fountain. Low enough to sit on, the sculpture was designed as an invitation to passers-by to linger for a while, reading, having a snack or just sitting in the sun in the company of the figures. It is as though the two women are engaged in conversation. The younger (with the features of Förster's wife Angelika) sits in a beautifully generous pose with her knees drawn slightly up to her body, listening to her companion. Meanwhile the older woman, who has an open book on her lap, seems – by the controlled gesture of her left hand – to be giving an account of the book's contents. Both women have adopted strikingly upright poses.

As we know from Claude Keisch, Förster's intention in this piece was 'to create the greatest possible distance between two plastic elements in such a way that the whole area of the sculpture was filled with tension. This idea arose in conversation with Bernhard Heiliger…[327] The final plastic solution calls to mind the work of Henry Moore – pieces such as his seated figures from the 1950s, whose poses and proportions (the small heads ensuring that the bodies dominate the composi-

tion, the thin arms) are seen here in Förster's work. There are also echoes of Moore's draped figures.'[328]

Looking back later in conversation, Förster accepted the comparison with Moore's majestic draped figures, which also left their mark on Cremer's *O Germany, pale mother* (fig. 365) made at much the same time.[329] And it is interesting to note that the strikingly sensitive hands of the older woman are clearly related to those of the figures in Moore's *King and Queen*.

With reference to the highly charged space between the figures, in conversation Förster paid tribute to Moore's progressive handling of space: 'His holes, his perforations through the block, creating a depth that matches the spiritual aspect of the work, was a great discovery in the history of modern sculpture. Moore made us aware that the space in-between forms is also space.'[330]

Another, essentially formal connection between Förster's work and that of Henry Moore is evident in the stone sculptures he was making between 1965 and 1967, when he made two reclining figures that recognisably derive their forms from the layered strata of the cuboid block. In this, and in the markedly curled up legs at one edge of the block, Förster's *Große Liegende [Reclining Woman]* (fig. 387) recalls one of

388 Wieland Förster: *Hero*, 1966, Plaster for Bronze (cast 1974), H. 71 cm (Photography after the plaster)

the main features of Moore's early *Reclining Figure* in Leeds, made in 1929 (fig. 2). Förster integrated this feature into a bodily scheme that is itself influenced by analytical Cubism.

The radical determination with which he retained the characteristics of the cube was in part a result of the nature of the diabas stone which is so hard as to preclude certain shapes and to require an overall planarity. In addition to this, there was also Förster's new understanding of the need to create forms that obey recognisable laws. This had arisen by chance in 1960 when he 'discovered' ovoid forms.[331] From that point onwards, it was his aim 'to provoke sculptural forces, to really learn to feel and develop egg-like forms.'[332]

'The egg is the most vigorous, basic sculptural form. Unlike the sphere, whose core rests within a perfect, but tension-free external form, the egg draws its enormous dynamic potential from the asymmetric position of its energy centre/core in relation to the outer form whose dimensions are constantly changing. Asymmetry and innate tensions are elements of growth and change, they are synonyms for life.'[333]

With its unequal poles, its adaptability to different scales and its amenability to rhythmic compression or elongation, the egg-form served Förster as a vehicle to convey weight and buoyancy, sinking and rising, indeed as the essential basis of his forms. His bronze *Hero* of 1966 (fig. 388) perfectly exemplifies the way that the egg functions as a basic form 'that draws its energy from its own dynamic centre, from within its core'.[334] Förster thus created for himself a framework within which he has been able to construct his own, uniquely concentrated language of forms. It gives his male figures the stability needed to sustain their expressive, almost excessive weight, and it gives his overtly erotic female figures an added layer of expressive consolidation. Precisely this is seen to advantage in his torso *Große Daphne I [Large Daphne I]* of 1992 (fig. 389).[335]

This all-round figure rises upwards in a visibly evolving sequence of forms in which one part seems to grow into the next. The real theme of the work, bound up in the myth of Daphne, is in the creative growth that ensues from this movement. In 2004 Förster once again summed up his thoughts on this form: 'The choice to work with ovoid forms is of course a pledge of allegiance to the primal seed, to vitality, to burgeoning growth, to the force that breaks through everything.'[336] Thus Förster created his realistic figures in compliance with formal parameters that he also deliberately sought to handle as though they were part of the natural world.[337] In so doing he was taking his lead from a systematic aesthetic rooted in Nature, as Brancusi, Arp and Moore had also done in their own work, to the enduring benefit of twentieth-century sculpture.

With this we have already touched on the second area of Moore's work that appealed to Förster, that is to say, his broad range of references to the natural world. Förster's own

389 Wieland Förster: *Large Daphne I*, 1996, Bronze, H. 180 cm, Wieland-Förster-Stiftung, Dresden

390 Wieland Förster: *The Guardians of the Source* (*Die Quellwächter*), Pencil, 43.2 x 62 cm, Convent Unser Lieben Frauen, Magdeburg

crucial realisation of the connections between the body and the landscape came to him on a journey to Tunisia in 1967. The occasion was the presentation of an exhibition of prints and drawings from Berlin in the Maison de culture in Tunis that he had selected at the request of the Ministry for Culture in the GDR. It was during this time in Tunisia – his first major trip abroad – that he wrote a travel journal and made a number of coloured works on paper. These later became the basis of his *Tunisia Cycle*, consisting of almost forty full-sized drawings.

Whenever there is talk of Förster's artistic merit, the conversation rightly always turns to these unusual drawings and travel journal. This was the first time that his double talent properly came to light. Sure of his intentions yet circumspect in their execution, the delicate, often cloudy lines of his drawings fill in vast tracts of the landscape or penetrate deep into the structures of rocks and trees, while the sensual, compelling language of his journal explores the many sides of this new world. And he attaches special importance to his first sight of the rock arch spanning the gorge of the River Seldja. 'To be like the rock, that was the mission I was given on my

thirty-seventh birthday, on a relentlessly rainy day in the Seldja gorge. It was a place, or so it seemed to me at least, that no-one had set foot in since the day the world was created… and the sight of the primal forces and might of Nature filled my inner being like an empty vessel.'[338]

This intense recollection should be read in conjunction with a passage from his first journal, published in 1974, which shows how these encounters with Nature were coloured by a subliminal consciousness of death. As he makes his way through the Steppes to the rock arch, he writes: 'I am running. There is no fear in me, just emptiness. I am out in the open, in oblivion, I am a dot in the yellow. Losing distances… – who should be afraid here? You detach yourself, and there is more emptiness in you… The cliff face seems close enough to touch, throwing itself up into the air. A deep wound cuts through the rock… All power dies here, it is not opposed, not vanquished, it expires. I am drawing the cliff, its faces, bones, its holes, its bulges… I can't get away from these rock formations.'[339]

The brooding appearance of the rock arch seemed to suggest faces to the highly sensitive artist, which – as in *Die Quell-*

391 Wieland Förster: *Felled Olive Trees I (Gefällte Ölbäume I)*, 1970, Pencil, 43.5 x 61.5 cm, Archive Förster, Berlin

*wächte*r *[The Guardians of the Source]* (fig. 390) – call to mind death's-heads or skulls, in keeping with Förster's own sensation of emptiness. In a similar vein, his studies of burnt olive trees are less about organic structures than about his terror at the thought of his own living body being somehow deformed, for they remind him of the traumas he suffered as an adolescent: 'Terrifying sketches and drawings of uprooted olive groves, strewn with the charred carcases of olive trees that were all but indistinguishable from the corpses left by the air raids on Dresden, the burnt women and children: I stood trembling as I looked through a time-window into my childhood, a window that I had thought long closed. After just a few drawings I forbade myself to continue with this theme solely because the burnt bodies of the olive trees had such disturbing formal similarities with Henry Moore's large reclining figures [cf. *Reclining Figure* outside the UNESCO building in Paris, fig. 1] (*Gefällte Ölbäume I [Felled Olive Trees I]* 1970, pencil).'[340]

Although Förster felt that this outstanding drawing (fig. 391) was too obviously reminiscent of the work of Henry Moore, precisely that connection is of interest here. For in the lower, horizontal motif, Förster achieved a much more independent figuration than he himself perhaps realised. To me it seems less reminiscent of Moore's sculptures than of the drawings of imagined recumbent figures he made in the 1940s in connection with his *Shelter Drawings* – although it is true to say that Förster's lineature is more delicate and restrained. Firmly drawn, fine contours alternate with broad bands of shadow that mark out the shoulders and the knees. In a sequence of undulating layers he built up his *Ölbaum-Liegende [Olive Tree Reclining Figure]*, even to the extent of the loop-shaped head that is so typical of Moore's sculptures. The same meticulousness is also evident in the upper right of the drawing in the shaping of a hole cutting through another tree fragment.

The similarity of the work of these two artists derives solely from their honest application of their observations of Nature, with both of them having an acute feel for formal processes and an eye for analogies. Yet there is also one major difference. For in Förster's case, everything he saw was filtered

by his constant awareness of his own personal experience of death and illness.'[341] This can be seen in his bronze *Olivenstruktur [Olive Structure]*, made in 1967– 68. In this piece it is fascinating and shocking to see how the chapped body of the tree references a human body – old, injured, wounded, burnt. Förster never experienced the calm and serene objectivity that emanates from Moore's studies of natural phenomena and his analyses of vertebrae in his *Transformation Drawings*.

Conclusion

This first attempt to present an overview of the reception of Moore's work in West and East Germany could not claim to be exhaustive. In the West there are of course other artists whose work would merit closer consideration in this context – artists such as Michael Croissant,[342] Ernst Hermanns,[343] Hans Steinbrenner,[344] Otto Herbert Hajek[345] and Günter Ferdinand Ris.[346] And the same can be said of the East too, where there are yet more whose work ought to be taken into account – artists such as Friedrich B. Henkel,[347] Jo Jastram,[348] Peter Kern,[349] and Wolfgang Kuhle,[350] to name but a few. Yet this section should not become a book within a book. And for this reason we shall also leave aside the particular reception of Moore's work in Switzerland and Austria. Yet it is worth noting that when he was in Vienna, in spring 1971, Moore did visit Alfred Hrdlicka in his studio.[351]

Bearing in mind the present debate on the contrasts and the connections in the German art scene during the forty years of its enforced political separation, one might say that even if the prevailing conditions meant that the West was drawn towards abstraction and art from the East was more obviously figurative, there were also strong sculptural figures in the West indebted to Moore and examples of abstraction in the East inspired by his work. However, we shall conclude here with two examples demonstrating the fact that, as a rule, in the West Moore's biomorphous abstract side was most admired, while in the East it was his more representational figures, and most specifically his anti-war sculptures, that found favour.

I shall start with the example from the East: in 1965 Werner Tübke (1927–2005) created the third version of his painting *Lebenserinnerungen des Dr. jur. Schulze, III [Dr Schulze LLB Looks Back on His Life, III]* (fig. 392).[352] In the eyes of the critic Günter Meißner, this painting 'with its synchronistic amalgamation of the real and the fantastic, constitutes a fundamentally new compositional type in the artist's output.'[353] One of the leading artists of his generation (alongside Bernhard Heisig [b. 1925] and Wolfgang Mattheuer [1927–2004]), Tübke made numerous studies of Anti-Fascist subjects in the period 1964–67, and completed five paintings on the subject. The third version is the largest and most intense in terms of both form and content. In total this cycle consists of eleven paintings, sixty-five drawings and fifteen watercolours.

The painting is dominated by the puppet-like main figure of Dr Schulze, a grotesquely deformed image of a corrupt National Socialist judge. Clothed in flowing legal robes, the dehumanised figure sits enthroned against a busy backdrop with a Fascist-style tower in the midst of the multiple layers of his own memories. The left half of the painting shows the terrible consequences of his judgements: concentration camp, torture and death. In the right half the viewer sees images of protagonist's sheltered, respectable childhood (boy in a sailor suit on a flowered carpet) and his seduction as an adolescent (Fascism and sex for money). On his own admission, Tübke's monstrous puppet and its past deeds was attacking neo-Fascist tendencies in the Federal Republic. At the same time he was also partly moved to create this painting by the Auschwitz trials. In 1966 Tübke made specific reference to this highly politicised painting: 'Complete neutralisation seemed essential to me, an "it" in the expression; harsh stringency to prevent any sympathy arising for Dr Schulze LLB… On principle I like to paint through, following a single formula, from the lower left to the upper right. The colour is not very harmonious. And it is a painting "against my better judgement". Instead of a harmonious complex there is a shrill trumpet yellow, to prevent the viewer's eye coming to rest, so that it is not lulled into an aesthetic calm, so that the colours remain hard. The whole thing is shrill, painted "against the grain". I felt that was necessary; it seemed right to me with this subject matter.'[354]

Bereft of all humanity, like an empty shell, this oversized bogeyman with his horribly grinning cardboard head is held in place by six ropes. Like guidelines they point to the consequences of his deeds.[355]

Of particular interest here is the scene at the top of the flight of open steps, where there are four motifs: firstly there is a memorial stele with a hero's wreath propped against it. On the stele is a relief image, apparently beaming with pleasure. In fact it is a double image of a dove of peace and a girl's face – a quotation from Picasso.[356] Next to this subtle reminder of Picasso, much greater prominence is given to a second quotation, this time citing Moore's *Warrior with Shield* (figs. 171–173),[357] which Tübke could perhaps have seen with his own eyes in 1954.[358] Between these two objects there is a set table, although no-one dare touch the delicacies on it – a detail that has hitherto been overlooked. Finally, as the last of the four motifs we see a sleeping man under the table. Dressed in gold-brown, red and ultramarine, the colours of his trousers, waistcoat and overcoat strike a sonorous, formal note. Is this really, as has often been suggested,[359] the stigmatisation of an Imperialist? Not only the colours, but also the man's half hidden face, with a faintly foreign-looking beard and lips seem not to support this view. Whatever the case, the exhausted sleeping figure and the mutilated warrior are cut off from life and all of life's pleasures.

392 Werner Tübke: *Dr Schulze LLB Looks Back on His Life, III*, 1965, Tempera, canvas and wood, 188 x 121 cm, Staatliche Museen zu Berlin, Nationalgalerie, Berlin

393 Mac Zimmermann: *Perforated Figures*, 1946, Pen and ink, 29.5 x 21 cm, Private Collection R. Z., Hart

to the Lord: 'Thou preparest a table before me in the presence of mine enemies: thou anointest my head with oil; my cup runneth over.'[361] This hope of peace is underlined as much by the sleeper, perhaps dreaming of a proper life, as by the warrior, who goes into battle in the cause of peace. And the Picasso quote from his time in Vallauris is also associated with thoughts of peace. Thus the carefully laid table could be understood as an offering indicative of the humanity that both Picasso and Moore were striving for. As early as 1956, the much-criticised editor of *Bildende Kunst*, Herbert Sandberg, identified Moore as one of the artists in the English art world who 'were close to the peace movement'.[362] Tübke's Moore quotation can be read in very much the same way in the context of this anti-Fascist masterpiece.

While Werner Tübke, working in the East, cited Moore's existential image of a warrior and added his own political charge, in the West the graphic artist, painter and set designer Mac Zimmermann went straight for a free paraphrase. Between 1946 and 1953 he engaged on a more fantastical level with certain aspects of Moore's artistic interests. Thus in his early pen and ink drawing, entitled *Durchlöcherte Figuren [Perforated Figures]* (fig. 393)[363] of 1946, we see the holes familiar from Moore's human forms turned into a game of drawn equivalents: the hole piercing the body of the figure on the left is set to the accompanying rhythm of similarly formed voids. In his well-known sketchbook of 1947–49,[364] there are yet more perforated figures where the element of abstraction is taken to an even higher level.

In 1955 a facsimile of this sketchbook was published by Piper in a popular paperback series. In his Afterword, Bernhard Degenhart aptly called it a Surrealist reader.[365] Having been prevented from pursuing his artistic career by the war, now Zimmermann became known to a wider public overnight. As we leaf through this sequence of Zimmermann's favourite themes, we come across the alter ego of the working artist – alone or in the company of his Muse – we find Ovidian myth (Deukalion),[366] Roman history (Virgil and Octavia), people walking, cycling and dancing, strange couples in the landscape. Zimmermann's pen is always light and the lineature translucent. He liked to situate his elongated figures in a rarefied, romantic atmosphere that gives a singular, dreamlike expansiveness to his landscapes that, for their part, draw as much on his memories of his native Stettin as on the paintings of Caspar David Friedrich.

There is also an unreal air in the sculptor's studio, depicted in the same *sketchbook* (fig. 394). Zimmermann made two works (the second of which is illustrated here) on this theme in 1948 in Achern.[367] According to Degenhart, the drawing shows Zimmermann's friend Georg Brenninger at work. As Herbert Hahn's youngest student, Brenninger was on the staff at the Technische Universität in Munich, where he passed on to his own students a form of figurative sculpture that pre-

With a remarkable sure touch, in his quotation of Moore's *Warrior with Shield* Tübke rightly focuses on the dominant defensive gesture. In our earlier examination of this work, we saw it as a representation of the warrior's readiness to take action and offer resistance. The other side of the figure – the suffering induced by its mutilation – is given less prominence by virtue of the strong sidelight.

The sleeping figure has sought refuge at the feet of this symbol of warlike resistance, presumably a freedom fighter. And here he has found peace. For both of these figures the set table is out of reach. The sleeping man looks almost like a prophet from the Old Testament. Is this the 'eternal Jew'? Or is it a reference to the words of Psalm 23, which would have come easily to Tübke with his wide knowledge and frequent use of religious imagery.[360] The speaker in Psalm 23 is praying

served the legacy of Hildebrand's Munich School. Against this thoroughly traditional backdrop, the two sculptures on the floor of Brenninger's studio are more than alien. They are clearly indebted to the work of Henry Moore. On the left, casting deep shadows, we see a free response to Moore's studies of bones and, on the right, a piece referencing his string figures from the 1930s. However these two sculptures come to be in this studio – as indications of a fellow-artist's forays into abstract sculpture or purely to add an avant-garde perspective – one cannot help but be struck by the depiction of deep shadows in the objects which implies an understanding of their highly spatial nature.

In 1953, in his painting *Nachdenkender vor einem Moore-Denkmal [Figure Contemplating a Moore Memorial]* (fig. 395), Zimmermann created a more concentrated version of the motifs in his earlier drawings and brought them together in a surreal setting.[368] The standing, contemplative figure in the centre of the composition is joined by two other thinking artists: in the right foreground there is a figure, seen from behind, holding up and apparently examining an airy, geometric wire sculpture. On the steps of the exaggeratedly opened-out plinth there is a second figure, brooding over a drawing of a geometric configuration under his feet. Up above him is the Moore memorial, which is clearly intended to call to mind Moore the artist and consists of a rudimentary figure, with wires spanned across its centre, that bears a distinct resemblance to Moore's Hornton stone *Reclining Figure* of 1949. It is possible that Zimmermann might have seen an illustration of Moore's 1945 maquette for this piece (fig. 396) in the abovementioned review in *Neues Deutschland*. In the sense that Zimmermann opened the figure out even further, entirely removing the centre and spanning it with a linear, geometric star, it almost looks as though – like the contemplative protagonist in the painting – he may have anticipated the multi-part reclining figures that Moore was yet to make. Or he may simply have wanted to explore other aspects of the hole, as in the unreal plinth. Whatever the case, it seems that Zimmermann was as fascinated with the holes in Moore's sculptures as his Berlin colleagues Hartung, Heiliger, Hajek, Balden and Graetz. And it is true to say that this aspect of Moore's work was the topic of much heated debate at the time in many artists' studios. By negotiating the topic in his quiet way, Zimmermann made it his own and incorporated it into his metaphysical pictorial world all the more memorably. Hartung and Hajek also connected the hole with their own metaphysical interests.

Reviewing the reception of the work of Henry Moore in West and East Germany it is clear that artists were often drawn for very different reasons to the same works and aesthetic precepts. The works that aroused the greatest interest include the *Reclining Figure* in Leeds, *Composition* of 1931, the early reclining figures carved from wood, the *Recumbent*

394 Mac Zimmermann: *Sketchbook 1948*, Pen and ink, 18.5 x 12 cm, whereabouts unknown

Figure in the Tate Gallery, the *Northampton Madonna*, reclining and seated, draped figures of 1952 and later, warriors, *Upright Motives* and the multi-part reclining figures.

In terms of art theory, it was Moore's handling of space – giving it the same status as solid forms – that won him the greatest respect, as did his metamorphoses of organic forms drawn from the natural world and the correspondences he established between sculptural forms and the landscape.

On the whole, therefore, there is no doubt that the reception of Moore's work in Germany has a variety and intensity that is not matched in any other country. Why should this be? For a start, it is worth noting that after 1945, above all in Germany, there was an intense need for artistic renewal and a

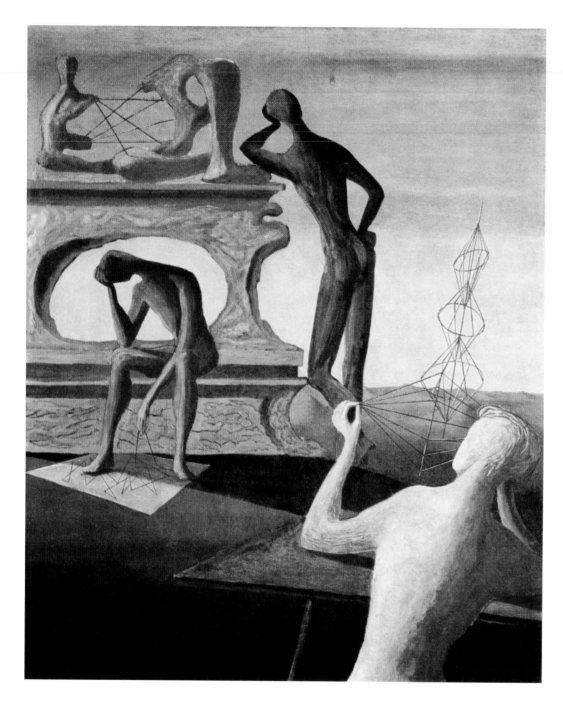

395 Mac Zimmermann: *Figure Contemplating a Moore Memorial*, 1953, Oil on canvas, 39 x 49 cm, Private Collection

desire, in sculpture too, to reconnect with Modernism. Arp, Brancusi, Giacometti, and later on the sculptor Picasso were all highly respected. In addition to this, there were certain German artists – already sensitised by the inner dimensions of Lehmbruck's work – who felt the real growth force and positivity that emanated from Moore's carefully calibrated world of harmoniously rhythmic forms.

However, I think one ought also to ask if there is not in fact a specific, German mindset that is fundamentally receptive to Moore's work? In Part II we saw that Moore's all-embracing interest in Nature was anchored in a notion of the organic that was present both in the thinking of the English Romantics and German Idealism (Coleridge/Schelling/Goethe). From

the seeds sown by the German philosophy of Idealism, which had itself been crucially shaped by the eighteenth-century writer Shaftesbury, a concept of organic form came into its own that was to oust old notions of mimesis and that was, 'like Nature', to develop from its own inherent living processes. To the extent that his forms followed the principles of organic growth that were also intrinsic to his striving for humanity, Moore raised the notion of the organic – which had long been a topic in German art[369] – to new heights of sculptural expression. Thus any artist in Germany who had in any sense internalised the history of aesthetics in his native land could not have failed to have discovered points of interest in Moore's work.

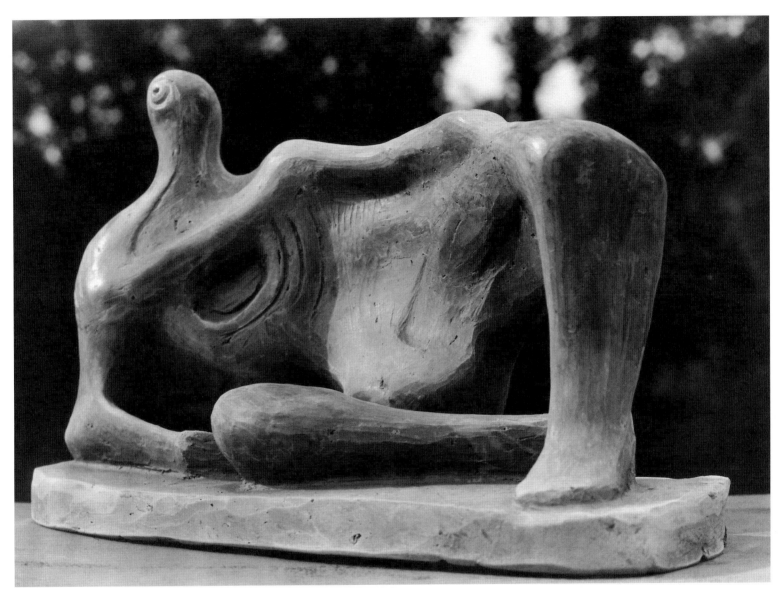

396 *Reclining Figure*, 1949, Hornton stone, L. 76 cm, Private Collection (LH 273)

Henry Moore in England

By demonstrating the communicative power of three-dimensional forms, Henry Moore fundamentally raised the status of sculpture in England. His fame grew steadily at home and abroad from the mid-to-late 1940s onwards.[370] Soon his work was in evidence all over England – in town squares, in museums, galleries, collections, in the papers and in the minds of art connoisseurs.[371] In London alone, there are thirteen works in public places from the period 1928–83. In addition to this there are works in the collections of the Contemporary Art Society, the British Council, the British Museum and the Tate Gallery, which received a major donation in 1967.[372] But the most remarkable collection of works by Henry Moore – the largest in the world, consisting of sculptures, drawings, prints, carpets and textiles – is held at the Henry Moore Foundation in Much Hadham.[373] Both the Foundation and the highly

effective Henry Moore Institute in Leeds[374] seek to fulfil Moore's underlying artistic aim, promoting the cause of sculpture the world over by presenting exhibitions, maintaining extensive archives,[375] producing publications and facilitating research. Over the years, major exhibitions – tirelessly supported by the staff at Much Hadham – catalogues, books, newspaper articles, conferences and numerous films have continued to communicate Moore's artistic aims. In a programme broadcast by the BBC to mark Moore's seventieth birthday, his former assistant Bernard Meadows suggested that Moore's influence in England was less about style and more about 'making it easier for artists to work and be accepted.'[376] Many of the most important artists of the younger generation, such Roland Piché, Bernard Meadows, Anthony Caro, Eduardo Paolozzi, Michael Ayrton, Phillip King and William Tucker, were only too glad to express their gratitude to Moore.[377] In 1985 Elisabeth Frink put forward the

view of many of her fellow-artists when she wrote, '...he has been a great help to young artists and indeed to myself while I was at the Chelsea School. He has been a great land-mark in sculpture in the world. In England he has helped to put sculpture on the map as far as the public is concerned, and for that we should all be very grateful'.[378]

At the same time, it was only normal that some younger artists would seek dialogue with Moore only to reject his views later on and pursue their own ends.[379] And so it was that, in the early 1950s, the 'angry generation of sculptors'[380] – Armitage, Butler, Chadwick, Meadows and others – took a determinedly different direction with their new materials, their broadly figurative interest in the fantastic and lack of interest in 'truth to material' or in *taille directe*.

And there was an even sharper break after 1960, involving Caro and his school (Tim Scott, Phillip King and William Tucker), when coloured metal and abstraction started to dominate the art scene. All of those named here, having found their own stylistic paths, greatly enriched the spectrum of English sculpture which today enjoys a level of international recognition that is not least a product of so many artists' creative and critical dialogue with the work of Henry Moore.

Thus our examination of the reception of Moore's work by English artists of the older generation – such as Bernard Meadows, Kenneth Armitage and Anthony Caro – will focus both on processes of detachment and on the discovery of new terrain; in the case of the younger generation – such as David Nash and Tony Cragg – we will find conceptual connections.

Bernard Meadows

Bernard Meadows (1915–2005), seventeen years younger than Moore, was his assistant from early April 1936 until January 1940, and mainly worked with Moore at his small property, Burcroft, near Canterbury in Kent.[381]

We have Bernard Meadows to thank for his invaluable memories from that time, of Moore's life, work and personality. These were the years when Moore, very much open to surrealist ideas and role-models, was engaged in the most productive and experimental phase of his work. In one of the many interviews he later gave (in this case, to Richard Cork in 1988), Meadows described how well organised Moore was. Thanks to the sheer intensity of their collaboration, during Meadows' time in Burcroft the two men together completed twenty to thirty sculptures per year. The *Recumbent Figure* (figs. 119, 120)[382] in the Tate Gallery, was carved in just five weeks. Meadows later described Moore's technical skill as nothing short of brilliant. Added to which: 'He had a puritanical feeling that he had to work all the time. He had a guilty conscience if he felt he had wasted time which could have been used working.'[383] At the same time, Moore also saw to it that he created a pleasant working atmosphere: 'He had a

nice sense of humour... We would sing a lot while we worked. We each had a considerable repertoire of songs, hymns and slightly dirty army songs. We used to sing at the tops of our voices; we were in the middle of a field and there was never anyone around.' Living out in the country, Moore was keen not to be disturbed: 'no telephone; I can't ever remember going to the village pub'.[384] And their shopping trips to Dover or Canterbury always ended with a visit to the cinema: 'I have never seen so many bad films.' The only contact with the outside world in Moore's cottage was the radio, which he needed for the news and, above all, for music: '...he liked listening to baroque music. It was the only classical music he seemed interested in, probably because of its affinity to hymns. It was singable. He could sing Handel's *Messiah* almost all the way through, as well as *The Beggars Opera*.'[385]

Although Meadows was to make a name for himself as one of the abovementioned 'angry' sculptors by 1952 at the latest, when his work was shown at the Venice Biennale, he later held a chair very successfully at the Royal College of Art for twenty years and understandably suffered from the fact that often he was merely regarded as the 'closest follower' of Henry Moore.[386] It was only in 1995, in a comprehensive monograph on Bernard Meadows' work (with an informative essay by Penelope Curtis) that Alan Bowness managed to set the record straight.[387]

Meadow's artistic personality was largely shaped by his experience of Surrealism. As Penelope Curtis has rightly said in this connection: 'Working for Henry Moore from 1936 meant that Meadows was opened to a world of influences and contacts that was unusual for a young British artist at that time. Perhaps it is from this date that the "personnages" which people Meadows' work, and by which term he denotes their presence make their entrance.'[388] At the important *International Surrealist Exhibition* in the Burlington Galleries in July 1936, the twenty-one year old Meadows saw and experienced first hand the great French Surrealists who came to show their work in London. No doubt he will have talked about all this with Moore.

Meadows collaborated with Moore not only on the large Hornton stone *Recumbent Figure* (Tate Britain; figs. 119, 120) and the elmwood *Reclining Figure* (Detroit[389]; figs. 121, 290–292), he also assisted Moore with around eighteen lead statuettes. As we have already seen, the latter constitute Moore's most obviously surrealist works. Their formal audacity and wealth of invention soon caused a stir. At the time, the English painter, Gordon Onslow-Ford – a member of the Paris Surrealists' group around André Breton – bought not only a recently completed elmwood *Reclining Figure*[390] but also one of the most daring small, lead *Reclining Figures* of 1939 (fig. 64).[391] Another, no less stunning *Reclining Figure*[392] found a home in the collection of Moore's mentor, the art historian and later director of the National Gallery, Sir Kenneth Clark.

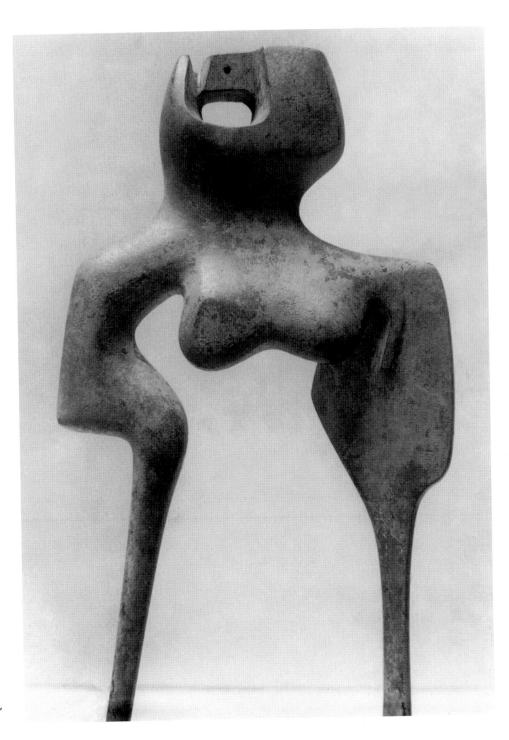

397 Bernard Meadows: *Standing Figure*,
1950, Bronze, H. 28 cm, Private Collection

The bodies of these reclining figures seem to extend and stretch, as though they are breathing. The space flows through them, articulated by bands and planes. The outside and the inside become one. Even the head has a narrow slit so that here, too, space can also be accommodated within it.

Amongst the lead figures that Moore and Meadows made, by means of a lost wax method in Irina's pots, one work stands out above all, where the body is reduced and the space liquefied to created a positively inspired cipher. The work in question is the *Reclining Figure* of 1938, now in the Museum of Modern Art, New York (fig. 64).[393] A bone-like lower body

stretches out its two tips, like feelers, towards the centre of the figure, where it is met by the wide, enveloping arch of the upper body. Straining, solid movement down below; a calm over-arching space up above – constrained weight below, light above: contrasts that set up the many resonances of this highly charged, yet lightsome sculpture.

As a young, up-and-coming sculptor, Meadows naturally absorbed these new forms and formal processes. Years later his bronze *Standing Figure* of 1950 (fig. 397)[394] seemed to be a response to the upper right section of Moore's *Reclining Figure* of 1938. Meadows drew the supports of the bridge closer

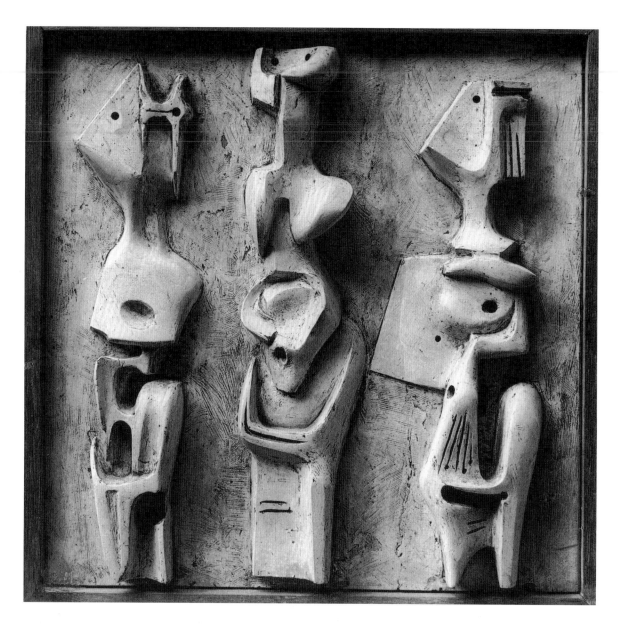

398
Bernard Meadows:
*Three Standing
Figures Relief*, 1950,
plaster model,
17.8 x 17.8 cm
(destroyed)

together and integrated the suspended motif of the isolated, pointed breasts into the strongly modelled shoulder section. And the split head is now closed with a cross-bar to form an eyehole. Another echo of the work of Moore the Surrealist is seen in Meadows' small plaster model of 1950, *Three Standing Figures Relief* (fig. 398),[395] which was later destroyed. The multi-part, stacked figures – up to and including the eye holes – appear to relate to Moore's drawing *Two Upright Forms* (fig. 399) of 1935. This drawing was shown in 1936 at Moore's solo exhibition in the Leicester Galleries.[396]

In the years to come, Meadows was still preoccupied with Moore's organic, perforated bodies and the reduction of solid forms to little more than a framework. Later he took these same ideas and adapted them to his own notions of form that

had come to him during his involuntarily extended studies of the natural world. As a soldier serving in the Second World War, Meadows was sent to India, Ceylon and finally to the Cocos Islands in the Indian Ocean. Here he had no choice but to make friends with the teeming crabs of all kinds. He observed their different forms, their sideways gait and their behaviour. Back in England these memories were to form the basis of his most important motifs. In his hands the crabs become threatening *personnages*, which, standing upright, look increasingly like belligerent, hybrid monster-humans. In 1952 Herbert Read talked of these strangely uncanny examples of a new bronze species 'scuttling at the floors of silent seas'.[397]

In one case, the *Black Crab* of 1951–52 (fig. 400),[398] there are still echoes of Moore's surreal lead pieces from the late

399 *Two Upright Forms*, 1935, Pencil, chalk, pen and ink, wash, 56.5 x 38.2 cm, The Henry Moore Foundation, AG 36.17 (HMF 1253)

1930s. In this bronze two faintly ovoid forms rise up above four claws. It seems to me that this piece both recalls and distorts the shape of the interior figure in *The Helmet* of 1939 (fig. 343).[399] Where Moore forms harmoniously resonant rings that reflect the openness and inner concordance of the internal human figure as opposed to its martial casing, Meadows produces an aggressively clawed, much more surreal zoomorphic being. And in other related works, such as his *Large Jesus Crab (Larger Spider Crab)* of 1954, now in Toronto,[400]

Meadows again translated the knowledge gained through years of firsthand observations in the field into new fantastic, uncannily wild figures. In conceptual terms, he was pursuing a similar path here to Moore in his *Transformation Drawings* of 1931–32, when he studied various bones and other natural forms until at last they yielded up their own inner secrets to his instinct for transformation. Thus it is clear that the early years Meadows spent as Moore's assistant, from 1936–40, were to have a lasting influence on his own work.

400 Bernard Meadows: *Black Crab*, 1951–52, Bronze, H. 43 cm, Collection Dr. Jeffrey and Ruth Shervin

Kenneth Armitage

Kenneth Armitage (1916–2002) sprang from nowhere. In 1952, when he was still relatively unknown, his work was included in the group exhibition in the British Pavilion at the Venice Biennale.[401] Within a few weeks all of his works on show there had been sold, and he left Italy with an international reputation. One of his most striking exhibits in Venice was the bronze *People in the Wind* of 1950 (fig. 401).[402] This work already had two features that Armitage was to develop in the coming years: firstly, the figures in the group are connected by planar fillers. In this case, the sail-like forms could have been derived from the impressions left on him from his days with the Royal Air Force during the Second World War. Looking back in 1997, he recalled that 'there was a constant awareness of shape.'[403] Possibly also connected with this is the second feature, namely a wall-like plane which is clearly

recognisable in the bronze *Diarchy* of 1957 (fig. 402).[404] Here the figures are incorporated into a single planar form. It is even possible that Armitage was influenced here by the flat bodies in Moore's *King and Queen* (figs. 231–233), although he did not speak warmly of this work, referring to it as a piece 'which I never really liked very much anyhow; I had seen them at the foundry, and liked his other work much better.'[405]

By definition, we can tell which figures he preferred from his two reclining figures of 1957, which were amongst his best postwar pieces: *Figure Lying on Its Side (version 5)* (fig. 403) and *Sprawling Woman (large version)* (fig. 404). Armitage's figuratively worked planes and his striking preference for frontal views fundamentally contradict Moore's concept of the human form, which was always primarily about three-dimensionality and – implied or real – monumentality.[406] In terms of their content, both of these bronzes are typical of British postwar sculpture. Thus David Alan Mellor wrote of *Figure Lying on Its Side* of 1957 that 'the phenomenology of the body's weight, and its paroxysmic instability in the world, tip over into a horizontality which seems almost like an oblique allusion to the predicament of Gregor Samsa in Franz Kafka's celebrated short story *Metamorphosis* which enjoyed wide circulation in post-war British culture'.[407]

401 Kenneth Armitage: *People in the Wind*, 1950, Bronze, 65 x 40 x 34.3 cm, Tate Britain, London

402 Kenneth Armitage: *Diarchy*, 1957, Bronze, 170.8 x 108.6 x 100.3 cm, Tate Britain, London

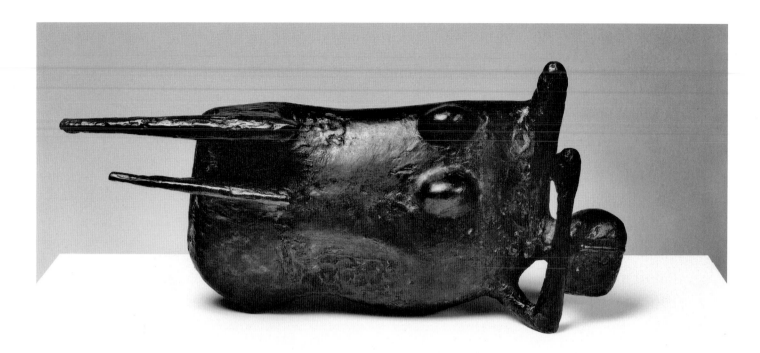

403 Kenneth Armitage: *Figure Lying on Its Side (version 5)*, 1957, Bronze, 38.1 x 82.5 x 22.3 cm, Arts Council Collection, South Bank Centre, London

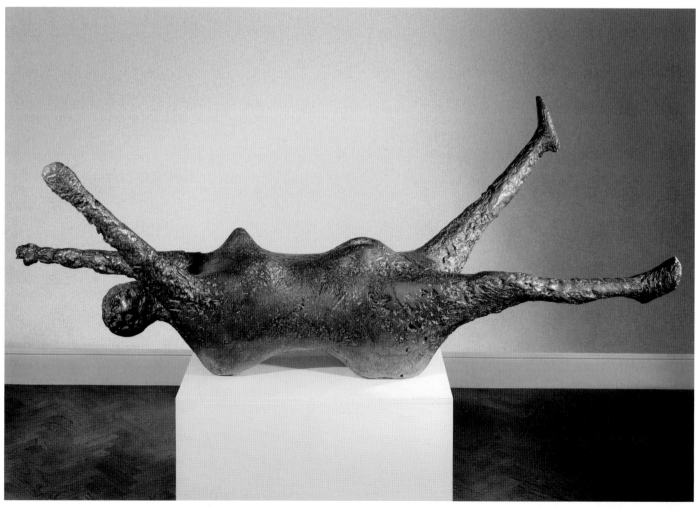

404 Kenneth Armitage: *Sprawling Woman (large version)*, 1957, Bronze, B. 258 cm, Hazlitt Holland-Hibbert, London

405 Maquette for *Fallen Warrior*, 1956, Bronze, L. 23 cm, The Henry Moore Foundation (LH 404)

This comment, which comes in conjunction with an impression of existential dereliction, is supported in formal terms by the fact that the figure is entirely horizontal, which intensifies the sense of its hopelessness. And the same could also be said of the female figure lying on its back in fig. 404. A similar use of horizontality to underline the figure's powerlessness is seen in Moore's Maquette for *Fallen Warrior* of 1956 (fig. 405). But unlike Armitage's basically abstract image of a female figure with much too thin legs sticking straight out into the air, Moore's warrior embodies the drama of the moment of being struck down. Will Grohmann wrote of this figure: 'the movement of sprawling, falling, propping himself up and lying on his back is seen from all sides and, as we walk around the figure, the view changes with every step. From some viewpoints the 'Fallen warrior' looks like a miserable rep-

tile, especially as the head is not much more than a perforated, elongated knob and the long arms and legs those of a lifeless puppet. There is nothing conciliatory about this fallen hero, nothing that mitigates the brutality, and perhaps that is why Moore modified him.' [408]

Consequently there are fewer connections with Armitage's work in the second, less brutal version, the *Falling Warrior* of 1956–57 (fig. 369) – more rhythmical, more self-contained and more dignified. In his response to the first version, Armitage radicalised the figure's self-evident helplessness. Although this is not to say that Moore was not also capable of images of extreme, existential situations. Some of the most eloquent of these are seen in Moore's sinister human/helmet works, in his warriors, and in his illustrations for Edward Sackville-West's *The Rescue*.

Anthony Caro

In the years following Moore's death, Anthony Caro (b. 1924) was the undisputed figurehead of British sculpture. With the abstract welded steel pieces he started to make in the 1960s – classics today – he has transformed the face of British sculpture.[409] As a graduate of the Royal Academy and as Henry Moore's assistant from 1951–53, it was as though he completed a fast-track survey of British sculpture from the lingering remnants of the nineteenth century right through to its very latest manifestations. This experience, and above all his intense intellectual contact with Moore, gave him a self-confidence that prepared him for his keenly sought interaction, in 1959–60, with the New York avant-garde (Clement Greenberg, Kenneth Noland and David Smith) and his subsequent breakthrough to constructive abstraction. Soon his own students – artists such as Phillip King, who was Moore's assistant in 1958–60 – were consolidating the ground he had gained.[410]

In 1960, without first making preparatory sketches or maquettes, Caro started to weld together industrial materials (finished items or waste products) creating coloured spatial configurations from sheets, plates, supports, rods, tubes, segments of circles, sections of piping, grids, planes and the like.[411] By now two generations of artists have purified and extended their sculptural ideas through their contact with these works. As a radical successor to the Synthetic Cubists, Caro showed how simple means and fundamental perceptions can be combined to create new spatial-plastic meanings. For over forty years now – never losing their freshness – Caro's works have shown what can be done with heights and depths, interlocking planes, object-like spatial connections (from 1966 onwards in the Table Pieces), the visual conquest of gravity, 'drawing in space', and increasingly architectural works. With his own unique flexibility he has been inspired by paintings from the past and the present alike, by artists ranging from Kenneth Noland, Willem de Kooning, Jean Dubuffet, Picasso, Matisse and Edouard Manet to Andrea Mantegna, Peter Paul Rubens and Rembrandt.

Through all the transformations and 'sculptural analogies'[412] in Caro's work, there is a consistent higher rationale and harmony that ensues from the formal coherence of his compositions. And it was thanks to this sense of aesthetic security that Caro was able to avoid the pitfalls of narration in his late 'encyclopaedic' sculptural ensembles, such as *The Last Judgement* of 1995–99. In this group, consisting of twenty-eight large sections (located in the Johanniter-Halle, Schwäbisch Hall, since 2001), pieces of unfired earthenware were combined with elements made from steel and wood. The carefully calculated forms intensify the emotive indictment of the wars and bestiality of the twentieth century. With its skulls and underlying belief in sculpture as magic, here Caro came as close to Picasso as he had only previously done in his early work.[413]

406 Anthony Caro: *Man Holding His Foot*, 1955, Bronze, H. 67.3 cm, Private Collection

407 Anthony Caro: *Man Taking off His Shirt*, 1955/56, Bronze, H. 78.7 cm, Private Collection

408 Anthony Caro: *Woman waking up*, 1955, Bronze, B. 66 cm, London, Tate Britain/ Arts Council of Great Britain, London

And, as though equipped with a rear-view mirror, this early work points to his first dialogue with Henry Moore. In the period 1954–59, Caro turned his attention to the human figure. At the same time he also drew inspiration from the experience of handling clay. In his generous, deliberately primitive-looking human forms he sought to break open the smooth epidermis of Moore's figures. He admired and had made a careful study of Picasso's *Man with a Lamb* (1943) and its open modelling.[414] Striving above all to connect with Modernism and artists of his own generation, and – as Ian Barker and others have shown – influenced both by Picasso's aggressive emotionalism and more recent examples of work by Dubuffet and de Kooning, he formed figures from roughly amassed towers of material that seem to be releasing an unstoppable, steady stream of energy. And as if that were not enough, in works like *Man Holding His Foot* of 1955 (fig. 406)[415] and *Man Taking off His Shirt* of 1955–56 (fig. 407)[416] Caro transcends his own striving for originality and arrives at a whole new perception of the human body. As Barker has aptly said: 'His primary concern was to grasp the primeval quality of the body as "felt", rather than paying too much attention to the body as "seen".'[417]

Picasso had been pursuing this same internal perspective in his sculptures ever since the bathers he devised for the beach promenade in Cannes in 1927. Caro will certainly have been familiar with a well-known offshoot of this group, the plaster *Baigneuse* of spring 1931, even if only from the sympathetic photographs by Brassaï that Kahnweiler published in 1949.[418] In both Picasso's *Baigneuse* and Caro's *Man Taking off His Shirt* the movement in the lower regions of the figure runs

upwards through its diminishing proportions: in Caro's case the figure reaches backwards for its imaginary shirt, with the upper body light, the lower body heavy and the head – unimportant in this instance – shrunken[419]; in Picasso's case we see the heavy steps of the bather in swirling water, adding weight to the bottom half of the figure.

The young Caro achieved an even greater level of eloquence in his bronze *Woman waking up* of 1955 (fig. 408)[420] when he gave visual form to another inner-body sensation. The woman is seen stretching, gathering her thoughts and gradually preparing to raise herself up. Caro worked pebbles into her heavy breasts and buttocks, as his erstwhile mentor had done in some of his maquettes.

An even more significant parallel to Moore's work, which also concerns this internal perspective, is evident in the back view of Caro's bronze *Woman's Body* of 1959 (fig. 409).[421] It seems to me that the main influence here is not so much Matisse's late, fourth back relief of 1929 as Moore's rear view of a *Seated Woman* of 1957 (fig. 410), especially since both artists prefer the heavier, more mature female figure. Moore himself pointed to the connection between this figure and his own mother's rheumatic back, to which he tirelessly used to apply ointments as a young boy. No doubt the ease this gave his mother and the powerful expanses of her back left a deep impression on him. Early on, in 1924, Moore was already replicating his mother's pose and the shape of her back in his life-filled drawings of backs. And the old memories returned to him again when he was working on the plaster original in 1957: 'I found that I was unconsciously giving the back the long-forgotten shape of the one I had so often rubbed as a

409 Anthony Caro: *Woman's Body*, 1959, Bronze, H. 188 cm, Private Collection

boy.'[422] Caro adopted something of this deeply sensual, somehow warm image of a human back and applied it to his own female figure, if anything heightening the effect in its bulges and amorphous shapes.

The connections between Anthony Caro's work and that of Henry Moore were founded in a unique relationship that went through both highs and lows.[423] It has only been more recently that Caro could be entirely positive about the importance of his mentor's influence.

In July 1951, at the age of twenty-seven Caro became Moore's assistant, working half days.[424] For the next two years, one of his tasks was to maintain the small bronze foundry that had recently been installed in the Moores' garden. Caro was also responsible for patination. He learnt a lot from both of these duties, as he also did from his work on Moore's largest commission to date, the *Time-Life Building Screen* (fig. 411), which he and other assistants carved, and on the *Draped Reclining Figure* (fig. 176),[425] for which he made the intermediate plaster model. But more important to Caro

than all these tasks, was the fact in Moore he had found his 'first real teacher in art'.[426] Occasionally he even talked in terms of a father. This was also the first time that Caro was in close contact with an artist who was entirely at home with Modernism and who could tell him of his wide experience of working with artists such as Picasso, Joan Miró, Giacometti and others; in addition to this, Moore also took him seriously as a young artist, responded in depth to his questions and supported him as and when he could. Caro later described this time: 'Henry had a mind that was a pleasure to meet, extraordinary, so inquiring, and he was quite prepared to throw the ball in the air and see if you caught it: "Who is your favorite sculptor? If you could have three paintings in the world, which would you choose?"... My impression of him was a very open-minded man, quite amazingly open to the possibilities in sculpture and anything else really; and fun, too, with a nice sense of humour.'[427]

In this atmosphere there were two main factors that were greatly to Caro's advantage. Firstly, Moore significantly helped him to widen his artistic horizons by lending him whatever he wanted from his library. It was at this time that Caro discovered his love of African carvings, which had an immediate impact on his own work. A *Head*,[428] clearly influenced by Wobe masks and two *Warriors*,[429] made in 1952–53, testify to his eye for the direct magic of African art. Even before that, in an earlier *Rainwater Spout*, he in effect combined Moore's use of masks with the planar forms of African carvings.[430] It was also Moore who taught him to see and to draw more like a sculptor. The same situation we saw earlier, when Moore took a generously didactic interest in the development of his assistant Brigitte Matschinsky-Denninghoff's drawing skills,[431] occurred again in Caro's case. Moore went through the life drawings that Caro brought back with him from his studies at the Royal Academy. In addition to this, Caro was allowed to look at Moore's sketchbooks. Caro later gave a very lively account of what Moore had taught of the three laws of sculptural drawing: 'First, perspective works when drawing a figure just as it does in drawing a landscape. What is closer to you is bigger. You can see how he's made the leg and hand big because they're closer to him. Then also, just the same as with landscape, what is closer is more intense, the blacks blacker, the whites whiter. What is further away is grey, the same as with a landscape where the distant hills are grey, not sharply black and white. Thirdly, and by far the most difficult to grasp and realise, the direction the light comes from is exceedingly important and imposes a logic to the drawing. There is a law of light, a clear law of light, which says that whatever is at right angles to the light source is going to appear white and whatever is turned away, in whatever direction, is going to be dark. So if any part is turned away completely it's going to be registered black, just as whatever faces the source will be white. In order for me to grasp this clearly in my head he sug-

410 *Seated Woman*, 1957, Bronze, H. 145 cm, Nationalgalerie, Berlin/The Hirshhorn Museum and Sculpture Garden, Washington D.C. (LH 435)

411 *Time-Life Building Screen*, 1952–53, Portland stone, 304 x 807.7 cm, Bond Street, London (LH 344)

gested that rather than just taking where the light was coming from in nature, I should invent a source of light for each drawing.'[432]

In order to properly understand these principles, occasionally Caro deliberately attempted to imitate Moore's style of drawing. Witness, for instance, the study of a female back for his bronze *Woman in Pregnancy* of 1955[433] (fig. 412) compared to Moore's nude seen from the rear of 1925 (fig. 413). In both cases bold brushwork creates the powerful shadows of the strongly modelled buttocks. It was the immediacy of this representation of sculptural values on paper that Moore wanted to communicate to the younger artist[434] and which Caro, for his part, was soon to pass on as a teacher at St Martin's School by encouraging his students to be aggressively daring in their own drawings.[435]

It was Peter Fuller, who – tackling some fundamental issues – asked Caro in an interview in 1979 about his aesthetic position with regard to Moore: 'The essence of Moore's sculpture is his experience of nature and natural forms – shells, bones, pebbles, and especially the human body, isn't it?' Caro answered as though he knew what Fuller had in mind: 'Yes, there is a big difference between his art and that of people of my generation. It is misleading to call our art "urban" but if his art is to do with the countryside and nature then ours could certainly be said to be more urban than his." Fuller: 'Did you see *Sheep Piece*?' (fig. 414)[436] Caro: 'I thought *Sheep Piece* was terrific.' Fuller: 'What did you admire about it?' Caro: 'It is undeclaratory. It is not too big for itself, and that has not been true of all Moore's sculptures in recent years. *Sheep Piece* is the right size for its feeling. It is a grand sculpture. I first saw it at his farm… and I thought "That is a really felt piece." I would be happy to have made it.'[437]

Caro's replies are possibly in need of some explanation. The adjective 'urban', which he slightly reluctantly accepts as

the opposite to pastoral, in order to set his own work apart from Moore's with its connections to Nature and the country-side, had been used two years earlier in a similar context by Hilton Kramer in a discussion of Caro's most recent works: 'In all the new work there is a play on unlike, countervailing forms – the smooth and the rough, the straight-edged and the torn edge, the flat and the round… Is it merely fanciful to see in these conjunctions of countervailing forms an attempt to bring together both an urban and a pastoral imagery? … On the pastoral side it is remarkable how close Mr. Caro now seems to certain works of Henry Moore… The urban elements represent the obverse of this impulse… these sculptures mark an interesting turn in an important artistic career.'[438]

Hilton saw echoes of Moore's allegiance to Nature in Caro's more recent works; he may well have had in mind pieces such as *Cliff Song* (1976)[439] and *Conspiracy* (1976–77).[440] And the horizontality of these works does indeed evoke thoughts of the natural landscape. Yet Caro would also be right to insist that his constructive collages exist entirely in their own right.

413 *Standing Nude*, c. 1925, pen and ink, chalk, wash, 56 x 24 cm, Tate Britain, London, AG 25.60 (HMF 323)

412 Anthony Caro: Standing Woman. Study for *Woman in Pregnancy*, 1955, Brush and ink on newspaper paper, measure and whereabouts unknown

For unlike Moore, Caro's main interest was not in organic forms and a rhythmically taut morphology. He felt he had to make this quite clear: '…if his art is to do with the countryside and nature then ours could certainly be said to be more urban than his'. Moreover, in light of his current, large-scale, power-fully tectonic works, such as *Emma Dipper* of 1977–78[441] or *Table Piece CCCXCI Ledge* of 1977–78,[442] integrated directly

414 *Sheep Piece*, 1971–72, Bronze, H. 570 cm, The Henry Moore Foundation (LH 627)

into the architecture, Caro was bound to see himself primarily as an urbanist.

At the same time, however, his comments on Moore's *Sheep Piece* show how well he still understood Moore's intentions. For when he describes this work in admiring terms as a 'felt piece', it is clear that – for all its monumentality – he was in tune with the work's naturalness, which was possibly also what Moore was striving for with his humanity of form. Presumably Caro saw his enduring aim – to portray the internal perspective of a body – realised in this biomorphous-abstract, plastic *imago* of the palpable togetherness of sheep and

lamb. His statement 'I would be happy to have made it' is thus all the more telling.

If one looks at Caro's complex relationship to Moore – as far as that is already possible today – with its mixture of attraction and resistance, one cannot help but be struck by the fact that, for all their differences (town and architecture versus Nature/abstractions derived from Cubist collage, or construction versus biomorphous abstraction, steel versus bronze), Caro has much in common with Moore: the strong, albeit differently weighted relationship to Picasso, the growing need for monumentality as the years pass, the unwavering

observation of sculptural laws such as tension, balance, rhythm, a preference for horizontality, the search for sculptural analogies to painting and genuine pedagogic skills.

And yet there is a dividing line that Caro could not have drawn more distinctly. In his view Moore was, as he put it, 'the last great artist of the Renaissance'.[443] By contrast, he saw himself – as part of the 'Quiet Revolution of the British Sculpture'[444] – very much as an artist of the modern era. What did Caro mean by making this distinction? Perhaps the main point of Caro's statement is that Moore still had access to an ideal picture of humankind, so that there is always a sense of wholeness to counter his deliberately fragmented pieces. Perhaps he was also thinking of Moore's good-natured, disarmingly modest personality which – with his cosmopolitanism, his social commitment and steadfast work ethic – calls to mind the humanist tradition in the best sense. Are not Moore's wide-ranging interests, his intense study of the natural world and his immense knowledge of art history in fact typical of the *uomo universale*? Whatever the case, it is to Caro's credit that with these words he once again drew attention to Moore's artistic stature and intellectual standing, and in effect located him as a leading figure in the history of art.

Nevertheless there have to be certain reservations. After all, the great Renaissance artists were ultimately hoping to perfect the styles established in Antiquity and could be said to be permanently looking to the past. By contrast, Henry Moore – in his striving to instil the dynamism of the forms and rhythms of Nature into his images of human beings – was on an intrinsically Romantic course, which nevertheless had its own avant-garde features in its modern reincarnation. Nor does his unhierarchical, open approach to the world language of sculpture have much in common with the carefully circumscribed world of a Renaissance artist. The modern challenge that Moore set his viewers was that they should remain flexible in their study of his sculptures so that, as they absorbed the dynamism of the works' forms, they might also understand something of their spiritual vitality and of their being.

As much through his sculptural œuvre as through his contact with Henry Moore – both personal and professional – Anthony Caro paved the way for the future reception of Moore's work in his own homeland. While the early work of artists such as Meadows, Armitage and Caro, with direct references to certain *Reclining Figures* and other works, still manifested relatively close connections with Moore's work, the next generation's dialogue with Moore took place on a much freer meta-level. The inventiveness and energy that came to the fore in these circles can in part be seen in the response to Henry Moore of artists such as Tony Cragg and David Nash. In their very different approaches these artists reflect the diversity that was to characterise the continued impact of Moore's ideas on contemporary British sculpture.

Tony Cragg

Tony Cragg's (b. 1949) early influences included Land Art, Conceptual Art, Performance Art and Arte Povera. This, combined with his ironic attitude to the legacy of Marcel Duchamp, meant that his position could not be further from that of Henry Moore. Or is there more to it than that? Could there nevertheless be some connections, however contradictory?

In 1979 Cragg achieved his international breakthrough with his floor installation *New Stones – Newton's Stones*,[445] consisting of all sorts of plastic waste spread out loosely in a large rectangle and ordered according to Newton's colour spectrum. However, in the mid-1980s Cragg abandoned his free use of everyday, preshaped synthetic items in favour of identifiable forms connected with his own earlier experience. Now his floor installations played with the shapes associated with the glass cylinders and vessels that he had worked with as a technical assistant in a biotechnology laboratory. This work had nurtured in him a fascination for the microstructures of materials and had, in his own words, given him 'a great, and still passionate interest in science and the latest developments in technology'.[446] And it would be true to say that Cragg's sculptural approach was defined by his discovery of the physical, material world.[447] With his preference for series, the result of a 'mixture of intuition and research',[448] his work – as Kay Heymer has said – is like 'a scientific experiment… capable of engaging with numerous questions within sculpture: mass and weight, density and porosity of surfaces, proportion and ratio, material properties of various substances, visual ideas, the contours of forms, unity and fragmentation, repetition, isolation, movement and temporality. His complex and prolific work is correspondingly varied.'[449]

When Kay Heymer presented his major Cragg exhibition in Bonn in 2003, he managed to order this rich œuvre by identifying various leitmotifs in Cragg's work. These could be summed up as follows: stacking and piling up found materials; using waste plastic items to create airy, schematic figures on the floor or walls; fragments that become structures; demonstration models from biology; games with homogenised skins; vessels; early forms; rational beings.

Cragg, very consistently, treats sculpture as a test bed. In his hands sculpture becomes an instrument that he can use to provide visual answers to questions regarding artistic materials (natural and plastic), possible changes in their forms and the nature of the 'molecular structures of materials, their appearance and their functions'.[450] All the many things in life that interest Cragg – with his unfailing curiosity and social commitment – appear to him (with his earlier experience of modern chemistry) in terms of material and structures. A typical instance of this is seen in his spirited outburst in conversation with Heinz-Norbert Jocks in 1998: 'It's so fantastic when you think of the complicated structures and developments that we are confronted with day in day out; it's almost

enough to make me religious. All of a sudden we sense what it means that creatures swimming in the primal sludge formed – in what looked like a totally hostile environment – into configurations that became self-reproducing cellular molecules and ultimately turned into protein-based, cell-forming units. It's wonderful to know where tiny organisms come from and what complex structures are found in higher plants.'[451]

In Cragg's case these investigations into physical matter, into the Whence of organisms and their development, fed directly into his sculptural methods, as in his observation of the particle-structures of things such as grasses, soil and sand, and of the ways that layers form. And it is also in these terms that he sees skin: as an accumulation of particles. Moreover, 'where there is skin, there is also a body at some point, which I convey in the form of bottles. When I take a waste pipe, it's possible to use it to describe structures like the intestines or the way that not necessarily visible chains of proteins hold together'.[452] This last remark could be applied to Cragg's *George and the Dragon* of 1984,[453] although in Catherine Grenier's somewhat presumptuous view, the interlocking bent waste pipes are 'an ironic reference to Henry Moore's contorted figures'.[454]

Despite the inappropriateness of this remark, since Moore's distorted figures have nothing to do with convoluted intestines, it still raises a relevant question: what do we know of the relationship between Tony Cragg and Henry Moore? In the same conversation with Heinz-Norbert Jocks, Cragg also discussed the work of Moore: 'In terms of invention and modes of expression – compared to Brancusi, Picasso or Duchamp – I don't find his work very exciting. With regard to the forms, it's conservative, even romantic at times. The viewer is supposed to admire how beautiful weathered stone or bleached sheeps' bones from moors and heathlands can be. Moreover, with his particular brand of Formalism he blocks our access. You can touch his sculptures, which I don't like very much.' When asked why, Cragg replied: 'Because the eye has the capacity to perceive information from a distance. A capacity that can't be compared with haptic sensibility. I have problems with Moore where he adopts an artistic position that very vaguely problematises humanist issues. He engages with the relationship between human beings and the landscape, without coming to any concrete conclusion. I'm not against that, on an aesthetic level, but it is little more than a form of beach-combing, or saying how lovely an object looks that was lying on the beach.'[455]

This comment sums up the differences between these two artists. Most importantly, in this statement Cragg – unlike Moore – is not primarily interested in 'haptic sensibility'. But seven years later he took a slightly different line. In 2005, in a conversation with the present author he declared at one point that for him Moore's greatest strength was the fact that he had 'given the human being dignity again'. He had found

new ways to handle humanity in art. Above all, Moore had created a 'connection between the vocabulary of Nature and the world language of sculpture'. However, he did feel that Moore lacked Picasso's emotion and had no real interest in new materials. And in addition to this, in Cragg's opinion Moore should never have allowed himself to be used as a 'cultural flagship'.[456]

Peter Anselm Riedl and Carla Schulz-Hoffmann have discussed the significance of Cragg's resistance to the notion of viewers touching a sculpture, which comes across in his comments on Moore's work.[457] Riedl even goes so far as to read this aversion as the 'secret law of Cragg's art', and he continues, 'This rejection of the idea of a work of art that invites a tactile response has a double root: suspicion of a too blatant closeness to Nature… and scepticism in the face of the seemingly unquestioned presence of a plastic mass. But it was Moore who had discovered and repeatedly explored the pictorial value of the hole. However, in Cragg's view, this kind of hole was always the outcome of a natural event, of the sort that is no longer appropriate in our own day and age with its interest in more complex ways of investigating reality and its new synthetic materials. In truth, in Cragg's work there is a strange ambivalence between corporeality and a tendency to undermine corporeality.'[458]

It seems to me that the mature work of Tony Cragg invites comparison with that of Henry Moore whenever the former, in his own particular way, addresses the question of organic form. This is first seen in 1989 in his *Early Forms*, in the *Rational Beings* and in the works that Heymer classed as *Thinking Models – Organs and Organisms*.[459]

Cragg's series of *Early Forms* has its origins in a much earlier key moment in his life when he saw a number of palaeontological animal forms that had been deformed during a volcanic eruption.[460] It is as though Cragg combined this discovery with his underlying interest in sculptural vessels. As Peter Anselm Riedl has said: 'What Cragg achieved in his *Early Forms* … could be described as having continued the evolutionary process, using existing archetypes, to create his own utopian-looking art reality. By subjecting vase forms to a kind of anamorphosis, he generates new, powerfully coherent forms… The tautly precise plastic forms of all the works in the *Early Forms* series are the outcome of an extremely complicated production process.'[461] Each piece starts with a thrown vase or bowl-like vessel, where the inner shape has also been formed on a wheel. This is then subjected to a series of highly intricate procedures, involving stretching, the use of polystyrene inserts, a coating of plaster and the artist's own modelling hand before the final piece is cast in bronze.

It is only when one takes into account the 'vessel past' of these pieces, that one can properly understand the remarkable cohesion that is intrinsic to all the *Early Forms* despite their multiple openings. The drawing of 1992 (fig. 415),[462]

415 Tony Cragg: *Early Forms*, 1992, Pencil on paper, 30 x 42 cm, Private Collection

illustrated here, shows that although Cragg developed a further plastic form from the section of a circle (seen from above), he always kept the full circle in mind, as can be seen from the overlapping section in the lower right. Similarly, the drawing *Early Forms* of 1996 (fig. 416) shows very clearly the line circling out of a bowl-like form.

In one of his finest *Early Forms*, in *Meander* of 1998 (fig. 417), Cragg creates a flowing, convoluted yet controlled interplay of plastic volumes and openings. It immediately calls to mind Moore's *Reclining Figure: External Form* of 1953–54, now in Freiburg (figs. 308, 309), although Cragg has pointed out that he had not seen this piece firsthand before making his

own work. Nevertheless, he will have come across photographs of it, of which there are seven in Moore's catalogue raisonné. Both of these sculptures work with outer casings. The viewer sees the outside and the inside of a bronze wall. As we have seen above, Moore created a dynamic housing originally intended to contain an internal figure, with the dimensions of the openings determined by their internal flow. This proportional relationship between housing and figure also defined Moore's empty form, which we read as a reclining figure.

Cragg counters the binary rhythms and tactile proximity of outer casing and figure with a pure, undulating fluidity that flows back in on itself, rising upwards and sinking back down

again. With their prominent, continuous edges, his forms retain their 'vessel past' and by their contours are registered primarily as a single optical entity. In other words: the two artists treat the hollowing out of the plastic form in phenomenologically similar ways although they arrive at these solutions from their own distinct attitudes to form. Where one is guided by the human form, the other has in mind a vessel drawn out on a horizontal axis.

These observations also apply in principle to Cragg's marble *White Hollow Stone* of 2001 (figs. 418. 419), which once again invites comparison with Moore's *Reclining Figure: External Form* in Freiburg. Seen from the side (fig. 420), the openings are less prominent than the closed, rounded back of the piece. By the same token, Cragg accentuates the bowl-like

nature of his piece. Seen from above, there are only two openings cut into the hollow piece. This floor sculpture deliberately undermines the intrinsic nobility of the marble and is also very different to Moore's in that it underlines the vessel-like nature of an object created from a vase-shape by means of anamorphosis. *White Hollow Stone* is still very readily recognisable as a vase of sorts when the viewer looks in through the large opening and sees the conical form of its slightly skewed axial line (fig. 419).

White Hollow Stone is already one of those *Rational Beings* exploring the notion of a flexed axial framework. As soon as he placed them upright, Cragg described these works as 'vertebrae' or 'articulated columns'. For him these works are about 'the development of a volume around an axis. In this

417 Tony Cragg: *Meander*, 1998, Bronze, 90 x 120 x 190 cm, Museum Het Valkhof, Nijmwegen

case there is no longer a straight axis, the axis bends and re-orientates itself compressing the volumes around it. The form is no longer architectural or organic but dynamic. Obviously, the forms associated with these kinds of variable axis infer an energetic dynamic, the kind of constant material condition found in the whirlings of tornadoes or the eddies of the bath drain. The effect evokes the basic root of the words turbo, turbulent, turban and disturbing. Words already recognising the deeper psychological effects of seeing material subject to a powerful but erratic dynamic.'[463]

The association that Cragg makes here with the chemical processes of Nature, or more precisely, with the behaviour of solids and the dynamic vocabulary of forms in his *Articulated Columns*, can be seen in the *Articulated Columns* of 1996 (fig.

421).[464] Erik Schönenberg has described its characteristics: it is 'a vertically organised linear form with a dividing centre in the middle. Like Artemis it has a waist from which the form initially broadens and then tapers upwards and downwards… Cragg achieves a dynamisation and movement through the stacking of pillow-like, bulging, irregular circular elements of different size.' The effect is one of 'enormous dynamic tension. The vertical is accentuated but experienced as labile.'[465] *Wirbelsäule* – and the related drawing *Project Nijmwegen* (fig. 422) – has an affinity with Moore's *Upright Motives*.[466] Both works echo Moore's principle of piling up analogous, organoid forms.

Yet further confirmation of Cragg's desire 'to understand and experience forms which reveal simultaneously their internal and external lives'[467] is seen in his coloured bronze *Tongue*

418, 419 Tony Cragg: *White Hollows Stone*, Marble (Thassos), 75 cm diametral, L. 165 cm, Collection Würth, Künzelsau

419

420 *Reclining Figure: External Form*, 1953 – 54, Bronze, L. 213.5 cm, Europaplatz, Freiburg i. Br. (LH 299)

in Cheek of 2002 (fig. 423). Moore's internal/external forms – with their many variants exploring the various implications of protective outer casing and inner activity – here take on the appearance of apparatus of some kind, an evenly perforated object. With the evenness of the openings at either end (as long as the 'cheek' opening is pointing downwards and the 'tongue' opening is pointing upwards), this piece is more abstract in its appearance. The extent to which this greater degree of abstraction also implies a higher level of philosophical content is clear from the following statement by the artist: 'In these works the concern for scale is dominated by references internal to the work and the emotion attached to the works is strong and demanding – insisting on extensions necessary to cope with a new degree of complexity, evoking curiosity, posing questions of territory, zones, invasion, injury, even a sense of insecurity.'[468] This is in itself in keeping with the 'labile' nature of the abovementioned *Wirbelsäule* and the continuous flow of the *Early Form* around a flexible axis.

Yet another connection to Moore can be seen in *Caught Dreaming* of 2006 (fig. 424), made from multi-coloured Jesmonite stone. In this piece computer-generated distortions are used to toy with the theme of fluid, organoid forms and human profiles. While the shapes extend rhythmically outwards they are nevertheless still in the grip of the vertical lines that contain them. Moore's 'two-sectional line method' makes a passing appearance here.

Two generations younger than Moore, it seems that Tony Cragg stands for the values of the Enlightenment while Henry Moore is an exponent of a more Romantic mode. Cragg's microbiological knowledge of Nature and materials takes his organoid forms in a more scientific direction. Yet the sense of duty and responsibility that Cragg associates with contemporary sculpture has echoes of Moore's own humanist convictions and came to the fore in an interview with John Wood: 'I think the world will need sculpture in the future, in order to decide about the form and structure of many things – we will need sculpture and sculptural thinking. I would like to apply sculptural thinking to biomechanics, to government institutions, to social structures etc. I don't mean in terms of dictating what the structures would be, but in order to use the analysis of form and relate that to ideals and to moral imperatives even. I think I could imagine the work of artists becoming much more integral to the form of social political institutions, of educational practices, to agriculture, to forestry, to ecology generally, to nutrition, to human relationships, to justice, to the resolution of conflicts. … I do believe that sculpture, perhaps sometimes more than any other artistic or cultural activity, is a tool for building a better world.'[469]

421 Tony Cragg: *Articulated Columns*, 1996, Fibreglass synthetics, 120 x 125 x 130 cm, Lisson Gallery, London

422 Tony Cragg: *Project Nijmwegen*, Pencil on paper, 29.5 x 32 cm, Buchmann Gallery, Basel

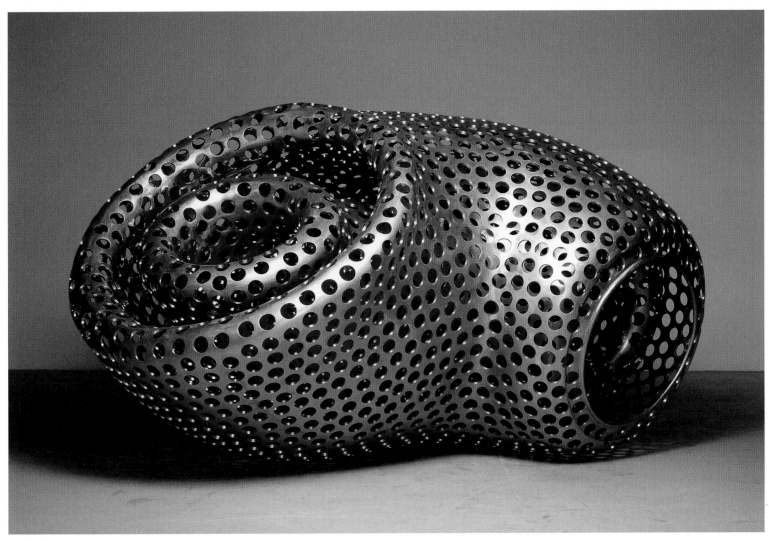

423 Tony Cragg: *Tongue in Cheek*, 2002, Bronze, 130 x 170 x 230 cm, Chantal Crousel Gallery, Paris

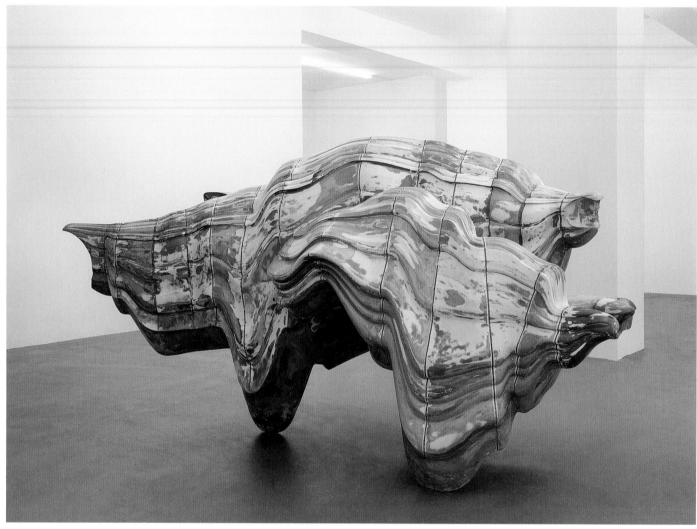

424 Tony Cragg: *Caught Dreaming*, 2006, Jesmonite, 120 x 140 x 270 cm, Buchmann Gallery, Berlin

David Nash

At no point in the career of David Nash (b. 1945), also two generations younger than Moore, have there been direct formal matches with Moore's sculpture. Yet, in his innovative work with tree trunks, there are connections which, on closer examination – on both a concrete and a conceptual level – do build on certain aspects of Moore's legacy.

In the early stages of his career, Nash was greatly inspired by Brancusi's search for the essence of artistic forms and his commitment to his work;[470] he also learnt from Anthony Caro's handling of space in the 1960s and Richard Long's ability to make room for the human being in his Land Art. As he himself put it, looking back much later on: 'When I was a student in the early sixties there was Henry Moore and Barbara Hepworth who seemed to be like the grandparents and then there were artists like Anthony Caro and Phillip King who were new and challenging. Anthony Caro's work introduced me to space, object and space... I was really interested in Richard Long and Hamish Fulton in the early 1970's. Each has a

rigour on a high intellectual level, and commitment and consistency. We are all related to the same impulse... we want to be, in a physical sense, actually in the landscape itself.' [471]

The young Nash was also fascinated by Surrealism, in particular by the work of Duchamp and Magritte, which he first encountered at the age of seventeen when he was still at school. Around 1966 he returned to surrealist practices. As his biographer Julian Andrews has put it, 'two aspects of Surrealism appealed to him instantly: The fundamental seriousness of the absurd, and the power of subversive activity within a formal institutionalized system.'[472] Thus it seems only logical that Nash was also interested in the surrealist Giacometti and the early surrealist work of David Smith.[473] Above all Giacometti was in his mind when he was making some of his early pieces.

Inevitably, in his engagement with the ideas of the Surrealists, Nash will also have come across their interest in a new, psychoanalytical approach to the object. Magnelli's famous designation of a root as a *Runner*[474] or, at home in England, Paul Nash's *Vegetable Kingdom* and related photographs and

pictures[475] may have alerted the young artist to the artistic potential of the tree as a sculptural material. Having gone his own way since the 1970s, it was the tree that was to become the centre of his life's work. In 1986 he explained something of what trees mean to him: 'The word "tree" is near to being a verb with a sense of increase, growing, spreading, doing and being, working with plant instinct, transforming raw materials, engaging light, moisture and warmth. There is a presence of evolved wisdom in the success of a tree's life. When a tree dies or is cut down, the "tree" ceases as an activity leaving only its fibrous body material. Alive, all parts of a tree are in fluid relationship from root hair to bud. When no longer a tree each body contains an imprint of that fluid whole, an echo that gives a sense of origin and nature wisdom. Wood can be worked to retain that echo. While natural branch and twig shapes are beautiful in themselves, reminiscent of nature, it is transformation that creates meaning. The objects I make are vessels for the presence of the human being, aware and surrendering to the realities of nature. Realities, that are the fundamental base to our survival. WOOD CRACKS / IN FIRE WOOD BURNS / IN AIR IN WATER WOOD FLOATS / IN EARTH WOOD ROTS.'[476]

With poetic precision Nash here describes the tree as a world in its own right, in which the full wisdom of Nature comes into its own. And this is what Nash is seeking to tap into when he makes objects that follow the once living forms of trunks, branches and twigs, bundling them and compressing them, or countering them with a geometric form and 'transforming' them.

In his art Nash has explored the extent to which the four elements affect wood: under the influence of air and warmth, the wood will crack, and its will to life will run counter to the artist's intention (*Cracked Box*, 1990).[477] Fire burns the wood which, now in its charred state, is used by Nash as an image of purification but also of death (*Threshold Column* of 1990, fig. 425).[478] Steeped in water, the wood changes as time passes (*Wooden Boulder*, 1978–97: petrified raw oak that was once immersed in water).[479] Lastly, earth provides the artist with a culture bed for his planted sculptures (*Ash Dome* of 1977ff.).[480] Thus the artist David Nash presents the tree in a wide-ranging, cosmic context.

It is clear that Nash's vision goes well beyond Moore's intentions. And yet it seems to me that there are more connections with the art of the older man than might be apparent at first sight. One of the most striking points of contact is the fact that the nature of the tree trunk has by definition taken Nash in the direction of Moore's internal/external pieces. In the mid-1980s Nash was making works such as *Inside/Outside* of 1986 (fig. 426),[481] for which he cut an internal shape out of an existing standing form and placed it in front of it, as a figure in its own right. The eye imagines the moment when the figure was extracted: the internal form comes to the fore and

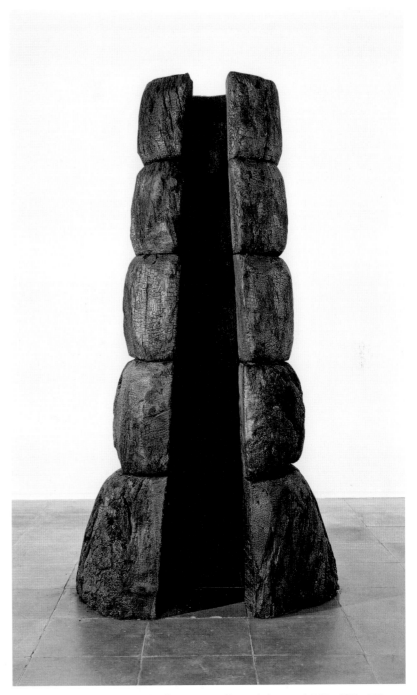

425 David Nash: *Threeshold Column*, 1990, Charred elmwood, 249 x 135 x 117 cm, Llandudno, Nord Wales

stakes its claim as the main figure, leaving behind it the larger piece which, although the mightier of the two, is nothing but an empty shell. Here the internal/external question is expressed in the time sequence of two related pieces seen in front of and behind one another.

In *Three Descending Vessels* of 1992 (fig. 427)[482] Nash drew the internal and external forms closer together. The vessel motif – vessel and ship in one – has been one of Nash's main interests since 1985, and he himself has given an account of how he came across it, made it his own, and developed its

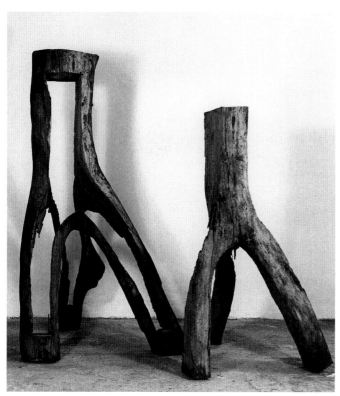

426 David Nash: *Inside/Outside*, 1988, Elmwood, Two elements,
200 x 107.5 x 127.5 cm / 160 x 87.5 x 107.5 cm, Private Collection

427 David Nash: *Three Descending Vessels*, 1992, Beech, 124 x 15 x 17 cm /
147 x 19 x 13 cm / 131 x 10 x 14 cm, Private Collection

associations: 'Passing a big gum tree on a dirt road in Australia I noticed a scar the size and shape of a boat, sharp end downwards – the image of an arrival. It felt like an idea arriving to take form, a vessel shaped space with direction from above to below – above being there, below being here. This sense of ascent and descent through the vertical has been a recurring theme in my work since the *towers* and *columns* I made in the late sixties. The vessel image in the gum tree rekindled this interest… This shape's gesture has inspired many other associations: not only is it a descending vessel, but an ascending flame; from the front, an open female, and from the side, an erect male. Above all, the shape is a magnification of the fibrous structure of wood, arranged to raise water by capillary action.'[483]

Whichever direction dominated his designs – the rise and fall of the vertical, one vessel gliding behind the other, as in the memorable piece *Serpentine Vessels* of 1989 (fig. 428)[484] – Nash always showed (to particular effect in the vessels) the agile, animated flowing of the same life force that he found in trees. And this same life force flows through the noticeable closeness of internal and external forms in *Three Descending Vessels*. The greater continuum of the motion of the trunk is expressed in the flow of the form as a whole.

If one compares Nash's handling of internal/external forms with Moore's bronzes, pieces such as his *Upright Internal/External Form: Flower* (fig. 302), then it is immediately clear that in the case of the latter the outer casing has a more self-contained air and the internal figure is more individual. Both

428 David Nash: *Serpentine Vessels*, 1989, Beechwood, 98 x 48 x 368 cm / 96 x 34 x 315 cm, Annely Juda Fine Arts, London

parts form independent entities. The interplay between the two becomes the basis of what Moore called the organic whole. However, as we will see, when Nash talked of a 'fluid whole', he had in mind a very similar concept.

This term, which itself derives from the nature of trees, also provides the aesthetic key to Nash's pairs of figures such as *King and Queen* (1988),[485] *Red Throne* (1989)[486] and *Veil* (1990),[487] and *Two Ubus* (1991).[488] At times playfully, all three pairs of figures explore similar territory to Moore's hierarchical cult figures. And if one looks more closely at Nash's understanding of trees and their forms, as it is reflected in these pairs of figures, then – on a conceptual level at least – his unconstrained relationship with Moore's work is very evident.

All three pairs are made either from an ash or an oak branch. Let us look first at *King and Queen* (fig. 429). Nash always places the pieces facing each other. A typical photograph of this pair shows *King and Queen* in a corner with the paler ash of the Queen against the darker oak of the King. The Queen's long, thin upper body stretches forwards across the King. Nash has left the bark on her head. The attitude and shape of her head gives it an expression of longing that runs right through her form and the angle of her stance. Meanwhile the King is more self-contained. His paler head breaks off flatly and his body seems overall more truncated.

As Nash has himself said of this piece – and the same certainly applied to *Red Throne* and *Veil*, and to *Two Ubus* – he sees these as beings in which the different tree-characteristics

429 David Nash: *King and Queen*, 1988, king: oakwood, H. 343 cm; queen: ashwood, H. 340 cm, Private Collection

of ash and oak come into their own: 'Ash and oak contributed their particular qualities and personalities, sun-soaked ash, fractious and bright; oak, stubborn, enduring and resonant.'[489]

These different characteristics are seen to advantage in a coloured, composite drawing by Nash showing all the pieces he had made in ash and oak; he created this drawing in 1988 for the monastery in Tournus (Musée Greuze), where he exhibited it with the title *Chêne et frêne*. The watercolour reproduced in the catalogue is very telling (fig. 430).[490] On the left of the wide landscape format we see works (in pale yellow and light green) extracted from a specially reconstructed ash tree. By contrast, the pieces made in oak, in the right half of the painting, are coloured a warm red. At the far right of

the picture there are a number of works blackened with charcoal. The characteristics listed by the artist are evident in his different treatment of the works: the ash sculptures are more delicate, lighter and airier, the oak sculptures are heavier and more solidly made.

This careful differentiation of the two types of wood is most probably connected with Nash's openness to the anthroposophy of Rudolf Steiner. It is perhaps worth noting that in all his published curriculum vitae Nash lists the inauguration of a new Steiner school under 1985 – an act that presupposes a long-term interest in the philosophy and pedagogical reforms put forward by Rudolf Steiner. Presumably as one of the founders of this institution, Nash notes that the Ysgol Steiner Eryri in Tremadoc, in his native Wales, opened its doors to

430 David Nash: *Chêne et frêne*, 1988, watercolour, Private Collection, UK

forty-five pupils on that occasion. Nash's wife, the painter Claire Langdown, taught at this school for six years.[491]

In a comment referring to his *Threshold Column* of 1990 (fig. 425),[492] Nash makes no bones about his familiarity with Steiner's ideas: 'With wood sculpture one tends to see "wood", a warm familiar material, before reading the form: wood first, form second. Charring radically changes this experience. The surface is transformed from a vegetable material to a mineral – carbon – and one sees the form before the material. The sense of scale and time are strangely changed, the charred form feels compacted yet distanced in an expanded space. Rudolf Steiner spoke about human responses to carbon being on two levels: the feeling and the thinking. The feeling instinct – connected to one's soul – is repulsed, withdraws; while the thinking instinct – connected to one's spirit – is attracted and advances. These two simultaneous experiences vie with each other.'[493]

The artist is evidently tapping into these experiences in *Threshold Column*. He draws the viewer's eye up the narrowing shadow of the opening in the charred wood, as it rises up from one segment to the next. The charred form alienates the dimensions and time of the piece, and the viewer is confronted with a sight that may well encourage him or her to ponder on the nature of death, which takes us across a particular 'threshold'.

With regard to Nash's respect for different types of wood, it is possible that he was influenced in this by Steiner's view of the natural world.[494] Taking the different characteristics of trees into account, Steiner related particular species to particular planets, in keeping with esoteric traditions from the past.

Thus, for Steiner, the ash was linked with the sun and the oak with Mars.[495] The anthroposophical logic of these connections has been confirmed on the basis of precise botanical descriptions by Frits H. Julius and Ernst-Michael Kranich.[496] Kranich's comments on the ash tree read like a continuation of Nash's own characterisation of this species: 'In the case of the ash, the tree opens itself utterly to the light. In every respect it connects and is permeated with the invigorating energies of the sun. The form of its crown is a sphere yielding up to the light above it.'[497] There is also a detailed description of the oak: 'More so than any other tree, the oak has a character that forcibly pushes its way outwards… Due to the energies that give such intensity to the life forces in the oak, the wood of this tree is heavier and more resilient than any other of our native trees. The wood of the oak has the closest affinity with solid minerals [cf. Nash's *Water Boulder*], and as such the oak is the earliest of all the deciduous trees.'[498]

When Nash talks of 'personalities' in connection with ash and oak, this invites our third comparison between his work and that of Henry Moore. For in 1937, Moore himself wrote in his programmatic text *The Sculptor Speaks*: 'Each particular carving I make takes on in my mind a human or occasionally animal character and personality, and this personality controls its design and formal qualities, and makes me satisfied or dissatisfied with the work as it develops.'[499]

Nash took a very similar approach. But there are also unmistakable differences: while the younger artist sought out the existing objecthood of the tree and derived the form of the piece from this, Moore felt that the personality of a piece only formed as the work progressed. Pebbles and vertebrae

were formed into figures, because for Moore the most important thing was always the human-organic element that gave the sculpture its vitality.[500] Although Moore took on board the existing forms of his found objects, he was also always his own stage director and added his own ideas to the process. Even when he was working with wood, he would still fundamentally adhere to the plans he had laid in the preparatory maquette. And yet he, too, sought to retain the sense of a 'fluid whole' when he was working the wood for his *Reclining Figures*. As he famously said: 'What wood can do that stone cannot is give you the sense of its having grown. Stone doesn't grow – it's a deposit.'[501] Of course Moore was simplifying matters here in order to make his point. For, with its coloured layers, surprising formations and the like, stone also has its own history and is not without life.

In his large-scale pieces in wood, Moore drew attention to precisely this innate sense of growth. These works create the impression of continuing to grow, partly by virtue of the fact that Moore incorporates his image of the human being into a rhythmic continuum, which in turn connects with the temporality of the tree. By contrast, Nash – not concerned with biomorphous-abstract depictions of the human being – strives to create tree-objects that will alert his fellow human beings to the cosmic interconnections all around us in the natural world.

While we have seen Moore taking his place in the traditions of the organic whole, Nash took this tradition onto a new level where – in keeping with an ancient Chinese saying – he sought to create a dialogue between the four elements and wood, as the fifth element.[502] Thus, without exaggeration, one could say that Nash took the organic whole and extended it to create a new, cosmic terrain.

In the hands of David Nash, the reception of Henry Moore's work in his own native land bore fruit in a way that now had little to do with the at times resistant, sceptical response his work had prompted amongst artists from the generation immediately after his own. With his search for the 'fluid whole', Nash was the most likely to be able to advance Moore's main precept, namely to arrive at artistic forms on the basis of the creative, organic principles found in the natural world. Looking at Nash's work and his impressive efforts to seek out the wisdom of Nature, one has the sense that he shares something of Moore's positive outlook on life. That he, too, has drawn on Celtic traditions,[503] was attracted by the 'vibrant life' of colours[504] and is especially appreciated in Japan,[505] merely serves to underline the deeper connections between the two artists.

Henry Moore in North America

When it comes to the enthusiastic response to Moore's work by the public in the United States and Canada, the major com-

missions that he realised in New York, Chicago, Dallas, Washington and elsewhere (including the establishment of a permanent exhibition in Toronto); when it comes to the impassioned welcome that awaited his work in museums, galleries and private collections, not to mention the numerous exhibitions, awards and prizes that came his way, the reader will not be disappointed by the highly informative, well-written book published in 1973 by Henry Seldis, a journalist with the *Los Angeles Times* and an ardent admirer.[506]

In the wider expanses of the art scene in North America, the artistic response to Moore's work was by definition not hampered (as it had been in the United Kingdom) by the complicated survival strategies devised by artists living in the great man's shadow. There was a sense of connection – thanks to the shared language – but at the same time sculptors in North America were far enough away for their work not to be constantly measured against his achievements. While the reception of Moore's work in these territories deserves an entire study of its own, here we can of course do no more than outline some of the most striking positions.

By way of an introduction, it is worth bearing in mind that North America already had a thriving sculptural scene. Even before the legendary Armory Show in 1913, Rodin's huge impact in the studios of his American colleagues had already ensured that European Modernism had successfully followed suit.[507]

The 1920s and 1930s saw the advent of Archaism and Primitivism in American sculpture. The work of William Zorach (1889–1966) played an important part in this development, and he was to become one of the leading exponents of *taille directe* in the United States. A painter by training, in 1922 – under the influence of Fauvism – Zorach decided to concentrate on sculpture instead. His expressive, deliberately simple figures, groups and animals in stone or wood are moderately stylised and strikingly appealing both in their forms and in their finish. As a dedicated champion of what Moore called 'truth to material', he also shared Moore's striving for three-dimensionality, but did not share his interest in free-form holes. In his autobiography, written in much later life, he casts an interesting sidelight on Moore: 'I have never been tempted to put holes in the wrong places. There have always been holes in sculptures but they have been in the right places. No one ever put holes through the chest of a figure or cracked the skull of a figure right down the middle until Henry Moore appeared. Nor did they break sculpture into separate and almost unrelated sections. These highly stylized effects can be very interesting, a kind of personal idiom and a trademark. And yet Moore's followers are legion… but I give him credit as someone with the vision to see a possible new direction.'[508]

In the 1930s and 1940s Surrealism took hold of American sculpture, with Alexander Calder leading the way. It also left its mark on the early work of important sculptors such as

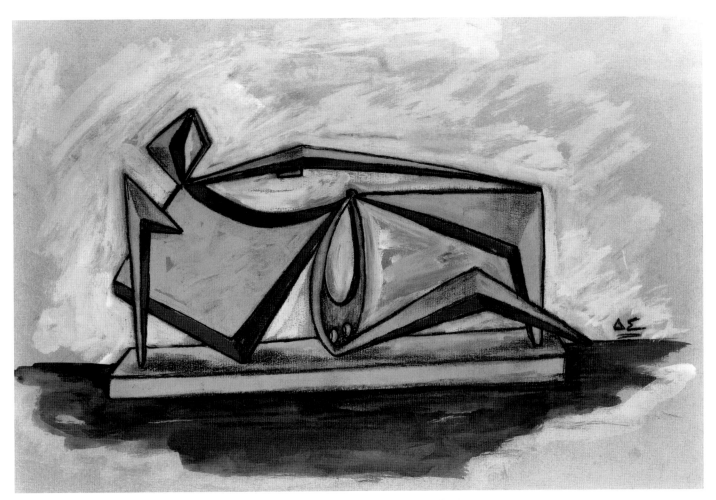

431 David Smith: *Reclining Figure*, 1939–40, Tempera on paper, 30.5 x 45.7 cm, Private Collection

David Smith and Herbert Ferber. A glance at just some of their works gives a sense of the extent to which Moore's surrealist works were known to many artists on the other side of the Atlantic.

David Smith

The influence that Picasso, Gonzalez, Giacometti and Magritte had on David Smith (1906–1965) has variously been discussed in the literature.[509] And with his curiosity for all the latest developments in the European avant-garde, he will also have paid close attention to the work Henry Moore was producing. In October 1935 Smith travelled to Europe where he spent the next nine months. Having visited Paris, Greece and Moscow he ended his trip in London.[510] In all likelihood he will have seen the major *International Surrealist Exhibition* presented in London in June–July 1936, and he is known to have owned a copy of the book *Surrealism* (with four images of works by Henry Moore) edited by Herbert Read and published to accompany the exhibition. It is also known that he read the text by George Hugnet which traces the development of surrealist

poetry back to its Romantic roots in France. Smith copied out a section from this essay at the point where the author is describing the liberating power of *écriture automatique*. Since Smith was mainly painting at the time, he altered the text so that it would apply to painting instead: '...automatism of the painting process aims at: exteriorising all man's desires, his obsessions and his despairs: it gives him the means to free himself, to venture forth… What is dream, what is reality (?) (At) what point do images begin (?)'[511]

It may well be that when Smith was in London in 1936, he found his way to the exhibition *Abstract and Concrete* at the Lefèvre Gallery, where works by Moore were shown in the company of others by Naum Gabo, Calder, Léger, Mondrian, Ben Nicholson and John Piper.[512] Smith was also a member of the circle of artists connected with the gallery owned by Curt Valentin (at that time still the Buchholz Gallery), who presented his sculptures in January 1946 and wrote the foreword to the catalogue. Besides being the most determined champion of modern sculpture in the USA, Curt Valentin was also a promoter and close friend of Henry Moore. He first showed Moore's work in New York in 1943 and was the most impor-

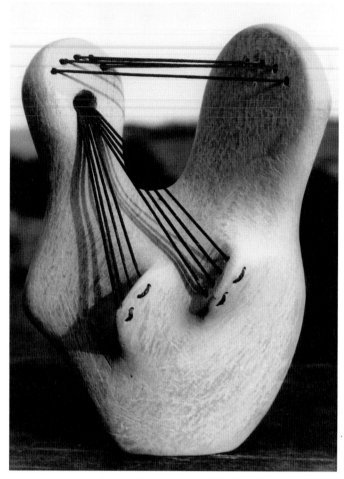

432 *Mother and Child*, 1938, Lead and wire, H. 12.7 cm, The Henry Moore Foundation (LH 186)

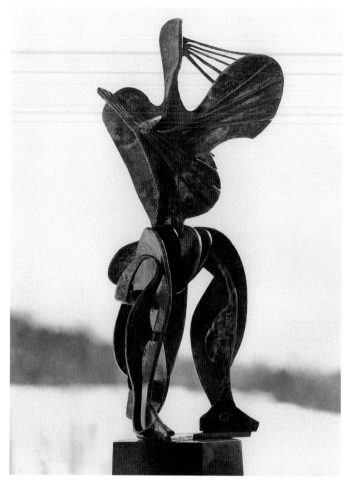

433 David Smith: *Woman Music*, 1945, Steel painted ochre, 46 x 22.2 x 16.5 cm, Private Collection, Courtesy Foundation H. Looser, Zürich

tant mediator for the retrospective presented in New York, Chicago and Los Angeles in 1946–47.[513] Hence it is fair to assume that Smith had ample access to good quality illustrations of Moore's work.

And we can indeed identify traces of Moore's influence in Smith's early Surrealist works, particularly where – rather unusually – he was exploring somewhat calmer themes. Thus Smith's tempera sketch of a *Reclining Figure* (1939–40, fig. 431)[514] looks like an angular, geometric response to Moore's *Reclining Figure* in lead of 1931 (fig. 71, 71a).[515]

1944 saw the publication of the first volume of the catalogue raisonné of Moore's work. This included an illustration of his string figure, *Mother and Child*, of 1938 (fig. 432), which may well have been the main inspiration for Smith's steel sculpture of 1945, *Woman Music* (fig. 433).[516] While Moore uses the strings to connect the mother and child, Smith uses them to connect the singer and her music.

In another work from the same period, *Reliquary House* (fig. 434), Smith engages with the Surrealists' psychoanalytical reading of objects. Taking into account the relevant sketches, Rosalind Krauss described this piece as 'an individual relic of

Smith's history as an artist'.[517] While, in Krauss's view, the lower elements were about sexuality and gender differences, the bronze object in the upper section represented a reclining female nude. The biomorphous abstraction of this figure and its inherent fluidity could both be at least partly inspired by Moore's *Reclining Figure* of 1937 (fig. 435). Smith might well have seen this splendid figure in Hopton Wood stone as it was on show in the MOMA 1946. See below 'Dates and Documents', fig. IX.

In conclusion, it is noticeable that all the parallels suggested here between the work of David Smith and that of the surrealist Henry Moore are found in works made between 1939 and 1945. At that time, Smith also made a public stand as a determined opponent of the war and a leftist Utopian with his famous *Medals for Dishonor*. In these he used a narrative, quite representational visual language whose impact he heightened by making perverse connections between human beings and machines. It was only after thoroughly working through this topic that, in the early 1960s, he arrived at his phenomenal, abstract iron sculptures. Compared to Smith's much more passionate response to the work of Picasso, Gon-

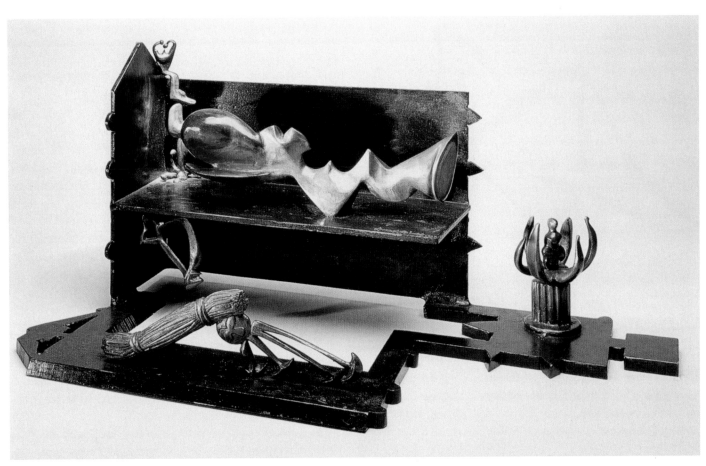

434 David Smith: *Reliquary House*, 1945, Bronze, steel, painted black, 31.75 x 64.77 x 29.84 cm, Collection Mr. and Mrs. David Mirvish, Toronto

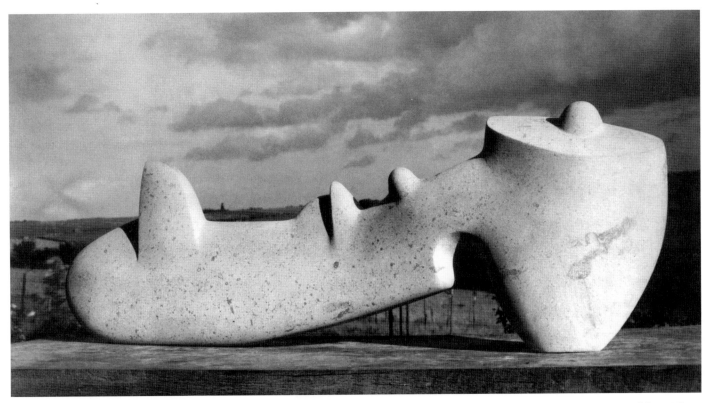

435 *Reclining Figure*, 1937, Hopton Wood stone, L. 83.82 cm, Fogg Art Museum, Harvard University Art Museums, Gift of Louis Orswell (LH 178), Boston

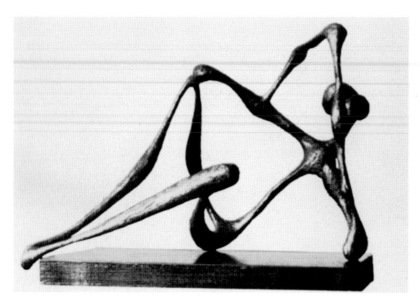

436 Herbert Ferber: *Metamorphosis I*, 1946, Bronze, 19.05 x 30.48 cm, former Collection Mark Rothko; Ilse Falk, New York

zalez and Giacometti, it seems that Moore's organic forms in his images of mother-and-child and reclining figures brought out the deeper, more contemplative side of him, for these poetic, quieter tones were also in the nature of the young Smith.

Herbert Ferber

Herbert Ferber (1906–1991) – along with David Smith, David Hare, Ibrahim Lassow, Seymour Lipton, Theodore Roscak and Louise Bourgeois – was one of a group of American sculptors who were to leave their mark on the New York School in the immediate postwar years. Amongst his closest friends were artists such as Barnett Newman, Mark Rothko and other exponents of Abstract Expressionism, although he himself was clearly not a follower of this movement. All these artists, whose work was generally greeted with blank non-comprehension, even in art museums, found spiritual refuge in the Betty Parsons Gallery. Their main concern was not commerce and making money; above all they wanted to further their ideas in discussions and through mutual support.

Herbert Ferber had his first solo exhibition at the Betty Parsons Gallery in 1947–48 and it was at this point, as he has said, that he started to see himself as 'part of an American scene'.[518] By that time he had already carved out his own path with his particular mixture of Surrealism and abstraction. He owed this clarity and self-awareness to the fact that in 1944–45 he had both engaged intensively with Moore's work and struggled to shake off the latter's influence. He, too, had first been introduced to Moore's sculptures and publications by Curt Valentin. In Ferber's case, his interest in the work of Henry Moore went hand in hand with a fascination with the

Surrealists and the surrealist art that he saw in New York at Peggy Guggenheim's Art of This Century gallery. Ferber never forgot the new artistic self-awareness he observed in the new arrivals from Europe, such as Max Ernst, André Masson, Marcel Duchamp, André Breton and Frederick Kiesler.

Ferber came across Moore's work at precisely the right moment. He had arrived at a point in his own development when he was growing out of his interest in the expressive *taille directe* of one such as Zorach and in the heavy corporeality of sculptors such as Maillol and Barlach. In his 1943 bronze, *Shadow of a Hero (Alter Ego)*, he reduces the sheer weight of the figures and allows more space for their thinned limbs.[519] This then opened his eyes to the new formal liberties that the surrealist Henry Moore was taking in his alienated, biomorphous abstract pieces.[520] Works such as *Reclining Woman I* of 1944–45[521] and *Metamorphosis I* of 1946 (fig. 436)[522] show Ferber experimenting with a new concept of space. In the second of these pieces, he advanced the notion of the hole to a new extreme. In this reclining figure he took the anatomical distortions and their emphatically linear quality and translated these into a gestural quality.[523] The balanced, coherent rhythms that Moore strove for above all in his surrealist reclining figures were of no interest to Ferber.

By pursuing a language of forms that became increasingly differentiated in its lineatures and gestures, Ferber ultimately produced outstanding work, including his 'environment sculptures'. In the end his sense of space and characteristic gestures had little to do with Moore's work, particularly when one bears in mind Moore's aversion towards over-powerful movement in his own sculptures.[524] Looking back in 1968, Ferber describes how his struggle to shake off Moore's influence bore fruit for his own art: 'I had gone through a period of being very influenced by Henry Moore. Although I didn't do any sculpture, maybe one or two small things, which might be considered to have been influenced by Moore. In fact, I spent a whole year, I think it was from 1946 to 1947, doing no sculpture at all but just doing drawings, working my way out of the Henry Moore influence. It was such a strong influence that I realized that if I were to make any sculpture it would look too much like his work. And I simply made drawings so that I could use those as a kind of catharsis, cathartic in order to get rid of the Moore influence.'[525]

Willem de Kooning

Exactly the opposite could be said of Willem de Kooning (1904–2003). He set great store by Moore's personal approval and willingly admitted this. It was only with Moore's active encouragement that the painter de Kooning dared to make the leap from three-dimensional sketches to fully-fledged works.

The background[526] to all of this is well known: on holiday in Rome in 1969, de Kooning came across an old friend, the

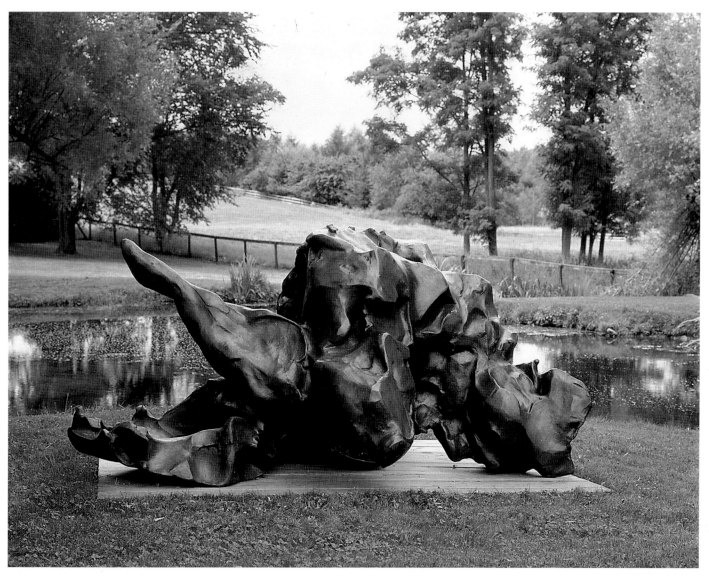

437 Willem de Kooning: *Reclining Figure*, 1969–82, Bronze, 170 x 330 x 244 cm, Private Collection

American sculptor Herzl Emanuel, who had set up a small bronze workshop just outside the city. When the two met up in Emanuel's studio, the latter pressed a piece of clay into the sixty-five year-old's hand. The spark connected and in the weeks to come, in sheer delight, de Kooning made numerous three-dimensional sketches – the size of the palm of one's hand – of sitting and reclining figures. Thirteen of these were selected to be cast in bronze, which Emanuel duly realised in editions of six. But when de Kooning had them sent to New York, they met with little response. His gallerist, Xavier Fourcade, was not particularly interested in them. Then Moore appeared. It must have been in mid-April 1970, when he was doing business in the Marlborough Gallery in New York, that he visited de Kooning and discovered the thirteen small bronzes. He was instantly enthusiastic and insisted that they had certain qualities that would come into their own if they were enlarged.

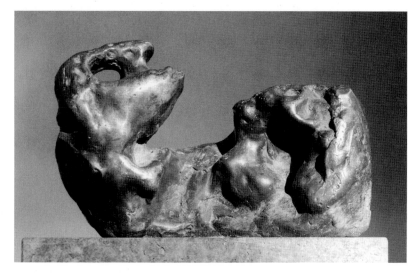

438 *Reclining Figure: Bunched, No. 2*, 1961, Bronze, L. 13.5 cm, The Henry Moore Foundation (LH 489b)

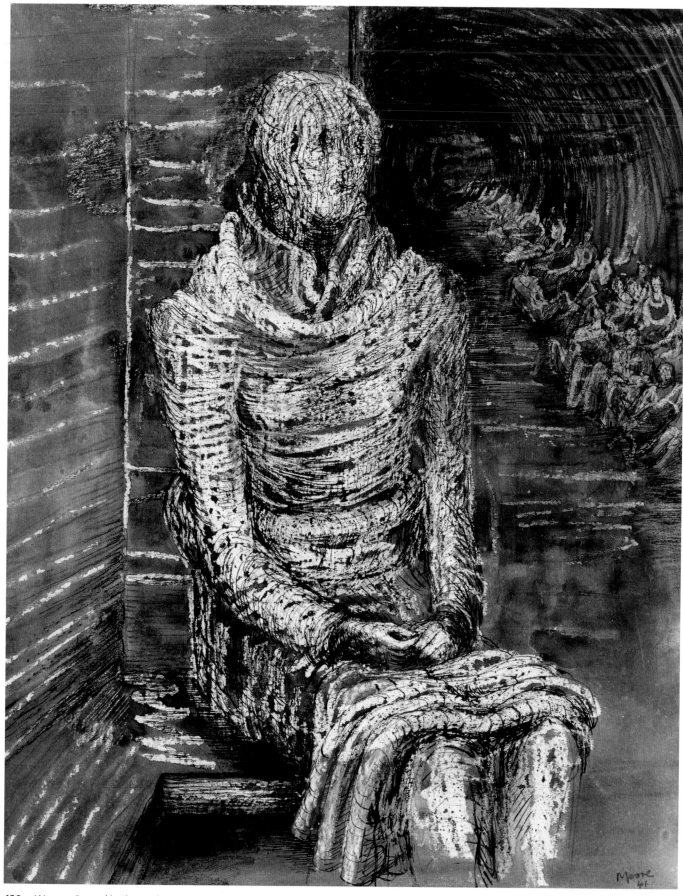

439 *Woman Seated in the Underground*, 1941, Pencil, wax crayon, coloured crayon, watercolour, pen and ink, 48.2 x 38 cm, Tate Britain, London, AG 41.78 (HMF 1828)

Years passed, but in 1980 de Kooning had a series of these first statuettes cast in larger-than-life formats. It is fascinating to see how he remained true to himself in these works. Already very well known as an Abstract Expressionist painter, he pursued the same path in his sculptures. Having painted himself free of the primal woman, in the 1960s his colours took on an unprecedented lightness, floating like clouds into and around each other. A dance of the elements ensued. Outlines of any kind were avoided. The colour forms seemed to be in a constant state of flux. Things never came to rest. Where a figure – a woman – emerged in appealing rose-coloured tones only to be hidden again by other layers of colour, it always still glowed through, often with a threatening presence.

And de Kooning wanted to retain all of these elements in his sculptures. As far as he was concerned, sculpture was painting in the third dimension.[527] How very real the connections between the two genres are in his case, is evident from the way he handled plastic forms. When he started enlarging pieces in 1980, he sought to keep the impact of his modelling hands to a minimum – making it both more perfunctory and sweeping – and worked wearing several pairs of gloves, worn one over each other. He then handled the clay in a way that always left room for spontaneity. As in his paintings, he avoided clearly defined lines and shapes. Things cohered in a fairly loose way. His figures loom into view like fleeting, dynamic *modèles* that are open to a wide variety of readings.

It almost seems that the *Reclining Figure* of 1969–82 (fig. 437)[528] has been smashed down by a huge wave. Its never fully formed shapes are still breathing, in motion, as though the figure is on the point of rising up again. In the same way that, on the painted canvas, de Kooning's colours 'emerge as pure food for the senses' and have their own 'non-referential appeal',[529] his sculptures have a similar sensuality. In these he presents the viewer with matter that is endowed and filled with life, matter through which and with which everything is possible. And as such, it is as though de Kooning is dealing with matter before it becomes form.

On that occasion in 1970 it was not by chance that Moore so readily appreciated de Kooning's first three-dimensional efforts and saw the full extent of their potential. Moore's response has its roots in his own work – in pieces such as his *Reclining Figure: Bunched, No. 2* of 1961 (fig. 438), which exists in two bronze versions, where he models his material so that its final form has the appearance of a moving, amorphous mass that has suddenly come to a stop. In comparison with de Kooning's *Reclining Figure*, Moore's figure – for all its sketchiness – is much more carefully balanced and a sense of proportion is retained in the relationship of the legs and the upper body. Indeed, returning to this piece from that of de Kooning, one sees it with new eyes.

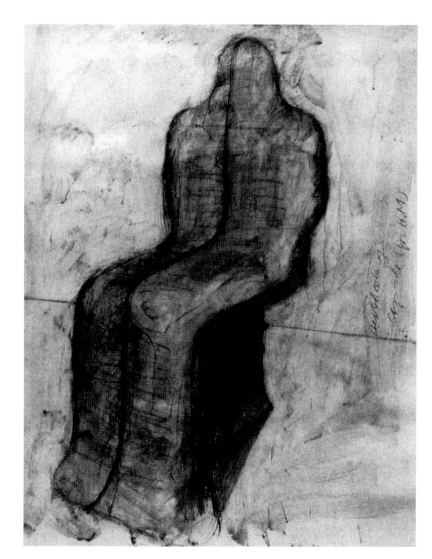

440 Bruce Nauman: *Seated Storage Capsule (for H. M.)*, Pastell and acryl on paper, 106.7 x 90.8 cm, Private Collection

Bruce Nauman

Henry Moore and Bruce Nauman (b. 1941) – what reason could there be for comparing these two artists? An American who grew up under the shadow of the injustice of the Vietnam War, permanently sensitised to any kind of political terror, an artist whose declared intention is to painfully wake up and disturb his fellow men, who regards the avoidance of style as a virtue, who deliberately makes no connections between one Action and the next as he pursues his research into human perceptions and particularly into bodily awareness in different spaces – how can this type of investigative artist (who originally studied mathematics and physics in addition to art) be inclined to engage with the work of Henry Moore?

All the works that Nauman made with an eye to Moore predate 1968, from before his first neon pieces, first video performances, his *Corridors*, his large suspended sculptures and

animal sculptures, and his wax objects. The works Nauman dedicated to Moore are early pieces made by an artist who was still exploring a whole number of possibilities. At that time he was looking at what other artists were doing. Marcel Duchamp, in his estimation, 'was just sort of in the air'.[530] In his youth he regarded May Ray as a role model[531]; he was also very aware of the Dadaists, in particular Kurt Schwitters.[532]

With the coded openness that Nauman always managed so brilliantly, in 1970 he described his working methods as a young artist to the art critic Willoughby Sharp: '...the only things that I could think of doing at that time were presenting these objects as extensions of what I was thinking about in the studio.'[533] And his *Flour Arrangements*, that he himself photographed, were for him '...a way of testing yourself to find out if you are really a professional artist. That's something I was thinking about at the time.'[534] It was at this early stage in his work, when Nauman was searching for his own path and deliberating at great length, that he made his works for Henry Moore. They constitute a self-contained group and are highly reflective.

The group starts with two works on paper entitled *Seated Storage Capsule (for H. M.)* (fig. 440) and *Seated Storage Capsule for H. M. Made of Metallic Plastic*.[535] The same motif occurs in both drawings, although on the second sheet it is smoother and more suited to being worked in metallic plastic. The idea of creating a seated figure in a markedly upright position – in an almost hieratic pose – may have come during Nauman's study of Moore's *Shelter Drawings*, the works that were to establish Moore's reputation in the United States. In the catalogue of 1946, known to everyone in the United States who was interested in Moore's work, there is a reproduction of *Woman Seated in the Underground* (fig. 439), which may well have caught Nauman's eye. The two studies by Nauman seem like a development of this motif. While the figure in Moore's drawing is waiting with stoic determination, bundled in her warm clothing, a pale shape against a dark ground, Nauman's figure is dark without individuality, encapsulated in its immobility like an Egyptian statue that merges into the stool it is seated on. Moore's ghostly figure of a woman mutates into an unapproachable, anthropomorphic box. Nauman later explained the significance of this piece to Coosje van Bruggen: bearing in mind the dominant position of Henry Moore in British art and his high reputation, Nauman decided that one day younger sculptors would have need of him, so he came up with the idea of a storage capsule to preserve him until that time.[536]

In 1966–67 Nauman took the idea of a storage capsule a stage further. In two more drawings, *Study for Henry Moore Trap* (fig. 441) and *Henry Moore Trap* (fig. 442),[537] the encapsulated figure becomes increasingly schematic and diaphanous: encircled by curved lines until it breaks up into a series of linear sections.

The trend underlying this lightening then finally leads to two photographic works: *Light Trap for H. M., No. 1* and *Light Trap for H. M., No. 2* (fig. 443 and fig. 444). Along similar lines to Picasso's famous film by Gjon Mili (made in 1949), Nauman used a torch in a darkened room to create spiral lines – now wider, now narrower – tracing the outlines of imaginary Henry Moore figures. While the first seems to recall the shape of the *Seated Storage Capsule*, in the second the lines of light merge more densely around a wholly upright figure. In her discussion of these two photographs from 1967, Dörte Zbikowski has suggested that the figure 'is represented by its casing. Nauman heightens the immaterial nature of its absence by depicting the casing as a light spiral.'[538] Or, as Nauman himself put it: Moore has fallen into the light trap, the casing and light have melted into each other as one.[539]

In the abovementioned MoMA catalogue, Nauman may well also have been struck by the watercolour *Crowd Looking at a Tied-up Object* of 1942 (fig. 445).[540] This image of a trussed up object is very much in the surrealist tradition of Man Ray's object *L'énigme d'Isodore Ducasse*. And in 1967 this led directly to Nauman's wax model, subsequently cast in iron: *Henry Moore Bound to Fail* (fig. 446).[541] This piece portrays a section of the artist's headless upper body, seen from behind and with his arms tied behind his back. It is based on a coloured photograph entitled *Bound to Fail*, which shows part of the artist's back, in a pullover and with his arms tied back. Nauman made yet another version of this, in reverse, in a swiftly executed charcoal drawing[542] The German translation of the title *Bound to Fail* ('Muss ja schief gehen'[543] or 'Zum Scheitern verurteilt'[544]) concentrates solely on the notion of failure, inviting an emotional reaction and direct response from the viewer.

Beatrice von Bismarck felt that the work could be 'interpreted as symptomatic of the burden of the artist's vocation'.[545] This suggestion arises from Nauman's own, very telling comment on this piece in 1972: 'Well, that piece comes out two ways. It comes out *Henry Moore Bound to Fail*, and just *Bound to Fail*, which is more general. But there were several pieces that dealt with Henry Moore at that time, and they had to do with the emergence of the new English sculptors, Anthony Caro and William Tucker and several other people. There was a lot written about them and… some of them sort of bad-mouthed Henry Moore – that the way Moore made work was old-fashioned and oppressive and all the people were really held down by his importance. He kept other people from being able to do work that anyone would pay attention to. So he was being put down, shoved aside, and the idea I had at the time was that while it was probably true to a certain extent, they should really hang on to Henry Moore, because he really did some good work and they might need him again sometime.'[546]

Nauman's remarks are usually cited up to this point. But Lorraine Sciarra, who was conducting the conversation with

441 Bruce Nauman: *Study for Henry Moore Trap*, 1966/67, Feder und Acryl auf Papier, 106.7 x 83.8 cm, Private Collection

442 Bruce Nauman: *Henry Moore Trap*, 1966, Bleistift, 106.7 x 76.2 cm, Private Collection

443 Bruce Nauman: *Light Trap for H. M., No. 1*, Black and White Photography, 162.6 x 101.6 cm, Sperone West Water, New York

444 Bruce Nauman: *Light Trap for H. M., No. 2*, Black and White Photography, 170.1 x 101.6 cm, Private Collection

445 *Crowd Looking at a Tied-up Object*, 1942, Pencil, wax-crayon, charcoal (rubbed), watercolour wash, pen and ink, 43.2 x 55.9 cm,
The British Museum, London: from the Estate of Lord Clark, AG 42.174 (HMF 2064)

Nauman, immediately responded with the question: 'Another anchor?' To which the artist replied: 'Right, and that's what I was thinking about.'[547]

An astonishing remark: Moore as an anchor for future use? It is in keeping with Nauman's later explanation for Coosje van Bruggen concerning his 'storage capsule for Henry Moore', in the sense that he might be useful one day. And in order to focus on Moore as this anchor, Nauman created his *Henry Moore Bound to Fail*; as a good student of Wittgenstein, he gave it a duly ambiguous title. Perhaps it can even be taken quite literally: Moore's hands are tied by critical comment and seems doomed to failure, but will free himself at some point in the future and his work will come to the rescue of future generations of artists.

Was that the main thought behind Nauman's cast-iron object? In my view this seems highly likely, particularly in light of other areas in which – despite their very different approaches – there is a degree of contact between the two. For: Moore's main focus was on form, Nauman's was on body awareness. Nauman was interested in 'bodily reactions, unaffected by learning processes, and their impact on a person's state of mind'. [548]

In their work both artists convey a polarised view of space. In Moore's case the sculptural form integrates with the space; in Nauman's case human beings are needed to complete the spatial installation. Nauman's spatial zones are unsettling, creating in the viewer a sense of uncertainty and anxiety,[549] of being under threat. While Moore, in his early *Reclining Figures* carved in wood drew the active viewer into a rhythmic sequence of events that calms the soul like a figure of eight folding back in on itself, in Nauman's work – in the *Corridor* works for instance – viewers can find themselves merci-

lessly manipulated by the spatial layout of the piece. Viewers have to use their balance or sense of hearing and/or sight or their sense of orientation to react in a particular way, or to fail.[550]

In her discussion of Nauman's *Corridor* installations (1969–71), Melitta Kliege has noted 'that Nauman always connects two heterogeneous spaces and juxtaposes spatial qualities by creating a contrast with the surrounding, neutral exhibition space and incorporating it into his installation. Precisely the difference between inside and outside, between a brightly lit space and a darkened one, or between coloured and non-coloured surroundings allows the viewer to perceive both qualities, making a connection with one or other space.'[551]

This observation touches on Nauman's pronounced awareness of the differences between inside and outside,[552] although these are played out in spatial situations rather than, as in Moore's case, in form-in-form compositions. In addition to this, there is also the fact that both Moore and Nauman rely on drawing as the basis of all their artistic undertakings. And in his own way, Nauman also attaches great importance to rhythm. The differences between the two artists that unmistakably come to light, arise from their contrasting natures that were formed in very different eras.

As we saw in Part II of this study, in Moore's estimation rhythm was bound up with the equivalence of form and space. He specifically learnt from the forms and rhythms of the natural world and incorporated what he had discovered, in a mediated form, into his own artistic works. In his case the intrinsic, rhythmic articulation of the forms and spaces gave his works a sense of direction, a beginning and an end, and hence a life of their own. It was only the innate rhythms of a piece that gave it cohesion within the organic whole of its flowing changes of direction. In Moore's view rhythm and balance were the most powerful contributors to a work's vitality.[553] Thus rhythm in Moore's work could be described as the essential substratum for his organic approach to form.

By contrast, in Nauman's case rhythm is either about sound[554] – as in the early video *Rhythmic Stamping in the Studio* and in his serial repetitions of speech rhythms – or it can be generated by the repetition of the same body movements intended to set in motion certain 'mental exercises'. The following observations relate to the wider context of the different attitudes to rhythm in the work of these two artists.

In 1966 Moore made two marble versions of a composition that consisted of three rings set out along a curved line, *Three Rings* (fig. 447). As is to be expected, he does not rely here on mathematically exact circles, but prefers more freely formed elements, thicker here, with a larger hole there, that have been made with an eye to the interaction of the different views they afford. In our discussion of similar configurations made up of two elements, we talked earlier of the variety of forms derived from a single dynamic, rhythmic entity.[555]

446 Bruce Nauman: *Henry Moore Bound to Fail*, 1967/1970, Cast in iron, 64.8 x 61 x 6.4 cm, Sperone West Water, New York

At first sight, Nauman's *Study for Untitled (Model for Trench, Shaft and Tunnel)* of 1977 (fig. 448) might appear to be similarly coherent. With the piece already partly executed as plastic models, Nauman combines three rings 'whose triangular sections always open in a different direction. This in turn led to a configuration where the pieces touch in different ways: flat contact, edge against edge and mutual interpenetration. Thus the rings form new entities, but with their different colourations, do not relinquish their individuality. The large entities are not fully exploited in a liberated sculpture, but also literally relate to the space which they help to define as permeable drawings.'[556] What Siegmar Holsten reads as a spatial work of art[557] was conceived by Nauman as a model for three huge circular tunnels to be constructed underground.[558] Beckett had been his inspiration for this piece.[559] The idea was that people would run round and round inside these circles. With this extreme concept, Nauman – as he himself explained – was making a protest against the political ter-

447 *Three Rings*, 1966, Red travertine marble, L. 261.6 cm, Mrs. Robert Levi, Maryland, USA (LH 549)

ror that reigned in parts of Latin America, and he was publicising his critical stance by creating metaphors of an underground situation where there was no hope of escape.[560] By turning the notion of helplessness into a tangible, physical experience, Nauman was hoping that those who encountered his work would come to a higher level of self-awareness and body awareness. Now, in 1977, art was connecting with life in a way that the Surrealists may have championed in theory but which they would never dared to have implemented with the same logical determination as Bruce Nauman.

Moore, on the other hand, produced his work in the certainty of the strength that could be conveyed by the idea of a form *per se*. His work was to bear witness to an inner spiritual vitality. The creative horizon in which his notion of form was embedded was all around him, in the parklands he had designed himself and in the English countryside as a whole. In the United States there was no similar, organic historical context for Nauman. Yet his art was also about describing a

path[561] – a path that was to lead directly into society. Nauman saw himself as an American successor to Joseph Beuys. And no doubt it was partly for this reason that he was able to grasp the value of Moore's art as an 'anchor' to be appreciated and preserved.

Further Afield: Japan and the Eastern Bloc

There is a great temptation to examine the impact of Henry Moore's work elsewhere in the world with the same intensity as in the above cases. However, to do so would be to completely skew the proportions of this study. In presenting this glimpse of studio practices further afield, with information on some of the relevant literature, the hope is that other scholars or scholarly teams will take up the baton at this point. Moore would be the perfect focus for a meaningfully globalised study of art history. For there would be much to be gained

448 Bruce Nauman: *Study for Untitled (Model for Trench, Shaft and Tunnel)*, 1977, Charcoal and pencil on paper, 156 x 214 cm, Collection Kröller-Müller Museum, Otterlo, the Netherlands

not only from examining what we can discover through the eyes of other artists responding to his work but also – and no less fascinating – which cultural legacies (with their own historical developments) shaped these responses.

Henry Moore in Japan

Well before the idea of a Henry Moore exhibition had even been floated at home, interested parties in Japan were already making contact with England.[562] Moreover, when it seemed that Herbert Read's first monograph was not selling well in pre-war England, stocks were shipped in bulk to Japan and sold there. Thus by 1935/36 Moore was already known to the Japanese avant-garde as an exponent of Surrealism. Much of what followed was to the credit of the poet and art critic Shuzo Takiguchi (1903–1979).[563] Not only did he translate Herbert Read's *Meaning of Art*, but even as a young man was also one of the most important advocates for Surrealist art in

Japan. In a review published in November 1936 in the magazine *Mizue* (no. 381), he discussed the *International Surrealist Exhibition* held in London, and in June 1937 he and André Breton presented the exhibition *Exposition Internationale du Surréalisme* in Tokyo. This presentation included photographs of works by Moore.[564] Other illustrated articles followed (up until 1938) with Takiguchi already making a clear distinction between Moore's position and that of the Surrealists.

The Second World War brought everything to a halt, but by 1950 Shuzo Takiguchi was already publishing articles about Henry Moore again. In 1953 a work by Moore was shown in the group exhibition *Modern Sculpture: Japan and the West* at the National Museum for Modern Art in Tokyo. In 1959 the British Council presented its first exhibition of Moore's work in Japan, which toured seven cities: Tokyo, Osaka, Takamatsu, Yawata, Hiroshima, Ube and Nakamura. On show were fifteen sculptures and thirty drawings. For the first time, members of the Japanese public were able to experience Moore's work

first hand. At the time Takiguchi made the point that some of Moore's rock-like formations had an affinity with the stones in Japanese gardens.[565] This 1959 exhibition, which proved to be of great importance, was to make an impact throughout the country, notably in Tokyo, Osaka, Hiroshima and at the Hakone Open-Air Museum. Later on there were to be more important exhibitions, four of which we will highlight here.

In 1969–70 the National Museum for Modern Art in Tokyo, with the support of the British Council, presented an exhibition of Moore's work comprising sixty-five sculptures and thirty-two drawings. In the introduction to the catalogue, David Thompson wrote of the power of Moore's forms to touch a deeper chord in the viewer's subconscious: 'We become aware of forces which can be both exhilarating and frightening.' With regard to the figures in the Shelter Drawings he wrote that in a sense these could be read as 'both the unborn in the womb and the dead in their winding-sheets'. In the most recent works from the 1960s he saw 'a new sense of the tremendous'. In his view these were ambiguous, unsettling and reassuring all in one. Now bones were increasingly serving as models and, once enlarged created effects that, in Thompson's view, ranged from wild to appealing to light-hearted.[566]

In 1974 the Kamakura Museum for Modern Art in Tokyo presented a retrospective with eighty-three sculptures. In the accompanying catalogue, the sculptor and art writer Yoshikuni Iida (b. 1923) described Moore's work as having a place somewhere between the human figure and infinity. Meanwhile B. Inque regarded the holes in Moore's sculptures as indefinable and mysterious, affording the viewer a brief glimpse into eternity.[567]

From April to July 1986, when Moore was still alive, he enjoyed a major triumph in another exhibition presented by the British Council, this time at the Metropolitan Museum of Art in Tokyo and at the Fukuoka Art Museum. This exhibition attracted 35,000 visitors and was widely covered by the press, television and radio. Prince Hironomiya toured the exhibition in Tokyo with David Mitchinson of the Henry Moore Foundation; he was visibly moved by the experience.

In 2004, the Hakone Open-Air Museum presented an exhibition of 160 sculptures entitled Henry Moore. The Expanse of Nature. The Nature of Man to celebrate its foundation in 1969. The ethos of the museum has a close affinity with Moore's own approach to works of art in natural surroundings. In 1968 the media baron and founder of the museum, Nobutaka Shikanei, had visited Moore in Much Hadham. Deeply affected by the sight of Moore's sculptures in the natural landscape, he decided to found an open-air museum at the foot of the Hakone Mountains. In 1986, not long after the death of Henry Moore, he bought (at the cost of ten million dollars) sixteen sculptures by Moore from the oil magnate George Ablah in Kansas.[568] These formed the basis of the museum's present collection of twenty-six works.[569] Following this spectacular

purchase, on 2 October 1986 Susan Chira, writing in the New York Times, alluded to the great popularity that Moore enjoyed in Japan. She also made a particular point of the conceptual affinity between a rock in a Japanese garden and Moore's artistic work.

In addition to the many exhibitions and instances of Moore's work in Japanese museum collections, there have also been major purchases of pieces for display in public spaces. Typical of these is the acquisition of Large Torso Arch of 1963–69 by the City of Hiroshima in 1986. Two years later this bronze, measuring six metres in height, was installed outside the Modern Art Museum – a symbol of the city's indomitable will to life (fig. 449).

Moore's image in Japan was also importantly shaped by Japanese sculptors.[570] As early as November 1951 Atsuo Imaizumi visited Moore in his studio in Much Hadham; soon after this he wrote an article[571] in which he talked of Moore's preference for placing his works in the natural landscape and that he regarded them more as organic constructions than as abstract creations. In conversation with his Japanese colleague, Moore once again referred to the great importance of drawing and spoke openly both of his admiration for Arp, Brancusi and Giacometti and of his antipathy to the work of Zadkine.[572] Interestingly, Atsuo Imaizumi described Moore, the man, as being 'somehow just like an ancient animist'.

In the years to come there were more sculptors who actively admired Moore's work, most notably Kakuzo Tatehata (1919–2006) and Yoshikuni Iida, whom we have already mentioned. The attitude of the first of these was described in 1986 by Masahiro Ushiroshoji, Curator of the Fukuoka Museum, in the catalogue of the major Moore exhibition in Tokyo and Fukuoka that he co-supervised. His article, 'Henry Moore from the View Points of Japanese Sculptors'[573] indicates that in the period 1959–69, when Tatehata was writing about his English colleague, he expressed his admiration for two aspects of Moore's work in particular: firstly the way that – by cutting holes through his sculptures – Moore had been the first to engage with the coexistence of forms and empty spaces as a sculptural issue. In Tatehata's view, the value of the 'negative space' had hitherto been completely overlooked in traditional sculpture. At this point Masahiro Ushiroshoji comments that many Japanese sculptors took the same view, and cites Yoshitatsu in this connection who felt as though he were drawn into a debate that was under way in Moore's drawings and sculptures, a debate 'between the hollowness and the realness'. Secondly, Tatehata also discussed Moore's Shelter Drawings and the way that Moore had been able to bring his humanist attitude to bear on these depictions of resistance in the face of the cruelties of war.

Yoshikuni Iida was one of the many Japanese visitors who sought out Moore at his home in Much Hadham. According to the records[574] he was there in 1980 and 1982. In his autobiog-

449 *Large Torso Arch*, 1963–69, Bronze, H. 610 cm, Modern Art Museum, Hiroshima (LH 503b)

raphy of 1991 he devotes a whole chapter to Henry Moore. He first saw Moore's work firsthand in Vienna.[575] In his eyes Moore had uncovered universal values in sculpture and this had greatly inspired him in his own work.[576] The book on Moore that Iida published (with Tatehata) in 1986 and the documentary film he made of Moore's life and work in 1990 for Japanese television (N.H.K's Educational Channel), both sought to define Moore's position in the history of art. It is also not without significance that, looking back on his visit in 1980, Iida made the point that in their conversations, Moore had avoided any kind of philosophical discussion, preferring instead to concentrate on aspects of his studio praxis such as the genesis of the holes in his sculptures, the forms he arrived at and the issues that concerned him regarding the materials he used.[577] Many will have registered this apparently pragmatic approach. However, as we saw in Part II, Moore most certainly did have his own theories. He handled them purely intuitively and was always able to put across the key concepts in his theories with great eloquence, be it in conversation or on paper. However, he had no interest in systematically reflecting on them in any art-historical context.

Ushiroshoji's account of the situation in the 1986 catalogue also made the point that besides the areas of contact already outlined here, many Japanese sculptors (such as the above-mentioned museum founder Nobutaka Shikanei) were particularly fascinated by Moore's view of the natural world. Many had observed the degree to which his imaginary organic forms were derived from the close observation of natural forms. Connected with *grand nature* in this way, Moore's work tapped into the subconscious which was, in Ushiroshoji's view, instinctively at one with Nature. Similar sentiments are found in Japanese press reports which talk, amongst other things, of a religious undertone[578] or an air of mystery[579] in Moore's work.

It was not by chance that the response in Japan was so strikingly sensitive and reflective, and ultimately it raises the question as to whether the religious and philosophical traditions of that country had not in fact perfectly prepared the ground for Moore's broad acceptance. Moore, for his part, saw no immediate connection between himself and Japan. Once he remarked that although he admired Japanese art he had never been influenced by it, only to add, 'But I suppose that everything which one appreciates must have some influence even though one isn't aware of it.'[580]

Nevertheless, Moore's friend of many years, the writer Maurice Ash was convinced – as a follower of Zen Buddhism – that there was an affinity with the Japanese psyche in Moore's work.[581] Although Moore was never particularly interested in Zen Buddhism, Ash made the point that the reality that Moore captured in his sculptures was not representational but much more mysterious in its nature. He saw emptiness in Moore's work – 'sunyata'. And in his view a sculpture

of this kind was 'the product of "the non-observing self"'. For Ash, a sculpture by Moore 'may be seen as a koan in stone or bronze'. Furthermore, Moore's work contained animist connotations, and his stone sculptures would be best placed in the contemplative garden of a Zen temple. In conclusion, Ash declares that for him Moore's sculptures were like meditation objects. They were not merely about worldly relationships, since they had nothing to do with mimetic description, in his view. It was their openness and emptiness that made them so mysterious.

When Ash declares that Moore's sculptures 'may be seen as a koan in stone or bronze', his use of the conditional tense should not be overlooked. In Zen Buddhism, a koan is in essence an expression of the harmony between empty oneness and the world of single things.[582] Perhaps the practising Zen Buddhist Maurice Ash saw the sculptures of Henry Moore, his friend of over thirty years, as a doorway to this harmony.

Ash's view was reflected in those of the Japanese artists mentioned above. In 1951 Atsuo Imaizumi was already describing the English sculptor as an 'ancient animist' because of his close contact with the natural world. And Ash used the same term. Elsewhere, other Japanese writers constantly returned to concepts such as 'eternity', 'mystery' and 'minus space'. More often than not it is clear that for the Japanese artists and writers who encountered the art of Henry Moore, their response to his work was crucially coloured by their own philosophical and religious traditions.

In this context there are two particularly important points of contact. Firstly there is the Japanese appreciation of the holes and spaces in Moore's sculptures, which clearly came from the Zen Buddhist teachings concerning universal emptiness or, in other words, the plenitude of nothingness. Moore would no doubt have found this approach too indeterminate; after all, in his eyes the spaces were never empty but an intrinsic component in the dialogue of the piece and, as such, tangibly present to the viewer's mind and senses.

Secondly, the repeated comparisons between Moore's rock-like forms and the carefully selected and arranged stones in Japanese gardens is completely in keeping with the Japanese nation's familiarity with the symbolic meanings of such stones. With specific references to mountains and watercourses, the Japanese garden is a replica of the landscape and an expression of the makers' longing to be in harmony with the landscape. It was this potential for a harmonious relationship with the landscape that Shuji Yashiro saw in Moore's *Two Piece Reclining Figure* of 1960 (fig. 357)[583] and that prompted him to write of the fundamental connection between Moore's work and the concept of harmony that was at the heart of the Japanese stone garden.[584]

It is a well-known fact that after the Second World War, Zen Buddhism attracted greater numbers of followers, and also met with considerable interest amongst artists in Europe

and North America.[585] 1949 saw the founding in Munich of the group ZEN 49. The members of the group (the South-German group consisted of Willi Baumeister, Fritz Winter, Rolf Cavael, Rupprecht Geiger, Gerhard Fietz, Brigitte Matschinsky-Denninghoff, Willi Hempel and Theodor Werner[586]) were united in their admiration for Eugen Herrigel's book *Zen in the Art of Archery*.[587] These artists regarded Eastern meditation and the contemplation of inner experiences in the same light as engagement with the spiritual values of abstraction. Outside Germany it was above all the Japanese-American sculptor Isamu Noguchi (1904–1988), whose work (as a sculptor and garden designer) was largely founded on Zen Buddhism, albeit combined with input from the work of the modernist Brancusi and the surrealist Giacometti.[588]

It is not surprising that in Japan Moore's work was associated with the principles of Zen Buddhism and interpreted in terms of emptiness, spiritualised Nature, the unconscious and the koan. Without doubt this was the main source of his immense popularity. In addition to this, numerous reviews pointing out the harmonious nature of Moore's sculptures attest to the extreme desire – after two atomic attacks – for peace. This social and political response to Moore's work also in part accounts for the high status it still enjoys in Japan today.

Henry Moore in Russia

It is clear that for many years there was no room for Moore in Stalinist Russia, where for decades there was a total ban on any kind of Formalism and where sculpture had been demoted to the monumental stooge of a gigantic cult of the individual. The official scorn that was poured on the head of artists such as Henry Moore is typified in the response of Vladimir Kemenov, editor of *Voks Bulletin*, the voice of the Society for International Cultural Relations in the Soviet Union. In 1947 he took Moore's work as evidence of the 'pitiable decline of modern bourgeois civilisation'. According to Kemenov, in his *Family Group*[589] Moore had turned 'man, woman and child into repulsive animals with reptilian heads. The appearance of these repugnant creatures is an attack on the human race. His more abstract sculptures are an attempt to destroy all that is humane in human beings, and to make way for the animal with all its primitive instincts.' Moreover, in future assessments of bourgeois civilisation and the epoch of imperialism, Moore – along with Picasso and Lipchitz – would, according to Kemenov, be of interest to psychiatrists, not to art experts.[590]

Attacks of this kind, by no means unusual at the time, which had ominous echoes of the National Socialists' baiting of so-called degenerate artists, were only to let up after the death of Stalin (5 March 1953), when a brief thaw set in in cultural politics as a consequence of Khrushchev's policy of de-Stalinisation in 1956. However, this threatened to come to an

end again following the furore surrounding the infamous Manege exhibition in late 1962[591] and was finally over when Brezhnev came to power in 1964. Nevertheless, the first tentative contact with artists abroad could not be reversed. The few artists determined to open their minds to Modernism were forced underground in order to survive, where they continued to experiment – generally only supported by their closest friends.

The resulting secret reception of the work of Henry Moore was outlined by Sergei Kuskow in 1991 in the catalogue that accompanied the first Moore exhibition on Russian soil.[592] In Kuskow's account, the 'unofficial' sculptors' prime interest was always in the work of Henry Moore, which they pursued as and when they could, even before they turned their attention to the work of other sculptors such as Zadkine, Brancusi, Giacometti, Archipenko, Lipchitz and Naum Gabo.[593] Kuskow's explanation for this was that, to these artists, 'Moore embodied the whole of the history of contemporary sculpture since Cubism, Post-Cubism and other geometric tendencies in the 1910s and 1920s… On one hand Moore's art reflected the trends that were not allowed to develop in the Soviet Union – these included the abstract and surrealist sculpture in the 1930s and in the immediate postwar period. On the other hand, it was also attractive by virtue of the powerful individuality expressed by an artist whose work could not directly be ascribed to any one art movement. Above all the Soviet artists were drawn to Moore's remarkable affinity with the natural world.'[594]

Furthermore, they were also fascinated by Moore's approach to nature and the study of natural forms that was so different to what they had experienced in their own art academies. These artists working underground, looking at the work of this Western artist, were above all moved by his individuality, independence, imagination and honesty.

For the artists of the Russian avant-garde, who had no hope of showing their work in public, no hope of a wider response, no commissions and certainly no exposure in publications, their admiration for Moore's work was part of their own survival strategy. They took courage from an artist such as Moore, who was faithful to his own moral principles and to himself. For artists who were able to defy an unjust regime merely by continuing to produce their own creative work, everything took on an existential dimension. Their engagement with the work of an artist of their choice was by no means solely about artistic preferences. There was so much more at play here.

In this context, the work of the internationally renowned Russian sculptor Vadim Sidur casts a telling light on the situation as a whole. Both Kuskow and Ernst Neizvestny (b. 1926) regarded his work in the same light as that of Henry Moore. Yet it seems to me that Neizvestny (b. 1926), without question one of the most important Russian sculptors of our time, was

450 Vadim Sidur: *Seated Woman*, 1963, Bronze, 17 x 7 x 8 cm, Sidur Estate

following more in the footsteps of Rodin and Lipchitz. He has freely pointed out on a number of occasions that he also values Moore's work very highly.[595]

Vadim Sidur

Vadim Sidur (1924–1986) was born in Dnepropetrovsk in the Ukraine.[596] During the Second World War he won a number of medals and awards for bravery. In 1944 a German sniper's bullet shattered his jaw. Miraculously he survived the ensuing operations and the trauma of finding himself in a military hospital surrounded by extreme suffering and death. Having abandoned his plans to become a doctor, he enrolled at the then Stroganov Moscow State University of Arts and Industry, where he studied monumental sculpture. He graduated in 1953, the same year that Stalin died, and found employment as a sculptor working on architectural projects. He became a member of the Union of Artists of the USSR and was given a

100-square-metre basement studio on the Komsomolsky Prospect in Moscow. He retained this basement studio until the end of his life and it was here that he welcomed artist-friends and numerous admirers from the West such as Heinrich Böll, Lew Kopelew and Siegfried Salzmann, Director of the Lehmbruck Museum in Duisburg.

Sidur's œuvre, recorded in a catalogue raisonné published by Bochum Museum in 1984,[597] is filled with surprising twists and turns. It was only in the late 1950s and early 1960s, when the temporary 'thaw' set in, that he was able to break free from the coarse Classicism of official Soviet sculpture. At that time catalogues of the work of Western sculptors were already circulating underground, although we have no way of knowing for certain how much he might have seen of the work of artists such as Moore, Lipchitz and Archipenko. Yet whatever the source, there was a move to embark on a new, greatly simplified form of representative figuration, and it is astonishing to see with what speed and consistency Sidur

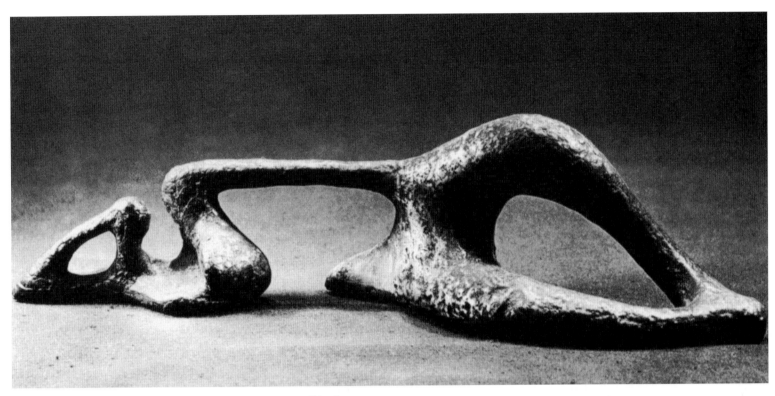

451 Vadim Sidur: *Lying Female*, 1963, Bronze, 7.5 x 30 x 7 cm, Sidur Estate

worked his way through the development of modern sculpture since Rodin. He worked in *taille directe*, tried out Archaism (*Seated Troll* of 1957),[598] created reduced, rhythmic bands (influenced by Lipchitz' *Embrace* of 1928[599]) as in *Connections (Tenderness)* of 1963[600] and *The Victims of Violence* of 1965[601] – installed in Kassel in 1974 thanks to a citizens' initiative – and at times even adopted the organic language of forms of one such as Henry Moore.

This connection is seen very clearly in two small-format bronzes of 1963. In these we observe Moore's diction (small head, thin arms, swelling, flowing body) applied to a *Seated Woman* (fig. 450)[602] and to a *Lying Female* (fig. 451).[603] Evidently Sidur's interest in these pieces was in their linear dynamics – an interest that later sometimes even took him into the realms of ornament. And even later on, there are still echoes of Moore's approach, as in his wooden steles of *The Holy Family* (1973),[604] which openly draw on prehistoric Russian idols. Moreover, Sidur – like Moore visiting the British Museum – studied the 'world language of sculpture' in Moscow's museums, where he was particularly attracted to Assyrian-Babylonian, Egyptian and early Greek sculptures.

Ultimately, having followed entirely his own path, Sidur arrived at an almost identical point to Moore: in 1976 he finished his *Structure, No. 1* (fig. 452)[605] and was able to install this – rare – commissioned work outside the Institute for Human Morphology in Moscow. The fifteen-metre long cement sculpture, with its intricately interlocking bands can be read as a tribute to the various corresponding life processes in human existence. Moore would certainly have respected a work such as this, had he been fortunate enough to see it first-hand.

These connections with the work of the English sculptor are, however, no more than isolated moments of calm in Sidur's œuvre. Seen in the wider context of his work, they are swept along in the current of an art that avails itself of hugely diverse genres and styles, even including 'coffin art' made from waste materials, with memorable, often harsh figures and forms screaming their protest against war, violence, stupidity and all the various forms of decay that can affect present-day society. In so doing Sidur often drew inspiration from the Bible and was well capable of creating – both on paper and as sculptural forms – compelling images of distressed prophets and a deeply serious Christ figure.

'The miracle of all miracles – the fact of having survived the meat-grinder of the war unscathed'[606] – served the artist as a constant spur to alert his fellow men to all forms of injustice. He made this comment in 1980 in conversation with the Slavist Karl Eimermacher, who 'discovered' him in the West and later became his mentor. In response to Eimermacher's question as to the main difference between his art and Western art, Sidur suggested that in the world model favoured by many Western artists, the human being was completely absent; he, on the other hand, had no interest in a world without people.[607]

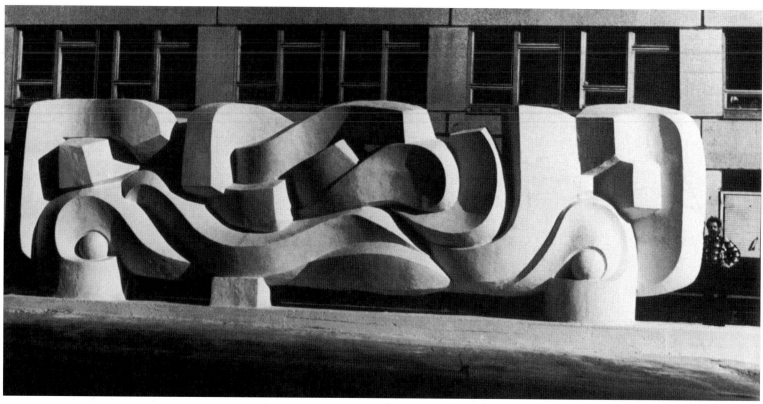

452 Vadim Sidur: *Structure, No. 1*, 1976, Concrete, 4 x 15 x 2.5 m, Institute for Human Morphology, Moscow

Sidur's determination to serve human beings by playing his part in life explains his personal connection to the figurative Moore. More than this, it is also typical of an approach to art that was very much in evidence amongst sculptors in the Eastern Bloc and amongst the majority of their fellow-artists in the former GDR. That abstract art can also be concerned with people's hearts and minds and is often determined by real-life experiences is another story all of its own. In Sidur's case, there was also the fact that, with his highly socially aware art, he was operating in the same realms as one such as Leo Tolstoy. Even as a child he was drawn to Ilya Repin's famous portrait of Tolstoy seated in a chair, which he saw as reproductions in shop windows in his neighbourhood. At the age of fifteen he made a small plasticine statuette after this painting.[608] This little piece was destroyed in the war – a loss that still troubled the artist even as an old man.

If Sidur's insistence on a human presence was typical of the Eastern Bloc, this approach still prevailed in the post-Soviet era. In 1991 the curators of the first exhibition of the work of Henry Moore in Russia (at the Pushkin Museum in Moscow and at the Peterhof in St. Petersburg) deliberately selected works that highlighted Moore's 'human dimension', with the emphasis on figurative sculptures; they also increased the number of *Shelter Drawings* they had originally planned to show.[609] The many visitors who crowded into the exhibition responded with enthusiasm and gratitude.

Henry Moore in Poland

The Russian olive branch of 1991 was preceded by a number of other exhibitions behind the Iron Curtain organised by the British Council. With political resistance most daunting in Russia, it had not been possible to do anything there before. Not so in Yugoslavia, Poland, Romania, Czechoslovakia and Hungary. Here Moore's work had already been seen and well received by an interested public in Belgrade (1955), Warsaw and other Polish cities (1959), Bucharest (1966), Prague (1966) and Budapest (1967).[610]

Immediately after the war, in 1946–47, when the cultural and political divide between West and East had not yet started to freeze over, the Tate Gallery – under the aegis of its Director, John Rothenstein – sent out a touring exhibition of contemporary British art. It went to Brussels, Paris, Rome, Vienna, Budapest, Prague and Warsaw. Amongst the exhibits were eight *Shelter-Drawings*. Katarzyna Murawska-Muthesius has described the way that in Warsaw, with its long Francophile traditions, the public were particularly appreciative of Moore's formal innovations.

After 1949, with the increasing dominance of the Soviet Union, the Polish authorities now insisted with brutal force that Socialist Realism was the only acceptable style, to the exclusion of all others. Nevertheless, reproductions of works by Moore were still seen in Polish art magazines where the informed reader knew how to take the accompanying, some-

453 Henryk Tomaszewski: *Poster*, 1959, Kunstbibliothek, Staatliche Museen zu Berlin

what negative comments. It was only in Soviet articles that found their way to Poland that Moore continued to be openly derided. However, after 1956 when Gomulka was reinstated, Poland started to edge towards independence, freeing itself from the grip of the Soviet Union – albeit only within the context of the Warsaw Pact. Now the state-sponsored friendship with the Soviet Union was replaced by state-sponsored patriotism, although this was often undermined by the Catholic Church with its centuries old connections to the West.

This new loosening of certain constraints allowed Polish artists to turn their backs on Socialist Realism and to focus once again on international Modernism. And so it was, between 1955 and 1960, as Murawska-Muthesius has described it, that 'Henry Moore's streamlined asymmetrical form, perforated by irregular holes, was seen as the stereotypical Modernist idiom and was trivialised by large numbers of reproductions.'[611]

In this context, the exhibition of the work of Henry Moore that opened in Warsaw in 1959 was a resounding success. Films about Moore's work and recordings of conversations provided an interested public with much additional information. With major works such as *Reclining Figure: Festival*, *King*

and *Queen*, and *Warrior with Shield*, the exhibition made its triumphant way through a number of Polish cities. Artists and intellectuals alike saw it as an affirmation of their desire for political and cultural freedom, their desire to break away from the rest of the Eastern Bloc. This sentiment is reflected in the *poster* for the 1959 exhibition (fig. 453) by Henryk Tomaszewski, one of the most important exponents in Poland of the new art of poster design.[612] Moore's name appears in singly formed letters above a dark blue zone. Above the central 'O', which is formed like a plinth with a hole, Tomaszewski placed a photograph of one of Moore's surrealist mother-and-child pieces shown in the exhibition. The piece in question was *Mother and Child* of 1936.[613] Seen from a distance, it looks like a fist raised in the air, which in turn reflects the view Moore's fellow-artists in Poland had of him: as one of them, as a spiritual compatriot.

Conclusion

If one looks at the full extent of the immense distance that Moore's work covered in the postwar years, one cannot help but be astonished at how subtly, how deeply, how passion-

ately and how seriously the work of this artist – the epitome of Modernism to so many – was studied, cited, paraphrased and developed.

Two main points emerge from this study. Firstly, there is the wider picture we now have of Moore's life. For the first time we see him providing work for young sculptors, as a committed teacher and nurturer of young talent, helping his protégés to find employment and secure financial support. In addition to this, we also see him as a political authority and British peacemaker in the art field.

With regard to the second point, which concerns the real, deeper understanding of his art, it is astonishing to see just how many different stylistic and conceptual connections there are. With so many strings to his own bow – *taille directe* combined with an archaism gleaned from the study of non-European art, his own individual response to Surrealism, biomorphous abstraction, Classicism, reclining figures, internal/external forms, mother-and-child groups, warriors and war (*Shelter Drawings*), 'negative spaces', analogies with natural forms, associations with the landscape – all these and more, for instance the *Upright Motives*, kindled the interest of very different artists. In purely numerical terms the themes that prompted the widest responses were his reclining figures, *taille directe*, archaism, Surrealism, analogies with natural forms, war, voids and biomorphous abstraction.

As a representative of the second phase of Modernism, Moore came up with his own individual artistic solutions and holistic forms, whose unique qualities were recognised the world over; in the end he was known for his exploration of a whole cosmos of organic forms posited on his specific understanding of Nature, for his investigations into the rhythmic conjunction of internal and external forms, and above all for the interdependence of empty spaces and solid forms. This and his extraordinary feeling for the landscape were his main legacy to posterity. The creative potential of all these topics was first recognised by other artists, with their superior antennae.

In our study of Moore's impact as a sculptor, it has been fascinating to observe – in the seven selected countries – how different responses were subjected to change and how they arose not only from particular cultural and art-historical traditions but also from political necessity. The response in the Eastern Bloc was to a greater or lesser extent constrained by the senseless doctrine of Formalism but was also, with justification, shaped by fears for the preservation of the humanity of society as a whole; here the main focus was naturally on Moore's figurative works (including the *Shelter Drawings*). Meanwhile, in the West and in Japan, the response was freer, if anything pluralistic, and embraced all the different genres in Moore's art. Yet here, too, there are distinct preferences. Thus the Germans – Karl Hartung, Bernhard Heiliger, Brigitte and Martin Matschinsky-Denninghoff, Wieland Förster – and the British artist David Nash, all in their own way reacted to and developed Moore's feeling for the aesthetics of the natural world. Ultimately, all these artists share a Goethean-Romantic view of Nature, which was the same sentiment that had led Moore to his concepts of 'spiritual vitality' and the 'organic whole'. In Japan, the artistic response to Moore's sculpture, above all its 'empty spaces' and their connection with Nature, was informed by the teachings of Zen Buddhism.

Thus it is clear that time, aesthetics and sculptural history are all crucial to the many, diverse responses to Moore's art. Moore's forms – rooted in his own immense humanity and fundamental connectedness with Nature – set new standards for sculpture. In an age when there is a terrifying, ever greater lack of potential in the realms of sensual, haptic experience, the sculpture of Henry Moore may be the remedy we need. Perhaps the many artists who have engaged with his work already suspected exactly that.

Appendix

Henry Moore – Dates and Documents

1898–1912: Childhood, Youth, First Encounters with Sculpture
Henry Spencer Moore is born into a mining family on 30 July 1898 at 30 Roundhill Road, Castleford, Yorkshire. The seventh of eight children, he has a happy childhood surrounded by his family. His father, Raymond Spencer Moore (1849–1922), was of Irish extraction and had, by his own efforts, advanced to a managerial position at the mine where he worked (fig. I). A committed Socialist and trade union member, he valued education above all else and was determined that his children should have better lives than his own. Three of Moore's siblings did in fact become teachers. However, the rigour of the somewhat Victorian standards Moore's father set for his children's upbringing was mitigated by the warm-heartedness of his mother Mary (née Baker, fig. II). Eight years younger than her husband, she was an unusually strong, humorous woman and Moore remained very close to her until her death in May 1944. It seems that he inherited his robust constitution from her. Looking back as an adult, Moore recalled the importance of the role she played in his childhood: 'She was to me the absolute stability, the rock, the whole thing in life that one knew was there for one's protection. If she went out, I'd be terrified she wouldn't return. So it's not surprising that the kind of women I've done in sculpture are mature women rather than young.'

1902–10 Moore attends primary school in Castleford. At the age of eleven, he hears about Michelangelo at Sunday School and is deeply impressed. He decides that he, too, will be a sculptor. In 1910 he wins a scholarship to Castleford Secondary (later Grammar) School. Here, as good fortune would have it, the Headmaster – who studied at the University of Bonn and at the Sorbonne and has progressive, liberal educational ideals – takes his pupils on trips to cathedrals, supports the school's drama group and organises evening lectures with guest speakers. It was on one of these trips that Moore first saw St Oswald's Church in Methley, West Yorkshire, where he was especially fascinated by its late Gothic sculptures. In his old age he still clearly remembered his feelings at the sight of the 'Monument to Lionel, Lord Welles and His Wife' (fig. III): 'It was… the almost Egyptian stillness of the figure that appealed to me.' – By far the most demanding teacher, from Moore's point of view, was his young, very dedicated art teacher Alice Gostick (1873–1960). Not only did she teach him drawing and how to throw pots, she also introduced him to the latest developments in European art by allowing him free access to her art library and lending him her copies of *The Studio*, to which she subscribed. During the war years Moore regularly wrote to her. In 1919, she actively supported his application to the Leeds School of Art. In 1946 she became godmother to

I Raymond Moore in 1909, aged 60

II Henry Moore's mother Mary, c. 1908, aged 52

two years of war experience. He reads avidly. His favourite writers are Tolstoy, Dostoyevsky, Thomas Hardy and D. H. Lawrence. Throughout his life he retains his passion for literature; he is also curious to meet the poets and writers of his own time. Later his circle of friends and acquaintances will include Stephen Spender, W. H. Auden, T. S. Eliot, Walter Strachan, Elias Canetti, Maurice Ash, Somerset Maugham and Graham Greene, to name but a few. – In 1917 Moore writes his only stage play, *Narayana and Bhataryan*, an 'oriental' drama, which is performed by the amateur drama group at Castleford Grammar School in 1920. He and his sister Mary take the main parts. In the play Bhataryan mourns the death of his sister: 'Dead! Narayana, my sister, dead, Narayana, my little sister whom I loved more than myself... And I shall never again know the peace in your gentle speech, your flowing hair, never again know the touch of your kind fingers, the smooth soothing softness of your cheek, your companionable closeness has left me.' However, this is not the end of Moore's interest in the theatre. In 1932 he makes a mask for W. H. Auden's play *The Dance of Death* and in 1967 he designs a sculptural stage set for a production of Mozart's *Don Giovanni* at the Festival dei Due Mondi in Spoleto. He was on friendly

III Monument for Lionel Lord Welles und his wife, St Oswald's Church, Methley, West Yorkshire, late 15th century

Moore's daughter, Mary. Moore and Gostick were to remain lifelong friends.

1912–19: Adolescence, the Young Teacher, the War, Gas Poisoning, Writing Poetry

As he was preparing for his Confirmation, Moore entered a brief, but intense religious phase that lasted until he volunteered for military service in February 1917. Although he was not a churchgoer in later life, he did retain a fundamentally religious outlook. On 26 July 1915 Moore was awarded his School Leaving Certificate, which also allowed him to proceed into higher education. 1915 also saw the death of his beloved younger sister, Elsie, from sudden heart failure. She was a keen athlete, and Moore had always encouraged her ambition but, as it turned out, she overexerted herself while swimming. Filled with remorse, it took a long time for him to come to terms with the loss. – Complying with his father's wishes, Moore trains as an elementary school teacher and accepts a full-time post in his home town – much too young and defenceless to cope with his pupils' pranks ('I think this was the most miserable period of my life'). – In February 1917 Moore enlists in the Civil Service Rifles, 15th London Regiment (fig. IV). On 30 November 1917, during the Battle of Cambrai (France), he suffers gas poisoning and has to return to England for treatment lasting three months. Now a Lance Corporal, Moore is redeployed to a training camp where he is to instruct new recruits. On his own insistence, he is sent back to the frontline in France, only to find that the Armistice is signed shortly after his return. Moore's personality was crucially influenced by his

IV Moore shortly after he joined the army in 1917, aged 18

terms with actors such as Sophia Loren, Lauren Bacall and Charles Laughton, many of whom owned examples of his work.

1919–39: Training, Self-Discovery, Academic Study, Marriage, First International Contacts, Extended Interest in Surrealism, Political Activities

In September 1919 – his father had at last given in to his wishes – Moore is finally able to enrol at Leeds School of Art. He puts his name down for sculpture, but it is not until his second year that a Sculpture Department is set up, especially for him. From now on the twenty-one year old sets about discovering 'his' world, at breakneck speed. Of particular importance to him at this time is the fact that he is a welcome visitor in the house of the Vice-Chancellor of the University of Leeds, Sir Michael Sadler, where he can peruse the latter's collection of African and modern art (with works by Gauguin, van Gogh, Cézanne, Picasso, Matisse, de Chirico and Kandinsky). The two men are to stay in touch. In the 1930s, Sadler buys three sculptures and three drawings from Moore. In 1914 Sadler's son Michael had published his own translation of Kandinsky's *Über das Geistige in der Kunst* (as *The Art of Spiritual Harmony*). In 1920 Moore spends time in the library at the School of Art independently studying the history of sculpture across the world and looking at aspects of architectural history. His reading of Roger Fry's *Vision and Design*, which introduces him to 'primitive art' and has a decisive impact on his development. – In autumn 1921 Moore wins a scholarship to the Royal College of Art in London where he studies sculpture until 1924. He explores vast swathes of the British Museum, where is particularly drawn to the collection of Mexican art: 'The Royal College of Art meant nothing in comparison.' On his weekly visits to the museum, he often drops into Zwemmer's bookshop where he can catch up, undisturbed, on the latest developments in modern art. Anton Zwemmer (1892–1979), a London bookseller, publisher and art dealer was a leading authority in his field. He was quick to recognise Moore's importance; in 1934 he published the first monograph on the artist (by Herbert Read) and in 1935, in his own gallery, presented the first exhibition devoted exclusively to Moore's drawings. The earliest surviving sculptures by Moore date from 1921 and bear eloquent witness to his early allegiance to 'direct carving' and to 'stoniness' or 'truth to material'. As he progresses down this route, he draws strength from his encounters with the sculptures of Henri Gaudier-Brzeska and the early work of Jacob Epstein. Both were associated with a form of 'Primitivism' that, in conjunction with Moore's study of the work of Paul Cézanne and non-European sculpture, was to influence his work until well into the late 1920s.

1921 In autumn Moore visits Stonehenge. No sooner has he arrived in Salisbury than he makes his way by moonlight straight to the sacred site: 'I was alone and tremendously impressed, Moonlight… enlarges everything, and the mysterious depths and distances made it seem enormous.'

1922 Accompanied by a fellow student, the painter Raymond Coxon, Moore makes his first trip to Paris. He goes armed with a letter of recommendation to Aristide Maillol from the Principal of the Royal College of Art, the painter William Rothenstein. Rothenstein, of German-Jewish origin, had an unfailing eye for quality and did his best to support Moore whenever he could. When Moore arrives at Maillol's door and hears the sound of hammering, he turns round and goes away, so as not to disturb the master at work. This leaves him all the more time to explore the museums and galleries of Paris, which he subsequently returns to at least once a year. During his 1922 visit, he is greatly impressed by the extensive group of works by Cézanne owned by the collector Auguste Pellerin. In the Trocadero Museum (now the Musée de l'Homme) he discovers a plaster cast of a pre-Columbian chacmool statue (fig. 7).

1924: First group exhibition at the Redfern Gallery in London. By 1928 Moore has his first solo exhibition, at the Warren Gallery in London. In winter 1924–25 he produces his highly expressive half-length figure *Woman with Upraised Arms* in Hopton Wood stone (LH 23), that paves the way for the elemental, block-bound aspect of subsequent masterworks such as *Mother and Child* (LH 26, finished in autumn 1925) and the *Reclining Figure* of 1929 (fig. 2).

1925 Moore is awarded a travel scholarship by the Royal College of Art and spends five months in Italy. He sets off from Paris in February. His trip takes him from Turin, Genoa, Pisa, Rome, Siena, Florence (where he stays for three months), Assisi, Padua, Ravenna, Venice and back to Paris via Munich. Above all he seeks out the work of Giotto, Masaccio and Michelangelo. On his return from Italy Moore becomes assistant to Professor Ernest Cole at the Royal College in London.

1928 With the backing of Jacob Epstein, Moore receives his first major public commission. From autumn 1928 to autumn 1929 he works on a large relief, entitled *West Wind* (fig. 150), for what is now the headquarters of the London Underground (above St. James's Park tube station). He produces over a hundred sketches as he successfully strives to create a recumbent figure that radiates a hitherto unseen sense of freedom. In this work highly individual expression (as the figure listens with rapt attention and holds its hand up to the viewer) is wholly at one with the generous, planar forms. – 1928 was also an *annus mirabilis* in another important respect: Moore meets his future wife, Irina Radetsky (1907–1988). All his life, she stands by him, always demonstrating admirable independence, grace and what Moore himself called 'real practical com-

V Henry Moore with his young wife Irina, 1929

mon sense'. Russian by birth, Radetsky was studying painting at the Royal College when they met. She and her mother had been driven out of Russia (her father had died in the Russian Revolution). After some years in Paris, she had come to England at the age of fifteen. Looking back in his old age, Moore expressed his gratitude to his wife: 'Irina has always been a tremendous inspiration, my most valuable constructive critic.'

1929 Henry Moore and Irina Radetsky marry (fig. V). They move to Hampstead and are soon enjoying a lively social life with other artists in the neighbourhood, both from home (Barbara Hepworth, John Skeaping, Ben Nicholson, Graham Sutherland, John Piper) and abroad (Naum Gabo, Walter Gropius, Marcel Breuer, Laszlo Moholy-Nagy, to name but a few).

1930 Moore exhibits with the Young Painters' Society, the London Group, and in the British Pavilion at the Venice Biennale.

1931 In spring Moore has his second solo exhibition, this time in the well known Leicester Galleries in London. Despite an enthusiastic catalogue foreword by Jacob Epstein ('For the future of sculpture in England Henry Moore is vitally important') and a glowing review by Herbert Read, the press is torn between approval and condemnation ('nothing more or less than Bolshevism in art'). – Having been alerted to Moore's work by Herbert Read and the German sculptor Gustav Hein-

rich Wolff, Max Sauerlandt, Director of the Museum für Kunst und Gewerbe in Hamburg, acquires from the London exhibition a small, ironstone head in profile, four drawings and three watercolours. In the difficult years of the Depression, this purchase by a museum abroad gave Moore great encouragement. The works acquired by Sauerlandt were soon confiscated by the National Socialists and are believed largely to have been lost. Sauerlandt, who had also championed the work of Emil Nolde, Ernst Ludwig Kirchner and others, was forced out of office in 1933 and died in 1934. – Moore moves to the Chelsea School of Art where he builds up a new sculpture department. – Following the exhibition at the Leicester Galleries in London, Moore and his wife can realise a dream. For £80 they buy Jasmine Cottage in the village of Barfreston in Kent, near Canterbury. Now with a studio in the country, Moore produces his first lead figures and other major, surrealist works. Taking the *objet trouvé* aesthetic of his Surrealist friends a stage further, Moore now goes deeper into the 'principles of form and rhythm' that he sees embodied in pebbles, bones, shells, rocks, flowers, etc., and uses these as the basis for new figurations. At the same time he is also inspired by the research published by the renowned biologist and human D'Arcy Wentworth Thompson, whose book *On Growth and Form* (1917) passed rapidly from hand to hand in the Hampstead studios of the day. Following his more detailed study of natural forms, from 1931 onwards Moore started to produce his so-called *Transformation Drawings* (figs. 57–60, 62), which take the progressive changes seen in studies of natural phenomena (bones, shells, stones etc.) and transform them into new imaginary, yet natural-looking forms. These are to be of pivotal importance in Moore's later sculptural exploration of his own world of biomorphic abstraction.

1932 Moore participates in the exhibition *Neue Englische Kunst* in the Hamburger Kunstverein. In the catalogue the critic and writer R. H. Wilenski describes him as the leading exponent of young, English sculpture. In his book, *The Meaning of Modern Sculpture*, published to coincide with the exhibition, he seeks to locate Moore in the wider history of sculpture (fig. VI).

1933 In *Carving* (fig. 74) we see Moore's first hole cut through a block of stone, following Barbara Hepworth's lead. New sculptural dimensions open up for Moore. – Moore becomes a member of the influential group Unit One, founded by Paul Nash. Striving for 'individuality' within a 'unit', the group's aim is to provide the British avant-garde with a forum for ideas, or as another of the founder members, Herbert Read, put it, to 'form a point in the forward thrust of modernism in architecture, painting and sculpture.' In the group's publication of the same name, Moore writes a keynote article where he outlines the five qualities by which he measures his own work: truth to

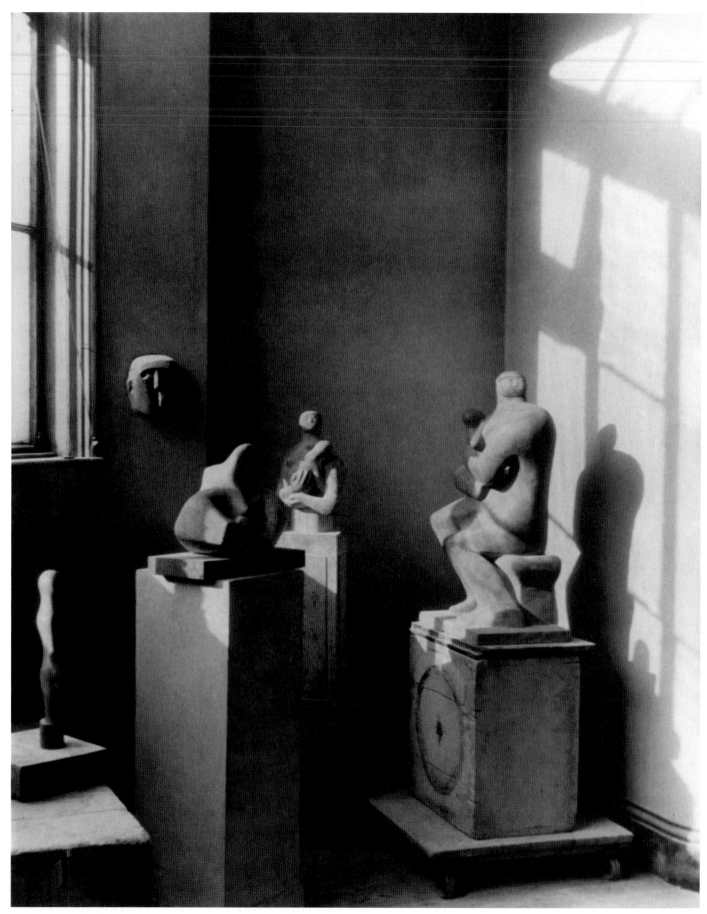

VI Corner of Henry Moore's studio, 11a, Parkhill Road, Hampstead, London, 1932

material, full three-dimensional realisation, the observation of natural objects, vision and expression, vitality, and power of expression. With the exception of 'truth to material', which he will start to abandon in the early 1950s, Moore will remain faithful to the other principles for the rest of his life.

1934 sees the publication of the first monograph on Moore. The author is Herbert Read (1893–1968), who will tirelessly promote Moore's work until his death. The two have already been close friends since 1929. Read was a free spirit. As poet, art historian, exhibitions curator, art critic and writer, by the 1930s it seemed he had become the conscience of the art world in England. Early on, he already recognised the threat posed by Hitler, tried to alert his compatriots to the latter's barbaric racial and cultural politics, and did his utmost to help émigrés wherever he could. After the war, his books on the educational value of art set new standards in much of the West. In 1965, he published a second, longer monograph entitled *Henry Moore: A Study of His Life and Work*. For the ten years up until the publication of the catalogues raisonnés of sculptures (starting in 1944), Read's portrait of 1934 was easily the most informative and best illustrated source of information on Moore's work. With great perspicacity, Read sets Moore's work apart from that of Brancusi. Compared to the latter's purist approach, he explains that Moore 'does not wish to limit his function in this way. He feels that if he can link his formal conceptions with the vital rhythms everywhere present in natural forms, that then he will give them a force altogether more dynamic than the force of abstract conceptions.' – In the late summer Moore and his wife Irina along with the painter Raymond Coxon and his wife Edna go on a motoring holiday to Spain where they visit Altamira (to see the caves), Toledo, Madrid and Barcelona. In autumn Moore takes part in *The Social Scene*, a group exhibition organised by the Marxist-oriented Artist's International (later Artist's International Association, AIA). He supports the Association's efforts to mobilise resistance against Fascism. In 1935 Moore, Ben Nicholson, John Piper, Fernand Léger and Ossip Zadkine all show work at the AIA exhibition *Artists Against Fascism*. Moore never made any secret of his commitment to the Left. Looking back in 1984, he commented, 'I was approached by the communists in the 1930s when a lot of people did join them. But I didn't go that far. To be a member of the communists was an active role which I didn't want to have.'

1935 The Moores buy Burcroft, a relatively large country cottage in Kingston near Canterbury. Here, with the help of a young Bernard Meadows, Moore produces the first groundbreaking *Reclining Figures* in wood (see figs. 288–92).

1936 Moore is Honorary Treasurer for the committee preparing the first *International Surrealist Exhibition (ISE)* in London,

which takes place in the Burlington Galleries in June–July. All the leading French Surrealists take part. For Moore, it is as though the Surrealists' approach to pictorial invention, the way they handle objects, their ethnological interests and certain, seminal works by Pablo Picasso and Alberto Giacometti equip him with the tools to take new experimental liberties which from that point onwards set his art alight. Up until 1940 he repeatedly shows work in various Surrealist exhibitions in London, New York and Paris. – In November Moore signs the 'Declaration on Spain' that the Surrealist Group in England publicly delivers to the British Government. In it the signatories demand that the British should rescind their policy of non-intervention in republican Spain. The authorities thwart his plans to travel to Spain.

1937 Moore participates in another group exhibition organised by the AIA. – On a visit to Paris in May, Moore, Irina, André Breton, Paul Eluard, Max Ernst and Giacometti spontaneously decide to visit Picasso in his studio, to see his as yet unfinished painting *Guernica*. Moore was a lifelong admirer of Picasso's work. In 1979, when he and the author of this book, visiting the Städel Museum in Frankfurt found themselves face to with the newly acquired third bronze head from the series of portraits of Marie-Thérèse, Moore declared without hesitation, 'Oh, that's powerful.'

1938 As an active member of the Artists' Refugee Committee, Moore is involved in helping to resettle artists who have fled the Nazi regime in Germany.

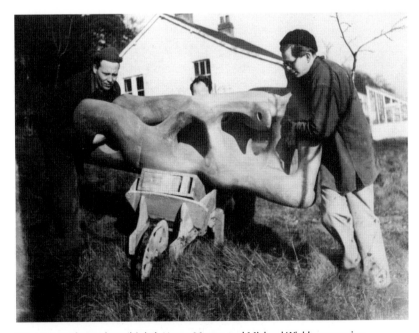

VII Bernard Meadows (right), Henry Moore and Michael Wickham moving the *Reclining Figure*, Burcroft, Kent, 1939

1939 Working at Burcroft, Moore produces his largest recumbent figure in elmwood to date. Of all the forty-five sculptures in wood that he made between 1921 and 1978, this piece embodies the finest example of dynamic rhythms expressed in voids and solid forms (fig. VII). – The outbreak of war cuts the artist to the quick. Various letters underline his hatred for Hitler and he slates the tactics of the British Cabinet: 'The Chamberlain Government I think is the worst in our history, it helped rear the Hitler Germany' (to Arthur Sale, 24 April 1940).

1940–51: Life During the Blitz: The *Shelter Drawings*, Incipient Worldwide Fame
In summer 1940 the Moores return to Hampstead, to a studio hitherto occupied by Barbara Hepworth and Ben Nicholson who have decided to move to St Yves. But very soon, in October 1940, the studio suffers damage during an air raid. Fortunately only one sculpture is destroyed. The Moores move to Perry Green near Much Hadham, Hertfordshire, where they rent one half of a small, 15th-century farmhouse called Hoglands. In 1941 they are able to buy both their half of the house and the other half next door; much later on they build a substantial extension. However, the house always retains its air of modest, rural charm – this combined with the Moores' legendary hospitality completely captivates their many visitors. Throughout his life, Moore gradually buys up land around the property, creating a parkland that can serve as a suitable setting for his monumental sculptures. Moore volunteers for the Home Guard in Much Hadham and remains a member until it is disbanded at the end of the war.

In autumn 1940 Moore resigns from his teaching post at the Chelsea School of Art when the entire college is evacuated to Northampton. With sculptural materials in short supply due to the war, Moore concentrates on drawing instead. Late at night on 11 September 1940 he and Irina find themselves at Belsize Park Underground Station when the alarm is sounded for an air raid. Moore sees hundreds of people seeking shelter on the station platforms. 'I had never seen so many rows of reclining figures and even the holes out of which the trains were coming seemed to me like the holes in my sculpture.' Moore is fascinated by the underworld of the tube system, where thousands take cover at night in miserable conditions while up above ground, in the city's streets, all hell has broken loose. Moore returns time after time, drawn by the throng underground, sometimes discreetly making tiny sketches, which he afterwards develops from memory in his studio. Not long afterwards the film *Out of Chaos* (1944) included a scene showing him making sketches in full view of those seeking refuge. This scene, publicised through stills by Lee Miller, was intensely irritating to Moore, who would never have planted himself in front of his fellow-men so shamelessly.

During the brief year of intense activity on the *Shelter Drawings* (figs. 127–141), which he was able, so to speak, to

produce despite the war, it was as though Moore were driven: 'Here was something I couldn't help doing. I had previously refused a commission to do war pictures. Now Kenneth Clark saw these and at once got the War Artists Committee to commission ten. I did forty or fifty from which they made their choice. The Tate also took about ten. In all I did about a hundred large drawings and the two shelter sketch books.' In view of this, in January 1941 Moore was appointed an Official War Artist (like Graham Sutherland before him) by Sir Kenneth Clark, Chairman of the War Artists' Advisory Committee.

Moore and Kenneth Clark (1903–1983) had been friends since 1938, and in the coming decades he often drew inspiration from Clark's wide-ranging, highly cultured outlook. Director of the National Gallery from 1933–45 and subsequently Slade Professor of Fine Art in Oxford, Clark was a modern traditionalist following in the footsteps of John Ruskin and Walter Pater. Never making a show of his aristocratic background, Clark was by nature a realist and sought to open up the art world to a much wider social mix than hitherto. As a writer and art critic, he gladly took advantage of any media outlet available to him to communicate to others his deep conviction of the importance of high art in the advancement of civilisation. At the time when Moore was working on his *Shelter Drawings*, the young Director of the National Gallery caused something of a stir when he put on extremely well attended evening concerts in the gallery (having had electric lighting installed for the first time) and introduced the exhibition series *Picture of the Month*. The author of standard works such as *Leonardo* (1939), *Landscape into Art* (1949), *The Nude* (1956), *Civilisation* (1970) and with a particular expertise in the art of the Italian Renaissance, no doubt influenced Moore's interests and preferences as an art collector. On his first reading of Clark's study of Leonardo, Moore wrote to the author: 'The whole spirit of it, the values & mental attitude it creates, – is just what we mustn't let the war destroy or dim' (1 October 1939).

1941 The first retrospective of Moore's work, together with pieces by Graham Sutherland and John Piper, is presented in Leeds (fig. VIII). Four years later, in 1945, the University of Leeds awards him the first of over twenty honorary doctorates that he will receive in the coming decades. – Moore becomes a Trustee of the Tate Gallery (until 1956) and commits himself to active involvement in various other cultural committees.

1943 Thanks to the efforts of the enterprising German émigré Curt Valentin, Moore has his first exhibition abroad; it is presented at the Buchholz Gallery in New York, one of the leading venues for modern sculpture.

1944 The commissioned piece, *Madonna and Child*, is consecrated at St Matthew's Church in Northampton. Moore's real-

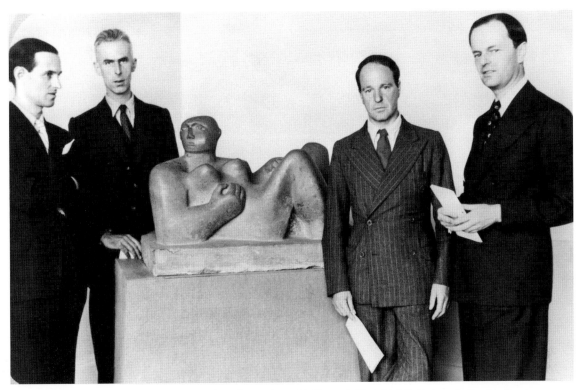

VIII Henry Moore beside *Reclining Figure* (1930) together with Kenneth Clark (right), Graham Sutherland and John Piper, Temple Newsam, Leeds, 1941, at the time of their joint exhibition

IX View into the exhibition in the Museum of Modern Art, New York, 1946

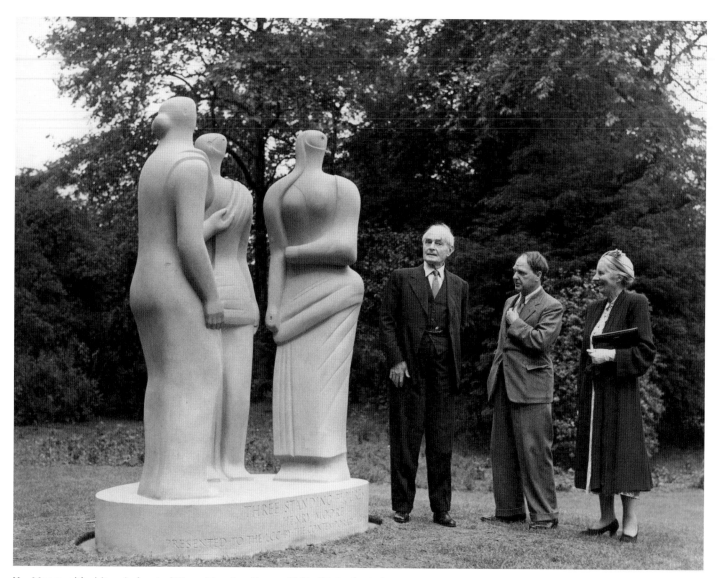

X Moore with visitors in front of *Three Standing Figures* (1947–48), Darley Dale stone, Battersea Park Open Air Sculpture Exhibition, London, 1948

isation of a Christian theme seriously damages his reputation amongst the French Surrealists who had long counted him as one of their number.

1945 The book of the BBC radio play, *The Rescue*, by Moore's friend Edward Sackville-West is published, illustrated with six of Moore's drawings (some in colour). In November Moore meets Brancusi and Picasso in Paris.

1946 Irina gives birth to the Moores' much longed-for child, Mary. Since 1945 Moore – in response to various commissions – has been exploring theme of the family in his work. In 1948–49, a larger-than-life family group (with parents and child) is cast in bronze; as a result Moore finds himself increasingly drawn to this material. The retrospective in the Museum of Modern Art, New York, is a resounding success (fig. IX). It travels to Chicago and San Francisco (and later, with

a reduced selection of works, to Australia). The fifty-eight sculptures and forty-eight drawings in the original exhibition earn Moore international recognition and bring his work to the attention of a number of American collectors. The majority of the drawings on display are from the *Shelter Drawings* series. With the war still a vivid memory, these have the greatest impact on visitors to the exhibition. Moore is present at the opening and also travels to Boston, Washington and Philadelphia. While he is in the United States he meets various artists including Jackson Pollock, Georgia O' Keefe and Marc Tobey.

1948 Moore becomes a member of the Royal Fine Arts Commission (until 1971). He is the sole artist representing the United Kingdom in the British Pavilion at the 24th Venice Biennale, where he is awarded the prestigious International Sculpture Prize. While he is in Italy, he takes the opportunity to renew his

XI Moore in conversation with George Katsimbalis (left), Athens, 3 March 1951

acquaintance with the work of Giotto, Masaccio and Michelangelo, and this time also discovers for himself the art of Giovanni Pisano. – Moore's *Three Standing Figures* (fig. 168) are installed at the highly acclaimed open-air display at Battersea Park in London (fig. X).

In the first years after World War II, Moore dedicated himself to the social resurrection of his country. Besides of several honorary engagements in museums and cultural institutions, he was busy with comissions for schools and churches, edited for instance in 1949 his so-called School Print, a colour lithography *Sculptural Objects* (fig. 154) and did not hesitate to deliver even colourful sketches for textiles.

1949 The British Council organises a two-year touring exhibition that goes to Brussels, Paris, Amsterdam, Hamburg, Düsseldorf, Bern and Athens. Moore's work is now much discussed throughout Europe; he was of course already known to any particularly observant artist – through his first catalogue raisonné in 1944 and the New York catalogue of 1946, which happened to be an unusually opulent publication for that postwar period. On 30 March 1948 one such artist, Gerhard Marcks, wrote from Hamburg to his friend Richard Scheibe (Professor of Sculpture at the Hochschule für Bildende Künste) in Berlin: '…my own work seems so hopelessly old-fashioned. Do you know Moore, making those things that you can look through?'

1950 Moore publishes an album of lithographs done as illustrations for Goethe's dramatic fragment 'Prometheus' (in the French translation by André Gide). – Moore turns down a knighthood: 'I find it very difficult to explain why I feel unable to accept this very great honour. I have been trying to consider how I myself should feel if I were addressed as "Sir Henry" every day, even in my workshop, and I cannot help thinking that it would somehow change my conception of myself, and with it the conception of my work… I also feel that such a title might tend to cut me off from fellow artists whose work has aims similar to mine.'

1951–58: A Wealth of Ideas – from Dialogue with Antiquity to the Articulation of the Figure and Its Relationship with the Landscape, Working with UNESCO

1951 Moore has his first retrospective at the Tate Gallery, London. – When the British Council touring exhibition goes to Athens, Moore makes his first trip to Greece (fig. XI) and visits Athens, Mycenae, Corinth, Delphi and Olympia. Above all he is struck by the light conditions in Greece: 'The Greek light is, as everyone says, something you can't imagine till you've experienced it. In England half the light is, as it were, absorbed into the object, but in Greece the object seems to give off light as if it were lit up from inside itself.' – The young Anthony Caro becomes an assistant to Moore, working half days. Looking back later, he remarked of his employer and mentor, 'He had a real gift for explaining things, he enjoyed explaining things – he did to me, anyway… He used to be interested in what young people were doing. It was encouraging.' – The, as it were, strangely tunnelled-through bronze *Reclining Figure: Festival* (figs. 123–124a) becomes a major attraction at the Festival of Britain on London's South Bank. – The British Council mounts a small but influential exhibition at the Haus am Waldsee in Berlin.

XIII Moore with some of his bronzes, Much Hadham, 1958

1952 From 1952 to 1957 Moore produces a stream of master-pieces that not only draw on the groundwork in poses and drapery that the artist in effect laid down in some of his *Shelter Drawings*, but also show the influence of his interest in Classical art. In this post-war period, Moore makes statues of warriors, female figures with drapery and heroic attitudes, mythological themes such as the *King and Queen* (figs. 231–233), which immediately struck a chord with the public, and also one of his most fascinating animal sculptures, *Animal Head* (fig. 238). At the same time, he also comes up with his first three-dimensional solutions to the problem of *Internal and External Form* (figs. 302–309) that has already been a major preoccupation in his drawings since the late 1930s. The works he now produces in wood and bronze embody, with extraordinary rhythmic freedom, the notion of interdependent co-existence of form and space that has also been in his mind since the 1930s.

1954 In October Moore travels to Naples and Pompeii (fig. XIIa, b). As the contact prints of shots taken by the artist on this trip show (published here for the first time), he was particularly intrigued by the plaster casts of the corpses of figures lying on the ground. Different shots attest to his fascination with the sight of figures caught up in the sudden catastrophe – almost like rough-hewn embodiments of themes on which he was already working. Certain poses seem to be echoed in 1955–56 in his *Reclining Figures* (see LH 401, 402) and in the *Maquette for Fallen Warrior* (LH 404).

1958 In spring Moore visits Auschwitz as Chairman of the International Auschwitz-Birkenau Memorial Competition; the memorial itself was completed in 1965. – Moore's five-metre long *Reclining Figure* in travertine is unveiled outside the UNESCO building in Paris (fig. 1). With the natural rhythms of its vibrant forms, this reclining figure epitomises Moore's view of civilisation as an 'organic process', as he had described at a UNESCO event in 1952. This work paves the way for the large-format late works. – Moore embarks on what is to be a highly fruitful collaboration with the long-established Hermann Noack foundry in Berlin-Friedenau, where a total 128 of sculp-

DATE

SUBJECT

TECHNICAL DATA

XIIa, b Moores photographs done in Pompeji, October 1954

tures by Moore will be cast over the years. Moore particularly valued Noack's skill with patinas and the special technique he had evolved for making concealed welds (fig. XIII).

1959–83 Late Work: New Ideas for Sculpture in Public Spaces, Abstraction and Inwardness
1959 Moore's *Two Piece Reclining Figure, No. 1* (fig. 125) opened up a rich seam for his future work: the multiple articulation of a reclining figure with an affinity to the shapes of natural rock formations calls to mind the notion of a 'landscaped' figure at the same time as it raises issues concerned with the interplay of solid shapes and spaces, unity and multiplicity, the part and the whole. – On the invitation of Eduard Trier, the young Curator-in-Chief of the sculpture section, Moore takes part in documenta II in Kassel (fig. XIV). He will also show work at documenta III (1964). – The British Council

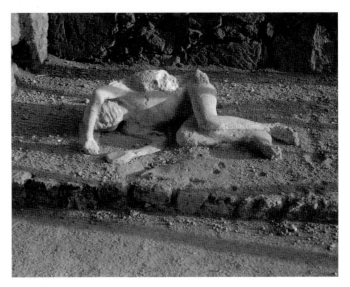

XIIb

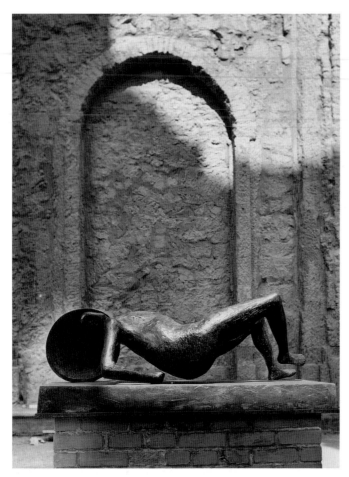

XIV *Falling Warrior* (1957) in front of the ruined Orangerie, documenta II, Kassel, 1959

ure outside the Lincoln Center in New York (1963–65; fig. 126), during the 1960s Moore continues to take great relish in exploring new themes. His work, more dynamic and monumental than ever, becomes increasingly eloquent and he strives above all for full three-dimensionality. From 1968 the preparation of working models for much larger objects is eased by the availability of a new material, namely polystyrene. – In pieces such as *Large Standing Figure: Knife Edge* (figs. 185, 186) and the more abstract *Knife Edge Two Piece* (figs. 216, 217), Moore's attention is primarily on the tension between graduated planes and extremely fine extremities. – In *Locking Piece* (figs. 218–220) we see solid, expansive forms 'fitting together'; at the same time it is as though they are expanding outwards from their ring-like formation, involving the viewer in an ongoing process of liberation. The many-faceted variety of *Three Way Piece No. 2, The Archer* (LH 535) first meets the public gaze in a snow-white plaster version when it is seen at the Memorial Service for T. S. Eliot at the Globe Theatre in London (in June 1965). Presented on a turntable, it is as though the interplay of tranquillity and motion were a visual embodiment of the entirety of a richly varied poetic life. In the 1960s one of only two large versions of this piece (3.25 metres in height) is installed on the terrace of the Neue Nationalgalerie in Berlin. The other is at Toronto, in Nathan Phillips Square.

1966 In London Philip James publishes his highly informative collection of texts entitled *Henry Moore on Sculpture*. The German translation is published in 1972. – Giacometti and Arp die.

1967 Moore receives an honorary doctorate from the Royal College of Art and becomes a Fellow of the British Academy. – Death of Karl Hartung and Ossip Zadkine.

1968 To mark Moore's 70th birthday, the Tate Gallery presents a wide-ranging retrospective of his work. At the same time, another major exhibition of Moore's work opens at the Rijksmuseum Kröller-Müller, Otterloo. This exhibition, with an accompanying catalogue, travels to Düsseldorf, Baden-Baden, Nürnberg and Darmstadt/Mathildenhöhe; this exhibition includes detailed materials relating to the biography researched by David Mitchinson. – Moore is given the skull of an Indian elephant as a present, and becomes absorbed by its *Gestalt* connections. He publishes a highly regarded album of etchings worked straight onto the plate (1969). – Herbert Read dies.

1972 The City of Florence presents a spectacular exhibition of Moore's work at the Forte di Belvedere, with 168 sculptures and 121 drawings. Recalling his first trip to Italy in 1925, Moore tells the Mayor what Florence means to him: 'I feel it is my artistic home.' In an effort to escape temporarily from the

sends an exhibition of Moore's work to Poland where it tours for five months. The response is predominantly positive. In Warsaw, where the exhibition opens in the Zachenta Galerie, visitors numbers are between 1,300 and 1,500 per day. The public resoundingly vote with their feet in favour of the removal of the cultural barriers that have grown up between East and West. Moore becomes a legendary figure in Poland; here, and elsewhere too, he is accorded the same status as Picasso. – Touring exhibitions of Moore's work are also presented in Japan, Spain and Portugal.

1960 sees an important exhibition of Moore's work in the Whitechapel Gallery, London. Another widely acclaimed British Council exhibition makes its way from Hamburg via Essen, Zürich, Munich, Rome, Paris, Amsterdam, Berlin and Vienna to Louisiana. The warm reception that greets Moore's work in West Germany secures a wide readership for Will Grohmann's richly illustrated book *Henry Moore*.

1961 Moore becomes a member of the Akademie der Künste in Berlin. – Besides continuing to work on multi-part figures, which culminate in the colossal bronze two-part *Reclining Fig-*

XV The artist during the installation of the Moore Gallery, The Art Gallery of Ontario, Toronto, October 1974

lengthy preparations for the exhibition, Moore takes refuge in Much Hadham in a small studio next to a meadow grazed by a flock of sheep. He now sets about drawing the sheep at close quarters, scrutinising them with calm detachment as though he were seeking to discover the very essence of their existence. Later he will produce a much admired series of etchings on this theme.

1974 On 26 October the Henry Moore Sculpture Centre at the Art Gallery of Ontario, Toronto, is opened (fig. XV). Following the ninety-minute ceremony, Moore spends two hours signing books, catalogues and posters – never omitting to exchange a few words with each individual. With a similar ethos to the Rodin Museum in Philadelphia, this first centre abroad devoted to Moore's work is generously endowed by the artist himself (above all with original plaster models and bronzes) and is home to 101 sculptures, 57 drawings and numerous prints. It largely owes its existence to the efforts of the young Canadian art historian Alan G. Wilkinson, who also has a good working relationship with the artist. As a student of Alan Bowness, Wilkinson started classifying and research-

ing Moore's drawings in 1969. His later catalogue of 1977, *The Drawings of Henry Moore*, for an exhibition which originated in the Tate Gallery and travelled to Toronto and Japan, was to constitute the first fully researched analysis of Moore's drawings so far.

1976 A major exhibition in the summer on the shores of Lake Zurich is greeted with enthusiasm by the people of the city. Consequently, *Sheep Piece* (fig. 414) – a great hit with the public – was acquired and remained where it is by the waterside.

1977 sees the first major presentation of Moore's work in Paris – in the Orangerie des Tuileries, and in an exhibition of prints and drawings at the Bibliothèque Nationale. Generous in its praise, *Le Monde* publishes a two-page spread on Moore (12 May 1977). In Germany the well-known author, art critic and authority on the work of Picasso and Max Ernst, Werner Spies, writing in the *Frankfurter Allgemeine Zeitung* on 28 June 1977, is harshly dismissive. In his view 'almost all the formal elements are distorted, coarser versions of the sculptural vocabulary of Archipenko, Picasso and Brancusi.' Thus it is in Germany

XVI Eduardo Chillida visiting Much Hadham with Bernard Meadows (centre) und David Mitchinson

– the country (after Britain, the United States and Japan) that is most alive to Moore's work, where there have been numerous inspired exhibitions devoted to his output and that has produced the subtlest followers – that Moore is first accused of merely imitating others. However unfounded this accusation, it still lingers on today in certain quarters. In an outstanding overview of Moore's work and life in 1987, his biographer, Roger Berthoud, skilfully made light of the matter: 'Such views were a healthy corrective to the often unselective praise of some of Moore's admirers.'

In the 1970s, Moore turns his attention to his artistic legacy. In 1977 all the studios at Much Hadham and the works that he has stipulated should remain there are incorporated into the Henry Moore Foundation – itself a symbol, recognised worldwide, for the new status enjoyed by sculpture. The aim of the Foundation is to catalogue all the existing documents, to research and record Moore's work and to promote awareness of it throughout the world through exhibitions. In 1982 the Henry Moore Centre for the Study of Sculpture is opened at the City Art Gallery in Leeds. In the twenty-five years of its existence it has become a unique focus for the contemporary debate on sculpture.

1978 With the help of his longstanding assistants, Malcolm Woodward and Michel Muller, Moore finishes *Reclining Figure: Holes* (fig. 299), the last of the large elmwood pieces. In this work Moore demonstrates once again the 'spiritual vitality' of form here conveyed through the medium of wood sculpture. – To mark his eightieth birthday, Moore makes a very generous donation of his work to the Tate Gallery. Major exhibitions are held at the Tate Gallery and at the Serpentine Gallery. – Moore collaborates with the American-Japanese architect I. M. Pei, and *Mirror: Knife Edge* (LH 714) is installed outside the new

East Building of the National Gallery in Washington, as is *Dallas Piece* (LH 580a) outside the new City Hall in Dallas.

1979 Despite resistance from the German art world, Chancellor Helmut Schmidt succeeds in having Moore's six-metre wide bronze sculpture, *Large Two Forms* (fig. 315), installed outside his offices in Bonn. The inauguration of the sculpture is marked by an exhibition. – The Victoria & Albert Museum in London shows tapestries realised after drawings by Moore. – Despite his arthritis becoming more acute, Moore's sculptural imagination is as vigorous as ever. Work had, after all, always been a source of joy to him. He now concentrates on small formats and above all turns to drawing. His wide-ranging late work in this field is largely empirical in its subject matter: people, animals, landscapes and drawings after Old Masters form a body of work with an atmospheric intensity all of its own.

1980 Moore donates a large travertine marble version of *Large Torso Arch* (fig. 449) to Kensington Gardens in London. – He is awarded the Grand Cross of the Order of Merit (with Star) of the Federal Republic of Germany. – Although his health is deteriorating, in 1980 alone Moore produces 350 drawings.

1982 Last visit to Italy where the Moores have had a holiday home in Forte dei Marmi (near Carrara) since 1965. Here Moore used to recoup his energy by working with marble. His most frequent guest was the great Italian sculptor Marino Marini.

1984 Moore is now confined to a wheelchair. – The French President, François Mitterrand, visits Much Hadham and invests him as Commandeur de l'Ordre National de la Légion d'Honneur. – The first touring exhibition devoted predominantly to the *Shelter Drawings* travels to Berlin, Leipzig, Halle and Dresden in the German Democratic Republic.

1986 Following major exhibitions in Madrid, Lisbon, Barcelona (1981), Mexico City (1982), Venezuela (1983) and New York (at the Metropolitan Museum in 1983), Moore is happy to hear of the warm reception that greets a travelling exhibition of his work in Hong Kong, Tokyo and Fukuoka.

Henry Moore dies on 31 August at the age of eighty-eight. A Service of Thanksgiving for the Life and Work of Henry Moore is held in Westminster Abbey, London, on 18 November. Stephen Spender, poet and longstanding friend of Moore's, addresses the congregation.

Eduard Beaucamp, writing in der *Frankfurter Allgemeine Zeitung* on 8 July 1987, describes the arrangements in place for the artist's estate as 'exemplary'. Moore had stipulated that there were to be no posthumous casts of sculptures nor editions of prints. Furthermore, any unfinished works were to be left unfinished (fig. XVI).

Introduction

1 Wilkinson 2002, p. 39.

2 See Gruetzner 1978. See also 'Henry Moore – Dates and Documents' in this volume.

3 As cited by Wilkinson 1984, p. 36.

4 The relevant passage Moore's address, given in Venice in 1951, reads: 'I believe that much can be done, by Unesco and by organisations like the Arts Council in my own country, to provide the external conditions which favour the emergence of art. I have said – and it is the fundamental truth to which we much always return – that culture (as the word implies) is an organic process. There is no such thing as a synthetic culture, or if there is, it is a false and impermanent culture. Nevertheless, on the basis of our knowledge of the history of art, on the basis of our understanding of the psychology of the artist, we know that there are certain social conditions that favour the growth and flourishing of art, others that destroy or inhibit that growth. An organisation like Unesco, by investigating these laws of cultural development, might do much to encourage the organic vitality of the arts, but I would end by repeating that by far the best service it can render to the arts is to guarantee the freedom and independence of the artist.' As cited in Philip James (ed.), Henry Moore on Sculpture, London 1968, p. 90. Hereafter referred to as James 1968.

Works

1. The Early Work

1 Moore often used the term 'stoniness', for example in his contribution to the programmatic *Unit One*, a collection of statements by artists edited by Herbert Read and published in 1934. Wilkinson 2002, p. 191. Among those included were painters, sculptors and architects from Moore's circle of friends, such as Paul Nash, Barbara Hepworth, Ben Nicholson, Edward Burra and Edward Wadsworth. On the book's major importance in establishing an identity for the avant-garde in Britain, see Harrison 1978, pp. 1–3; Harrison 1981, pp. 231–253.

2 The term 'direct carving' (Fr. *taille directe*) is used to describe sculptures produced by carving in stone or wood without preparatory works (*maquettes, bozetti*). Eschewing the traditional studies in clay or plaster, the sculptor engages directly with the material and its characteristics so as to bring forth what Apollinaire, in his introduction to the catalogue of Alexander Archipenko's 1914 exhibition at the Sturm gallery, Berlin, called 'plastique pure'. For the young Moore, as for his predecessors Adolf von Hildebrand, Joseph Bernard, Constantin Brancusi, André Derain, Henri Gaudier-Brzeska, Jacob Epstein and Ossip Zadkine, and for such contemporaries of his as Frank Dobson, John Skeaping and Barbara Hepworth, working in accordance with the principle of 'truth to materials' was bound up with pride in being a carver rather than a modeller. Emphasis on 'stoniness' opposed the practice of Auguste Rodin and thus proclaimed allegiance to a new avant-garde: carving directly represented an unconditional claim to modernity, and not just in Britain. In Germany von Hildebrand had begun carving directly in 1885; he was followed in France by Bernard in 1905. Attitudes towards materials became less strict after the Second World War, when many sculptors distanced themselves from exclusive reliance on direct carving. They included Moore, who in 1951 warned against making a rigid doctrine of it and himself began increasingly to appreciate the qualities of bronze. For direct carving, see Lichtenstern 1980, pp. 43–45, 54–55 and *passim*; Trier 1999, pp. 61ff.; Henry Moore, 'Truth to Material', in Wilkinson 2002, pp. 200–203; Curtis 2002–03.

3 In some sketches for sculptures made at this time Moore indicated the imaginary limits of the block. See for example AG 22-24.9, 22-24.22v, 22-24.29v and *passim*.

4 Moore later recalled making endless copies of Myron's *Discus Thrower* and the Hellenistic sculpture *Boy with a Goose*, based on a bronze original from the 2nd century BC. See Berthoud 1987, p. 49.

5 For similarities between Underwood's and Moore's drawings in 1923–24, see Wilkinson 1984a, p. 14.

6 Among the nine studios Moore set up at Much Hadham, his home 50 kilometres north-east of London, was one in which he devoted himself exclusively to drawing and graphics.

7 AG 22.3, 22.17r. See Wilkinson 1977, p. 50, N 6.

8 See Berthoud 1987, pp. 54–55, where Sadler, who was Vice-Chancellor of Leeds University from 1911 to 1922, is referred to as 'the most remarkable figure in the cultural life of Leeds' (p. 54). See also Sadler 1949.

9 Rewald 1996, p. 301, N 857 (Venturi 719).

10 Henry Moore, "Cézanne", in James 1968, p. 190.

11 AG 21-22.27r, see Wilkinson 1977, p. 67, N 62.

12 Gasquet 1991, p. 163.

13 Wilkinson 2002, p. 146.

14 Wilkinson 2002, p. 146. Pellerin had purchased the painting *Les Grandes Baigneuses* from Ambroise Vollard; in 1937 it was acquired from Pellerin's estate by an American collector.

15 Geelhaar 1989, p. 296, fig. 237 (LH 741).

16 LH 741. See AG 79.45, 79.46, 79.81-79.85, 80.108-80.111.

17 Moore's extensive corpus of drawings have been studied by Kenneth Clark, David Mitchinson and Alan Wilkinson, as well as by Ann Garrould and a team of researchers that included Juliet Barreau, Angela Dyer, Anita Feldman, David Mitchinson and Reinhard Rudolph. See the Bibliography in the present volume.

18 See below, Chapters Two and Five.

19 London and Toronto 1977, pp. 77ff., N 80; Wilkinson 1984a, pp. 263ff.

20 Lehmann 1922, p. 27. For Moore's relevant ethnological reading material that went beyond Lehmann, see Barbara Braun's profound study: Braun 2000, p. 98. In her chapter on »Henry Moore and Pre-Columbian Art« (pp. 94–135), the author comes to the conclusion that the intensity of Moore's study of Pre-Columbian Art surpassed that of Gauguin, Derain and Brancusi. – Further background material: London 2002.

21 AG 28.27v (*Subjects for Garden Reliefs*).

22 Wilkinson 1984, p. 264.

23 James 1968, p. 159.

24 See Zbikowski 1998, esp. p. 131 for current doubts about the previous identification of *Chacmool* as the rain god of the Maya.

25 Zbikowski 1998, p. 128.

26 Zbikowski 1998, p. 141.

27 AG 20.1-20.19. The Henry Moore Institute Archive, Leeds.

28 AG 21.1v. This sketch of the Virgin Mary from an Annunciation was based on a late drawing by Michelangelo in the British Museum (BM W.71). It marks the beginning of Moore's lifelong creative engagement with the work of the Florentine. See Chapter Five in this volume.

29 For Fry as a promoter of formalism in Britain, see Causey 1986.

30 James 1968, p. 49.

31 Berthoud 1987, p. 55.

32 Kandinsky 1914. See also Friedman 1982, p. 23.

33 Quoted in Friedman 1982, p. 22.

34 Moore 1926, p. 5.

35 Moore 1926, introduction.

36 Lichtenstern 1981a; Wilkinson 1984b; London 1981b; Braun 1989; Zbikowski 1998.

37 Lichtenstern 1981a.

38 Moore expressed his reservations about the art of ancient Greece in such statements as: 'This removal of the Greek spectacles from the eyes of the modern sculptor (along with the direction given by the work of such painters as Cézanne and Seurat) has helped him to realise again the intrinsic emotional significance of shapes instead of seeing mainly a representation value, and freed him to recognise again the importance of the material in which he works, to think and create in his material by carving direct'. James 1968, p. 57.

39 AG 81.142–81.145. See also Bremen and Berlin 1997, illus. pp. 186–87. The Persian marble sculpture is reproduced in London 1981, p. 18.

40 Moore 1981.

41 Moore used this expression in conversation with the author, Much Hadham, 12 Oct. 1977. A parallel expression appeared in his *Notebook No. 4* of 1925 (p. 155). See Part Two in this volume.

42 Wilkinson 1977, p. 146; Wilkinson 1984, p. 35.

43 See LH 9 and Gauguin's *Mask of a Tahitian Woman (Portrait of Tehura)*, 1892, pua wood, 25 x 20 cm, Musée d'Orsay, Paris; Gray 1963, N 98

44 Cork 1976, vol. 1, 1976, pp. 1ff.; Schmied 1996, pp. 92–99.

45 Quoted in Cork 1976, vol. 2, p. 551.

46 Buckle 1963; Friedman 1987; Cork 1976, vol. 2, pp. 454–482.

47 Moore: 'The wideness of [Epstein's] sympathies is shown in his own fine collection of sculpture, which included Negro, Egyptian, Chaldean work as well as much else, and in his collecting he was even more appreciative of carving than he was of modelling.' Wilkinson 2002, p. 150.

48 Wilkinson 2002, p. 151.

49 Pound 1960. For Pound's relations with Gaudier-Brzeska, see Schmied 1994, pp. 138–42 and Cork in Wolfsburg 2002, p. 41.

50 For the genesis of this bust, which played an important part in the development of imaginary portraiture in twentieth-century sculpture, see Cork 1976, vol. 1, pp. 179–83.

51 Pound 1960, p. 117.

52 Pound 1960, p. 79.

53 Pound 1960, p. 106 (complete artist), p. 101 (form-understanding), p. 106 (historical synthesis).

54 Weisner 1969, pp. 29, 36. Weisner characterises Gaudier's drawings, most of them done from nature, as 'energy-laden and latent with movement'. Jotted down quickly with an emphasis on contours, they contrast markedly with the intense seriousness of purpose and experimental boldness evinced by Moore's drawings – qualities that were developed, however, in the course of a far longer life.

55 Weisner 1969, p. 23; Pound 1960, p. 20. With this quotation Gaudier-Brzeska opened his emphatic article "VORTEX", published for the first time in *BLAST*, June 1914.

56 Pound 1960, pp. 27–28.

57 Pound 1960, p. 26.

58 See Part Two in this volume.

59 See Kausch in Vienna 1998, fig. 47 (p. 299), who mentions Gaudier-Brzeska in this connection. See also Cork 1998, p. 78 (with coloured ill.).

60 See Silber 1996, N 69. with the remark that Sophie Brzeska, the artist's companion, citicised the new style of *Redstone Dancer* as: 'Brancusi eggheads'. All the works by Gaudier-Brzeska cited here were reproduced in Pound's book of 1916 and were thus known to Moore. For *Redstone Dancer* and its possible relationship to works by Archipenko (*Susanna*, 1909; *Fragment*, 1911; *L'Ere nouvelle*, 1911), see Lewison 1983, N 56, pp. 47–48.

61 Silber 1996, N 77.

62 See also Milan 1993, N 50 (with ill.).

63 Silber 1996, N 97. For a detailed account of the genesis of this sculpture, see Cork 1976, vol. 1, pp. 436–39.

64 Silber 1996, N 107

65 Silber 1996, N 61.

66 LH 29. See also *Girl Torso* of 1966 (LH 553).

67 Clark 1974, N 71.

68 Silber 1996, N 80. According to Cork 1976, vol. 2, p. 444, Gaudier-Brzeska here 'came closest of all to the cold militancy of the Vorticist ideal'.

69 In 1930, for example, Moore stated: 'The sculpture which moves me most is full blooded and self-supporting, fully in the round, that is, its component forms are completely realised […] it is static and it is strong and vital, giving out something of the energy and power of great mountains. It has a life of its own, independent of the object it represents.' Wilkinson 2002, p. 150.

70 Berthoud 1987, pp. 85–86.

71 See Chapter Four.

72 Nevertheless, in 1931 a newspaper article that called Moore's art 'Bolshevist' and claimed he was unsuitable to occupy a public teaching post forced the artist to give up his job at the Royal College of Art. Berthoud 1987, pp. 106ff.

73 *Sunday Times*, 22 Aug. 1959; James 1968, pp. 215–216.

74 For a detailed account of this work, evincing a robot-like verism achieved with the aid of a real electric drill and full of Vorticist-style violence from which Epstein later distanced himself, see Cork 1976, vol. 2, pp. 464–482.

75 Illustrated in colour in: Causey 1987, pl. 54.

76 It concerns a solar deity, who was responsible for flowers, celebrations, music, dance and poetry. Epstein also dealt with this solar aspect in one of his figures (fig. 18). – For Moore's admiration of the Xochipilli, see London 1981b, p. 68 and Braun, 2000, p. 94.

77 See, for example, *Family* of 1935 (LH 157a), illustrated in colour in Vienna 1998, p. 178, N 31.

78 Cork 1976, vol. 1, pp. 122–123.

79 Cork 1976, vol. 2, pp. 454–455.

80 Cork 1976, vol. 2, pp. 454–455.

81 Cork 1976, vol. 2, pp. 454–456.

82 Einstein 1915, fig. 17. This book belonged to the artist's library; it is signed «Henry Moore 1924».

83 AG 22-24.43v. See Alan Wilkinson, in Moore 1981, p. 87.

84 Moore here combined a number of features derived from the illustrations in Carl Einstein's book *Negerplastik*. The head at upper right, for instance, was based on Einstein's fig. 15, the head of the mother on his fig. 34.

85 Cork 1976, vol. 2, pp. 457ff. (with an illustration of the related African sculpture).

86 In the evenings Moore sometimes attended life drawing courses at the Colorossi and La Grande Chaumière private academies. Berthoud 1987, p. 65.

87 Wilkinson 2002, p. 121.

88 James 1968, p. 162.

89 James 1968, p. 64.

90 See Bach 1987, pp.181–187. Moore must have been unaware of the facts uncovered by Bach – that it was on Brancusi's highly polished bronzes that the artist first released his simplified form and endowed them with subjects of immanent transformation – because he always referred to Brancusi as a stone sculptor.

91 See also Mitchinson 1971, N 24.

92 In Moore's library were present: Maurice Raynal, Alexander Archipenko, Paris 1923; Erich Wiese, *Alexander Archipenko* (= Junge Kunst, Bd. 40), Leipzig 1923.

93 Archipenko saw himself in the role of 'inventor'. Taillandier 1963.

94 See also Koeltzsch 1986, N 4; Janszky-Michaelsen 1977, pp. 35ff.

95 See above n. 92 and Archipenko 1960, fig. 90; Janszky-Michaelsen 1977, N S27, p. 163; Barth 1997, cat. N 32.

96 For a systematic examination of the historical context, see Schnell 1980, pp. 116–29.

97 Wiese 1955, n.p.

98 Berthoud 1987, p. 66, tells how Moore set out to visit Maillol in 1922 armed with a letter of introduction. Reaching the studio door, he heard Maillol carving inside and went away again so as not to disturb him. One can only agree with Berthoud when he writes: 'If only more of his own admirers had been as considerate in later life!'

99 AG 26.2.

100 For the innovative conception of this allegorical figure, originally intended for the Blanqui monument, see Le Normand-Romain 1996, pp. 123–124.

101 AG 25.98.

102 For the genesis of the Cézanne monument, see Lichtenstern 1996, pp. 423–430.

103 Lecombre 1994, p. 127, N 83. Other than indicated there, this work does no belong to the Hirshhorn Museum and Sculpture Garden, Smithsonian Institution, Washington, D.C.

104 Raynal 1921, fig. 1.

105 A sketch for LH 33.

106 Lecombre 1994, pp. 120–121, N 77. See also Raynal 1924. The artist owned this book. It is signed «Henry Moore». For a detailed discussion of Zadkine's early woodcarvings, see Lichtenstern 1980, pp. 46ff.

107 Lecombre 1994, p. 168, N 125.

108 Both sculptures are illustrated in Liverpool, New Haven and Toronto 1994–95, p. 24 (fig. 7) and p. 22 (fig. 11). Hepworth met Zadkine in Paris in 1933. See Gale and Stephens 1998, p. 11.

109 See Wilkinson 1994, p. 31.

110 Reproduced in Fontainebleau 2007, n.p. See also Zervos 1932–78, vol. 4, p. 318, fig. 319.

111 Moore confirmed to Wilkinson that he was familiar with them.

112 Zervos 1932–78, vol. 4, fig. 181.

113 The connection has been noted by Angela Dyer (commentary on AG 24.55) and, before her, by Alan Wilkinson, in Wilkinson 1987, p. 49, cat. N 8.

114 Conzen 2004, p. 44.

115 *Four Nudes by the Sea*, 1 May 1921, pastel on paper, 24.3 x 29.9 cm, Staatsgalerie Stuttgart (Zervos 1932–86, vol. 4, N 281); *Three Nudes by the Sea*, 4 May 1921, pastel on paper, 24.2 x 30.1 cm (ibid., N 280).

116 See Moore's account of the visit and of Picasso's ability to relieve the gloom radiated by *Guernica*, in Wilkinson 2002, pp. 166–67.

117 Zervos 1932–86, vol. 8, N 331.

118 AG 40-41.44, 40-41.47, 41.78. The last of these takes its cue from *Two Figures taking a Snack in a Shelter*. In this second version of the subject Moore heightened the image. The woman is more frail and appears almost transparent in the new grey-green colour scheme. Half the niche-like space behind her opens to reveal a 'landscape' of people lying in a tunnel. The space enfolds the individual and symbolises the privacy guarded by this woman, with her dignified pose redolent of stoic composure.

119 Wilkinson 2002, p. 168.

2. Surrealist Stimuli

1 The studies on Moore's relationship to Surrealism are still worth examining, including: Gruetzner 1978, pp. 22–25; Gruetzner 1981, pp. 113–123; Morphet 1979, pp. 116–122; Lichtenstern 1981a, pp. 645–658. The current study is based on these investigations. Among other aspects, it was enhanced by further comparisons with Giacometti, which for their part were complemented in an informative study later published by Steven A. Nash. See Nash 2001, pp. 43–51. I would like to emphasise Nash's conclusion (p. 51): '…his [Moore's] most radical sculptures and drawings of the 1930s should not be seen as merely experimental diversions. The liberation of invention and imagination they represent could not be reserved.'

For the complex phenomenon of biomorphism in twentieth-century art, see Glózer 1974, Poley 1978, Mundy 1987 and Lichtenstern 1992a, pp. 167–206.

2 Quoted in Alan Wilkinson 1984a, p. 270.

3 See the comparison in Wilkinson 1979, pp. 34–35, no. 20, of the drawing *Idea for Sculpture: Figure Seated on a Block* of 1928 (AG 28.142) with Picasso's painting *Seated Woman*, 1927.

4 AG 28.146. See also AG 27.37, 28.142, 28.144, 29.46v.

5 Rubin 1972, p. 124.

6 Moore's political sympathies in the 1930s tended to be left-wing and strongly anti-Fascist. See 'Introduction' and 'Henry Moore – Dates and Documents' in this volume.

7 The term 'biomorphic construction' was coined by Alfred H. Barr, the first director of the Museum of Modern Art, New York. Barr 1966, p. 190.

8 AG 30-31.6r, 30-31.7r, 30-31.8r, 30-31.9r, 30-31.10, 30-31.10v. The first two are not illustrated here. The following discussion on the genesis of the stone sculpture *Composition* forms the core of my chapter on Moore (Lichtenstern 1992, pp. 186–193, 206). Anne Middleton Wagner also described the metamorphic content of this sculpture without this knowledge. Her argument is based on a psychoanalytical point of view. See Anne Middleton Wagner 2005, pp. 116–122. When I became acquainted with her well-researched study in England in 2007, my book had already been concluded.

9 Wilkinson 2002, p. 238.

10 Sketchbook no. 95, Zervos 1932–86, vol. 7, no. 104.

11 AG 30-31.9r.

12 *Documents*, vol. 2, no. 13, 1930. This Paris periodical, edited by Carl Einstein, Georges Bataille and Michel Leiris, appeared only in 1929 and 1930. It was greatly valued in some Surrealist circles for the anti-Breton stance apparent in articles that paid homage to Bataille's heterology and in an art criticism that developed the ethnographic interests of Leiris and Einstein. See Ades 1978, pp. 229–243.

13 Zervos 1932–86, vol. 7, no. 252.

14 Rubin 1972, p. 134.

15 The remarkable phrase 'mouvement continuel' is Christian Zervos's, used in the stylistically similar context of Picasso's 1928 designs for sculptures to be installed on the promenade at Cannes. Zervos 1929, p. 342.

16 Moore, in conversation with the author, Much Hadham, 21 Oct. 1982.

17 LH 350.

18 Lichtenstern 1992a, p. 193. See also AG 31.18.

19 AG 26.1, *Notebook No. 6*, 1926.

20 For the significance of 'ordered inspiration', a term coined by Max Ernst, see Lichtenstern 1992a, p. 269. See Max Ernst, 'Inspiration to Order', in: *This Quarter* V/1 (Sept. 1932), pp. 79–85.

21 For the influence on the Surrealists of Leonardo's recommendations for stimulating the imagination, see Lichtenstern 1992a, pp. 156ff., 266ff.

22 Beginning with AG 32.52, the subtitles given to the *Transformation Drawings* in the catalogue raisonné of Moore's drawings either specify the subject (*Ideas for Sculpture: Transformation of Bones, Ideas for Sculpture: Transformation of Shells* etc.) or refer to them simply as *Ideas for Sculpture: Transformation Drawing*.

23 Quoted in Garrould 1988, p. 16. For the *Transformation Drawings*, see Wilkinson 1979, pp. 24, 84ff., and Lichtenstern 1990a, pp. 120–27.

24 Wilkinson 2002, p. 192. For a discussion of the philosophical dimension of Moore's approach to nature, see Wedewer 1980, pp. 186–193.

25 The author wishes to thank Professor Dr. med. Dr. phil. Heribert Schulz, Osnabrück, for invaluable help with identifying the bones, undertaken here for the first time.

26 AG 32.83r.

27 Quoted in Wilkinson 1979, p. 24.

28 Wilkinson 2002, p. 192.

29 LH 127.

30 For the doctrine of 'as in nature' in the more recent history of sculpture, see Lichtenstern 1993a, pp. 19–42.

31 For a detailed discussion of Brancusi's birds, see Bach 1987, pp. 53ff., 76ff., 194ff.

32 For Arp's *Growth*, see Lichtenstern 1992a, pp. 171ff.

33 Arp 1955, p. 79. See also Poley 1978, p. 115.

34 Causey 1980, pp. 253–54.

35 Nash 1932, pp. 130–131. For a discussion of Blossfeldt's work in its historical and cultural context, see Mattenklott 1994.

36 Thompson 1917. Moore himself told me in conversation (Much Hadham, 10 Sept. 1980) that he had a copy of the book in his library. For Nash's admiration of Thompson, see Causey 1980, p. 228. See also Thistlewood 1996, pp. 95–153; Hammer/Lodder 2000, pp. 385–88; Kemp 2000, pp. 116–118; and Read 1963, p. 345.

37 Thompson 2006, p. 12. See also Ritterbush 1968, pp. 81ff.

38 Thompson 1966, p. 268.

39 Thompson 1966, pp. 270–271.

40 Thompson 1966, pp. 268–325.

41 Commentary by Anita Albus in the most recent German translation of Thompson: Thompson 2006, p. 377.

42 Thompson 1966, pp. 306–307.

43 Thompson 1966, p. 269.

44 Thompson 1966, pp. 221–267.

45 Thompson 1966, pp. 230–238.

46 Wilkinson 2002, p. 221.

47 Hedgecoe 1968, p. 131.

48 Thompson 1966, pp. 263–264.

49 James 1968, p. 60.

50 Juliette Huxley and her husband, the well-known biologist Sir Julian Huxley (1887–1975), were long-standing friends of Moore's. In his capacity as first director-general of UNESCO (founded in 1946), Julian Huxley had invited Moore to speak on 'The Sculptor and Modern Society' at an artists' conference in Venice in late September 1951. He had also secured the commission for the large reclining figure in travertine marble (Fig. 1) installed in front of the UNESCO headquarters in Paris (LH 416).

51 Wilkinson 2002, p. 296.

52 Quoted in Seldis 1972, p. 42. See also Rudolph 1997, illus. pp. 77–98.

53 Seldis 1972, p. 43.

54 CGM 109–147.

55 Seldis 1972, p. 44.

56 Seldis 1972, p. 44.

57 LH 299.

58 LH 524–26 (height of large version 366 cm).

59 Rudolph 1997, p. 92.

60 LH 601.

61 LH 600.

62 LH 602.

63 Wilkinson 2002, p. 221.

64 Herder 1969, p. 106.

65 Herder 1969, p. 107.

66 Berthoud 1987, pp. 104–105.

67 LH 141, 142, 147, 149–51, 153, 154, 158, 160, 161, 164, 167–69, 172, 174, 177–79, 181, 194. For formal correspondences between these sculptures and the abstract works of Hepworth and Nicholson, see Wilkinson 1994–95, pp. 59–60. Moore contributed two statements to the anthology *Circle: International Survey of Constructive Art*, edited by Leslie Martin, Gabo and Nicholson, and published in July 1937. See Wilkinson 2002, p.193.

68 Berthoud 1987, p. 102.

69 The Surrealist exhibitions were *Fantastic Art, Dada, Surrealism*, Museum of Modern Art, New York, 1936–37; *The International Surrealist Exhibition*, New Burlington Galleries, London, 1936; *Exposition Internationale du Surréalisme*, Galerie des Beaux-Arts, Paris, 1938; *Realism and Surrealism*, Guildhall, Gloucester, 1938; *Eposición Internacional del Surrealismo*, Galeria de Arte Mexicano, Mexico City, 1940; and *Surrealism Today*, Zwemmer Gallery, London, 1940.

70 Gascoyne 1935b, p. 10. *Axis*, edited by Myfanwy Piper, was a quarterly devoted to abstract art.

71 Wilkinson 2002, p. 197. See also Part Two, 'Balance', note 161.

72 Wilkinson 2002, p. 197.

73 In conversation with the author, Much Hadham, 12 Oct. 1977.

74 Jeremy Lewison has said that, in his day, Read was the 'leading art critic in the world'. Lewison 2002–2003, p. 70.

75 Read 1933, p. 12.

76 This figure and other details about the exhibition come from press cuttings preserved in the library of the Victoria & Albert Museum, London (II R.C.L. 22). Especially useful is Quennell 1936.

77 At a later date Breton still regarded these five artists – Arp, Brancusi, Calder, Giacometti and Moore – as adequately representing Surrealism in sculpture. Breton 1972, pp. 49–83. See also Bonnefoy 1991.

78 Gruetzner 1978, p. 23.

79 Paris 1947, p. 46.

80 LH 101, 134, 138, 137. Only one of the three drawings has been identified beyond doubt: *Two Upright Forms* of 1936 (AG 36.18).

81 See Moore's contribution to *Unit One* in Wilkinson 2002, p. 191–193.

82 For example, AG 31.23, 32.30 and 33.1.

83 See *Joy of Life* and *Nude with Guitar*; Lipchitz 1972, pp. 96ff., fig. 81, and p. 103, fig. 83. See also Wilkinson 1989, pp. 29, 107–108.

84 See *Femme couchée qui rêve*, 1929, painted bronze; Hohl 1971, fig. 51.

85 Curtis 1994–95, p. 25. Curtis surmises that Hepworth may have been inspired to carve this first hole by Skeaping, her first husband. See also Wilkinson 1994–1995b, pp. 37–38.

86 Wilkinson 1994–95b, p. 48ff.

87 Curtis 1994–95, p. 38.

88 James 1968, p. 66. See Part Two, 'The Conjunction of Space and Form', note 116.

89 LH 138.

90 The term, especially well suited to describe Surrealist sculpture, was used by Carola Giedion-Welcker. Giedion-Welcker 1964, p. XXIV: '…bringing space to life as an emotional stumulus'.

91 Hence, Moore could claim 'emptiness is form' in conversation with the author, Much Hadham, 12 Oct. 1977. He often uses this formulation.

92 LH 142.

93 Much Hadham, 12 Oct. 1977.

94 *Circuit*, 1931, wood, 4.5 x 48.5 x 47 cm, Musée national d'art moderne, Centre Georges Pompidou, Paris; Hohl 1971, p. 83. Moore could have seen *Circuit* in Giacometti's exhibition at the Galerie Pierre Colle, Paris, in 1932 or in the periodical *Transition*, no. 21, 1932, p. 146.

95 Frances Joseph Bruguière (1879–1945) worked mainly in London, where in 1930 he produced a notable six-minute abstract film, *Light Rhythms*.

96 See note 17.

97 In conversation, Much Hadham, 12 Oct. 1977.

98 *Boule suspendue*, 1930–31, wood and metal, 60.5 x 36.5 x 34 cm, formerly collection of André Breton, Musée national d'art moderne, Centre Georges Pompidou, Paris; Hohl 1971, p. 82, and Beaumelle 1997. Moore would have had access to an illustration of this work in *Le Surréalisme au Service de la Révolution*, no. 3, Dec. 1931, p. 19.

99 *Pointe à l'œil*, 1932, wood and metal, l. 49 cm, formerly collection of Eleftheriades Teriade, Paris, Musée national d'art moderne, Centre Georges Pompidou, Paris; Hohl 1971, p. 82.

100 *Disagreeable Object*, 1931, plaster, 10.4 x 49.3 x 15 cm, Musée national d'art moderne, Centre Georges Pompidou, Paris; Hohl 1971, p. 79ff.

101 Quoted in Schnell 1987, p. 296.

102 Significantly, in his essay 'Artistic Genesis and the Perspective of Surrealism', Breton described Moore's approach as marked by 'necessary, dialectical games with the full and the empty'. Breton 1972, p. 79.

103 Asked for his opinion of Giacometti on the occasion of that artist's major retrospective at the Tate Gallery in 1965, Moore was quoted as saying: 'Yes, good but over-rated. The famous dog with the hanging ears, for example. It's a copy from a Greek vase […] his elongation of the figure is Mediterranean art from the era before Greek sculpture. If only the critics went more often to the British Museum, they could put all this into historical perspective […] the great success of Giacometti in England comes from the painterly qualities of his sculpture'. Berthoud 1987, p. 297.

104 For Giacometti's Surrealist phase, see especially Hohl 1971, pp. 80–105; Poley 1977, pp. 175–186; Koepplin n.d.; Hall 1980; Dufrêne 1994; Bonnefoy 1992; Umland 2001–2002, pp. 12–29 (with reproductions of works by Giacometti from Surrealist periodicals that Moore consulted mainly in Zwemmer's bookshop in London); and the commentaries in Klemm 2001, pp. 83–112.

105 Breton 1972, p. 79.

106 Klemm 2001, p. 85, fig. 36 (*L'Heure des traces*); p. 87, fig. 38 (*Suspended Ball*); p. 86, fig. 37 (*Cage*); p. 101, fig. 50 (*Palace at 4 a.m.*); p. 93, fig. 43 (*Model for a Square*); p. 105, fig. 53 (*Woman with her Throat Cut*); p. 115, fig. 61 (*The (Surrealist) Table*); p. 113, fig. 58 (*Hands holding the Void (The Invisible Object)*); p. 79, fig. 33 (*Femme couchée qui rêve*).

107 Wilkinson 1994–95b, p. 56ff. and fig. 22: *Two Segments and Sphere*, 1935–36; Glózer 1974, p. 52ff. and figs. 31, 32 (the relevant sketches from 1932 and 1934).

108 For this sculpture, see also Cork 1998, p. 137ff. (with colour illus.).

109 Hohl 1971, p. 84, fig. 61.

110 Hohl 1971, p. 104, fig. 72.

111 Hohl 1971, p. 79, fig. 61.

107 Lecombre 1994, p. 168, N 125.

108 Both sculptures are illustrated in Liverpool, New Haven and Toronto 1994–95, p. 24 (fig. 7) and p. 22 (fig. 11). Hepworth met Zadkine in Paris in 1933. See Gale and Stephens 1998, p. 11.

109 See Wilkinson 1994, p. 31.

110 Reproduced in Fontainebleau 2007, n.p. See also Zervos 1932–78, vol. 4, p. 318, fig. 319.

111 Moore confirmed to Wilkinson that he was familiar with them.

112 Zervos 1932–78, vol. 4, fig. 181.

113 The connection has been noted by Angela Dyer (commentary on AG 24.55) and, before her, by Alan Wilkinson, in Wilkinson 1987, p. 49, cat. N 8.

114 Conzen 2004, p. 44.

115 *Four Nudes by the Sea*, 1 May 1921, pastel on paper, 24.3 x 29.9 cm, Staatsgalerie Stuttgart (Zervos 1932–86, vol. 4, N 281); *Three Nudes by the Sea*, 4 May 1921, pastel on paper, 24.2 x 30.1 cm (ibid., N 280).

116 See Moore's account of the visit and of Picasso's ability to relieve the gloom radiated by *Guernica*, in Wilkinson 2002, pp. 166–67.

117 Zervos 1932–86, vol. 8, N 331.

118 AG 40-41.44, 40-41.47, 41.78. The last of these takes its cue from *Two Figures taking a Snack in a Shelter*. In this second version of the subject Moore heightened the image. The woman is more frail and appears almost transparent in the new grey-green colour scheme. Half the niche-like space behind her opens to reveal a 'landscape' of people lying in a tunnel. The space enfolds the individual and symbolises the privacy guarded by this woman, with her dignified pose redolent of stoic composure.

119 Wilkinson 2002, p. 168.

2. Surrealist Stimuli

1 The studies on Moore's relationship to Surrealism are still worth examining, including: Gruetzner 1978, pp. 22–25; Gruetzner 1981, pp. 113–123; Morphet 1979, pp. 116–122; Lichtenstern 1981a, pp. 645–658. The current study is based on these investigations. Among other aspects, it was enhanced by further comparisons with Giacometti, which for their part were complemented in an informative study later published by Steven A. Nash. See Nash 2001, pp. 43–51. I would like to emphasise Nash's conclusion (p. 51): '…his [Moore's] most radical sculptures and drawings of the 1930s should not be seen as merely experimental diversions. The liberation of invention and imagination they represent could not be reserved.'

For the complex phenomenon of biomorphism in twentieth-century art, see Glózer 1974, Poley 1978, Mundy 1987 and Lichtenstern 1992a, pp. 167–206.

2 Quoted in Alan Wilkinson 1984a, p. 270.

3 See the comparison in Wilkinson 1979, pp. 34–35, no. 20, of the drawing *Idea for Sculpture: Figure Seated on a Block* of 1928 (AG 28.142) with Picasso's painting *Seated Woman*, 1927.

4 AG 28.146. See also AG 27.37, 28.142, 28.144, 29.46v.

5 Rubin 1972, p. 124.

6 Moore's political sympathies in the 1930s tended to be left-wing and strongly anti-Fascist. See 'Introduction' and 'Henry Moore – Dates and Documents' in this volume.

7 The term 'biomorphic construction' was coined by Alfred H. Barr, the first director of the Museum of Modern Art, New York. Barr 1966, p. 190.

8 AG 30-31.6r, 30-31.7r, 30-31.8r, 30-31.9r, 30-31.10, 30-31.10v. The first two are not illustrated here. The following discussion on the genesis of the stone sculpture *Composition* forms the core of my chapter on Moore (Lichtenstern 1992, pp. 186–193, 206). Anne Middleton Wagner also described the metamorphic content of this sculpture without this knowledge. Her argument is based on a psychoanalytical point of view. See Anne Middleton Wagner 2005, pp. 116–122. When I became acquainted with her well-researched study in England in 2007, my book had already been concluded.

9 Wilkinson 2002, p. 238.

10 Sketchbook no. 95, Zervos 1932–86, vol. 7, no. 104.

11 AG 30-31.9r.

12 *Documents*, vol. 2, no. 13, 1930. This Paris periodical, edited by Carl Einstein, Georges Bataille and Michel Leiris, appeared only in 1929 and 1930. It was greatly valued in some Surrealist circles for the anti-Breton stance apparent in articles that paid homage to Bataille's heterology and in an art criticism that developed the ethnographic interests of Leiris and Einstein. See Ades 1978, pp. 229–243.

13 Zervos 1932–86, vol. 7, no. 252.

14 Rubin 1972, p. 134.

15 The remarkable phrase 'mouvement continuel' is Christian Zervos's, used in the stylistically similar context of Picasso's 1928 designs for sculptures to be installed on the promenade at Cannes. Zervos 1929, p. 342.

16 Moore, in conversation with the author, Much Hadham, 21 Oct. 1982.

17 LH 350.

18 Lichtenstern 1992a, p. 193. See also AG 31.18.

19 AG 26.1, *Notebook No. 6*, 1926.

20 For the significance of 'ordered inspiration', a term coined by Max Ernst, see Lichtenstern 1992a, p. 269. See Max Ernst, 'Inspiration to Order', in: *This Quarter* V/1 (Sept. 1932), pp. 79–85.

21 For the influence on the Surrealists of Leonardo's recommendations for stimulating the imagination, see Lichtenstern 1992a, pp. 156ff., 266ff.

22 Beginning with AG 32.52, the subtitles given to the *Transformation Drawings* in the catalogue raisonné of Moore's drawings either specify the subject (*Ideas for Sculpture: Transformation of Bones*, *Ideas for Sculpture: Transformation of Shells* etc.) or refer to them simply as *Ideas for Sculpture: Transformation Drawing*.

23 Quoted in Garrould 1988, p. 16. For the *Transformation Drawings*, see Wilkinson 1979, pp. 24, 84ff., and Lichtenstern 1990a, pp. 120–27.

24 Wilkinson 2002, p. 192. For a discussion of the philosophical dimension of Moore's approach to nature, see Wedewer 1980, pp. 186–193.

25 The author wishes to thank Professor Dr. med. Dr. phil. Heribert Schulz, Osnabrück, for invaluable help with identifying the bones, undertaken here for the first time.

26 AG 32.83r.

27 Quoted in Wilkinson 1979, p. 24.

28 Wilkinson 2002, p. 192.

29 LH 127.

30 For the doctrine of 'as in nature' in the more recent history of sculpture, see Lichtenstern 1993a, pp. 19–42.

31 For a detailed discussion of Brancusi's birds, see Bach 1987, pp. 53ff., 76ff., 194ff.

32 For Arp's *Growth*, see Lichtenstern 1992a, pp. 171ff.

33 Arp 1955, p. 79. See also Poley 1978, p. 115.

34 Causey 1980, pp. 253–54.

35 Nash 1932, pp. 130–131. For a discussion of Blossfeldt's work in its historical and cultural context, see Mattenklott 1994.

36 Thompson 1917. Moore himself told me in conversation (Much Hadham, 10 Sept. 1980) that he had a copy of the book in his library. For Nash's admiration of Thompson, see Causey 1980, p. 228. See also Thistlewood 1996, pp. 95–153; Hammer/Lodder 2000, pp. 385–88; Kemp 2000, pp. 116–118; and Read 1963, p. 345.

37 Thompson 2006, p. 12. See also Ritterbush 1968, pp. 81ff.

38 Thompson 1966, p. 268.

39 Thompson 1966, pp. 270–271.

40 Thompson 1966, pp. 268–325.

41 Commentary by Anita Albus in the most recent German translation of Thompson: Thompson 2006, p. 377.

42 Thompson 1966, pp. 306–307.

43 Thompson 1966, p. 269.

44 Thompson 1966, pp. 221–267.

45 Thompson 1966, pp. 230–238.

46 Wilkinson 2002, p. 221.

47 Hedgecoe 1968, p. 131.

48 Thompson 1966, pp. 263–264.

49 James 1968, p. 60.

50 Juliette Huxley and her husband, the well-known biologist Sir Julian Huxley (1887–1975), were long-standing friends of Moore's. In his capacity as first director-general of UNESCO (founded in 1946), Julian Huxley had invited Moore to speak on 'The Sculptor and Modern Society' at an artists' conference in Venice in late September 1951. He had also secured the commission for the large reclining figure in travertine marble (Fig. 1) installed in front of the UNESCO headquarters in Paris (LH 416).

51 Wilkinson 2002, p. 296.

52 Quoted in Seldis 1972, p. 42. See also Rudolph 1997, illus. pp. 77–98.

53 Seldis 1972, p. 43.

54 CGM 109–147.

55 Seldis 1972, p. 44.

56 Seldis 1972, p. 44.

57 LH 299.

58 LH 524–26 (height of large version 366 cm).

59 Rudolph 1997, p. 92.

60 LH 601.

61 LH 600.

62 LH 602.

63 Wilkinson 2002, p. 221.

64 Herder 1969, p. 106.

65 Herder 1969, p. 107.

66 Berthoud 1987, pp. 104–105.

67 LH 141, 142, 147, 149–51, 153, 154, 158, 160, 161, 164, 167–69, 172, 174, 177–79, 181, 194. For formal correspondences between these sculptures and the abstract works of Hepworth and Nicholson, see Wilkinson 1994–95, pp. 59–60. Moore contributed two statements to the anthology *Circle: International Survey of Constructive Art*, edited by Leslie Martin, Gabo and Nicholson, and published in July 1937. See Wilkinson 2002, p.193.

68 Berthoud 1987, p. 102.

69 The Surrealist exhibitions were *Fantastic Art, Dada, Surrealism*, Museum of Modern Art, New York, 1936–37; *The International Surrealist Exhibition*, New Burlington Galleries, London, 1936; *Exposition Internationale du Surréalisme*, Galerie des Beaux-Arts, Paris, 1938; *Realism and Surrealism*, Guildhall, Gloucester, 1938; *Eposición Internacional del Surrealismo*, Galeria de Arte Mexicano, Mexico City, 1940; and *Surrealism Today*, Zwemmer Gallery, London, 1940.

70 Gascoyne 1935b, p. 10. *Axis*, edited by Myfanwy Piper, was a quarterly devoted to abstract art.

71 Wilkinson 2002, p. 197. See also Part Two, 'Balance', note 161.

72 Wilkinson 2002, p. 197.

73 In conversation with the author, Much Hadham, 12 Oct. 1977.

74 Jeremy Lewison has said that, in his day, Read was the 'leading art critic in the world'. Lewison 2002–2003, p. 70.

75 Read 1933, p. 12.

76 This figure and other details about the exhibition come from press cuttings preserved in the library of the Victoria & Albert Museum, London (II R.C.L. 22). Especially useful is Quennell 1936.

77 At a later date Breton still regarded these five artists – Arp, Brancusi, Calder, Giacometti and Moore – as adequately representing Surrealism in sculpture. Breton 1972, pp. 49–83. See also Bonnefoy 1991.

78 Gruetzner 1978, p. 23.

79 Paris 1947, p. 46.

80 LH 101, 134, 138, 137. Only one of the three drawings has been identified beyond doubt: *Two Upright Forms* of 1936 (AG 36.18).

81 See Moore's contribution to *Unit One* in Wilkinson 2002, p. 191–193.

82 For example, AG 31.23, 32.30 and 33.1.

83 See *Joy of Life* and *Nude with Guitar*; Lipchitz 1972, pp. 96ff., fig. 81, and p. 103, fig. 83. See also Wilkinson 1989, pp. 29, 107–108.

84 See *Femme couchée qui rêve*, 1929, painted bronze; Hohl 1971, fig. 51.

85 Curtis 1994–95, p. 25. Curtis surmises that Hepworth may have been inspired to carve this first hole by Skeaping, her first husband. See also Wilkinson 1994–1995b, pp. 37–38.

86 Wilkinson 1994–95b, p. 48ff.

87 Curtis 1994–95, p. 38.

88 James 1968, p. 66. See Part Two, 'The Conjunction of Space and Form', note 116.

89 LH 138.

90 The term, especially well suited to describe Surrealist sculpture, was used by Carola Giedion-Welcker. Giedion-Welcker 1964, p. XXIV: '…bringing space to life as an emotional stumulus'.

91 Hence, Moore could claim 'emptiness is form' in conversation with the author, Much Hadham, 12 Oct. 1977. He often uses this formulation.

92 LH 142.

93 Much Hadham, 12 Oct. 1977.

94 *Circuit*, 1931, wood, 4.5 x 48.5 x 47 cm, Musée national d'art moderne, Centre Georges Pompidou, Paris; Hohl 1971, p. 83. Moore could have seen *Circuit* in Giacometti's exhibition at the Galerie Pierre Colle, Paris, in 1932 or in the periodical *Transition*, no. 21, 1932, p. 146.

95 Frances Joseph Bruguière (1879–1945) worked mainly in London, where in 1930 he produced a notable six-minute abstract film, *Light Rhythms*.

96 See note 17.

97 In conversation, Much Hadham, 12 Oct. 1977.

98 *Boule suspendue*, 1930–31, wood and metal, 60.5 x 36.5 x 34 cm, formerly collection of André Breton, Musée national d'art moderne, Centre Georges Pompidou, Paris; Hohl 1971, p. 82, and Beaumelle 1997. Moore would have had access to an illustration of this work in *Le Surréalisme au Service de la Révolution*, no. 3, Dec. 1931, p. 19.

99 *Pointe à l'œil*, 1932, wood and metal, l. 49 cm, formerly collection of Eleftheriades Teriade, Paris, Musée national d'art moderne, Centre Georges Pompidou, Paris; Hohl 1971, p. 82.

100 *Disagreeable Object*, 1931, plaster, 10.4 x 49.3 x 15 cm, Musée national d'art moderne, Centre Georges Pompidou, Paris; Hohl 1971, p. 79ff.

101 Quoted in Schnell 1987, p. 296.

102 Significantly, in his essay 'Artistic Genesis and the Perspective of Surrealism', Breton described Moore's approach as marked by 'necessary, dialectical games with the full and the empty'. Breton 1972, p. 79.

103 Asked for his opinion of Giacometti on the occasion of that artist's major retrospective at the Tate Gallery in 1965, Moore was quoted as saying: 'Yes, good but over-rated. The famous dog with the hanging ears, for example. It's a copy from a Greek vase […] his elongation of the figure is Mediterranean art from the era before Greek sculpture. If only the critics went more often to the British Museum, they could put all this into historical perspective […] the great success of Giacometti in England comes from the painterly qualities of his sculpture'. Berthoud 1987, p. 297.

104 For Giacometti's Surrealist phase, see especially Hohl 1971, pp. 80–105; Poley 1977, pp. 175–186; Koepplin n.d.; Hall 1980; Dufrêne 1994; Bonnefoy 1992; Umland 2001–2002, pp. 12–29 (with reproductions of works by Giacometti from Surrealist periodicals that Moore consulted mainly in Zwemmer's bookshop in London); and the commentaries in Klemm 2001, pp. 83–112.

105 Breton 1972, p. 79.

106 Klemm 2001, p. 85, fig. 36 (*L'Heure des traces*); p. 87, fig. 38 (*Suspended Ball*); p. 86, fig. 37 (*Cage*); p. 101, fig. 50 (*Palace at 4 a.m.*); p. 93, fig. 43 (*Model for a Square*); p. 105, fig. 53 (*Woman with her Throat Cut*); p. 115, fig. 61 (*The (Surrealist) Table*); p. 113, fig. 58 (*Hands holding the Void (The Invisible Object)*; p. 79, fig. 33 (*Femme couchée qui rêve*).

107 Wilkinson 1994–95b, p. 56ff. and fig. 22: *Two Segments and Sphere*, 1935–36; Glózer 1974, p. 52ff. and figs. 31, 32 (the relevant sketches from 1932 and 1934).

108 For this sculpture, see also Cork 1998, p. 137ff. (with colour illus.).

109 Hohl 1971, p. 84, fig. 61.

110 Hohl 1971, p. 104, fig. 72.

111 Hohl 1971, p. 79, fig. 61.

112 Hohl 1971, p. 79.

113 See Part I, Chapter Seven in this volume.

114 For this prehistoric monument in relation to early modernist sculpture, see Giedion-Welcker 1964, p. 87, and Lichtenstern 1990, p. 9–21. Alan Wilkinson examines its influence on Hepworth, who is known to have been fascinated by the menhirs of Cornwall. Wilkinson 1994–95a, pp. 83–84.

115 Hohl 1971, p. 82, fig. 65. The most comprehensive discussion of this work is Hall 1980. Julian Stallabrass has explored its relationship to Moore's *Composition* (LH 140), in Mitchinson 1998, pp. 135–36.

116 See Klemm 2001, p. 104.

117 AG 34.70, 34.71, 34.72.

118 AG 36.18. Kenneth Clark, then director of the National Gallery, had acquired various works by Moore since 1928, before making the artist's acquaintance in 1938.

119 AG 35.73, 36.6, 36.17, 36.23, 36.24.

120 See also AG 36-72.2.

121 This issue is not among those preserved in the Moore archives at Much Hadham, which contain only nos. 1, 5, 6 and 10–13. However, the artist stated that he was able to consult foreign art periodicals at his leisure in Zwemmer's bookshop in London. San Lazaro 1972, p. 21. For the popularity of *Minotaure* with British Surrealists, see Gascoyne 1935a, p. 126.

122 James 1968, p. 62.

123 AG 39.34 (study for the lithograph CGM 3).

124 See also LH 509. For *Large Totem Head*, see also Lichtenstern in: Mitchinson 1998, pp. 287–88.

125 Lichtenstern 2002, pp. 78–87.

126 LH 256, LH 350, LH 438.

127 AG 32.61, 35.95v, 37.68.

128 AG 36-72.1.

129 LH 212, LH 282.

130 LH 290.

131 Inscription on AG 37.69.

132 *Standing Female Figure*, wood, H. 33.8 cm, New Ireland, British Museum, London, Inv. 1884, 7-28.2.

133 For a detailed discussion of metamorphosis as a fundamental principle of modern art, see Lichtenstern 1992a, pp. 121–294.

134 Morphet 1979, p. 121.

135 This was a widespread practice among the Surrealist, with countless examples in painting and literature. See Lichtenstern 1981b, pp. 187–219.

136 The two sketches of figures with prominent box-shaped elements meant enough to Moore for him to repeat them in 1963 in a lithograph (CGM 53).

137 See also AG 37.57v.

138 Carter 1933, p. 112, fig. 25.

139 Bonnet 1952, Article «Sarg», p. 660.

140 AG 37.15-37.24. Edited by Roger Roughton, *Contemporary Poetry and Prose* was the mouthpiece of British Surrealists until the *London Bulletin* began publication in April 1938.

141 Dupin/Lelong-Mainaud 1999, no. 88.

142 Dupin/Lelong-Mainaud 1999, no. 115.

143 See Dupin 1962, p. 220: Circus Horse, 1927, Cat.-No. 201; See also Dupin/Lelong-Mainaud 1999, nos. 117, 129.

144 See also AG 37.39.

145 James 1968, p. 209.

146 LH 182.

147 In 1936 Gabo settled in Hampstead, where he numbered Moore, Hepworth, Nicholson and others among his friends. For his pioneering role with regard to Moore's stringed figures, see Wilkinson 1981, p. 286. See also Susan Compton's commentary on *Stringed Figure* (LH 206) in London 1988a, pp. 188–89. For Moore's influence on the stringed constructions that Hepworth began making in 1939, see Wilkinson 1994, p. 66.

148 *Cahiers d'Art*, XI, nos. 1–2, 1936, pp. 7–9 and 11–20. Man Ray discovered his mathematical objects at the Institut Henri Poincaré in Paris. They represented models for the reproduction of Euclidean and non-Euclidean space, which were intended to illustrate algebraic equations and the fourth dimension. Man Ray defamiliarised the objects by having them evoke eerie, surreal space.

149 Lichtenstern 1987, p. 56, fig. 34.

150 This is made clear by two drawings (AG 32.30 and AG 33.1) in which Moore experimented further with the rods in the sculpture reproduced here as figs. 71, 71a and 72.

151 James 1968, p. 209.

152 See the valuable comments by Michael Kausch on the symbolism of this *Mother and Child* of 1938, in Vienna 1998, pp. 289–90, cat. no. 25.

153 LH 197. 'The metamorphic form might easily be confused with some primitive stringed musical instrument were it not for the title identifying it with a reclining figure'. Compton, in London 1988a, p. 188.

154 LH 205. See the discussion of *Bird Basket* in Hofmann 1959, p. 76ff.

155 LH 213. 'The surreal riddle of this image [*Bride*] is easily solved. [...] The wires allude to the bride's veil, transforming it into a protective, though transparent, grille, into a cross between a visor and a chastity belt.' Hofmann 1959, p. 78.

156 Quoted in 'Gespräch mit Henry Moore [1954]', in Hofmann 1959, p. 58.

157 Wilkinson 2002, p. 198.

158 In conversation with the author, Much Hadham, 12 Oct. 1977.

3. The Dominance of the *Reclining Figures* Theme

1 London 1968, p. 5. Will Grohmann had devoted a separate chapter to Moore's reclining figures of 1929–58 in his monograph on the artist, Grohmann 1960, p. 43–101. For the reclining figure as a leitmotiv of the artist's oeuvre, see Lichtenstern 1994a, pp. 36–41; Lichtenstern 1999, pp. 7–25.

2 James 1968, pp. 264–265.

3 Wilkinson 2002, p. 212.

4 Translated from Gert Schiff, 'Die Plastik, der Mensch und die Natur: Eindrücke von einem Besuch bei Henry Moore', *Frankfurter Allgemeine Zeitung*, 9 Jan. 1954.

5 For the genesis of *Recumbent Figure*, see Moore's statements in James 1968, p. 99–101. The sculpture's history of after its installation at Halland was notably eventful. When Chermayeff emigrated to Canada in 1939 the carving was acquired by the Contemporary Art Society and presented to the Tate Gallery. That year the Tate lent it to New York for the world fair. In 1940 it was entrusted for the duration of the Second World War to the Museum of Modern Art, which set it up in its sculpture garden. In June of that year the sculpture was knocked from his base: the head broke off and the right knee and other parts were damaged. A restoration was undertaken in New York. Returned to the Tate in 1946, the figure was found to have suffered from the New York air. Tessa Jackson, entrusted with an extensive restoration in 1999, noted: 'Although *Recumbent Figure* needed cleaning, the question was how much dirt should be removed.' It was decided to clean the sculpture thoroughly, and in the course of this work the New York fillings were removed and corresponding sections of the left knee and the right shin reconstructed. See Jackson 1999.

6 For Chermayeff see Powers 2001.

7 For a discussion of this whole complex see Garlake 2003, pp. 175–193; Feldman Bennet 2005.

8 James 1968, p. 99. In opposition to Penelope Curtis and Fiona Russell, I take Moore's political phrase "ageless land" as a circumscription of "earth", of imperturbability, just as he emphasized it in the *stoniness* of his *Recumbent Figure*. With an organic counterpart he tried in Halland to outbalance the functionalism of modern architecture (see Curtis/Russell 2003, p.134).

9 For the bronze maquette of 1938 (LH 185), see Compton in London 1988a, no. 35.

10 Levine 1983, p. 113.

11 LH 162 (Albright-Knox Art Gallery, Buffalo, NY) and LH 175 (Wakefield Art Gallery, UK).

12 AG 38.55, 3-40.13.

13 Quoted in Berthoud 1987, p. 160.

14 Berthoud 1987, p. 232.

15 Quoted in Tylor/Lapp 1999, unpaginated.

16 Represented in painting by, for example, James Fritton, John Bratby and Reginald Brill, and in sculpture by Ghisha Koenig.

17 James 1968, p. 118. Moore's description of the figure in terms of a tunnel led John Read to show *Reclining Figure: Festival* from the inside in his film about the artist. Read 1998, p. 228.

18 Rodin 1984.

19 James 1968, p. 118.

20 Especially when compared with the countless other heads in the artist's oeuvre, which often have a vulnerable quality, the split head in *Reclining Figure: Festival*, high up and, in the plaster version, surrounded by 'rays', possesses an almost spiritual character. Split heads first appear in Moore's work c. 1934, in the context of his Surrealist interests (AG 34.22) and as a formal experiment based on Picasso's sexually charged double heads. Not until the war years did he grant them a phantasmagorical aspect, for example in the shelter drawing *The Three Fates* (fig. 169). In his sculpture, this kind of split head, redolent of strangeness and destructive power, occurred again in *Warrior with Shield* of 1953–54 (figs. 171–73), in which it embodies actual destruction. Prior to this, the father in *Family Group* of 1945 (LH 259) had a split head as a kind of stigmatising mark of war. A split head with the other, positive meaning proposed here in connection with *Reclining Figure: Festival* had appeared in a 1938 drawing of a reclining female figure with her head likewise held high (AG 38.57). The special significance attributed here to Moore's split heads accords with his own estimation of heads in general: 'In a figurative sculpture, the head is for me the vital unit. It gives scale to the rest of the sculpture and, apart from its features, its poise on the neck has tremendous significance.' Quoted in Hedgecoe 1968, p. 233; See also Julian Stallabrass in Moore 1998, p. 275 (commentary on *Moon Head*).

21 Translated from Hofmann 1959, pp. 58–59.

22 James 1968, p. 119.

23 James 1968, p. 266.

24 Lichtenstern 1994a.

25 For a seminal discussion of Moore's paradigmatic switch from drawings to *maquettes* or *bozetti* in the preparation of his sculptures, see Steingräber 1978, pp. 240–60.

26 The Center occupies approximately six hectares in the heart of Manhattan and is dominated by the structure housing the Metropolitan Opera. To the left of the Met lies Damrosch Park, containing the Guggenheim Shell for open-air concerts; to the right is the Vivian Beaumont Theater, linked to the Met building by the Library & Museum of the Performing Arts.

27 See also Seldis 1973, pp. 169–70.

28 Quoted in Seldis 1973, p. 170.

4. The *Shelter Drawings*:
Moore and the Reality of War, 1940–42

1 See Julian Andrews' highly informative study (Andrews 2002).

2 See ibid., p. 6. It is clear from the author's acknowledgements that when he was a child he and his parents took refuge in Aldwych underground station which, like many others during the Second World War, was being used as an air-raid shelter.

3 On the relationship between Clark and Moore see Wilkinson 2002, pp. 82ff.

4 See Andrews 2001, p. 144.

5 Andrews 2002, p. 18.

6 Ibid., p. 19.

7 By this time Hepworth and Nicholson had moved to St. Yves, where they had set up their new studio, now open to the public as the Barbara Hepworth Museum.

8 Something of the impression made on a continental European by Londoners' coping strategies can be found in Elias Canetti's *Party in the Blitz: The English Years*, New York 2005. That the Moore were also not going to allow their social lives to be ruined by the war is clear from the description of their visit on the evening of 11 September 1940.

9 See Henry Moore, 'Shelter Drawings', in James 1968, p. 212.

10 Wilkinson 2002, pp. 261–63.

11 As Andrews rightly remarked (2002, pp. 40f.) the existence of a number of tiny drawings suggests that Moore only occasionally made the most discreet of notes. Moore himself was upset in the extreme by the later much-reproduced image of an imagined scene from the film *Out of Chaos* (shot by Lee Miller) made two years after he had finished his *Shelter Drawings*. It shows the artist drawing in full view of those seeking refuge – with a lack of sensitivity that Moore would never have been guilty of. See also above ill. 4, p. 106.

12 James 1968, p. 216. – Moore was appointed as an Official War Artist in January 1941. Of the two sketchbooks mentioned here, the first (AG 40-41.1-68) went to the British Museum in 1976 (from the estate of Kenneth Clark). Irina Moore donated the second (AG 40-41.69-163) to the Henry Moore Foundation.

13 As cited by Andrews 2002, p. 45. See also Moore's inscription in AG 40-41.96.

14 From the wealth of literature on this subject, particular mention should be made of the following: Herbert Read, 'The Drawings of Henry Moore', in *Art in Australia*, series 4, N 3, Sept. 1941, pp. 10–17; Alan Wilkinson, *The Drawings of Henry Moore*, exh. cat. Tate Gallery, London 1978, pp. 28–36; Frances Carey, *Henry Moore. A Shelter Sketchbook,* Munich 1988; Andrews 2002; Andrew Causey, 'New Light on Henry Moore's Shelter Drawings', in: Schmoll gen. Eisenwerth, Helga 2004, pp. 319–231.

15 Typical of this are the *Eighteen Ideas for War Drawings* from the second sketchbook (AG 40.67).

16 Notes in Moore's own hand on the drawing *War: Possible Subjects* (AG 40-41.45), in the second sketchbook.

17 AG 40-41.65.

18 Moore, as cited in Hedgecoe 1968, p. 170.

19 This is one of around ten drawings of tunnel openings. See Andrews 2002, p. 92.

20 James 1968, p. 66.

21 Friedrich Dürrenmatt explored a similar sense of fear in his short story *Der Tunnel* (1952). Dürrenmatt certainly knew Moore's *Shelter Drawings*. It would be interesting to research whether they were a specific source of inspiration in the case of this short story.

22 The sense of increasingly being sucked into a vortex and, by association, the acceleration of time, stands in stark contrast to the other underlying tendency in the *Shelter Drawings,* where so many human figures look more like motionless monuments. The torment of waiting is often etched into the supra-individual, unmoving faces of these people who know no more than that time has come to a standstill. For more on this monumental quality in the *Shelter Drawings* and possible connections to Giorgio de Chirico see Causey 2004, pp. 327.

23 In early October 1940 Moore's house and studio in Hampstead suffered a direct hit during an air raid. Although his works were largely unscathed, the house was no longer habitable. So Moore and his wife, Irina, moved to Perry Green, from where he travelled in to London two or three times a week.

24 On 10 October Moore wrote to his friend Arthur Sale: 'The night-time in London is like another world – the noise is terrific and everything seems to be going on over one's own little spot – and the unreality is that of exaggeration like in a nightmare.' As cited in Andrews 2002, p. 38. W. R. Valentiner described the same situation in the following terms: The figures have something supernatural about them. They appear like ghosts of the earth, as if they had lived for eternities under the ground of which they are part. Their connection with the protecting earth around them is complete.' As cited in Causey 2004, p. 326.

25 Moore had already long since declared his allegiance to the real world. In 1937 he wrote in *Circle. International Survey of Constructive Art*: 'I dislike the idea that contemporary art is an escape from life. Because a work does not aim

at reproducing the natural appearance it is not therefore an escape from life… but an expression of the significance of life, a stimulation to greater effort in living', James 1968, p. 73.

26 See Ch. 4 in this volume on Italy, Michelangelo and Moore's interest in Christian subject matter.

27 'And here, curiously enough, is where, in looking back, my Italian trip and the Mediterranean tradition came once more to the surface. There was no discarding of those other interests in archaic art and the art of primitive peoples, but rather a clearer tension between this approach and the humanist emphasis'. James 1968, pp. 216, 218.

28 AG 28.146.

29 For more on Moore's growing interest in colour in the late 1930s (which he used freely regardless of the object in question) and on his use of mixed media, see Wilkinson 1977, pp. 34f.

30 LH 133.

31 The fluid oneness of body and drapery, which Moore achieves particularly memorably here, has echoes of the way in which Michelangelo in the Sistine Chapel at times apparently dashed off female figures in his lunette paintings who were draped in such a way as to also appear as though they were at one with the space around them. See for instance the lunette *Asa. Josaphat. Ioram*, illustrated in Vecchi, di 2001, p. 59.

32 In this respect Moore's drawings have a striking affinity with Barlach's prints. Compare, for instance, Barlach's treatment of draperies in 1912 in his lithographs illustrating his own play, *The Dead Day*. Moore is known to have been familiar with these lithographs and in 1958 he talked to Rudolf Huber of his great appreciation of Barlach's work, although he did feel that in his sculptures, Barlach tended at times towards exaggeration. Moore adds that, in his view, Barlach was at his best in his drawings and lithographs where he achieved an uncommonly intense level of expression. See Huber 1958, p. 11. For more on the connections between Moore and Barlach, see Hoffmann 1948, p. 207; statement by Helmut Schmidt in Schmidt 1982b, p. 121; Thurmann 1998, pp. 21, 49.

33 As cited by Wilkinson 1984, p. 36.

34 See Moore's inscription in AG 40-41.75.

35 See Moore's inscription in AG 40-41.148.

36 See the drawing AG 41.32. See the commentary on this in Wilkinson 1988, cat. N 49.

37 AG 40-41.135; AG 41.89; AG 41.90; AG 41.91.

38 Wilkinson 1977, p. 35. This is the first time that reference is made in this connection to the sleeping Apostles that Moore would have seen from below in London's National Gallery in the Gethsemane paintings by Mantegna and Giovanni Bellini. Details of these sleeping figures were also included in the 1938 illustrated publication by Kenneth Clark on the collection of paintings at the National Gallery. See Causey 2004, p. 322.

39 Andrews 2002, p. 126

40 *Gus Asleep (in his Boiler-Suit)*, 1978, illustrated in Garrould 1988, p. 204, fig. 252.

41 Wilkinson 1977, p. 36.

42 Moore's detailed knowledge of this tradition is evident in the drawing of the same name made two years later (fig. 169) and to be discussed in the next chapter. For more on the iconography of the Fates see Blisniewski 1992; Maisak 2004, pp. 69–88.

43 Hesiod, *Theogony*, l. 211.

44 Transl. from Blisniewski 1992 (with reference to Hesiod, *Theogony*, l. 218), p. 5.

45 Ibid., p. 14

46 Note by Moore on the sketch on p. 39 of the second *Shelter Sketchbook* (AG 40-41.107): 'People in bunks like Etruscan reclining figures'. For more on Moore's detailed knowledge of Etruscan funerary art see Lichtenstern 1994b, pp. 28–32.

47 For more on this, see Stallabrass 1992, pp. 13–39; City Art Gallery Huddersfield, Much Hadham 1992, pp. 18ff.

48 See Ch. 7 in this volume on 'Englishness'? A Matter of Definition.

5. Under the Banner of Humanism: A Dialogue with Tradition

1 In his contribution 'Henry Moore: In the Light of Greece', Roger Cardinal (University of Kent) refers prominently to this essay (first published in: Lichtenstern 1994b) and its inherent comparisons of works. Cf. Andros 2000, p. 17–51.

2 Fuchs 1969, pp. 5f.

3 This definition goes back to Apollinaire. For its foundation in Cubism see Lichtenstern 1980, p. 45. For the appreciation of archaic Greek art in the sculpture of the Classical Moderns see ibid., pp.101ff.; Wayne 1994; Paris 2000.

4 'This removal of the Greek spectacles from the eyes of the modern sculptor (along with the direction given by the work of such painters as Cézanne and Seurat) has helped him to realise again the intrinsic emotional significance of shapes instead of seeing mainly a representation value.' Quoted from Wilkinson 2002, p. 187; see ch. 1 in this volume on Moore's relationship with Primitivism.

5 Quoted from Wilkinson 1984b, p. 611.

6 AG 20.1-20.19. For the Bushey Sketchbook in the archives of the Henry Moore Institute, Leeds, see Chapt. I,1; Berthoud 1987, pp. 50–51.

7 Moore 1926 (introduction), p. 5.

8 For the numerous copies in Moore's early drawings see Wilkinson 1984a, pp. 28ff. In particular regarding our Sketchbook examples see pp. 31, 115f., 117.

9 Quoted from a letter by Moore to Lord Eccles, Chairman of the Trustees of the British Museum, in June 1969. Printed in London 1981, p.13.

10 Ibid.

11 Moore gladly left the acquisition of these collector's pieces to his wife Irina. She bought them at the Caledonian Market in London. Moore, with a smile, to the author, 12 September 1980: 'She was the collector.'

12 Moore 1981, p. 47 (with regard to his sculpture *Moon Head* from 1964).

13 Moore 1926/76 (introduction), p. 5; Wilkinson 1984a, p. 6.

14 Ibid., p. 18 (commentary by A. Wilkinson).

15 Mylonas 1966, pp. 120ff., fig. 112.

16 See Cork 1981, pp. 91–101.

17 Wilkinson 1982.

18 For the 'Tower of the Winds' see Tavlos 1971, p. 281ff. The 'Zephyr' engraving was reproduced from Stuart/Revett 1762, vol. 1, chapter ill, plate XVIII.

19 See Chapt. I,1, note 3 in this volume.

20 Cork 1981, p. 97.

21 LH 92.

22 Wilkinson 1979, cat. 74, pp. 99ff.

23 In London 1988, cat. 13, p. 176.

24 Wilkinson 1979, p. 100.

25 Wilkinson 1977, cat. 110, p. 93.

26 See Ch. I.6 in this volume.

27 Clark 1974, p. 113: 'It is a purely pictorial idea … conceived in the spirit of antique tragedy. No wonder that producers of Wagner's Ring and Shakespeare's King Lear have tried to persuade Moore to design the scenery, offers that he has very wisely declined.'

28 CGM 7.

29 I warm-heartedly thank Angela Dyer of the Henry Moore Foundation, Much Hadham, for providing me with information regarding the genesis of the School Prints (from 1937), as well as the popular pedagogical intentions that underlay them.

30 Walters 1903, p. 72 (B 12).

31 Berlin 1988, p. 225.

32 Sally Arnold-Seibert, Luxemburg, kindly pointed out this interpretation to me.

33 Moore accordingly expressed himself in his text 'The Sculptor Speaks' published in 1937 in the Listener. 'The violent quarrel between the abstractionists and the surrealists seems to me quite unnecessary. All good art has contained

both abstract and surrealist elements, just as it has contained both classical and romantic elements – order and surprise, intellect and imagination, conscious and unconscious. Both sides of the artist's personality must play their part. And I think the first inception of a painting or a sculpture may begin from either end.' See also Chap. I,2.

34 The Rescue Sketchbook, AG 44.14-44,47. For the genesis of these illustrations and Moore's friendship with Sackville-West, see Mitchinson in Much Hadham 2007, p. 4 – 9.

35 In 1949 Moore created his colour lithographs for Goethe's poem Prometheus (translated by Andre Gide). See Lichtenstern 1982, pp. 25 – 44; Mitchinson 2004, pp. 303 – 316. Moore commented to Walter Strachan that, had he had more time at his disposal, he would gladly have done more illustrations for artists' books. See Strachan 1988, p. 49.

36 London 1988a, cat. 102.

37 Tuchelt 1970.

38 Fuchs 1969, p. 249.

39 London 1981b, p. 50.

40 Sackville-West 1945, p. 12: 'For the startling parallel between the story, as I have told it, and the present state of Greece, I make no apology. It was too obvious to require underlining, but its continual presence in my own mind did, I believe, contribute something both to the character-drawing and to the balance of action.'

41 LH 268.

42 See for example AG 42.200 and AG 42.205.

43 LH 224

44 Three Standing Figures was ultimately intended for Battersea Park in London, where 'the world's first big, public open-air sculpture exhibition' took place in 1948. Berthoud 1987, p. 210 and Moore in James 1968 pp. 101–103.

45 London 1981b, p. 50.

46 Russell 1973, pp. 135–136.

47 Strachan 1988, p. 13.

48 Wilkinson 1984a, p. 36.

49 Several coincidental remarks made by Moore can be furnished for this epoch. Here is one example only: 'I think that the most "alive" painting and sculpture from now on will go more "humanist".' Quoted from Henry Moore in London 1951; for the conception of humanism in those days see Part II in this volume.

50 Klaus Herding compiled the respective evidence for German post-war art in his essay 'Humanismus und Primitivismus. Probleme früher Nachkriegskunst in Deutschland', in Jahrbuch des Zentralinstituts für Kunstgeschichte, IV (1988), p. 295 and notes 56, 57. I do not agree with Herding's theory (p. 296), that the 'resumption of antiquity … was primarily about form' and that the references to antiquity effected 'a rejection of the concrete historical surroundings' – in the sense of a proof of respectability – and that they 'propagated timeiesness', since it does not take into account the metalinguistics and time-content of the relevant works of, for example, Baumeister, Nay, Gilles, Gerhard Marcks and many others. It has to be remarked moreover, that the term humanism after 1945 was not only discussed by existentialists like Jean-Paul Sartre, Albert Camus and Maurice Merleau-Pouty but also in the communist block. Based on Marx' critic 'criticism' of classical humanism, it gained a very pragmatical-political meaning which was meant to fail regarding the inhumanity in the conduct of execution.

51 Concerning the 'mythical' sphere of this motif, which has not yet been systematically examined with regard to sculpture, I refer to the following; for Prometheus: Lichtenstern 1980, pp. 118 – 128, and ibid. 1982, pp. 25 – 43; for Orpheus: ibid., pp. 141 – 153; for Phoenix: (ibid., pp. 196f.) and Uwe Haupenthal: 'Der Phönix als Sinnbild einer existentiellen renovatio. Zu einem bevorzugten Motiv nach 1945', in Marburger Jahrbuch für Kunstwissenschaft, vol. 23, 1993, pp. 105 – 123; for Daphne: cf. Lichtenstern 1980, pp. 170 – 183; Lichtenstern 1992, pp. 85 – 107; for Narziss ibid., pp. 24 – 81; for Amphion: Lichtenstern 1985, pp. 54 – 61; for the Sphinx: Demisch 1977, pp. 204f.

52 Grohmann 1960, p. 217.

53 LH 360. The Ludwig Museum in Cologne possesses the maquette for the Warrior with Shield (Inv. No. P 311); the Kunsthalle in Mannheim purchased the executed bronze in 1955, together with a wooden base made according to

Moore's specifications. This base reminds of an altar which Moore could have meant as a harbour of refuge, in an antique sense, of the unassailableness of the warrior (see note 78 below).

54 Mitchinson in Much Hadham, S. 15.

55 James 1968, pp. 278 – 281.

56 'The figure may be emotionally connected (as one critic has suggested) with one's feelings and thoughts about England during the crucial and early part of the last war. The position of the shield and its angle gives protection from above.' James 1968, p. 250.

57 See for example the drawing Ideas for Metal Sculpture: Heads 1939, AG 39.29, in colour reproduction in Grohmann 1960, p. 109 Here the head sketched in the bottom row (centre) forms the next phase in the development of the warrior's head.

58 AG 50.36.

59 Wilkinson 2002, p. 192.

60 Ibid., p. 281.

61 The exhibition of 53 sculptures and 44 drawings took place in the Zappeion Gallery, and was organised by the British Council.

62 James 1968, p. 47.

63 Ibid.

64 Trier 1970, pp. 129–136.

65 I illustrate the old contour drawing here (from Enrico Brunn, I Relievi delle Urne Etrusche, I, Rome 1870, plate LXIX, no. 33) because it elucidates the presumed connection with Moore's Warrior, up to the altar-like base (see note 54 above).

66 Cook 1976, pp. 82ff.

67 LH 404.

68 LH 405.

69 See also London 1988a, p. 91 with reference to the Dionysus from the west pediment of the Parthenon.

70 Cook 1976, pp. 123ff.

71 James 1968, p. 48.

72 Lord Elgin purchased the Parthenon sculptures from his own funds in 1801 – 3, in order to save them from ruin and vandalism. As the result of a parliamentary resolution, they were bought by the English Government for the British Museum in 1817. With all due understanding for the Greeks' claim for their restitution, Moore's example proves once again how profoundly the Elgin Marbles have influenced European sculptural history by their presence in London. For the sculptures themselves see Brommer 1963. Brommer's volumes on the metopes and friezes followed in 1967 and 1977.

73 For Moore's morphogenetic sculptural practice as it crystallised from the 1930s onwards – via the so-called 'Transformation Drawings' – see above Ch. I,2.

74 James 1968, p. 231.

75 James 1968, p. 231. The relevant text commentary by Russell 1973, p. 158 is also important.

76 Moore 1981, p. 62.

77 Ibid.

78 Fuchs 1969, p. 312.

79 LH 457. For the genesis and importance for the history of sculpture of this first Two piece-conception see Lichtenstern 1994a.

80 For Moore's appreciation of the 'Ilyssos', ibid., p. 6.

81 James 1968, p. 278.

82 The photograph of this reworked found object is by John Hedgecoe, reproduced in Wilkinson 1979, No. 153, p. 174. Wilkinson sees in it 'an invaluable record showing the source for one of Moore's greatest sculptures of the 1960s. It illustrates how little Moore has altered the fragmented bone.' In contrast, John Farnham, who was Moore's assistant for many years, does not acknowledge that this bone piece was used as a model. In conversation, 14 Sept. 2006, Much Hadham.

83 LH 481.

84 See the article in the Frankfurter Rundschau of 9 October 1980, signed 'wp'.: 'Darf's etwas Moore sein? Millionen-Plastik steht lieblos in einer Opern-

Ecke' ('Anyone for a bit of Moore? Sculpture worth millions stands forlornly in a corner at the Opera'). Here one learns that the figure was purchased by the Departmental Head of Culture, Karl vom Rath, for DM 80,000 for the Opera House, inaugurated in 1963.

85 LH 482.

86 James 1968, p. 278.

87 This coincides with the fact that Moore gave a bronze cast of the Working Model to St Stephen's Green in Dublin, as a commemorative sculpture for the poet William Butler Yeats. See Compton, London 1988aPe, cat. 179, p. 261.

88 See Haskell/Penny 1981, no. 92, pp. 333ff.

89 Buschor 1936, p. 104.

90 Moore in conversation with the author, October 1982, Much Hadham.

91 James 1968, p. 278.

92 In the paintings *Lucretia* (1922) and *Self Portrait in the Studio in Paris* (1934) illustrated in Hanover 1970, pp. 103, 116.

93 Reprinted in full in *Mostra di Moore*, exh. cat. Florence-Forte di Belvedere, Florence 1972, p. 17.

94 See Middeldorf 1935, pp. 36f.

95 Transl. from ibid. See also John Pope-Hennessy, *Catalogue of Italian Sculpture in the Victoria & Albert Museum*, vol. I (text), London 1964, p. 148.

96 See Compton, in: London 1988 cat. N 1, p. 171.

97 Ibid. In 1926 Moore gave *Head of the Virgin* to his best friends, the painters Edna Ginesi and Raymond Coxon, as a wedding present.

98 The only existing report is the account of his first travels in a long letter to his mentor Sir William Rothenstein, Director of the Royal College of Art, on 12 March 1925. Reprinted in James 1968, pp. 37f.

99 As we saw already, this is confirmed by the *History of Sculpture Notebook* of 1920, in which Moore recorded the fruits of his study of the world history of sculpture and architecture. See AG 20.1–20.19. See above Ch. 1, p. 24 and this ch., p. 123.

100 Ekserdjian 2002, pp. 36–40.

101 As cited in Berthoud 1987, pp. 77f.

102 The heads in the lower third of the drawing are not inspired by Giotto. For a detailed account of the figures, see Wilkinson 1977, cat. N 66, with an illustration of the drawing now in the Uffizi (fig. 76).

103 'Arecò l'arte naturale e la gentileza con essa, non uscendo delle misure.' See Julius von Schlosser, *Lorenzo Ghiberti (I Commentarii)*, vol. 1, Berlin 1912, p. 36. See also Gosebruch 1961, pp. 32ff., partic. pp. 52ff.

104 At the same time as Moore was drawing this homage to Giotto, Carlo Carrà published his *Giotto, Valori Plastici*, Rome 1925. Henry Moore owned a copy of this study, in which Carrà emphasises the contemporary relevance of Giotto's work. He admires the mighty presence of Giotto's figures and the new unity of idea and form that they convey, which he achieved quite independently of any mimesis. For more on Carrà's contribution to the history of modern interpretations of the work of Giotto, see Gosebruch 1962, pp. 60f.

105 Henry Moore, introduction to Ayrton 1969, p. 7. For more on this book project see the informative, critical essay by Seidel 1971, pp. 413–16. Here Seidel rightly points out (p. 416) that, contrary to Moore's assumption, not all of the sculptures on the exterior of the Baptistery in Pisa are by Giovanni in person.

106 See Ayrton 1970, pp. 188ff. and pls. 180–183. For more on new research on this tombstone see *Giovanni Pisano a Genova*, compiled by Max Seidel and colleagues, exh. cat., Genoa 1987, pp. 121ff. The exhibition was dedicated to Henry Moore.

107 LH 360. Remarkably, by now there is another example in the second cloister of S. Croce in Florence. Presumably Moore was able to visit this location, which once again would confirm his interest in Giotto.

108 Both aspects are discussed in detail in Seidel. See note 105.

109 Wilkinson 2002, p. 169.

110 Ibid.

111 Ibid., pp. 169–70.

112 Ibid., p. 172.

113 Ibid., p. 172–173.

114 Ibid., pls. 177 and 230.

115 For more on this important concept in Moore's aesthetics see Part II.

116 Wilkinson 2002, p. 172. – Moore preceded this statement with the following comment: 'Giovanni Pisano's humanism has a quality which is for me the same as Rembrandt's humanism… or the humanism of the late Michelangelo drawings. He was the man who showed in his sculpture the whole situation of the human being.' Ibid.

117 Henry Moore, letter to the present author, 14 September 1977, Lichtenstern Archive.

118 According to John Pope-Hennessy, this was the work of a Neapolitan successor to Tino di Camaino (see James 1968, p. 19). With its clear, planar interconnections, Moore's angel – in terms of both its style and motifs – has to be related to the two angels drawing the curtains on a tombstone (made after 1323), by Tino di Camaino and owned by the Liebieghaus in Frankfurt am Main. See Detlev Zinke, *Italien, Frankreich, Spanien, Deutschland, 800–1380*, Bestandskatalog Liebieghaus, Museum Alter Plastik. *Nachantike großplastische Bildwerke*, vol. 1, Melsungen 1981, cat. N 23/24, p. 53.

119 Max Seidel (as note 106), p. 293 ('Il disegno fissa la metamorfosi di un angelo gotico – ancora chiaramente riconoscibile, anzi puntualmente identificabile – nel progetto di una scultura di Henry Moore.').

120 As cited in Florence 1972, p. 17.

121 With reference to the sheet illustrated here (AG 24.39), Wilkinson cited the artist's own words: 'It reminds me of the pose of Eve in Masaccio's *Expulsion*… She has the same sad, downcast, weightiness.' See Wilkinson 1977, cat. N 19, p. 53.

122 AG 25.38.

123 See Baldini/Casazza 1994, fig. p. 156.

124 The commission for this work came to Moore in the midst of the war, in 1942. The client was the Rev. Walter Hussey, vicar of St Matthews Church in Northampton. Moore started work on the commission in 1943, and the statue was consecrated in February 1944. See Clark 1944, pp. 247–49.

125 See Richard Cork, 'An Art of the Open Air: Moore's Major Public Sculpture', in London 1988a, p. 18.

126 Another twenty-five preparatory studies are contained in the 'Madonna and Child Sketchbook 1943'. See AG 43.79-43.102.

127 LH 215–224.

128 Andrea Mantegna: *Christ in Gethsemane*, c. 1480 (?), tempera on wood, 62.9 x 80 cm, National Gallery, NG 1417, London, see London 1995, p. 406.

129 Wilkinson 1977, cat. N 167 and fig. 97. – Another of the works with Mantegna-influenced, distinctly sculptural figures is Moore's pen-and-ink drawing *The Two Thieves, St. John and Roman Soldiers* of 1925, which Ekserdjian has traced to the Collection of Prints and Drawings in the Uffizi (as note 100), p. 36.

130 See Prater 1985, p. 282.

131 Berthoud 1987, p. 26.

132 AG 21.1v.

133 AG 21-22.26v.

134 Henry Moore interviewed by David Sylvester (*The Sunday Times Magazine*, 16 February 1964). As cited in James 1968, p. 175.

135 Information gathered from a two-page reproduction of Moore's library in his house in Much Hadham. Illustrated in *Henry Moore Intime*, ed. by Timothée Trimm, exh. cat. Galerie Didier Imbert Fine Art, Paris 1992, unpaginated.

136 James 1968, pp. 175–186.

137 James 1968, pp. 175f.

138 Kauffmann 1951, p. 150.

139 Ibid., p. 147.

140 Ibid., p. 150.

141 See Baldini 1982, N 37, p. 49.

142 Ibid.

143 LH 457.

144 Lichtenstern 1994a, p. 54.

145 James 1968, p. 72.

146 For more on Rodin see J. A. Schmoll, gen. Eisenwerth, 'Zur Genesis des Torso-Motivs und zur Deutung des fragmentarischen Stils bei Rodin', in idem (ed.), *Das Unvollendete als künstlerische Form,* Bern and Munich 1959, pp. 117–39; for more on Rodin and Brancusi see Werner Schnell, *Der Torso als Problem der modernen Kunst,* Berlin 1980, pp. 25–71 and p. 139; in an unpublished lecture (Marburg University, summer semester 1991) on the reception Michelangelo by twentieth-century sculptors and painters, the present author also discussed Alfred Hrdlicka's early interest in Michelangelo's *Slaves;* for more on Lorenzo Guerrini see Christa Lichtenstern, '"Solo con l'arte astratta si può capire l'importanza delle intuizioni di Michelangelo". Lorenzo Guerrinis Reisenotizen aus Florenz im Jahre 1956', in *Musagetes, Festschrift für Wolfram Prinz,* ed. by Ronald Keks, Berlin 1992, pp. 381–396.

147 James 1968, p. 186. – For a new attempt to read the 'dying slave' not as dying, but as a representative of the human being *ante legem* in contrast to the 'rebellious slave' which is an embodiment of the *sub lege* principle, see Elhanan Motzkin, 'Michelangelo's "Slaves" in the Louvre' in *Gazette des Beaux-Arts,* 134th year, vol. CXX, December 1992, pp. 207–28.

148 LH 402. The motif of the prostrate figure may have originated in a series of photographs that Moore took of the dead in Pompeii in the mid-1950s. Moore was not the only twentieth-century sculptor to be fascinated by the way that these figures had been cut down in an instant, that they had lived on as 'casts' and that it is still possible to see in them concrete evidence of past lives. I am thinking here of artists such as Germaine Richier, George Segal, Jürgen Brodwolf and Antony Gormley. For more on this see Christa Lichtenstern, 'Zwischen Verdinglichung und gebannter Gegenwart – Pompejis Tote und die Skulptur des 20. Jahrhunderts', paper delivered at the symposium *Jenseits von Pompeji. Faszination und Rezeption.* Institut für Klassische Archäologie an der Universität des Saarlandes; unpublished. See also 'Henry Moore – Dates and Documents' in this volume.

149 Maquette (LH 401) illus. in Florence 1972, cat. N 91. – A bronze version of this *Reclining Figure,* now enlarged to a length of 2.44 m is on display outside the Akademie der Künste, Berlin-Tiergarten.

150 As cited in *Henry Moore. Sculptures, Drawings, Graphics 1921–1981,* exh. cat. Madrid 1981, p. 136.

151 See Joachim Poeschke, *Die Skulptur der Renaissance in Italien. Michelangelo und seine Zeit,* Munich 1992, pp. 104f.

152 James 1968, p. 180. A similar line ('returning to the Middle Ages') is also taken by Herbert von Einem, *Michelangelo. Bildhauer-Maler-Baumeister,* Berlin 1973, p. 230. See also Baldini (as note 140) N 52/53, pp. 55f.

153 James 1968, p. 180

154 Wilkinson 2002, pp. 158–59. The 'swagger' Moore mentions here is presumably a reference to Michelangelo's *David.*

155 See Dörken 1936; for more on Delacroix' key work *Michel-Ange dans son atelier* (1849/50), see Johnson 1986, vol. IV, p. 204 N 305, pl. 126; Daguerre de Hureaux 1993, p. 16 (colour illustration), p. 21 and p. 288, note 29 (with further reading).

156 See AG 75.33-75.36, and AG nos. 229–231. According to Garrould the drawings were made in Forte dei Marmi after museum photographs. Moore had already studied the painting in detail in the Brera. The then director of the museum, Franco Russoli, had invited a number of leading artists to interpret a work of their choice. The results were to be shown in an exhibition to help the museum raise urgently needed funding.

157 See Hans Belting, *Giovanni Bellini: Pietà. Ikone und Bilderzählung in der venezianischen Malerei,* Frankfurt 1985, p. 56. Belting shows how Bellini became increasingly independent of artistic tradition.

158 See ibid., pp. 28ff.

159 Alan Wilkinson, 'Henry Moore Drawings 1979-83. Reminiscences and Continuing Themes', in exh. cat. *Henry Moore: Drawings 1979–1983* from The Henry Moore Foundation, London, Marlborough Fine Art, 5 September – 19 October 1984, London 1984, p. 11.

160 For more on the theme of Golgotha in Moore's work, see LH 377, 379, 386. On this, see Compton, London 1988a, cat. N 134, p. 237 and AG 54-56.5 – AG 54-56.8r.

161 See Jochen Sander, *Italienische Gemälde im Städel 1300-1550, Oberitalien, die Marken und Rom,* Mainz 2004, pp. 116–129.

162 LH 354, 355.

163 AG 44.67. See also Compton's commentary on this drawing and its new colour version in London 1988a, p. 252, cat. N 163 *Draped Standing Figures in Red.*

164 Moore made twelve copies after Ghiberti, paying particular attention to the story of Moses, where a mother and child represent the astonished Israelites (see AG 80.293v and AG 81.77).

165 Moore made express reference to expression of the 'power of goodness' in Masaccio's work (James 1968, p. 40). In the same context, he also named Giovanni Pisano, Rembrandt and Cézanne as other 'humanists' comparable to Masaccio.

166 See Lichtenstern 1994b, pp. 28–30.

167 It is worth mentioning here that Moore enjoyed meeting Italian sculptors. Amongst those he knew and admired were Umberto Lardera and Lorenzo Guerrini; Moore and Marino Marini were close friends for decades. In an unpublished letter to Ernest Musgrave, Director of the Leeds City Art Gallery, dated 14 March 1952 (Henry Moore Institute Archive, Leeds), Moore gives an account of a meeting he had with Umberto Lardera, when they talked about Michelangelo. – On 20 July 1967 Moore, his wife Irina and daughter Mary visited Lorenzo Guerrini in the quarries at Marina di Carrara. A photograph taken on that occasion shows the two artists engaged in lively discussion in front of Guerrini's stone sculpture *Uomo maccina verticali* (1963), illus. in Pier Carlo Santini, *Guerrini,* Bologna 1989, p. 47. – See also Lichtenstern 2003a, pp. 91–104 (with English translation).

6. The Late Work: Some Insights

1 For more on Hermann Noack see Part III, note 10.

2 See Lichtenstern 1994a, particularly the chapter 'Fragment und Ensemble', pp. 80ff.

3 Bowness 1977, p. 9.

4 LH 504, 516, see also Ch. I–3.

5 Bowness LH, vol. 4, p. 11.

6 Ibid., p. 17

7 Ibid.

8 As, for instance, in LH 543, 581. – For more on Moore's attitude see his reaction to Rodin, Ch. I–8 in this volume, p. 232.

9 Sylvester, London 1968, p. 128.

10 Ibid.

11 Joseph Gantner, 'Der alte Künstler', in *Festschrift für Herbert von Einem,* Berlin 1965, p. 74. This topic has been variously addressed in the literature. See Brinkmann 1925; von Einem 1973b, pp. 88–92; Schnell 2001, pp. 151–74.

12 Rodin in conversation with Judith Cladel, as cited in Schnell 2001, p. 169.

13 Schnell 2001, pp. 158ff.

14 See Ursel Berger and Jörg Zutter in: Berlin 1996/97, p. 15, cat. N 86.

15 See Schnell 1987, pp. 291–310.

16 For more on *Buscando la Luz I* (Hernani) and *Buscando la Luz II* (Pinakothek der Moderne) see Lichtenstern 2003b, pp. 229–65.

17 LH 515.

18 LH 592.

19 LH 634–36.

20 LH 503.

21 LH 549.

22 LH 621.

23 LH 627.

24 For more on this see Cork in: London 1988a, pp. 14–26; Feldman Bennet 2005; see also Henry Moore's comments on 'Sculpture and Architecture', in Wilkinson 2002, pp. 242–45.

25 See in London: *Time-Life Building Screen,* 1952–53 (LH 344), in Rotterdam: *Wall Relief* for the Bouwcentrum, 1955 (LH 375), in Paris: *UNESCO Reclining*

Figure (see fig. 1) 1957–58 (LH 416); in New York: *Lincoln* Center *Reclining Figure*, 1963–65 (LH 519), in Chicago: *Nuclear Energy*, 1964–66 (LH 526).

26 Wilkinson 2002, p. 243.

27 Ten casts of the preparatory model were made (LH 504, height 71.12 cm). There are three casts of the version under discussion here. One monumental example (*Mirror Knife Edge*) can be seen today outside the East Building of the National Gallery in Washington. It came into being as a result of the collegial relationship between Henry Moore and Ieoh Ming Pei, the architect of the East Building.

28 With the exception of Rodin's *Burghers of Calais* which were placed east of Parliament House near the banks of the Thames in London.

29 Scholars have attributed certain architectural details to the young Augustus Welby Northmore Pugin, who worked closely with Sir Charles Barry, the architect of the Houses of Parliament which epitomise the neo-Gothic style popular in Victorian England. See Hastings 1950.

30 LH 514, 515.

31 As cited in Wilkinson 1987, p. 207.

32 Ibid.

33 LH, vol. 3, figs. 160–70.

34 LH 571a: *Divided Oval: Butterfly*. The monumental version (LH 571b) has the same title.

35 LH 634, 635, 636.

36 CGM, N 105.

37 London 1988a, cat. N 189.

38 See David Cohen on *Hill Arches* in Mitchinson 1998, p. 305.

39 Wilkinson 2002, p. 246.

40 Ibid., p. 248.

41 LH 707, 708, 709.

42 By contrast, in his numerous smaller figurative works from the same period, Moore developed a new delicacy which at times even displayed mannerisms not seen before in his work.

43 See Hall 1960.

44 This motif is variously seen in the work of artists such as Caspar David Friedrich, Philipp Otto Runge, Ludwig Richter and John Constable.

45 Gantner 1965, p. 76.

46 Moore in conversation with John Hedgecoe. See Moore/Hedgecoe 1986, p. 175.

7. 'Englishness'? A Matter of Definition

1 Gerhard Marcks to Richard Scheibe, Cologne, 13 April 1961. Scheibe Estate, Kolbe-Museum, Berlin. I only chanced upon this comment having already finished this chapter. How very apt it is will be seen from what follows.

2 Andrew Causey on the political background of the exhibition at the Royal Academy: 'The Royal Academy's British exhibition marked itself unequivocally on taste, giving rise to a large, varied, and speculative literature on what constituted a national tradition in art. Coming as it did a year after Hitler's ascent to power and the beginnings of the reshaping of Germany's national traditions, there was an impulse and an example for the same kind of self-analysis in Britain.' Causey 1987, p. 18.

3 Herbert Read, 'English Art', in *The Burlington Magazine*, Dec. 1933, vol. LXIII, pp. 243–76.

4 Ibid., p. 244.

5 Ibid.

6 Ibid., p. 253.

7 Ibid., pp. 254ff.

8 Kevin Davey, 'Herbert Read and Englishness', in David Goodway, *Herbert Read Reassessed*, Liverpool 1998, p. 270.

9 Ibid., p. 271.

10 Ibid., p. 272.

11 As cited in Andrew Causey (ed.), *Paul Nash. Writings on Art,* Oxford and New York 2000, p. 109.

12 According to family tradition, Moore's great-grandfather was from Ireland. Genealogical research has shown that this connection was at least one generation further back. See Berthoud 1987, p. 19.

13 For more on this see Metken 1974, p. 111. With his various Arthurian scenarios, Edward Burne-Jones, for one, influenced a whole generation of artists in the period up until the First World War. His work was exhibited throughout Europe. On Burne-Jones' influence on the French Symbolists, but also on Charles Ricketts, Aubrey Beardsley, Pablo Picasso in Barcelona and even the young Paul Nash, see Harrison/Waters 1979, pp. 173ff.

14 Frey 1942. This very thorough, impressively expert overview is unfortunately impaired by its reliance on concepts that were current at the time of its writing. Although to my knowledge Frey was not a National Socialist, his study (conceived as early as 1928) has the declared intention of pursuing 'a study of national characteristics grounded in the art history of that country' (trans. from p. 9) with the result that it is still unacceptably ideologically biased.

15 The doubts intermittently voiced today regarding the existence of a specifically British art would have been unthinkable in Moore's day. See the report of a conference in the Tate Gallery by Franziska Augstein: 'Wirklichkeit und Warzen. Was ist das Englische an der englischen Kunst?', in *Frankfurter Allgemeine Zeitung*, 18 May 1996.

16 Trans. from Frey 1942, p. 376.

17 Ibid., p. 380.

18 Ibid.

19 AG 41.76.

20 For the *Book of Kells* see Brown 1992, pl. 9.

21 See Fillitz 1969, p. 244, commentary on fig. 315 by Georg Zarnecki: 'The English sense of types of linear forms [is developed] in the treatment of drapery folds, which often appear illogical in their movements.' [trans.]

22 Pevsner 1955/56, p. 128.

23 Cf. Butlin in London 1978b, p. 129 and Bindman 2001, cat. N 510.

24 Trans. from Huber 1958, p. 8.

25 For more on this see Lichtenstern 1992a, pp. 281–88.

26 See Selz 1959; Morschel 1972.

27 As cited in Mitchinson 1998, p. 241.

28 See London 1981, p. 38.

29 See Higgins 1954, cat. N 897, fig. p. 130: Demeter and Persephone in a carriage, late 7 BC, terracotta, height: 16.5 cm.

30 Trans. from Riedl 1957, p. 3.

31 Ibid.

32 James 1972, p. 246.

33 Ibid.

34 AG 50.36.

35 This manuscript, formerly in the collection of Robert Harley, came into the possession of the British Museum in 1802. See Henry 1964, p. 88.

36 Henry 1964, fig. 85.

37 As cited in Riedl 1957, p. 20.

38 The striking frequency of workings of the metamorphosis theme in the postwar years makes it possible to distinguish those founded on notions either of degradation or of ascension. For more on this see Lichtenstern 1992a, pp. 304ff. and 334ff.

39 This 'fabulous' identification with Pan is diametrically opposed to the surreally undermined, sensually image of Pan proposed by one such as Max Ernst. See Max Ernst, 'Au-delà de la peinture' (1936), in: Ernst 1970, pp. 286f. For more on this, see Lichtenstern 1993b, pp. 249ff.

40 Sir William Keswick spared no effort to find the perfect location for this sculpture near Dumfries in Scotland. He spent nine months trying out different positions. The final location, with the figures pointing southwest, takes full advantage of the changing light, the angle of the sun and the way the shadows fall.

41 Read 1933, p. 244.

42 I later found the following observations regarding the biographical authenticity of *King and Queen* confirmed in Feldman Bennett, Andros 2000, p. 65.

43 Spender 1986, p. 31.

44 Berthoud 1987, pp. 97f.

45 Henry Moore to Vera List, 6 March 1968, HMF Archive, Much Hadham.

46 See AG 50-51,62 and AG 50-51,65. As early as 1938 Moore had already made a drawing with the inscription 'New kind of plant' (see AG 38.27). In the same vein there are also the drawings *Standing figures and tree* of 1950, see, amongst others, AG 50.58.

47 James 1968, p. 265.

48 Hedgecoe 1968, p. 233.

49 LH 566.

50 Bronze (original in plaster), 37.9 x 20 x 25.9 cm, 1934, Musée National Picasso, Paris. See Spies 2000, N 157.

51 James 1968, p. 68.

52 This and the preceding comment: James 1968, p. 253.

53 See also James 1972, p. 284.

54 Skipwith 1988, unpaginated. – In the same volume, see Lingard 1988. See also Feldman Bennet 2006–07, pp. 52–55.

55 LH 342.

56 See Skipwith 1988, cat. nos. 4–9. See also two designs for large-format cornerstones intended for the fourth storey of the main façade. Ibid. cat. N 3a/b. These show reliefs of markedly biomorphous-abstract motifs which were later adapted for the wall relief on the Bouwcentrum in Rotterdam (LH 365).

57 In the film *Henry Moore looking at his work with Philip James* (1975), the sculptor described the base of *Glenkiln Cross*: '…and on it are little bits of drawing which don't matter sculpturally, which represent a ladder and a few things connecting it with the Crucifixion'. As cited in Wilkinson 1981, p. 300. – See also Moore's comment: 'The incision of a ladder and other Crucifixion symbols on the lower part of *Glenkiln Cross* suggests that a religious interpretation would not be misplaced' (Morphet 1981, p. 122).

58 AG 47.

59 AG 36-72.10.

60 The reading 'strips' suggested in AG 35.47 is misleading in the given context. In my view the inscription has to be read as 'strings'. It was then only a short, logical step from these 'strings' to the idea of the lyra bird in *Poetry London*.

61 James 1968, p. 253.

62 'When I came to carry out some of these maquettes in their final full size, three of them grouped themselves together, and in my mind, assumed the aspect of a Crucifixion scene, as though framed against the sky above Golgotha. But I do not especially expect others to find this symbolism in the group.' As cited in James 1968, p. 257. And he expressed a similar sentiment in conversation with Richard Morphet, Morphet 1981, p. 122.

63 Grohmann 1960, p. 197. In a similar vein, see also Compton in: London 1988a, p. 237, where there is talk of a 'resemblance to an ancient Celtic Cross'.

64 See Bettina Brandt-Förster, *Das irische Hochkreuz. Ursprung. Entwicklung. Gestalt*, Stuttgart 1978, p. 138.

65 Ibid., p. 95 and fig. 24.

66 Ibid., p. 98.

67 Ibid., pp. 67ff.

68 As note 66.

69 See pp. 211–212.

70 Bernhard Maier, *Stonehenge. Archäologie, Geschichte, Mythos,* Munich 2005, pp. 10ff.

71 Ibid., pp. 13f.

72 In conversation with the artist, Much Hadham, 10 September 1980.

73 Ibid.

74 For more on *Documents* see Ades 1978, pp. 228–49.

75 Moore and Nash, who first met in 1927, had worked together since autumn 1932 on the formation of Unit One and preparing the group's important London exhibition, which took place in 1934. (See Ch. I–1 in this volume, note 1). Besides Nash and Moore, other artists were also represented – such as Edward Burra and Tristram Hillier – who were part of the English contingent at the major International Surrealist Exhibition in London. See Causey 1980, pp. 244ff. and passim.

76 Nash used this phrase in a note found in his estate. As cited in James Laver, *Paul Nash. Fertile Image*, ed. by Margaret Nash, London (1st edn 1951) 1975, p. 13.

77 See Causey 1980, catalogue raisonné, nos. 783, 787, 786, 905. For more on the painting *Stone Tree* (no. 783) see Causey, pp. 255f.: 'The idea that wood and stone could be parallel manifestations of energy and strength and as such, significant examples to the artist who gains his own strength from the direct experience of nature's energy had been suggested to Nash by Moore.'

78 As cited in Laver 1951, p. 13.

79 As cited in Causey 1980, pp. 253f. and 256.

80 Of course magic was already a component in Moore's early interest in Mexican art. See pp. 21–23.

81 See also AG 33.39.

82 Broadly speaking the semi-abstract form of the *Stonehenge* figure recalls the stone sculpture *Two Forms* of 1934 (destroyed), see LH 150.

83 AG 34.69.

84 See Gale/Stephens 1998, pp. 69f. Alan Wilkinson makes specific reference to Hepworth's openness to the inspiration to be drawn from the *Mên-an-tol*. See Wilkinson 1994–95, pp. 83ff.

85 AG.37.67.

86 Gale/Stephens 1998, p. 69.

87 See p. 87.

88 CGM 207–223. For more on this see most recently: Schmidt 2004, pp. 64–67.

89 AG 72.112; 72.113; 72-74.1-72; 74.8; 73.32-73.38.

90 In the 1950s Moore and his wife frequently travelled to the Salisbury area, to visit their daughter Mary at boarding school. See Spender 1974, unpaginated.

91 Information kindly supplied by Michel Muller, formerly at Much Hadham.

92 As early as 1974 Spender already rightly recognised that in this Moore was following in the same tradition as Seurat (Moore owned three comparable dark charcoal drawings by Seurat). For more on this see Feldman Bennet 2001, p. 57.

93 See Causey 2003, pp. 81–106.

94 See LH 211.

95 Spender 1974.

96 See David Bindman, *William Blake. The Complete illuminated books*, London 2001, p. 245.

97 Bindman 2001, pp. 249f. and 366f.; and Erdman 1975, illustrations of *Jerusalem* 92 D and 94 D.

98 William Blake, *Jerusalem* (ca. 1804–20?), pl. 70, relief etching, finished in ink, 21.9 x 15.9 cm. See Bindman 2001, cat. N 549.

99 Louis Hawes refers to Dr. Stukeley, *A Peep into the Sanctum Sanctorum*, p. 12, pl. VII. See Louis Hawes, *Constable's Stonehenge*, Victoria & Albert Museum, London 1975, p. 21, note 46.

100 Citing a contemporary idiom, see William Gilpin, *Observations on the Western Parts of England, relative chiefly to Picturesque Beauty*, London 1778, p. 80, as cited in Hawes 1975, p. 13.

101 Hawes 1975, p. 2.

102 John Constable, *Stonehenge*, 1835, watercolour, 39 x 59 cm, Victoria & Albert Museum. For more on this see Hawes 1975, p. 1: 'Probably the best known and surely the most powerful artistic rendering of England's foremost pre-Roman monument'.

103 As cited in Hawes 1975, pp. 1f.

104 The term 'Englishness' is not used here with any nationalist overtones whatsoever. It refers purely to the inspiration and plentiful ideas that Moore

undeniably drew from Irish-Anglosaxon art. The artist himself was entirely sanguine about the use of this term, see Huber 1958.

105 See Fuller 1988, pp. 37ff.

106 James 1968, pp. 266, 274.

107 See Davis 1983, pp. 264–68. Davis researched Moore's allegiance to Wordsworth above all with reference to their similar love of Stonehenge. – See also King 1966, pp. 134–37. King specifically pointed out that both Moore and Wordsworth shared the 'quality of simplicity' and that both artists knew how to unite 'life and nature'.

108 Moore, with a portrait photograph and illustrations of his work, was featured as a 'Surrealist' in the *London Bulletin*, nos. 8–9: 'Living art in England'. Jan.–Feb. 1939, unpaginated.

109 Read 1936, pp. 17–91.

110 Ibid., p. 168.

111 James 1968, p. 79.

112 AG 78.5 and CGM 547.

113 See Reynolds 1960 (2nd edn 1973, p. 95, N 21.113 (pl. 319).

114 Kenneth Clark, *Landscape into Art*, London 1949, p. 79.

115 Ibid., p. 76.

116 It would only be possible to do justice to this area of Moore's work by devoting an entire study to his painting and use of colour.

117 The story of Ulysses and Polypheme is here underlaid with Turner's programmatical chiaroscuro. The dramatical setting of the picture appealed especially to the young Moore.

118 See AG 80.229; 80.230; 80.231; 81.281r.; 81.366.

119 Illustrated in Feldman Bennet 2001, p. 58.

120 Henry Moore, Introduction to the album *Auden Poems/Moore Lithographs*, London 1974, p. XIV.

121 Oil on canvas, 91, 5 x 122 cm, Lord Aster of Hever, Edenbridge, Kent.

122 See Haftmann 1972, pp. 8ff.

123 See his comments in conversation with Pat Gilmour, 25 March 1975, published in Wilkinson 2002, p. 185.

124 The surrealist reception of Blake is a rich, as yet unresearched area. In the opinion of the French Surrealists, Blake epitomised the *génie poétique*, the fascinating rebel and – like Baudelaire – the defender of the imagination. His influence is notably seen in the work of Philippe Saupault, Paul Eluard, André Breton, Pierre Mabille, Max Ernst, René Magritte and André Masson.

125 This was the view of David Mellor writing about the Neo-Romantics, amongst whom he counted artists such as Graham Sutherland, John Piper, Henry Moore, Cecil Collins, John Minton, John Craxton, Leslie Hurry, Michael Ayrton, Ceri Richards, David Jones and others: 'Neo-Romantic art of the 1940s fixed its gaze beyond Surrealism to the future, but it was often a future written in the British past. This was a projected past which found its myth of origins in the land of Britain itself. This narrative in British art seems coiled and involuted, with King Arthur and William Blake twined close to Picasso and André Masson as points of cultural reference. Here was an organic myth of rocks, hills and Arcadia . . .'. Mellor 1987, p. 16.

126 See Döring 2001, N 197, p. V.

127 As cited in Bradford 1975, p. 16.

128 See Grigson 1947. For more on Grigson see Jeffrey 1987, pp. 129–35.

129 See Causey 1980.

130 See Causey 2000, p. 109.

131 Ibid., p. 131.

132 Ibid., p. 140.

133 Causey 1980, cat. rais. N 956 and the relevant studies, cat. rais. N ˢ 974 and 975.

134 Causey 2000, p. 151.

135 See London 1978, cat. N 95.

136 Shakespeare, *Macbeth*, act 1, scene 7, lines 21–25. Shakespeare 1999, pp. 39f.

137 Sutherland 1936, pp. 7–13.

138 As cited in Mellor 1987, p. 111.

139 On the dominance of the line in Blake's theory of art, see Eaves 1988.

140 See Mitchinson 2002, p. 32, fig. on an interim print (with annotation) of *Mother and Child,* 1983.

141 This biblical title comes from John 12:46 and Revelations 3:20. See Maas 1984; Bronkhurst 2006, cat. 74, 80, 161.

142 See the commentary on *The Light of the World* in Metken 1974, p. 84, cat. N 36. – In 1851 John Ruskin reviewed the painting in an article in the *Times*, in which he made specific mention of the 'splendour' of Hunt's subtle colouration.

143 See Metken 1974, Introduction; Rossetti owned a sketchbook that had belonged to Blake. Ibid., cat. N 89.

144 Study for *The Light of the World*, 1851–52, pencil, brown ink, wash, 25.7 x 35.8 cm, Visitors of the Ashmolean Museum, Oxford. See Bronkhurst 2006, vol. II, Drawings, cat. D 59.

145 See for instance William Blake, *The Third Temptation*, ca. 1803–5, pen and watercolour over pencil, 41.6 x 33.4 cm, Victoria & Albert Museum, London. See Butlin 1981, cat. N 476, pp. 353f.

146 William Blake, *Jerusalem* (1810–1820?), pl. 1, frontispiece, relief etching, overworked in ink, 22 x 16.1 cm. See Bindman 2001, cat. N 480.

147 Wilkinson compares this drawing with Hunt's painting *The Light of the World*. See Wilkinson 1977, cat. N 179, p. 118.

148 Henry Moore Foundation Archive, Leeds.

149 Wilkinson 2002, p. 184. See also Darmstadt and others 1982, p. 53.

150 Wilkinson 2002, ibid.

151 See Gruetzner 1978, p. 24.

152 Grohmann 1960, p. 266.

153 Wilkinson 2002, pp. 116f.

154 AG 46.60-46.85 and CGM 4 c. 1946.

155 The full text of the poem reads: 'They came running over the perilous sands / Children with their golden eyes / Crying: Look! We have found samphire / Holding out their bone-ridden hands. It might have been the spittle of wrens / or the silver nest of a squirrel / For I was invested with the darkness / Of an ancient quarrel whose omens / Lay scatter'd on the silted beach. / The children came running towards me. But I saw only the waves behind them / Cold, salt and disastrous / Lift their black banners and break / Endlessly, without resurrection.'

156 Letter from Read to Moore on 12 October 1945. The correspondence between Moore and Read is held in the Henry Moore Foundation Archive in Much Hadham.

157 Undated letter from Herbert Read to Henry Moore. Since this included the urgent communication from the publisher Peter Gregory at Lund Humphries, written on 26 June 1946, this must be a case of *terminus post quem.*

158 Grigson 1944/51, p. 12.

159 For more on Blake's attitude to colour see Dittmann 1987, p. 270.

160 Moore came up with this technique by chance, as he explained later on: 'sometimes before the war when doing a drawing to amuse a young niece of mine, I used some of the cheap wax crayons… in combination with a wash of water-colour, and found, of course, that the water-colour did not "take" on the wax, but only on the background. I found also that if you use a light-coloured or even a white wax crayon, then a dark depth of background can easily be produced by painting with dark water-colour over the whole sheet of paper. Afterwards you can draw with India ink to give more definition to the forms.' Letter from Moore on 11 December 1964 to E. D. Averill, as cited in Much Hadham 2002, p. 28. James 1968, p. 218.

161 Cannon-Brookes 1983, p. 21.

162 The source for this is an undated note, probably penned in the early 1950s. See Wilkinson 2002, p. 237.

163 *Richard Gough's Sepulchral Monuments in Great Britain* (published from 1786 onwards) and *Vetusta Monumenta* (1789).

164 In this small fourteenth century church, which also includes other important pieces, such as the renowned Waterton Tombs, Moore was deeply moved

by the tomb for Lionel Lord Welles and his wife. As he explained to John Hedgecoe, he was particularly impressed by 'the almost Egyptian stillness' of the figures. As cited in Curtis/Russell 2003, p. 129. See also Wilkinson 2002, p. 36.

165 Wilkinson 2002, p. 111.

166 On the dating and style of this famous relief, see the groundbreaking study by Zarnecki 1953, pp. 105–19. As regards the dating, I favour the line taken by Morrison 1999, *http://www.crsbi.ac.uk/crsbi/frsxsites.html*, link "Chichester Cathedral" (retrieved 10/07/08). Information kindly supplied by Dr. Antje Fehrmann, University of Marburg.

167 Wilkinson 2002, p. 111.

168 The commission for the heads arose from an initiative on the part of Marc Norman, a patron of the arts and local dignitary in Much Hadham. It was also Marc Norman, son of Montague Norman, sometime Director of the Bank of England, who placed a commission shortly before his death in December 1994, for the large west window of St. Andrews with the motif of a tree of life. The commission was executed by the artists Patrick and John Reyntiens after a tree motif by Moore.

169 See Blake's copy after *Henry III*, pencil, Bodleian Library Oxford, see London 1978, N 1, p. 28.

170 Read 1936, p. 57.

171 A note from 1934 by Moore for his article in *Unit One* reads: 'I want to make sculpture as big in feeling & grandeur as the Sumerian, as vital as Negro, as direct & stone like as Mexican, as alive as Early Greek & Etruscan, as spiritual as Gothic.' As cited in Wilkinson 2002, p. 200.

172 AG 43.85.

173 For more on this see Coke 1992, pp. 52f.

174 It would be worth pointing out, in addition, how much Moore preferred living in the country and how, by progressively adding to the land he owned in Much Hadham, he in effect defined the scale of his late works with their powerful connections to the landscape.

175 See Part II.

176 For more on Moore's love of books and reading, see Wilkinson 2002, p. 39.

8. Moore's Encounter with Rodin

1 James 1972, p. 203.

2 Moore interviewed by Rosamond Barnier, 'Henry Moore parle de Rodin', in *L'Œil*, no. 155, November 1967, pp. 26–33. See also Moore: 'He [the bearded man] was very thin and scraggy, but he cracked, because I didn't know enough about armatures', in 'Henry Moore im Gespräch mit Alan Bowness', in *Rodin. Sculpture and Drawings,* exh. cat. Arts Council of Great Britain, Hayward Gallery, London 1970.

3 Auguste Rodin, *L'Art: Entretiens réunis*, trans. by Jacques de Caso and Patricia B. Sanders as *Conversations with Paul Gsell* (Berkeley, Los Angeles and London, 1984. Hereafter referred to as Rodin 1984, *Conversations*. See also Gsell 1916.

4 Wilkinson 2002, p. 176.

5 LH 183, 360, 402/03.

6 Wilkinson 2002, p. 176–77.

7 The works in question include the following: *St. John* (1879-80), *The Prodigal Son* (1885–87), *Crouching Woman* (1891), *The Fallen Angel* (1895), *Miss Eve Fairfax* (1902–03), *La France* (1904), *George Wyndham* (1904), *Cybele* (1904–05), *Duchesse de Choiseul* (1908), *Thomas Fortune Ryan* (1909).

8 See Beattie 1986; Appel 1998, pp. 76–80.

9 Moore interviewed by Rosamond Barnier (as note 2).

10 See Rodin 1984, *Conversations*, p. 38.

11 Wilkinson 2002, p. 178. – Further confirmation of identification between the two artists may be seen in the fact that Moore and Rodin admired some of the same artists. Both owned works by Renoir, Courbet, Millet and Carrière. For more on Moore's collection see, most recently, Feldman Bennett 2007, pp. 122–34 and p. 116.

12 Moore in conversation with Albert Elsen, see Elsen 1967, pp. 29f.

13 See Mauclair 1918, pp. 40f.

14 Wilkinson 2002, p. 179.

15 Ibid., p. 180.

16 Schmoll gen. Eisenwerth 1983, p. 92.

17 'J'entends par le mot "dessin" son tracé sur ma terre.' Rodin in conversation with Henri Dujardin-Beaumetz, as cited in de Butler 1998, p. 86.

18 Schmoll gen. Eisenwerth 1983, p. 91.

19 Rodin 1984, *Conversations*, p. 25.

20 James 1968, p. 60.

21 Rodin 1984, *Conversations*, p. 12.

22 Ibid., pp. 19, 20.

23 Ibid., p. 20.

24 James 1968, p. 70.

25 Rodin 1984, *Conversations*, p. 81.

26 Ibid.

27 Ibid.

28 Ibid., pp. 69–70.

29 Butler 1998, p. 113.

30 On this see Lichtenstern 1994a.

31 See *Henry Moore und englische Zeichner*, exh. cat. Tübingen, 1958, p. 8.

32 For more on the many comparisons that may be made here with Rodin's work – also in connection with Moore's hand-torsos (LH 349, 352, 354, 785) – see Lichtenstern 2005, pp. 29–32.

33 As cited in exh. cat. *Henry Moore. Drawings 1969–79*, Galerie Wildenstein, New York, 14 November 1979–18 January 1980, London 1979, p. 10. In this statement the eighty-year old confirms his belief in an expressive art where the human being's hands are the most eloquent component after the head and facial features.

34 AG 22-24.11.

35 As cited in Wilkinson 1987, p. 151, no. 97.

36 Rodin left in his estate over 450 small-format hand studies, which Schmoll gen. Eisenwerth described as 'expressive naturalistic fragments', as distinct from the monumental hand-torsos in stone, namely *La Main de Dieu (ou la Création)* of 1898, *La Main du diable tenant la femme* (1903), *Le Secret* (1910) and *La Main sortant de la tombe* (1910). With reference to the latter three works, Schmoll noted that they could partly be 'read as secularised relics of hands' and that in the case of *La Cathédrale*, the more telling title *L'Arche d'alliance* ['The Ark of the Covenant'] should also be taken into account. See Schmoll gen. Eisenwerth 1983, p. 120.

37 See the detailed description of the sculpture by Werner Schnell in connection with comparable gestures of prayer in the works of Ingres in Schnell 1999, pp. 61ff.

38 Ibid., p. 121.

39 AG 70-74.4v and AG 75.35; 75.36; 75.38.

40 See Moore's own description of how the situation arose where a drawing of the sitter's hands could suffice as a portrait of the human being, in: New York and others 1979, p. 13.

41 On this, see Schnell 1999, pp. 48f.

42 Information kindly supplied by Mike Phipps, archivist of the Henry Moore Foundation, Much Hadham.

43 AG 75-81.27-29; 81.161-163; 168r and 168v.; 81. 169; 781.254; 81.306.

44 AG 81.406; 81.407. Part of the inspiration for these drawings may have come from a cast of Rodin's right hand, made shortly before his death, apparently toying with a female torso from *The Gates of Hell* (Paris Musée Rodin, inv. S 834).

45 LH 354. In 1966–67 this 'Relief No. 1' of 1952 was set into the gravestone designed by Moore for Dame Edith Sitwell. See the preparatory drawing AG 66.70v and LH 355.

46 LH 352.

47 LH 785.

48 Comment by Moore made to Alan Wilkinson, in Wilkinson 1987, p. 157, no. 97.

49 This illustration shows the relevant plaster bozzetto of 1903 (?), 13 x 21 x 10.6 cm, Musée Rodin, Paris, inv. no. S. 2680.

50 For more on the Symbolist aesthetic of the vague in connection with the contemporary cult of Leonardo, see Bickmann 1999.

51 In the early 1960s Moore acquired Rodin's *The Walking Man* from around 1900, bronze, 83.8 cm. in height. His collection also included two small-format bronzes: *Psyche* of 1909 and *Dance Mouvement E, Nr. 4* of 1911. See Feldman Bennett 2001, pp. 53–61 and idem. 2007, pp. 122–34. So far it has not been noted that Moore also owned Rodin's pen and ink drawing of *The Three Shades*, in his copy of the book *L'Enfer de Dante Alighieri avec les dessins de Gustave Doré*, Paris 1884. This powerful drawing was glued into the front of the book with a letter written by Rodin on 22 January 1909 to Arthur Meyer, the previous owner of the book. It contains the dedication: 'fait pour Arthur Meyer dédié à sa fille Jacqueline Meyer et en hommage d'admiration au grand artiste Gustave Doré trop oublié. Auguste Rodin juin 1908'.

52 CGM 59.

53 See Garnier 2002.

Theory

1 *Notebook No. 4*, 1925, 228 x 18 cm. This single page was not included in the catalogue raisonné of drawings. The relevant note on fig. 285 reads: 'Humanity and form. Abstraction as pure abstraction is false – synthesis, simplification, austerity, etc. etc. is used instinctively in primitive art to vitalize intensity and emotional expressions – the milk of human kindness – the spirit behind etc. etc. (Thomas Hardy).' I could only hazard a guess as to the meaning of the last two references: the phrase 'the milk of human kindness' comes from Shakespeare's *Macbeth* (Act I, scene 5) where Lady Macbeth accuses her husband of being incapable of committing murder: 'Yet do I fear thy nature: It is too full of the milk of human kindness.' It may be that here Moore is indirectly referring to the sheer impact of intense, primitive art. There is no further indication of the connection between 'the spirit behind' and Thomas Hardy, with whose work Moore was very familiar.

2 See the relevant evaluations in Moore's introduction to Michael Ayrton, *Giovanni Pisano*, London 1969, in Wilkinson 2002, pp. 169–173.

3 Ibid., p. 197: 'I think the humanist organic element will always be for me of fundamental importance in sculpture, giving sculpture its vitality. Each particular carving I make takes on my mind a human, or occasionally animal, character and personality, and this personality controls its design and formal qualities, and makes me satisfied or dissatisfied with the work as it develops.'

4 Ibid., p. 200.

5 Exh. cat. *Henry Moore*, Venice, 1948, unpaginated

6 Nietzsche 2002, pp. 55–56 (Section 62).

7 See Raphael 1947; Hume 1739–40.

8 Wilkinson 2002, p. 218.

9 Ibid., p. 115.

10 Moore in conversation with John Hedgecoe. See Hedgecoe 1968, p. 121.

11 See catalogue to accompany the inauguration of *Large Upright Internal/ External Form*, Three First National Plaza, Chicago, Illinois, on 6 May 1983.

12 See Städtke 2001. Städtke here refers to Shaftesbury, *The Moralists*, in Shaftesbury, part 2, vol. 1 (1987), pp. 332ff.

13 Ibid.

14 In Herder 1883, p. 121.

15 Städtke 2001, p. 472.

16 In this context it is worth bearing in mind James Ensor's protest in 1894/95 in a letter to Pol de Mont: 'Form attracts mimicry, it means weakness, impoverished invention, it is senile, for centuries it has paid allegiance to the older generation that has consumed all feelings.' Trans. from *James Ensor. Ein Maler aus dem späten 19. Jahrhundert*, Stuttgart 1972, p. 36.

17 Städtke 2001, p. 472.

18 Trans. from Johann Wolfgang Goethe, *Diderot's Versuch über die Malerei*, 1799, in Norbert Miller and John Neubauer (eds.), *Johann Wolfgang Goethe, Sämtliche Werke nach Epochen seines Schaffens*, Münchner Ausgabe, vol. 7, Munich/Vienna 1991, p. 527.

19 Schelling 1989, p. 17.

20 For more on the complex history of the concept of 'organic form', see Waenerberg 2005, pp. 21–35 (with suggested further reading).

21 For more on this (with further reading), see Isabel Wünsche, 'Organische Modelle in der Kunst der klassischen Moderne', in ibid. pp. 97–111. Attention should be drawn to Wünsche's suggestion that it is time to abandon the widespread concentration on opposites, such as organic/geometric, straight line and square as opposed to curved line and circle. An organic approach to artistic creativity regard the straight line and the curve not as opposites but as two sides of one and the same reality. By and large, this was the approach that Moore took in his own work, where geometry is frequently seen to co-exist with biomorphism.

22 See Simpson 1999, pp. 41–53. In this very useful study, Simpson examines the attitudes of religious freethinkers that were to be so important to the reception of Goethe's work in nineteenth-century England. In this respect, too, Moore and Goethe appear to have been kindred spirits.

23 Bonn u.a. 1982; Wedel 1997; in the winter semester of 1994–95 I gave a lecture (unpublished) at Marburg University on Goethe's 'afterlife' in twentieth-century art.

24 Lichtenstern 1981a, p. 651; Idem 1990a, pp. 125f.

25 D'Arcy Wentworth Thompson, *On Growth and Form*, Cambridge 1942 (1st edn London 1917), p. 62.

26 See above, Chapter I–2, pp. 57–59.

27 Thompson (as note 25), p. 62. This passage could be translated as follows: 'Living organisms are indeed made up of separate elements, but they cannot be reconstructed or brought to life from these elements.'

28 Goethe, *Faust, Part One*, trans. by Philip Wayne (1st edn 1949) Harmondsworth, Middlesex, 1951, p. 195.

29 Thompson (as note 25), p. 1019.

30 On the law of compensation see Haecker 1927, pp. 34f.

31 Goethe, 'Metamorphosis of Animals' (1806), in Goethe 1983, pp. 161–63, p. 163.

32 *Goethe. The Collected Works*, vol. 3: *Essays on Art and Literature*, ed. by John Gearey, Princeton 1994, p. 81 ('spiritual-organic whole') and *Morphology*, in Goethe 1994, p. 58 ('unified whole').

33 For more on this, see Lichtenstern 1982, pp. 25–43; Mitchinson 2004, pp. 303–17; see Much Hadham 2007, pp. 11–15.

34 See Goethe 1962.

35 Alexander Davis in *Bibliography*, vol. 5, p. 91.

36 See Krätz 1992, p. 83.

37 See above Chapter I–2, pp. 61–65.

38 Trans. from Krätz 1992, p. 84.

39 James 1968, pp. 91ff.

40 Trans. from *Goethes Werke. Weimarer Ausgabe* I, 47, p. 64.

41 Ibid.

42 Ibid.

43 Goethe, 'On Granite', in Goethe 1988, pp. 131–34 (Section V: Geology). For more on Goethe's essay on granite and its material-iconological significance see Raff 1994, pp. 110ff.

44 In this connection, it is worth bearing in mind the meanings of different materials in Goethe's *Fairy Tale*, which was published in 1795 in Schiller's *Horen*, see Goethe HA, vol. 6, pp. 209–41. For more on this, see Lichtenstern 1999/ 2000, pp. 23–63.

45 Lichtenstern 1990a, pp. 1–10.

46 Ibid.

47 Goethe in 'Primal Words. Orphic/Daemon' (1817–18), in Goethe 1983, p. 231.

48 Kuhn 1988, p. 43.

49 Johann Wolfgang von Goethe, *Wilhelm Meister's Journeyman Years*, trans. by Krishna Winston, in *Goethe. The Collected Works*, vol. 10: *Conversations of German Refugees. Wilhelm Meister's Journeyman Years*, ed. by Jane K. Brown, Princeton 1989, p. 326.

50 On the history of 'types', see *Goethe. Sämtliche Werke. Briefe, Tagebücher und Gespräche*, 40 vols., Frankfurt am Main, 1985 ff., ed. by Hendrik Birus et al., Frankfurt am Main, 1987 ff., II, 3, p. 853 (commentary on p. 237).

51 Goethe, *Metamorphosis of Animals* (1806), in Goethe 1983, pp. 161–63, here p. 163.

52 Goethe 1988, p. 76–98.

53 Polarity, which Goethe saw epitomised in the opposites systole (contraction) and diastole (expansion), which were, in his view, together with enhancement the main principles of metamorphosis.

54 See Moore's own statements in Levine 1983, p. 20 and passim. This publication includes important comments by the artist concerning the wooden *Reclining Figures* discussed here.

55 See Trier 1999, p. 69. See also Wagner 2000.

56 See Levine 1983, p. 23.

57 Moore will certainly not have been aware of the developmental line underpinning these sculptures that becomes apparent from a detailed study of the individual works.

58 Comment by Moore, in Levine 1983, p. 113.

59 See commentary in Nantes 1996–97, p. 114.

60 In *The Courier-Journal*, 6 February 1983.

61 LH 657.

62 James 1968, p. 64.

63 Ibid., p. 66.

64 Ibid., p. 103.

65 Ibid., p. 265.

66 Ibid., p. 271.

67 On this see the detailed analysis by Morphet 1979, pp. 116–22.

68 Here and in what follows, I am indebted to Germann 1972, pp. 36–41. Germann does, however, restrict his study to architectural theory.

69 Ibid., p. 37.

70 See Lichtenstern, 1990a, pp. 53ff.

71 Trans. from Goethe HA, vol. 12, p. 75.

72 Goethe, *On German Architecture*, in Goethe 1986, pp. 3–10, here p. 8.

73 Schelling 1989, p. 9 (Introduction).

74 Ibid., p.10.

75 See Kaulbach 1974, vol. 3, pp. 3ff.

76 Hegel 1977, p. 20.

77 Wilkinson 2002, p. 141.

78 Read 1948, pp. 597–624. The text in question started life as a paper delivered in March 1948 by Herbert Read at Johns Hopkins University in Baltimore during a conference on great critics. It was later included in his publication, *The True Voice of Feeling. Studies in English Romantic Poetry*, New York 1953 and London 1968.

79 For detailed evidence supporting this point, see Engell/Bate 1983, vol. 1, pp. 236ff. and passim. Hereafter referred to as Coleridge, *Bibl. Lit.*

80 See Benziger 1951, pp. 33f. Also available on this subject: McKenzie 1977, pp. 1–106. For a discussion of 'organic whole' in light of Shakespeare's *Hamlet*, see p. 94.

81 As cited in S. T. Coleridge, *Bibliographia Literaria*, ed. by J. Shawcross, vol. 1, London 1949 (1st edn 1907), p. 162. For more on this philosophical concept, see below.

82 Lenz 1971, p. 173.

83 Coleridge, *Bibl. Lit.*, I, p. 304.

84 Ibid., I, p. 274, note 1.

85 Ibid.

86 Benziger 1951, p. 39.

87 Coleridge, *Bibl. Lit.*, I, p. 206.

88 Lenz 1971, p. 138.

89 Trans. from ibid., pp. 136f.

90 Trans. from ibid., p. 189.

91 Trans. from ibid., p. 188.

92 Trans. from ibid., p. 180.

93 Coleridge 1967, p. 198.

94 Samuel Taylor Coleridge, 'On Poesy or Art', in Coleridge 1949, vol. II, p. 258.

95 Coleridge, *Bibl. Lit.*, II, p. 257.

96 Ibid., p. 258.

97 Lenz 1971, p. 170.

98 Lenz 1971, p. 179; Coleridge, *Bibl. Lit.*, II, p. 10.

99 Trier 1999, pp. 106–18, Eduard Trier collected thirty-one statements by sculptors (ranging from Medardo Rosso to Mario Merz) on this theme. The standard work in German on this topic is still Albrecht 1977.

100 See Ott 2003, p. 136.

101 Trans. from Badt 1963, 13f.

102 Giedion-Welcker 1964, p. XXIV. Eduard Trier took this quote as a motto for his informative essay 'Raumplastik – Ein gelehrter Wahn?', Trier 1993, pp. 9–18.

103 Albrecht 1977, p. 102f.

104 Trier 1999, p. 107.

105 Hofmann 1959, p. 55; see also pp. 58f.

106 Trans. from Albrecht 1977, p. 69.

107 Trans. from the manuscript, Matschinsky-Denninghoff archive, Berlin. See Part III for more on Brigitte Matschinsky-Denninghoff's relationship with the work of Henry Moore.

108 It was in *Figur und Raum. Die Skulptur des XX. Jahrhunderts*, Berlin 1960, that Eduard Trier introduced the notion of 'kernel sculpture' into the theory of sculpture. He specifically used it with reference to self-contained, closed forms – such as Brancusi' ovoid shapes – as opposed to other, more open volumetric forms. For more on this see Justus Müller-Hofstede 1981, p. LIX. Trier, p. 10.

109 LH 292.

110 James 1968, p. 64.

111 Ibid., p. 66.

112 Ibid.

113 See Lichtenstern 1998, pp. 19–29.

114 James 1968, p. 118.

115 See above, Chapter I–3, pp. 100ff.

116 Wilkinson 2002, p. 204.

117 Vitruvius, *De Architectura libri decem/Zehn Bücher über Architektur*, trans. from Latin to German by C. Fensterbusch, Darmstadt 1991, pp. 414f.; See also Ott 2003, p. 120.

118 LH 457.

119 James 1968, p. 271.

120 Ibid., p. 266.

121 Ovid 1965, pp. 256–58 (Book X, ll. 261–326).

122 See Schneider 1987, pp. 111–23.

123 James 1968, p. 72.

124 See Thistlewood 1998, pp. 219f.

125 Read 1934, pp. 10f.

126 Ibid., p. 12.

127 The idea that art completes what Nature has left incomplete, was proposed by Aristotle in his *Physics*. See Lang 1998, p. 50, p. 275. Kant sees beauty defined by a delight that is 'disinterested'. See Kant 1987, p.77.

128 Read 1934, p. 14.

129 Thistlewood 1998, p. 226.

130 Read 1965, p. 257.

131 In 1937 Barbara Hepworth homed in on the concept of 'spiritual vitality', and wrote: 'The idea – the imaginative concept – actually *is* the giving of life and vitality to material… When we say that a great sculpture has vision, power, vitality, scale, poise, form or beauty, we are not speaking of physical attributes. Vitality is not a physical, organic attribute of sculpture – it is a spiritual inner life', in *Circle: International Survey of Constructive Art*, ed. by J. L. Martin, Ben Nicholson and Naum Gabo, London 1937, p. 113.

132 LH 293b.

133 LH 295.

134 LH 298.

135 Goethe HA 1, p. 258: 'Müsset im Naturbetrachten/Immer eins wie alles achten; / Nichts ist drinnen, nichts ist draußen: / Denn was innen, das ist außen. / So ergreifet ohne Säumnis / Heilig öffentlich Geheimnis. / Freuet euch des wahren Scheins, / Euch des ernsten Spieles: / Kein Lebendiges ist Eins, / Immer ist's ein Vieles.' English translation from http://mindfire.ca.

136 As the artist himself said about his preferred wooden version (now in the Albright-Knox Art Gallery, Buffalo): 'Wood is a natural and living material. [...] These qualities were in harmony with the idea, which is a sort of embryo being protected by an outer form, a mother and child idea, or the stamen in a flower, that is, something young and growing being protected by an outer shell.' James 1968, p. 247.

137 Information kindly supplied by Prof. Dr. Peter Anselm Riedl (Heidelberg), who was in the artist's company at just such a moment.

138 Neumann 1959, pp. 127f. Moore himself avoided reading this book, in order not to be influenced in his subsequent work by this psychoanalytical reading of his work, and to retain his independence as a creative artist.

139 LH 298.

140 LH 299. The work installed in Freiburg at Europaplatz, stands out even in the rich collection of sculptures on show at the campus. See Throl 1998, p. 38.

141 See Moore 1944–83, vol. 2, figs. 28, 28a–c; Brown 2001, pp. 16–19.

142 Michel Muller, a longtime assistant to Henry Moore, kindly supplied these photographs, at my request; I should like to take this opportunity to express my gratitude to him.

143 AG 35.9r.

144 Moore was not alone amongst the Surrealists in his lifelong interest in Oceanic sculptures. Breton, Eluard and Aragon all owned malanggan figures, and the influence of Oceanic art is also seen in the work of other sculptors, such as Lipchitz and Arp. However, Moore's interpretation of Oceanic art was distinctive for the methods he utilised and for the imaginative intensity with which he developed and used these forms over the years. Thus the principle of metamorphosis, proclaimed by the Surrealists, was perpetuated and reified through Moore's methods.

145 AG 39.27r.

146 LH 183.

147 Henry Moore in conversation with the author, 12 October 1977, Much Hadham.

148 See *The Helmet*, lead, height: 31,5 cm, private collection, LH 212.

149 Oxford Dictionary 1989, p. 894.

150 Ibid.

151 Henry Moore in conversation with the author, 12 October 1977, Much Hadham.

152 See Cramer et al 1931–1972, Geneva 1973, no. 7.

153 Certain motifs in this richly detailed composition can be traced as far back as 1934. See Chapter I–4.

154 Trans. from Kemp 1991, p. 205.

155 Ibid., p. 259.

156 As cited in Oxford Dictionary 1989, p. 894.

157 Henry Moore, "The Sculptor Speaks" (1937), in James 1968, p. 67.

158 Wilkinson 2002, p. 116.

159 Ibid., p. 117.

160 Ibid., p. 271.

161 For more on Moore's notion of a 'world tradition of sculpture' and 'universal form-language' that pertains in multiple cultures and through the ages, see Chapter I–5.

162 James 1968, p. 115.

163 Ibid., pp. 66.

164 For more on this, see Wilkinson 1987–88, pp. 226–27.

165 James 1968, pp. 57f.

166 At one time this work was owned by the Surrealist painter Gordon Onslow-Ford, whose own compositions at the time tended to portray a world of biomorphous forms occupying some cosmic dimension.

167 For more on rhythm in Renaissance painting, see Kuhn 1980, pp. 111ff.

168 See Corbinean-Hoffmann 1992, col. 1028f.

169 In *The Little Review*, winter 1926, unpaginated

170 See Wilkinson 2002, p. 127.

171 LH 343.

172 Wilkinson 2002, p. 278.

173 Ibid., p. 279.

174 Ibid., p. 192.

175 Hedgecoe 1968, p. 131.

176 See Gosebruch 1957, pp. 229–38.

177 See Gampp 1995, pp. 287–308, here, trans. from p. 295.

178 See Curtius 1979, p. 44 (*Myron's Discobolus*).

179 LH 522.

180 LH 700.

181 LH 522.

182 LH 556.

183 LH 559.

184 LH 700.

185 Wilkinson 2002, p. 190.

186 AG 31.53.

187 AG 35.7r. – 'its (sic) no use modern sculpture being only an / imitation (sic) of old (crossed out) ancient sculpture but it must have the (crossed out) its / life & vitality, intensity & power of (crossed out) sensitiveness & / emotional fulness to be able to stand up to it / 3dimensional; u.c.r. Shape; c.l. Shape & out of / it / make / figure; c. Completely in the round.'

188 James 1968, p. 68.

189 Trans. from Viebrock 1946, pp. 78f.

190 As early as 23 January 1931, the Berlin sculptor Gustav Heinrich Wolff wrote to Max Sauerlandt, Director of the Museum für Kunst und Gewerbe in Hamburg, in the following terms: 'The sculptor Henry Moore should not be overlooked. You must look him up, such a fine, serious character.' See Spielmann 1967, p. 36. For more on Max Sauerlandt and Moore see Part III.

191 Wilkinson 2002, p. 189.

192 James 1968, p. 271.

193 Wilkinson 2002, p. 222.

194 See above, pp. 52–59.

195 Wilkinson 2002, p. 126.

196 Gilot/Lake 1990, pp. 297–98.

197 Blumenberg 1960, p. 142.

198 See Trier 1999, pp. 32ff.

199 Wilkinson 2002, pp. 187ff.

200 Ibid., p. 187 (*A View of Sculpture*).

201 By using this phrase Goethe was suggesting that in his own way the artist was as precise as the scientist. See review by Ernst Stiedenroth, *Psychologie zur Erklärung der Seelenerscheinungen*, part I, Berlin 1824, in Goethe HA, vol. 13, p. 42.

202 In the notes for *A View of Sculpture*, first published by Wilkinson, Moore writes: 'Symmetry is death.' See Wilkinson 2002, p. 18.

203 Wilkinson 2002, p. 193.

Impact

1 LH 293.

2 Recklinghausen 1952, unpaginated. Arie Hartog has previously cited this source: Hartog 1997–98, pp. 171f.

3 Ibid.

4 Recklinghausen 1955.

5 See Trier 1955. As Trier reported to the present author, he first saw original works by Moore at the 1950 Düsseldorf exhibition. In 1959 he visited Moore in Much Hadham.

6 See Steingräber 1978, pp. 240–60, with English and French translations. The relevant exhibition, *Henry Moore – Maquetten, Bronzen, Handzeichnungen,* took place from 20 January–2 March 1980 in the Bayerische Staatsgemälde-sammlungen, Munich.

7 See Trier 1993b, p. 77.

8 For more on the role of the British Council, which was attached to the For-eign Office, see Frances Donaldson, *The British Council. The First 50 Years,* Lon-don 1984; for a critical analysis of the work of the British Council, for which Herbert Read was a consultant, and the co-opting of Henry Moore to serve the cultural-political aims of this government institution, see Margaret Garlake, 'Henry Moore als Cold Warrior', in *Biuletyn Historii Sztuki,* 61 (3–4), 1999, pp. 337–50. The hypostatisation of Moore as 'Cold Warrior' seems wholly unfound-ed to me.

9 Between 1958 and 1986 Hermann Noack III produced virtually all of Moore's works in bronze. Moore had over 120 models cast in Berlin. And when it was time to create the patina, he used to call out to Noack, 'Hermann, please, come over with your secret pot', see Paul O. Schultz and Ulrich Baatz, *Bronzegießerei Noack. Kunst und Handwerk,* Ravensburg 1993, pp. 200 and 212. See also David Mitchinson, who reports that in the late 1950s, it had been the London-based, Austrian art dealer Harry Fischer who had introduced Moore to Noack. See David Mitchinson, Introduction to *Henry Moore – Mutter und Kind/ Mother and Child,* exh. cat. (shown at Käthe Kollwitz Museum, Cologne; Schloss Cappenberg, Kreis Unna; Kunstkreis, Norden; Ernst Barlach Museum, Ratzeburg; City Art Gallery, Huddersfield) Henry Moore Foundation, 1992, p. 9. The most informative study of the singular collaboration between Moore and Hermann Noack III is found in Gabler 1997–98, pp. 129–37.

10 LH 556. For more on the genesis of this work and the problems surround-ing its interpretation, see Wenk 1997.

11 Foreword to Throl 1998, p. 9. H.-J. Throl introduces each of the twenty-three works. *Large Internal Form* (LH 297 b), acquired by the Sammlung Würth (Schwäbisch Hall) in 2005, should now also be included in the list of works in Berlin, Bielefeld, Bonn, Duisburg, Düsseldorf, Essen, Freiburg, Goslar, Hamburg, Hanover, Heidelberg, Cologne, Munich, Münster, Nürnberg, Recklinghausen, Stuttgart and Wuppertal – there are now twenty-four outdoor sculptures in Germany. For more on the new acquisition see Schwäbisch Hall 2005, pp. 39f.

12 For a first overview of this subject (albeit without reference to the situa-tion in the GDR) by a contemporary observer see Fischer 1987, pp. 233–53 with a bibliography compiled by Alice Trier; see also Schneider 1991; and idem 1989, pp. 1644–46.

13 See Heinz Spielmann's report in *Jahrbuch der Hamburger Kunstsammlun-gen,* vol. 14/15, Hamburg 1970, pp. 400ff.

14 These and the following visitor figures were researched by Hartog 1997–98, p. 170.

15 See Hofmann 1959, p. 27.

16 Ibid., p. 13.

17 Ibid., p. 15.

18 Grohmann 1960, p. 12. Grohmann's archive is now in the safe keeping of the Staatsgalerie Stuttgart.

19 Ibid., pp. 235–36.

20 Ibid., p. 234–35.

21 Ibid., p. 215.

22 Ibid., p. 196. Grohmann is referring here to LH 290.

23 As a voluntary assistant and student of Hermann Schnitzler, the Director of the Schnütgen Museum in Cologne, Trier had been introduced at a young age to the study of original medieval sculptures.

24 For more on Trier's academic career see Müller-Hofstede 1981, pp. LII–LXII.

25 Trier 1962.

26 Trier 1999, pp. 24f.

27 Ibid., pp. 51f., 212, 326.

28 Ibid., pp. 63ff., 80. For more on the Modernist scope of *taille directe*, that is to say, carving without making a preparatory model, see Chapter I–1, note 2.

29 Ibid., pp. 100ff., 116.

30 Ibid., p. 171.

31 Ibid., p. 300.

32 Ibid., p. 311.

33 These are listed in Alexander Davis 1992–94.

34 For the most detailed account, see Krause 1998 (with a catalogue raisonné), pp. 73f., 87f. Hereafter cited as Hartung CR.

35 See Sauerlandt 1957; Senckendorff 1983, pp. 68–76; Baumann 2002. – Two authors, both of whom were personally acquainted with Hartung, agree about his acquaintanceship with Sauerlandt: Hess 14th vol. 1961, number 9, pp. 17–30; and Spielmann 1998, p. 83. Hereafter cited as *Hartung/Dokumente.*

36 See *Hartung/Dokumente*; Hartung CR, pp. 28f.

37 Krause, Hartung CR pp. 15, 29, 2, 85, 92.

38 See the chronology of Hartung's life and work compiled by Irmtraud Frfr. von Andrian-Werbung on the basis of work by Markus Krause in *Hartung/ Dokumente,* p. 9. – Wolff's elemental stone sculptures (albeit less decisively so) have something of the same archaism that also connects Moore with Modi-gliani, Zadkine and Dobson. In his review of the Moore exhibition in Hamburg in 1960, Gottfried Sello wrote in the *Hamburger Abendblatt* of 30 May 1960: 'There is no mistaking the artistic kinship between the early Moore and Gustav H. Wolff, so much admired by Sauerlandt and all but forgotten today. (The let-ters that Moore wrote to Sauerlandt in 1931 and 1932 will be sold tomorrow as Lot 230 at Dr Hauswedell's auction of autographs…).' See also Heinz Spiel-mann on Wolff: 'Within the space of a decade (1924–34) the Berlin sculptor progressed from expressive sculpture, drawings and woodcuts to a pictorial form not unlike that of Henry Moore', in Spielmann 1971, p. 214.

39 See Read's dedication in *Art Now*: 'in admiration of his knowledge of the art of all ages and in recognition of his devotion to the cause of modern art …'. For more on this see Causey 1993, pp. 48f.

40 As cited in Holthusen 1964, p. 33.

41 This exhibition, with a foreword in the catalogue by Jacob Epstein, was enthusiastically reviewed by Read in *The Listener* on 22 April 1931. Read later included this article, almost verbatim, in his book *The Meaning of Art.* See Causey in Read 1993, p. 50.

42 As cited in Sternelle 1960, vol. 12, p. 16.

43 See Hünecke 1996–97, pp. 125–42. Hünecke lists 480 photographs that were passed on by the Hamburg Museum to the Kaiser-Friedrich-Museum in 1938 for the purpose of establishing an 'Archive of Degenerate Art', now in the possession of the Berliner Zentralarchiv (Stiftung Preußischer Kulturbesitz, Alte Nationalgalerie). Unfortunately, amongst these there is not a single photo-graph of any new acquisitions by Moore. Apart from a watercolour tracked down by Hünecke to the Kulturhistorisches Museum in Rostock, it has to be assumed that they have been lost.

44 Correspondence between Moore and Read, The Henry Moore Foundation Archive, Much Hadham.

45 Hartog 1997–98, p. 164. Reference is made here to the exhibition review by W–r., 'Neue englische Kunst', in *Hamburger Echo* 160 (5 July 1932).

46 Hartung CR 149.

47 LH 132. See Krause 1998, p. 73.

48 See above pp. 70–71.

49 Pencil, 30 x 46 cm, Hartung Estate. The legs in this drawing also recall Hartung's bronze *Reclining Figure* of 1947–48 (Hartung CR 370). Information on Hartung's early drawings kindly supplied by Dr Birk Ohnesorge, Berlin. See also Ohnsorge 2008, fig. 44, 45. This book came out after I had already finished the present publication.

50 Pencil, 46 x 35 cm, Hartung Estate.

51 LH 133.

52 Hartung CR 158.

53 Krause 1998, pp. 71f.

54 See LH 76, LH 88 and LH 89.

55 See also LH 89.

56 See catalogue of the 1946 solo exhibition at Godebuscher Weg in Berlin-Dahlem, see also the related charcoal drawing in Krause 1998, p. 107, which may have been made afterwards.

57 Hartung CR 311.

58 Hartung CR 422.

59 See Michael Grant and John Haxel, *Who's Who in Classical Mythology*, London 2002, p. 193.

60 The rear view is recognisable as such by Hartung's signature in capital letters. In addition to this, the existence of a 'viewing side' is confirmed by Hartung's own charcoal drawings of the finished piece which he made in 1950 for a poster design. See Ohnesorge, nos. 1741; 1742; 1743.

61 As cited in the highly informative account by Andrian-Werbung, 'Karl Hartung – sein Leben in Dokumenten', in *Hartung/Dokumente*, p. 91.

62 Estate of Karl Hartung, I.–14, Deutsches Kunstarchiv, Germanisches Nationalmuseum Nürnberg (hereafter abbreviated as Deutsches Kunstarchiv im GNM). See also Krause 1998, p. 170, note 95.

63 Estate of Karl Hartung I, A-11c, Deutsches Kunstarchiv im GNM.

64 See I, B-14, Deutsches Kunstarchiv im GNM: 'The most powerful expression the sphere, completely self-contained, dominating the space [Hartung draws a sphere]. The next thing would be to draw the space into the body [Hartung draws his *Spherical Form* next to this], opening out.' [Trans.] See Hartung CR 387 and p. 86.

65 Hartung's 'cosmic perspective' was also recognised by contemporary critics. Witness an anonymous review in the *Tagesspiegel* on 16 November 1949: 'In recent years his work has pursued the path of an increasingly pure, exclusive three-dimensionality – he is the archiplasticist amongst the Berliners… The less he relies on the solidity of matter, which is after all no more than an illusion, the more evocative his sculptures, with a sense of the beauty that we otherwise find in abundance in the cosmos.' Karl Hartung. I, B-123, Deutsches Kunstarchiv im GNM

66 I, A-11 c, Deutsches Kunstarchiv im GNM.

67 I, A-11 c, Deutsches Kunstarchiv im GNM.

68 At this point Hartung wrote the word 'Marc' with an arrow pointing to the adjacent page, in a remarkable indication of his spiritual affinity with Franz Marc and the latter's struggle to reach 'Neuland' [new land].

69 I, A-11c, Deutsches Kunstarchiv im GNM.

70 Hartung CR 198.

71 Hartung CR 278.

72 LH 147.

73 See Hartung CR 240, 542, 566, 696, 715 and 730, amongst others.

74 See Krause 1998, p. 72.

75 My enduring memory of my visit to Hartung's studio at the Rehwiese (4 December 1963) – besides the impression of immense calm and pent-up energy that emanated from the artist – is of the numerous stones and roots lying everywhere.

76 As cited in Krause, Hartung CR, p. 73, who comments on this note: 'A memorial to vegetation – that is what Hartung hoped to achieve with his work.'

77 See above, note 38. Karl Hartung's library included an extensive selection of anthroposophical literature. It must also be of interest that in the early 1960s, a group would meet once a month on a Sunday morning in Hartung's house. The group had been set up by Wilhelm Weischedel, Ordinarius at the Faculty of Philosophy at the Freie Universität in Berlin; the topics discussed at these meetings included anthroposophical subjects. Amongst the guests were Hartung's wife and their daughter Hanne, Karl Schmidt-Rottluff, Hans Scharoun and the architect Edgar Wedepohl. In addition to this, Hartung's wife cultivated their garden with a view to bio-dynamic issues. During and after the war Hartung is in touch with Vladimir Lindenberg, whom he admires for his many capacities: Russian diplomat, anthroposopher, composer, painter and collector. Information kindly supplied, in conversation, by Frau Hanne Hartung, Bromstedt, 3 October 2005.

78 See Rudolf Steiner, *Theosophy. An Introduction to the Supersensible Knowledge of the World and the Destination of Man*, trans. with the permission of the author from the third German edition by E. D. S., 1922, revised edn, London 1954. Here quited after the 5th edition of 1989, p. 70 – Hartung owned the Dornach edition of 1922. For the quotations see Section 'The Three Worlds'. (Steiner 1989, pp. 68–129) 'I. The Soul World' (pp. 68–80). Steiner also talks of 'Organs of Spirit' in his texts 'Knowledge of the Higher World and its Attainment' and in 'Occult Science – An Outline'.

79 I, A-11c, Deutsches Kunstarchiv im GNM.

80 In Steiner's view, the human being is a union of body, soul and spirit, which is itself divided into seven graded stages. These consist of the 'lower members', such as physical body, ether body, astral body and sentient soul, then the I as soul-kernel and above this the 'higher members', such as Spirit filled Conscious-soul, the Life-Spirit and Spirit-man. See Steiner 1989 (as note 78), I.4 'Body, Soul and Spirit', pp. 24–45.

81 See Steiner 1989, pp. 24–31. With grateful thanks to Frau Hanne Hartung, for allowing me to decipher these manuscripts, and also to Marie Halberschmidt in Berlin, who helped me to read Hartung's rather illegible youthful hand.

82 Slightly abbreviated quotation from Steiner 1989, p. 27.

83 Ibid., pp. 27–28.

84 Hartung CR 537, see Demisch 1967; Lichtenstern 1993a, pp. 19–42.

85 Hartung CR 652, see also Ohnesorge 2005, pp. 82ff.

86 Hartung CR 437. See Krause 1998, pp. 90f.; Demisch 1961, pp. 163–65.

87 As cited in Krause 1998, pp. 90f.

88 See Steiner 1989, p. 27. – For more on the concept of the 'ether body' and its influence on certain phenomena in modern art, see Demisch 1959, pp. 145f., note 43. Karl Hartung and Heinz Demisch knew each other well. The relevant correspondence is in the artist's estate, held in Deutsches Kunstarchiv im GNM.

89 Hartung CR 438.

90 For more on this see Lichtenstern 1990, pp. 69–79.

91 In other words: observe precisely and let the phenomena speak for themselves. This turn of phrase originated in the work of Gottfried Benn.

92 As cited in *Hartung/Dokumente*, p. 92.

93 I, B-14, Deutsches Kunstarchiv im GNM.

94 Hofmann 1959, p. 16.

95 Conversation in Berlin, July 1976. – In 1988 Heiliger still took this view. See Schneider 1991, pp. 159f., note 176. Heiliger also passed on to his students his preference for the work of Hans Arp, which left its mark on his early work. This is evident in the work of Roland Stalling in Bochum.

96 As cited in Wellmann 2005 (with a catalogue raisonné), p. 38. Hereafter referred to as Wellmann, or Heiliger CR. It is to Marc Wellmann's credit that, on the basis of research already conducted by Christoph Brockhaus (see below, note 120) and Katharina Schneider (1991), he has examined in closer detail Heiliger's biographical connections to Moore in light of newly discovered documents. He does not go into detailed, comparative analyses of the two artists' work.

97 Salzmann/Romain 1989, p. 12. In his account of his own life (ibid., p. 293) Heiliger fails to mention the time he spent as a student of Arno Breker.

98 Heiliger CR 89.

99 Information supplied to Marc Wellmann on 18 June 2000. See Wellmann 2005, p. 38.

100 For the following information on Will Grohmann I am indebted to Schneider 1991, pp. 52f.

101 Ibid.

102 As cited in Schneider 1991, p. 51.

103 Estate of Richard Scheibe, Kolbe-Museum, Berlin. See also Ohnesorge 2004a, p. 41.

104 Buesche 1950.

105 *Deutsche Zeitung und Wirtschaftszeitung*, N 25, 29 March 1950, p. 11.

106 Wellmann 2005, p. 40. This undated letter was addressed to the art historian Christian Adolf Isermeyer.

107 Information kindly supplied in conversation with the author, Berlin, autumn 2004. See also: Förster 2005, pp. 31 ff.

108 LH 336.

109 See Förster 2005, p. 34.

110 See Heiliger CR 77; also illustrated in Flemming 1962, p. 30. Named in Flemming's list of works as 'Liegende Figur II', 1948, length: 70 cm, stucco (destroyed)'. Yet the Berlin Rembrandt-Verlag produced the shot by Edmund Kesting, illustrated here, as a postcard.

111 LH 59.

112 LH 162.

113 By contrast, Heiliger's half-figure of 1949, with crossed arms, recalls the well known descriptive 'hole figure' by the early Archipenko, *Woman Combing Her Hair* (1912).

114 Heiliger CR 100.

115 Heiliger CR 109.

116 Heiliger CR 97.

117 LH 68.

118 Schneider 1991, p. 53.

119 Heiliger CR 116, 118.

120 See Brockhaus 1985–86, p. 11. Brockhaus suggests that both in its motifs and style, there is an affinity between this sheet and Moore's drawings of internal/external figures from 1940.

121 Heiliger CR 135.

122 A phrase coined by Kurt Martin, cited in Flemming 1962, p. 167.

123 Heiliger CR 138.

124 Letter from Heiliger to Moore, written on 8 April 1962, The Henry Moore Foundation Archive, Much Hadham.

125 Heiliger CR 254.

126 LH 268. Grohmann 1960, p. 141, figs. 129–132. It may have been of significance to Heiliger that Grohmann also interpreted Moore's figures as 'goddesses of fate', and used the names generally given to the three Fates (Clotho, Lachesis, Atropos).

127 The work illustrated here is *Etude II*, Heiliger CR 282.

128 See Steingräber 1978.

129 Heiliger CR 289.

130 Heiliger CR 306–308.

131 Toni Stadler would not tolerate the fact that his student steadfastly refused to engage with the human form and, to add insult to injury, did not attend the obligatory assessments of her work. In the end he expelled her from his class. Information kindly supplied in conversation by Brigitte Matschinsky-Denninghoff, Berlin, 28 September 2005. Unless otherwise indicated, the following information concerning Matschinsky-Denninghoff's relationship to Henry Moore was passed on during the same conversation. I should like to express my sincere gratitude to Brigitte and Martin Matschinsky-Denninghoff for this, and for so generously providing access to new sources.

132 John Anthony Thwaites (1909–1987) worked for the British Foreign Office in 1931 and 1949. He was a correspondent for a number of international art publications in Germany; he also led seminars at the Kunstakademie and the Fachhochschule in Düsseldorf. His best known book was *Ich hasse die moderne Kunst*, 1st edn, Krefeld and Baden-Baden 1957; 2nd enlarged edn, Frankfurt am Main 1960. For more on the life and work of Thwaites see Zuschlag 1998,

pp. 166–72. – In The Henry Moore Foundation Archive there are a number of mainly private letters from Thwaites to Moore written between 1958 and 1970.

133 Brigitte Matschinsky-Denninghoff in Költzsch 1992 (with a catalogue raisonné), p. 17. Hereafter cited as Matschinsky-Denninghoff CR.

134 The book was reprinted in 1946 and 1949. A copy of the 1949 edition, owned by Brigitte Meier-Denninghoff, has the dedication 'For Brigitte with love + all best wishes Henry Moore Much Hadham / January 1950'.

135 Moore told Thwaites that his choice was also influenced by the fact that young German artists were faced with particularly hard challenges at the time.

136 Terracotta, dimensions unknown, private collection, Munich. Present location unknown. Matschinsky-Denninghoff CR 0/5.

137 As far as the artist herself recollects, the works in question were LH 167 and LH 168.

138 Moore's former assistant Bernard Meadows also described a similarly happy working atmosphere. See p. 350.

139 These letters are held in the Brigitte and Martin Matschinsky-Denninghoff Archive, Berlin.

140 The assistants who worked longest for Moore were John Farnham, Michel Muller and Malcolm Woodward. It was as though they were part of the family – like Moore's incomparable secretary Betty Tinsley (1906–1998). Mention should also be made of John Farnham's father, Frank Farnham (1914–1990). At all times he was a reliable neighbour, friend and confidant for the Moores. A builder by trade, over the years he not only constructed successive studios for Moore, he also organised the purchases of additional land that gradually extended the grounds of the sculpture park in Much Hadham. When Moore suffered his final, serious illness, it was Frank Farnham who gave the artist such pleasure, almost daily, by taking him out through his grounds in his wheelchair.

141 As we can see from his letters, Moore certainly intended that she should be re-engaged as an assistant, although this came to nothing. It was only in the 1960s that she returned, just once, to Much Hadham for a private visit.

142 Matschinsky-Denninghoff CR 0/17 and 0/23.

143 Matschinsky-Denninghoff CR 11.

144 Matschinsky-Denninghoff CR 10: brass and pewter, height: 52 cm, Kunsthalle Bielefeld.

145 Matschinsky-Denninghoff CR 19: brass and pewter, height: 100 cm, Berlinische Galerie. Landesmuseum für Moderne Kunst, Fotografie und Architektur, Berlin.

146 The exhibition in question was a joint show with Rupprecht Geiger at the Galerie Schüler.

147 Also on the jury were Giacometti, Richier, Arp, Lipchitz, Antoine Pevsner, Zadkine, Karl Hartung and Marino Marini.

148 The Henry Moore Foundation Archive, Much Hadham.

149 When Werner Haftmann presented the artist duo in a solo exhibition in the Nationalgalerie in Berlin, he described them as follows: 'The name Matschinsky-Denninghoff is entirely new, as such, although it refers in part to the well-known sculptress Brigitte Meier-Denninghoff. By the mid-1950s she was already one of the leading young German sculptors working with metal. In Darmstadt in 1953–54, where she spent a short spell as a set designer, she met the young actor Martin Matschinsky. Soon the two were collaborating, ever more closely, until the point came when their separate artistic contributions could no longer be distinguished. While the original stylistic concept came from Brigitte Meier-Denninghoff, in recent years Martin Matschinsky has had such a crucial influence on this style, that it seemed only right to connect his name, too, with the work. Matschinsky-Denninghoff is the new name of this team, and it used here in this exhibition for the very first time.'

150 The two artists had a clear memory of a moment at Noack's foundry in 1965. Their bronze sculpture, *Schwarze Gruppe* (Matschinsky-Denninghoff CR 205), had just come out of the foundry. As they all looked at it together Moore spontaneously grasped the five columns and in one move, shifted them into the correct positions. In response to Martin Matschinsky's astonished inquiry as to how he had managed that so quickly, Moore replied – with disarming simplicity – that when Matschinsky was as old as he was, he would be able to do the same thing. Information kindly supplied in conversation by Martin Matschinsky-Denninghoff, Berlin 27 September 2005.

151 Brigitte Matschinsky-Denninghoff, obituary speech in honour of Henry Moore, Akademie der Künste, Berlin, 23 November 1986. Archiv Matschinsky-Denninghoff, Berlin.

152 Matschinsky-Denninghoff CR 0/18. The title of this work was not the artist's choice.

153 LH 209.

154 LH 651.

155 Grigson 1943.

156 Matschinsky-Denninghoff CR 0/19.

157 Matschinsky-Denninghoff CR 253 and 258 (large version).

158 Matschinsky-Denninghoff CR, p. 99.

159 The mutually influential relationship of the part and the whole played a crucial part in the aesthetics of Henry Moore. See above p. 258 and Lichtenstern 1994a, pp. 84–86 (chapter: 'The Organic Whole').

160 She was greatly moved by her early experiences of the mountains, on the Karwendelstein and, when she was a student in Munich, at the 'Sea of Stone' in Austria.

161 This is evident in a whole number of works, such as *Greif* (CR 62), *Daphne* (CR 106), *Skulptur auf dem Sipplinger Berg* (CR 300), *Trieb* (CR 317 and 373), *Ast* (CR 384, 385), *Großer Novemberwald* (CR 410) and *Seewind* (CR 622).

162 In 1949–50, thanks to a scholarship from the Solomon R. Guggenheim Foundation, Brigitte Matschinsky-Denninghoff worked for Antoine Pevsner in Paris. As she herself said, the nine months she spent in his company were 'just as exciting as the intense, action-packed months with Henry Moore'. See Matschinsky-Denninghoff CR, pp. 17, 23f., and 93. Both artists, who lived in Paris from 1961 to 1970, remained in close contact with Pevsner until he died in 1962.

163 Matschinsky-Denninghoff CR 462.

164 Obituary speech (as note 151).

165 Matschinsky-Denninghoff CR 905. For more on the late work see Lichtenstern 2001, pp. 54f.

166 This section is a reworked version of my essay '*Unsere Schönheit heute heißt Intensität* – Wilhelm Loths frühe Begegnung mit Moore, Picasso und Ossip Zadkine' (Lichtenstern 1995, pp. 26f).

167 See Grigson 1943.

168 Wilhelm Loth to Christa Lichtenstern, Karlsruhe 7 May 1982. Other parts of the letter refer to my essay 'Henry Moore and Surrealism', in *The Burlington Magazine*, CXXIII/944, November 1981, pp. 645–58 (Lichtenstern 1981a).

169 Estate of Wilhelm Loth.

170 Illustrated in Hamburg 1950, N 14. Loth had acquired a copy of this catalogue in Düsseldorf.

171 LH 204. Illustrated in ibid., N 40.

172 In his library Loth had a copy of Moore's album of prints *Heads, Figures and Ideas. A Sculpture Notebook*, ed. by G. Rainbird, Graphic Society, London and New York 1958 (with 64 facsimiles).

173 This is discussed by Haupenthal 1989, p. 84.

174 See above, note 168.

175 Grigson 1943, p. 8.

176 Ibid., p. 16.

177 For more on Moore's key concepts of 'intensity' and 'vitality', see Part II in this volume.

178 Information kindly supplied in conversation on 7 November 1982, Darmstadt, Neue Künstlerkolonie, Atelier Rosenhöhe.

179 See Weczerek 1988, pp. 15–25. Hereafter referred to as Stadler CR.

180 See, for instance, Stadler CR 69, *Männlicher Torso*, 1956, bronze, height: 68 cm, Städtische Galerie im Lenbachhaus, Munich.

181 Stadler CR 109–14, bronze and stone, length of the figures c. 2.20 m. Diameter of the round water basin: 6.25 or 6.10 m. Situated outside the Alte Oper, Frankfurt am Main.

182 Weczerek 1988, pp. 23f.

183 These figures are also described as Graces by Johann Wolfgang von Goethe, see idem, *Faust: Part Two*, transl. by Philip Wayne, London 1959, Act I, 'Spacious Hall', p. 46.

184 This transformation into water nymphs is also in keeping with the Classical iconography of the Three Graces. See Schwarzenberg 1966, p. 16.

185 Unfortunately the water level in the Frankfurt fountain never reaches up to the soles of the feet of the figures, as Stadler intended.

186 Hamburg/Düsseldorf 1950, fig. 109.

187 Kinkel 1967, p. 95.

188 Stadler CR 127a–c. See Ohnesorge 2005, pp. 144ff.

189 As cited in Weber 1978/79, p. 7.

190 Stadler, I, B-11, Deutsches Kunstarchiv im GNM. Both of the drawings illustrated here, plus a third very fragmentary view, are found in a small, wine-red sketchbook (c. 12 x 7 cm) with the words 'Ideal series, No. 4440/8' embossed on the cover. The sketchbook contains entries from November 1972.

191 Stadler's heightened lyricism impressed his contemporaries. In a review of the two-man exhibition of the work of Toni Stadler and Otto Ritschl in the Kunstverein Hannover, Rudolf Lange wrote that 'the most important piece in recent years has been… *Ägäis*. A plastic form, a bronze rock, fissured, perforated, formed over the centuries and millennia by the crashing of the sea, until it had taken on a form that is faintly reminiscent of a reclining female figure… not created by human hand but by Nature itself. … The movement of the water, the force of the waves, the ebb and flow of the whirling currents has taken on a permanent form in this artistic work.' See Rudolf Lange, 'Auf der Höhe des Alters. Toni Stadler und Otto Ritschl im Kunstverein Hannover', in *Hannoversche Allgemeine Zeitung*, 25 May 1965.

192 Estate of Toni Stadler, I, B-8. Undated sketchbooks from 1965 to 1970, Deutsches Kunstarchiv im GNM.

193 Stadler will have been able to see a reproduction of this first drawing in Grohmann 1960 (fig. 105); the second was illustrated in the Munich catalogue of 1960 (fig. 94).

194 The following section is a shortened reworking of my paper 'Plastik von Henry Moore von Beuys' (Lichtenstern 1995/1996, pp. 270–77, with a record of the ensuing discussion, pp. 278–79).

195 The interview with Mario Kramer was conducted on 9 December 1984. See Kramer 1991, p. 28. In response to my question, Hans van der Grinten informed me that he knew of no references to Henry Moore by Joseph Beuys. Nevertheless, Hans van der Grinten was very certain that Beuys became aware of Moore's work at an early stage in his own career. Information kindly supplied in conversation by Hans van der Grinten, Kranenburg, September 1995.

196 I am also indebted to Hans van der Grinten for this information (as note 195).

197 See Part II in this volume, pp. 259–260.

198 Information from a participant in the discussions at the Kranenburg Beuys Symposium (as note 194), p. 278.

199 See also the lead *Reclining Figure* of 1939 (LH 202) that Beuys will have been able to see illustrated in the exhibition catalogue of 1960, fig. 8.

200 Moore was certainly not alone in his use of a figure eight to introduce a sense of movement into his reclining figures. Witness Lipchitz' *Reclining Nude with Guitar* of 1928 (see Wilkinson 1989, pp. 107f., with illustration); witness also *Woman with Banjo* of 1939 by Henry Laurens, or his *Amphion* of 1937 (see Lichtenstern 1985, pp. 54–61). As early as 1936, in his drawing of a *Woman Walking*, Laurens replaced the female breast with a figure of eight (ibid. cat. N 75, with illustration). In all these works the circulating yet expansive forms of the figures of eight worked into them seem to anticipate the biomorphous abstraction of later artists.

201 From Joseph Beuys, *Secret Block for a Secret Person in Ireland*, N 71, in: Berlin 1988a.

202 See Peter Schata in Harlan et al. 1984, p. 100.

203 The Düsseldorf photographer Ruth Baehnisch chose this same title for her impressive photographs, which were shown in the Kranenburg Archive exhibition of Beuys photographs presented on the occasion of the 1995 symposium.

204 This work consists of strong brass wires running in the shape of a figure of eight through a rosewood core. Wenzel Beuys has written at length on the

piece's formation, its materials and its title. It is worth noting his particular reference to a book his father may be assumed to have known, namely George Adams' *Strahlende Weltgestaltung* (1965, 1st edn 1934). Wenzel Beuys cites a passage from this book in which the author describes the quality of mathematical space in terms of the implied motion in a figure of eight: '…the quality of the lemniscate – turning point and convolutions, wherein every opposite finds a certain balance. For in the S-curve and in the lemniscate inside turns out, outside turns in.' Trans. from Wenzel Beuys, in Beuys 1990, p. 332.

205 See, for instance, drawing N VII in *Zur Theorie der Plastik*, that was made during a conversation with Heiner Bastian in 1971 (see Berlin 1979–80, N 105). Here Beuys drew attention to the crossing point of the lemniscate with the words 'Denken' and 'Ich' placed one above the other, implying that the act of thinking – reinforced in the *Ich*-point – can lead the thinker to a greater awareness of his or her own transcendental potential. For more on the lemniscate in the work of Joseph Beuys see Schulz 2000, pp. 79–81.

206 Beuys certainly knew the knot designs from Lombardy or in Irish illuminated manuscripts. The knot is known in Lombardian architectural sculptures above all as an apotropaion and as a symbol of prosperity. Remarkably, it is predominantly found in places of liturgical importance, such as the altar, the baptismal font or the choir screen. See Kutzli 1974.

207 For more on the ruthless campaign mounted by the SED (Sozialistische Einheitspartei Deutschlands) against Formalism, see Blume/März 2003, pp. 318f.

208 There was virtually no free art market in the GDR and even fewer private sales.

209 See Grabowski 1949, p. 199.

210 Milde 2002, p. 372.

211 Anonymous, 'Hirnlose Roboter und Atomkriegs-Überlebende', in: *Neues Deutschland*, 15 July 1950.

212 Gärtner 1979, p. 157.

213 Ibid., p. 214.

214 Ibid., p. 219.

215 Schmidt 1965.

216 Artists named in this connection are Eberhard Bachmann, Theo Balden, Arnd Wittig and Jürgen von Woyski.

217 Ibid., p. 564.

218 Ibid., p. 565.

219 Ibid., p. 568.

220 Ingrid Beyer, 'Künstler und Gesellschaft (I). Antagonismus und Übereinstimmung', in *Bildende Kunst*, 4/1975, p. 194. Beyer cites Moore from Hofmann 1959, p. 64.

221 For more on Fritz Cremer see details provided in Bonn 1987–88, pp. 211f.; see also Brüne 2005. Brüne's work puts the study of Cremer's work on a new footing, with the emphasis on his commissions for public monuments.

222 Cremer 1975, p. 378.

223 Cremer 1976–77, p. 22.

224 Cremer 1975, p. 378.

225 Ibid.

226 For more on following the 'party line' as a means to defend the 'art of the people', see Peters 1983, pp. 5–8.

227 Hofmann 1959, pp. 39f.

228 Cremer 1975, p. 379.

229 Ibid.

230 By his own account, Cremer took this motif from the last stanza of Bertolt Brecht's poem 'O Deutschland, bleiche Mutter / Wie haben deine Söhne dich zugerichtet / Dass du unter den Völkern sitzest / Ein Gespött oder eine Furcht', in Cremer 1976/77, p. 150.

231 James 1968, p. 231. Brüne made this comparison without going into differences in the metaphorical meaning. See Brüne 2005, p. 341.

232 In his writings from this time Cremer often cites Marx's concept of 'the truth that is concrete'. See Cremer 1976/77, pp. 38, 44; see also Cremer 1975, p. 378.

233 Cremer 1976/77, p. 150.

234 Balden 1975, p. 381.

235 For more on Balden's various monuments to Karl Liebknecht (1966–69, 1979–83), his homages to Victor Jara (1974) and other anti-Fascist commissions, see Susanne and Klaus Hebecker (eds.), *Theo Balden 1904–1995 mit dem Verzeichnis der plastischen Arbeiten*, Erfurt 2004 (with a catalogue raisonné of his sculptural works), CR nos. 68-01, 68-03, 69-07, 70-02, 72-13, 74-08, 74-13, 78-05, 78-06, 79-01, 79-02, 79-07, 83-01 etc. Hereafter cited as Balden CR; see also Lichtenstern 2004, pp. 83–91. For the most recent study on Balden, see Ohnesorge 2005, pp. 28–43.

236 For more on Gerhard Lichtenfeld see Bonn 1987–88, p. 220.

237 Lichtenfeld 1975, pp. 383ff.

238 Hoffmann 1979, p. 196.

239 Ibid., p. 197.

240 Poljakowa 1982, pp. 484–88.

241 Ibid., p. 485.

242 Ibid., p. 488.

243 A selection of press reviews can be found in the Central Archive of the Alte Nationalgalerie, Berlin. However, there was no major report in *Bildende Kunst*. Inquiries at the Deutsches Rundfunkarchiv showed that in the surviving material shown on GDR television between 1952 and 1991, there appear to be no references to Moore. However, only fifty per cent of broadcast footage still exists. Information kindly supplied by Dr Peter Paul Schneider, Deutsches Rundfunkarchiv, Berlin-Babelsberg, 8 November 2005.

244 Barnett 1987, pp. 365–69.

245 Ibid., p. 369.

246 See Feist 1983, p. 47. I should particularly like to thank Susanne Hebecker MA, Bilderhaus Krämerbrücke, Erfurt, and Dr Birk Ohnesorge, Berlin, for the very useful conversations about Balden I enjoyed with them when I was setting out on my research.

247 Feist lists these artists in this order, ibid., p. 48. In his recollections of Sutherland's paintings Balden made specific mention of the latter's fascinating, bizarre tree stumps; in so doing he was touching on one of the most innovative themes in Sutherland's art. – Jacob Epstein's influence on Balden is at least seen in an alabaster head from 1946, *Die Mahnung* (Balden CR 46-01) and in his archaicising language of forms. Paul Nash may also have been important for Balden. Nash's preference for photography (especially when he was pursuing his Surrealist interests) and his discovery of the pictorial potential of uprooted trees in 1934, may later have encouraged Balden to take his own shots of trees.

248 For this and the following information, see Berthoud 1987, pp. 144ff.

249 Feist 1983, p. 48.

250 For more on the many activities of German artists (around a hundred in total) when they were in exile in England and the support they also received in the English press, see a report by one of these artists: Heinz Worner, 'Deutsche Antifaschistische Künstler im englischen Exil (1939–1946)', in *Bildende Kunst*, 3, 1962, p. 142–52. Here one comes across the comment: 'It was only rarely that individual colleagues had the courage to declare their German identity. But the most confident strove on an individual basis for national recognition; artists such as Theo Balden who put on exhibitions in the art gallery in Stoke-on-Trent and in the museum in Derby' (p. 149). For more on Balden's time in exile and his return to East Germany, see Schätzke 1999.

251 See Jacobi 2002, p. 5.

252 Balden 1986.

253 We know for certain that in 1984 Balden and his wife Edith attended the first official Henry Moore exhibition in the GDR, presented at the Nationalgalerie in Berlin. In 1965, when Balden had a touring exhibition, he was allowed to travel to England, to arrange to have his English works sent to the GDR; he also took the opportunity to visit a Henry Moore exhibition in London. This can only have been the exhibition shown in the Marlborough Fine Arts Gallery in July and August of that year.

254 Balden CR 48-02.

255 This work was last exhibited in the Balden exhibition at the Leipziger Galerie am Sachsenplatz. On the reverse, Balden made yet another sketch of

the same subject in pencil. This sheet, which came to the exhibition from another artist, was presumably sold at the time. Unfortunately it has not been possible to establish its present owner. A related graphite drawing is owned by the Stiftung der Akademie der Künste Berlin, inv. N Q 298. In this example, Balden abandons the motif of the child and concentrates entirely on the seated figure.

256 LH 226

257 Balden's bronze *Mutter und Kind* of 1974 (CR 74-07) is clearly related to Moore's eponymous group made from Hornton stone in 1924–25 (LH 26), which was illustrated in the catalogue of the exhibition shown in Hamburg and Düsseldorf in 1950. While Moore's figure remains strictly within the confines of the block, Balden's more expansive but less concentrated composition is all about the pathos of the gesture and the alienating simultaneity of the front and side views of the mother's head.

258 See Feist 1997–98, unpaginated.

259 Balden CR 70-09.

260 LH 119.

261 As cited in Frank 1983, p. 11.

262 Ibid., p. 10.

263 Balden 1971, unpaginated.

264 Balden CR 68-21.

265 LH 338.

266 See above p. 151.

267 Balden CR 61-09 and 72-10.

268 Balden CR 90-03, 90-04. For more on Balden's view of human beings as a 'ravaged creature', see Susanne Hebecker, in Hebecker 2004, p. 43.

269 See Schönemann 2004, p. 81; see also Lichtenstern, ibid. p. 88.

270 For more on the group that includes LH 293 b, 295 and 298, see Part II in this volume, pp. 264–273.

271 Balden CR 78-07.

272 LH 526.

273 *Atom Piece*, also called *Nuclear Energy*, was shown in the 1965 exhibition at the Marlborough Fine Arts Gallery, London.

274 Balden CR 83-01.

275 See Feist 1994, pp. 27–41.

276 Ohnesorge 2004b, pp. 92–100. For echoes of the work of Henry Moore in Balden's late work, with its connections to the natural world, see Lichtenstern ibid., pp. 88f.

277 Balden CR 80-08.

278 LH 191.

279 Balden's *Aufgestützte* of 1982 (CR 82-06.) also looks like an echo of Moore's *Memorial Figure* of 1945–46 (LH 262).

280 For more on the relevant dates see Barsch 1982, p. 134. Barsch bases her argument on a letter to Moore (published in the Appendix) written by René Graetz on 28 July 1971, where he speaks in support of the art writer Lothar Lang, who was keen to visit Moore in Much Hadham. He begins his letter with the words, 'I spent the war years in England and visited you a few times in your Parkhill Road Studio', ibid., Appendix 7, p. 48. For more on Graetz see Graetz 1978, with texts by Elizabeth Shaw, Theo Balden, Lothar Lang, José Renau, Fritz Cremer and Barbara Barsch; see also Graetz 2002.

281 Many of Graetz's contemporaries spoke of him in similar terms, and this image is reinforced by Horst Strempel's group portrait (a linocut of 1949) that shows the heads of Horst Strempel, Arno Mohr and René Graetz. Graetz is the only one with a smile on his face; illustrated in Schätzke 1999, p. 51. This group portrait of the three artists was made at the time of their collaboration on the hotly debated wall painting *Metallurgie Henningsdorf*. Ibid. pp. 50f.

282 See Schätzke 1999, p. 53.

283 In his report (25 August 1952) of a journey to the Soviet Union, he pleaded for an East German exhibition to counterbalance the Biennale in Venice 'which is now completely in the hands of American imperialists' (see Barsch 1982, p. 47). In the same report he also considered how one could introduce the Soviet model of a contractual arrangement binding artists to state-owned

companies and 'art education for the masses through targeted exhibitions' (ibid., pp. 40f.).

284 Ibid., p. 63.

285 In 1959 Graetz was awarded the National Prize of the GDR. As an active officer in cultural politics he was instrumental in ensuring that the GDR became a member of the A.I.A.P. (International Association of Plastic Arts at UNESCO). He himself became President of the A.I.A.P. and headed numerous conferences at home and abroad. In 1973 he was awarded the Käthe Kollwitz Prize by the Akademie der Künste of the GDR. In 1974 he was voted on to the committee of the visual artists' union (Verband Bildender Künstler) in the GDR, but died the same year of heart failure.

286 *Mutter und Kind*, 1950, bronze, height: 56 cm, Museen, Gedenkstätten und Sammlungen der Stadt Magdeburg, Kloster Unser Lieben Frauen, Nationale Sammlung der Kleinplastik. Illustrated in Graetz 1978, p. 91.

287 Russell 1973, p. 167.

288 Hofmann 1959, p. 90.

289 Neumann 1959, p. 109.

290 In an interview with J.P. Hodin, Moore commented that Giacometti particularly liked his geometric figure with the two heads, and his *King and Queen*. See Moore 1957, p. 21. Graetz owned a copy of this issue, which still exists in his estate which is today in the archive of the Akademie der Künste, Berlin. The main centre for research into the work of René Graetz is the Kunstarchiv Graetz in Berlin-Buch, which was built up by the artist's son, Patrick Graetz (1950–2006). In October 2005 Patrick Graetz kindly passed on much useful information. Also I am grateful to Ines Graetz, Anna Schneider and Guenter Roese for kindly helping in my search for images of the works.

291 Neumann 1959.

292 Bronze, height: 59 cm, model for a statue commissioned by the Magistrat of the City of Berlin. Kunstarchiv Graetz, Berlin-Buch. The finished large-format sculpture in bronze was posthumously installed in the park at Berlin-Rummelsburg in 1980. Originally Graetz intended the figure to be installed as part of a square, raised fountain, with abstract aluminium mobiles in the water around it. This never came to fruition because of the costs involved.

293 Illustrated in Jacobi 2002, pp. 39, 56, 57.

294 On the basis of the sketch in the upper left, showing an early stage of *Small Upright Figure B*, 1973, this sheet probably also dates to 1973.

295 Diary entry in English of March 1970, illustrated as a facsimile in Jacobi 2002, p. 34.

296 According to Barsch 1982, p. 88, nos. 1–7 were made between March and December 1970 and nos. 8–10 in early 1971. All the existing casts in bronze and composite stone are posthumous.

297 Bronze, height: 71 cm, illustrated in Jacobi 2002, p. 47.

298 Another head is seen in what is presumably a later study that takes the fourth version further. This dates to 9 January 1971, illustrated in Jacobi 2002, p. 38.

299 In *Upright Figure No. 5* (bronze, 80 x 32.5 x 21 cm, Staatliche Museen zu Berlin, Nationalgalerie) and *Upright Figure No. 7* (plaster, height: 86 cm, Kunstarchiv Graetz, Berlin-Buch) Graetz achieved a more symbolic, elemental diction. The figures are divided into four and three more angular sections respectively. This new laconic approach may have arisen from impressions (trees/ architecture) gained during a trip to Japan in 1966 or may have been a reflection of his early experience of African sculpture in Cape Town. – In the subsequent *Upright Figures No. 8* (composite stone, height: 104 cm, Kunstarchiv Graetz, Berlin-Buch) and *Upright Figure No. 9* (composite stone, height: 102.5 cm, Kunstarchiv Graetz, Berlin-Buch), Graetz retained the same clarity and decisiveness in the articulation of his forms, yet now the overall multi-sided, organic form was also more fluid. Thus this series ultimately arrives at a clear synthesis of its own thesis (torso) and antithesis (elemental symbols). In this group Graetz achieved a coherence rarely seen in his other work.

300 See the diary entries of 1982 published in a German translation in the Appendix of Barsch 1982, p. 4/K. Graetz, however, made his notes in English and French. The relevant passage in Moore's writings, referred to by Barsch (ibid., p. 90) is from the 'The Sculptor Speaks' (1937). See James 1968, p. 64: '...the sensitive observer of sculpture must also learn to feel shape simply as shape, not as description or reminiscence.'

301 Translated into English from the German version in Barsch 1982, Appendix, p. 2/D. Here Graetz is summing up a passage from Moore's 'Unit One' (1934). See James 1968, p. 72: 'Between beauty of expression and power of expression there is a difference of function. The first aims at pleasing the senses, the second has a spiritual vitality which for me is more moving and goes deeper than the senses.' A German translation of the same passage also appeared in Schmidt 1965, p. 566.

302 Translated from Barsch 1982, Appendix, p. 3/F.

303 Translated from Barsch 1982, Appendix, p. 3/E.

304 *Rosa Luxemburg*, 1973, bronze, height: 64.5 cm, Kunstarchiv Graetz, Berlin-Buch. Illustrated in Jacobi 2002, p. 31.

305 Translated from Barsch 1982, Appendix, p. 6/S.

306 As seen in the facsimile excerpt in Jacobi 2002, p. 35.

307 Werner Stötzer was born in Sonneberg, Thüringen, in 1931. Having trained as a ceramic modeller in Sonneberg, he went to Weimar to study sculpture; in 1951 he went to the Hochschule für Bildende Künste in Dresden to continue his studies with Eugen Hoffmann and Walter Arnold. Although he became Arnold's assistant, he found Arnold too politically conformist, abandoned a possible career in higher education and moved instead to Berlin in 1954, attracted by Seitz' *Eva* of 1947 in the Nationalgalerie. Thus he spent 1954–58 as a Master's student of Gustav Seitz at the Akademie der Künste.

308 See Berlin 1986, p. 33, note 25.

309 Written around 1920, it was not published until 1962. See Trier 1999, p. 108.

310 Seitz exh. cat. Berlin 1986, p. 54.

311 Ibid., cat. N 87, fig. p. 131.

312 Ibid., cat. N 109, fig. p. 147.

313 For more on this comparison, see Jacobi 1986a, p. 32.

314 Berlin 1986, p. 33, note 25.

315 See Stötzer 1991, p. 44.

316 Stötzer 2002, p. 107.

317 Stötzer 1975, pp. 394f.

318 As cited in Jacobi 1986b, p. 9.

319 Jacobi, ibid., pp. 9f.

320 In this respect Stötzer reveals his lineage, via his teacher Gustav Seitz, as the 'grandson-student' of Adolf von Hildebrand. Seitz was a great connoisseur and admirer of the work of Hans von Marées and Adolf von Hildebrand. Jacobi makes reference to Stötzer's connection to Hildebrand, Berlin 1977, p. 12.

321 See Moore in conversation with Arnold L. Haskell, *New English Weekly*, 5 May 1932, Reprinted in Wilkinson 2002, pp. 188ff.

322 In this respect there is a very striking affinity between Stötzer's work and that of Henry Moore. This is confirmed by his comment to Karin Thomas: 'When you see this landscape along the River Oder, you get a sense both of the immensity of the laws of Nature and of Nature's capacity to form itself. To experience the landscape like this is as great a pleasure as drawing a nude.' As cited in Stötzer, 1991, p. 48.

323 Ibid., p. 51.

324 Ibid., p. 49.

325 See above p. 299.

326 See Keisch 1977, p. 12.

327 In conversation with the present author (2 March 2006) Förster made specific reference to Heiliger's *Zwei Figuren in Beziehung [Two Figures in Relationship]* of 1953–54 (Heiliger CR, N 160). I should like to express my sincere gratitude to Professor Wieland Förster and Dr Angelika Förster for their various, always illuminating studio conversations and for so kindly helping in my search for images of the works.

328 Keisch 1977, pp. 13f.

329 Studio conversation with the present author, 16 July 2002, Berlin.

330 Information kindly supplied in conversation, 13 July 2002.

331 See the description of this discovery in Förster 2005, pp. 20ff.

332 Ibid., pp. 20f.

333 Ibid., pp. 56f.

334 Wieland Förster as cited in Schumann 1976, p. 60.

335 For more on this see Wieg 1998, pp. 75–88; Ohnesorge 2005, pp. 72–75.

336 Förster 2005, p. 56. In conversation with Henry Schumann, Förster also saw a parallel between this basic form and 'Goethe's concept of the 'ur-leaf'. See Schumann 1976, p. 62.

337 Förster 2005, p. 56.

338 Ibid., pp. 76f.

339 Förster 1974, pp. 53f.

340 Förster 2005, p. 113, fig. 49.

341 After the end of the war, the sixteen year-old Förster was 'denounced for being illegally in possession of a gun and, contrary to the law, condemned to seven years in custody which he spent at the NKWD-Speziallager Bautzen until his amnesty in 1950. Banned from talking about this period of his life in the GDR, the years spent in custody took a toll on both his psychological and physical well being.' See Ohnesorge 2005, pp. 61f.

342 See Gabler/Ohnesorge 2003, cat. N 33, 34. For more on Moore's influence on Croissant see Birk Ohnesorge, '"Einmal eine gute Plastik machen" – Der Bidlhauer Michael Croissant', ibid., p. 1.

343 See Boehm 1984, pp. 26–35; Steimann 1999, pp. 22–27.

344 See Hellweg 1991, pp. 58f.; Lichtenstern 1990b, pp. 17f.

345 See Heinz Demisch on Otto Herbert Hajek's wooden sculpture *Christusträgerin* of 1952 in connection with Moore's use of voids and holes, in: Demisch 1959, pp. 91f.

346 To the best of my knowledge, Günther Ferdinand Ris' connection to Moore has not yet been discussed in the literature. Basically the connection derives from the fact that Ris, like Moore, was interested in the flow of organic energies through precisely developed forms; he also had a similar interest in the relationship of the parts and the whole. For more on Ris, see Stemmler 1983.

347 In 1975, when asked what avant-garde sculptors of the twentieth century meant to him, Friedrich B. Henkel replied: 'Moore, Laurens, Arp fascinate me with their free, almost playful handling of form, with their sense of the organic, the wealth of the associations in their works.' Translated from Schumann 1976, p. 130.

348 See Jastram 1975, p. 375. For a discussion of Jastram's early perforated reliefs, influenced by Moore's *Time-Life Building Screen* of 1952–53 (LH 344), see Palme 1988, p. 18.

349 See Beloubek-Hammer 1989, N 19.

350 See Schmidt 1982, p. 386.

351 Hrdlicka 1987, pp. 57f.

352 Beaucamp talks of the entire cycle as 'heterogenous and tormented', a project that was primarily about the suffering of the Jews under Hitler: 'This memorial was prompted by the Auschwitz trials in Frankfurt, the earlier Eichmann trial and the case of Globke and his commentary on "racial laws".' See Eduard Beaucamp, 'Aufgewühltes Nachdenken', in *Frankfurter Allgemeine Zeitung*, 3 August 2007, p. 35.

353 Meißner 1989, p. 118. Meißner also points out that 'this painting was shown at the 7th Regional Exhibition in Leipzig in October 1965 and immediately became the "star" in amongst a whole number of other metaphorical realist works'. Ibid., p. 128.

354 Werner Tübke in a radio interview in 1966. See Meißner 1989, p. 128.

355 Three ropes lead to the steps and the picture, *The Seduction of Europe*, which refers here to the seduction of Europe by Fascism. Behind his back the ropes lead to the scenes of terror that the judge is responsible for. Two more ropes connect the puppet with the inferno of a bombed city by a river in the background, which could be intended to be read as Dresden. Above the scene a neo-Gothic angel is seen descending in a cloud of green light. In its right hand is a martyr's palm frond, in its left is a set of scales. The right-hand side of the scales is weighed down by the skull of an erstwhile winner of the Iron Cross, while the left-hand side with the dove of peace rises sharply upwards, like the blessed soul on the scales of St Michael. This juxtaposition of war, dying and death with peace, joy and life is further reinforced by Tübke elsewhere in this painting.

356 According to Meißner 1989, p. 127, this is 'Picasso's symbol of life, the dove with a head of a gorgon from the Temple of Peace in Vallauris'.

357 LH 360.

358 This is only a supposition, although we do know that in November 1954 Tübke travelled through the Federal Republic of Germany. See Meißner 1989, p. 382.

359 Irma Emmrich talks of the 'sleepiness of the Philistine' in idem 1976, p. 35.

360 This topic, often raised in the literature on Tübke, was first properly investigated by Emmrich (as note 359) with particular respect to Tübke's secularised use of the iconography of the Ecce Homo, the Pietà and the Last Day of Judgement.

361 *The Holy Bible*, King James Version, Psalms 23:5.

362 Sandberg 1956, p. 593.

363 Illustrated in Zinkand 1992, p. 58. For more on Mac Zimmermann see Helga Schmoll gen. Eisenwerth 2004, pp. 407–12.

364 Zimmermann 1955. Original size. The sketchbook measures 18.5 x 12 cm.

365 Ibid., p. 66.

366 For more on this see Lichtenstern 1992a, pp. 115–17.

367 This, at least, is how I read the artist's own writing in the bottom right. Helga Schmoll gen. Eisenwerth (as note 363, p. 408) reads it as 'Actäon'.

368 See Knapp/Petersen 1983, N 422, fig. pp. 253 and 422 a (relevant sketch, fig. p. 252).

369 For more on this see Waenerberg 2005, pp. 21–35.

370 Or more precisely, following his international breakthrough in the United States in 1946 and his receipt of the International Prize for Sculpture at the Venice Biennale in 1948.

371 See David Mitchinson, *Henry Moore in Public,* BBC Education Productions, 1998, pp. 18–27.

372 See Berthoud 1987, pp. 317–24.

373 On the history of the Henry Moore Foundation see Mitchinson 1998, pp. 11–66. Regular reports on the activities of the Foundation and the Henry Moore Institute in Leeds are published in *The Henry Moore Foundation Review* and at http://www.henry-moore-fdn.co.uk

374 Directed by Penelope Curtis.

375 See Phipps 2005, p. 11; see also Worsley 2005, p. 15.

376 Meadows 1968.

377 See *Time* (New York) 12 March 1965, pp. 48–52.

378 Letter to Roger Berthoud, 21 January 1985, The Henry Moore Foundation Archive.

379 Of the publications in English on the impact of Henry Moore particular mention should be made of O'Hear 1991, pp. 26–30; Parke-Taylor 1998, pp. 2–9; Coyen 2001, pp. 263–75; Williams 1998. Unfortunately I was neither able to hear this paper nor to see a copy of the text.

380 This expression, typical of the time, is entirely in keeping with Herbert Read's legendary reference to the 'Geometry of Fear' that characterised the art of the postwar generation of sculptors in England. In his introduction to the catalogue *New Aspects of British Sculpture*, Venice Biennale, 1952, he talked of 'images of flight, of ragged claws, scuttling the floors of silent seas, of excoriated flesh, frustrated sex, the geometry of fear.' As cited in Parke-Taylor 1998, pp. 3. The artists on show inside the British Pavilion were Robert Adams, Kenneth Armitage, Reg Butler, Lynn Chadwick, Geoffrey Clarke, Bernard Meadows, Eduardo Paolozzi and William Turnbull. Outside the pavilion, as though drawing visitors to it, was a work by Henry Moore.

381 He also assisted Moore in Much Hadham from time to time between 1946 and 1953. He remained a close friend of the family as long as Moore lived. From 1983 to 1988 he guided the progress of the Henry Moore Foundation as its first Director.

382 LH 191.

383 Meadows 1988, p. 245.

384 Ibid., p. 246. As we have already seen, this work ethos impressed Brigitte Matschinsky-Denninghoff. See above p. 304.

385 Opera by John Christopher Pepusch, first performed in 1728; it was to become the inspiration for Bertolt Brecht's *Dreigroschenoper*.

386 Described as such early on by Carnduff 1952, p. 35, fig. 197.

387 Bowness 1995. The catalogue raisonné in this publication will hereafter be referred to as Meadows CR

388 Curtis in Meadows CR, p. 19.

389 LH 210, made between March and December 1939.

390 For more on this purchase see Berthoud 1989, pp. 160f.

391 LH 208.

392 LH 204.

393 See Part I, pp. 59–61.

394 Meadows CR 5.

395 Meadows CR 9.

396 AG 35.17 with commentary.

397 As cited in Parke-Taylor 1998, pp. 2–9.

398 Meadows CR 18. – Moore also developed an interest in crablike creatures, particularly during the period when they were working together. On the drawing *Ideas for Sculpture: Reclining and Seated Figures* of 1937 (AG 37.68) Moore made a note to himself: 'Go & find bones & draw them & pebbles etc. / insects, octopus / crabs etc. bird cage.'

399 LH 212.

400 Meadows CR 28.

401 In the following discussion of the work of Kenneth Armitage, I am indebted to Tamsyn Woolcombe, *Kenneth Armitage: Life and Work,* Much Hadham 1997. Hereafter cited as Armitage CR.

402 Armitage CR 8.

403 As cited in Armitage CR, pp. 24ff.

404 Armitage CR 79.

405 Armitage CR, pp. 40ff. In 1959 Armitage once again exhibited work in the same context as Moore when Marlborough Fine Arts in London presented an exhibition with works by Kenneth Armitage, Lucian Freud, Henry Moore and Graham Sutherland. Armitage and Moore also both had their works cast at the Hermann Noack foundry, which they had been introduced to by Harry Fischer. See Armitage CR, p. 60.

406 For more on this see Glaves-Smith 1981, p. 133.

407 Mellor 2002, p. 110.

408 Grohmann 1960, pp. 217–18, plates 166, 167.

409 For more on Caro see Blume 1982–97; Waldman 1982; London 1984–85; Fenton 1986; Caro 2001; Wilkin 1991; Barker 2004.

410 On King's encounter with Henry Moore, his biographer Tim Hilton wrote that 'King was impressed by the professionalism in Moore's studios and… learnt how to work in plaster and how to enlarge from a maquette. There was an effect on King's own art. He… began to think of scale and a more delicate approach. The Much Hadham Library was also important… Yet there was an academicism inherent in Moore's practice and King was not totally convinced by the sculpture he helped to produce.' See Hilton 1992, p. 16. See also King's text in Mitchinson 1998, p. 256.

411 See Blume, 'Zu Anthony Caros Arbeitstechniken', in Blume 1982–97, pp. 5–8.

412 Barker 2004, p. 11.

413 See Caro 2001.

414 Spies 2000, pp. 236–40, pp. 243–44, plate 280, p. 401.

415 See Dieter Blume, *Anthony Caro. Catalogue Raisonné, vol. IV. Student Work 1942–1953 / Figurative Sculptures 1954–1959,* A 53. Hereafter cited as Blume IV.

416 Blume IV, A 69.

417 Barker 2004, p. 58.

418 Kahnweiler 1957 (fig. *Shepherd Carrying a Lamb*, 1944 [detail]).

419 See Caro's description in Barker 2004, pp. 69f.

420 Blume IV, A 67.

421 Blume IV, A 87.

422 See Wilkinson 1977, cat. N 15, p. 52.

423 Besides numerous expressions of gratitude, Caro also resisted Moore's 'star status', which he felt had been imposed on him. Without going into detail, he talked of 'weaknesses' in Moore's work. Clearly this view cast a shadow over their friendship. See Caro 1960, p. 21. Moore was deeply hurt in 1967 by a letter written by forty-one sculptors from the younger generation (including his former assistants Caro and King) and published in *The Times* on 26 May 1967. This letter was written in protest at the Tate Gallery's proposed large-scale display of works donated by Moore. The younger artists were anxious that this might not leave enough room for works by younger British sculptors. See also Berthoud 1987, pp. 120ff.

424 In what follows here I am indebted to Ian Barker's chapter 'Assistant to Henry Moore', Barker 2004, pp. 41–53.

425 LH 336.

426 Barker 2004, p. 45.

427 Berthoud 2004, p. 229.

428 Blume IV, A 50.

429 Blume IV, A 51/A 52.

430 *Rainwater Spout (The Green Man)*, 1952, lead, height: 15.2 cm, Cecil Sharpe House, The English Folk Dance and Song Society, L. Blume IV, A 42. Illustrated with the relevant comparison to Moore in Barker 2004, p. 42.

431 See above pp. 303–304.

432 As cited in Mitchinson 1998, pp. 115f.

433 Blume IV, A 65.

434 In fact the *Student Drawings 1951–1952* published by Dieter Blume cast a clear light on Moore's enlightening influence. See Blume (undated), vol. XII, cat. nos. D23–D75; see also Dieter Blume, *Die frühen Zeichnungen*, ibid., p. 5.

435 See the account by his former student Bates 1969, as cited in Barker 2004, p. 57.

436 LH 627.

437 *Art Monthly*, London, No. 23, 1979, p. 8.

438 *New York Times*, 6 May 1977. As cited in Barker 2004, p. 225.

439 Blume III, A 1142.

440 Blume III, A 1153.

441 Blume III, A 1171

442 *Table Piece CCCXCI Ledge*, 1977, rusty steel and grey paint, 442 x 597 x 272 cm, National Gallery Washington, D.C.

443 Caro: *Notes for a lecture. Unpublished manuscript*, late 1970s, as cited in Hilton 1984, p. 60.

444 This was the title of a catalogue with texts by a variety of authors, London and New York 1987.

445 Plastics, 300 x 400 cm, Arts Council of Great Britain, illustrated in Bonn 2003, fig. 11. Hereafter cited as Cragg, *Signs of Life*.

446 Translated from Jocks 2000, p. 219.

447 Cragg's present concept of material and its relationship to the human being can be seen in the recent, in-depth conversation between himself and Jon Wood. See Berlin 2006. pp. 13–125.

448 Kay Heymer, in the introduction to Bonn 2003, p. 9.

449 Ibid.

450 Conversation with Jocks (as note 446), p. 22.

451 Ibid., p. 25.

452 Ibid., p. 32.

453 Diverse materials, 100 x 400 x 120 cm, Arts Council Collection, South Bank Centre, London, illustrated in Bonn 2003, fig. 161.

454 Grenier in Bonn 2003, p. 427.

455 Conversation with Jocks (as note 446), p. 24.

456 Information kindly supplied by the artist. I am most grateful to Tony Cragg for the detailed conversations that we had on 2 November 2005 in Berlin and on 28 February 2007 in Wuppertal.

457 See Riedl 2001, p. 9; Schulz-Hoffmann in Bonn 2003, pp. 296ff.

458 Riedl 2001, p. 9.

459 See Heymer in Bonn 2003, pp. 13, 292.

460 Jacques Lipchitz shouted out in joy when he found a piece of glass that had been deformed in similar circumstances. See Lipchitz 1972, p. 195.

461 Riedl 2001, p. 10.

462 From Nantes 1994–95, fig. p. 53. For the most perceptive investigation of Cragg's autonomous drawings as 'processes in search of knowledge' see Christian Schneegass, in *Tony Cragg. In and Out of Material* (as note 445), pp. 260–80.

463 Bonn 2003, p. 459.

464 Ibid., N 450.

465 Schönenberg 2003, p. 469.

466 LH 376–392a.

467 Cragg 2005, p. 57.

468 Ibid.

469 As cited in Berlin 2006, p. 124.

470 See Recklinghausen 1997, p. 65.

471 As cited in Barker 2005, p. 158.

472 Andrews 1996, p. 16.

473 Ibid., pp. 16f. Even as this study was going to print, the author came across the penetrating, richly illustrated overview of Nash's work by Norbert Lynton: *David Nash*, Edition Scheffel, Bad Homburg v.d.H. 2008, which has also been published to accompany the solo exhibition of the work of David Nash in 2008–09 in Emden, Bad Homburg v.d.H. and Mannheim.

474 Exhibited at *Exposition surréaliste d'objets*. For more on this see Jean 1959, pp. 247ff.

475 See above p. 219.

476 London 1986, unpaginated.

477 Andrews, pl. 11.

478 Ibid., pl. 10, and Recklinghausen, pp. 14f.

479 Nash 1996, pp. 52–65.

480 Ibid., pp. 66–75.

481 See Andrews, fig. 150. For more on this see Andrews, pp. 132, 135, 141, 152f., 158, 160.

482 Andrews, fig. 182.

483 Warner 1996, p. 30.

484 Andrews, pl. 7.

485 Recklinghausen 1997, fig. 55.

486 Andrews, fig. 194.

487 Andrews, fig. 190

488 Recklinghausen 1997, fig. 53.

489 Andrews. p. 171.

490 In London 1989, unpaginated.

491 See Warner 1996, p. 18.

492 Recklinghausen 1997, fig. 15.

493 As cited in Recklinghausen 1997, p. 50.

494 In keeping with ancient esoteric traditions, Steiner connected each planet with its own tree. In his first Goetheanum (1913–1920, destroyed in an arson attack on New Year's Eve of 1922–23), where the main structure was made entirely from wood, the auditorium was lined on each side with seven columns, each of which was carved (including capitols and architraves) from a different wood. From west to east the connections were Saturn/hornbeam; Sun/ash; Moon/cherry; Mars/oak; Mercury/elm; Jupiter/maple and Venus/beech. For more on this see Raab 1995, p. 74.

495 See Kemper 1974.

496 Julius/Kranich 2004.

497 Ibid., p. 165.

498 Ibid., p. 166.

499 James 1968, p. 68.

500 Ibid.

501 Levine 1983, p. 23.

502 Andrews, pp. 155, 162.

503 Andrews, p. 139.

504 Recklinghausen 1997, pp. 38f.

505 See Warner 1996, p. 17.

506 Seldis 1973. Seldis lists nine visits by Moore to North America: 1946, 1953, 1958, 1962, 1965, 1966, 1967, 1970, 1971 (Toronto), ibid., p. 270. For more on the founding of the important Moore Gallery in the Art Gallery of Ontario (Toronto) see Wilkinson 1987. See also Berthoud 1987, pp. 319ff.

507 See Fort 1995, pp. 22–53.

508 Zorach 1967, p. 171.

509 See the standard work by Krauss 1971.

510 See Kirby 1986, p. 12.

511 See McClintic 1979, p. 20, cat. N 11. Here the notebook entry is dated 'c.1939'.

512 Berthoud 1987, p. 150.

513 Curt Valentin, who once worked for Alfred Flechtheim, fled Germany for New York in 1937. He died in August 1954, on a visit to Marino Marini in Pietrasanta. Moore flew to Italy specifically to attend the funeral. See Moore's moving obituary in Seldis 1973, pp. 58f. Seldis pays due homage to this great art dealer who was seminal in the establishment of private sculpture collections in the United States. Seldis 1973, pp. 56ff.

514 See Merkert 1986, fig. 62.

515 LH 101. This work was shown at the *International Surrealist Exhibition* in London in 1936. See above p. 67.

516 See Krauss 1977, N 163: *Woman Music*, 1944, steel painted in ochre, 45.7 x 22.9 cm, Collection of Victor Wolfson, New York.

517 Krauss 1971, p. 132.

518 Ferber described himself in these terms to Irving Sandler on 22 April 1968. See Irving Sandler: 'Oral History. Interview with Herbert Ferber': *www.aaa.si.edu/oralhist/ferber68.htm*.

519 See Andersen 1962 (with a catalogue raisonné), p. 14, CR N 31. Hereafter cited as Ferber CR.

520 At the same time Ferber also started working with lead casts (a process favoured by Moore), particularly between 1945 and 1949/50.

521 Illustrated in ibid., p. 15. Ferber CR, N 47. By contrast, *Reclining Woman II* (CR, N 38) is clearly influenced by Henri Laurens, whose work Ferber was also able to study at Curt Valentin's gallery.

522 Ferber CR, N 47.

523 Ferber himself described his work as 'gestural or largely gestural' in his interview with Irving Sandler (as note 518).

524 In conversation with Alan Bowness in 1970: 'One of my points is that sculpture should not represent actual physical movement. This is something I have never wanted. I believe that sculpture is made out of static, immovable material.' As cited in Wilkinson 2002, p. 179.

525 Interview with Irving Sandler (as note 518).

526 Here I am indebted to Forge 1996, p. 36. With a catalogue raisonné of the sculptures.

527 Forge 1996, p. 36.

528 Forge 1996, catalogue raisonné of the sculptures, N 31.

529 See Müller 2005, p. 33.

530 See Nauman 2005, p. 157.

531 Van Bruggen 1988, pp. 15, 109f.

532 Nauman 2005, p. 157.

533 Ibid., p. 118.

534 Ibid., p. 119.

535 Pencil and coloured pencils on paper, 101.6 x 88.9 cm. Illustrated in van Bruggen 1988, p. 146.

536 Van Bruggen 1988, p. 110.

537 Illustrated in van Bruggen 1988, pp. 145 and 146.

538 In Karlsruhe 1999–2000, p. 78. In the case of the first of the two photographs, Dörte Zbikowski also saw a connection to Nauman's spiral shaped, neon work of 1967, *The True Artist Helps the World by Revealing Mystic Truths.*

539 As yet no research has been conducted into what other meanings might be implied here in light of Nauman's fondness for wordplays.

540 Coosje van Bruggen, 1988, p. 111, also makes the connection with this earlier work that 'Nauman strangely never saw firsthand'. But Nauman will certainly have known the MoMA catalogue.

541 See Simon 1994, N 181.

542 Illustrated in van Bruggen 1988, p. 147.

543 Van Bruggen 1988, p. 147.

544 Nauman 1996, p. 74.

545 Bismarck 1998, p. 15.

546 Nauman 2005, pp. 159–60.

547 Ibid., p.160, note 544.

548 Kliege 1998, p. 58.

549 On the theme of anxiety, see Nauman 2005, pp. 177–79; see also Adams 1998, pp. 96–113.

550 For more on 'failure' as a point of contact between Beckett and Nauman see Simon 2000, pp. 16–37.

551 Kliege 1998, p. 51.

552 Nauman 2005, p. 117

553 See above Part II, pp. 275–277.

554 Nauman 2005, p. 145.

555 See above Part II, p. 277.

556 Holsten 1981, p. 40.

557 Ibid.

558 Nauman 2005, p. 298: 'If they were made in full scale they'd be huge. There would be a 10-foot cross-section to walk through and 100 or 300 feet in diameter.'

559 Ibid., p. 121.

560 Ibid., pp. 120f.

561 Ibid., p. 97.

562 Information kindly supplied in conversation by Alexander Davis (Moore's first bibliographer), Much Hadham, 11 June 1993. What follows here is based on the extensive materials relating to Japan in The Henry Moore Foundation Archive at Much Hadham. I was able to access these thanks to those who had already provided English-language summaries of the original Japanese documents. No doubt it would be worth a Japanese native speaker conducting a detailed study of these materials.

563 See Yasuyoshi Saito, 'Shuzo Takiguchi and Henry Moore', in *The Art of Henry Moore: Sculptures, Drawings and. Graphics 1921 to 1984,* exh. cat. Metropolitan Museum Tokyo, 11 April – 5 June 1986; Fukuoka Art Museum, 21 June – 27 July 1986, p. 208 (English summary).

564 The works in question were LH 71; LH 128; LH 25.

565 Shuzo Takiguchi ('Striving for an Image of the Female Body') [Japanese newspaper article], Mainichi, Tokyo, 18 May 1959. The Henry Moore Foundation Archive.

566 British Council exhibition catalogue, National Museum of Modern Art, Mainichi Newspapers, Tokyo 1969. The Henry Moore Foundation Archive.

567 Tadayasu Sakai *et al*, ('From the Henry Moore Exhibition') [Japanese periodical], Bijutsu Techno, Tokyo, July 1974. The Henry Moore Foundation Archive.

568 Berthoud 1987, p. 418. At the time the George and Virginia Ablah Collection contained a hundred works. Closely acquainted with the artist, they had built up one of the largest private collections.

569 See Toshio Matsumura, 'Henry Moore and the Hakone Open-Air Museum: Outdoor Sculpture and Environment', in *Henry Moore: The Expanse of Nature – The Nature of Man,* exh. cat. Hakone Open-Air Museum, Henry Moore Foundation 2004, pp. 20–23, with English translation.

570 It is clear from documents held at The Henry Moore Foundation Archive in Much Hadham that the following artists were also influenced by Moore:

Churyo Sato, Kazuo Yuhara, Yusuhisa Kotabe, Yoshitatsu Yanagihara, Rokusu Mizufune und M. Tada.

571 Atsuo Imaizumi, ('Visiting Henry Moore'), [Japanese periodical] no. 60, Bijutsu Techno, Tokyo, Sept. 1964. The Henry Moore Foundation Archive.

572 A piquant detail filling in something of the background to the early influence Zadkine had on Moore's work, as discussed in Part I of this study. I suspect that Moore's antipathy was directed at the global acclaim that Zadkine's late work was enjoying at the time.

573 In Saito 1986, p. 209.

574 *From the Town* 5, Miwa Gallery, Tokyo 1988 and N.H.K. Seminar, 20th Century Studies: *Henry Moore*, Tokyo 1990. The Henry Moore Foundation Archive.

575 Presumably in 1961 in the exhibition *Recent British Sculpture* in the Akademie der Bildenden Künste, Vienna.

576 Yoshikuni Iida, (A Sculptor: step toward creation), Iwanami Shoten, Tokyo 1991. The Henry Moore Foundation Archive.

577 Yoshikuni Iida ('A conversation with Henry Moore') [Japanese newspaper article], Asahi Shimbun, Tokyo, 10 April 1981. The Henry Moore Foundation Archive.

578 (Feature on Henry Moore), [Japanese periodical], Gendai No Me, Tokyo, Sept. 1969, pp. 1–8. The Henry Moore Foundation Archive.

579 See Yasuyoshi Saito, 'Shuzo Takiguchi and Henry Moore', in Saito 1986, p. 208.

580 Letter to George Washburn, who gave a paper at a UNESCO conference in 1968, entitled 'Mutual influences between Japanese and Western Arts'. See Chisaburoh F. Yamada (ed.), *Dialogue in Art: Japan and the West*, Zwemmer, London 1976.

581 Ash 1986, p. 10. – Moore made a drawing of Maurice Ash's daughter.

582 See Suzuki 1982. Chapter V 'The Koan', pp. 132–80.

583 LH 458.

584 See Yashiro 1970, pp. 19–34.

585 Baas 2005.

586 Baden-Baden 1986–1987.

587 Ibid., pp. 107ff.

588 Rychlak 2004, pp. 188–209.

589 Probably LH 259.

590 *Voks Bulletin* (Moscow), 52, 1947, pp. 20–36. The Henry Moore Foundation Archive, English summary.

591 For more on this see Pörzgen 1974: On 1 December 1962, at the exhibition *30 Years of the Moscow Artists' Union* held at the Moscow's main exhibition hall, known as the Manege, Nikita Khrushchev (First Secretary of the Communist Party), vented his fury at the direction modern Soviet art was taking: 'Unfortunately some of the artists portray people in a deliberately disfigured form… which plunges the viewer into a state of gloom and hopelessness. They present reality as they see it in their own distorted, subjective imaginations.' –

Vadim Sidur was not represented in this exhibition, which was followed by a remarkable debate with Ernst Neizvestny.

592 Kuskow 1991, pp. 147–53. On show were 70 sculptures, 44 drawings and three tapestries.

593 Ibid., p. 147.

594 Ibid., p. 148.

595 For more on Ernst Neizvestny see Schnell 1977, unpaginated; Salisbury 1979, pp. 102–05. Salisbury (p. 103) regards Neizvestny as being 'clearly influenced by Rodin and Moore'. Furthermore (p. 105): 'As might be expected, he loves Henry Moore. He recognizes the link between Moore's work and his own. He is more classical, he says. I am more romantic.'

596 See Eimermacher 1978. The fact that the Slavist, Karl Eimermacher, supported the much maligned artist in the West was very important to Sidur.

597 Bochum 1984, with a catalogue raisonné. Hereafter cited as Sidur CR.

598 Sidur CR 137.

599 Bronze, length: 161 cm, Estate of Jacques Lipchitz, Marlborough Fine Arts. See Wilkinson 1989, N 54.

600 Sidur CR 171.

601 Sidur CR 220.

602 Sidur CR 174.

603 Sidur CR 189.

604 Illustrated in Eimermacher 1978, p. 36, fig. 41.

605 Sidur CR 369.

606 Vadim Sidur in conversation with Karl Eimermacher, in Eimermacher 1978, p. XXXVI.

607 Ibid., p. XL.

608 Interview in Eimermacher 1978, p. XXXVI.

609 See Hughes 1991, p. 5.

610 For more on the reception of Moore's work in Poland and, in particular, by art critics and the media, see the informative study by Murawska-Muthesius 2003. This study is the basis of what follows here.

611 Murawska-Muthesius 2003, p. 210.

612 For more on Tomaszewski see Ammann 1980, p. 118. Information kindly supplied by Dr Lutz Malke, Berlin.

613 LH 165.

Dates and Documents

Roger Berthoud, *The Life of Henry Moore*, London 1987.

David Mitchinson (ed.), *Celebrating Moore: Works from the Collection of the Henry Moore Foundation*, London 1998.

Alan Wilkinson (ed.), *Henry Moore: Writings and Conversations*, London 2002.

Bibliography

Henry Moore Bibliography, compiled and edited by Alexander Davis, vols. 1–5, Much Hadham 1992–94.

Catalogues raisonnés

LH
(prefix for catalogue reference numbers)
Henry Moore: Complete Sculpture, vol. 1, *1921–1948*, ed. by Herbert Read 1944, reprint of the 5th edition, ed. by David Sylvester, London 1990; vol. 2, *1949–1954*, ed. by D. Sylvester 1955, 3rd revised edition ed. Alan Bowness 1986; vol. 3, *1955–64*, ed. by Alan Bowness 1965, 2nd revised edition 1986; vol. 4, *1964–1973*, ed. by Alan Bowness 1977; vol. 5., *1974–1980*, ed. by Alan Bowness 1983, 2nd revised edition 1994; vol. 6, *1981–1986*, ed. by Alan Bowness 1988, revised edition 1999. London.

AG/HMF
Henry Moore, Complete Drawings, vols. 1–7, 1916–1986, ed. by Ann Garrould, London 1996–2003.

CGM
Henry Moore, Catalogue of Graphic Work, vols. 1–4, ed. by Gérald Cramer (from vol. 3 by Patrick Cramer), Alistair Grant and David Mitchinson, Geneva 1973–1988.

Monographs and articles

Adams 1965
George Adams, *Strahlende Weltgestaltung*, Dornach 1965 (first edition 1934).

Adams 1998
Parveen Adams, "Bruce Nauman and the Object of Anxiety", in: *October*, no 83, 1998, pp. 96–113.

Ades 1978
"Documents", in: *Dada and Surrealism Reviewed*, ed. by Dawn Ades, Arts Council of Great Britain, Hayward Gallery 11.01–27.3.1978, London 1978, pp. 228–250.

Albrecht 1977
Hans Joachim Albrecht, *Skulptur im 20. Jahrhundert. Raumbewußtsein und künstlerische Gestaltung*, Cologne 1977.

Ammann 1980
Dieter Ammann, *Polnische Plakatkunst*, Dortmund 1980.

Andersen 1962
Wayne V. Andersen, *The Sculpture of Herbert Ferber*, catalogue raisonné, Walker Art Center, Minneapolis 1962.

Andrews 1996
Julian Andrews, *The Sculpture of David Nash*, Much Hadham/London 1996.

Andrews 2001
Julian Andrews, "The War Years", in: Dallas 2001, pp. 144–147.

Andrews 2002
Julian Andrews, *London's War: The Shelter Drawings of Henry Moore*, London 2002.

Andrian-Werbung 1998
Irmtraud Frfr. von Andrian-Werbung, "Karl Hartung – sein Leben in Dokumenten", in: *Karl Hartung. Werke und Dokumente*, Archiv für Bildende Kunst im Germanischen Nationalmuseum Nürnberg, Nuremberg 1998, pp. 87–97.

Appel 1998
Thomas Appel, "Die Bürger von Calais. Auguste Rodins Intentionen zu Aufstellung and Sockel", in: Marl 1998, pp. 76–80.

Archipenko 1960
Archipenko: Fifty Creative Years 1908–1958. Alexander Archipenko and Fifty Art Historians, New York 1960.

Aristotle 1998
Aristitle's *Physics*. A revised text with introduction and commentary by W. D. Ross, Reprint, XII Vols., Oxford 1998. Texts in Greek and English.

Arp 1955
Hans Arp, *Unsern täglichen Traum… Erinnerungen, Dichtungen and Betrachtungen aus den Jahren 1914–1954*, Zurich 1955.

Ash 1986
Maurice Ash, "Henry Moore and Japan Today", in: *The Japan Times*, 8.4.1986, p. 10.

Augstein 1996
Franziska Augstein, "Wirklichkeit und Warzen. Was ist das Englische an der englischen Kunst?", in: *Frankfurter Allgemeine Zeitung*, 18.5.1996.

Ayrton 1969
Michael Ayrton, *Giovanni Pisano, Sculptor*, intro. Henry Moore, London, 1969.

Baas 2005
Jacquelynn Baas, *Smile of the Buddha: Eastern Philosophy and Western Art from Monet to Today*, Berkeley 2005.

Bach 1987
Friedrich Teja Bach, *Constantin Brancusi. Metamorphosen plastischer Form*, Cologne 1987.

Badt 1963
Kurt Badt, *Raumphantasien and Raumillusionen. Wesen der Plastik*, Cologne 1963.

Balden 1971
Theo Balden, "Gedanken zur Arbeit", in: Berlin 1971, unpaginated.

Balden 1975
Theo Balden, "Im Dienste eines streitbaren Humanismus", in: *Bildende Kunst* 8, 1975, p. 381.

Balden 1986
Theo Balden, "Gedanken. Henry Moore", in: *Sonntag* 38, 1986, p. 12

Baldini 1982
Umberto Baldini, *Michelangelo. Die Skulpturen*, Stuttgart 1982.

Baldini/Casazza 1991
Umberto Baldini/Ornella Casazza, *The Brancacci Chapel*, London 1991

Baldini/Casazza 1992
Umberto Baldini/Ornella Casazza, *The Brancacci Chapel frescois*, London 1992.

Barker 2004
Ian Barker, *Anthony Caro: Quest for the New Sculpture*, Künzelsau 2004.

Barker 2005
Ian Barker, "From Moore to Kapoor: Turning Points from Six Decades of British Sculpture", in: Schwäbisch Hall 2005, pp. 151–163.

Barnett 1987
Anthony Barnett, "Formgewordenes Leben. Zu einigen Aspekten im Werk von Henry Moore", in: *Bildende Kunst*, 8/1987, pp. 365–369.

Barnier 1967
Rosalind Barnier, "Henry Moore parle de Rodin", in: *L'Œil* 155, Nov. 1967, pp. 26–33.

Barr 1966
Alfred H. Barr, *Cubism and Abstract Art*, New York 1966.

Barsch 1982
Barbara Barsch, *Zu Leben und Werk des Bildhauers René Graetz (1908–1974)*, Diss. Berlin, Berlin 1982.

Barth 1997
Anette Barth, *Alexander Archipenkos plastisches Œuvre. Seine Bedeutung für die Skulptur des 20. Jahrhunderts unter besonderer Berücksichtigung der Lichtplastiken* (Diss. Trier 1994), Frankfurt 1997.

Bates 1969
Merete Bates, "The Core of Caro", in: *The Guardian*, 27.1.1969.

Baumann 2002
Beatrice Baumann, *Max Sauerlandt. Das kunstkritische Wirkungsfeld eines Hamburger Museumsdirektors zwischen 1919 und 1933*, Museum für Kunst und Gewerbe Hamburg, Hamburg 2002.

Beattie 1986
Susan Beattie, *The Burghers of Calais in London: the history of the purchase and siting of Rodin's monument 1911–1956*, Arts Council of Great Britain, London 1986.

Beaumelle 1997
Agnes de la Beaumelle, "Boule suspendue par Alberto Giacometti", in: *Revue du Louvre* 47, 1997, pp. 19–21.

Beloubek-Hammer 1989
Anita Beloubek-Hammer, "Bekenntnis zum Stein, Plastiken von Peter Kern, Galerie am Prater Berlin", in: *Sonntag*, 7.5.1989, no 19.

Belting 1985
Hans Belting, *Giovanni Bellini: Pietà. Ikone and Bilderzählung in der venezianischen Malerei*, Frankfurt 1985.

Benziger 1951
James Benziger, "Organic Unity: Leibniz to Coleridge", in: *PMLA. Publications of the Modern Language Association of America*, vol. LXVI, no 2/March 1951, pp. 33.

Berthoud 1987
Roger Berthoud, *The Life of Henry Moore*, New York 1987.

Beuys 1990
Eva, Wenzel and Jessyka Beuys, *Joseph Beuys, Block Beuys*, Munich 1990.

Beyer 1975
Ingrid Beyer, "Künstler and Gesellschaft (I). Antagonismus and Übereinstimmung", in: *Bildende Kunst* 4, 1975, pp. 194–196.

Bickmann 1999
Isa Bickmann, *Leonardismus und symbolistische Ästhetik*, Frankfurt 1999.

Bindman 2001
David Bindman, *William Blake. The Complete Illuminated Books*, London 2001.

Binyon 1926
Lawrence Binyon, *The Engraved Designs of William Blake*, London 1926.

Bismarck 1998
Beatrice von Bismarck, *Bruce Nauman. Der wahre Künstler. The True Artist*, Ostfildern-Ruit 1998.

Blisniewski 1992
Thomas Blisniewski, *"'Kinder der dunkeln Nacht'". Die Ikonographie der Parzen vom späten Mittelalter bis zum späten XVIII. Jahrhandert*, Cologne 1992.

Blume 1982–1997
Dieter Blume, *Anthony Caro, Catalogue raisonné*, 12 vols., Cologne, Hanover and New York 1982–c. 1997.

Blume/März 2003
Eugen Blume and Roland März (Ed.), *Kunst in Deutschland. Eine Retrospektive der Nationalgalerie*, Berlin 2003.

Blumenberg 1960
Hans Blumenberg, *Paradigmen zu einer Metapherologie* (Archive for conceptual history, vol. 6), Bonn 1960.

Boal 2003
Iain A. Boal, "Ground Zero: Henry Moore's *Atom Piece* at the University of Chicago", in: Moore 2003, pp. 221–241.

Boehm 1984
Gottfried Boehm, "Ernst Hermanns. Plastische Konstellationen", in: *Das Kunstwerk*, vol. XXXVII, 4, 1984, pp. 26–35.

Bonnefoy 1991
Yves Bonnefoy, "André Breton et Alberto Giacometti", in: *Pleine Marge. Cahiers de littérature, d'arts plastiques et de critique*, Paris 1991, no 13, pp. 57–78.

Bonnefoy 1992
Yves Bonnefoy, *Alberto Giacometti. Eine Biographie seines Werkes*, Wabern-Bern 1992.

Bonnet 1952
Hans Bonnet, *Reallexikon der ägyptischen Religionsgeschichte*, Berlin 1952.

Bowness 1977
Alan Bowness, "Introduction" to: *Henry Moore: Complete Sculpture*, vol. 4, 1964–73, London 1977, pp. 7–18.

Bowness 1995
Alan Bowness, *Bernard Meadows: Sculpture and Drawings*. With an essay by Penelope Curtis, London and Much Hadham 1995.

Brandt-Förster 1978
Bettina Brandt-Förster, *Das irische Hochkreuz. Ursprung. Entwicklung. Gestalt*, Stuttgart 1978.

Braun 1989
Barbara Braun, "Henry Moore and the Pre-Columbian Art", in: *Res, Anthropology and Asthetics*, 17/18, Spring/Autumn 1989, pp. 159–197.

Braun 2000
Barbara Braun, *Pre-Columbian Art and the Post-Columbian World*, New York 2000.

Breton 1967
André Breton, "II. Artistic genesis and perspectives of surrealism (1941)", in: idem, *Surrealism and Painting*, transl. by Simon Watson Taylor, London 1972.

Brinkmann 1925
Albert E. Brinkmann, *Spätwerke Großer Meister*, Frankfurt 1925.

Brockhaus 1985/86
Christoph Brockhaus, "Grundlagen and Werkphasen", in: Duisburg 1985/86, pp. 9–14.

Brommer 1963
Frank Brommer, *Die Skulpturen der Parthenon-Giebel*, Munich 1963.

Bronkhurst 2006
Judith Bronkhurst, *William Holman Hunt: A Catalogue Raisonné*, vol. I, Paintings, New Haven/London 2006.

Brown 1980
Peter Brown (ed.), *The Book of Kells*, London 1980.

Brown 2001
Elizabeth Brown, "Moore Photographing Moore", in: Dallas 2001, pp. 16–19.

Brüne 2005
Gerd Brüne, *Pathos und Sozialismus. Studien zum plastischen Werk Fritz Cremers 1906–1993* (Diss. Kassel), Weimar 2005.

Brunn 1870
Enrico Brunn, *I Relievi delle Urne Etrusche*, vol. l, Rome 1870.

Buckle 1963
Richard Buckle, *Jacob Epstein, Sculptor*, London 1963.

Buesche 1950
Albert Buesche, "Henry Moore und die Wende der Plastik. Die Hamburger Kunsthalle stellt Moores Werke aus", in: *Der Tagesspiegel*, Berlin, 28.3.1950.

Buschor 1936
Ernst Buschor, *Plastik der Griechen*, Berlin 1936.

Butler 1998
Augustin de Butler (Ed.), *Auguste Rodin. Eclairs de pensée*, Paris 1998.

Butlin 1981
Martin Butlin, *The Paintings & Drawings of William Blake*, vol. I (Text), New Haven/London 1981.

Calvocoressi 1981
Richard Calvocoressi, "Public Sculpture in the 1950s", in: London 1981, pp. 135–153.

Canetti 2005
Elias Canetti, *Party in the Blitz: The English Years*, New York 2005.

Cannon-Brookes 1983
Peter Cannon-Brookes, *The British Neo-Romantics 1935–1950*, London 1983.

Cardinal 2000
Introduction in: Andros 2000, pp. 17–51

Carey 1988
Frances Carey, *Henry Moore: A Shelter Sketchbook*, Munich 1988.

Carnduff Ritchie 1952
Andrew Carnduff Ritchie, *Sculpture of the Twentieth Century*, NewYork 1952.

Caro 1960
Anthony Caro, "The Master Sculptor", in: *The Observer*, 27.11.1960, p. 21.

Caro 2001
The Last Judgement. Sculpture von Anthony Caro, ed. by Ian Barker and C. Sylvia Weber. Museum Würth, Schwäbisch Hall, Künzelsau 2001.

Carrà 1925
Carlo Carrà, *Giotto*, Rome 1925.

Carter 1933
Howard Carter, *The tomb of Tut-Ankh-Amon*, London 1933.

Causey 1980
Andrew Causey, *Paul Nash*, Oxford 1980.

Causey 1987
Andrew Causey, "*Formalism and figurative tradition in the English painting*", in: exh.cat. British Art in the 20th Century – The Modern Movement, Royal Academy of Arts, London 1987, pp. 17–36.

Causey 1993
Andrew Causey, "Herbert Read and the North European Tradition 1921–33", in: Leeds 1993, pp. 38–52.

Causey 2000
Andrew Causey, *Paul Nash: Writings on Art*, New York/Oxford 2000.

Causey 2003
Andrew Causey, "Henry Moore and the uncanny", in: Moore 2003, pp. 81–106.

Causey 2004
Andrew Causey, "Another look at Henry Moore's Shelter Drawings", in: J. A. Schmoll gen. Eisenwerth 2004, pp. 319–333.

Clark 1944
Kenneth Clark, "A Madonna by Henry Moore. Address by Sir Kenneth Clark", in: *The Magazine of Art*, 37 (Nov. 1944), New York, pp. 247–249.

Clark 1949/62
Kenneth Clark, *Landschaft wird Kunst* [Landscape into Art], London 1962 (first release 1949).

Clark 1974
Kenneth Clark, *Henry Moore Drawings*, London New York 1974.

Cohen 1998
David Cohen, comments on works, in: Mitchinson 1998, cat. nos. 92, 130, 137, 165, 173, 227, 232, 236, 265, 273.

Cohen 2001
David Cohen, "Who's Afraid of Henry Moore?", in: Dallas 2001, pp. 263–275.

Coke 1992
Karen Coke, "Henry Moore as medallist", in: *Medal*, 1992, no 21.

Coleridge 1949
Samuel Taylor Coleridge, *Bibliographia literaria*, ed. by J. Shawcross, vol. 1, London 1949.

Coleridge 1967
Samuel Taylor Coleridge. Shakespearean Criticism, ed. by Thomas Middleton Raysor, vol. 1, New York 1967.

Conzen 2004
Ina Conzen, "Angehaltene Bewegung. Picassos Badende", in: Staatsgalerie Stuttgart 2004, pp. 15–177.

Cook 1976
B. F. Cook, *Greek and Roman Art in the British Museum*, London 1976.

Corbinean-Hoffmann 1992
A. Corbinean-Hoffmann, entry on "Rhythmus", in: *Historisches Wörterbuch d. Philosophie*, vol. 8, Basle 1992, column 1028.

Cork 1976
Richard Cork, *Vorticism and Abstract Art in the First Machine Age*, vol. 1: "Origins and Development", vol. 2: "Synthesis and Decline", Berkeley/Los Angeles 1976.

Cork 1981
Richard Cork, *Overhead Sculpture for the Undergroand Railway*, in: London 1981, pp. 91–101.

Cork 1988
Richard Cork, "An Art of the Open Air: Moore's Major Public Sculpture", in: London 1988a, pp. 14–26.

Cork 1998
Richard Cork (comments on individual works), in: Mitchinson 1998.

Cragg 2005
Tony Cragg, "Wirbelsäule", in: Nuremberg 2005, pp.11–14.

Cremer 1975
Fritz Cremer, "Kritische Aneignung im Prozess künstlerischer Arbeit. Bildhauer der DDR über ihr persönliches Verhältnis zum Erbe", in: *Bildende Kunst* 8, 1975, pp. 378–380.

Cremer 1976/77
Fritz Cremer, *Projekte – Studien – Resultate*, ed. by Staatliche Museen zu Berlin, National-Galerie Berlin, Academy of Fine Arts GDR, Berlin 1976/77.

Curtis 1994-95
Curtis, Penelope, "Barbara Hepworth and the Avant Garde of the 1920s", in: Toronto 1994–95, pp. 11–28.

Curtis 2002
Penelope Curtis, "'Direct Carving (und die Auffassung von) Moderner britischer Skulptur.' International oder insular? Modern oder traditionell?", in: Wolfsburg 2002, pp. 63–69.

Curtis/Russell 2003
Penelope Curtis and Fiona Russell, "Henry Moore and the post-war British landscape: Monuments ancient and modern", in: Moore 2003, pp. 125–141.

Curtius 1979
Ernst Robert Curtius, *European Literature and Latin Middle Ages*, transl. by Willard R. Trask, London 1979

Daguerre de Hureaux 1993
Alan Daguerre de Hureaux, *Delacroix*, Paris 1993.

Darvill 2006
Timothy Darvill, *Stonehenge: The Biography of a Landscape*, Stroud, Gloucestershire 2006.

Davey 1998
Kevin Davey, "Herbert Read and Englishness", in: David Goodway, *Herbert Read Reassessed*, Liverpool 1998, pp. 270–286.

Davis 1983
Norma D. Davis, "Stone as Metaphor: Wordworth and Moore", in: *The Wordsworth Circle*, vol. XIV, Heft 4, ed. by Marylin Gaull, Philadelphia 1983, pp. 264–268.

Demisch 1959
Heinz Demisch, *Vision und Mythos in der modernen Kunst*, Stuttgart 1959.

Demisch 1961
Heinz Demisch, "Karl Hartung", in: *Neue Schau*, 22. 5. May 1961, pp. 163–165.

Demisch 1967
Heinz Demisch, "Maß und Vielfalt. Zum Tode von Karl Hartung", in: *Frankfurter Allgemeine Zeitung*, 25.7.1967, p. 20.

Demisch 1977
Heinz Demisch, *Die Sphinx. Geschichte ihrer Darstellung von den Anfängen bis zur Gegenwart*, Stuttgart 1977.

Demisch 2003
Heinz Demisch, *Ludwig Richter. Eine Revision*, ed. by Christa Lichtenstern, Berlin 2003.

Dittmann 1987
Lorenz Dittmann, *Farbgestaltung and Farbtheorie in der abendländischen Malerei*, Darmstadt 1987.

Donaldson 1984
Frances Donaldson, *The British Council: The First 50 Years*, London 1984.

Döring 2001
Tobias Döring, "Beherrscher der höllischen Methode. Prophet im Verborgenen: Peter Ackroyds Biographie des weltfremden Künstlers William Blake", in: *Frankfurter Allgemeine Zeitung*, 25.8.2001, no. 197, p. 5.

Dörken 1936
Eugen Dörken, *Geschichte des französischen Michelangelobildes von der Renaissance bis zu Rodin*, Bochum 1936.

Dufrêne 1994
Therry Dufrêne, *Alberto Giacometti: Les dimensions de la réalité*, Geneva 1994.

Dupin 1961
Jacques Dupin, *Joan Miró: Life and Work*, London 1962.

Dupin/LeLong-Mainaud 1999
Joan Miró: Catalogue raisonné. Paintings, vol. 1, ed. by Jacques Dupin and Ariane LeLong-Mainaud, Paris 1999.

Eaves 1988
Morris Eaves, *William Blake's Theory of Art*, Princeton, 1988.

Eimermacher 1978
Karl Eimermacher, *Vadim Sidur. Skulpturen. Graphik,* Constance 1978.

Einem 1973a
Herbert von Einem, *Michelangelo. Bildhauer – Maler – Baumeister*, Berlin 1973.

Einem 1973b
Herbert von Einem, "Zur Deutung des Altersstils in der Kunstgeschichte", in: J. G. van Gelder, *Album Amicorum*, The Hague 1973, pp. 88–92.

Einstein 1915
Carl Einstein, *Negerplastik*, Leipzig 1915.

Ekserdjian 2002
David Ekserdjian, "The young Henry Moore and Italy: The influence of Mantegna and a trip to Siena", in: *Apollo*, vol. CLV, no 488 (New Series), Oct. 2002, pp. 36–40.

Elsen 1967
Albert Elsen in Zusammenarbeit mit Henry Moore, "Rodins '*Walking Man*' as seen by Henry Moore", in: *The Studio*, July/Aug. 1967, p. 29.

Emmrich 1976
Irma Emmrich, *Werner Tübke. Schöpfertum and Erbe. Eine Studie zur Rezeption christlicher Bildvorstellungen im Werk des Künstlers*, Berlin 1976.

Engell/Bate 1983
James Engell/W. Jackson Bate (ed.), *Samuel Taylor Coleridge, Bibliographia Literaria or Biographical Sketches of My Literary Life and Opinions*, vol. 1, Princeton 1983.

Erdman 1975
David V. Erdman, *The Illuminated Blake*, London 1975.

Ernst 1936/70
Max Ernst, "Au-delà de la peinture 1936", in: Max Ernst: *Ecritures*, Paris 1970, pp. 235–248.

Feist 1983
Ursula Feist, *Theo Balden*, Dresden 1983.

Feist 1994
Peter H. Feist, "Wie gestaltet ein Bildhauer die Revolution? Theo Baldens Liebknecht-Denkmal in Potsdam", in: *Utopie kreativ*, Berlin, number 47/48, September/Oct. 1994, pp. 27–41.

Feist 1997–98
Ursula Feist, "Dunkler Zeiten, Bitterkeiten und mehr. Gedanken zum Werk Theo Baldens", in: *Theo Balden*, Leipzig 1997–98, unpaginated.

Feldman Bennet 2001
Anita Feldman Bennet, "A Sculptor's Collection", in: Dallas 2001, pp. 53–61.

Feldman Bennet 2003
Anita Feldman Bennet, in: *Imaginary Landscapes*, ed. by David Mitchinson, Much Hadham 2003.

Feldman Bennet 2005
Anita Feldman Bennet, in: *Henry Moore and the Challenge of Architecture*, ed. by David Mitchinson, Much Hadham 2005.

Feldman Bennet 2006-07
Anita Feldman Bennet, "Henry Moore. Sculptuur en architectuur", in: Rotterdam 2006, pp. 52–55.

Fenton 1986
Terry Fenton, *Anthony Caro*, London 1986.

Fillitz 1969
Hermann Fillitz (ed.), *Das Mittelalter I* (Propyläen Kunstgeschichte, vol. 5), Berlin 1969.

Fischer 1987
Wolfgang Georg Fischer, "Henry Moore in Deutschland", in: *Jahresring 87–88, Jahrbuch für Kunst und Literatur*, Stuttgart 1987, pp. 233–253.

Flemming 1962
Hanns Theodor Flemming, *Bernhard Heiliger*, Berlin 1962.

Forge 1996
Andrew Forge, "De Kooning's Sculpture", in: *Willem de Kooning: Sculpture.* With articles by Andrew Forge, David Sylvester and William Tucker, Matthew Marks Gallery, New York 1996, pp. 35–37.

Förster 1974
Wieland Förster, *Begegnungen – Tagebuch, Gouachen und Zeichnungen einer Reise in Tunesien*. With an afterword by Franz Fühmann, Berlin 1974.

Förster 2005
Wieland Förster, *Im Atelier abgefragt*, ed. by Skulpturensammlung, Staatliche Kunstsammlungen Dresden für die Stiftung Wieland Förster, Berlin 2005.

Fort 1995
Ilene Susan Fort, "The Cult of Rodin and the Birth of Modernism in America", in: *The Figure in American Sculpture: A Question of Modernity*, Los Angeles County Museum of Art 1995, pp. 22–53.

Frank 1983
Hilmar Frank, "Die großen Entsprechungen. Ein Versuch zum Werk Theo Baldens", in: *Theo Balden. Plastik, Zeichnungen, Graphik*, Akademie der Künste der DDR, Berlin 1983, pp. 9–18.

Frey 1942
Dagobert Frey, *Englisches Wesen in der bildenden Kunst*, Stuttgart 1942.

Friedman 1982
Terry Friedman, "Henry Moore 1921–1929", in: Leeds 1982, pp. 21–29.

Friedman 1987
Terry Friedman, "Epsteinism", in: *Jacob Epstein: Sculpture and Drawings*, Evelyn Silber and Tery Freidman (eds.), Leeds City Art Galleries, Whitechapel Art Gallery, London 1987.

Fuchs 1969
Werner Fuchs, *Die Skulptur der Griechen*, Munich 1969.

Fuller/Caro 1979
Peter Fuller, "Anthony Caro. Interview", in: *Art Monthly*, London, no. 23, 1979, pp. 6–15.

Fuller 1988
Peter Fuller, "Henry Moore: An English Romantic", in: London 1988, pp. 37–44.

Gabler 1997–98
Josephine Gabler, "Henry Moore und die Bildgießerei H. Noack Berlin", in: Bremen 1997, pp. 129–137.

Gabler/Ohnesorge 2003
Josephine Gabler and Birk Ohnesorge (ed.), *Der Bildhauer Michael Croissant (1928–2002), mit dem Werkverzeichnis der Skulpturen*, Berlin 2003.

Gale/Stephens 1998
Matthew Gale and Chris Stephens, *Barbara Hepworth: Works in the Tate Gallery Collection and the Barbara Hepworth Museum St. Ives*, London 1998.

Gampp 1995
Axel C. Gampp, "Varietas. Ein Beitrag zum Verhältnis von Auftraggeber, Stil und Anspruchsniveau", in: Hans-Rudolf Meier et al., *Für irdischen Ruhm und himmlischen Lohn. Stifter und Auftraggeber in der mittelalterlichen Kunst*, Berlin 1995, pp. 287–308.

Gantner 1965
Joseph Gantner, "Der alte Künstler", in: *Festschrift für Herbert von Einem*, Berlin 1965, pp. 71–77.

Garlake 1999
Margaret Garlake, "Henry Moore als Cold Warrior", in: *Biuletyn Historii Sztuki*, 61 (3–4), 1999, pp. 337–350.

Garlake 2003
Margaret Garlake, "Moore's eclecticism: Difference, aesthetic identity and community in the architectural commissions 1938–58", in: Moore 2003, pp. 173–193.

Garnier 2002
Bénédicte Garnier, *Rodin: L'Antique est ma jeunesse. Une collection des sculptures*, Musée Rodin, Paris 2002.

Garrould 1988
Ann Garrould, *Henry Moore Drawings*, London 1988.

Gärtner 1979
Hannelore Gärtner (ed.), *Die Künste der DDR*, Berlin 1979.

Gascoyne 1935a
David Gascoyne, *A Short Survey of Surrealism*, London 1935.

Gascoyne 1935b
David Gascoyne, "Comment on England", in: *Axis*, no 1, January 1935, p. 10.

Gasquet 1948
Joachim Gasquet, *Cézanne. Drei Gespräche*, Berlin 1948.

Geelhaar 1989
Christian Geelhaar, "Die richtigen Augen der Maler. Zur Rezeption von Cézannes 'Badenden'", Basle 1989, pp. 275–303.

Germann 1972
Georg Germann, "Das Organische Ganze", in: *Archithèse* 2/1972, pp. 36–41.

Giedion-Welcker 1964
Carola Giedion-Welcker, *Contemporary Sculpture. An evolution in volume and space*. Selective bibliography by Bernard Karpel. Transl. by Mary Hottinger-Mackie and Sonja Marjasch, London 1964.

Gilot/Lake 1990
Françoise Gilot/Carlton Lake, *Life with Picasso* [with a new introduction by Tim Hilton], London 1990.

Gilpin 1778
William Gilpin, *Observations on the Western Parts of England, relative chiefly to Picturesque Beauty*, London 1778.

Glass 1998
Ingo Gerhard Glass, *Constantin Brancusi und sein Einfluss auf die Skulptur des 20. Jahrhunderts*, Bucharest 1998.

Glaves-Smith 1981–82
John Glaves-Smith, *Sculpture in the 1940s and 1950s: the Form and the Language*, in: London 1981, pp. 125–133

Glózer 1974
Lászlo Glózer, *Picasso und der Surrealismus*, Cologne 1974.

Goethe 1962
Italian Journey by J. W. Goethe, transl. by Wynstan Hugh Auden and Elisabeth Mayer, Harmondsworth 1962.

Goethe 1983
Johann Wolfgang von Goethe, *Selected poems* (vol. 1) [Collected Works in 12 vols.], Executive ed. board Victor Lange, ed. by Christopher Middelton, Cambridge, Mass. 1983.

Goethe 1986
Johann Wolfgang von Goethe, *Essays on art and literature* (vol. 3), Collected Works in 12 vols., Executive ed. board Victor Lange, ed. by John Gearey, transl. by Ellen and Ernst H. von Nardoff, in: Johann Wolfgang von Goethe: Collected Works in 12 vols., New York 1986.

Goethe 1988
Johann Wolfgang von Goethe, *Scientific studies* (vol. 12), [Collected Works in 12 vols.], Executive ed. board Victor Lange, ed. and transl. by Douglas Miller, in: Johann Wolfgang Goethe: Collected Works in 12. vols., New York 1988.

Goethe 1989
Johann Wolfgang von Goethe, *Wilhelm Meister's Apprenticeship* (vol. 9), [Collected Works in 12 vols.], Executive ed. board Victor Lange, ed. and transl. by Eric A. Blackhall, New York 1989

Goethe/Eastlake 1967
Johann Wolfgang von Goethe, *Theory of colours*, transl. by Charles Lock Eastlake, London 1967

Goethe HA
Johann Wolfgang von Goethe, *Werke*, Hamburger Ausgabe, vols 1–14, 11th edition, Minich 1981 et seqq.

Gosebruch 1957
Martin Gosebruch, "Varietà bei Leon Battista Alberti und der wissenschaftliche Renaissancebegriff", in: *Zeitschrift für Kunstgeschichte*, vol. 20, 1957, pp. 229–238.

Gosebruch 1961
Martin Gosebruch, "Vom Aufragen der Figuren in Dantes Dichtung und Giottos Malerei", in: *Festschrift für Kurt Badt*, ed. by Martin Gosebruch, Berlin 1961, pp. 32–65.

Gosebruch 1962
Martin Gosebruch, *Giotto und die Entwicklung des neuzeitlichen Kunstbewußtseins*, Cologne 1962.

Grabowski 1949
Max Grabowski, "Was ist Realismus? Zu einem Vortrag im Kulturbund Berlin", in: *Bildende Kunst*, 3rd vol., 1949, p. 199.

Graetz 2002
René Graetz, *Skulpturen. Körper als Figur und Zeichen. Mit einem Beitrag von Fritz Jacobi*, ed. by Guenther Roese, Berlin 2002.

Grant/Haxel 2002
Michael Grant/John Haxel, *Who's Who in Classical Mythology*, London 2002.

Gray 1963
Christopher Gray, *Sculpture and Ceramics of Paul Gauguin*, Baltimore 1963.

Grenier 2003
Catherine Grenier, "Ein Forschungsreisender auf dem Mond", Cologne, Rome 2003, p. 418.

Grigson 1943
Geoffrey Grigson, *Henry Moore*, The Penguin Modern Painters series, ed. by Kenneth Clark, Harmondsworth 1943.

Grigson 1944/51
Geoffrey Grigson, *Henry Moore*, London 1951 (first published 1944).

Grigson 1947
Geoffrey Grigson, *Samuel Palmer: the visionary years*, London 1947.

Grohmann 1960
Will Grohmann, *The Art of Henry Moore*, transl. from the German by Michael Bullock, London 1960.

Gruetzner 1978
Anna Gruetzner, "Some early Activities of the Surrealist Group in England", in: *Artscribe*, 10th January 1978, pp. 22–25.

Gruetzner 1981
Anna Gruetzner, "The Surrealist Object and Surrealist Sculpture", in: London 1981, pp. 113–123.

Gsell 1916 (1984)
Paul Gsell, *Auguste Rodin. Art: Conversations with Paul Gsell*, London 1984.

Haecker 1927
Valentin Haecker, *Goethes morphologische Arbeiten und die neuere Forschung*, Jena 1927.

Haftmann 1970
Werner Haftmann, "Einführung" to the exhibition in Berlin 1970.

Haftmann 1972
Werner Haftmann, "Introduction" zu: *J. M. W. Turner. Der Maler des Lichts*, ed. by Henning Bock and Ursula Prinz, Berlin 1972, pp. 7–20.

Hall 1960
Donald Hall, "Henry Moore: an Interview by Donald Hall", in: *Horizon*, New York, Nov. 1960, pp. 102–115.

Hall 1980:
Douglas Hall, *Alberto Giacometti's 'Woman with her throat cut' 1932*, Edinburgh 1980.

Hammer/Lodder 2000
Martin Hammer/Christina Lodder, *Constructing Modernity: The Art & Career of Naum Gabo,* New Haven; London 2000.

Harlan/Rappmann/Schata 1984
Volker Harlan/Rainer Rappmann/Peter Schata: *Soziale Plastik. Materialien zu Joseph Beuys*, Achberg 1984.

Harrison/Waters 1979
Martin Harrison/Bill Waters, *Burne-Jones*, London 1979.

Harrison 1981
Charles Harrison, *English Art and Modernism 1900–1939*, London 1981.

Hartog 1997–98
Arie Hartog, "Kein englischer, ein universaler Künstler, Beobachtungen zu Henry Moore", Bremen 1997, p. 163.

Haskell/Penny 1981
Francis Haskell/Nicholas Penny, *Taste and the Antique*, New Haven, London 1981.

Hastings 1950
M. Hastings, *Parliament House*, London 1950.

Haupenthal 1989
Uwe Haupenthal, *Das plastische Menschenbild bei Wilhelm Loth. Mit einem Werkverzeichnis der Plastiken von 1946 bis 1956*, Darmstadt 1989.

Haupenthal 1993
Uwe Haupenthal, "Der Phönix als Sinnbild einer existentiellen renovatio. Zu einem bevorzugten Motiv nach 1945", in: *Marburger Jahrbuch für Kunstwissenschaft*, vol. 23, ed. by Christa Lichtenstern, Marburg 1993, pp. 105–123.

Hawes 1975
Louis Hawes, *Constable's Stonehenge*, Victoria & Albert Museum, London 1975.

Hebecker 2004
Susanne and Klaus Hebecker (ed.), *Theo Balden 1904–1995*. With a catalogue of works, Erfurt 2004.

Hedgecoe 1968
John Hedgecoe, *Henry Spencer Moore*, London 1968.

Hedgecoe 1998
John Hedgcoe, *A Monumental Vision: The Sculpture of Henry Moore*, London 1998

Hegel 1981
Georg Wilhelm Friedrich Hegel, *Phänomenologie des Geistes*, (Suhrkamp paperback edition) 5th edition, Frankfurt 1981.

Hellweg 1991
Claire Hellweg, *Hans Steinbrenner: Die Entwicklung der Formensprache im plastischen Werk*, Frankfurt 1991.

Henry 1964
Françoise Henry: *L'Art Irlandaise*, vol. 3, Paris 1964.

Henry 1970
Françoise Henry, *Irish Art in the Romanesque Period, 1020–1170*, London 1970.

Herder 1892
Johann Gottfried Herder, *Sämmtliche Werke*, Historisch-Kritische Ausgabe, ed. by Bernhard Suphan, Carl Redlich, Reinhard Steig et al, 33 vols., Berlin 1877–1913, here vol. 18; 1892.

Herder 1969
Johann Gottfried Herder, *Plastik. Einige Wahrnehmungen über Form und Gestalt aus Pygmalions bildendem Traume*, ed. and introduced by Lambert A. Schneider, Cologne 1969.

Herding 1988
Klaus Herding, "Humanismus und Primitivismus. Probleme früher Nachkriegskunst in Deutschland", in: *Jahrbuch des Zentralinstituts für Kunstgeschichte*, IV (1988), pp. 281–311.

Hess 1961
Walter Hess, "Karl Hartung", in: *Das Kunstwerk*, 14th vol., 1961, number 9, pp. 17–30.

Higgins 1954
R. A. Higgins, *Catalogue of the Terracottas in the Department of Greek and Roman Antiquities, British Museum*, vol. I, London 1954.

Hilton 1984–85
Tim Hilton, "On Caro's Later Work", in: London, Düsseldorf 1984–85.

Hilton 1992
Tim Hilton: *The Sculpture of Phillip King,* London; Much Hadham 1992.

Hoffmann 1948
Edith Hoffmann, "Sculpture at Battersea Park", in: *The Burlington Magazine* XC, July 1948, p. 107

Hoffmann 1979
Raimand Hoffmann, "Modernität ohne Abkehr vom Leben. Zum Werk Henry Moore", in: *Bildende Kunst* 4, 1979, pp. 196–200.

Hofmann 1959
Werner Hofmann (ed.), *Henry Moore, Schriften und Skulpturen*, Frankfurt 1959.

Hohl 1971
Reinhold Hohl, *Alberto Giacometti*, Stuttgart 1971.

Holsten 1981
Siegmar Holsten, "Verrätseln als Methode", in: Otterlo, Baden-Baden, 1981, pp. 33–41.

Holthusen 1964
Agnes Holthusen, *Gustav H. Wolff. Das plastische und graphische Werk*, Hamburg 1964.

Hrdlicka 1987
Alfred Hrdlicka, "Gegensätzliches und Gemeinsames", in: Michael Lewin (ed.): *Alfred Hrdlicka. Das Gesamtwerk. Schriften*, Vienna/Zurich 1987, pp. 57–58.

Huber 1958
Rudolf Huber, "Besuch bei Henry Moore", in: *Henry Moore und englische Zeichner*, Tübingen May 1958.

Hughes 1991
Henry Meyric Hughes, "Preface", in: Leningrad, Moskow 1991, p. 5.

Hume 1739–40
David Hume, *A Treatise of Human Nature*, London 1739–40.

Hünecke 1996/97
Andreas Hünecke, "Entartete Kunst im Museum für Kunst und Gewerbe Hamburg", in: *Jahrbuch des Museums für Kunst und Gewerbe*, Hamburg, vol. 15/16, 1996/97, pp. 125–142.

Jackson 1999
Tessa Jackson: "Recumbent Figure 1938, Henry Moore", in: *Material Matters: the Conservation of Modern Sculpture*, ed. by Jackie Heuman, London 1999, pp. 63–71.

Jacobi 1986
Fritz Jacobi, "Würde and Ausdruckskraft des menschlichen Körpers – Zum plastischen Schaffen von Werner Stötzer", in: Bremen 1986, p. 9.

Jacobi 1986b
Fritz Jacobi, "Plastische Realität zwischen Formenstrenge und Sinnlichkeit. Zum bildhauerischen Schaffen von Gustav Seitz", in: *Gustav Seitz 1906–1969. Plastik. Zeichnungen. Graphik*, Altes Museum Dezember 1986–Februar 1987, wissenschaftliche Betreuung v. Fritz Jacobi and Horst-Jörg Ludwig, ed. by Akademie der Künste der DDR/Staatliche Museen zu Berlin Nationalgalerie, Berlin 1986, pp. 20–32.

Jacobi 2002
Fritz Jacobi, *René Graetz. Skulpturen. Körper als Figur und Zeichen*, Berlin 2002.

James 1968
Philip James, *Henry Moore on Sculpture*, London 1966, 3rd edition 1968 (paperback edition), London 1968.

James 1972
Philip James (ed.): *Henry Moore über die Plastik. Ein Bildhauer sieht seine Kunst*, Munich 1972.

Janszky-Michaelsen 1977
Katherine Janszky-Michaelsen, *Archipenko. A Study of the Early Works, 1908–1920* (Diss. New York 1975), New York/London 1977.

Jastram 1975
Jo Jastram, "Von der Dialektik der Erbeaneignung", in: *Bildende Kunst* 8, 1975, pp. 383–384.

Jean 1959
Marcel Jean, *L'Histoire de la peinture surréaliste*, Paris 1959.

Jeffrey 1987
Ian Jeffrey, "Neo-Romanticism against itself. The case of Geoffrey Grigson", in: *A Paradise lost: The Neo-Romantic Imagination in Britain, 1935–1955*, ed. by David Mellor, London 1987, pp. 129–135.

Jocks 2000
"Tony Cragg, Der Fußabdruck der Zeit. Ein Gespräch mit Heinz-Norbert Jocks", in: *Kunstforum International*, vol. 150, April–June 2000, pp. 216-227.

Johnson 1986
Lee Johnson, *The Paintings of Eugène Delacroix. A Critical Catalogue 1832–1863*, 4 vols., Oxford 1986.

Julius/Kranich 2004
Frits Hendrik Julius and Ernst-Michael Kranich, *Bäume and Planeten. Beitrag zu einer kosmologischen Botanik*, Stuttgart ⁴2004.

Kahnweiler 1957
Daniel Henry Kahnweiler, *Picasso – sculptures* [exh. cat. Fine Arts Associates], New York 1957.

Kandinsky 1914
Wassily Kandinsky, *Art of Spiritual Harmony*, transl. by Michael T. H. Sadler, London 1914.

Kant 1978
Immanuel Kant, *Kritik der Urteilskraft* (1790), ed. by Wilhelm Weischedel, edition in 12 vols, vol. 10, 3rd edition, Frankfurt 1978.

Kant 1987
Immanuel Kant, *Critique of the Power of Judgement*, transl. by Werner S. Pulhar, New York 1987.

Karlsruhe 1999–2000
Bruce Nauman. Werke aus den Sammlungen Froehlich und FER, Museum für Neue Kunst, ZKM Karlsruhe 1999–2000, ed. by Götz Adriani, Ostfildern-Ruit 1999.

Kauffmann 1951
Hans Kauffmann, "Bewegungsformen an Michelangelo-Statuen", in: *Festschrift für Hans Jantzen*, Introduction by Kurt Bauch, Berlin 1951, pp. 141–151

Kaulbach 1974
F. Kaulbach, entry for "Ganzes/Teil", in: *Historisches Wörterbuch der Philosophie*, ed. by Joachim Ritter, Basle 1974, vol. 3, pp. 3.

Kausch 1998
Michael Kausch, "Henry Moore – Mensch und Natur", in: Vienna 1998, pp. 15–99.

Keisch 1977
Claude Keisch, *Wieland Förster. Plastik und Zeichnung*, Dresden 1977.

Kemenov 1947
Vladimir Kemenov, "Aspects of two cultures", in: *Voks Bulletin* (Moscow), 52, 1947, pp. 20–36.

Kemp 1983
Wolfgang Kemp, *John Ruskin. Leben and Werk*, Munich 1983.

Kemp 2000
Martin Kemp, *Visualization: Nature Book of Art and Science*, Oxford 2000.

Kemper 1974
Carl Kemper, *Der Bau. Studien zur Architektur und Plastik des Ersten Goetheanum*, ed. by Hilde Raske, Stuttgart ²1974.

King 1966
Alec King, *Wordsworth and the Artist's Vision: an essay in interpretation*, London 1966.

Kinkel 1967
Hans Kinkel, *14 Berichte, Begegnungen mit Malern und Bildhauern*, Stuttgart 1967.

Kirby 1986
Rachel Kirby, "Biographie", in: Jörn Merkert (Ed.), *David Smith. Skulpturen. Zeichnungen*, Munich 1986, p. 12.

Klemm 2001
Christian Klemm, "Im Banne des Surrealismus (Teil III)", in: Zurich, New York 2001–02, pp. 83–112.

Kliege 1998
Melitta Kliege, "Situationen der Verunsicherung. Bruce Naumans Werke der siebziger Jahre", in: Hamburg 1998, p. 58.

Knapp/Petersen 1983
G. Knapp and P. H. Petersen, *Mac Zimmermann, Œuvre 1931–1982*, Munich 1983.

Költzsch 1986
Georg W. Költzsch (ed.): *Alexander Archipenko*, (vol. 1) *Alexander Archipenkos Erbe. Werke von 1908–1963 aus dem testamentarischen Vermächtnis*, ed. by Helga Schmoll gen. Eisenwerth und Angela Heimann, Moderne Galerie des Saarland-Museums, (no 4), Saarbrucken 1986.

Költzsch 1992
Georg W. Költzsch (ed.), *Matschinsky-Denninghoff. Monographie and Werkverzeichnis der Skulpturen. With articles by Georg W. Költzsch, Johannes Langner, Eberhard Roters and a catalogue raisonné by Anette Schwarz*, Cologne 1992.

Koepplin o.D.
Dieter Koepplin, "Surrealistische Raum-Zeit-Modelle von Alberto Giacometti", in: *Neue Sachlichkeit and Surrealismus in der Schweiz 1915–1940*, ed. by Rudolf Koella, Berne, unpaginated, pp. 133–141.

Krätz 1992
Otto Krätz, *Goethe und die Naturwissenschaften*, Munich 1992.

Kramer 1991
Mario Kramer, *Joseph Beuys, Das Kapital Raum 1970–1977*, Heidelberg 1991.

Krause 1998
Markus Krause, *Karl Hartung 1908–1967. Metamorphosen von Mensch und Natur. Monograph and catalogue raisonné*, Munich 1998.

Krauss 1971
Rosalind E. Krauss, *Terminal Iron Works. The Sculpture of David Smith*, Cambridge/Mass./ London 1971.

Krauss 1977
Rosalind E. Krauss: *The Sculpture of David Smith: A Catalogue Raisonné*, New York 1977.

Kuhn 1980
Rudolf Kuhn, *Komposition und Rhythmus. Beiträge zur Neubegründung einer historischen Kompositionslehre*, Berlin/New York 1980.

Kuhn 1988
Dorothea Kuhn, *Typus und Metamorphose. Goethe-Studien*, Marbach 1988.

Kuskow 1991
Sergei I. Kuskow, "The Influence of Moore's Work on the Emergence of the Soviet 'Unofficial Art' of the 1960s and 1970s", in: Leningrad, Moscow 1991, pp. 147–153.

Kutzli 1974
Rudolf Kutzli, *Langobardische Kunst. Die Sprache der Flechtbänder*, Stuttgart 1974.

Lang 1998
Helen S. Lang, *The Order of Nature in Aristotle's Physics. Place and Elements*, Cambridge 1998

Lange 1965
Rudolf Lange, "Auf der Höhe des Alters. Toni Stadler und Otto Ritschl im Kunstverein Hannover", in: *Hannoversche Allgemeine Zeitung*, 25.5.1965.

Laver 1951
James Laver, *Paul Nash: Fertile Image*, ed. by Margaret Nash, London (first published 1951) 1975.

Lecombre 1994
Sylvain Lecombre, *Ossip Zadkine. L'Œuvre sculpté*, Paris 1994.

Le Normand-Romain 1996
Antoinette Le Normand-Romain, "Rodin and Maillol", in: Berlin 1996, pp. 119–126.

Lehmann 1922
Walter Lehmann, *Altmexikanische Kunstgeschichte. Ein Entwurf in Umrissen*, Berlin 1922.

Lenz 1971
Günter H. Lenz, *Die Dichtungstheorie S. T. Coleridges*, Frankfurt 1971.

Levine 1983
Gemma Levine, *Henry Moore: Wood Sculpture*, with a commentary by Henry Moore, London 1983.

Lewin 1987
Michael Lewin (ed.), *Alfred Hrdlicka. Das Gesamtwerk. Schriften*, Vienna/Zurich 1987.

Lewison 1983
Jeremy Lewison, "Gaudier-Brzeska: Sculptor 1891–1915", in: Cambridge 1983.

Lewison 2002
Jeremy Lewison, "Modern werden und britisch bleiben. Die Herausforderung der dreißiger Jahre", in: Wolfsburg 2002, pp. 70–109.

Lichtenfeld 1975
Gerhard Lichtenfeld: "Die 'Vier großen M'", in: *Bildende Kunst* 8, 1975, pp. 384–385.

Lichtenstern 1980
Christa Lichtenstern, *Ossip Zadkine 1890–1967. Der Bildhauer und seine Ikonographie*, Berlin 1980.

Lichtenstern 1981a
Christa Lichtenstern, "Henry Moore and Surrealism", in: *Burlington Magazine*, 123, no 944, November 1981, pp. 645–658.

Lichtenstern 1981b
Christa Lichtenstern, "Zwischen Magie und Parodie: Zur Bedeutung der Statue bei Giorgio de Chirico und den Surrealisten", in: *Jahresring XXVIII*, 1981, pp. 187–219.

Lichtenstern 1982
Christa Lichtenstern, "Henry Moore in der Begegnung mit Goethe: Die Prometheus-Illustrationen", in: *Goethe in der Kunst des 20. Jahrhunderts*, ed. by Petra Maisak, Bonn/Frankfurt/Düsseldorf 1982, pp. 25–44 (with Italian translation).

Lichtenstern 1985
Christa Lichtenstern, "Der Amphion von Laurens. Plastischer Prozess and Mythos", in: exh. cat. *Henri Laurens 1885–1954*, Sprengel Museum Hanover 1985, pp. 54–61.

Lichtenstern 1988
Christa Lichtenstern, *Picasso: Denkmal für Apollinaire. Entwurf zur Humanisierung des Raumes*, Frankfurt 1988 (with French and Spanish translation).

Lichtenstern 1990a
Christa Lichtenstern, *Metamorphose in der Kunst des 19. and 20. Jahrhunderts*, vol. 1, *Die Wirkungsgeschichte der Metamorphosenlehre Goethes. Von Philipp Otto Runge bis zu Joseph Beuys*, Weinheim 1990.

Lichtenstern 1990b
Christa Lichtenstern, "Hans Steinbrenners Weg in die 'Biomorphe Abstraktion'. Ein Beitrag zur Skulpturgeschichte der 50er Jahre", in: *Hans Steinbrenner. Skulpturen 1948–1960*, Sinclair-Haus, Bad Homburg v. d. H. 1990, pp. 16–22.

Lichtenstern 1992a
Christa Lichtenstern, *Metamorphose in der Kunst des 19. und 20 Jahrhunderts*, vol. 2: *Vom Mythos zum Prozessdenken, Ovid-Rezeption, Surrealistische Ästhetik, Verwandlungsthematik in der Nachkriegskunst*, Weinheim 1992.

Lichtenstern 1992b
Christa Lichtenstern, "Solo con l'arte astratta si può capire l'importanza delle intuizioni di Michelangelo". Lorenzo Guerrinis Reisenotizen aus Florenz im Jahre 1956, in: *Musagetes, Festschrift für Wolfram Prinz*, ed. by Ronald Keks, Berlin 1992, pp. 381–396.

Lichtenstern 1993a
Christa Lichtenstern, "Voraussetzungen und Entwicklungen naturästhetischer Perspektiven in der Skulptur and Plastik nach 1945", in: *Marburger Jb. f. Kunstwissenschaft*, vol. 23, Marburg 1993, pp. 19–42.

Lichtenstern 1993b
Christa Lichtenstern, "Max Ernst auf der Suche nach dem Mythos seiner Zeit", in: *Begegnungen. Festschrift für Peter Anselm Riedl*, ed. by Klaus Güthlein and F. Matschke (Heidelberger Kunstgeschichtliche Abhandlungen, vol. 20), Worms 1993, pp. 244–259.

Lichtenstern 1994a
Christa Lichtenstern, *Henry Moore, Zweiteilig Liegende I. Landschaft wird Figur*, Frankfurt 1994.

Lichtenstern 1994b
Christa Lichtenstern, "Henry Moore und die Antike. Ein langer Weg zurück zu sich selbst", in: Pforzheim, Bad Homburg v. d. H. 1994, pp. 32–34 (with English translation).

Lichtenstern 1995
Christa Lichtenstern, "Unsere Schönheit heute heißt Intensität – Wilhelm Loths frühe Begegnung mit Moore, Picasso und Ossip Zadkine", in: *Wilhelm Loth zu Ehren, Retrospektive*, Mathildenhöhe Darmstadt, 1995, pp. 26–31.

Lichtenstern 1995
Christa Lichtenstern, "Plastik von Henry Moore von Beuys", in: *Sammelband, Joseph Beuys- Symposion in Kranenburg*, 29.9.–3.10.1995, Basle 1996, pp. 270–277.

Lichtenstern 1996
Christa Lichtenstern, "Zur Entstehungsgeschichte des *Monument à Paul Cézanne*", in: Basle 1996, pp. 423–430 (with French translation).

Lichtenstern 1998
Christa Lichtenstern, "Geburt und Grab. Zur Bedeutungsvielfalt der Höhle and des ausgehöhlten Baumstamms im Werk von Henry Moore", in: Heilbronn 1998, pp. 19–29.

Lichtenstern 1999/2000
Christa Lichtenstern, "Geprägte Form, die lebend sich entwickelt. Goethe und die Skulptur", in: Karl Richter/Gerhard Sauder (Ed.), *Goethe. Ungewohnte Ansichten. Beiträge einer Ringvorlesung der Philosophischen Fakultät der Universität des Saarlandes im Wintersemester 1999/2000*, St. Ingbert 2001, pp. 23–63.

Lichtenstern 2001
Christa Lichtenstern, "Und das Schöne wird zu einer absoluten Notwendigkeit." Beobachtungen zu Matschinsky-Denninghoffs Skulpturen im öffentlichen Raum, in: Jörn Merkert (Ed.): *Brigitte und Martin Matschinsky-Denninghoff. Werke aus fünf Jahrzehnten in der Sammlung der Berlinischen Galerie*, Schweinfurt/Berlin 2001, pp. 26–55.

Lichtenstern 2002
Christa Lichtenstern, "Zwischen Spiel und Gewaltanklage. Mirós Deformationen der Zwanziger und Dreißiger Jahre", in: Düsseldorf 2002, pp. 78–87 (with English translation).

Lichtenstern 2003a
Christa Lichtenstern, "Marino Marini and Henry Moore – eine Freundschaft", in: Recklinghausen, Heilbronn 2003, pp. 91–104 (with English translation).

Lichtenstern 2003b
Christa Lichtenstern, "Meine Skulpturen sprechen deutsch. Chillidas Liebe zur deutschen Kunst", in: *Jahrbuch der Bayerischen Akademie der Schönen Künste*, vol. 17, Munich 2003, pp. 229–265.

Lichtenstern 2004
Christa Lichtenstern, "Es wird eine Formenlehre geben müssen. Theo Balden im Gespräch mit Henry Moore", in: Susanne and Klaus Hebecker (Ed.), *Theo Balden 1904–1995 mit dem Verzeichnis der plastischen Arbeiten*, Erfurt 2004, pp. 83–91.

Lichtenstern 2005
Christa Lichtenstern, "Im Dialog mit Rodin. Moores skulpturgeschichtlicher Ort", in: Schwäbisch Hall 2005, pp. 29–45 (with English translation).

Lingard 1988
Timothy Lingard, "Michael Rosenauer, Architect (1884–1971): A Biographical Sketch", in: London 1988.

Lipchitz 1972
Jacques Lipchitz, *My life in sculpture*, New York 1972.

London 1981
Henry Moore at the British Museum, with photographs by David Finn, London 1981.

London 1995
National Gallery. Complete illustrated Catalogue, ed. by Christopher Baker and Tom Henry, London 1995.

Lynton 2008
Norbert Lynton, *David Nash*, Edition Scheffel, Bad Homburg v. d. H. 2008.

Maas 1984
Jeremy Maas, *Holman Hunt and The Light of the World*, London 1984.

Maier 2005
Bernhard Maier, *Stonehenge. Archäologie, Geschichte, Mythos*, Munich 2005.

Maisak 2004
Petra Maisak, "Die Parzen: Mythos and ästhetische Form. Zur Rezeption in Weimar um 1800", in: J. A. Schmoll gen. Eisenwerth 2004, pp. 69–88.

Martin/Nicholson/Gabo 1937
Circle: International Survey of Constructive Art, ed. by J. L. Martin, Ben Nicholson and Naum Gabo, London 1937.

Matsumura 2004
Toshio Matsumura, "Henry Moore and the Hakone Open Air Museum: Outdoor Sculpture and Environment" (with English translation), in: Tokyo 2004, pp. 20–23.

Mattenklott 1994
Gert Mattenklott, *Karl Blossfeldt. Urformen der Kunst. Wandergarten der Natur. Das fotografische Werk in einem Band*, Munich/Paris/London 1994.

Mauclair 1918
Camille Mauclair, *Auguste Rodin. L'Homme et l'Œuvre*, Paris 1918.

McClintic 1979
Miranda McClintic, *David Smith*. The Hirshhorn Museum and Sculpture Garden Collection, Smithsonian Institution, Washington 1979.

McKenzie 1977
Gordon McKenzie, *Organic Unity in Coleridge* (University of California, Publications in English, vol. VII) Reprint New York 1977.

Meadows 1988
"Bernard Meadows remembers Henry Moore", in: *Apollo*, October 1988, p. 245.

Meißner 1989
Günter Meißner, *Werner Tübke*, Leipzig 1989.

Mellor 1987
David Mellor, *A Paradise lost: The Neo-Romantic Imagination in Britain 1935–1955*, London 1987.

Mellor 2002
David Alan Mellor, "Apokalyptische Visionen. Britische Kunst in den vierziger und fünfziger Jahren", in: exh. cat. Wolfsburg 2002, pp. 112–134.

Melville 1971
Robert Melville, *Sculpture and drawings 1921–1969*, London 1970.

Merkert 1986
Jörn Merkert (ed.), *David Smith, Skulpturen – Zeichnungen*, Munich 1986.

Metken 1974
Günter Metken, *Die Präraffaeliten*, Cologne 1974.

Middeldorf 1933
Ulrich Middeldorf, "Some new Works of Domenico Rosselli", in: *The Burlington Magazine*, vol. 62 (April 1933), pp. 165–175.

Middeldorf 1935
Ulrich Middeldorf, Art. "Domenico Rosselli", in: Thieme/Becker, *Allgemeines Lexikon der Bildenden Künstler*, ed. by Hans Vollmer, vol. 29, Leipzig 1935, pp. 36–37.

Middleton Wagner 2005
Anne Middleton Wagner, *Mother Stone: The Vitality of Modern British Sculpture*, New Haven/London 2005.

Milde 2002
Brigitta Milde, "Picasso in der DDR", in: Chemnitz 2002, pp. 372–385.

Mitchinson no date
David Mitchinson, introductory essay, in: *Henry Moore in Public*, BBC Education Production 1998, pp. 18–27.

Mitchinson 1971
Henry Moore: Unpublished Drawings, ed. by David Mitchinson, Turin 1971.

Mitchinson 1998
Celebrating Moore: works from the collection of the Henry Moore Foundation, ed. by David Mitchinson, London 1998.

Mitchinson 2002
David Mitchinson, *Moore: The Graphics*, Much Hadham 2002.

Mitchinson 2004
David Mitchinson, "Henry Moore's Prométhée Lithographs", in: J. A. Schmoll, gen. Eisenwerth 2004, pp. 303–319.

Moore 1926/76
Henry Moore, *Sketchbook 1926* (introduction), London 1976.

Moore 1957
Henry Moore, "Monumentale Form im Raum. Nach Gesprächen mit dem englischen Meister niedergeschrieben von J. P. Hodin", in: *Das Kunstwerk* 2, XI, August 1957, p. 21.

Moore 1958
Henry Moore, *Heads, Figures and Ideas. A Sculpture Notebook*, ed. by G. Rainbird, London and New York 1958 (with 64 facsimiles).

Moore 1964
Henry Moore, Interview with David Sylvester, in: *The Sunday Times Magazine*, 16.2.1964.

Moore 1974
Henry Moore, *Introduction* to 'Auden Poems/Moore Lithographs', London 1974.

Moore 1983
Interview with Henry Moore, in: *The Courier Journal*, 6.2.1983.

Moore 2003
Henry Moore: Critical Essays, ed. by Jane Beckett and Fiona Russell, London 2003

Moore/Hedgecoe 1968
Henry Moore and John Hedgecoe, *Henry Moore: My ideas, Inspiration and Life as Artist*, London 1986.

Morphet 1979
Richard Morphet, "Henry Moore. Four Piece Composition: Reclining Figure 1934", in: *The Tate Gallery. Illustrated Catalogue of Acquisitions 1976–78*, London 1979, pp. 116–122.

Morphet 1981
Richard Morphet, *The Tate Gallery. Illustrated Catalogue of Acquisitions 1978–80*, London 1981.

Morschel 1972
Jürgen Morschel, *Deutsche Kunst der 60er Jahre*, Munich 1972.

Motzkin 1992
Elhanan Motzkin, "Michelangelo's 'Slaves' in the Louvre", in: *Gazette des Beaux-Arts* (December 1992), pp. 207–228.

Müller 2005
Hans-Joachim Müller, "In der Malerei verdorrt kein Grün. Nur im Leben muß alles vergehen, verlöschen, verblassen: Willem de Kooning in einer großartigen Ausstellung im Kunstmuseum Basle", in: *Frankfurter Allgemeine Zeitung*, 1.11.2005, p. 33.

Müller-Hofstede 1981
Justus Müller-Hofstede, "Eduard Trier als Interpret der modernen Plastik", in: Justus Müller-Hofstede and Werner Spies (ed.), *Festschrift für Eduard Trier zum 60. Geburtstag*, Berlin 1981, pp. LII–LXII.

Mandy 1987
J. Mandy, *Biomorphism* (Diss. University of London), Courtauld Institute, London 1987.

Murawska-Muthesius 2003
Katarzyna Murawska-Muthesius, "Dreams of the Sleeping Beauty: Henry Moore in Polish art criticism and media, post 1945", in: Moore 2003, pp. 195–220.

Mylonas 1966
George E. Mylonas, *Mycenae and the Mycenaean Age*, Princeton 1966.

Nash 1932
Paul Nash, "Photography and Modern Art", in: *The Listener*, vol. VIII, 27th July 1932, p. 130.

Nash 1996
David Nash, *Forms into Time*, with an essay by Marina Warner, London 1996.

Nash 2001
Steven A. Nash, "Moore and Surrealism Reconsidered", in: Dallas 2001, pp. 43–51.

Nauman 1996
Bruce Nauman, *Interviews 1967–1988*, edited by Christine Hoffmann, Dresden 1996.

Nauman 2005
Please Pay Attention Please: Bruce Nauman's Words: writings and interviews, ed. by Janet Kraynak, New York 2005 (paperback edition).

Neumann 1959
Erich Neumann, *The Archetypical World of Henry Moore*, London 1959.

New York 1979
Henry Moore: Drawings 1969–79, Galerie Wildenstein, New York 14.11.1979–18.1. 1980, London 1979.

Nietzsche 1960
Friedrich Wilhelm Nietzsche, *Werke in drei Bänden*, ed. by Karl Schlechta, Munich 1960.

Nietzsche 2002
Friedrich Wilhelm Nietzsche, *Beyond Good and Evil: prelude to a philosophy of the future*, ed. by Rolf Peter Horstmann, Cambridge 2002.

O'Hear 1991
Anthony O'Hear, "Figurative Sculpture after Henry Moore", in: *Modern Painters*, vol. 4, no 2, Summer 1991, pp. 26–30.

Ohnesorge 2004a
Birk Ohnesorge, "Richard Scheibe und Gerhard Marcks. Als kein Mensch mehr in Öl malen konnte. Die Kunst der jungen Bundesrepublik im Spiegel zweier meinungsfreudiger Protagonisten: Auszüge aus den Briefen der beiden Bildhauer", in: *Frankfurter Allgemeine Zeitung*, 30.11.2004, p. 41.

Ohnesorge 2004b
Birk Ohnesorge, "'Das wunderbare, eben aber doch gänzlich unfreie Leben' – Theo Baldens Verhältnis zur Natur", in: Susanne and Klaus Hebecker (Ed.): *Theo Balden 1904–1995* mit dem Verzeichnis der plastischen Arbeiten, Erfurt 2004, pp. 92–100.

Ohnesorge 2005
Birk Ohnesorge, *Ein anderer Zeitgeist. Positionen figürlicher Bildhauerei nach 1950*, Berlin 2005.

Ohnesorge 2008
Birk Ohnesorge, *Karl Hartung. Zeichnungen*. With an introduction by Christa Lichtenstern, Berlin 2008.

Ott 2003
Michaela Ott, Art. "Raum", in: *Ästhetische Grundbegriffe*. Historical Dictionary, vol. 5, Stuttgart/Weimar 2003, p. 136.

Ovid 1965
Ovid's Metamorphoses, The Arthur Golding translation of 1567, ed. by John Frederick Nims, London 1965.

Oxford Dictionary 1989
The Oxford English Dictionary, ed. by J. A. Simpson and E. S. C. Weiner, vol. 1, Oxford ²1989.

Palme 1988
Peter Palme, "Jo Jastram. Plastik", in: Rostock 1988.

Panofsky 1964
Erwin Panofsky, *Grabplastik. Vier Vorlesungen über ihren Bedeutungswandel von Alt-Ägypten bis Bernini*, ed. by Horst W. Janson, Cologne 1964.

Paris 1947
Le Surréalisme en 1947, ed. by André Breton and Marcel Duchamp, Paris 1947.

Paris 1982
Henry Moore Intime, edited by Timothée Trimm, Galerie Didier Imbert Fine Art, Paris 1982.

Parke-Taylor 1998
Michael Parke-Taylor, "Humanity Refigured: Henry Moore and Postwar British Sculpture", in: Toronto 1998, pp. 2–9.

Peters 1983
Hermann Peters, "Über Parteilichkeit, Volksverbundenheit, Agitation und Kunst", in: *Bildende Kunst* 1, 1983, pp. 5–8.

Pevsner 1936/42
Nikolaus Pevsner, *Pioneers of the Modern Movement from William Morris to Walter Gropius (1936)*, New York² 1942.

Pevsner 1943/63
Nikolaus Pevsner, *Europäische Architektur von den Anfängen bis zur Gegenwart*, Munich 1963 (English edition 1943).

Pevsner 1951–74
Nikolaus Pevsner, *The Buildings of England*, London 1951–74.

Pevsner 1955/56
Nikolaus Pevsner, *Das Englische in der englischen Kunst*, Munich 1974 ('The Englishness of English Art'. An expanded and annotated version of the Reith Lectures broadcast in October and November 1955), London 1956.

Phipps 2005
Michael Phipps, "The Henry Moore Archive", in: *The Henry Moore Foundation Review* 14, Winter 2005, p. 11.

Poeschke 1996
Joachim Poeschke, *Michelangelo and His World: Sculptures of the Italian Renaissance*, New York 1996.

Poley 1977
Stephanie Poley, "Alberto Giacomettis Umsetzung archaischer Gestaltungsformen in seinem Werk zwischen 1925 und 1935", in: *Jahrbuch der Hamburger Kunstsammlungen*, vol. 22, 1977, pp. 175–186.

Poley 1978
Stephanie Poley, *Hans Arp. Die Formsprache im plastischen Werk*, Stuttgart 1978.

Poljakowa 1982
Natalja Poljakowa, "Volumen und Raum", in: *Bildende Kunst* 10, 1982, pp. 484–488.

Pörzgen 1974
Hermann Pörzgen, "Ein Golgatha des Atomzeitalters. Der russische Bildhauer Ernst Neizvestny", in: *Frankfurter Allgemeine Zeitung* (no. 204), 4.9.1974.

Pound 1974
Ezra Pound, *Henri Gaudier-Brzeska: A Memoir*, New York ³1974.

Powers 2001
Alan Powers, *Serge Chermayeff: Designer, Architect, Teacher*, London 2001.

Prater 1985
Andreas Prater, "Mantegnas Cristo in Scurto", in: *Zeitschrift für Kunstgeschichte* 3, 1985, pp. 279–300.

Quennell 1936
P. Quennell, "The Surrealist Exhibition", in: *New Statesman*, 20th June 1936.

Raab 1995
Rex Raab, *Sieben Kapitele aus dem großen Kuppelraum vom ersten Goetheanum als Offenbarer von Stützkräften*, Dornach 1995.

Raff 1994
Thomas Raff, *Die Sprache der Materialien. Anleitung zu einer Ikonologie der Werkstoffe*, Munich 1994.

Raphael 1947
D. D. Raphael, *The Moral Sense*, London 1947.

Raynal 1921
Maurice Raynal, *Zadkine* ("Valori Plastici" edition), Rome 1921.

Raynal 1923
Maurice Raynal, *Alexander Archipenko*, Paris 1923.

Read 1931
Herbert Read, "Henry Moore", in: *The Listener*, vol. V, 22.4.1931, p. 68.

Read 1933
Herbert Read, "English Art", in: *The Burlington Magazine* LXIII, December 1933, pp. 243–276.

Read 1934a
Herbert Read, *Henry Moore, Sculptor: An Appreciation*, London 1934.

Read 1934b
"*Henry Moore*", Statement in *UNIT I*, ed. by Herbert Read, London 1934.

Read 1936
Herbert Read, "Introduction", in: *Surrealism*, ed. by H. Read., with articles by André Breton, Hugh Sykes Davies, Paul Eluard et al, London 1936, pp. 17-91.

Read 1941
Herbert Read, "The Drawings of Henry Moore", in: *Art in Australia*, sequence 4, no 3, September 1941, pp. 10–17.

Read 1948
Herbert Read, "Coleridge as Critic", in: *Sewanee Review* LVI, 1948, pp. 597–624.

Read 1953/68
Herbert Read, *The True Voice of Feeling: Studies in English Romantic Poetry*, New York 1953/London 1968.

Read 1963
Herbert Read, *The Contrary Experience: Autobiographies*, London 1963.

Read 1967
Herbert Read, *Henry Moore*, Munich/Zurich 1967.

Read, John 1998
John Read [comments on individual works], in: *Celebrating Moore: Works from the Collection of the Henry Moore Foundation*, selected by David Mitchinson, London 1998, cat. no 8, 30, 44, 143, 100, 170, 206, 231, 240.

Rewald 1996
John Rewald, *The Paintings of Paul Cézanne: a catalogue raisonné* (vol. 1), New York 1996.

Reynolds 1960
Graham Reynolds, *Catalogue of the Constable Collection in the Victoria & Albert Museum*, London 1960, 2nd edition 1973.

Richter 1926
Hans Richter, "Rhythm", in: *The Little Review*, winter 1926, unpaginated

Riedl 1957
Peter Anselm Riedl, *Henry Moore. König und Königin*, Stuttgart 1957.

Riedl 2001
Peter Anselm Riedl, "'While I dig in unexpected corners of our world', Zur Kunst des Anthony Cragg", in: Chemnitz 2001, pp. 9–19.

Ritterbush 1968
Philip C. Ritterbush, *The Art of Organic Forms*, Washington 1968.

Rodin 1984
Conversations (see: Gsell 1916).

Rubin 1972
William Rubin, *Picasso in the Collection of the Museum of Modern Art*, New York 1972.

Rubin 1984
William Rubin (ed.), *Primitivism in 20th Century Art: Affinity of the Tribal and the Modern*, New York 1984.

Rudolph 1997
Reinhard Rudolph, "Der Elefantenschädel – Bestätigung, Inspiration und die Thematik des 'Internal / External'", in: Bremen 1997–98, pp. 77–98.

Russell 1973
John Russell, *Henry Moore*, Harmondsworth 1973, 2nd edition 1980.

Rychlak 2004
Bonnie Rychlak, "Sitting Quietly. Isamu Noguchi and the Zen Aesthetic", in: Valerie J. Fletcher, *Isamu Noguchi: Master Sculptor*, Washington 2004, pp. 188–209.

Sackville-West 1945
E. Sackville-West, *The Rescue*, London 1945.

Sadler 1949
Michael Sadler, *Michael Ernest Sadler 1861–1943: A Memoir by His Son*, London 1949.

Saito 1986
Yasuyoshi Saito, "Shuzo Takiguchi and Henry Moore", in: Tokyo, Fokuoka 1986, p. 208 (English summary).

Salisbury 1979
Harrison E. Salisbury, "The Monumental Dreams of Ernst Neizvestny", in: *Art News*, no. 78, May 1979, pp. 102–105.

Salzmann/Romain 1989
Siegfried Salzmann and Lothar Romain, *Bernhard Heiliger*, Berlin 1989.

Salzmann 1993
Festschrift zum 65. Geburtstag von Siegfried Salzmann, ed. by Kunstverein in Bremen, Heidelberg 1993.

Sandberg 1956
Herbert Sandberg, "Die realistischen Maler auf der XXVIII. Biennale", in: *Bildende Kunst* 7, 1956, p. 593.

Sander 2004
Jochen Sander, *Italienische Gemälde im Städel 1300–1550. Oberitalien, die Marken und Rom*, Mainz 2004.

Sandler/Ferber 1968
Irving Sandler, "Interview with Herbert Ferber", 22.4.1968, in: *Smithsonian Archives of American Art, Oral History Interviews*, http://www.aaa.si.edu/collections/ oralhistories/ transcripts/ferber68.htm (accessed: 11.6.2008).

San Lazzaro 1972
Gualtieri di San Lazzaro (ed.), *Homage to Henry Moore*, Special issue of the XXe Siècle Review, Paris 1972.

Santini 1989
Pier Carlo Santini, *Guerrini*, Bologna 1989.

Sauerlandt 1957
Max Sauerlandt, *Im Kampf um die moderne Kunst. Briefe 1902–1933*, ed. by Kurt Dingelstedt, Munich 1957.

Saupault 1928
Philippe Saupault, *William Blake*, Paris 1928.

Schätzke 1999
Andreas Schätzke, *Rückkehr aus dem Exil: Bildende Künstler und Architekten in der SBZ und frühen DDR*, Berlin 1999.

Schelling 1989
Friedrich Wilhelm Joseph Schelling, *The Philosophy of Art*, ed., transl. and introduced by Douglas W. Scott, Foreword by David Simpson, in: Theory and History of Literature, vol. 58, Minnesota/Minneapolis 1989

Schiff 1954
Gert Schiff, "Die Plastik, der Mensch und die Natur. Eindrücke von einem Besuch bei Henry Moore", in: *Frankfurter Allgemeine Zeitung*, 9.1.1954.

Schlosser 1912
Julius von Schlosser, *Lorenzo Ghiberti (I Commentarii)*, vol. 1, Berlin 1912.

Schmidt 1965
Jutta Schmidt, "Lernen bei Henry Moore? ", in: *Bildende Kunst* 11, 1965, pp. 563–568.

Schmidt 1982a
Diether Schmidt, "Leid und Selbstbehauptung. Der Bildhauer Wolfgang Kuhle?, in: *Bildende Kunst* 8, 1982, pp. 384–386.

Schmidt 1982b
Helmut Schmidt u.a., *Kunst im Kanzleramt. Helmut Schmidt und die Künste*, Munich 1982.

Schmidt 2004
Sabine Maria Schmidt, "Colour is a bit of a holiday. Remarks on the graphic works of Henry Moore / 'Farben sind wie Ferien'. Anmerkungen zur Druckgraphik Henry Moores", in: Wolfsburg 2004, pp. 64–67.

Schmied 1994
Wieland Schmied, *Ezra Pound. Ein Leben zwischen Kunst und Politik. Essays*, Innsbruck 1994.

Schmied 1996
Wieland Schmied, "Ezra Pound, Wyndham Lewis und die Vortizisten", in: Hanover 1996, pp. 92–99.

Helga Schmoll gen. Eisenwerth Helga 2004
Helga Schmoll gen. Eisenwerth, "Phantasten in Kontrasten: Aspekte der deutschen surrealistischen Malerei", in: J. A. Schmoll gen. Eisenwerth, 2004, pp. 407–412.

Schmoll gen. Eisenwerth 1959
J. A. Schmoll gen. Eisenwerth, "Zur Genesis des Torso-Motivs and zur Deutung des fragmentarischen Stils bei Rodin", in: idem (ed.): *Das Unvollendete als künstlerische Form*, Bern/Munich 1959, pp. 117–139.

J. A.Schmoll gen. Eisenwerth 1983
Joseph A. Schmoll gen. Eisenwerth, *Rodin-Studien. Persönlichkeit – Werke – Wirkung – Bibliographie*, Munich 1983.

Schneider 1987
Mechthild Schneider, "Pygmalion-Mythos. Zur Aktualität eines Themas in der französischen Kunst von Falconet bis Rodin", in: *Pantheon* XLV, 1987, pp. 111–123.

Schneider 1989
Katharina Schneider, "Henry Moore. Zur Rezeptionsgeschichte seines plastischen Werkes in Deutschland", in: *Weltkunst*, 1989, pp. 1644–1646.

Schneider 1991
Katharina Schneider, *Zwischen Figuration and Abstraktion. Tendenzen deutscher Plastik der Nachkriegszeit. Eine morphologische Untersuchung der Œuvres von H. Uhlmann, K. Hartung, B. Heiliger, W. Loth, F. Koenig, B. und M. Matschinsky-Denninghoff, O. H. Hajek, E. Cimiotti und N. Kricke zwischen 1945 and 1965* (Diss.), Heidelberg 1991.

Schnell 1977
Werner Schnell, "Zu den Plastiken von Ernst Neizvestny", in: Leverkusen 1977, unpaginated.

Schnell 1980
Werner Schnell, *Der Torso als Problem der modernen Kunst*, Berlin 1980.

Schnell 1987
Werner Schnell, "Apparation als Skulptur. Medardo Rosso und Alberti Giacometti. Auf der Suche nach dem Erscheinungsbild des Menschen", in: *Städel-Jahrbuch*, new series, vol. 11, 1987, pp. 291–310.

Schnell 1999
Werner Schnell, "Rodins 'Hände'. Von Rodins Händen – oder: Wie ein Teil die Hauptsache wird", in: Heilbronn 1999, pp. 61.

Schnell 2001
Werner Schnell, "Die Geburt der Innovation aus dem Alterswerk: Auguste Rodin", in: *Ästhetische Probleme der Plastik im 19. und 20. Jahrhundert*, ed. by Andrea M. Kluxen (Academy of Fine Arts in Nuremberg series, vol. 9), Nuremberg 2001, pp. 151–174.

Schönemann 2004
Heinz Schönemann, "Theo Baldens 'Vogelbaum' im Park Babelsberg", in: Susanne and Klaus Hebecker (eds.): *Theo Balden 1904–1995,* with a catalogue of sculptural work, Erfurt 2004, p. 81.

Schönenberg 2003
Erik Schönenberg, "Inside out – zum bildnerischen Handeln bei Anthony Cragg", in: Bonn 2003, pp. 467–473.

Schulz 2000
Heribert Schulz, "Herz-Kreislaufgestaltungen bei Beuys und Klee. Trennendes und Verbindendes", in: Moyland 2000, pp. 78–87.

Schulz/Baatz 1993
Paul Schulz and Ulrich Baatz, *Bronzegießerei Noack – Kunst und Handwerk*, Ravensburg 1993.

Schulz-Hoffmann 2003
Carla Schulz-Hoffmann, "Auf meine Arbeiten bezogen, sehe ich es sehr ungern, wenn jemand sie betastet. – Zum bildnerischen Denken von Tony Cragg", in: Bonn 2003, pp. 296.

Schumann 1976
Henry Schumann, *Wieland Förster, Ateliergespräche*, Leipzig 1976.

Schwarzenberg 1966
Erkinger Schwarzenberg, *Die Grazien*, Bonn 1966.

Seidel 1971
Max Seidel, "Henry Moore interpretiert das Werk Giovanni Pisanos", in: *Pantheon* XXIX/5 (Sept. – Oct. 1971), pp. 413–416.

Seldis 1972
Henry J. Seldis, "Henry Moore's Elephant Skull Etchings", in: *Art International*, Paris, summer 1972.

Seldis 1973
Henry J. Seldis, *Henry Moore in America*, London/Los Angeles 1973.

Selz 1959
Peter Selz, *New Images of Man*, The Museum of Modern Art, New York 1959.

Senckendorff 1983
Eva von Senckendorff, "Der Fall Sauerlandt", in: Hamburg 1983, pp. 68–76.

Shaftesbury 1999
Anthony Ashley Cooper (Lord) Shaftesbury, "The Moralists, a Philosophical Rhapsody", in: *Characteristics of Man, Manners, Opinions, Times*, ed. by Lawrence E. Klein, Cambridge 1999, pp. 231–338.

Shakespeare 1999
William Shakespeare, *Macbeth*, ed. by Kenneth Muir (Arden Edition) London 1999.

Silber 1996
Silber, Evelyn, *Gaudier-Brzeska: Life and Art. With a Catalogue raisonné of the Sculpture*, London 1996.

Simon 1994
Joan Simon (ed.), *Bruce Nauman, Catalogue raisonné*, in: Minneapolis 1994.

Simon 2000
Joan Simon, "Sound Problems: Beckett, Nauman", in: Vienna 2000, pp. 16–37.

Simpson 1999
James Simpson, "Goethe und England", in: *Goethe Jahrbuch*, vol. 116, 1999, pp. 41–53.

Skipwith 1988
Peyton Skipwith, "Abstract Sculpture and Modern Architecture", in: exh. cat. London 1988, unpaginated.

Spender 1974
Stephen Spender, *Einführung zu Henry Moore. Stonehenge*, London 1974.

Spender 1986
Stephen Spender, *In Irina's Garden with Henry Moore's Sculpture*, London 1986.

Spielmann 1967
Heinz Spielmann, Acquisitions report, in: *Stiftung zur Förderung der Hamburgischen Kunstsammlungen*, Hamburg 1967.

Spielmann 1971
Max Sauerlandt. Ausgewählte Schriften, ed. and com. by Heinz Spielmann, vol. I. Reiseberichte 1925–1932, Hamburg 1971.

Spielmann 1998
Heinz Spielmann, "Parallel zur Bildhauerei: Das zeichnerische and malerische Werk", in: *Karl Hartung. Werke and Dokumente. New series*, vol. 12, Archiv für Bildende Kunst im Germanisches Nationalmuseum Nürnberg, Nuremberg 1998, p. 83.

Spies 2000
Werner Spies, *Picasso – The sculptures*. Catalogue raisonné of the sculptures in collaboration with Christine Piot, Ostfildern-Ruit 2000.

Städtke 2001
Klaus Städtke, entry for "Form", in: *Ästhetische Grundbegriffe. Historisches Wörterbuch*, vol. 2, Stuttgart/Weimar 2001, p. 472–494.

Stallabrass 1992
Julian Stallabrass, "The Mother and Child Theme in the work of Henry Moore", in: Cologne 1992, pp. 13–39.

Steimann 1999
Dirk Steimann, "Entwicklungslinien im plastischen Werk: Ernst Hermanns zum 85. Geburtstag", in: Münster 1999, pp. 22–27.

Steiner 1989
Rudolf Steiner, *Theosophy. An introduction to the supersensible knowledge of the world and the destination of Man. 5th edition*, London 1989

Steingräber 1978
Erich Steingräber (in collaboration with Michael Semff), "Henry Moore – Maquetten. Zum Wandel des Arbeitsprozesses in seinem Werk", in: *Pantheon* III, year XXXVI, July/August/ September 1978, pp. 240–260.

Stemmler 1983
Dierk Stemmler, *G. F. Ris. Lichtwände/ Lichtpfeiler/ Lichtfelder,* Heidelberg (Edition Rothe) 1983.

Sternelle 1960
Kurt Sternelle, "Henry Moore im Hamburger Kunstverein", in: *Die Weltkunst,* Munich 1960, vol. 12, p. 16.

Stötzer 1975
Werner Stötzer, "Arbeit am Stein", in: *Bildende Kunst* 8, 1975, p. 394.

Stötzer 2002
Werner Stötzer, *Gedanken und Gefühle,* Berlin 2002.

Strachan 1988
Walter J. Strachan, *A Relationship with Henry Moore 1942–1976,* London 1988.

Stuart/Revett 1762–1816
James Stuart/Nicholas Revett, *The Antiquities of Athens,* 4 vols., London 1762–1816.

Sutherland 1936
Graham Sutherland, "A trend in English draughtsmanship", in: *Signature,* 3rd July 1936, pp. 7–13.

Suzuki 1982
Daisetz Teitaro Suzuki, *Living by Zen,* ed. by Christmas Humphreys, London 1982.

Taillandier 1963
Yvon Taillandier, *Conversation avec Archipenko,* in: XXe Siècle, NS. XXV, no. 22 (Christmas 1963), supplement.

Thistlewood 1996
David Thistlewood (ed.), *Barbara Hepworth reconsidered,* Liverpool 1996.

Thistlewood 1998
David Thistlewood, "Herbert Read's Organic Aesthetic, Teil I, 1918–1950", in: David Goodway (ed.), *Herbert Read Reassessed,* Liverpool 1998.

Thompson 1917
D'Arcy Wentworth Thompson, *On Growth and Form,* London 1917.

Thompson 1966
D'Arcy Wentworth Thompson, On growth and Form, abridged edition, edited by John Tyler Bonner, Cambridge 1966.

Thompson 2006
D'Arcy Wentworth Thompson, *Über Wachstum and Form.* Vorgestellt von Anita Albus und der von John Tyler Bonner besorgten Ausgabe. Vorwort von Stephen Jay Gould. (Die Andere Bibliothek), Frankfurt 2006.

Throl 1998
Hans-Joachim Throl, *Henry Moore unter freiem Himmel in Deutschland. Skulpturen des englischen Bildhauers im öffentlichen Raum,* published to mark Henry Moore's 100th birthday on the 30th July 1998, Städtische Galerie Wolfsburg, Wolfsburg 1998.

Thurmann 1998
Ernst Barlach, *"Mehr als ich",* ed. by Hans-Werner Schmidt and Peter Thurmann, Schleswig-Holsteinischer Kunstverein, 21.6.–13.9.1998, Kiel 1998.

Thwaites 1957/1960
John Anthony Thwaites, *Ich hasse die moderne Kunst,* Krefeld/Baden-Baden ¹1957, Frankfurt am Main ²1960.

Travlos 1971
John Travlos, *Pictorial Dictionary of Ancient Athens,* London 1971.

Trier 1955
Eduard Trier, "Kunstgespräch auf dem Bahnhof. Versuch eines Interviews mit Henry Moore", in: *Welt der Arbeit* (supplement), no 13, 24.6.1955.

Trier 1969
Eduard Trier, *Form and Space. The Sculpture of the Twentieth Century,* Berlin 1960.

Trier 1970
Eduard Trier, "Motivwanderungen aus der Antike ins 20. Jahrhundert", in: *Festschrift für Heinz Ladendorf,* Cologne/Vienna 1970, pp. 129–136.

Trier 1993a
Eduard Trier, "Raumplastik – Ein gelehrter Wahn?", in: *Marburger Jahrbuch für Kunstwissenschaft,* vol. 23, Marburg 1993, pp. 9–18.

Trier 1993b
Eduard Trier, "Erinnerungen an Henry Moore", in: *Festschrift zum 65. Geburtstag von Siegfried Salzmann,* ed. by Kunstverein in Bremen, Heidelberg 1993, p. 77.

Trier 1999
Eduard Trier, *Bildhauer-Theorien im 20. Jahrhundert,* revised edition, Berlin 1999.

Tübingen 1958
Henry Moore und englische Zeichner, May 1958, Tübingen 1958.

Tuchelt 1970
Klaus Tuchelt, *Die archaischen Skulpturen von Didyma. Beiträge zur frühklassischen Plastik in Kleinasien,* Berlin 1970.

Tyler/Lapp 1999
Dorcas Tyler/Axel Lapp, *Sculpture for a New Europe: Public Sculpture from Britain and the two Germanies: 1945–68,* Leeds City Art Gallery, Leeds 1999.

Umland 2001/02
Anne Umland, "Giacometti und der Surrealismus", in: Zurich, New York 2001/02, pp. 12–29.

Van Bruggen 1988
Coosje van Bruggen, *Bruce Nauman,* Basle 1988.

Vecci, di 2001
Pierluigi di Vecci, *The Sistine Chapel,* Lucerne 2001.

Viebrock 1946
Helmut Viebrock, *Die Anschauungen von John Keats über Dichter and Dichtung. Nach seinen Briefen, Essays and Gedichten,* Marburg 1946.

Vitruv 1991
Vitruvius, *De Architectura libri decem/*Zehn Bücher über Architektur, Latin-German, transl. by C. Fensterbusch, Darmstadt 1991.

Waenerberg 2005
Annika Waenerberg, "Das Organische in Kunst and Gestaltung. – Eine kurze Geschichte des Begriffs", in: Annette Geiger (ed.), *Spielarten des Organischen in Architektur, Design und Kunst,* Berlin 2005, pp. 21–35.

Wagner 2000
Monika Wagner, *Lexikon des künstlerischen Materials: Werkstoffe der modernen Kunst von Abfall bis Zinn,* Munich 2000.

Wayne 1994
Kenneth Eric Wayne, *The Role of Antiquity in the development of modern sculptures in France, 1900–1914,* Ph.D. thesis, Stanford University 1994.

Waldman 1982
Diane Waldman, *Anthony Caro,* New York 1982.

Walters 1903
H. B. Walters, *Catalogue of the Terracottas in the Department of Greek and Roman Antiquities,* British Museum, London 1903.

Warner 1996
David Nash: Forms into Time, with an essay by Marina Warner, London 1996

Weber 1978/79
Wilhelm Weber, "Toni Stadler im Mittelrheinischen Landesmuseum", in: Mainz 1978, pp. 5–7.

Weczerik 1988
Thomas Weczerik, *Toni Stadler. Das plastische Werk.* With a catalogue of works, Munich 1988, pp. 15–25.

Wedewer 1980
Rolf Wedewer, "Zur Naturvorstellung Henry Moores", in: *Pantheon* XXXVIII, 1980, pp. 186–193.

Weisner 1969
Ulrich Weisner, "Die Zeichnungen Henri Gaudier-Brzeskas", in: *Henri Gaudier-Brzeska 1891–1915,* Kunsthalle Bielefeld 1969, pp. 29–36.

Wellmann 2005
Marc Wellmann (ed.), *Bernhard Heiliger 1915–1995. Monographie und Werkver-zeichnis,* Cologne 2005.

Wenk 1997
Silke Wenk, *Henry Moore. Large Two Forms. Eine Allegorie des modernen Sozial-staates,* Frankfurt 1997.

Wieg 1998
Cornelia Wieg, "Metamorphosen. Zu den Daphne-Figuren von Wieland Förster", in: Dresden 1998, pp. 75–88.

Wiese 1923
Erich Wiese, *Alexander Archipenko* (Junge Kunst, vol. 40), Leipzig 1923.

Wiese 1955
Erich Wiese, Introduction to: Darmstadt 1955.

Wilkin 1991
Karen Wilkin, *Caro,* ed. by Ian Barker, Munich 1991.

Wilkinson 1977
Alan Wilkinson, *The Drawings of Henry Moore,* London 1977.

Wilkinson 1979
Alan Wilkinson, *The Moore Collection in the Art Gallery of Ontario,* Ontario 1979.

Wilkinson 1981
Alan Wilkinson, *Gauguin to Moore: Primitivism in Modern Sculpture,* Toronto 1981.

Wilkinson 1982
Alan Wilkinson, *Henry Moore Sketchbook 1928: The West Wind Relief,* Much Hadham 1982.

Wilkinson 1984a
Alan Wilkinson, *The Drawings of Henry Moore,* New York/London 1984.

Wilkinson 1984b
Alan Wilkinson, "Henry Moore", in: *Primitivismus in der Kunst des 20. Jahrhun-derts,* ed. by William Rubin, Munich 1984, pp. 609–627.

Wilkinson 1984c
Alan Wilkinson, "Henry Moore Drawings 1979–1983: Reminiscences and Continu-ing Themes", in: London 1984.

Wilkinson 1987
Alan Wilkinson, *Henry Moore Remembered.* The Collection at the Art Gallery of Ontario in Toronto, Toronto 1987.

Wilkinson 1989
Alan Wilkinson, *Jacques Lipchitz: A Life in Sculpture,* Toronto 1989.

Wilkinson 1994–95a
Alan Wilkinson, "Cornwall and the Sculpture of Landscape: 1939–1975", in: Liver-pool 1994, pp. 79–116.

Wilkinson 1994–95b
Alan Wilkinson, "The 1930s: Constructive Forms and Poetic Structure", in: Liver-pool 1994, pp. 31–69.

Wilkinson 2002
Alan Wilkinson (ed.), *Henry Moore: Writings and Conversations,* London 2002.

Williams 1998
Glynn Williams, "Moore, a Relevance: Influence on Contemporary Practice", Con-tribution to the Symposium *Place – Body – Script: Contemporary Views on Henry Moore,* University of East Anglia, Norwich, 4.–6.12.1998.

Woollcombe 1997
Tamsyn Woollcombe, *Kenneth Armitage: Life and Work,* Much Hadham 1997.

Worner 1962
Heinz Worner, "Deutsche antifaschistische Künstler im englischen Exil 1939–1946", in: *Bildende Kunst* 3, 1962, pp. 142–152.

Worsley 2005
Victoria Worsley, "Discoveries in the Henry Moore Institute Archive", in: *The Henry Moore Foundation Review* 14, winter 2005, p. 15.

Wünsche 2005
Isabel Wünsche, "Organische Modelle in der Kunst der klassischen Moderne", in: Annette Geiger (ed.) et al, *Spielarten des Organischen in Architektur, Design und Kunst,* Berlin 2005, pp. 97–111.

Yashiro 1970
Shuji Yashiro, "Sculpture and Landscape. An Essay on Henry Moore's sculpture" (English translation), in: *Geibun Kenkyu,* no. 29, May 1970, pp. 19–34.

Zarnecki 1953
George Zarnecki, "The Chichester Reliefs", in: *The Archaeological Journal,* vol. CX, July 1953, pp. 105–119.

Zbikowski 1998
Dörte Zbikowski, "Der Chacmool als Anregung für Moores Reclining Figures", in: exh. cat. Vienna 1998, pp. 127–143.

Zervos 1929
Christian Zervos, "Projets de Picasso pour un monument", in: *Cahiers d'Art* 8–9, 1929.

Zervos 1932–86
Christian Zervos, *Pablo Picasso,* vol. I–XXXIII, catalogue raisonné of the paintings 1895–1972, Paris 1932–1986.

Zervos 1934
Christian Zervos, *L'art en Grèce des temps préhistoriques au début du XVIIe siècle,* Paris 1934.

Zimmermann 1955
Mac Zimmermann. Ein Skizzenbuch, with an afterword by Bernhard Degenhart, (Piper Library) Munich 1955.

Zinkand 1992
Werner Zinkand (ed.), *Mac Zimmermann zum 80. Geburtstag,* Bayerische Akade-mie der Schönen Künste, Munich 1992.

Zinke 1981
Detlev Zinke, *Italien, Frankreich, Spanien, Deutschland, 800–1380,* Bestandskata-log. Liebieghaus, Museum Alter Plastik. Nachantike großplastische Bildwerke, Melsungen 1981.

Zorach 1967
William Zorach, *Art is my Life,* Cleveland and New York 1967.

Zurich 1966
Die Heilige Schrift des Alten and Neuen Testaments, Zurich 1966.

Zuschlag 1998
Christoph Zuschlag, "Vive la critique engagée! – Kunstkritiker der Stande Null: John Anthony Thwaites (1909–1981) ", in: exh. cat. Heidelberg 1998, pp. 166–172.

Exhibition Catalogues

Andros 2000
Henry Moore: In the light of Greece, Museum of Contemporary Art, Andros, 25.6.–17.9.2000, Goulandris Foundation, Anauseydros 2000.

Baden-Baden 1973
Präraffaeliten, ed. by Günter Metken, Staatliche Kunsthalle Baden-Baden, 23.11.1973–24.2.1974, Baden-Baden 1973.

Baden-Baden 1986–87
ZEN 49. Die ersten zehn Jahre. – Orientierungen, ed. by Jochen Poetter, Staatli-che Kunsthalle Baden-Baden, 6.12.1986–15.2.1987, Baden-Baden 1986.

Bad Homburg v.d.H. 1990
Hans Steinbrenner. Skulpturen 1948–1960, Bad Homburg v. d. Höhe, Sinclair-Haus, 23rd October until 16th December 1990, Bad Homburg v. d. H. 1990.

Bad Homburg v.d.H. 1994
Henry Moore. Ethos and Form, eine Ausstellung der Henry Moore Foundation in association with the city of Pforzheim and Altana AG, Bad Homburg v. d. H., Reuchlinhaus Pforzheim, 3.7.–28.8.1994, Sinclair-Haus, Bad Homburg v.d. Höhe, 13.9.–30.11.1994, Pforzheim and Bad Homburg v. d. H. 1994.

Basle 1989
Paul Cézanne: The Bathers, ed. Mary Louise Elliot Krumrine with contributions by Gottfried Boehm and Christian Geelhaar, in association with Kunstmuseum Basle, 10.9.–10.12.1989, London 1990.

Basle 1996
Canto d'Amore. Klassizistische Moderne in Musik and bildender Kunst 1914–1935, ed. by Gottfried Boehm, Ulrich Mosch, Katharina Schmidt, Kunstmuseum Basle, 27.4.–11.8.1996, Basle 1996.

Berlin 1970
Matschinsky-Denninghoff, Nationalgalerie Berlin, Stattliche Museen Preußischer Kulturbesitz, 21.3.–20.4.1970.

Berlin/Halle 1977
Werner Stötzer. Plastik and Zeichnung, Altes Museum Berlin, Staatliche Galerie Moritzburg; Berlin and Halle 1977.

Berlin 1978
René Graetz 1908–1974. Grafik and Plastik, Gedenkausstellung zum 70. Geburtstag, Staatliche Museen zu Berlin, Nationalgalerie, Kupferstichkabinett, Sammlung der Zeichnungen, August – October 1978, Berlin 1978.

Berlin 1986
Gustav Seitz 1906–1969. Plastik. Zeichnungen. Graphik, Altes Museum Dezember 1986–Februar 1987, ed. by Fritz Jacobi and Horst-Jörg Ludwig, Akademie der Künste der DDR/Staatliche Museen zu Berlin Nationalgalerie, Berlin 1986.

Berlin/Tübingen 1988a
Joseph Beuys: The Secret Block for a Secret Person in Ireland, curated by Céline Bastian, ed. by Heiner Bastian. With a text by Dieter Koepplin, Martin Gropius Bau Berlin/Kunsthalle Tübingen, Munich 1988

Berlin 1988b
Das mykenische Hellas – Heimat der Helden Homers, ed. by Katie Demakopoulou, Staatl. Museen Preuß. Kulturbesitz, 1.6.–19.8.1988, Athens 1988.

Berlin/Bonn Heilbronn/Magdeburg/Rostock 1991–92
Werner Stötzer. Skulptur and Zeichnung, ed. Akademie der Künste zu Berlin, Landesregierung Nordrhein Westfalen and Landschaftsverband Rheinland, 1991–1992, Akademie der Künste zu Berlin, Cologne 1991

Berlin/Lausanne/Bremen/Mannheim 1996–1997
Aristide Maillol, ed. by Ursel Berger and Jörg Zutter, Berlin, Georg-Kolbe-Museum 14.1.–15.5.1996 (and elsewhere), Munich 1996.

Berlin 2003
Kunst in Deutschland. Eine Retrospektive der Nationalgalerie, ed. by Eugen Blume and Roland März, Nationalgalerie, Preußischer Kulturbesitz, Berlin 2003

Berlin/Duisburg 2006
Tony Cragg. In and Out of Material, Akademie der Künste, Berlin, 16.9.–29.10.2006, Wilhelm Lehmbruck Museum, Duisburg, 18.2.–15.4.2007, Cologne 2006.

Bochum 1984
Vadim Sidur. Skulpturen, Museum Bochum, 24.3.1984–29.4.1984 (documents and articles referring to Russian art and literature, vol. 1), Bochum 1984.

Bonn, Frankfurt/Düsseldorf 1982
Goethe in der Kunst des 20. Jahrhunderts, ed. by Petra Maisak, Bonn-Bad Godesberg Wissenschaftszentrum, 22.3.–2.5.1982, Frankfurt Goethe-Museum, 26.5.–3.1.8.1982, Düsseldorf Goethe-Museum, 12.9.–3.1.10.1982, Frankfurt 1982.

Bonn/Munich/Mannheim 1987–88
Bildhauerkunst aus der DDR, Bonn, Rhein. Landesmuseum 10.9.1987–18.10.1987, Munich, Staatsgalerie Moderner Kunst 5.11.1987–3.1.1988, Mannheim, Städt. Kunsthalle 24.1.1988–21.2.1988, Zentrum für Kunstausstellung der DDR, Berlin 1987.

Bonn/Rome 2003
Tony Cragg. Signs of Life, Kunst- and Ausstellungshalle der Bandesrepublik Deutschland, 23.5.–5.10.2003, MACRO, Museo d'Arte Contemporanea, Roma, 6.6.–7.9.2003, Düsseldorf 2003.

Bremen 1986
Werner Stötzer. Plastik and Zeichnungen, Gerhard Marcks-Stiftung, Bremen, in Zusammenarbeit mit der Akademie der Künste der Deutschen Demokratischen Republik, Bremen 1986

Bremen/Berlin/Heilbronn 1997–98
Henry Moore – Animals, ed. by the Gerhard Marcks-Stiftung, curated by Martina Rudloff, Gerhard-Marcks-Haus, Bremen 12.10.1997–25.1.1998, Georg-Kolbe-Museum, Berlin 8.2.–3.5.1998, Städtische Museen, Heilbronn 15.5.–23.8.1998, Bremen 1997.

Cambridge/Bristol/York 1983
Henri Gaudier-Brzeska: Sculptor 1891–1915, ed. by Jeremy Lewison, The Arts Council of Great Britain: Kettle's Yard Gallery, Cambridge 15.10.–20.11.1983, City of Bristol Museum and Art Gallery 26.11.–7.01.1984, York City Art Gallery 14.01.–19.02.1984, Cambridge 1983.

Chemnitz 2001
Anthony Cragg. Skulpturen, ed. by Ingrid Mössinger and Beate Ritter, Kunstsammlungen Chemnitz, Leipzig 2001

Chemnitz 2002
Picasso et les femmes, ed. by Ingrid Mössinger, Beate Ritter and Kerstin Drechsel, Kunstsammlungen Chemnitz, Cologne 2002

Dallas/San Francisco/Washington 2001
Henry Moore: Sculpting the 20th Century, ed. by Dorothy Kosinski, Dallas Museum of Art 25.2.–27.5.2001; Fine Arts Museums of San Francisco, 24.6.–16.9.2001; National Gallery of Art, Washington, 21.10.2001–27.1.2002; Dallas 2001.

Darmstadt 1955
Alexander Archipenko. Plastik – Malerei – Zeichnungen – Druckgraphiken, Mathildenhöhe Darmstadt, 5.6.–1.8.1955 (and elsewhere), Darmstadt 1955.

Darmstadt/London 1982
Graham Sutherland, edited by Sabine Michaelis, Mathildenhöhe Darmstadt, Tate Gallery London, Darmstadt 1982.

Dresden/Moritzburg/Halle 1998
Wieland Förster. Plastik. Zeichnung, Staatliche Kunstsammlungen Dresden. Skulpturensammlung Albertinum/Staatliche Galerie Moritzburg Halle/Kunstverein Aurich e.V./Kunstpavillon am Ellernfeld, Dresden 1998.

Düsseldorf/Baden-Baden/Nuremberg 1968–69
Henry Moore, Düsseldorf, Städtische Kunsthalle 23.7.–8.9.1968; Staatliche Kunsthalle Baden-Baden, 15.11.1968–12.1.1969; Städtische Kunstsammlungen, Nuremberg, 24.1.–16.3.1969, Düsseldorf 1968.

Düsseldorf 2002
Joan Miró. Schnecke, Frau, Blume, Stern, ed. by Wiese and Silvia Martin, Museum Kunst Palast Düsseldorf, 13.7.–6.10.2002, Düsseldorf 2002.

Florence 1972
Mostra di Moore. Florence, Forte di Belvedere 20.5.–30.9.1972, Florence 1972.

Fontainebleau 2007
Picasso à Fontainebleau été 1921, Chateau Fontainebleau 2007

Hamburg/Düsseldorf 1950
Henry Moore. Skulpturen und Zeichnungen, Kunsthalle Hamburg/Städtische Kunstsammlungen Düsseldorf, London 1950.

Hamburg 1960
Henry Moore, Kunstverein Hamburg, 28.5.–3.7.1960, Hamburg 1960.

Hamburg 1983
Verfolgt and Verführt – Kunst unter dem Hakenkreuz in Hamburg 1939–1945, Kunsthalle Hamburg, Hamburg 1983

Hamburg 1998
Bruce Nauman. Versuchsanordnungen. Werke 1965–1994, Hamburger Kunsthalle, Hamburg 1998.

Hanover 1970
Giorgio de Chirico, curated by Wieland Schmied, Kestner-Gesellschaft Hanover 10.7.–30. 8.1970, Hanover 1970.

Hanover / Munich 1996
BLAST. Vortizismus. Die erste Avantgarde in England 1914–1918, curated by Karin Orchard, Hanover, Sprengel Museum 18.8.–3.11.1996; Munich, Haus der Kunst 15.11.1996–26.1.1997, Berlin 1996.

Heidelberg 1998
Brennpunkt Informel, ed. by Christoph Zuschlag/Hans Gercke/Annette Frese, Kurpfälzisches Museum der Stadt Heidelberg, Heidelberger Kunstverein, Cologne 1998

Heilbronn 1998
Der ausgehöhlte Stamm. Kunst and Kultobjekte aus Europa, Afrika and Ozeanien, Städtische Museen, Heilbronn, 11.9.–8.11.1998, Heidelberg 1998.

Heilbronn 1999
La Mano: Die Hand in der Skulptur des 20. Jahrhunderts, curated by Dieter Brunner, Städt. Museen Heilbronn, Heidelberg 1999, pp. 61.

Kiel 1998
Ernst Barlach – "Mehr als ich", ed. by Hans-Werner Schmidt and Peter Thurmann, Schleswig-Holsteinscher Kunstverein, 21.6.–13.9.1998, Kiel 1998

Köln/Unna/Ratzeburg/Huddersfield 1992
Henry Moore – Mutter and Kind/Mother and Child, Käthe-Kollwitz-Museum Köln 19.3.–1.5.1992, Schloss Cappenberg Kreis Unna 7.5.–21.6.1992, Kunstkreis Norden 28.6.–6.8.1992, Ernst Barlach Museum Ratzeburg 28.8.–11.10.1992, City Art Gallery Huddersfield 23.10.–5.12.1992, Much Hadham 1992.

Cologne/Rome 2003
Cragg. Signs of Life, ed. by Kay Heymer, Kunst- and Ausstellungshalle der Bundesrepublik Deutschland and Museo d'Arte Contemporanea Roma, Düsseldorf 2003.

Leeds 1993
Herbert Read: A British Vision of World Art, ed. by Benedict Read and David Thistlewood. Leeds City Art Galleries in partnership with the Henry Moore Foundation, London 1993.

Leningrad/Moscow 1991
Henry Moore: The Human Dimension. English version ed. by The Henry Moore Foundation in collaboration with the British Council, London 1991.

Leverkusen 1977
Ernst Neizvestny. Plastiken, Grafiken, Zeichnungen, Städtisches Museum Leverkusen. Schloss Morsbroich, Leverkusen 1977.

Liverpool/New Haven/Toronto 1994–95
Barbara Hepworth. A Retrospective, ed. by Penelope Curtis and Alan Wilkinson, Tate Gallery Liverpool, 14.9.–4.12.1994, New Haven, Yale Center for British Art, 4.2.–9.4.1995, Toronto, Art Gallery of Ontario, 19.5.–8.7 1995; Liverpool 1994.

London 1951
Sculpture and drawings by Henry Moore, Tate Gallery, London 2.5.–29.7.1951, London 1951.

London 1968
Henry Moore, ed. by David Sylvester, Tate Gallery 17.7.–22.9.1968, London 1968.

London 1978a
Dada and Surrealism reviewed, ed. by Dawn Ades, Arts Council of Great Britain, Hayward Gallery 11.01.–27.3.1978, London 1978.

London 1978b
William Blake, Tate Gallery, 9.3.–21.5.1978, London 1978.

London 1981
British Sculpture in the Twentieth Century, ed. by Sandy Nairne and Nicholas Serota: Whitechapel Art Gallery, London 1981

London 1984
Henry Moore. Drawings 1979–1983 from The Henry Moore Foundation, London, Marlborough Fine Art, 5.9.–19.10.1984, London 1984.

London and Düsseldorf 1984–85
Anthony Caro. Skulpturen 1969–84, Arts Council of Great Britain, Serpentine Gallery, London, 12.4.–28.5.1984, Kunstmuseum Düsseldorf, 27.1.–1.3.1985, London 1984.

London 1986
Tree to Vessel. David Nash Sculpture, Juda Rowan Gallery, London 17.4.–24.5.1986, London 1986.

London/New York 1987
A Quiet Revolution of the British Sculpture, London, New York 1987

London 1988
Henry Moore, ed. by Susan Compton, with articles by Richard Cork and Peter Fuller, Royal Academy of Arts, London 1988.

London 1988
Henry Moore and Michael Rosenauer at the Fine Art Society, 31.10.–16.11. 1988, Gallery Lingard/The Fine Art Society, London 1988

London 1989
David Nash. Sculpture and Projects 1986–1989, Annely Juda Fine Art, 24.5.–24.6.1989, London 1989.

London 2002
Aztecs, ed. by Eduard Matos Moctezuma and Felipe Solis Olguin, Royal Academy of Arts, London 16.11.2002–11.4.2003, London 2002.

Madrid 1981
Henry Moore. Sculptures, Drawings, Graphics 1921–1981, Palacio de Velázquez, Palacio de Cristal, Parque El Retiro, Madrid, May–August 1981, Madrid 1981.

Milan 1993
Henry Moore. Disegni, sculture, grafica, with an introduction by Mario Botta, Galeria Pieter Coray Lugano, April–May 1993, Milan 1993.

Mainz/Munich 1978
Toni Stadler, Mittelrheinisches Landesmuseum Mainz 1979, ed. by Armin Zweite, Städtische Galerie im Lenbachhaus, Munich 1978

Minneapolis 1994
Bruce Nauman, Walker Art Center, Minneapolis 1994.

Moyland 2000
Paul Klee trifft Joseph Beuys. Ein Fetzen Gemeinsamkeit, ed. by Tilman Osterwold, Museum Schloss Moyland, Bedburg-Hau, 13.8.–29.10.2000, Ostfildern-Ruit 2000.

Much Hadham 2002
Hands On! Creative Projects, Henry Moore Collections and Exhibitions, The Henry Moore Foundation, Much Hadham 2002.

Much Hadham 2005
Anita Feldman Bennet, *Henry Moore and the Challenge of Architecture*, Sheep Field Barn Gallery, Perry Green, The Henry Moore Foundation, Much Hadham 2005.

Much Hadham 2007
David Mitchinson, *Moore and Mythology*, Sheep Field Barn Gallery, Perry Green; Musée Bourdelle, Paris; Much Hadham 2007.

Münster 1999
Ernst Hermanns, Westfälisches Landesmuseum für Kunst and Kulturgeschichte Münster, Münster 1999.

Nantes/Saarbrucken/St. Gallen 1994–95
Tony Cragg. Zeichnungen, Musée des Beaux-Arts de Nantes 22.1.–24.4.94, Stadtgalerie Saarbrücken 30.4.–26.6.94, Kunstmuseum St. Gallen 3.12.–29.2.95, Ostfildern 1994.

Nantes/Mannheim 1996–97
Henry Moore. Ursprung and Vollendung: Gipsplastiken, Skulpturen in Holz and Stein, Zeichnungen, ed. by Claude Allemand-Cosneau, Musée des Beaux-Arts, Nantes 3.5.–2.9.1996, Städtische Kunsthalle, Mannheim 29.9.1996–12.1.1997, Munich 1996.

New York/Chicago/San Francisco 1946
Henry Moore. With an introduction by James Johnson Sweeney, Museum of Modern Art, New York 1946

Nuremberg 2005
Tony Cragg familiae, Neues Museum Nürnberg, Nuremberg 2005.

Otterlo/Baden-Baden 1981
Bruce Nauman, 1972–1981, Rijksmuseum Kröller-Müller, Otterlo and Staatliche Kunsthalle Baden-Baden, Amsterdam 1981.

Paris 2000
D'aprés l'antique, Musée du Louvre, 16.19.2000–15.1. 2001, Paris 2000

Pforzheim/Bad Homburg v. d. H. 1994
Henry Moore. Ethos and Form, exh. cat. Pforzheim, Bad Homburg v. d. H. 1994.

Philadelphia 1995
Friedrich Teja Bach/Margit Rowell/Ann Temkin, *Constantin Brancusi 1876–1957*, Philadelphia Museum of Art 08.10.–31.12.1995, Centre Georges Pompidou, Paris 14.04.–21.08.1995, Philadelphia 1995.

Portsmouth 1978
UNIT I, Portsmouth City Museum and Art Gallery, 20.5.–9.7.1978.

Recklinghausen 1952
Mensch and Form unserer Zeit. Städtische Kunsthalle Recklinghausen 13.6.–3.8.1952, Recklinghausen 1952.

Recklinghausen 1955
Das Bild des Menschen in Meisterwerken europäischer Kunst, Städtische Kunsthalle Recklinghausen 12.06.–26.07.1955, Recklinghausen 1955.

Recklinghausen 1997
David Nash. Skulpturen, ed. by Ferdinand Ullrich, Kunsthalle Recklinghausen 5.10.–5.11.1997, Bielefeld 1997.

Recklinghausen, Heilbronn 2003
Marino Marini. Skulptur, Malerei, Zeichnung (with English translation), ed. by Ferdinand Ullrich, Hans-Jürgen Schwalm, Andreas Pfeifer, Dieter Brunner, Kunsthalle Recklinghausen and Städtische Museen Heilbronn 2003.

Rostock 1988
Jo Jastram, Berlin, Akademie der Künste der DDR, Kunsthalle Rostock, 1988.

Rotterdam/Berlin/Bielefeld/Bonn 1979–80
Joseph Beuys: Zeichnungen – tekeningen – drawings, Catalogue by Heiner Bastian and Jeannot Simmen, Museum Boymans-van Beuningen, Rotterdam, November 1979–January 1980; Nationalgalerie Berlin, Staatliche Museen Preußischer Kulturbesitz, March-May 1980; Kunsthalle Bielefeld, June–July 1980; Wissenschaftszentrum Bonn, August-September 1980, Berlin 1979.

Rotterdam 2006–07
Henry Moore. Sculptuur en architectuur, ed. by Wim Pijbes, Kunsthalle Rotterdam, 14.10.2006–28.1.2007, Rotterdam 2007

Schwäbisch Hall 2005
Henry Moore: Epoche und Echo. Englische Bildhauerei im 20. Jahhundert, ed. by Sylvia Weber, Kunsthalle Würth, Schwäbisch Hall, Künzelsau 2005

Stuttgart 1972
James Ensor. Ein Maler aus dem späten 19. Jahrhundert, ed. by Uwe M. Schneede, Württembergischer Kunstverein, Stuttgart 4.3.–7.5.1972, Stuttgart 1972.

Stuttgart 2004
Picassos Badende, ed. by Ina Conzen, Staatsgalerie Stuttgart, Stuttgart 2004, pp.15–177.

Tokyo and Fokuoka 1986
The Art of Henry Moore. Sculptures, Drawings and Graphics 1921 to 1984, Metropolitan Museum Tokyo, 11.4.–5.6.1986; Fukuoka Art Museum, 21.6.–27.7.1986.

Tokyo 2004
Henry Moore: The Expanse of Nature – The Nature of Man, The Hakone Open Air Museum, Tokyo 2004

Toronto 1994–95
Barbara Hepworth. A Retrospective, ed. by Penelope Curtis and Alan Wilkinson, Tate Gallery Liverpool; Art Gallery of Ontario, Toronto, 1994/95; London 1994, pp. 11–28.

Venice 1948
Henry Moore, exh. cat. Venice Biennale, 1948.

Venice 1952
New Aspects on British Sculpture, exh. cat. Venice Biennale, 1952.

Wedel 1997
Barlach and Goethe – Zur künstlerischen Goethe-Rezeption bei Ernst Barlach, ed. by Jürgen Doppelstein, Ernst Barlach Museum Wedel, Hamburg 1997.

Vienna 1998
Henry Moore 1898–1986. Eine Retrospektive zum 100. Geburtstag, ed. by Winfried Seipel, and Michael Kausch, Vienna, Palais Harrach, 16.3.–9.8.1998, pp. 15–99.

Vienna 2000
Samuel Beckett/Bruce Nauman, Kunsthalle Vienna, Vienna 2000

Wolfsburg/Toulouse 2002
BLAST to freeze: Britische Kunst im 20. Jahrhundert, ed. by Holger Broeker, Kunstmuseum Wolfsburg, 14.9.2002–19.1.2003, Les Abattoirs, Toulouse, 24.2.–11.5.2003, Ostfildern-Ruit 2002.

Wolfsburg 2004
Henry Moore – Human Landscapes/Menschliche Landschaften, ed. by Susanne Pfleger, Städtische Galerie Wolfsburg 28.3.–27.6.2004, Bielefeld 2004.

Zurich/New York 2001–02
Alberto Giacometti, ed. by Christian Klemm, Kunsthaus Zurich, The Museum of Modern Art, New York 2001–2002.

Index

Index of Moore's Sculptures

Photo Credits

© The Henry Moore Foundation, Much Hadham: ill. 1, 2, 3, 5, 6, 7, 8, 9, 10, fig. 1, 2, 2a, 4 (photo: Michel Muller, Straßburg), 5, 6, 8, 9, 11, 13, 15 (photo: © Manchester Art Gallery, UK/bridgemanart.com), 16, 17, 20, 23, 25, 26, 28, 30, 32 (photo: Courtesy Art Gallery of Ontario), 34, 37 (photo: Michel Muller, Straßburg), 39, 40, 41, 42, 43 (photo: Menor Creative Imaging), 45 (photo: Menor Creative Imaging), 47 (photo: Wallace Heaton), 49, 50, 52, 54, 55, 56, 57 (photo: John Webb, London), 58, 59, 60, 61, 62, 63, 64, 65, 66 (photo: Errol Jackson, London), 67 (photo: Errol Jackson, London), 68 (photo: Errol Jackson, London), 69 (photo: Wallace Heaton, London), 70 (photo: John Hedgecoe, London), 71, 71a, 72, 73, 74, 75, 76, 77, 79, 81, 84, 86 (photo: Michel Muller, Straßburg), 88, 89, 90, 94, 96 (photo: Michel Muller, Straßburg), 97, 99, 102, 103, 104, 105, 107, 108, 110, 112, 113, 115, 116 (photo: Michel Muller, Straßburg), 117, 118 (photo: Alan Wilkinson, London), 119, 120, 121, 122, 123, 124, 124a, 125 (photo: Thomas Riehle, Köln), 126 (photo: author), 127 (photo: Wallace Heaton), 129, 130 (photo: Michel Muller, Straßburg), 131, 132, 133, 134, 136 (photo: Michel Muller, Straßburg), 137, 138 (photo: Michel Muller, Straßburg), 139, 140 (photo: Reunion Musées Nationaux), 141, 142, 143, 145 (photo: Michel Muller, Straßburg), 147, 150, 151, 153, 154, 156, 157, 158, 159, 160, 161, 162, 165, 168, 169, 171, 172, 173, 174, 176, 178, 179, 181, 181a, 183, 184, 185, 186, 188, 190, 191, 194 (photo: Courtesy Art Gallery of Ontario), 195, 198 (photo: Michael Phipps, Much Hadham), 199, 200 (photo: Prudence Cuming Associates Ltd., London), 202, 203, 207, 210, 212, 214, 215, 216, 217, 218 (photo: Errol Jackson, London), 218a (photo: Errol Jackson, London), 219 (photo: Errol Jackson, London), 220 (photo: Errol Jackson, London), 221 (© photo: Ulrich E. Milatz, Berlin), 222, 223 (photo: Collection, The Museum of Modern Art, New York), 224 (photo: Anita Feldman Bennet), 225 (photo: Michel Muller, Straßburg), 226 (photo: author), 230, 231, 232, 233, 236, 238, 240, 241, 242, 243 (photo: Titandra Arya), 244, 245, 246, 247 (photo: Michel Muller, Straßburg), 248 (photo: Michel Muller, Straßburg), 249, 250, 251, 253, 254, 255, 256, 260, 261, 263 (photo: Menor Creative Imaging), 264 (photo: Michel Muller, Straßburg), 269, 270, 273, 274, 275, 277, 278, 279 (photo: Michel Muller, Straßburg), 280, 281, 283, 285, 286 (photo: Michel Muller, Straßburg), 287 (photo: author), 288 (photo: Michel Muller, Straßburg), 289, 290, 291, 292, 293, 294 (photo: Jörg Pütz, Saarbrücken), 295 (photo: Jörg Pütz, Saarbrücken), 296 (photo: Jörg Pütz, Saarbrücken), 297 (photo: Jörg Pütz, Saarbrücken), 298 (photo: Jörg Pütz, Saarbrücken), 299 (photo: Jörg Pütz, Saarbrücken), 299a (photo: Jörg Pütz, Saarbrücken), 300, 301 (photo: Michel Muller, Straßburg), 302, 303, 304, 305, 306, 307, 308 (photo: Jörg Pütz, Saarbrücken), 309 (photo: Jörg Pütz, Saarbrücken), 310, 311, 312, 313, 314, 315, 316 (photo: author), 317, 321, 330, 335, 343 (photo: Errol Jackson, London), 344 (photo: David Rudkin), 347, 351, 354 (photo: Prudence Cuming Associates Ltd., London), 357, 359, 360, 362, 369, 371, 379, 382, 396, 397, 398, 399, 400, 405, 410, 411, 413, 414 (photo: Michel Muller, Straßburg), 418 (photo: author), 419 (photo: author), 420 (photo: author), 432, 435, 438, 439, 445, 447, 449, fig. I, II, III, IV, V, VI, VII, VIII, IX, X, XI, XIIa, XIIb, XIII, XIV, XV, XVI

© Lee Miller Archives, Chiddingly, England: ill. 4 (Photograph by Lee Miller)

Philadelphia Museum of Art: Purchased with the W. P. Wilstach Fund, 1937: fig. 3 (photo by: Graydon Wood)

Museo Nacional de Antropología, Mexico City: fig. 7

© Tate, London 2008: fig. 10, 266, 272

© Kettle's Yard, University of Cambridge: fig. 12 (photo: Paul Allitt)

Kunsthalle Bielefeld: fig. 14

© The estate of Sir Jacob Epstein: fig. 18 (Courtesy Nottingham City Museums and Galleries), 21 (photo: © Tate, London 2008), 22 (© 2008. Digital image, The Museum of Modern Art, New York/Scala, Florence), 24 (Yale University Art Gallery)

© 2008 The Trustees of The British Museum, London: fig. 19, 128, 135, 155, 163, 164, 166, 167, 175, 177, 180, 182, 234, 235, 237

© VG Bild-Kunst, Bonn 2008: fig. 27, 29, 31, 33, 35 (photo: ullstein bild/Roger Viollet), 332, 333 (photo: Jörg Pütz, Saarbrücken), 334, 336, 337, 338 (photo: Jörg von Bruchhausen), 361, 363 (photo: Jochen Littkemann), 364, 365, 366, 367 (photo: Ulrich Windoffer), 368, 370, 372, 373, 374, 375, 376 (photo: MCM ART Verlag, Bernd Kuhnert), 377 (photo: MCM ART Verlag, Bernd Kuhnert), 378 (photo: MCM ART Verlag, Bernd Kuhnert), 385 (photo: Maria Obenaus), 386 (photo: Maria Obenaus), 387 (photo: Hans Pölkow, Berlin), 388 (photo: Hans Pölkow, Berlin), 389 (photo: Ilona Ripke, Berlin), 390 (photo: Hans-Wulf Kunze, Mag-

deburg), 391, 392 (photo: bpk / Nationalgalerie, SMB / Jörg P. Anders), 393, 394, 395, 425, 426, 427, 428, 429, 430, 434, 440, 441, 442, 443 (photo: courtesy Sperone Westwater, NY), 444, 446 (photo: courtesy Sperone Westwater, NY), 450, 451, 452

© Succession Picasso/VG Bild-Kunst, Bonn 2008: fig. 36 (photo: bpk / RMN / Musée Picasso / Béatrice Hatala), 38 (photo: © The Metropolitain Museum of Art), 45 (photo: Peter Willi/ARTOTHEK), 46, 48 (© 2008. Digital image, The Museum of Modern Art, New York/Scala, Florence), 51 (photo: bpk / RMN / Musée Picasso / Thierry Le Mage), 53, 114

© ADAGP/FAAG, Paris/VG Bild-Kunst, Bonn 2008: fig. 80 (photo: 2008 © Paris, Centre Pompidou – CNAC-MNAM / Vertrieb bpk Berlin), 82 (photo: Martin Bühler), 83, 85 (photo: Peggy Guggenheim Collection, Venice [Solomon R. Guggenheim Foundation, NY])

© Successió Miró/VG Bild-Kunst, Bonn 2008: fig. 111

Nationalmuseum, Athen: fig. 144, 152

Deutsche Fotothek, Dresden: fig. 146

Louvre, Paris: fig. 187

© Victoria & Albert Museum, London: fig. 192, 258, 259

Uffizi, Florence: fig. 193

National Gallery, London: fig. 201, 204, 262

Bildarchiv Foto Marburg, Marburg: fig. 205

Florence, Museo della Casa Bounarroti, bpk / Scala: fig. 206

Florence, Galleria dell'Accadèmia, bpk / Scala: fig. 208,

Milan, Castello Sforzesco, bpk / Scala: fig. 209

© bpk / Scala / Milan, Pinacoteca di Brera: fig. 211

Städelsches Kunstinstitut, Frankfurt/M.: fig. 213 (photo: © Blauel/Gnamm-Artothek)

© Board of Trinity College, Dublin, Ireland/Bridgeman Art Library: fig. 227

Courtauld Institute of Art, London: fig. 228, 276

Yale Center for British Art, Paul Mellon Collection, USA/The Bridgeman Art Library: fig. 229, 257, 268, 271

Corpus Christi College, Bodleian Library, University of Oxford: fig. 239

The Warden and Fellows of Keble College, Oxford: fig. 267

Musée Rodin, Paris: fig. 280, 284

Kunstsammlungen Chemnitz: fig. 282 (photo: PUNCTUM/Bertram Kober)

Estate Karl Hartung, Oesdorf: fig. 318 (photo: Angelika Kohlmeier, Berlin), 319, 320, 322, 325, 326, 327 (photo: Jörg Pütz, Saarbrücken), 328, 329, 331 (photo: Frank Bartsch)

Matschinsky-Denninghoff, Berlin/Schönfeld: fig. 339 (photo: Vlasta Lische, Hamburg), 340, 341, 342, 345, 346, 348, 349

Estate Wilhelm Loth, Galerie Schlichtenmaier, Stuttgart: fig. 350

Estate Toni Stadler, München: fig. 352 (photo: Tina Volk, Saarbrücken), 353 (photo: Tina Volk, Saarbrücken), 355

Germanisches Nationalmuseum, Nürnberg: fig. 356, 358

Gustav Seitz Stiftung, Hamburg: fig. 380, 381 (photo: Kunsthalle Mannheim, Margita Wickenhäuser)

Kunstmuseum Kloster Unser Lieben Frauen, Magdeburg: fig. 383 (photo: Hans-Wulf Kunze)

Kunstmuseum Dieselkraftwerk, Cottbus: fig. 384